815/10
$37.00
Ted purc.

AMERICA'S ROME

AMERICA'S

VOLUME ONE ◆ CLASSICAL ROME

Volume II. Catholic and Contemporary Rome

Contents

Volume I. Classical Rome

Published with the assistance of the
Getty Grant Program

Title page illustration: Hermon Atkins MacNeil, *The
Sun Vow*. Courtesy Art Institute of Chicago.

In an earlier version the essay on the Colosseum
appeared in *Roman Images*, a volume of papers from
the English Institute edited by Annabel Patterson and
published by the Johns Hopkins University Press. An
essay based on material in Chapter 5 appeared in
Augustan Age.

Designed by Jo Aerne and set in Trump type. Printed
in the United States of America by Halliday
Lithograph, West Hanover, Massachusetts.

Library of Congress Cataloging-in-Publication Data
Vance, William L.
America's Rome / William L. Vance.
 p. cm. Includes bibliographies and indexes.
 Contents: v. 1. Classical Rome — v. 2. Catholic and
contemporary Rome.
 ISBN 0-300-03670-1 (v. 1 : alk. paper). ISBN
0-300-04453-4 (v. 2 : alk. paper)
 1. Arts, American—Italian influences. 2. Arts,
Modern—19th century—United States. 3. Arts,
Modern—20th century—United States. 4. Artists—
Travel—Italy—Rome. 5. Art and literature—United
States. 6. Rome (Italy) in art. 7. Rome (Italy)—
Intellectual life—19th century. 8. Rome (Italy)—
Intellectual life—20th century. I. Title.
NX503.7.V36 1989 88-20737
700'.973—dc19

10 9 8 7 6 5 4 3 2 1

William L. Vance

ROME

YALE UNIVERSITY PRESS
NEW HAVEN AND LONDON

Illustrations

Plates

following page 196

Acknowledgments

Most of the reading for this book was done in the McKim Building of the Boston Public Library, and it is to that noble institution that I am chiefly indebted. In the course of several years I was courteously and efficiently aided by the professional staff in Bates Hall, where I sat near the bust of Henry James, and in the Art Reference Library, where both the Medici Venus and the Venus of Canova kept me company along with William Wetmore Story's *Arcadian Shepherd Boy*, made in Rome. To take a breather in the library's sunny arcaded courtyard was to bring very close the subject of the books I was reading. An equally sympathetic environment was frequently found in the Boston Athenaeum, whose rare volumes are not too jealously guarded by a friendly staff and more Venuses. To the people in both of these libraries I extend my thanks.

I am grateful for the work of scholars who have explored the realm of my interest before me—especially for books by Van Wyck Brooks, Nathalia Wright, and Paul Baker, who mapped out much of the territory. But my indebtedness in volume I is even greater to those art historians, chiefly Wayne Craven and William Gerdts, whose herculean labors to establish the primary facts about nineteenth-century American sculpture and painting have established the historical foundations that make other commentary possible. My reliance on these scholars, and on other authors who have researched primary sources to write monographs on individual artists, has been extensive; specific cases of indebtedness I have tried to acknowledge in the notes and bibliography, an inadequate indication of the general value I have found in their work. Professors Craven and Gerdts also kindly responded to particular inquiries, as did Regina Soria, whose invaluable dictionary of American artists in Italy was not available until very late in my work, but whose long immersion in the life of Elihu Vedder in Rome had been an inspiration to me.

Peter Blume, Paul Cadmus, and Jack Levine beautifully replied to questions about their paintings, and I am very grateful to them. To the painter Alfred Russell and his wife, Joan, I owe a memorable and instructive evening of conversation over wine and cheese in their flat at the Chelsea Hotel.

Several colleagues and friends have read portions of the manuscript in its earlier

stages. For their criticism and encouragement I wish to thank John Malcolm Brinnin, George Landow, Naomi Miller, Roger Stein, and Helen Vendler. To Trevor J. Fairbrother I am especially indebted; he took an active interest in my project from its inception, passing on useful information and advice, showing me Sargents in storage, and giving my long essay on the Campagna a careful reading that greatly helped. Barton Levi St. Armand, of Brown University, wonderfully demonstrated how scholars can become friends without ever meeting; his incisive and sympathetic commentaries upon three of a stranger's drafted chapters displayed a generosity of spirit far beyond mere professional courtesy. At Boston University, a colleague in another department became a friend through the interest that he took in my book; it is impossible to overstate how much Fred Licht's enthusiastic response to the several hundred pages I imposed upon him meant to me—it provided the reassurance that saw me through to the end.

Many other people have my gratitude for contributions of various kinds. Among the countless blessings I have received from the friendship of my colleague Gerald P. Fitzgerald, an increase in my knowledge of Rome and in the ways of loving it is one of the more inestimable. Friends in Rome, to whom the book is dedicated, have sustained my work by changing their city from a place observed to a place of domestic intimacy, a second home. In Rome I am also indebted to Alessandra Pinto Surdi, chief librarian of the Centro di Studi Americani; the personal interest she took in my work made me the beneficiary of her energy, wit, and generosity. Professor Andrea Mariani of the University of Rome, who not only volunteered bibliographical suggestions but went far out of his way to assist me in the acquisition of photographs, is another friend whom I gained through my studies. At the library of the American Academy in Rome I was given generous access to interesting documents. In Boston I received gracious help from Carol Troyen of the Museum of Fine Arts, from Roger Howlett at the Childs Gallery, and from Howard Gotlieb, director of special collections at the Mugar Memorial Library of Boston University.

To the more than eighty individuals and institutions that have supplied me with photographs of artworks in their possession and permission to reproduce them, I extend my sincere thanks. Although the care and time of many people were involved in the process of locating works and assembling the photographs, I must mention in particular Patricia C. Geeson of the Office of Research Support at the National Museum of American Art (Smithsonian Institution). The project was also facilitated by the cheerful help of Barbara Gage Coogan, whose assistance was made possible by a grant from Boston University's Humanities Foundation, to which I wish to express my appreciation. Bobbi Coogan also applied her editorial skills to a wonderfully enthusiastic and attentive reading of the manuscript. Further contributions toward the cost of manuscript preparation were made by Boston University's Graduate School of Arts and Sciences, for which I am grateful to Deans Michael Mendillo and William C. Carroll.

My thanks for help in particular ways go also to Warren Adelson, Rodney Armstrong, James M. Dennis, Gianfranco Grande, Gerald Gross, Jonathan P. Harding, Donald Kelley, Harriet Lane, Lynne Lawner, Thomas W. Leavitt, David Garrard Lowe, John Matthews, Judy Metro, Richard Ormond, Marlene Park, Jan Seidler

Ramirez, Linda Smith Rhoads, Deborah Rosenthal, Judithe Speidel, and Theodore E. Stebbins. I was fortunate to have as my copy editor a most sympathetic and sharp-eyed reader, Cecile Watters.

To Charles W. Pierce, Jr., the first reader of all these pages, I owe a debt beyond words.

Preface

Those have not lived who have not seen Rome.
　　　　　　—Margaret Fuller (1848)

Rome became a city for me only when I chose, as did many before me, to give it a sense and for me Rome can exist only in so far as I have shaped it to my idea. . . . We are not in relationship with anything until we have enwrapped it in a meaning, nor do we know for certainty what that meaning is until we have costingly labored to impress it upon the object.
　　　　　　—Julius Caesar in Thornton Wilder's **The Ides of March** *(1948)*

This is a book about Rome.

This is a book about America.

For over two hundred years American writers, painters, and sculptors have been visiting Rome and making artifacts of their own national culture from what they saw and experienced there. This is a book about those artifacts—the representations of that experience in ink, paint, marble, and bronze.

Americans, sharing a fascination for Italy with German, French, and English writers and artists, were extremely conscious of the uses to which Italy had been put by other European nations in their own cultural self-definitions. But as citizens of a new nation, they felt that they had the most to gain and that what they gained would be distinctive. Both the uniqueness of their political identity and the deprivations of their cultural circumstances intensified their experience of Italy. In Italy were to be found a concentration of history and an access to experience, knowledge, and pleasure that could not be had at home. In 1869 Charles Eliot Norton wrote to his friend John Ruskin, "Italy is the country where the American, exile in his own land from the past record of his race, finds most of the most delightful part of the record." Two years later he contrasted the American experience of Italy with that of Germany: "In Italy one feels as if one had had experience, had known what it was to live, had learnt to know *something* if but very little, and could at least enjoy *much*."[1]

Although some Americans preferred to live in Florence or (later) Venice, Rome offered by far the richest repository of historical suggestion and the most provocative stimuli to creative representation. Indeed, in all the ways that Americans were obliged to confront the fact of Europe in the shaping of their own identity (an identity that owed more to Europe than it did to the western frontier), Rome offered the greatest challenge and some of the most precious gifts. England, as the "old home" of the Anglo-Saxon Americans who founded our culture and determined our language, was the place from which America most needed to differentiate itself. In contrast Rome before 1870 was the place most alien to America. Burdened and enriched by more historical strata than any other place; preserver of great art from antiquity and the Renaissance that had been inspired by pagan myths and celebrated the nude; center of a medieval religion from which the original Americans had fled; oppressed by autocratic rule and populated by a sensual and degraded people— Rome, a city with no future, was antithetical to what America was and (in all ways except the aesthetic) to dreams of what it might become. Rome thus originally had for Americans the attraction of the Other, both in the knowledge and beauty that it offered and in the horrors of its spiritual and social condition.

The story of American representations of Rome, however, is one of changes, in the representers as in the Rome represented. Hundreds of writers and artists have written their Roman fictions and commentaries or painted their Roman images and in doing so have represented themselves. But those who wrote of the modern capital of Italy in 1944, when the American Fifth Army passed through its walls, or painted it in 1955, in the days of la dolce vita, had little in common with those Americans who in 1844 or 1855 had visited a supposedly dying little papal city surrounded by a desolate Campagna. Within our narrative of America's possession of Rome through the works of its artists and writers, then, is the story of two great changes: in America's own idea of itself and in Rome as the place against which that idea could be measured.

Much has been written on the subject of Americans in Italy—first and most notably by Henry James, subsequently by Giuseppe Prezzolini, Van Wyck Brooks, Howard S. Marraro, Paul Baker, and Nathalia Wright, and most recently by Michele Rivas and Eric Amfitheatrof. One of the ways in which this book differs from theirs is that the subject of Americans in Italy has a secondary place; its primary focus instead is on Rome and on the actual works by Americans—the writings, paintings, and sculpture—that resulted from their encounter with Rome. These works, of course, always involve a degree of self-representation. This fact is of major significance since it determines the character of the Rome represented, which is always the product of partial perception and selective emphasis. But exploring what individual Americans *made* of their experience is a different thing from describing the historical phenomenon of the American presence in Italy. The lives of Americans in Rome appear here only as they affected representations of Rome. On the other hand, it has sometimes been necessary to consider the ideas of writers and the works of artists who never went to Rome at all, in order to define more sharply the motive of an argument or the relative quality of an achievement in the representations of those who did go.

But neither has a catalog of those representations been my purpose. I have been

most interested in exploring how the representations spoke to each other (not always knowingly), and in how they were devised as messages to America about itself or, in the case of paintings and sculptures, as appropriate, even necessary contributions to American culture. For nothing is further from the truth than the idea that American artists in Europe forgot who they were or where they came from. With rare exceptions, they labored as Americans for America. Some of the most eloquent testimonials from fellow citizens who visited their Roman studios are tributes to the heroism of the artists who lived in self-imposed exile so that they might become capable of giving America the great art it needed and deserved. Their sacrifice was a measure of their patriotism. The necessity of Rome to artists, and its effect upon them, were, of course, points of contention in the writings about Rome (including many by artists themselves). Indeed, Rome in all its aspects was problematical for Americans, as I have already intimated. Italy as a whole was very far from being the Dream of Arcadia or the Enchanted Land that it has been represented as being through a romantic emphasis upon its happier features. And in none of its four contemporary phases—papal, monarchical, fascist, and republican—has Rome offered unalloyed pleasure or an escape from "reality." The question of what could be ignored in order to enjoy what one wished Rome to be is therefore a common element in representations of Rome down to the present day. Starting from the Campagna in 1822 or from the Via Veneto in 1922, we may soon find ourselves far from the actual place, in an aesthetic forest or an aristocratic salon, equally pure products of the imagination.

I have attempted an exposition of my subject sufficiently comprehensive to include the major qualifications necessary to a complex truth. By organizing my descriptions and analyses of hundreds of artifacts around Rome's most prominent sites and sights—those physical things that make Rome Rome, things of which *everyone* had to take notice—I have hoped to discover the dominant perceptions and to bring them into relief by placing them against dissenting and eccentric views, which are often more eloquent because more deeply felt. One of the things I have most wished to avoid is to allow the individual representation to be swallowed up in a generalization about "American" opinion. Such generalizations are sometimes necessary as well as possible, but the truth is that there is no "American" representation of Rome, for not only did Americans change over time, but at any given period there were Americans who saw things very differently from other Americans. This is obviously true in the present century characterized by ethnic pluralism, but from the beginning the Americans who described Rome were far more varied, particularly in economic background, than is commonly thought. The majority of Americans who took up permanent residence in Italy or visited annually were no doubt wealthy, but the writers and painters and sculptors who created our Rome were far more typically poor: the work they did in Rome they did for a living. So "America's Rome" is necessarily a multifaceted and inconsistent Rome collectively created by many diverse individuals. To demonstrate and to preserve their disagreements over matters political, religious, and aesthetic has been one of my major concerns.

I have thought it important, too, to keep them, so far as possible, in the language of the original debates. Nothing is more depressing, or less authentic, than the bland

paraphrase from which the engaged individual voice has been removed. It is, in any case, less the *idea* to which paraphrase reduces any statement than the total character of the statement itself that has interested me. I could no more do without my quotations from writers than I could do without adequate illustration of the paintings and sculptures. This is as true of the scores of forgotten writers as it is of Henry James and Nathaniel Hawthorne. Travel writing or art criticism loses vitality only when it is pared down to a common core of experience or limited to the most frequently restated received opinions. Every individual perceived Rome differently, and the best professional writers possessed distinctive styles of representation adequate to the task of rendering their differences. They also calculated differently what would please their readers back in America, since it was for specific American audiences that they wrote. So every Rome differed and every statement was in some sense fresh. My concern has been much more with the recovery of a vast and varied body of American writing—much more easily lost and less easily recoverable than the paintings and sculptures to which the writing is intimately related—than it has been to simplify hundreds of representations into a single national vision.

Travel books and other kinds of writing engendered by the encounter with Rome besides fiction and poetry—journals, letters, chapters of autobiographies, aesthetic, political, and religious commentary and polemics—are essential records of the experience of Rome in its entirety as it mattered to Americans. Travel writing especially is far more vital than one might anticipate. As Henry James, himself a worker in the field, wrote of William Dean Howells's books on Italy: they "belong to literature, and to the center and core of it,—the region where men think and feel, and one may almost say breathe, in good prose, and where the classics stand on guard."[2] Allowing for all calculations of commercial popularity, one still finds in these books immediate personal representations of Rome, representations valuable both in themselves and in the way they provide a context for the usually more artful versions of stories and poems. It is through their representations that we can best recapture what it was like to know Rome in 1850—or even 1950. In digging through old letters and other sources in order to recapture papal Rome, Henry James himself first felt the pathos and the significance of this effort. Thinking of the once-famous painter Jasper Cropsey, and all the forgotten Cropseys of the Hudson River School who also painted Roman scenes with a brilliant palette, James asks "what the Cropseys can have been doing by the bare banks of the Tiber." What makes such questions in "the history of taste" so "thrilling" is that they require us, in living "over people's lives," to "live over their perceptions, live over the growth, the change, the varying intensity of the same—since it was *by* these things they themselves lived." To follow this inquiry is to discover "how such dramas, with all the staked beliefs, invested hopes, throbbing human intensities they involve in ruin, enact themselves."[3]

My narrative, with its stops for descriptions and analyses, makes an irregular circuit of Rome's topography in a sequence determined by the merging of two chronologies. The three great phases of Roman history—classical, Catholic (medieval and baroque), and contemporary (the Rome in which Americans actually lived)—are reflected in my three divisions, the first of which occupies volume I, and the others

volume II. It happens that the earliest American interest in Rome as a place (rather than as the Antichrist of Puritanism) centered on the earliest period: classical Rome. The Roman Republic filled the imagination of Adams and Jefferson during the same decades that American artists were first seeing the actual ruins of the Empire. And their own imperial possibilities dominated the imaginations of Americans for the following century. Later Americans (including Catholic Americans) became preoccupied with the character and power of the Roman Catholic church and finally interested themselves in the possibility of democratic developments in an Italy with Rome as its capital. Thus by instructive coincidence the chronology of successively emerging American interests in Rome (none of which ever fully fades away) parallels the chronology of Roman history.

A brief guide to the two volumes of *America's Rome*, with an indication of recurrent political, religious, ethical, and aesthetic themes, may be useful. The first three chapters of volume I take the reader from the Forum, center of the ancient Republic, to the Colosseum, greatest emblem of empire, to the Campagna, the melancholy evidence of empire's fall. Political and social questions dominate the representations of the Forum and the Colosseum; they provoke questions about the uses of history for thinking about republics and empires and for imagining new ones. The Campagna also relates to "the course of empire," but interest there shifts to themes from classical mythology and conceptions of symbolic or ideal landscapes (a crucial concern for painters whose obvious alternative was the American wilderness). In the final two chapters of volume I we consider what may survive the fall of empire: the gods and an ideal of beauty. At the Pantheon a consideration of Greco-Roman mythology serves as a prelude to tours of the museums of the Capitoline and the Vatican, where still stand those images of nude gods and heroes that so long served as the problematic ideal toward which American sculpture aspired. Neoclassical works of sculpture and painting produced by American artists as icons for an emergent religion of Beauty are explored at length, in the context of related American writing, as the most conspicuous products of the nineteenth-century encounter with Rome.

Volume II begins with representations of Rome as the center of Roman Catholicism. The Church's three most familiar local icons—as they were regarded by most observers in the nineteenth century—are described: the Santo Bambino, the Mother of God, and the pope. By pursuing representations of the popes down to the present day, we are able to compare the conflicted representations of contemporary American Roman Catholics with those of the antipapal Protestants of the preceding century, whose views had previously been dominant. Religious and aesthetic questions combine in chapter 2, a brief interlude in which we consider the largely negative reaction of nineteenth-century Americans to Rome's predominantly baroque sculpture and architecture. This judgment would be reversed a century later, when neoclassical sculpture was scorned and everyone adored Borromini.

The third chapter of volume II is the counterweight to the fifth chapter of volume I, in which the values, materials, and commitments necessary for aesthetic achievement were considered. Here some of the questions about political and social achievements, previously asked in relation to the ancient Roman Republic, return in the context of Italy's move toward national unification and liberalization. The

representation of Rome consists now of its people and of the walls, both real and symbolic, that divided them. Not long after 1871, when Rome became the capital of United Italy, it ceased to be the magnet for artists it had been, and visual representations (other than by photography) became the incidental products of artists on brief visits, whose primary centers of activity and artistic influence were elsewhere. But Rome as the capital of a nation undergoing rapid transformation held a new fascination. As the American publishing industry prospered and international journalism developed, written representations of Rome greatly increased between 1870 and 1920 and continued down to World War II, and even then they were kept up by a spy and a nun. Therefore it was possible to compose a continuous collective American representation of the volatile social conditions and dramatic events in Rome from the early days of the Risorgimento to the foundation of the Republic of Italy after World War II.

The significance of such an account lies not in its questionable reliability as contemporary Roman history (foreign eyewitnesses could hardly be expected to provide that) but in the commitments, ambivalences, and contradictions about social and political values displayed by the American recorders themselves. For better or worse, America is always the point of comparison with Rome. Usually it is thought of as better—as the model for Italian progress; but often enough, in 1848 as in 1918 and 1948, American disciples of freedom could declare that only in Rome did they find their "true America." These representations of Rome thus serve as a kind of running commentary on the changes that America itself was undergoing. Once more, in representing Rome the Americans represented—and sometimes discovered—themselves. The dual process continues to this day. After the war American artists and writers returned to Rome in unprecedented numbers, and chapter 4, as an epilogue, accounts for something of what Americans have made of Rome in the last forty years. Unquestionably they have been a different people visiting a drastically changed city. But in finding their own ways of taking imaginative possession of Rome, these writers and artists have demonstrated once more Rome's apparently inexhaustible capacity to contribute to America's unending process of critical self-definition. That Rome—America's Rome—is the subject of this book.

AMERICA'S ROME

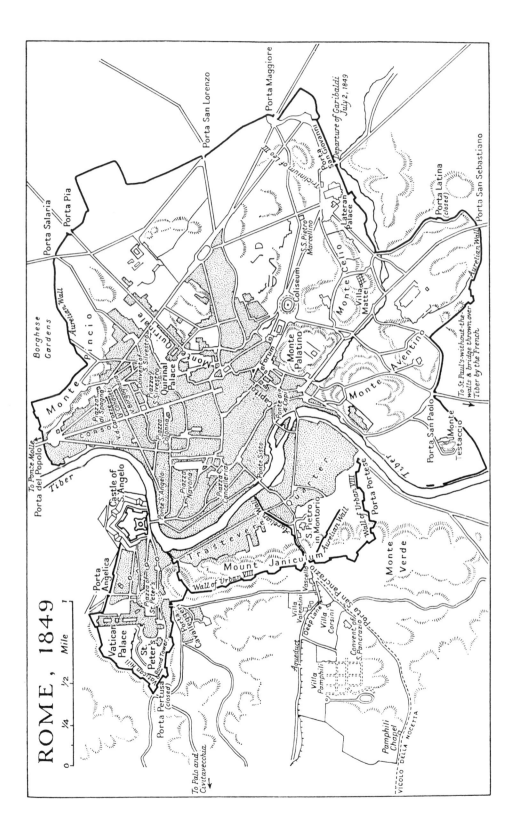

ROME, 1849

0 ¼ ½ Mile 1

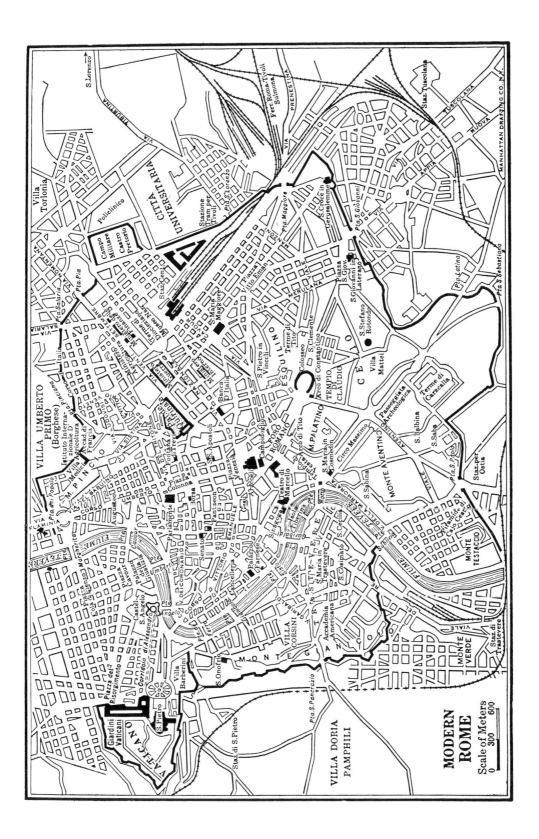

MODERN ROME

Scale of Meters
0 300 600

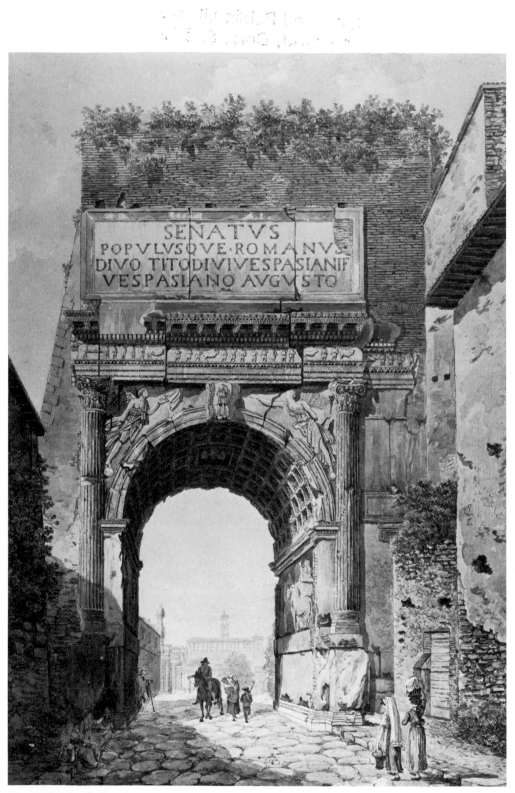

Fig. 1. John Vanderlyn. *View in Rome [Arch of Titus]*. ca. 1805. Watercolor and ink on paper. 17½ × 12¼". New York State Office of Parks, Recreation, and Historic Preservation. Senate House State Historic Site.

I

The Forum: History's Largest Page

 In the winter of 1864, when the final battles of the Civil War were being fought and the assassination of President Lincoln was only a few months in the future, a young man from Ohio stood among the ruins of the ancient Roman Forum (fig. 1). Four years earlier he had written Lincoln's campaign biography, in which he celebrated the rural and plebeian values that he shared with his subject. As a reward for his book, and to escape the coming conflict, he had asked to be made the American consul at Munich. Refused this, he in turn refused the offer of Rome because that was a post too insignificant to carry a stipend. William Dean Howells then accepted the consulship at Venice, where as many as four American ships a year were likely to dock. In legendarily romantic Venice he spent the next three years cultivating his resistance to all romantic ways of seeing, feeling, and thinking. Then, with the anti-Byronic manuscript of his first book, *Venetian Life*, completed, he and his wife made their first visit to Rome.

 Rome was even more disagreeably un-American than Venice. As a boy Howells had read Oliver Goldsmith's *History of Rome* and dreamed of being a "slayer of all tyrants";[1] but the historic site itself stirred no such childish passions. Howells saw only a "dirty cowfield" "filled with mere fragments and rubbish," "obscenely defiled by wild beasts of men." The Forum was essentially meaningless: "incoherent columns overthrown and mixed with dilapidated walls—mere phonographic consonants, dumbly representing the past, out of which all vocal glory had departed."[2] Even the ruins as ruins said nothing to this American, aged twenty-seven, who for the next half-century would provide through his fictions the most sharply observed picture of contemporary life in an increasingly imperial America.

 In 1908, a few years after America had emerged as a world power in a war with Spain, Howells visited Rome a second time. Now famous both as a novelist and as an author of books on the Italian people and their literature, he was escorted around the city by the mayor of Rome and the ambassador from the United States. He was

granted a private audience with the king of now-united Italy,[3] and he had as his guide to the Forum its current "Genius Loci," the great Commendatore Giacomo Boni, who had in 1899 announced his discovery of the tomb of Romulus. Howells remained unimpressed. In an essay called "An Effort to Be Honest with Antiquity," America's champion of the here-and-now and the commonplace still concluded that "Rome, either republican or imperial, was a state for which we can have no genuine reverence."[4]

Howells's visits to the Forum in youth and in old age define the middle period of American representations of Rome. His attitude directly contradicted that of most educated Americans of the preceding hundred years. From Thomas Jefferson and John Adams down through Howells's contemporaries Henry James and Henry Adams, ancient Rome—with the Forum as its literal and symbolic center—was for Americans a place of unrivaled cultural significance. The heroes of the Roman Republic—Cincinnatus, Cicero, Cato the Younger—were American heroes because they were champions of liberty, and liberty was the meaning of America. But in the century following Howells's first visit, his deafness to the "vocal glory" of Roman ruins and his irreverent attitude toward Rome's history became increasingly typical. Instead of being the historical and inspirational source of liberty and law, ancient Rome became at best a setting for costume pageantry and didactic Christian melodrama in novels and films. By the 1950s, Rome was teaching Americans other lessons—those of la dolce vita. Neither the Forum nor the Vatican, but the Via Veneto, avenue of luxury hotels and the American embassy, was at its center.

Yet the relevance to America of the Forum and the expanding imperial Republic it symbolized could never be forgotten by classically educated Americans. Although allusions to Roman history would not have been so widely employed in the 1830s both to attack and to defend Gen. Andrew Jackson if they had not been commonly understood, in the 1970s perhaps relatively few citizens clearly understood the connotations of the term *imperial presidency*. Yet the novelist John Hersey, while in Rome at the American Academy during the Nixon administration, wrote *The Conspiracy* (1972), set in the reign of Nero, and the poet Robert Lowell included in *History* (1973) a sequence of twenty sonnets on republican and imperial Rome. In one sonnet the poet Ezra Pound, who had made madly traitorous broadcasts from Rome during the Second World War, is identified with Cicero, courageous defender of the Republic. In another, "General Sulla once, again, forever" struggles with "Marius, the people's soldier" over control of the realm; in an obvious allusion to the American war in Vietnam, both praise "defoliation of the East."[5]

That a consciousness of ancient Rome has figured prominently in American intellectual and political history there can be no doubt; the phenomenon has been extensively documented, and its importance debated.[6] Our subject here is more specific: how that consciousness informed the American experience of the ancient Forum, and how the experience of the Forum in turn focused certain American concepts of patrician and plebeian politics, masculine and feminine virtues, and the uses or uselessness of history. Representation of the Forum constituted the first step by which Americans took possession of the fabulous city through their writings and paintings, making it their own.

The Speaking Fragments

Beyond the crowded quarters of modern Rome, the ruins of the ancient city lie scattered and solitary. Like gravestones above the race that reared them in their prime, they cover dust, which, in the shadowy or the thoughtful hour, appears to be recreated in the forms of long-buried generations. Old conflicts, old triumphs, and old heroes sweep through the broken arches and crowd about the sunken columns, until these, too, assume the shapes they once wore, and revive to greet the phantoms which have been brought back to them by the memory of the watcher or the pilgrim.

—*Samuel Eliot,* The Liberty of Rome *(1849)*

What excited, challenged, or appalled all visitors to the Forum was the characteristic that made it most antithetical to America. Like all of Rome, it possesses a visible historical density that makes it extremely difficult to comprehend. America, still in the process of putting down its earliest layers of history, presented no such palimpsest to be interpreted by the artist or writer. Yet all the more could American observers see the Forum as speaking particularly to them, since it was an image of endings in a place famous as a place of beginnings, enclosed at either end by arches of triumph.

The visual complexity of the scene is evident in a small watercolor of about 1806 (fig. 1) attributed to John Vanderlyn, one of the earliest American artists to work in Rome and protégé of Aaron Burr, the Revolutionary patriot who, as vice president of the new Republic, killer of Alexander Hamilton, and would-be emperor of Mexico, was doing what he could to make the annals of the American Republic as sensational as those of its Roman model. The painting, which is completely conventional in subject and composition, registers the historical density of the Forum while avoiding the fragments of its interior ruins that Howells found so incoherent. Positioned as though standing upon the ancient stones of the Via Sacra, we look through the Arch of Titus into the Forum. Picturesque contemporary peasants in the foreground are diminished by the massive antique work of self-commemoration through which they daily come and go. They have only an ironic relation to the powerfully inscribed "SENATVS POPVLVSQVE ROMANVS," the famous formula which itself is qualified by the words that follow: "DIVO TITO DIVI VESPASIANII—VESPESPIANO AVGVSTO." Were the Senate and people, or the Caesars, the gods of Rome? For a long time, neither: the buttresses, brickwork, and blocked-up openings that still encased and degraded the ancient arch in 1806 were the remnants of the fortress of the Frangipani, a mighty feudal family who had throughout the Middle Ages fought the rival Colonnas, Caetani, and Orsini over their share of the ruined city. For a time even the Divine Titus's Colosseum was part of their stronghold. In an engraving of 1819 by Luigi Rossini nearly identical with Vanderlyn's painting, the street sign on the wall to the right can be read: "VIA COLOSSEO," a reminder that just beyond the Forum rises the Colosseum, the greatest monument of the imperial stage of history (compare the opposite view through the arch in fig. 15).

But the painting contains still another overlay of history, adding Renaissance imagery to these remnants of the Ancient and Medieval epochs, and thus conveying

Latin, and seems not to have read ancient history beyond his boyhood acquaintance with Goldsmith, the fragments were necessarily consonants only, and therefore "dumb." He presumed in 1864 that his was a more "objective" view of the Forum, but it really only displayed the partial—and deliberate—deafness of realism. For earlier Americans, imagination and knowledge did not falsify, but were essential to the wholeness and truth of their experience of the external world. The Bostonian George Ticknor, who was preparing himself for his career as America's first great scholar-teacher of European languages and literatures, arrived in Rome in November of 1817 and immediately found it "worth all the other cities in the world." Although in the Forum there was "so little to be seen," there was nevertheless "a great deal to be felt and fancied . . . on a spot so full of the past, from the times of Hercules and Evander to our own." Not content with these initial grandly vague recollections of his classical studies, Ticknor hired the best possible guide to the ancient sites—Professor Antonio Nibby, who was just then preparing his authoritative *Del foro romano, della via sacra* (1819). Insisting that Nibby lecture to him in Italian, Ticknor proceeded to fill a volume of his journal with what he learned on their tours.[12]

Ticknor set a standard for conscientious intellectual, linguistic, and emotional possession of Rome hardly to be surpassed. But he expressed an attitude that was nearly universal among Americans down through Henry James: the great legendary Latin city of their earlier studies lay waiting to be more intimately apprehended. Theodore Dwight, son and namesake of a prominent Federalist pamphleteer and nephew of Timothy Dwight, one of the "Connecticut Wits" of Revolutionary days, wrote of the Forum in 1821: "So familiarly did many of these objects strike my eye, that it was hardly necessary to decipher 'P. P. OPTIMIS FORTISSIMISQ,' &c. on the Triumphal Arch . . . to claim a closer kindred with the silent language of ancient Rome, than I can ever feel for any thing in the modern city."[13] The "silent language" forever supplements the image at the Forum, and the most common metaphor for the Forum itself sees it as the richest page of all history, whose fragmentary and overwritten words become eloquent to the degree that one is inwardly equipped to read them. To Nathaniel Hawthorne, a generation older than Howells but seeing the Roman Forum only six years earlier, the tower on the Capitoline "looks abroad upon a larger page, of deeper historic interest, than any other scene can show." After an exploration of the excavations in the Forum, Hawthorne wrote in his notebook that the ancient world seemed to him both less antique than the Gothic and more irretrievably remote—the page was written in an alien language after all, reflecting an entirely different system of morality. But in *The Marble Faun*, whose central character is a survivor of that pagan world, Hawthorne emphasized only its closeness. Roman literature, he observed, afforded us such "intimacy" with the "classic world" that we can "stand in the Forum . . . and seem to see the Roman epoch close at hand."[14]

In such apprehensions of the classical world Americans of the romantic period typically practiced a visionary mode of perception defined by Goethe and, after him, Stendhal. Readers of Goethe were promised that in Rome, "the First City of the world," "a new life begins": "All the dreams of my youth have come to life. . . . Wherever I walk, I come upon familiar objects in an unfamiliar world; everything is

just as I imagined it yet everything is new."[15] Stendhal claimed that he was "almost ashamed" to admit that on a sixth arrival in Rome he was still "deeply stirred." Yet "nothing on earth can compare to this. The soul is moved and elevated, a calm felicity fills it to overflowing." But these great emotions do not arise from the scene alone; Goethe and Stendhal emphasize that the recognizing vision depends upon what one brings. Stendhal explicitly states that the appeal to his childish imagination made by the Latin authors formed the only possible basis for his later capacity to appreciate Rome: "the memory of them precedes all experience." Moreover, such a vision, produced by an interaction of memory and imagination, was not to be dimmed by the corrective assertions of modern archaeologists. "The phrases of these poor people are indeed ridiculous," said Stendhal, "and one is well advised not to read them; any discussion, even a well-developed one, takes something away from the beauty of the admirable ruins of antiquity." Stendhal appended several vaguely effusive lines from Byron's *Childe Harold's Pilgrimage* to illustrate the proper attitude.[16]

Since Byron's poem rejoices in the unknown and the unnameable, it was a convenient emotional guide for several generations of travelers whose reverence for Latin literature surpassed their knowledge of it. Naturally this resulted in certain conventional stances of dubious authenticity. The popular journalist and versifier "Grace Greenwood" (Sarah Jane Lippincott), the most exclamatory of visionaries, records in several pages of her travel book the characters and scenes from Roman history that were realized before her eyes in the Forum in 1852. Her frequent shrieks of recognizing delight must have made her a disturbing companion, even to such enthusiastic guides as the sculptor Harriet Hosmer and the actress Charlotte Cushman, both of whom had recently settled in Rome. But the substance of her visions was undoubtedly found in source books and then fixed in prettily alliterated prose upon the blank page of her manuscript, rather than actually evoked from memory by the "silent language" of the Forum.[17] Yet a profoundly felt and authentically rapturous experience of the Forum was not the exclusive privilege of geniuses like Goethe and Stendhal, or the formally educated like Ticknor and Dwight. The twenty-year-old Bayard Taylor, a Quaker farmer's son who would provide America with its standard translation of Goethe's *Faust* and would achieve the fame as a popular poet that Walt Whitman could only dream of, arrived in Rome in 1845 at the climax of his walking tour of Europe. To see Rome, Taylor had suffered miseries for the sake of economy that he barely hints of in his essays for the *Saturday Evening Post* and *Galaxy*, essays afterward reprinted in several editions of his best-selling *Views A-Foot*. He was hardly going to permit his boyhood dream of "giant, god-like, fallen Rome" to fail upon the spot. Goethe had promised otherwise. Reveling in "a glow of anticipation and exciting thought," Taylor went to the Forum and saw far more than can have met his eye: "grandeur" and "splendor inconceivable." But he is explicit about the key to his visionary capacity: "words of power and glory" that now came back to him. His imagination, fed by the classics, Goethe, and Byron, supplied what was literally absent but was not therefore less authentically realized.[18]

Literary responses to the Forum by which Americans identified themselves with the people of ancient Rome reached their greatest intensity and variety in the 1840s.

In addition to the journalists Bayard Taylor in 1845 and Margaret Fuller in 1847–48 (who will be considered later in different contexts) and the lawyer George Hillard in 1848, three writers of special interest were George Washington Greene, the American consul in Rome from 1837 until 1845; W. M. Gillespie, a civil engineer whose particularly Roman specialities were road building and land surveying and who also qualified as one of Edgar Allan Poe's "Literati of New York"; and William Ware, son of the distinguished Unitarian minister Henry Ware and himself a clergyman until he resigned his pulpit in 1836. That was the year in which Ware's very popular romance *Zenobia* was serialized in the *Knickerbocker* magazine as *Letters of Lucius M. Piso from Palmyra, to His Friend Marcus Curtius at Rome.*

The appropriately named George Washington Greene occupied his time as American consul by writing a Plutarchian biography of his grandfather Nathanael, a famous general in the army of the American Revolution, and by turning himself into an amateur archaeologist with the intention of writing a history of Rome. This second effort resulted in a relentlessly sober series of "Letters from Rome" published in 1841–42 in the *Knickerbocker*, America's first serious literary journal with a substantial readership. The initial letter follows convention by recommending the panoramic view of Rome from the top of the tower of the Capitol as the starting point for all knowledge of the city. A comprehensive description of the classical topography as seen from that vantage point is filled with the pleasure of recognition. But subsequent letters concern the variety and reliability of our sources of knowledge of ancient Rome, the probable means by which the city was buried to such depth, and the character and construction of the successive walls that engirdle the place. The pedantry of these letters tends to confirm Stendhal's advice against listening to scholarly squabbles if you want to sustain an ennobling vision of Rome.[19]

The engineer William Gillespie, in contrast, is entirely concerned with conveying a sense of his personal vision in *Rome: As Seen by a New-Yorker in 1843–4*, one of the more individualized American accounts of a Roman sojourn. Remarkably untroubled and joyful, Gillespie is most informative on the subjects of pasta and wine. But he testifies also to the "intense quivering excitement" he felt in the Forum, where even his "fingers' ends tingled with enthusiasm." This was "alone enough to repay a dozen voyages across the Atlantic": "I walked on in solitude through the fields which were once the Forum in which the people met to decide upon the fates of empires, and in which the eloquence of Cicero had re-echoed from the temples and palaces which then studded every eminence and filled every valley." Later, as Gillespie imagines Horace (whom he quotes in Latin) walking along the Via Sacra, he is deeply moved by being able "to tread in his steps" while recalling the famous poem about the Bore who attached himself to the poet in the Forum and would not let go. At another spot, going much beyond anything legitimated by either guidebook archaeology or actual ruins, Gillespie imagines where Galen's apothecary shop might have been and, further on, the shop "where Virginius bought the knife with which he stabbed his daughter, to save her from Appius Claudius." With reluctance he awakens from the vivid "dream-like sensation" of "standing in the midst of such scenes."[20]

In his fictions William Ware also delighted to imagine such subhistorical details

as the purchase of a knife—or a Grecian pot—in a shop in the Forum. But after his sojourn in Italy in 1848–49, the former clergyman wrote sternly that it was the "first duty" of any visitor to ascend the tower of the Capitol with a map of ancient and modern Rome, there to pass an entire morning identifying everything in sight, from the Alban mount on the horizon to the Arch of Septimius Severus directly below. In *Zenobia* the Forum had provided the setting for the denouement, as the great queen of Palmyra was led in chains in Emperor Aurelian's Triumph. Now, with obvious satisfaction, Ware finds the Forum the "most remarkable" place in the world, the place that "presents the greatest unity with the greatest variety" of historical interest. As you "look off from the tower of the capitol, the eye falls upon the very objects for which you had been waiting with a fever of impatience,—the time-worn vestiges, the sublime yet melancholy ruins of the ancient city." The Forum is "a name that can never be uttered without emotion": "Temples, basilicae, comitiae, curiae, all adorned in the most sumptuous manner by columns, flights of steps, statues of marble and bronze, and by rostra, or pulpits, from which the orators harangued the people on all occasions of great political excitements." Although of all this "scarce a vestige now remains," nowhere else in Rome "does one experience the sensations that crowd upon the mind, as he paces to and fro along the site of the Forum" with the Capitoline and Palatine hills on two sides and the Colosseum on a third: "characteristic funeral monuments all, of the greatest of earthly empires."[21]

Yet, exhilarating as the experience of the Forum was to all who could read its fragmentary words, its meaning was so entirely dependent upon a prior knowledge of history, philosophy, and poetry as to render the place itself superfluous. Ware himself states that in the end the architectural monuments are not the worthiest or most lasting memorials, "magnificent" and "imperishable as they seem." Rome's literature and her language, "wrought . . . into the substance of every living tongue of Europe," are "evidences of her universal sovereignty greater than any other." These memorials alone will survive until the last speaking "remnant of mankind" disappears from the earth. After the Italophile Henry T. Tuckerman stood in the Forum in 1836 and conjured up Cicero's attack upon the Cataline conspirators, he concluded that the "comparative worthlessness of the outward scene" is actually salutary, since it reminds us that "it is the acts themselves, with all their beautiful philosophy, which alone have hallowed these portions of the earth." In the words of George Hillard, where "the eye of the body" could see only an "unsightly piece of ground, disfeatured with filth and neglect," the eye of the mind saw a people characterized by "wisdom, valour, and eloquence."[22]

Thus not the ruined Forum but the ancient Romans who lived there were the proper object of study, and the initial vision of a glorious past provoked by this broadest page of history gave way to three closer readings that concerned its meanings for the present. The first was political: the parallels between Rome and America were such that America could not do better than to imitate its republican system and guard against the corruption that had destroyed it. The second was ethical: more of the most impressive individuals of history had appeared on the stage of the Forum than had appeared in any other single place on earth; examples of whatever was most admirable and most evil in human potential could be found there. Finally, when—as with Howells—the reverence expressed by Tuckerman, Ware, and Hil-

lard ceased, and the usefulness of the Forum's lessons in either political science or ethics came to be doubted, a third reading was still possible: ancient Rome was the grandest entertainment in the world.

Retrieving the Ideal Republic

Yesterday was the 22nd of Feb.—the birthday of Washington. The Americans here must needs get up a dinner, with speeches, toasts, etc. . . . A General Dix presided and made a speech about the repudiation; the consul, Mr. Green[e] made another excellent speech—so did Dr. Howe. Mr. Conrade of Virginia gave us a most characteristic specimen of American eloquence, and toasted "Washington and Cincinatus! Patrick Henry and Cicero!"

—Francis Parkman, Journal *(Rome, 1844)*

Excavations of the Forum were given a new impetus when Rome became the capital of newly united Italy in 1871. The symbolic process of recovery was witnessed by Henry James in 1873. His description, although cast in terms of a satisfying aesthetic realization of the past, is actually an emblem of America's initial relation to Roman history. Although the emphasis soon shifted to a romantic appreciation of heroic individuals, the original neoclassic relation stressed the virtue of the republican political system that had placed limits both on ambitious individuals and on the mob.

James allows that the tourist who approaches the ancient sites "primed for retrospective raptures" is bound to be disappointed. The Capitoline, which rises above the Forum but is now climbed from the opposite side, is "much more of a mole-hill than a mountain." Since nothing from antiquity comes into view, "Roman history seems suddenly to have sunk through a trap-door." But when one looks down upon the new excavation in the Forum, hope arises that the stifled sublimity may reemerge: "Nothing in Rome helps your fancy to a more vigorous backward flight. . . . It 'says' more things to you than you can repeat to see the past, the ancient world, as you stand there, bodily turned up with the spade and transformed from an immaterial, inaccessible fact of time into a matter of soils and surfaces."[1] The transformation of the ancient world from "an immaterial, inaccessible fact of time" into a contemporary reality, not merely the aesthetically perceived "soils and surfaces" but the body politic itself—this was what much of the preceding hundred years had been all about, from the founding of the American Republic to the reunification of Italy itself. James finds the "fresh-faced superstructure" surmounting the "rugged constructional work of the Republic" merely "entertaining to the eye"; yet it was in fact an extraordinary political emblem. Those who had done the "rugged constructional work" for our own Republic had been building a new Rome. In the history of the Roman Republic John Adams had found his best proofs that senates were indispensable, and in Roman architecture Jefferson had found the appropriate symbolic style for America. A sense of continuity with antiquity, and of indebtedness to it, motivated visits to the Forum in the first place, and then was realized in writing as a special aspect of the American experience of Rome.

One of the earliest Americans to record his impressions of the Forum was James

Sloan, who arrived in 1817 and afterward anonymously published his engaging *Rambles in Italy*. He was deeply moved to recall that the Forum was "the sanctuary of freedom":

> No object can exceed in moral grandeur that senate house, where liberty reigned, and upon the floor of which she expired. In sight of this senate house stood the temple of Jupiter Stator, three columns of whose portico are yet standing. It was to this that the sublime address of Cicero was directed, when unveiling to the senate the secret transactions of Cataline's ruffian band, and anxious for the safety of Rome, he invoked the protection of her tutelary divinity.[2]

Similarly George Hillard, as a representative of the legal profession, declared the Roman Forum "the Mecca of the law": "Here were laid the foundations of that wonderful political system, which lasted so long and worked so well," a system that has "a controlling influence over the legislation and jurisprudence of the civilized world down to the present day." Unable to imagine a Mark Twain or a William Dean Howells on the horizon, he could ask rhetorically, "Who, that has the least sense of what the present owes to the past, can approach such a spot without reverence and enthusiasm?"[3]

The most massive response to the Forum came from an American who discovered his life's purpose there. After graduating from Harvard in 1839, Samuel Eliot went to Italy for reasons of health (and to escape the family business). In Rome he conceived the task to which he expected to devote his life—writing the history of liberty from its birth in the Forum to its maturity in America. In scale his work as projected would have surpassed even Gibbon's, the idea for which had also been born among the ruins of Rome. Passages from Eliot's history published in 1847 were followed in 1849 by two volumes called *The Liberty of Rome*, which were in turn extensively rewritten as the first two volumes, constituting "Part 1: The Ancient Romans," of the sumptuously printed *History of Liberty* (1853), whose third and fourth volumes brought the tale down through the reign of Justinian, A.D. 565. That was as far as Eliot got. Like a good Roman, he had become much involved in civic, educational, and religious activities in Boston. But in writing his history of liberty in Rome, he had written the first chapter in the essential history of America.[4]

Eliot believed liberty was the most important possible topic for a historian, a subject "to which all the events of human history are related." He had too "high an aim" to address himself exclusively to "fellow-scholars" and the "literary class," preferring as readers his "fellow-men." History "is given us by God" and should "not only inform us in regard to the past, but console us with regard to the future." The consolation in this case would come from a demonstration that liberty ultimately failed in Rome because it was born and struggled to survive under conditions wholly different from those of the modern world; it would not fail again. "The fall of Rome beneath the stroke of the destroying angel was the fall of heathenism." History is wholly providential. God "made the Romans His instruments in bringing about the humiliation of antiquity. And this was the preparation for the redemption of modern times." Therefore there is no need to "fall into censures or alarms" while reading of the decline of Rome.[5]

For several hundred pages covering an equal number of years, Eliot's history of liberty unfolds almost entirely in the Roman Forum. Since he holds that Christian readers find battle scenes repugnant and resent their being made the point of history, Eliot avoids them as much as possible; we hear of them through messengers arriving in Rome or through debates in the Senate. We witness all essential history as though from a convenient post on the Capitol. As so often in Plutarch's *Lives*—one of Eliot's favorite sources—people are constantly rushing into the Forum with some exciting report, heroes confront each other on the steps of a temple, kings and emperors descend into the Forum from the Palatine, and senators emerge from the Curia to harangue the crowd from the Rostra. In this turbulent setting, liberty is born with the foundation of the plebeian class during the reign of Ancus Marcius, fourth king of Rome, in the seventh century B.C. A typical scene (drawn from Livy) shows the plebeians still "murmuring in the Forum" a century and a half later, after the establishment of the Commonwealth. Eliot is demonstrating that "in proportion as the poor become enfeebled in any state, the rich become more arrogant." The Senate is meeting to approve new levies to support the patrician wars when an infirm old centurion appears before the crowd and, baring his chest to display wounds received in the service of Rome, tells them of his present enslaved condition: "It flashed upon the minds of those who stood there in the Forum, that the misery they witnessed . . . and which they, too, were enduring, . . . was not for the sake of their country so much as for the gratification of their masters, the Patricians; [and] liberty . . . was no longer . . . in their possession."

The alarmed Senate hears the bad consul Appius Claudius offer to put down the mob through violence, while the good consul, Publius Servilius, calms the crowd and then advises the Senate to adopt a moderate course. The next day, as the rebellious crowd increases, word arrives that the Volscian army is approaching. The patricians happily assume that everyone will now unite to save Rome. "But the Plebeians stood still in the Forum. Some pointed to the chains they yet wore as bankrupt debtors, . . . and many more exclaimed, it was better to be conquered or slain than live with hands tied and bodies bruised like theirs." Servilius gets the Senate to promise relief after the war, whereupon "the Forum, just before swarming with an angry populace, now seemed to be filled with orderly and willing soldiers. Bond and free gave in their names together, and to all, promiscuously, the usual oath of fidelity was administered." Servilius leads this army quickly to victory and divides the spoils, so that "for the first time . . . the lowest ranks had something to carry home with them from war." Obviously, the immediate result will be conflict between two factions of patricians, represented by the two consuls, but its exploitation by the plebeians begins their rise toward greater power and freedom.[6]

Eliot's equation of liberty with the growth in plebeian power places his work in the 1840s post-Jacksonian context of the extended franchise in America and distinguishes it from the history of the Roman Republic as interpreted by John Adams in 1787–88. Eliot notes that since originally only the patricians possessed the "rights of liberty and law," it appeared that the "character" and "destinies of their country" depended entirely upon them; but it was "the good fortune of Rome, that another class of citizens, at first inferior, was included within her fold, to whose elevation her prosperity and freedom, before both failed her under heathenism, are, humanly

speaking, to be ascribed." It had been John Adams's chief concern to demonstrate that, on the contrary, liberty could be preserved only by limiting the power of the masses. To have achieved a balance of powers was in fact precisely the genius of the Roman Republic. In his *Defence* of the American constitutions (that is, those of the several states), Adams confidently asserted that since the "institutions now made in America will not wholly wear out for thousands of years," it was "of the last importance . . . that they should begin right."[7] So to begin required the careful analysis of historic precedents, the most positive of which was to be found in ancient Rome. Such—to use James's phrase—was the "rugged constructional work of the Republic." Whatever mysterious hand Providence might have in the matter, the result depended primarily upon wise choices made by rational men enlightened by history.

What Roman history shows to Adams is the necessity of a senate as well as a popular assembly. This is not, he protests, a mindless imitation of the aristocratic system of England with its hereditary House of Lords. It is instead a reflection of the American realization that the English system, and the Roman before it, were superior to all other democratic means of assuring both liberty and stability precisely because they provided for the interests of the few as well as the many. By study of the history of the Roman Republic in the first and third volumes of his *Defence*, Adams attempts to show that all was for the best when the patricians and the plebeians were most respectful of each others' rights. It was the destruction of the balance that finally opened the way "to popular and ambitious men, who destroyed the wisest republic, and enslaved the noblest people that ever entered on the stage of the world," wrote Adams, quoting one of his sources, Jonathan Swift.[8]

Although it is clear that Adams believed the Roman Senate—that is, the patricians—to be the essential protectors of liberty, checking the dictatorial tendencies of both caesars and plebeians (singly and in consort), he does not idealize the senators themselves. He sees their function as institutionally determined, dependent for its effectiveness on the senators' self-interest. Self-interest can be assumed to be the leading motive of all classes. Adams denies the perfect disinterestedness of such a man as Cincinnatus and argues that in any case altruistic men in love with poverty are so rare in any generation as to be irrelevant to the foundation of a government. The true situation is indicated by the title of his first section on Rome: "Plebeians scrambling after Patricians; or Democracy hunting down Aristocracy; or Tribunes in chase of a Senate." This looks satirical of plebeians, but Adams immediately observes that until there was a constitutional plebeian force, the history of Rome was one of squabbles between kings and nobles, equally tyrannical. "It is impossible to say which are worst, the nobles or the kings; both were bad enough in general, and both frequently violated the laws."[9] But if the interests of the plebeians must be assured through free education as well as legal checks upon the power of the senate and executive, this is in the interest of liberty for all, not equality. Adams repeatedly asserts that nature, reason, and history all testify to an inevitable inequality among men, which is what requires that a constitutional *balance* of eternally competing forces be established.

Both his thesis and his proofs are antithetical to romantic intuitions about the innate virtue of the common man. But Adams also has his ideal and a belief in

historical evolution toward its realization. His ideal is his image of the Roman Republic at its "maturity," a state that endured for centuries: "The distinction between patrician and plebeian was become altogether nominal. . . . The wisest and most respected of the citizens, from every condition, were raised into office; and the assemblies, whether of the senate or the people, without envy and without jealousy, suffered themselves to be governed by the counsels of a few able and virtuous men." Thus a true aristocracy emerged, "partly hereditary, founded on the repeated succession to honors in the same family; and partly personal, founded on the habits of high station and on the advantages of education, such as never fail to distinguish the conditions of men in every great and prosperous state." The people "submitted to the senate, as possessed of an authority which was founded in the prevailing opinion of their superior worth; and even the most aspiring of the commons allowed themselves to be governed by an order of men, amongst whom they themselves, by proper efforts and suitable merit, might hope to ascend."[10]

This ideal of the Republic, which had actually been realized in Rome for 230 years (according to Adams), was the best—*was* ideal—because it allowed the best men (from whatever class) to rise to power. These *aristoi* had a crucial place and function. They were those who had made Rome great, those who were remembered today. Less than half a century after Adams wrote, a young professor of classical literature named Edward Everett—one of the greatest orators in a period when American oratory was truly Ciceronian—was nominated for Congress as the result of an oration delivered before the Society of Phi Beta Kappa at Harvard. Among his auditors was General Lafayette, then making the great tour that excited such fervent recollection of the founding of the Republic and so great a sense of rivalry with Rome.[11] In the course of his speech Everett—who would later be not only a congressman but a governor, an ambassador, a secretary of state, and a senator— alludes to his own visit to the Roman Forum a few years before, as though the history of the democratic principles he is celebrating really began there. Everett notes that he and most of his auditors have risen from "honest poverty or a frugal competence," and owe their enlightenment to the "free and popular institutions of our native land." It is up to them "to settle, and that forever, the momentous question—whether mankind can be trusted with a purely popular system." The "departed wise and good" who fought for "the one great cause of Freedom and Truth" may be supposed to be watching:

> As I have wandered over the spots, once the scene of their labors, and mused among the prostrate columns of their Senate Houses and Forums, I have seemed almost to hear a voice . . . from the sepulchres of the nations. . . . They exhort us, they adjure us to be faithful to our trust. . . . By the wrecks of time, by the eloquent ruins of nations, they conjure us not to quench the light which is rising in the world. . . . It is by the intellect of the country, that the mighty mass is to be inspired; . . . its character reflected, its feelings interpreted to its own children, to other regions, and to after ages.[12]

America, having revived the popular liberties of the past, owes it both to that past and to the future to make them permanent. Everett demonstrates in his own person

the rise of talent to power that Adams had hoped for, and he explicitly affirms the function of the aristocracy of intellect in a republic. Apparently less concerned than Adams with institutional protections, Everett seems to trust that the inspiring effect of an eloquent individual upon the "masses" will be wholly benign. But the concern that Everett shares with Adams, that a culture be defined by its superior individuals, is what relates neoclassical politics to the romantic preoccupation with heroic men and women, even a Caesar—or a Napoleon. In this view, the Forum's association with the growth of freedom for the many is subordinate to that with the virtues of the noble few.

Roman Virtue

And the brave Romans,—they were giant men,
Caesar and Scipio; may they live again,
Stalk through thy inward Forum!—seek no more;
The sands of Europe gleam on Salem's shore.
—William Ellery Channing the Younger,
Conversations in Rome *(1847)*

Benjamin West, the first American artist to study in Rome, stopped in London in 1763 on a journey back to America that he never completed. According to his contemporary biographer, while in Rome West had been a member of an international community of artists who forgot "national and personal peculiarities and prejudices" in their shared "contemplation of the merits and glories of departed worth." They studied both the literature that "perpetuated the dignity of the Roman character" and the ancient monuments "raised to public virtue."[1] The universal significance perceived in the history of ancient Rome was what made it a source for the highest art.

In 1765 the archbishop of York asked his son to read for West's benefit the passage in Tacitus describing Agrippina's return to Italy with the ashes of her husband, Germanicus, who had been poisoned in Syria. West thereupon produced a fine painting (fig. 2) that demonstrated how thoroughly he had mastered the neoclassical style during his years in Italy. He in fact took it further, aiming for an unprecedented degree of historical fidelity, a convincing visual retrieval of the past. The relieflike central group is derived from a procession of the imperial family on the *Ara Pacis Augustae*, erected in Rome by Agrippina's grandfather Augustus only a few decades before the event West depicts. In the painting the grieving mother and children move across an architectural stage setting in which the port of Brundisium is given buildings suggested by Robert Adam's just-published drawings of the Diocletian palace at Spalato. But equally to the purpose is the suggested retrieval of ancient virtues: ethically, this is a contemporary painting. Its verisimilitude does not yield the pleasures of exotic historicism, but as an *exemplum virtutis* brings close and renders credible the noble Roman style of behavior. Some critics, recalling that the popular hero Germanicus (adoptive son of Emperor Tiberius) was thought to favor Rome's return to republican freedom and equality under the laws, have been

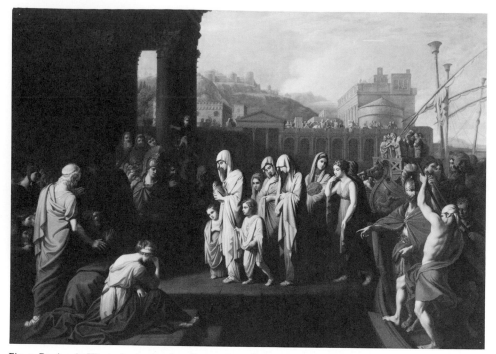

Fig. 2. Benjamin West. *Agrippina Landing at Brundisium with the Ashes of Germanicus.* 1766. Oil on canvas. 5' 4½" × 7' 10½". Yale University Art Gallery. Gift of Louis M. Rabinowitz.

tempted to suggest that West was here asserting his American sympathies. This is unlikely, given the date and circumstances of the painting, which was greatly admired by King George III. West simply accepted a pictorially promising commission and followed closely what was read to him from Tacitus.

The focus is not on the virtues of Germanicus but on the composure of Agrippina and her children (Caligula, the next emperor, and Agrippina the Younger, future mother of Nero) during their profoundly emotional reception. Germanicus's last words to his wife implored her to subdue her pride and to submit to fate. She in fact raged with grief and eagerly plotted for revenge, but stopped on an island off Calabria to compose her mind before coming ashore. "When Agrippina descended from the vessel with her two children, clasping the funeral urn, with eyes rivetted to the earth, there was one universal groan." This is what West painted. Agrippina was thereafter adored by the Romans themselves, Tacitus tells us, as the glory of the country, the only survivor of the Divine Augustus, the supreme embodiment of the noble comportment of the old days. What was not evident to them, or to the viewer of West's painting, is that her winning of sympathy was calculated as necessary to her intended revenge. In the exemplum virtutis there is always some simplification of character.[2]

That American artists should come to the service of their country's Revolution, as David did to the French, by depicting heroic scenes of antique virtue applicable to the modern cause was of course impossible. There was no art establishment with a constant relation to the public in a great capital city, and the only two artists

capable of such art—West and John Singleton Copley—resided firmly in the bosom of the enemy. West's second exemplum virtutis from Roman history, *The Departure of Regulus* (1767; Kensington Palace), is an image of self-sacrificial patriotism suggested by George III himself, who read the passage from Livy to the artist. By the time America declared its independence, West was the king's official historical painter and on his way to becoming president of the Royal Academy, which he helped found. West's Roman paintings are an American's contribution to the international genre by then over two hundred years old. Jefferson could admire David's *Oath of the Horatii* (1785) not because it had immediate function as French propaganda but because it drew upon Roman history for an image of timeless virtue. John Trumbull began to learn his art by painting a copy of the copy of Poussin's *Continence of Scipio* that John Smibert had brought with him to Boston in 1729 only because it was an available example of what a great painting ought to be;[3] and after he had studied with West in London he could apply the genre to historic American moments: the *Death of General Warren at the Battle of Bunker's Hill* (1786; Yale) and the *Signing of the Declaration of Independence* for the rotunda of the American Capitol.

Explicit attempts to equate American political experience and heroic virtue with Roman precedents were made, however, by political essayists and poets and, later, playwrights and sculptors. Except for the sculpture, these works were not dependent upon a direct experience of Rome itself, but were effects of the Latin literary heritage with its strong ethical and political emphasis. They are relevant here only to suggest how extensively the Americanization of that heritage formed a part of the consciousness of those Americans who wrote and painted in Rome. They saw that the classic European tradition had extended to "Salem's shore," and that the Scipios and Caesars were active in their "inward Forum." In his polemical essays Alexander Hamilton styled himself—among other classic names—"Publius," and in *Federalist* no. 70 he extensively discussed the role of the executive in the early Republic, just as the Romans had done. Among the Founding Fathers there was a conscious sense of reenacting, or rather resuming, the deliberative work and passionate debates of the Roman Forum. And in the first half of the nineteenth century more than a few senators saw themselves as successors of Cicero not only as orators but as supreme patriots, the wise and eloquent saviors of their country in moments of crisis.

The same heroic declamatory style characterized the American theater, in which Joseph Addison's *Cato* was one of the most popular imports,[4] and for which the new American playwrights wrote stirring ethical dramas also derived from Plutarch's *Lives.* John Howard Payne (immortal as the author of "Home, Sweet Home") wrote *Brutus, or the Fall of Tarquin* (1818) about the founder of the Roman Republic; David Paul Brown wrote *Sertorious, or the Roman Patriot,* Jonas B. Phillips *Camillus, or the Self-Exiled Patriot* (1833), and the southern dramatist Nathaniel H. Bannister *Gaulantus* (1837) about the Roman conquest of Gaul. For the new Republic, theatrical realization of such models of patriotism had an obvious pertinence and function beyond entertainment. The plays lack the ethical ambiguity of Shakespeare's Roman tragedies, which had the same source. But their character as "American" didactic dramas is qualified by the fact that (like West's paintings) they

were created for an international audience. Payne's *Brutus*, for example, was first produced at Drury Lane, London. No more than historical painters could play-wrights depend solely upon an American audience. Perhaps for this very reason their appeals to patriotism were best cast in the guise of classical republican history, an objectively removed dramatic realm in which American and English republicans could see (or not see) their own situation mirrored, as they pleased. A similar situation no doubt prevailed in the instance where ancient Rome was held up as a negative model, in Robert Montgomery Bird's long-popular *The Gladiator* (1831). The hero is the slave-rebel Spartacus: the passionate attack upon an imperial republic based upon slavery was more safely directed at Rome than America.

As for sculptural renderings of Americans as Romans, the new nation did not need to wait for Hiram Powers and Horatio Greenough to go to Italy. Rome came to it. A radical republican Roman named Giuseppe Ceracchi, who would eventually go to the guillotine (posing as an ancient Roman) for his part in a plot to assassinate Napoleon, certainly meant to be flattering when he proposed to model various American Founding Fathers as Cato or some other noble Roman. He in fact ex-ecuted over two dozen of these, including busts of Washington and Alexander Hamilton.[5] This set the precedent for the numerous statues of statesmen in togas produced by American sculptors in Rome and Florence between 1835 and 1870. Of these, Hiram Powers's full-length depiction of the expansionist senator John C. Calhoun (c. 1850; destroyed) was one of the most thoroughly Roman; his otherwise realistic bust of *Andrew Jackson* (1835; fig. 3), one of the more convincing; and Edward Sheffield Bartholomew's relief called *William George Read in the Charac-ter of Belisarius* (1853; Maryland Historical Society, Baltimore), the most explicit in drawing its parallel. To objections to these depictions of Americans as Romans, the sculptors often simply advanced the argument of taste—the superior sculptural simplicity of ancient costume as opposed to the ungraceful shapes and fussy detail of modern dress. But the result certainly implied that the subject's virtuous achieve-ments had given him a permanent historical stature equal to that of a Roman senator-orator. The American-Roman parallel was suggested with more explicit propagandistic force than usual when Harriet Hosmer created in Rome her heroic statue of Senator Thomas Hart Benton (1868; fig. 4) whose voluminous cloak—and sandals—give him the Roman appearance, while beneath the westward-turned figure with a map in his hands are inscribed the words: "There is the East. There lies the road to India."[6]

George Washington was, of course, chief object of efforts in all media to Roman-ize American history. He himself knew no Latin and is not known ever to have referred directly to Roman history for inspiration or guidance, although Addison's *Cato* was his favorite play.[7] But he was immediately thought of as the modern General Fabius, a man equally suited to military and civic duties, Plutarch's "happy compound of confidence and cautiousness," who had defeated the superior force of Hannibal through a wise strategy of delay, harassment, and surprise attack. Later Washington was hailed as a Cincinnatus returning to the plow and was so depicted in a transparency illuminated within a triumphal arch by Charles Willson Peale and in the statue Jean Antoine Houdon made of him for the state of Virginia in the late 1780s. Houdon, however, showed him in modern dress, against Jefferson's advice,

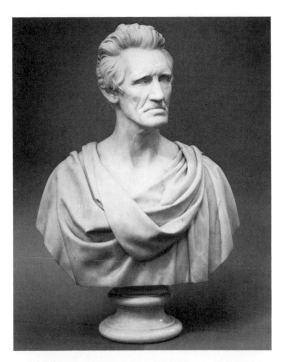

Fig. 3. Hiram Powers.
General Andrew Jackson. ca.
1835. Marble. Metropolitan
Museum of Art. Gift of Mrs.
Frances V. Nash, 1894.

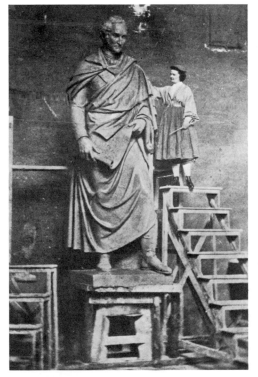

Fig. 4. Harriet Hosmer at
work in her Roman studio
on statue of Senator Thomas
Hart Benton for St. Louis.
Photo reprinted from Harriet
Hosmer, *Letters and
Memories.*

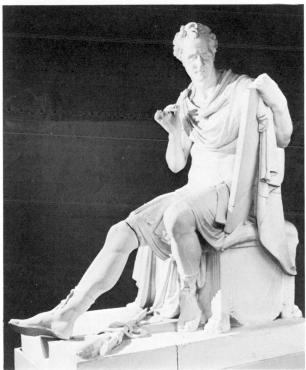

Fig. 5. Antonio Canova.
George Washington. 1819–
20. Destroyed 1831. Re-
created 1970. North Carolina
State Capitol. Photo from
North Carolina Division of
Archives and History.

and when Jefferson later recommended "old Canove of Rome" as the only sculptor competent to make a statue of Washington for North Carolina, his view that "every person of taste" would wish the "style of costume" to be "the Roman" was reflected in Canova's rendering of Washington as a seated Roman general (fig. 5). The less controversial literary practice of hailing the Father of His Country, and many a lesser statesman, in Roman terms was ubiquitous for a century after the Revolution. Phillip Freneau, in his poem "American Liberty," immediately proclaimed Washington "a Roman Hero or a Grecian God," and a century later in *Democracy*, Henry Adams has a character remark without irony (while the party is visiting Mount Vernon), "To us he is Morality, Justice, Duty, Truth; half a dozen Roman gods with capital letters."[8]

When romantic democrats like Ralph Waldo Emerson, William Ellery Channing the Younger, and Margaret Fuller went to Rome, they naturally summoned up a past whose significance was neither in its collectively striving masses nor in its patricians as a class, but in those heroic individuals who had assumed an almost allegorical ethical status to which Americans might aspire. On March 22, 1833, the twenty-nine-year-old Emerson wrote these verses in his Roman *Journal:*

Alone in Rome. Why Rome is lonely, too;—
Besides, you need not be alone; the soul
Shall have society of its own rank.
Be great, be true, and all the Scipios,
The Catos, the wise patriots of Rome,
Shall flock to you and tarry by your side,
And comfort you with their high company.
Virtue alone is sweet society.[9]

This is the soul selecting its own society with a vengeance—aristocratic society "of its own rank": the great, the true, the wise.

Moral and intellectual aristocrats were sought as a necessity also by Margaret Fuller, who, upon arriving in Rome in the spring of 1847, was revolted by the "Anglicized Rome" of "taverns, lodging-houses, cheating chambermaids, vilest *valets de places* and fleas!" As a "child of Protestant Republican America," she at first found papal Rome equally disagreeable: "a senseless mass of juggleries" which would require time to read as "really growths of the human spirit." It was for a vision of the *ancient* city that she longed, and only in January of 1848, after an absence and a return, did she find herself able to discern its outlines, "recognize the local habitation of so many thoughts" and feel "first truly at ease in Rome": "Then the old kings, the consuls and tribunes, the emperors, drunk with blood and gold, the warriors of eagle sight and remorseless beak, return for us, and the togated procession finds room to sweep across the scene; the seven hills tower, the innumerable temples glitter, and the Via Sacra swarms with triumphal life once more." Carried away by her enthusiasm, Fuller was much less discriminating than Emerson. When the editors of her *Memoirs*, of whom Emerson was one, republished this passage, they thought it prudent to delete the phrase about emperors "drunk with blood and gold."[10]

Fuller is the most interesting conjoiner of American with Roman aspirations, both ancient and modern. She had written in 1845 that Greece and Rome "brought some things to a perfection that the world will probably never see again," and the fact that "our practice" differs should not make us "lose the sense of their greatness." Her essay in the *New York Tribune* for New Year's Day, 1846, foresaw that the American eagle would "lead the van" in the rising age of democracy, although it had "scarce achieved a Roman nobleness, a Roman liberty." The question—in view of the American gaze toward Spanish territories—was whether it would avoid the vulturelike propensities of the "fierce Roman bird," whether it was "to soar upward to the sun or to stoop for helpless prey."[11] In the revolutionary atmosphere of December 1847, when Rome's new Representative Council was to be inaugurated, Fuller and other American women stitched together the Stars and Stripes (after inquiring of recent arrivals how many stars were currently required) so that the banner could wave for the first time "in the home of Horace, Virgil, and Tacitus." They intended to surmount the flag with a "magnificent" (though tail-less) spread eagle removed from a piece of furniture. But the pope, fearing tumultuous behavior, prohibited the display of any ensign but the Roman. A year later the pope fled from Rome, and on the morning of February 9, 1849, Fuller walked through the Forum to the Capitol to witness the declaration by which a new "pure democracy" regained "the glorious name of Roman Republic." She was distressed to see that the "lowest and vilest" citizens had been the first to put on liberty caps, but her letter to the *Tribune* is scornful of the ignorant fellow countryman who told her that he had no faith in the Republic because the Italians were "not like *our* people." She laughs too at his mistaking the Civic Guard for mere soldiers, when they were really—Fuller indignantly insists—"all the decent men of Rome." (The father of Fuller's newborn illegitimate child, the Marchese Giovanni Ossoli, belonged to the Civic Guard.)[12]

Fuller thoroughly sympathized with the rise of popular power and reported at length her friend Mazzini's first address to the Assembly, which declared that to the Rome of emperors, achieved by conquest, and the Rome of popes, achieved by words, now succeeded a Rome of the people, "which shall work by virtue of example." But she also believed that a natural nobility was required to set the example of virtue, and that it exercised by right the power of leadership. She wished to assimilate her earlier vision of the heroes from the past coming along the Via Sacra to the present image of new republicans mounting up to the Capitol. In a letter she wrote that "Mazzini is a great man; in mind a great poetic statesman, in heart a lover, in action decisive and full of resources as Caesar."[13]

In her comparison Fuller goes back to the earliest standard of praise she had ever known. Her father had begun to teach her Latin grammar simultaneously with English when she was six years old, and for years thereafter she read Latin daily. Consequently the "thoughts and lives" of the "great Romans" were her "daily food." She learned that

the genius of Rome displayed itself in Character. . . . Who, that has lived with those men, but admires the plain force of fact, of thought passed into action? . . . Everything turns your attention to what a man can become . . . by a single thought, an earnest purpose, an indomitable will, by hardihood, self-command, and force of ex-

pression. . . . The ruined Roman sits among the ruins; he flies to no green garden;
he does not look to heaven; if his intent is defeated, if he is less than he meant to
be, he lives no more. . . . We are never better understood than when we speak of a
"Roman virtue," a "Roman outline." . . . ROME! it stands by itself, a clear Word.
The power of a will, the dignity of a fixed purpose, is what it utters. Every Roman
was an emperor. . . . In vain for me are men more, if they are less, than Romans.[14]

That Fuller can conclude so admiring a celebration of Roman virtue with an
indication that it is a *minimal* qualification for heroic status suggests that even she
was aware of the deficiencies emphasized by others—especially Christian apolo-
gists. Fuller wrote elsewhere that Mazzini possessed *"virtue, both in the modern
and antique sense of that word,"* indicating the insufficiency of the latter alone.[15]
The austere concentration of energy into a willed act of self-fulfillment in the
service of the state that constituted antique virtue could be vicious in its effects:
selfish, cruel, destructive, and inhumane. The fact that patriotism was the funda-
mental motive might redeem the act for the Romans, but it could not for most
Christians, who had another idea of virtue.

When Samuel Eliot in his *Liberty of Rome* found occasion to sum up the virtues
of the early Romans, he made his negative point by a series of famous vignettes of
Roman family relationships:

> Horatius, the conqueror of the Curiatii, slew his sister for lamenting her lover's
> death; but was acquitted by acclamation of his crime. Tullia, the daughter of the
> good king Servius, drove over the corpse of her father, whom she had urged her hus-
> band, Tarquin, to murder; but none the less was she proclaimed the queen, and he
> the king of Rome. The daughter who fed her father from her own breast, that he
> might not die in his dungeon, was of "a sweeter," but solitary, "ray."

Since in fact Eliot admires many Romans who were compelled to less ambiguous
demonstrations of virtue—for example, the Gracchi brothers (noblest of dema-
gogues) and their mother, Cornelia, Cato the Censor, and above all Cicero (all of
whom are given extended moments on the stage of the Forum in his narrative)—his
thesis, that all Romans would have benefited from the humbling revelation that
true liberty awaited the coming of Christ, is sometimes forgotten. But he recalls the
Gracchi and Cicero in his conclusion, precisely to recognize them as exceptions
whose "aspirations" toward "higher powers . . . than those of conquerors and rul-
ers" were "not allowed to spread." The Romans as a whole "lacked the first neces-
sities of humanity"—a knowledge of right and wrong, personal humility, and the
revealed truth of God's purpose. That was not their fault, but the result of the
Almighty's desire to "prove through ages of conflict and loss that no lasting joy and
no abiding truth could be procured" by heathen ideas of liberty and virtue.[16]

Eliot's citation of the famous Roman Daughter who fed her imprisoned father
from her own breast as a "solitary" example of a "sweeter" virtue than was usually
found among even the women of Rome raises the question of what did constitute
virtuous behavior in women, a question of particular importance because Roman
virtue was typically perceived as inherently "masculine," in contrast to the "femi-

nine" virtues of Christianity. The Roman Daughter's legend has a peculiar popularity that must owe more to its piquancy than to its usefulness as a practical lesson in "caritas," as the virtue was specifically called. Travelers sometimes mention the Roman prison, located beneath the Church of San Nicola in Carcere, where the legendary event supposedly occurred, and Rembrandt Peale painted the scene in a version derived from Rubens (fig. 6).[17] (The subject had also been treated by Murillo and Guido Reni, and in an antique Pompeian painting reproduced in 1765.) In the version told in Pliny's *Natural History* the pair are mother and son; the more popular version in Valerius Maximus identifies them as father and daughter, describing the event as one that is somehow both classic and novel; finally, in some instances the incipient incest motif is avoided by making them simply a young woman and an unrelated older man (a version notoriously reenacted by Rosasharn in Steinbeck's *Grapes of Wrath*).[18] This exclusively feminine mode of charity seems not to have been celebrated by women, certainly not by Margaret Fuller.

The other great exemplar of feminine virtue to whom Eliot refers, Cornelia, achieved the identity she desired when she ceased to be known as "the Daughter of Scipio Africanus" and became "the Mother of the Gracchi." A statue in the Forum, erected in her lifetime, so honored her. The extraordinary virtue of her sons, both of whom died young in defense of the rights, property, and welfare of the poor against the land-usurping and slaveholding senators, was attributed more to the education she gave them than to their noble blood. When the sculptor Harriet Hosmer sent a photograph of her statue of Zenobia (fig. 7) to the popular writer Lydia Maria Child, Mrs. Child praised the image of the "Warrior Queen," but immediately proposed that Hosmer do one of "that Mother of the Gracchi who has been quoted to us women, even to tediousness." She imagined the statue would show "a noble-looking matron" cuddling her youngest son, while the "older boy" looks up "with a frank, manly smile into the maternal face" filled with "loving pride."[19] Obviously Mrs. Child was not going to confuse the gender-related virtues she celebrated in *The Frugal Housewife* and *The Mother's Book*. Hosmer, who was surely attracted to Zenobia precisely because she had dared—like Hosmer herself—to engage in a traditionally masculine profession, ignored the insensitive suggestion. Instead, when she got the chance she made a heroic sculpture of her friend, the contemporary queen of Naples bravely appearing on the ramparts of Gaeta. Zenobian virtue could be as contemporary as that of the Mother.

Hosmer's statue of Zenobia was probably inspired by the presentation of the queen in *Celebrated Female Sovereigns* (1831) by her friend in Rome, the well-known English writer Anna Jameson, and by William Ware's popular romance, which was often cited in relation to Hosmer's work.[20] *Zenobia, or The Fall of Palmyra* and its sequel *Probus* (also published as *Aurelian*) are to a large extent fictionalized debates on the relation of Roman to Christian virtues, which are explicitly identified as "masculine" and "feminine." Ware's interest in antiquity evidently originated in a desire to prove that his Unitarian theology was not a novelty, but was in fact "the earliest of all the forms of Christianity" and "the only religion of the New Testament."[21] His study of the early Christians of Rome, before the establishment of the Roman Catholic church and the trinitarian dogma, resulted in eloquent rhetorical romances whose major characters are mainly noble

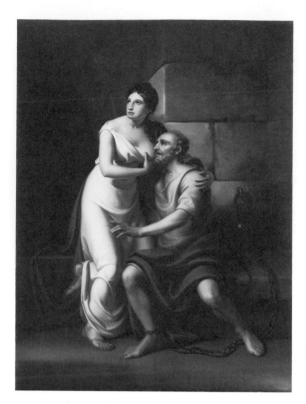

Fig. 6. Rembrandt Peale. *The Roman Daughter.* 1811. Oil on canvas. 84¾ × 62⅞". National Museum of American Art, Smithsonian Institution. Gift of the James Smithson Society.

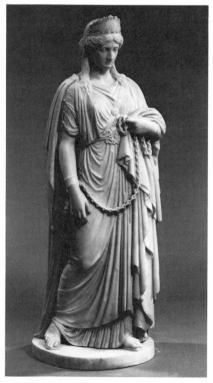

Fig. 7. Harriet Hosmer. *Zenobia in Chains.* 1859. Marble. H: 49". Courtesy Wadsworth Atheneum, Hartford. Gift of Mrs. Joseph M.J. Dodge.

Romans who convert to Christianity. They unify the best of both worlds. The Roman element is purified while the Christian inherits the stoic strength and worldly realism of the Roman. The synthesis is opposed both to sensual debauchery and to ascetic fanaticism. But in the first and more popular romance the heroine is an enlightened pagan whose fascination derives from her possession of "masculine" Roman virtue.

Zenobia takes the form of letters written by a noble Roman, forced to reside in the voluptuous eastern city of Palmyra, to his friend in Rome. The initial effect is to exalt Roman virtue. "Palmyrenes, charming as they are, are not Romans. They are enervated by riches, and . . . luxurious sensual indulgences." There are exceptions: "All Rome cannot furnish a woman more truly Roman than Fausta, nor a man more worthy [of] that name than Gracchus." But "the younger portion" of the population "are without exception effeminate," a sure sign that Palmyra is doomed to fall. Here a Roman judges another empire in the terms by which Rome itself will soon be judged by Christians. Simplicity, frugality, and temperance are equally Roman and Christian virtues; when the Romans abandon them, they are continued by converts to the new faith. But these virtues are good only because they serve the higher purpose for which one lives. On this point Roman and Christian are opposed. The highest Roman virtue is devotion to the state, and Zenobia the eastern queen is thoroughly Roman in her identification of her personal ambition with the good of her country, and in her expression of it through military conquest. When she appears armed with javelin and shield, riding her white Numidian charger into combat, everyone is awestruck by the "marvelous union of feminine beauty, queenly dignity, and masculine power."

The only criticism of Zenobia comes, appropriately, from Gracchus, a descendant of the famous Mother. Agreeing that Zenobia surpasses Cleopatra in beauty, character, and intellect, he nevertheless fears her ambition. "Caesar himself was not more ambitious," he says, but admits that "in her even this is partly a virtue," since her wish is that "her country may with and through her be great also." Although Gracchus fears that in overreaching she will rather bring about the ruin of her country (which in fact is what happens), Ware tends to support a liberating idea of women's capacities, just as he believes that Christianity liberates the "feminine" virtues in men. He allows Fausta, Gracchus's daughter, to retort to her father that he reminds her of "the elder Cato," who praised women as long as their entire lives were "to promote the interests of their worthy husbands, the lords of the world," but condemned them as soon as they showed some ambition of their own. Fausta is happy in Zenobia's vindication of "her sex against the tyranny of their ancient oppressors and traducers": " 'I see not that our Queen has any more of this same ambition than men are in the same position permitted to have, and accounted all the greater for it. Is that a vice in Zenobia which is a glory in Aurelian?' " This is the crucial question; but the entire discussion occurs while they are watching wild animals fight in the arena, and Zenobia's unblinking pleasure in seeing an elephant gored by a rhinoceros, and both destroyed by a tiger—a sight from which even Fausta must turn aside—is disquieting. Zenobia's daughter, Princess Julia, who has fallen under the influence of Christians, cannot watch at all.[22]

Julia is the instrument of Piso's conversion; from her woman's lips the Christian

message sounds even more natural and attractive than it had when the manly Roman Probus had gently preached to him on the ship from Rome. "Is there any thing in our Roman superstitions, or philosophy even, that is at all kindred to the spirit of a perfect woman?" Piso asks.

> Has it ever seemed as if woman were in any respect the care of the gods? In this, Christianity differs from all former religions and philosophies. It is feminine. I do not mean by that, weak or effeminate. But in its gentleness, in the suavity of its tone, in the humanity of its doctrines, in the deep love it breathes toward all of human kind, in the high rank it assigns to the virtues which are peculiarly those of woman.

The probability of the divinity of Christ comes from the fact that no human— certainly no Roman—could have conceived any such reversal of values.[23]

After this, much of Ware's concern—in *Zenobia* and much more in *Probus*—is to show that Roman men who convert to Christianity retain their urbanity and essential masculinity. When Piso, after his conversion, stops at a shop in the Forum to sample the newest perfumes and then goes on to take a critical look at the latest works of sculpture, Ware is emphasizing that the Christian gentleman does not give up the pleasures of this world; but his delicate discrimination distinguishes him from the vulgar materialist, just as his aesthetic appreciation separates him from the world-hating ascetic.[24] More important, his tender nature has not been gained at the expense of his courage. A sequence of death scenes in the two romances seems designed to suggest a progressive relation rather than an opposition between Roman and Christian virtue. Gracchus is shown facing his death with the admirable philosophical resignation of a Stoic; Longinus (Zenobia's court philosopher), who as a Platonist believes in a single God and in the immortality of the virtuous soul, awaits his end with a curious expectancy and without fear; finally, in *Probus*, the Christians go to their martyrdom with positive faith and a solemn joy. Their passivity before an increasingly brutal Emperor Aurelian is their most "feminine" virtue, but it is also understood to be the greatest sign of their strength, the virtue by which paradoxically they will become conquerors of Rome.

In historical Roman romances since Ware's—among which Gen. Lew Wallace's *Ben-Hur* (1885) and Rev. Lloyd C. Douglas's *The Robe* (1942) are the most widely read—a sentimental submission of the self to a Christian woman typically follows a victory in a battle or in the arena by which the hero has proven his essential Roman manhood (Ben-Hur, a patrician Jew, originally shares the manly virtues of his Roman friend but is moved inexorably toward a conversion to Christianity in the company of mother and sister, whereas his friend becomes ever more brutal.) This conventional ascendancy of Christian, or "feminine" over Roman, or "masculine" values in historical romances is not characteristic of most writers of the Revolutionary period and the nineteenth century. They do not seem to have found martyrs for Christ more attractive than martyrs of the Roman Republic. When John Adams wrote that "all the ages of the world have not produced a greater statesman and philosopher united than Cicero," he was undisturbed by the fact that Cicero had somehow achieved this status in a "heathen" age.[25] Margaret Fuller herself does not

celebrate "feminine" values or hold up the Roman Daughter or even the Mother of the Gracchi as models for women. Frugality and temperance, traditionally associated with the best of the old Romans and exemplified in "aristocratic" Founding Fathers like Adams and Washington, are not essentials in her definition, which if anything encourages splendor and excess. Roman virtue for Fuller is primarily a matter of "masculine" self-fulfillment through energy, strength, and will. Personal ambition is something that in Roman history was as often found in plebeians who rose to power by means of this single virtue as in noble-born tribunes like the Gracchi, who also possessed every other grace. In America intimate knowledge of the classics may have been the property of a privileged class, but what the classics often illustrated was the power of the people to produce their own champions. When James Fenimore Cooper recognized Andrew Jackson as an "old Roman," it was with this conception in mind, one quite different from that which identified the "Roman" nobility of a Washington. The "feminization of American culture," to which Ware's books made their contribution,[26] had no counterpart in the popular political process that made presidents of Generals Jackson and Grant.

Fuller's reference to the "ruined Roman" who "sits among the ruins" is to Gen. Caius Marius, a military hero of the late Republic. As Plutarch told his story, and as Eliot repeated it at length in *The Liberty of Rome*, Marius exemplified Fuller's definition of Roman virtue both in its active power and in its limitations. Marius's character illustrates how that Roman virtue, in ancient Rome and in republican America, was not to be found alone in Fabii and Gracchi, Washingtons and Adamses; it was also found in Aaron Burrs and Andrew Jacksons. Marius was made the subject of a lost play by Richard Penn Smith written about the time that the Indian fighter General Jackson, rough man of the people, was elected president; the great tragedian Edwin Forrest performed the role in 1831 while Jackson was in office. *Marius amid the Ruins of Carthage* (fig. 8) was the subject of one of John Vanderlyn's best-known paintings, a reduced replica of which he made in 1832, but which was originally painted in Rome in 1807 while his former patron, Aaron Burr, was being tried for treason. ("Was there in Greece or Rome a man of virtue and independence, and supposed to possess great talents, who was not the object of vindictive and unrelenting persecution?" Burr asked his daughter, charging her with the task of writing an essay on the subject.)[27]

Marius represents a universal democratic type. A person of low provincial birth, he "came from combat in the field to combat in the Forum," says Eliot. As an elected tribune of the people, he was rough in manners and unskilled as an orator. He "laughed at refinement or learning" as "disgraceful to a Roman" and scorned the "avarice and corruption of the Commonwealth," himself living "frugally, almost solitarily," concerned only with his advancement to power. He pitted himself against the aristocracy, including the patrician who had sponsored him. Eliot regrets that the "universal profligacy" of the age makes "such a spirit as animated Marius" seem "honorable" in its opposition to the corrupt state, the weakness of which he exploited. Marius presented himself to the people as "the new man" who has learned not from books but from war, whose "nobility" derives not from ancestry but from "my labors, my virtues, . . . my perils, . . . my wounds." Such an appeal naturally got him reelected (he was the first man to be tribune seven times). His

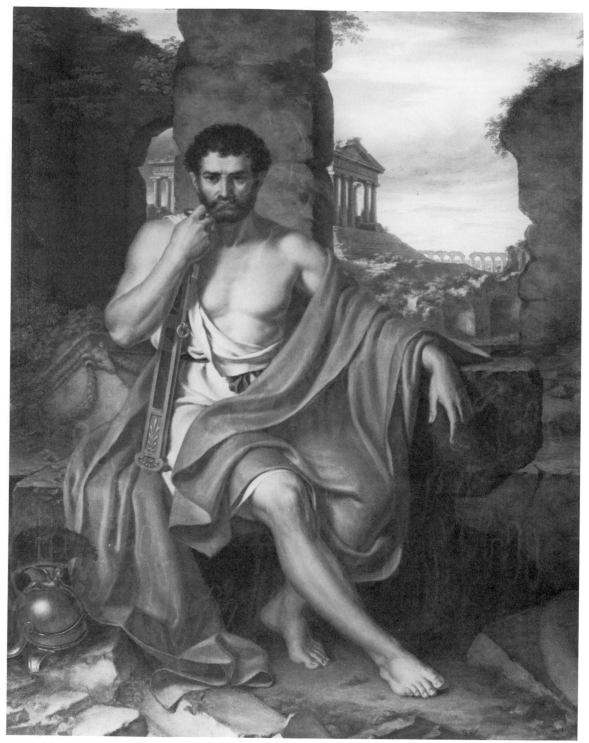

Fig. 8. John Vanderlyn. *Marius amid the Ruins of Carthage.* 1832 (re-
duced replica of 1807 version). Oil on wood panel. 32 × 25⅜". Collection
Albany Institute of History and Art.

military victories did in fact result from his ferocious valor, but the same violent character sustained his faction's power in the Forum. (Eliot's chapter on Marius has as its epigraph a comment from the Unitarian scholar-minister Henry Ware— William Ware's father—on the "worst features of party spirit" in contemporary America.) The fact that Marius was acknowledged "the preserver of the Commonwealth and the third founder of Rome" did not save him from banishment and the threat of death when an opposing faction assumed power. Arriving in Africa, where he expected to find security with the military governor, he heard instead the governor's messenger state that the Senate's decree would be executed if he did not leave. He then made the famous reply comparing himself, a ravaged old soldier fallen from his former greatness, with the ruins of the great city also destroyed by Rome: "Go tell him that you have seen Caius Marius sitting in exile among the ruins of Carthage."

Vanderlyn's painting, the first published reference to which is, appropriately, in the *Ulster Plebian* of New Jersey, is ambiguous in its effect. Plutarch's Marius is a disease-ridden man over seventy years old, a corpulent drunkard disfigured with scars and skin tumors. Obviously Vanderlyn had no wish to paint such a figure. His Marius is instead, in his own words, an embodiment of "the strongest, most masculine characteristics." In the words of the promotional pamphlet that accompanied exhibitions of the painting (in which it was paired with the ideal of feminine beauty, his nude Ariadne [fig. 70]), "the relaxed state of his herculean limbs and athletic muscles, shew the fatigues he has undergone, and the misfortunes he has endured." Marius thus does not appear as a ruined man, stoically accepting the turn of fortune, but one capable of the terrible revenge he subsequently carried out. Plutarch describes him at this point as grief-stricken, and sighing deeply. Later, after he has seized the opportunity for an alliance to overthrow the established government of Rome and has led a pillaging army of refugees and slaves whom he has freed to the heights of the Janiculum, he looks down upon Rome with his "natural fierceness of expression," not so much "dejected as exasperated by his change of fortune."

This is the moment Vanderlyn has anticipated in his painting. When he began it in January he wrote that he wished to show Marius "in sombre melancholy, reflecting the mutability of Fortune," and Marius's face appears to derive from that of Lucius Brutus in David's painting of the founder of the Roman Republic after his traitorous sons had been executed at his command. But when Vanderlyn completed the work in December he wrote that he intended "the countenance of Marius" to show "the bitterness of disappointed ambitions, mixed with meditation of revenge." From a stoical exemplum virtutis the painting thus changed into a romantic mood piece with no moral whatever. It is significant that Henry T. Tuckerman persisted in seeing it in the old-fashioned way. In *The Book of the Artists* (1867) he asserts: It "embodies the Roman character in its grandest phase, that of endurance; and suggests its noblest association, that of patriotism. It is a type of manhood in its serious, resisting energy and indomitable courage, triumphant over thwarted ambition,—a stern, heroic figure, self-sustained and calm."[28] In contrast, the promotional pamphlet for which Vanderlyn himself was surely the authority, urges the spectator to perceive "a mind inflexible and resolute, a temper fierce and irritable, a

disposition sordid and avaricious." The painting, of course, has not shown quite all this, but the commentary is consistent with the fact that the streets of Rome were shortly littered with the mutilated and beheaded enemies of Marius, now "under the control of passion too fiendish to bear with a moment's humanity," according to Eliot. Not surprisingly, *Marius* attracted the attention of Napoleon at the Salon in Paris and received a gold medal.[29]

Such a painting and fascination with such a character initiate a third reading of the page of history represented by the Forum: one that does not seriously seek to discover in it lessons of political science, nor individual examples of great virtue worthy of imitation, but simply a source of entertainment—a catalog of great passions and an index to human folly.

The Rubbish Heap

In 1863 an artist named Henry P. Leland published a curious book called *Americans in Rome*. Its hero is also an artist, named James Caper. He has come to Rome to paint animals. Soon after his arrival he inquires of a monk (who turns out to be illiterate) the meaning of the word *immondezzaio* (rubbish heap), the most common sign in Rome: "Perhaps it is the name of the street—may-be of the city?" Standing in the tower of the Capitol, from which Hillard and Hawthorne and Greene had beheld a "glorious page" of history, Caper is glad to have the word ROMA—hated "noun of the first declension, feminine gender"—"literally under foot" where he can throw cigar ashes on its head. Caper nevertheless manages to work up a sham enthusiasm and is just imagining a Triumph marching "past pillared temples, under the walls of shining palaces," when he is interrupted:

> "Pray, and can you tell me—if that pile of d——d old rubbish—down there, you know—is the Forum—for I do not—see it in Murray—though I'm sure—I have looked very clearly—and Murray, you know—has everything down in him—that a traveller" . . . "A commercial traveller?" . . . interrupted Mr. Caper . . . looking coolly into the eyes of the blackguard Bagman. . . . "The ruins you see there, are those of the Forum. Good morning."[1]

The artist's indignation arises from having his effort at romantic self-delusion spoiled when a mere "Bagman" voices what Caper actually feels.

The metaphor of the Forum as an eloquent page that could rightly be read only by scholars and romantics began to compete with the perception of it as a rubbish heap. Instead of an eloquent repository of lessons in politics and ethics, it could seem, as it did to Howells, merely an accumulation of arbitrarily surviving signs without rational relationship or present function: an apt symbol for the insignificance and irrelevance of history itself. Individual objects within the heap might have the amusing and purely aesthetic glitter of beautiful, terrible things from a remote and alien age, fragments of historical memory distorted into dream. This was the material of romance. But by extension of the metaphor, the Forum provided materials for

satire as well: it was the place where the intolerable rot and stench of true history was exposed. Ancient Rome was a society motivated by avarice and lust, powered by slavery and tyranny, inherently corrupt, its virtues the mask of hypocrisy, and therefore worthless. Rome was a society to be rejected, not imitated, fit only for a refuse heap.

Nathaniel Hawthorne and his family arrived in Rome on January 20, 1858, and only two weeks later he was comparing it in his notebook to "a dead and mostly decayed corpse, retaining here and there a trace of the noble shape it was, but with a sort of fungous growth upon it, and no life but of the worms that creep in and out." In *The Marble Faun* (1860) the "noble shape" of the ancient city is even more sharply excluded from the image of what it now is—"nothing but a heap of broken rubbish, thrown into the great chasm between our own days and the Empire." Rome's "annals" for these nearly two thousand years are similarly "broken rubbish, as compared with its classic history."[2]

An eloquent passage in Sophia Hawthorne's *Notes in England and Italy* (1869), however, describes her disillusionment with classic history as well and attributes the loss to her residence in Rome. The occasion is the family's return to the city in October, after a summer sojourn in Florence and travel in the North. Sophia expresses her astonishment that they all felt a heart-wrenching sense of homecoming to the miserable city in which they had passed many wretched days. At a high place on the road to Rome, she had asked their vetturino to stop so that everyone could get out to enjoy the view. The vetturino cried out "Roma!" and removed his cap, "J[ulian] gave a shout, and then we all gazed in silence for some time." Sophia, looking for the sites of the ancient destroyed towns of Corioli and Veii, thinks of the "terrible and desolating hand of Rome, who grasped every body and thing." Least of all could the best escape. "Genius, Beauty, Efficiency—wherever the Imperial Eagle could see them were pounced upon and swooped up into the possession and service of the absorbing domination." She recalls that as a "youthful student" she had "always sided and fought" with the Roman legions, who seemed "the sole rightful victors. . . . I then devoutly believed that a Roman was a cunning composition of perfect honor, bravery, and virtue (not virtue in a Latin meaning, but a Christian). . . . The Conscript Fathers stood with me for all majesty, patriotism, and wisdom. . . . Roman matrons were ideal womanhood, 'without suspect.' " But when she reviews history now, she sees the "six thousand crucified men of Crassus," and they "throw into black eclipse forever my flashing Empire."

> Yet history might never have destroyed my fancies, if I had not come to Rome. Here I both feel how it all was, and strange to say, I am also magnetized with the power that hovers invisibly in this air, like the spirit of the eagle that never stooped in the hand of the Roman standard-bearer. What, then, is this Rome that *will* hold sway over mankind, whether or no, in past and present time?[3]

The Forum ceased to be a place of pilgrimage, although it could still evoke "wonder," when ancient Rome—the Republic as well as the Empire—became associated more with ideas and images of insidious and inexorable power than with liberty, law, or virtue. But this release of the matter of Rome from positive political

and moral contexts made it more available for satire and romance. For purposes of satirical parallel there were four interrelated aspects of Rome's power that inevitably related to America. First, patriotism as the supreme virtue, requiring the absolute submission of the individual to the commonwealth and most purely exemplified by the soldier's self-sacrifice in war, made possible, second, the Empire, the achievement of a great nation's Manifest Destiny. Third, slavery, in Rome enormously extended as an economic and political fact by imperialistic conquests, existed there and in America as a contradiction to the republican idea of liberty, although fully authorized by law. Finally, both slavery and national expansion fostered, fourth, the accumulation of wealth and the growth of luxury.

In *Zenobia* William Ware's noble Roman, Piso, is finally constrained to ask, "Since the days of Cicero and the death of the Republic, what has Rome done to advance any cause, save that of slavery and licentiousness?" His expatriated brother, denying that he owes filial loyalty to Rome, is even more bitter on the subject of patriotism, "the mother of war," the "instinctive slavery of the will":

> Men . . . have not inquired, is the cause of my country just, but merely what it is. That has ever been the cry in Rome. "Our country! our country!—right or wrong— our country!" . . . I am no Roman in this sense. . . . What is this country? Men like myself. Who enact the decrees by which I am to be thus bound? Senators, no more profoundly wise perhaps, and no more irreproachably virtuous, than myself.[4]

These were familiar questions and outcries in the America of the 1830s, as were other aspects of the debate. In the same year that the first volume of George Bancroft's great *History of the United States* (1834) appeared, he published a long essay on "The Decline of the Roman People." The literary results of Bancroft's postgraduate visit to Rome in 1822 had been merely some jejune aesthetic poetry printed in a slim volume the next year, but since then he had become the highly political, intensely nationalistic and expansionist supporter of Andrew Jackson. He carefully analyzed the decline of the people of Rome (not the Empire) as the result of extreme differences in wealth and property, and the institution of slavery. *Democracy* in itself, he insisted, did not lead to despotism.[5] Ware's romances broach these issues as well. When Piso (who owns five hundred slaves himself) hears that his correspondent's slaves have become rebellious, he says that slavery makes him "hate my country and my nature, and long for some power to reveal itself . . . capable to reform a state of society, rotten as this is to its very core." In the sequel, *Probus, or, Rome in the Third Century*, which is also primarily in the form of letters by Piso, now addressed from Rome to Fausta in Palmyra, his attack on slavery destroys respect for the Republic itself: "Rome never was a republic. It was simply a faction of land and slave holders, who blinded and befooled the ignorant populace by parading before them some of the forms of liberty, but kept the power in their own hands. . . . And among no people can there be liberty where slavery exists. . . . He who holds slaves cannot in the nature of things be a republican." Slavery, he concludes, destroys the virtue of the slaveholders as well as the slaves; of necessity violent and selfish, they cannot be "the stuff that republics are made of."[6] In such a spirit Howells later observed that the antique Roman portrait statues closely resem-

bled modern American politicians—especially southerners. This encouraged him to believe that character depended less on race than on circumstances: "a republicanism based upon slavery, . . . the same unquestioned habits of command, and the same boundless and unscrupulous ambition."[7]

Robert Montgomery Bird's long-popular drama *The Gladiator* (1831), whose hero is the slave-rebel Spartacus, no doubt made American audiences ponder the contradiction between their ideal of liberty and the fact of slavery, although Thomas Jefferson's comparison of Roman and American slavery had long since provided one of the reasons for distinguishing between them: Roman slavery was not based on race. But slavery in the Roman Republic did not become irrelevant to America after the Emancipation. Howard Fast's *Spartacus*, one of the most popular novels of the 1950s, clearly had a message for America: Spartacus's rebellion personifies liberation of the masses of laboring men and women, the productive members of society, from their "enslavement" by the parasitic possessors of wealth and property. *Spartacus* is a satirical romance. Its romance resides both in its re-creation of the remote Roman past and in its own vision of a puritanical utopian future. In spite of muddled narrative strategies that confuse points of view, it engagingly presents a world of exotic practices (from the highly specialized training of gladiators to the arcane procedures for manufacturing perfumes), while polemically dividing society into Good and Evil and foreseeing a world when the Good shall prevail. Spartacus, who leads the rebellion in which thousands of soldiers are slaughtered, is incredibly "pure and gentle." Fast insists repeatedly upon his purity, simplicity, and humility, although immediately after telling his comrades that they, not he, shall make the laws of the new society, Spartacus pronounces two: all property shall be held in common, and monogamy and lifelong fidelity shall be required of all men. These are naturally two of the points in which his society of the future most differs from contemporary Roman (and twentieth-century American) society.

Fast satirizes Rome by holding it up to its own famous virtues. In the early pages of the novel a Syrian trader expresses his great admiration for Rome, contrasting the *gravitas* of its citizens with the *levitas* of orientals like himself: " 'The Roman does not trifle; he is a student of virtue. *Industria, disciplina, frugalitas, clementia*—for me those splendid words are Rome.' " The context, however, renders the statement doubly ironic. First, the occasion for the remark is the impression of Roman power that has been made on the Syrian by the "tokens of punishment" displayed along the entire Appian Way to Rome—six thousand crucified followers of Spartacus (the same horrendous image that had eclipsed Sophia Hawthorne's vision of a brilliant empire). Second, the auditor of the Syrian's praise is a rich and effete young Roman, Caius Marius, who is incestuously attracted to his sister and that same night will share his bath and bed with General Crassus, the conqueror of Spartacus and savior of Rome. It is part of Fast's satirical strategy to debase the manly military hero (as by other means he must trivialize Cicero, the champion of liberty, into a mere politician, ambitious and unscrupulous). Fast asserts at one point that a society that finds homosexuality "normal" also is one that finds the crucifixion of six thousand rebel slaves "normal." The twin depravities unite in Crassus. At the same time Fast the popular romancer makes the most of a world in which such sensational behavior occurs. He attacks it through graphic exploitation of its vices.[8]

The judgment of imperial Rome by the standards of the early Republic was of course a classic satirical device. Any reader of the imperial historians themselves—Polybius, Plutarch—automatically inculcates the strategy. The Empire had not been created by emperors; it had made them possible. The Republic itself, when it lost its austere virtues and simplicity and became imperial and luxurious, brought on tyranny. In Ware's *Probus* even a fanatical Christian who normally has nothing good to say about Rome at any period mounts the steps of a temple in the Forum to mock "Roman justice" under Aurelian, claiming that "it was not so once in Rome. Were Cincinnatus or Regulas at the tribunal . . . [and so on]."[9] This contrast between what Rome (ideally) was and what it became is recurrent in most of the power-conscious interpretations of the Forum's meaning, with the frequent implication that what it *now* is—a ruin—was naturally the next stage in a necessary sequence. For Americans—as for writers of the English "Augustan" age before them[10]—decades rather than centuries had sufficed in their own countries for the change from republican virtue to imperial tyranny and corruption. There have always been Americans ready to assume, with greater or less seriousness, the togas of Cicero or of Cato the Younger, imagining themselves already living in the last days of the Republic. They extend from the slavery-hating (and slaveholding) oratorical senator from Kentucky, Henry Clay (expansionist "War Hawk" and compromising savior of the Union), to the novelist-essayist Gore Vidal, who, perhaps observing that the banal wickedness of Washingtonians as yet failed to live up to Caligulan standards, took up residence in Rome itself in anticipation of the end.

No one perceived the parallel more anxiously than Charles Eliot Norton in the last decades of the nineteenth century. He had been in Rome in 1856–57, had edited the *North American Review* from 1864 to 1868, and helped to found the *Nation* in 1865. As the centennial year approached, he joined other pessimists in noting a scarcity of Americans of Roman virtue in comparison with the early days. Back in Italy in 1870, he lamented in a letter to the philosopher Chauncey Wright that there were no "best men"—no *aristoi*—at the nation's maturity who could replace Emerson (who was still alive) as a national influence: "He belongs to the pure and innocent age of the Presidency of Monroe and John Quincy Adams,—to the time when Plancus was Consul." Later, when some of his friends were the chief architects of Chicago's World's Columbian Exposition of 1893, which was thought to rival in splendor the Rome of the third century (precisely the period of Ware's novels), Norton—now celebrated as Harvard's first Professor of Fine Arts—tried to think well of it. But its location indicated how quickly America's western empire had grown, becoming a new determinant of American character. To Norton the increase in democracy was having barbaric results, both in the destruction of standards of taste and behavior and in the rise of the war spirit.[11] In a notorious address called "True Patriotism," delivered to the Cambridge Men's Club in 1898, Norton advised the young men in his audience that the enlightened among them would be wrong to fight in America's imperialist war against Spain. The intelligent and educated had higher services to perform for the country, such as reestablishing its true virtue, which was *not* military. He concluded with an apparently invented quotation that converts past-tense Ciceronian despair into a negative Horatian imperative: " 'Nil desperandum de republica.' "[12]

The attempt to separate republican virtue from military patriotism was itself desperate and unhistorical. Indeed, what becomes most evident in American allusions to Rome is their arbitrary quality; they are based upon rhetorical convenience and not upon a philosophy of historical recurrence or necessity. Norton could as readily adopt the Empire as the Republic as the standard of high civilization when the target of his criticism differed. In 1896 he wrote to Sir Leslie Stephen, "I can understand the feeling of a Roman as he saw the Empire breaking down, and civilization dying out." Henry Adams, a representative of the natural nobility that his great-grandfather had envisioned arising in republics, provides an even more significant instance, since no one attempted more anxiously than he to understand historical change. When he wrote his *Education* early in this century, he recalled how in 1860, when he was a boy of twenty-two, he had sat self-consciously upon the steps of the Capitoline, where his idol Gibbon in 1764 had conceived the idea for *The Decline and Fall of the Roman Empire* (a work finished in 1787, the year of John Adams's publication of his *Defence* of the nascent American republican system). "One looked idly enough at the Forum or at St. Peter's, but one never forgot the look and it never ceased reacting," Henry wrote; for what one absorbed was a lesson in "anarchy and vice" that destroyed one's assumptions "that everything had a cause, and nature tended to an end." One felt that "Rome was actual; it was England; it was going to be America," yet the sequence could be explained by no "systematic scheme" of evolution or progress. One desperately wanted an answer to the question of why Rome had failed, because "to make it personal" one simply substituted "the word America for the word Rome." By 1905 the predicted and inexplicable change seemed already to have occurred. Looking from the window of a hotel on Fifth Avenue, Adams "felt himself in Rome, under Diocletian, witnessing the anarchy, with no Constantine the Great in sight."[13]

A historian's doubt that history has meaning would seem to legitimate its use for pure romance. When Adams wrote that "Rome seemed a pure emotion, quite free from economic or actual values," that "not even time-sequences—the last refuge of the helpless historians—had value for it," that "the Forum no more led to the Vatican than the Vatican to the Forum," and "Rienzi, Garibaldi, Tiberius Gracchus, Aurelian might be mixed up in any relation of time, ... and never lead to sequence,"[14] he was describing the freedom with which visitors to the Forum and writers of historical romance and drama might disregard chronology and context in the interests of pure emotion.

It is probably no accident that works by two American expatriates, who were very famous in their day and lived long in Rome far from the rapid social changes in America between 1870 and 1900, best exemplify the use of the ancient city for amoral and apolitical romance. Francis Marion Crawford was in fact born in Italy, the son of Thomas Crawford, the first American sculptor to take up permanent residence in Rome. The best-selling romances that made Crawford for many years the richest American writer of his time will concern us in a later chapter. Of interest here is a book that also sold extremely well in several editions: *Ave Roma Immortalis*, first published as two volumes in 1898. In purpose and form, this work is original. Its first sentence asserts Crawford's thesis: "The story of Rome is the most

splendid romance in all history." The rest of the book is written in a charged, incantatory style that forestalls any reflective pauses to consider anything, certainly not truth. The early legendary figures emerge with "faces of beauty or of terror, sublime, ridiculous, insignificant." Personification, easy similes, and the present tense are used constantly: "Terror descends like a dark mist over the young nation" when the Etruscan Porsena threatens it and Horatius must defend the bridge. When "fair young Virginia" is "stabbed by her Father in the Forum," it is "romance again, but the true romance, . . . full of fate's unanswerable logic":

> You may see the actors in the Forum, where it all happened,—the lovely girl, with frightened, wondering eyes; the father, desperate, white-lipped, shaking, . . . Appius Claudius smiling . . . ; the sullen crowd of strong plebeians, and the something in the chill autumn air that was a warning of fate and fateful change. Then the deed. A shriek at the edge of the throng; a long, thin knife, high in air, trembling before a thousand eyes; a harsh, heartbroken, vengeful voice; . . . and then the rising yell of men overlaid, ringing high in the air from the Capitol right across the Forum to the Palatine, and echoing back the doom of the Ten.[15]

Crawford does not even tell us *why* Virginia is being stabbed; either it doesn't matter or the reader already knows. The author asserts elsewhere that the name of his beloved poet Horace is "a household word," but a man who had grown up in a Roman palazzo and played as a child in his father's studios built into the ruins of the Baths of Diocletian perhaps had unusual ideas of what is commonly known. In any case "fate" suffices to explain all, and as a romancer Crawford can happily go on to summarize "riot after riot in the Forum" in the last days of the Republic. Marius, Sulla, Cinna, and Octavius conduct their "reigns of terror" with beheadings, house burnings, and general slaughters. Blood flows continuously, and Crawford delights in the quickly accumulated horrors. It takes him only twenty-six pages to cover the first seven hundred years of Rome's history: "Then the greatest figure in all history suddenly springs out of the dim chaos and shines in undying glory"—Julius Caesar. Rome owes its "charm," says Crawford, to its incomprehensibility. Topographically bewildering and historically inexplicable, Rome can be known superficially after ten years of study, according to the great scholar Jean Jaques Ampère, but only after twenty might one say something new. Therefore it is better "to feel much than to try and know a little, for in much feeling there is more human truth than in that dangerous little knowledge which dulls the heart."[16]

After Crawford's hundred-page intensely emotional review of Roman history, the book is divided into explorations of each of the city's fourteen "regions" and the Vatican. By this method chronology and its implied cause-and-effect developments are necessarily sacrificed to topographical accidents and associations. Consequently, random episodes of the past seem to exist simultaneously on a given spot. Lacking any other context, they emerge as thrilling, fateful melodramas (much like Crawford's fictions), and the city becomes a sequence of superb stage sets. When Crawford arrives at the tenth region, Campitelli, in which the Forum is situated, his method is explicitly hallucinatory. This is not the ennobling, challenging, and sweetly melancholy vision of lost human grandeur evoked by Goethe and Stendhal

and the earliest Americans through Margaret Fuller; it has simply the appeal of dream life for its own sake, vivid, illogical, bizarre. Old crones selling chestnuts and Hebrew money changers in yellow eastern gowns are as important as the Gracchi, and barons from the Middle Ages pop up beside the umbilicus of the world simultaneously with Catiline or Caligula. When he is done, Crawford states that "whether the day-dream much resembles the reality of ages long ago" is immaterial, since in any case "the traveller has had an impression, which has not been far removed from emotion, and his day has not been lost, if it be true that emotion is the soul's only measure of time." That, he concludes, is "Rome's secret": "The place, the people, the air, the crystal brightness of winter, the passion-stirring scirocco of autumn, the loveliness of spring, the deep, still heat of summer, the city, the humanity, the memories of both, are all distillers of emotion."[17]

William Wetmore Story also saw history simply as material for an emotional daydream, both for his sculpture and for his poetry and plays. He too lived in a princely manner in Rome, performing for many decades as the genial multitalented host in vast apartments of the Palazzo Barberini. Among his many productions is a drama called *Nero*, written in the summer of 1872, which he read aloud to the great actress Fanny Kemble in March 1873 and dedicated to her. The reading took place over two nights in Mrs. Kemble's apartment in Rome. The young Henry James found himself "accidentally" present when the five-act tragedy began: "He got through three acts in three hours, and the last two were resumed on another evening when I was unavoidably absent," James wrote to Norton in London. He attributed this effort by Story (fifty-three years old and already famous as a sculptor) to vanity and "a most restless ambition," rather than to any "inward necessity." Since Norton was in those days enjoying the more substantial conversation of Thomas Carlyle, James envied him the "company of genius," little dreaming that thirty years later he would write Story's biography.[18]

If James had heard the tragedy's final acts, the reading of which was pleasantly interrupted by an earthquake, he might not have made a distinction between "inward necessity" and Story's vanity and ambition, since it becomes increasingly evident that Story identified with Nero. As the fourth act opens, the emperor and his new wife Poppaea are rehearsing a song he himself has written. Tigellinus states:

> He is an artist,—that we must admit.
> Pity he tries so many forms of art.
> Were he content with one he might excel,
> But nothing will content him; he aspires
> Not to sing only, but to model, paint,
> Drive, dance, sing, fight, do everything, at once.
> Life is not long enough for every art.[19]

This was the wisdom that both Nero and Story defied, yet Nero at least demonstrated the exciting extremes to which an "artist" in Rome once could go. Story's own interest was in the display of emotion for its own sake, so Nero was the perfect alter ego through whom to achieve imaginative fulfillment. Basing his play on the "historical truth" of Suetonius and Tacitus, he wished "to present a picture of a

period characterized by cruelties and crimes which would not now be tolerated, and by passions so violent and unrestrained, that they seem to bear the taint of insanity."[20] Obviously no contemporary resurgence of these crimes required their exposure anew by Story, the son of a famous Massachusetts judge and himself a successful lawyer. Precisely their absence from the modern age of repressed passions made them attractive as vicarious thrills. When Story abandoned law to become an artist in Rome, his mother had told him that he was the greatest fool she had ever known. Nero's mother Agrippina (the noble Germanicus's power-mad daughter), who married and murdered Emperor Claudius in order to advance her son's political career, similarly regarded Nero. In the role perhaps intended for the aging Mrs. Kemble, Agrippina dominates the first three acts with imperious maternal speeches. These alternate with Polonius-like diatribes from Nero's teacher, the philosopher Seneca, on the uses of hypocrisy in the exercise of power. In the meantime Nero tries to write poems like Catullus's, wrestles and fences with the gladiators, reads Ovid, makes love to the Greek slave girl Acte, violently quarrels with his new mistress, Poppaea (wife of his friend Otho), and goes to an orgiastic feast given by Petronius Arbiter. When Agrippina threatens to transfer power to Britannicus, Claudius's son, Nero poisons him at a banquet. In a soliloquy opening act 3, Agrippina decides to try the "arts of love" on her son to distract him from Poppaea. There follows a passionate attempt at incestuous seduction that must have reawakened the attention of both Mrs. Kemble and James.

Meanwhile, people in the Forum are beginning to talk about what is going on in the imperial palace. At the urging of Poppaea, Nero "shelves" his mother. When Agrippina survives an attempt on her life by swimming ashore from a scuttled ship, Seneca, informing Nero that "the moment's grave," advises him to try again. Agrippina is stabbed to death in her villa at the end of act 3. This is the turning point; the last two acts concern the rise of resistance to Nero, who is judged "worse than Caligula, . . . foul with debauch and crime; / Insatiate with blood." The emperor meanwhile is shown enjoying the famous fire, the chariot racing, and the persecution of Christians. Tigellinus informs Nero that Seneca, besides taking credit for his student's best writings, has joined a conspiracy. The conspirators are arrested and tortured one by one. Seneca, the last to survive, is condemned by Nero primarily because he is jealous of his genius. The tiresome philosopher and his wife exchange noble speeches and commit suicide at the end of act 4. In the final act Poppaea suffers a miscarriage and dies from Nero's abuse of her. The muttering in the Forum grows louder, and in Spain Galba, declaring himself Caesar, marches toward Rome. Nero, meanwhile, makes love to Sporus (a man), suffers from nightmares, and thinks of killing himself. In the penultimate scene, set in the Forum, Tigellinus changes sides. Outside the city in an underground villa, Nero has his grave dug, weeps, and cries out "Think what an artist perishes in me!" as he bungles his suicide, which is then completed by servants.

In 1972, exactly a hundred years after Story's exercise in sensationalism, the material used for his fourth act was re-presented in an entire novel by John Hersey, who the year before had been Writer in Residence at the American Academy in Rome. Originally a journalist, Hersey had won the Pulitzer Prize in 1945 for his first Italian novel, *A Bell for Adano*, had written books of contemporary social impor-

tance such as *The Wall* and *Hiroshima*, and had served as master of a college at Yale. His Roman novel, *The Conspiracy*, was mistakenly—or willfully—dismissed by reviewers as though it were a frivolous irrelevancy like Story's *Nero*. This was possible because, whereas in *Spartacus* Fast had made satire serve the purposes of romance, in *The Conspiracy* satire and romance defeat each other. By way of justifying the liberties he had taken with his inherently unreliable sources, Hersey stated in a note that he intended his novel to be "an entertainment." This would seem to place it with the works of Story and Crawford: Roman history is a sensational diversion. But since there are throughout the book suggestions that it is meant to be a satire on contemporary America, the thoughtful reader is expected to find the analogies between Nero's Rome and modern America entertaining as well. The entertainer's delight, however, in detailing the excesses of Neronian Rome, a romantic realm where capricious power knows no limits, only makes the domestic wickednesses of Nixonian Washington seem relatively feeble and innocuous. At the same time, the satirist's morose and narcissistic preoccupation with the "responsibility of the writer" in a corrupt state constantly intrudes on the fun. In effect if not in fact, Lucan the sullen poet manages to kill the imperial clown.

The Conspiracy ends with the suicides of Seneca and his wife, the execution of Lucan, a proclamation of rejoicing for Nero's deliverance, and preparations for a celebratory banquet at which Nero, disguised as a tiger, will mount four young noblewomen, a beautiful young nobleman, and a female sheep, before being driven back into a cage by his "wife," the eunuch Sporus. The novel began with orders for an "occasion" at the Golden House which required everything from flamingos to hippopotamuses, one thousand swans harnessed to pull Nero's barge, and a number of hunchbacked dwarfs to run an obscene race. First and last, Hersey is as fascinated by a lost standard of decadent achievement as Story was and can be even freer in the invention of details for his readers' amusement. Roman history alone provides matter so titillating, so liberating to the sensual imagination. Not to lose Agrippina's triple triumphs in incest (brother, uncle, and son), Hersey has Seneca write long reminiscences to Lucan that far surpass in specifics of sordid act and salacious speech what Story dared to show; Suetonius himself seems a comparatively inhibited historian.

All this lewd entertainment, however, is filtered through the files of the Roman Secret Service, or FBI; Tigellinus and his agents comment at length upon the letters intercepted and conversations recorded. The spies assume that the "arrogant literati" ("crab lice in the pubic hair of Rome") are as given to encoding their messages as the spies are expert at decoding them. And the first report to Tigellinus appears to be an invitation to the reader to practice his art. It concerns a literary dinner at which Lucan's "historical" poem *Pharsalia*, with its critical view of Julius Caesar and its open admiration for Cato the Republican, was perceived by everyone as a transparent criticism of Nero. Shortly thereafter Lucan himself is made to reinforce Hersey's hint: "Who said my *Pharsalia* is about the past? Not I. A writer is not responsible to the past, he must answer to the future. And therefore he cannot pretend that the present does not exist."[21]

Although Hersey's method of narration allows him to disappear—responsibly?— behind several masks, Lucan is at the dramatic center of the book, and his point of

view implies that *The Conspiracy* is not about the past and Rome; it is about the present and concerns America's future. Serious contemporary concerns are undeniably there: the state becomes in fact intolerable to those who most love "the idea of Rome," when their denunciation of its departures from the ideal makes them suspected subjects of official files recording their every move; oppressions motivated by paranoid suspicion of conspiracies engender real conspiracies; and so on. There is much to think about. But one wonders: were receptions for writers at the White House really much like those at the Golden House? Lucan guiltily attends one and fearfully attempts to instruct as well as amuse his host, the ruler whom he hates. Hersey similarly read from his *Hiroshima* for a president's benefit and perhaps his own. But Lucan risked losing his life. In toying with a fundamentally flawed analogy, and by constantly expressing self-doubt about a writer's power and responsibility, *The Conspiracy* ironically succeeds in exemplifying the political impotence of literature. Yet no American writers have been executed or driven to suicide by the state. Presidents, rather, have been driven from office. John Adams's study of Roman history has not been without effect.

At one point in *The Conspiracy* Seneca advises Lucan, "A writer cannot change the world; his duty is to describe it." Lucan much later returns to the question, and indicates a problem with Seneca's prescription. In an arcade near the Tiber where two mirror makers' shops faced each other, two mirrors endlessly reflected the void between them. What Lucan would like his poem to be is "a magical dialogue of reflections, with pure Rome [and America?] between the mirrors, Rome as it truly was [is], with all its pain, wonder, and glory, its contradiction of love of liberty and love of tyranny, its need for Caesar and for Cato, its vitality and squalor and pride and bustle. But I feel that I distort this Rome when I intrude on it."[22] Perhaps in this moment, in the candid consciousness of a writer's tendency to distort and diminish what he describes, Hersey comes closest to a description that, in its generality, does evoke simultaneously both America and Rome.

To what degree had the American Republic, in its first two hundred years, paralleled the growth of Rome? No American attempted an answer, to see whether the "rugged constructional work" done by John Adams, Alexander Hamilton, and Thomas Jefferson, with the ancient example before them, had been sound or flawed. Rather, a Frenchman, a believer in History, undertook the task. Amaury de Riencourt's *The Coming Caesars* (1957) is an astounding compilation of parallels between Roman and American history, intended to foretell the future. It links the Flaminian Way and the Oregon Trail; the Pontine Marshes and the Great American Desert; Appius Claudius, "reluctant expansionist" and builder of the Via Appia, with Jefferson, purchaser of Louisiana and patron of Lewis and Clark—and so on. With the prophetic zeal of a fundamentalist scrutinizing the Old Testament to date the end of the world, Riencourt inevitably arrives at the Gracchi distributing lands to the people, Marius thriving on factional strife, and the charismatic Julius Caesar assuming dictatorial powers, all to explain the growth of the executive branch under Roosevelt, his New Deal, and his fourth term.

But the book unwittingly encourages only skepticism about history's coherence and a greater appreciation for its endless innovations and distinctions. The irrelevance of historical precedent and the novelty of the American "experiment" remain

the operative assumptions of Americans, some historians excepted. Riencourt's own message in its self-contradiction invites dismissal. He reminds us that "circumstances, not conscious desire, create Caesarism." If the Republic is lost, Caesar is not to blame. "Historical Destiny" simply replaces Samuel Eliot's "Providence" and Crawford's "Fate" as the explanation for whatever occurs: "profound historical trends" should not be reduced to "any one man's dictatorial ambitions." Unlike Eliot, however, Riencourt is not trying to be reassuring about the future. On the contrary, his book is intended to alarm us and, paradoxically, to move us to action, as though "Destiny" were in our own hands. Near the end he quotes Cicero himself as the best commentator on contemporary America. " 'It is due to our own moral failure and not to any accident of chance that, while retaining the name, we have lost the reality of a republic.' " Only "human will," concludes Riencourt, "can preserve liberty."[23] But Riencourt has already more persuasively demonstrated that "historical destiny" will be what it will.

Whether or not history is rubbish, the American tendency has been to treat it so, and to be glad that it encumbered Europe, not America. As accurately symbolized by the ruins of the Forum, it is a heavy accumulation of fragmentary truths that in their very nature are burdensome without being enlightening. When Henry James wrote his first full-length novel, *Roderick Hudson,* in 1874, he endowed the central point of view character, Rowland, with what he liked to consider a "historic consciousness," an aesthetic appreciation of emergent or dissolving forms and richly suggestive textures of time. Late in the book Rowland is shown strolling with Mary Garland, the quintessential New England girl, on the Palatine Hill overlooking the Forum. James does not see the excavations now as emblemizing a resurgent past; the hill is simply a "sunny chaos of rich decay and irrelevant renewal." He adds, however, that "nothing in Rome is more interesting than this confused and crumbling garden, where you stumble at every step on disinterred bones of the past; where damp frescoed corridors, relics possibly of Nero's Golden House, serve as gigantic bowers." The rubbish pile for James is a compost heap. To Mary, however, "Rome was a ponderously sad place." " 'Everything,' she said, 'seems to insist that all things are vanity indeed.' " It would surely be depressing " 'to live year after year among the ashes of things that once were mighty.' "[24] Between them Rowland and Mary divide the options that remain after political relevance and moral grandeur have faded: the Forum and history offer a dense and chaotic beauty or an unbearable sadness.

When Howells returns to the Forum more than forty years after his original visit and finds how far the archaeological excavations have advanced, it is amusing to find him expressing nostalgic preference for the "simple, old, unassuming Cow Field" which he now claims had "all the elements of emotion and meditation." With so much exposed, the new image of the Forum suggests only "the kaleidoscopic clutter" that it must have shown in its heyday. Sophia Hawthorne, inspired by Mme. de Staël's *Corinne,* had thought that the Forum when it was "fresh" must have been "a dream of unexampled beauty." But according to Howells, "the grandeur that was Rome" was in fact a "crazy agglomeration of temples and basilicas and columns and arches and statues and palaces . . . supremely tasteless, almost

senseless; [a] mob of architectural incongruities." To have vandalized Rome was the chief virtue of the barbarians. By imagining the Forum as architectural trash to begin with, Howells made it fit his view of the historical character of the Republic and Empire. His denigration and flippancy, however, are replaced by the end of his essay with a reading of the excavations in the Forum of 1908 that is a more effective metaphorical condensation of the post–romantic American attitude than James's. For Howells the archaeological labors at the Forum are "for the sake of knowledge" only—nothing useful, only irrelevant facts. But when he watches a shaft being sunk down through layer after layer of Roman civilization until it arrives at "what mortal part remained of a little child, with beads on her tattered tunic and an ivory bracelet on her withered arm," a theory of historical nihilism seems to have been confirmed:

> History in the presence of such world-old atomies seemed an infant babbling of yesterday, in what it could say of the Rome of the Popes, the Rome of the Emperors, the Rome of the Republicans, the Rome of the Kings, the Rome of the Shepherds and Cowherds, through which a shaft sunk in the Forum would successively pierce in reaching those aboriginals whose sepulchres alone witnessed that they had ever lived.[25]

History's one truth, written on its largest page, is of Shakespearean simplicity.

2

The Colosseum: Ambiguities of Empire

Strange fate, but yet to ev'ry country known,
To love all other riches but its own.
Thus fell the mistress of the conquer'd earth,
Great ROME, who ow'd to ROMULUS her birth,
Fell to the monster Luxury a prey,
Who forc'd a hundred nations to obey.

.

But if AMERICA, by this decay,
The world itself must fall as well as she.
—*Freneau,* **The American Village** *(1772)*

Near the end of *The Portrait of a Lady* (1881), Henry James makes the Colosseum the object of an excursion intended to amuse Isabel Archer's sister-in-law, Countess Gemini. The countess, James tells us, "had not the historic sense, though she had in some directions the anecdotic," and when she visited antiquities "her preference was to sit in the carriage and exclaim that everything was most interesting." On this occasion, however, her niece, Pansy Osmond, persuades her to enter the monument and "to climb to the upper tiers." Isabel remains below, and James sketches a portrait of Isabel alone in the Colosseum. In doing so, he associates his heroine with the sublime romantic image of the Colosseum that derives from Goethe, Mme. de Staël, Byron, and Stendhal:

> She had often ascended to those desolate ledges from which the Roman crowd used to bellow applause and where now the wild-flowers (when they are allowed) bloom in the deep crevices; and today she felt weary and disposed to sit in the despoiled arena. . . . The great enclosure was half in shadow; the western sun brought out the pale red tone of the great blocks of travertine—the latent colour that is the only living element in the immense ruin. Here and there wandered a peasant or a tourist, looking up at the far skyline where, in the clear stillness, a multitude of swallows kept circling and plunging.[1]

This is one of many juxtapositions in nineteenth-century American literature and painting of a representative American character and a classical architectural image, of which the Colosseum is by far the most commonly chosen. The Colosseum had by this time a complex accumulation of meanings in European architectural history, literature, art, and folklore.[2] The American writers and painters naturally exploited these traditional understandings of the Colosseum's significance, but they also sometimes raised—more sharply than did their European predecessors and contemporaries—questions about the meaning of the Colosseum for a modern, Christian, and democratic culture. James's image of the once imperious Isabel Archer sitting alone in the ancient arena is the last in a series of four passages that together chart her changing relation to classical Rome. It may serve as a preliminary indication of how, in an extended context, the Colosseum as backdrop may be used to define character and in turn be itself redefined. The great amphitheater contributes to the general symbolic classical setting, while its own particular attributes receive metaphorical stress.

The first two of James's passages show Isabel long before her disastrous marriage to Gilbert Osmond: "She had an imagination that kindled at the mention of great deeds," James says of her first acquaintance with Rome, and it responded readily to "the terrible human past." But it required something "altogether contemporary" to "give it wings." James then shows Isabel in the Forum, where even her keen interest in the "rugged relics" does not keep her mind from wandering soon to "regions and objects charged with a more active appeal"—namely, Isabel Archer's future: it is over that "nearer and richer field" that her imagination "hovered in slow circles." Now, at the end, in the Colosseum, while the swallows circle and plunge above her, she sits in a despoiled arena. The displacement of imagery of flight by imagery of ruin measures the alteration in Isabel's vision of her own reality. In the preceding chapter, James had shown her in the Campagna and had generalized that "in a world of ruins the ruin of her happiness seemed a less unnatural catastrophe":

> She rested her weariness upon things that had crumbled for centuries and yet still were upright; she dropped her secret sadness into the silence of lonely places, where its very modern quality detached itself and grew objective, so that as she sat in the sun-warmed angle on a winter's day, or stood in a mouldy church to which no one came, she could almost smile at it and think of its smallness. Small it was, in the large Roman record, and her haunting sense of the continuity of the human lot easily carried her from the less to the greater.[3]

In these passages James establishes with characteristic tact Isabel's changed understanding of the less and the greater, and the diminishment of her egoism only increases our regard for her. The destiny of a contemporary American is linked to the grand historical images without the cynicism or satire of the mock-heroic tradition, without the naively self-aggrandizing equations of the neoclassicists, and without the self-pity and rage of Byronic romanticism, all of which we find in other American instances. The image of the Colosseum in James's sequence from Forum to Campagna is the most sharply expressive of "the terrible human past," and several aspects of the structure's traditional meanings are evoked: above all, its monumentality and beauty as architecture; second, the memory of it as a place of

barbaric entertainment (the crowd bellowing applause)—a negative image, which has, however, its positive side, since the same entertainment was the occasion for heroic trials of skill and courage, and also afforded so many glorious martyrdoms; and finally—in sharp distinction from the preceding—its nineteenth-century character as a sublimely melancholy imperial ruin covered with flowers and visited by wandering peasants, pilgrims, and tourists.

James's relation of the Colosseum in both its present image and historical associations to his character's personal experience and knowledge is unobtrusively yet profoundly expressive. This cannot be said of all the selective collocations of the Colosseum's meanings in nineteenth-century American art and literature; yet from other instances we can create a cumulative American image of the Colosseum that in its complexity expresses an ambivalent attitude toward imperial power, its rise, its glories and terrors, and its fall. The Colosseum becomes the Moby-Dick of architecture, a sublimely multivalent symbol, sacred yet malignant, alien and dreadful yet magnificent, ravaged yet enduring.

The Colosseum as Landscape

Nineteenth-century paintings of the Colosseum alone (that is, without significant figures) are a version of landscape in obvious contrast to the close architectural studies made in the Renaissance, but also differing from the precise yet visionary works of Piranesi in which nature is not the essence but the embellishment. The Colosseum had first appeared capriciously as part of the natural landscape in the idyllic world of Claude Lorrain (d. 1682), where it was as likely to stand beside a seashore as in its proper place just beyond the Forum.[4] Nineteenth-century painters do not use the image with such ahistorical freedom. Their works are closer to the eighteenth-century souvenir paintings of Bellotto and Panini, picturesque but relatively literal. Yet the best of the later artists brought to the Colosseum their own particular genius (or at least point of view). With Turner and Corot, for example, one perceives the results in the first instance as paintings *by* Turner and Corot rather than as paintings *of* the Colosseum.

Of the many American artists, mostly forgotten, who painted landscape views of the Colosseum, Thomas Cole is the most important. In Cole, too, the informing idea—his concept—matters more than the object, but the concept is more thematic than formal, and his theme is common to his paintings of the Campagna as well: the transmutation of man-made objects by time and nature. By virtue of becoming a ruin, a building is improved; it becomes part of nature. Cole considered the Colosseum to be the most affecting of the "wondrous things" he saw in Rome, and he made sketches of its interior,[5] where the architectural elements are most thoroughly eroded. The verbal description in his notebook of 1832[6] opens with the same perspective adopted in the small canvas probably painted in the same year (fig. 9):

It is stupendous, yet beautiful in its destruction. From the broad arena within, it rises around you, arch above arch, broken and desolate, and mantled in many parts with the laurustinus, the acanthus, and numerous other plants and flowers, ex-

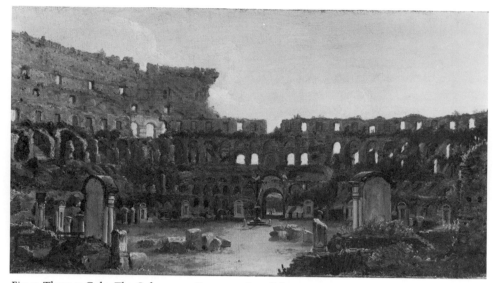

Fig. 9. Thomas Cole. *The Colosseum, Rome.* c. 1832. Oil on canvas. 10⅛ × 18⅜". Collection Albany Institute of History and Art. (See plate 1.)

quisite both for their color and fragrance. It looks more like a work of nature than of man; for the regularity of art is lost, in a great measure, in dilapidation, and the luxuriant herbage, clinging to its ruins as if to "mouth its distress," completes the illusion. Crag rises over crag, green and breezy summits mount into the sky.

"To walk beneath its crumbling walls," he concludes, is "to lapse into sad, though not unpleasing meditation." Several aspects of the painting itself encourage this attitude: the sense of an enclosed space is created by the curving wall that stretches from edge to edge; the lower broken buttresses are in deep shadow while the jagged ridge of the highest stones catch the light; the conspicuousness of the Stations of the Cross, and the presence of the cross itself, relate the scene to those picturesque paintings of enclosed mountain spaces in which religious shrines define the proper feeling for nature itself. In its organization the painting is close to one of Piranesi's views, but the execution in oil blurs the outline and details that Piranesi stressed. Green vegetation sprouts along the crown of the earth-colored slopes.

Cole's notebook description in a second paragraph goes where painting finally cannot follow. It shifts to a view from a high terrace from which by moonlight the Colosseum is metamorphosed into Vesuvius, that other favorite romantic object of contemplation. Gazing into the "abyss," Cole finds that the "mighty spectacle, mysterious and dark," becomes "more like some awful dream than an earthly reality,—a vision of the valley and shadow of death, rather than the substantial work of man." The volcanic metaphor briefly suggests the "terrible fires" that once "blazed forth with desolating power" in this "crater of human passions"—an association to which Gérôme's historicism would later give literal embodiment. Here it serves chiefly to heighten by contrast the quietude of the present, where a union of nature and religious feeling is evident in the harmony of the only sounds—warbling birds and chanting monks.

Herman Melville and Henry James also saw the Colosseum, if not as Vesuvius, as

essentially a mountain. James, in "A Roman Holiday" (1873), even says that "the roughly mountainous quality of the great ruin is its chief interest."[7] Years earlier (1845) the young Bayard Taylor, having just descended from the Alps and Apennines with knapsack on his back, raced to the Colosseum on his first night in Rome to see it by moonlight, only to discover that there was no moon. Taylor settled for a sunset view (also recommended by his poet-hero Goethe) and wrote: "A majesty like that of nature clothes this wonderful edifice. Walls rise above walls and arches above arches on every side of the grand arena like a sweep of craggy, pinnacled mountains around an oval lake."[8]

It is easier to appreciate the early nineteenth-century image of the Colosseum as a work of nature if we recall that one of the touristic tragedies of the late nineteenth century occurred when the archaeologists of the New Italy after 1870 thoroughly carried out what the French under Napoleon had but feebly begun in 1812, the "debushing," or one might well say deflowering of the Colosseum—the ruin of a ruin. William Wetmore Story, through many an edition of his invaluable *Roba di Roma,* had told how practically alone among ancient ruins the Colosseum stood ("despite the assault of time and the work of barbarians, it still stands, noble and beautiful in its decay—yes, more beautiful than ever"), and had lovingly described how when the sunset transfigures the travertine to "brown and massive gold," "the quivering stalks and weeds seem on fire; the flowers drink in a glory of color, and show like gems against the rough crust of their setting." Then, in his thirteenth edition, he felt constrained to add a long, sour footnote: "The arena, once so peaceful and smoothed over with low grass, has been excavated to exhibit the foundations. . . . All the charm of the place has been destroyed." Now you may, "if that satisfies you, gaze down into ugly pits and trenches."[9]

The preference for the Colosseum as a "natural" ruin was explicitly stated by many, but by no one more forcefully than George Hillard in his popular guidebook, *Six Months in Italy* (1853). After inconsistently and ungratefully attacking the "rapacity" and "cupidity" of those wealthy Renaissance nobles and cardinals who ruined the Colosseum by using it as a quarry, he expressed the hope that the current pope's efforts at restoration "may not be carried so far as to impair the peculiar and unique character of the edifice." For if "as a building the Colosseum was open to criticism, as a ruin it is perfect. The work of decay has stopped short at the exact point required by taste and sentiment." In short, the tiresomely classical has been transformed into nature's superior Gothic—"formal curves and perpendicular lines" replaced by "interruptions and unexpected turns which are essential elements of the picturesque": "When a building is abandoned to decay, it is given over to the dominion of Nature, whose works are never uniform. . . . Now that it is a vast ruin, it has all the variety of form and outline which we admire in a Gothic cathedral." Hillard loved the Colosseum as passionately as any Renaissance architect but for exactly the opposite reasons: it expresses no "rule and measure," no "contriving mind," no "hand of man." The original builders seem even to have been granted remarkable foresight in choosing travertine as the material, since it is "exactly fitted to the purposes of a great ruin."[10] These purposes are, of course, much higher, as we shall see, than the purposes the original designers had more immediately in mind.

The Historical Arena

It was here that the Roman mastery of engineering problems perhaps reached its height: it was here that the Roman delight in quantitative achievement conceived an architectural form whose very success depends upon mass and scale, with the spectators ranged, tier upon tier, in a steeply angled ascent. . . . Rome had become the arena of arenas, where the usual activities of a city were subordinated to the mass production of violent sensations derived from lust, torture, and murder.

—Lewis Mumford, The City in History *(1961)*

At the opposite extreme from the perception of the Colosseum as a sublime mountain or as a Gothic cathedral was the later attempt to re-create it, visually and verbally, as it was at the time of the Empire: to see it as the pristine and splendorous architectural ground for gladiators and martyrs with a vast audience of humanity—ranging from the imperial family to slaves—united by sensational experience. This romantic historicism (executed with the detail of specious realism) reached its climax in the academic painting of Gérôme. His celebrated *Ave Caesar, Morituri te Salutant* (1859; fig. 10) depicts a high moment in the gladiatorial games when the emphasis is on character rather than physical violence. Story, in *Roba di Roma*, uses a lengthy description of Gérôme's painting as the point of departure for his own verbal evocation of the activities within the Colosseum at the height of Empire. It is only one of the many paintings by Gérôme that were bought by, and in several cases commissioned by, Americans; and through the photogravure reproductions of Gérôme's father-in-law, Goupil, they furnished America in the second half of the nineteenth century with its popular image of imperial Rome—an image so familiar that Thomas Nast could use it as the basis for cartoons on American political corruption in the post–Civil War period.[1] That image is equivocal. In *Ave Caesar* the Colosseum is enormously exaggerated, and the image of splendor provided by the building, with its unfurled velarium, and by the masses of spectators displayed in sunlight is not diminished greatly by the evident brutality of the games, since the emphasis is on the heroism of the gladiators themselves in declaring and facing their mortality. The point of view is that of someone *within* the arena rather than that of the spectator above. The historical realism Gérôme strove for as the chief value of his paintings is even more evident in later works such as *Pollice Verso* (1874; Phoenix Museum of Art); yet Gérôme also saw the world he re-created as "barbaric, savage, and strange"—a romantic conception he emphasized not only through the specialized trappings of the gladiators, so bizarre to modern eyes, but also through the exaggerated behavior of the crowd, in particular that of the Vestal Virgins, about whom Victorians seem to have been extremely curious.[2] The young Henry James, who had criticized Gérôme for a "heartlessness" equal to that of Flaubert, nevertheless responded enthusiastically to his *Chariot Race* (1876; George F. Harding Museum, Chicago).[3] *The Christian Martyrs' Last Prayer* (commissioned by Mr. Walters in 1863, finished in 1883; Walters Art Gallery, Baltimore) supplied the most impressive image of steadfast Christians facing lions and tigers and was perhaps the source for the novelist Francis Marion Crawford's pathetic description of martyrdom in *Ave Roma Immortalis* (1898).[4]

Gérôme's productions being so satisfactory and so widely distributed, there was

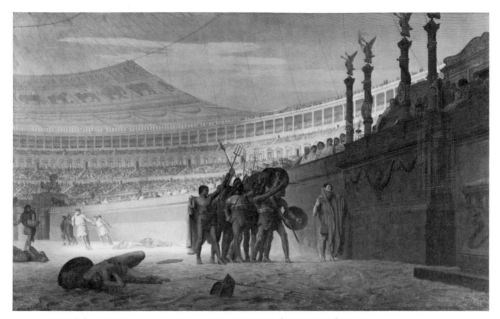

Fig. 10. Jean-Léon Gérôme. *Ave, Caesar, Morituri te Salutant (Hail Cae-sar! We Who Are about to Die Salute You).* 1859. Oil on canvas. 36⅝ × 57¼". Yale University Art Gallery. Gift of C. Ruxton Love, Jr., B.A., 1925.

little need for an American artist in his field. There were, of course, illustrations for such popular works as Gen. Lew Wallace's *Ben-Hur* (1880), whose events occur before the Colosseum was built but include a famous scene in a provincial arena that belongs to the same genre. There also must have been Colosseum-inspired (and slightly anachronistic) backdrops for such stage productions as the long-popular drama, *The Gladiator* (1831), written by Robert Montgomery Bird for the great Edwin Forrest and one of the actor's most famous productions.

But only one American painter of some importance indulged in Gérôme's kind of unidealized historical re-creation of ancient Rome. He was Edwin Howland Blash-field,[5] who began his career in Paris painting directly under the influence of Gérôme (and using his props) and exhibited at the Salon in the 1870s works with such titles as *Roman Ladies: A Lesson in the Gladiator's School* (1879) and *The Emperor Commodus, Dressed as Hercules, Leaves the Amphitheater at the Head of the Gladiators* (1878; fig. 11). Blashfield strives for Gérôme's archaeological exactitude; he similarly heightens the sense of drama through the use of bold contrast in shadow and light, and deep perspective to convey the grandeur of the Colosseum as viewed from the floor of the arena. His choice of specific subject, however, differs significantly. There is no ambiguity arising from a sense of human fatality, en-durance, martyrdom, or athletic skill, as in Gérôme. Departing even further from the neoclassical ethical idealism (typically centering on crises of the Republic) that was central to the scenes of ancient Rome painted by Benjamin West and in France by David, Blashfield's emphasis is purely on the decadence of the Empire, for which the spectacular architecture provides a congruently luxurious setting instead of a grandly ennobling theater.

Blashfield could hardly have chosen a more disagreeable personality to place at

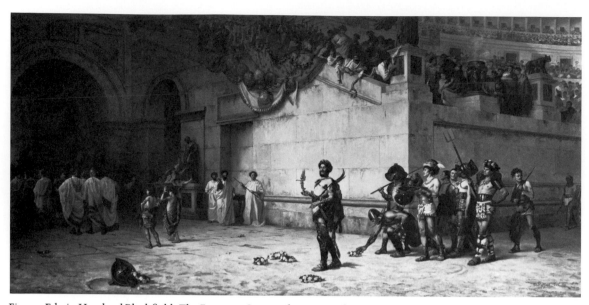

Fig. 11. Edwin Howland Blashfield. *The Emperor Commodus, Dressed as Hercules, Leaves the Colosseum at the Head of the Gladiators.* 1878. Oil on canvas. 44½ × 91". Courtesy Hermitage Foundation Museum, Norfolk, Virginia.

the exact center of an enormous canvas than Commodus, half-mad son of the saintly Marcus Aurelius, who patterned himself after Caligula and Nero rather than after his father. His reign (A.D. 180–192) has been said to have initiated the Empire's decline, and he himself was called by a contemporary Greek historian, Dio Cassius, "a greater plague to the Romans than any pestilence or crime." Blashfield's image of Commodus, based closely upon a celebrated antique statue in the Vatican (a copy of which was at Versailles), shows how the emperor's exaltation of himself as Hercules reborn (complete with lionskin and club) was preposterously expressed through his participation as a gladiator in the public arena. This behavior was perceived as degrading to the imperial name and proof of his depravity; the common people avoided his shows for shame and fear (members of the audience were sometimes victims of Hercules' rage). Eventually Commodus was assassinated while exiting from such a performance into the dark passageway shown to the left in the painting.[6]

This contribution to the image of the Colosseum by Blashfield, who was to become for a time the most successful painter of academic allegories of Law and Justice in American courthouses, was one of moral reprobation, which at the same time exploited a fascination for the historically alien and antithetical as re-created in minute and vivid detail. His work in this respect is closer to Thomas Couture's *Les Romains de la décadence* (1847; Louvre), which in spite of its explicit moralism owes its fame as much or more to the vulgar appeal of the sensationally depicted scene. James indirectly alludes to this painting when characterizing contemporary English society in *The Princess Casamassima* (1885). The half-American, half-Italian Christina Light of *Roderick Hudson*, now married to Prince Casamassima, says to the half-English, half-French Hyacinth Robinson that English society is "a

Fig. 12. Thomas Cole. *The Course of Empire: The Consummation.* 1836.
Oil on canvas. 51 × 76". Courtesy New-York Historical Society, New
York City.

reproduction of the Roman world in its decadence, gouty, apoplectic, depraved,
gorged and clogged with wealth and spoils, selfishness and scepticism, and waiting
for the onset of the barbarians."[7]

Questions about motive and interpretation that arise with Couture, Gérôme, and
Blashfield may be found much earlier in Thomas Cole's *Consummation* (fig. 12),
the central panel of his series, *The Course of Empire* (1836). This depiction of a
gorgeous triumphal arrival at a port from which monumental architecture has
eliminated all natural contours is, of course, romantic fantasy rather than historical
realism. Although Cole regretted not being able to paint the *Consummation* in
Rome, where the entire series had been conceived and where he would have had the
actual "objects of study" (both architectural and human models) around him,[8]
greater neoclassical authenticity would not have altered the central ambiguity: Is
this luxurious world being celebrated or deplored? Is it proposed as the goal or the
inevitable fate of America? Does Cole's entire series, in "progressing" from Savag-
ery to Desolation, constitute dispassionate historical myth or moral exemplum?
Commentaries by Cole himself and by his pastor, Louis Legrand Noble, which most
more recent critics simply repeat as adequate explication, evade the question of
historical causation and inevitability, just as Byron did in the stanza on the course of
empire from which the series took its title: one stage of civilization simply follows

another. And so it seemed when by the end of the century the imperial potentialities of America were much more fully realized, but causes and ends remained unclear. The "White City" of the World's Columbian Exposition in Chicago (1893) employed America's most prominent designers in the creation of a setting whose central "Court of Honor" was remarkably reminiscent of Cole's *Consummation.* The planned ephemerality of Chicago's image of imperial pride, which consciously echoed Roman design but was made of easily destructible materials, only added to the irony and presumption of the analogy and to the ambiguity of the symbolism. Charles Eliot Norton said that in spite of its incongruities and vulgarities, Chicago forbade "despair," but within the decade he was unequivocally opposed to the "bastard 'imperialism,' . . . this turn toward barbarism" represented by the "miserable war in the Philippines." When Henry Adams viewed the Court of Honor on the banks of Lake Michigan, he felt himself back upon the steps of the Ara Coeli in Rome, equally puzzled by this new "breach of continuity—a rupture in historical sequence!"[9]

Writers, of course, could not hope to re-create the visual scene in the Colosseum as vividly as did the historical painters, and their vague allusions to the Colosseum as architecture amount to little more than verbal gaping. Their sense of the significance of what transpired within it, however, can be very explicit and runs the gamut from the exalted feeling of Margaret Fuller to the contemptuous satire of Mark Twain. In between these extremes are relatively neutral and factual descriptions such as those of Cooper, Hillard, and Story. Guidebooks simply give the facts, with a few famous quotations from Gibbon and Byron, and the popular romances and stage productions have it both ways: they combine self-righteous indignation with the thrill of vicariously witnessing the bestiality and suffering they deplore, while taking satisfaction in painless identification with steadfast martyrs or rebellious slaves. The more highly charged travel books also indulge in this mode of representation. In 1852 Grace Greenwood thought she heard the lions "roaring and bounding beneath me" when she walked about in the Colosseum:

> I involuntarily looked to see them leaping into the arena, with eyes aflame and jaws agape. I listened to hear the final shriek of the Christian victims, and the mad yells, the applauding uproar, of the heathen spectators. I seemed to see the tiger burying his claws deep in the white bosom of the maiden, and the fierce leopard playing with the mangled child ere devouring it. . . . And, more fearful and pitiable still, fair patrician dames looking on through all, with calm, unblenched faces, and young peasant maidens clapping their brown hands, while the long thunders of acclamation rolled round the vast amphitheatre.

Greenwood (like Charles Dickens, whose *Pictures from Italy* of 1846 employs similar rhetoric) says she found "unspeakable joy" in the ruined state of the Colosseum. This joy was modified only by the thought that the Christian martyrs (who at least suffered a quick death there) would perhaps not have been willing to die at all if they had foreseen that in the future Christians would subject other Christians to the much more prolonged tortures of the Inquisition. The next spring Greenwood took her last walk around the inside of the Colosseum just before leaving Rome, and she

burst into tears (she wrote) upon seeing for the last time what she had by then decided was "infinitely the most interesting, impressive, enchanting, the grandest and dearest" place on earth![10]

Although at one point Mark Twain also sarcastically compares the Inquisition with the persecution of Christians in the Colosseum (an anti-Catholic maneuver frequently employed), in his lighthearted *Innocents Abroad* (1869) he does not use pagan violence as evidence against the "damned human race," as in later books he would use the cruelties of Christians themselves. Young Clemens can acknowledge that the Colosseum is sacred ground, but as an American he can only "make it personal" by imagining those who attended the ancient sports as Americans going to the opera or to the circus—to Mark Twain, essentially the same thing. After describing everyone from the "man of fashion with his private box" to the street boy in the gallery with his peanuts, Mark Twain claims to have found two items: a playbill and a review. The playbill ends with the promise of a "chaste and elegant GENERAL SLAUGHTER!" The review parodies American dramatic criticism in all its irrelevancy and sycophancy, with references to the audience and to the decor of the refurbished theater. The description of the performance is ambivalent as satire, since the incongruity between the reviewer's prissy standards and style and the brute action he is favorably describing may turn the balance against either the Americans or the Romans:

> When at last he fell a corpse, his aged mother ran screaming, with her hair disheveled and tears streaming from her eyes, and swooned away just as her hands were clutching at the railings of the arena. She was promptly removed by the police. Under the circumstances the woman's conduct was pardonable, perhaps, but we suggest that such exhibitions interfere with the decorum which should be preserved during the performances, and are highly improper in the presence of the Emperor.

The critic praises the star, "Marcus Marcellus Valerian (stage name—his real name is Smith)," and apologizes for departing from his usual practice of criticizing only the martyrs and the tigers when he dares to suggest that Smith has one fault: "the pausing in the fight to bow when bouquets are thrown to him is in bad taste," a habit evidently picked up in the provinces and unsuitable to the metropolis. Finally, "the General Slaughter was rendered with a faithfulness to details which reflects the highest credit upon the late participants in it," and the entire performance sheds honor "upon the city that encourages and sustains such wholesome and instructive entertainments." Notice is given that "a matinee for the little folks is promised for this afternoon, on which occasion several martyrs will be eaten by the tigers."

Mark Twain was not really concerned about either the insipidity of Victorian American entertainments or the barbarities of imperial Rome. He was attacking rather the romantic conventions and sentimentality of the sort expressed by Byron, Dickens, and Greenwood that had attached themselves to the Colosseum. At the end he congratulates himself on having written about "the gladiators, the martyrs, and the lions, and yet . . . never once [using] the phrase 'butchered to make a Roman holiday.' I am the only free white man of mature age who has accomplished this since Byron originated the expression," he brags. The Colosseum and its bogus

historical glamour have been leveled by common sense from America's own arena of violence and homicide, the western frontier.[11]

But there was more than one American measure, and Margaret Fuller's exultation in the Rome that built the great arenas was something different from the derivative sentimentality and sensationalism of a Greenwood, and something less vulnerable to Mark Twain's mockery. As she journeyed toward that Rome that was her destination and was to provide her destiny, her anticipation was so great that the splendid ancient amphitheater at Arles was sufficient to evoke a rapture that the Colosseum itself could hardly later surpass: "Here for the first time I saw the great handwriting of the Romans in its proper medium of stone. . . . It looked as grand and solid as I expected, as if life in those days was thought worth the having, the enjoying, and the using." Blessedly released at last from the confines of Concord and Boston, Fuller exulted in a large sense of aggressive life that could include without criticism the "fierce excitements" of "fights of men and lions."[12] Violence and sacrifice were merely expressive elements within a larger life conceived on the imperious scale worthy of Man.

The Measure of Man

If men could rear such piles as these ruins denote, and such a mountain of stone as the Colosseum, why should they not be able to perform the extravagant wishes even of Nero himself? When the human power has reached this point, where shall the limit be placed?
 —*Theodore Dwight (1821)*

For both Margaret Fuller and Mark Twain the Roman arena provides a measure for man: for one it is an indication of his apparently limitless potential; for the other it embodies the universal fraudulence and triviality of his pursuits, his pleasures, and his myths. Historical comparisons, biblical and classical, had been a part of American consciousness from the beginning, and the relation of the contemporary world to the classical world was for Americans, as representatives of the most progressive and democratic nation, more problematic than it was for the French or the English, or even the Germans. It became more so to the extent that America's westward expansion enhanced the possibilities of imperial power, and this model superseded the ideal of the Republic. Juxtaposition of images of the ancient world with those of contemporary life, which characterizes so much European and English art and literature from the Renaissance onward (to say nothing of Dante), is also an important means of cultural self-definition for Americans.

John Adams, indulging in "a piece of Vanity" as he called it, posed for Copley in London with a classical statue behind him at the very time when he was ransacking the history of the Roman Republic for proofs in defense of the American constitutions. But his great-grandson Henry imagined a different and increasingly imperial America eighty years later when he sat on the steps of the Ara Coeli, thinking of Gibbon. The powerful future for his nation that he prophesied by saying that Rome was "going to be America" was not attractive to him, but that did not mean that there was anything to be said for the mediocre present. "Rome dwarfs teachers," he

wrote. "The greatest men of the age scarcely bore the test of posing with Rome for a background. Perhaps Garibaldi—possibly even Cavour—could have sat 'in the close of the evening, among the ruins of the Capitol'" (Adams here quoted Gibbon). "Tacitus could do it; so could Michelangelo; and so, at a pinch, could Gibbon, though in a figure hardly heroic." But one "hardly saw Napoleon III there, or Palmerston, or Tennyson, or Longfellow."[1]

Yet, no matter what Adams was to think, American artists and writers (including Longfellow), like those of England and France and Germany, were frequently tempted to place themselves, their subjects, or their fictional characters against this backdrop of classical Rome, and chose more often than any other the famous monument of imperial grandeur, the Colosseum. The consequences, from their point of view, were not always so discouraging as the cynical Adams assumed. This is partly because the Colosseum had other meanings than that of impermanent cultural fulfillment—the recurrent monumental failures of civilization—which Adams assigned to Rome. As we have seen, even in the brief passage in James's *The Portrait of a Lady*, several different aspects of the Colosseum are evoked as relevant to the foreground figure of Isabel. As different artists stress or imply different associations, the image of the Colosseum is altered, and with it the meaning of the contemporary figure.

The problem of interpreting the relationship rises in simplest and starkest form in portraits with the arena in the background, the sort to which Adams was referring. The effect (not the intention) of the paintings can be understood when placed in the context of a minor European tradition to which they belong. Most suggestive for our purposes is the *Self-Portrait* with the Colosseum painted by Maerten van Heemskerck in the 1530s (fig. 13). Heemskerck, as one of the many northern humanist artists to take inspiration from ancient Rome, had drawn many designs of the Colosseum and had included versions of it in more or less fantastic and reverential paintings. Here he sets up an equation between himself and the monument of antiquity by letting it occupy half the space in his own self-portrait, placing it not so much behind as beside him, as though this were a double portrait. At the same time he places in the lower right-hand corner another image of himself—much diminished and in a pose of devotion—in the act of recording the mighty icon that from this altered perspective now looms above him. The result beautifully renders the two-sidedness of the Renaissance regard for ancient Rome—aspiration to equality and submission to authority. It may be contrasted to Ingres's *Joseph Antoine Moltedo* (1815; Metropolitan), in which a miniature Colosseum in effect sits upon the shoulder of a Corsican official who was in Rome during the Napoleonic occupation. The Colosseum is here an honorary epaulet, a badge of conquest; but Rome, supremely worth dominating, is nevertheless diminished by domination.

The pertinent American paintings are closer in intention than either of these to the typical English souvenir paintings (often done by Italians), in which the Colosseum serves to establish the fact that certain Milordi had reached the ultimate goal of the Grand Tour (its chief rival in this being Vesuvius, with St. Peter's dome in third place).[2] Henry Adams's sense of incongruity between setting and figure did not occur to English gentlemen. The earliest appearance of the Colosseum in an American painting is in the double portrait by John Singleton Copley of Mr. and Mrs.

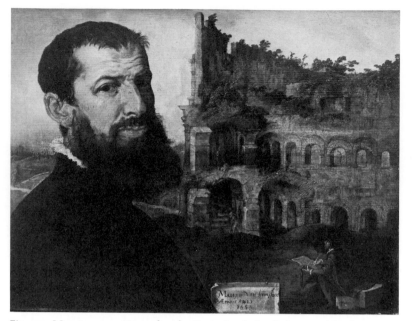

Fig. 13. Maerten van Heemskerck. *Portrait of the Painter, with the Colosseum Behind.* 1530s. Oil on wood. 422 × 540 mm. Fitzwilliam Museum, University of Cambridge.

Ralph Izard, painted in Rome in 1775 (fig. 14). It resembles a double portrait of Sir William and Lady Hamilton painted five years earlier in Naples by David Allan, in which Vesuvius fulfills the function of the Colosseum in the Copley. An atmosphere of refined culture (the first Lady Hamilton plays the harpsichord for her relaxed but attentive husband) prevails in both paintings. In Copley's portrait, the Colosseum itself is hardly more than a tiny place sign in the center background, far beyond the grand loggia where the Izards inhabit anything but a world in ruin. Yet the sumptuous furnishings and artifacts clearly do not belong to the New World that Copley had just left behind, that simpler world where sufficient accessories had been found in peaches, pet squirrels, and teapots. But neither are the Izards in the Old World. They belong instead to a wholly imaginary classical Rome, that is, to a timeless, unchipped, dustless, connoisseur's world of aristocratic neoclassicism, as evoked by Winckelmann but supplied with comfortable sofas. The Izards discuss the sketch of the statue that stands on the table beside them and is reflected in its polished surface; they are far from the contemporary musket fire on the fields of Lexington and Concord that presaged the new Republic on whose behalf Izard, a South Carolinian resident in England, was soon to make futile diplomatic overtures to the Grand Duke of Tuscany and in whose first Senate he was to sit. All this was in the future, but the portrait is consistent with the confident identification with an ideal of the ancient world that characterized the nascent Republic. Here the Colosseum itself appears to be merely a lovely soft element against the theatrically painted sky, the whole a purely artificial and therefore unthreatening backdrop. Copley locates the Izards within the frame in such a way that the great monument, hardly perceptible as a ruin, but near the center, radiates its rich cultural associa-

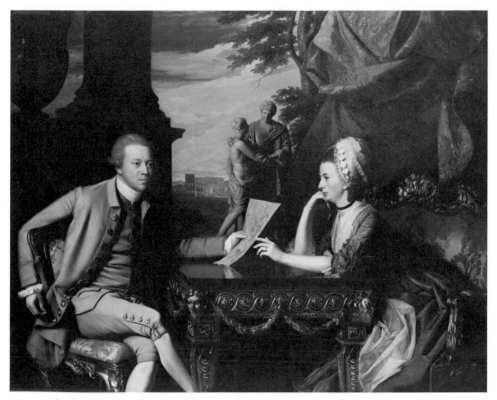

Fig. 14. John Singleton Copley. *Mr. and Mrs. Ralph Izard*. ca. 1775. Oil on canvas. 69 × 88½". Courtesy Museum of Fine Arts, Boston. Edgar Ingersoll Browne Fund.

tions upon them. The Izards clearly do not make Isabel Archer's distinction between the personal less and the historical greater.

Nearly a century later, George Healy—the Boston Irishman who had achieved favor in the court of Napoleon III approaching that enjoyed by Benjamin West in the court of George III, being the semiofficial painter of European royalty and the first American painter to have his self-portrait requested by the Uffizi,[3]—jointly produced with two other American painters a work (fig. 15) as aesthetically naive as Healy was socially sophisticated. Naïveté is not what one would expect from this former student of Couture and an occasional member of that colony of American artists resident in Rome (who were, according to James—who seems to have had many candidates for the role—themselves the Romans of the Decadence).[4] The painting is sometimes called merely *The Arch of Titus* (1871) (the monument now stripped of the encumbrances recorded by Vanderlyn in 1805; see fig. 1), but this work is also a portrait. For those two stiff little dolls standing beneath the arch are Longfellow, the most respected representative of democratic culture, and his daughter Edith. No wonder Adams thought Longfellow should not risk posing before the ruins of Rome! Even now we feel he *ought* to have looked bigger in 1871. The two are caught in Victorian complacency staring straight into the camera; for the painting is in fact taken from a photograph preserved in the Archives of American Art,

Fig. 15. G. P. A. Healy, Frederic Church, and Jervis McEntee. *Arch of Titus*. 1871. Oil on canvas. 73½ × 49". The Newark Museum.

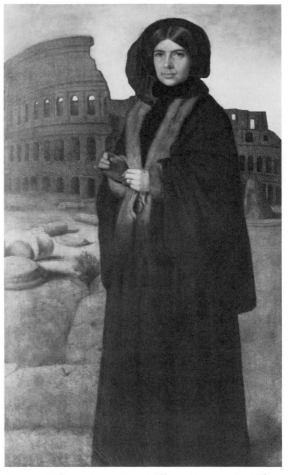

Fig. 16. William Page. *Mrs. William Page*. 1860. Oil on canvas. 60¼ × 36¼". The Detroit Institute of Arts. Gift of Mr. and Mrs. George S. Page, Blinn S. Page, Lowell Briggs Page, and Mrs. Leslie Stockton Howell.

still bearing carefully drawn rulings to determine exact perspective and proportions (those unfortunate proportions).[5] Also, Healy and his colleagues, Frederic Church and Jervis McEntee, have further confused the subject by introducing themselves into the right foreground, one of them sketching the Longfellows, the three of them together forming a pyramid that buttresses the right leg of the arch itself. Beyond and through the arch looms the Colosseum. This is not conscious Adamsian satire, of course. It is rather a glorified equivalent in oil to the naively composed tourist photograph that says, "We were there!"

One wonders, however, whether William Page, who was called the American Titian before either he or any of his admirers had seen a real Titian, might not have been partially conscious of what he was doing when in 1860 he chose to place his third wife in front of the Colosseum (fig. 16). (This is the only painting of a woman alone at the site.) The historian James Thomas Flexner describes Mrs. Page rather

58

luridly as a "dragonlike widow and newspaper woman who for the rest of her life warmed Page with the fire of her nostrils and forced her businessmen brothers to keep her genius financially afloat."[6] Page has certainly rendered her forcefulness, and—no Isabel—she stands there like a Victorian female gladiator posing before the scene of her triumphs. The irregular outline of her hood even gives the impression that she herself might have been ripped from the stones behind her, a notion encouraged by the telling fact that the straight diagonal buttress erected on the south wall of the Colosseum a half-century earlier is missing, so that an improbably craggy profile frames one side of her head. Although living in Rome, Page has not troubled to paint the actual Colosseum, but has anachronistically copied an eighteenth-century rendition, perhaps the same that appears as a studio backdrop in the last photograph taken of the Pages' close friend, Elizabeth Barrett Browning (1861).[7] The celebrated but frail Mrs. Browning is similarly posed and dressed, but the figure is less dramatically related to the Colosseum than in Page's painting. There the perspective makes the self-assured Mrs. Page commensurate with the monument. She in fact appears more sturdy, more noble than the Colosseum itself, and in her own way as beautiful and imposing.

The three most familiar American portraits with the Colosseum thus have (respectively) aggrandizing, diminishing, and equalizing effects on the American figures who appear before it. In literature the relations are more complex but the figures are from a narrower range.

The Colosseum is the apt setting for madwomen and geniuses in American poetry and fiction at all levels of accomplishment. One Theodore S. Fay, who also wrote a so-called "True Tale of the Coliseum," set in ancient Rome, published in 1835 the first version of his *Norman Leslie,* the most popular novel of the day until Edgar Allan Poe made his critical debut by demolishing it. At its climax Rosalie Romaine, a New York fashion plate and Sunday school teacher who has gone mad as a consequence of being confined to a madhouse by her Neapolitan abductor, is seen leaping about the upper reaches of the Colosseum, from which the villain falls to his death. (When Fay unaccountably rewrote the book in 1869, he transferred the scene to the Corso during Carnival, where Rosalie's wild behavior seems less remarkable, and where the villain is simply shot.) The painter Washington Allston, in his gothic romance *Monaldi* (1841, but written twenty years earlier) has one of his two alter ego heroes (the writer) say to the other (the painter) that he sees his own condition in the "oppressive splendor" of "that proud pile of Titus" (the Colosseum); "so dark and desolate within," it speaks from without "in the gorgeous language of the sun" to his own heart, about himself.[8]

Extreme emotion and great aspiration characterize the typical figure at the Colosseum, the romantic soul that feels itself misplaced in the nineteenth century, trying to extend its capacities or to understand its limitations, measuring itself against heroic architecture once achieved and powerful feelings once experienced. The artist above all is the appropriate perceiver of the Colosseum because he alone can adequately feel its meaning as classical symbol and romantic ruin. The model for this meeting of Colosseum and great soul was set primarily by Byron, who—anticipating Adams's question—thought that there was only one modern genius

worthy of posing with Rome as a background: George Washington, whose Brutus-like mind was supposedly "nourished in the wild, / . . . 'midst the roar / Of cataracts, where nursing Nature smiled." Europe can no longer produce men so noble, Byron says; but by constantly posing himself in the center of the arena, he implies that he knows at least one who can withstand the association.[9]

Edgar Allan Poe, who was never in Rome, directly imitated Byron's two celebrated passages—those in *Manfred* (1817) and in *Childe Harold's Pilgrimage*, canto 4 (1818). Poe's poem, "The Coliseum," was originally the final scene from his unfinished verse-drama, *Politian* (1833). In all three works the Colosseum is seen, in Poe's words, as a "Rich reliquary / Of lofty contemplation left to Time / By buried centuries of pomp and power!" Poe specifically isolates the attributes and associations that appeal to him: Size, Age, Memory, Silence, Desolation, Night. For Poe as for Byron the Colosseum instills an essentially modern religious feeling, more potent than that of either paganism or Christianity. Poe's single important revision of this poem—and its only significant departure from Byron—consisted precisely of changing the words "I stand" to "I kneel." Humility is inculcated by the obvious evidence of man's insignificance before Time. Poe lists former and present things in alternation, a method that had long since become conventional in both prose and poetry describing Roman ruins. Here, says Poe, where once there were eagles, gilded hair, and monarchs, there are now bats, thistles, and lizards. But these are not all. To Poe's hero's despairing cries, the stones answer:

> "Prophetic sounds and loud, arise forever
> From us, and from all Ruins, unto the wise,
> As melody from Memnon to the Sun."

The stones of the Colosseum "rule the hearts of the mightiest men" and "all giant minds" with their magic, wonder, mystery, and memories. Thus even here, where it seems that the ruin will convey above all a lesson in humility, ultimately—as with Byron—what is enforced is an impression of superior genius, the poetic aristocrats, who alone are capable of hearing the voice that speaks from the stones of human capacity for achievement. More than that, they are the ones who *evoke* the voice that would otherwise be dumb; the analogy with the statue of Memnon, which emitted music when struck by the sun's rays, makes artists the equivalent of the awakening and enlightening sun.[10]

Nathaniel Hawthorne often seems to combine the romantic aspiration of Poe with the hardheaded (even hard-hearted) realism of Mark Twain. This is evident in *The Marble Faun* (1860), when his group of artists go on their obligatory moonlit visit to the Colosseum. Hawthorne initially sounds like Mark Twain when he points out that there is anything but solitude—the arena is jammed with visitors, and on the "topmost wall" a party of English and Americans are "exalting themselves with raptures that were Byron's, not their own." As for the moonlight, it is too bright; it makes everything "too distinctly visible." Yet as artists Hawthorne's characters have the capacity to enjoy "the thin delights of moonshine and romance." They are abundantly pleased, claiming—like Hawthorne's friend Hillard—that the Colosseum has only now come into its "best uses"; it was built for

their pleasure. That pleasure, in spite of their gaiety and the classical setting, is primarily gothic, and as they sit imagining ghosts and recalling the demons that Cellini and his necromancer had raised on the spot, Hawthorne's critical humor gradually becomes mixed with horror, preparing for the reentrance of Miriam's specter of the Catacombs and for the completely gothic scene in which Miriam is transformed into an almost superhuman madwoman raging "under the dusky arches of the Coliseum." Now all the earlier allusions to martyrdom, demons, gladiatorial combat, and power contribute to the characterization of Miriam and her situation, even as her behavior reinforces both the gothic and the heroic associations of the ruined arena. When Donatello, the innocent "faun" of the title, makes his explicit avowal to die for her, Miriam reasserts much of her imperious superiority: "I used to fancy that . . . I could bring the whole world to my feet." Now she sees only the threatening evil that hangs over her and Donatello like the crumbling dark vaults of the mighty Colosseum. Like Byron and Poe, Hawthorne finds the classical ruin the apt setting for the doomed but heroic contemporary personality martyred by misplacement in the ignobility and decay of the present.[11]

Unquestionably Hawthorne's use of the Colosseum encouraged that of Henry James, who employed it no fewer than five times at crucial moments in the lives of his characters. In the earliest instance, in the story "Adina" (1874), a Donatello-like character undergoes *his* transformation from innocence to experience at the center of the Colosseum, where he swears revenge upon the man who has wronged him. In his first full-scale novel, *Roderick Hudson* (1875), James much more fully exploits the scene in the book's central chapter, using every romantic aspect of what he saw as the Colosseum's Alpine topography—its ruggedness, its opportunities for lovers' trysts and for eavesdropping, its flowers on high ledges. But all this might have been found in the Baths of Caracalla, of which James was equally fond. The special symbolic appropriateness of the Colosseum lies only in its classical association with athletic and heroic action: contests of will, questions of strength, even the definition of manliness, all those, moreover, as something observed, witnessed, as Rowland here witnesses Christina Light's tigerish challenges to Roderick and Roderick's attempts to prove himself. Roderick is the young man who has proposed to become the Whitman of American sculpture, but Christina tells him that he is too weak for "splendid achievement," that he has "not the voice of a conqueror"; on the contrary, he is a drifter, a dodger, a self-doubter, in short, a "scant" person. Roderick takes Christina herself to be a very superior person who judges him by the highest standards of achievement—against the "best"; and by a great effort of will he manages momentarily to control her. But, so shaken is he by this "episode of the Coliseum," that his decadence really begins at this point. He is the genius who fails, and the Colosseum measures his fall.[12]

The important scene in *The Portrait of a Lady*, already discussed with respect to Isabel, goes on to use the Colosseum for comic-pathetic purposes as the backdrop for a young man's declaration of strength. Isabel sees little Ned Rosier, her stepdaughter Pansy's faithful suitor, "planted in the middle of the arena" in a pose "characteristic of baffled but indestructible purpose." He has sacrificed all his bibelots—the chief source of his identity; but he nevertheless cries out, "I feel very safe!" James observes: "It evidently made him feel more so to make the announcement in a

rather loud voice, balancing himself a little complacently on his toes and looking all round the Colosseum as if it were filled with an audience."

The Colosseum is used by James even in *The Bostonians* (1886) to heighten the effect of the most tumultuous denouement to any of his novels. Boston in those days lacked an arena naturally associated with violent entertainment for the masses, so James has the aggressively masculine Basil Ransom perceive, on the occasion of his own descent to brute force, a resemblance between the Boston Music Hall and the Roman Colosseum. James draws the parallels in detail. Thus fulfillment of the feminist Olive Chancellor's desire for martyrdom is strongly implicit when at the end she desperately plunges out onto the stage to face the roaring crowd.

James's most famous use of the Colosseum is that in *Daisy Miller* (1878), his early attempt to see how much dignity and importance could be attributed to the presumptively small and unaware. Almost the last words Daisy speaks to her undeclared suitor Winterbourne are "Well, I *have* seen the Colosseum by moonlight! . . . That's one thing I can rave about!" The breaking of one convention to conform to another—that of Byronic romanticism—kills her. Winterbourne, himself a "lover of the picturesque," has found Daisy and the infatuated Giovanelli together in the Colosseum just after he has interrupted his own recitation of Byron's lines from *Manfred* by reminding himself that "the historic atmosphere" is a "villainous miasma," "scientifically considered." Daisy sees him looking at her "'as one of the old lions or tigers may have looked at the Christian martyrs!'" And he is in fact sacrificing her at the moment he recognizes her. His judgment of her— "I believe it makes very little difference whether you are engaged or not!"—parallels her reply—"I don't care . . . whether I have Roman fever or not!" The relation between her death and her failure to win respect on her own terms is clear. Like Roderick, like Christina, like Ned Rosier, like Isabel herself and the fiercely shy and self-deprecating Olive Chancellor—like all of James's characters who respond to the Emersonian injunction to descend into the dust of the arena to take the measure of themselves—"She would have appreciated one's esteem."[13]

The Colosseum as Negative Model

In the course of the nineteenth century, America developed its own "ancient history," and found in Washington and Franklin, Adams and Jefferson, its Cincinnatus, Cicero, and Cato, rendering the originals superfluous. However, many of the Founding Fathers themselves, as we have seen, had shared the belief that the modern nation could find its model in the Roman Republic, that contemporary men could rival and surpass the high achievements of even imperial Rome, without—it was hoped—loss of republican virtue. By providing models both of national fulfillment and of individual greatness, then, Rome had a relevance.

As several intellectual historians have shown,[1] however, there was always some confusion as to what the relevance was, since there was confusion about America's place within history, and disagreement about the meaning of history itself. If history was cyclical, America's own origins combined primitivism with commer-

cial, political, and cultural sophistication in a way that defined the nation equivocally: was it new, its cycle just beginning, or was it a necessarily contemporaneous offshoot of the British Empire, already (supposedly) at its height and corrupt? If America was essentially at its beginning, could it read the history of Rome with sufficient intelligence to slow down or even evade the ultimate implications of cyclical theories, free will overcoming fate as revealed in history? Should it believe, instead, in a millennial interpretation of history, in which America represented the western edge of civilization progressing toward its perfection, the fulfillment of which was history's purpose? In 1780 David Humphreys had written "On the Happiness of America" thus:

> All former empires rose, the work of guilt,
> On conquest, blood, or usurpation built:
> But we, taught wisdom by their woes and crimes,
> Fraught with their lore, and born to better times;
> Our constitutions form'd on freedom's base,
> Which all the blessings of all lands embrace;
> Embrace humanity's extended cause,
> A world our empire, for a world our laws.[2]

Such a declaration of political novelty had implications for architecture as well. A passage spoken by the Genius of Long Island Sound in the final book of Timothy Dwight's *Greenfield Hill* (1794) (dedicated to John Adams) explicitly attacks imitation in perfectly conventional heroic couplets. His point is that *everything* is to be thought of as being "done first" in America—not in Rome. The image informing his verse is clearly the Colosseum as it had been perceived in the Renaissance, as the architectural ideal of superimposed orders:

> Her pride of empire haughty Rome unfold:
> A world despoil'd, for luxury, and gold:
> Here nobler wonders of the world shall rise;
> Far other empire here mankind surprise:
> Of orders pure, that ask no Grecian name,
> A new born structure here ascend to fame.
> The base, shall knowledge, choice, and freedom, form,
> Sapp'd by no flood, and shaken by no storm;
> Unpattern'd columns, union'd States ascend;
> Combining arches, virtuous manners bend;
> Of balanc'd powers, proportion'd stories rise.[3]

Obviously, a visual representation of Dwight's "Mansion of Freedom under Law" with its "unpattern'd columns" of nameless orders would have little resemblance to the edifice eventually constructed at Washington to house the Congress and "pompously"—as Tocqueville said—called the "Capitol." The model of imperial Rome was not so easily dismissed as Dwight implied. Many writers in the nineteenth century, when the extreme possibilities of American empire became more apparent,

obviously shared a general feeling that power and wealth were perhaps worth the moral cost. "Although the crimes and cruelties of the ancient Romans made their fall merited," commented the engineer William Gillespie in *Rome: As Seen by a New-Yorker in 1843–4* while imagining the gladiatorial games of the Colosseum, "yet their grandeur half excuses their enormity."[4]

Such ambivalence is evident in the two contrasting discussions of the Colosseum written by the distinguished art critic, moralist, and collector James Jackson Jarves. In the relatively personal essays of *Italian Sights and Papal Principles Seen through American Spectacles* (originally published as a series in *Harper's* in 1852–54), Jarves expresses his unbounded "passion" for amphitheaters, aroused by their combined "symmetry and strength." The Roman arena "combines a grandeur of force and beauty in a higher degree than any other of the architectural works of man." The "stupendous" Pyramid of Cheops is after all "only artificial bulk and weight," whereas the "Colosseum . . . is a noble triumph of art—an expansion of science and strength which stamps the character of a nation for all time." Thus a positive description of the Colosseum employs the same terms as a description of the Empire. And while Jarves reluctantly goes on to admit that Roman arenas commemorate not only "the daring genius of the conquerors of the world" but also "their brutalization and inhumanity," he qualifies this by saying that what Christianity has done "in the name of the merciful Savior" should make us practice "humility when we sit in judgment upon the Past." However, in Jarves's more formal and pedagogical work, *Art Hints: Architecture, Sculpture, and Painting* (1855), intended specifically to enlighten artistic practice in America, Jarves uses the Colosseum as an entirely negative model. The "mistress of the Old World" achieved in such works as the Colosseum an art "of gigantic display and enervating luxury; a mingling of pride and vanity, giving vent to the fouler passions in gladiatorial shows, and abundant means of gratuitous enjoyment of sensual pleasures." Imperial Rome engaged in the worst possible "moral training" of its subjects. The citizen was regarded exclusively as an animal to be fed and bathed, after which he took his seat in the amphitheater and glutted his eyes "with the dying agonies of fellow-beings": "Such was the Roman, and of such a character his Art, the basest in its motives the world has ever exhibited, and the most ruinous in its downfall." Thus for Jarves, the Colosseum and the Roman character of which it is the best expression can be seen as either "noble" or "base."[5]

By the middle of the nineteenth century commercial and territorial expansionism, political corruption, and signs of growing luxury and dissipation made Jarves's warnings necessary but somewhat desperate. Certainly the eighteenth-century optimism about the political purity and disinterested historical destiny of America was difficult to sustain. In congressional debates of the 1840s leading up to the Mexican War, imperial Rome as a negative reference replaced invocations of the Roman Republic.[6] The analogy became only more pertinent in the last decades. By the turn of the century, Henry Adams could state that America had made "so vast a stride to empire" that the Civil War already seemed ancient history. Americans had since become "as familiar with political assassination as though they had lived under Nero. The climax of empire could be seen approaching, year after year, as though Sulla were a President or McKinley a Consul."[7]

In this period Henry James alone among American "realists" could create a noble character like Isabel Archer for whom the contemporary and the past converge in an awareness of the individual life within the political mutations of history, lending a tragic dignity to both. Historicism in architecture had a final flowering in the classical mode (with the Colosseum itself influencing aspects of the Boston Public Library and San Francisco's Palace of Fine Arts),[8] but in literature and painting the interests of realism shifted wholly to the contemporary world. There developed a large indifference to the *entire* past, classical or medieval; and humanity, both social and individual, both classic and contemporary, became—in spite of the efforts of Walt Whitman and Winslow Homer—very small. Not only the past, but history itself—and thus the future, too—lost significance. But the American predilection toward such antihistoricism had actually been expressed in satirical verses by Freneau as early as 1775:

> This age may decay, and another may arise,
> Before it is fully revealed to our eyes,
> That Latin and Hebrew, Chaldaic and Greek,
> To the shades of oblivion must certainly sneak;
> Too much of our time is employed in such trash
> When we ought to be taught to accumulate cash.[9]

The Abyss of Time

Henry Adams, trying to find relatedness in history, could not imagine Longfellow posed before the ruins of Rome, but he could think of Michelangelo as adequate to the setting. Longfellow himself imagined Michelangelo there, and in a remarkable passage in his unfinished verse drama *Michael Angelo: A Fragment* (1882), most of the meanings of the Colosseum that we have observed come together. Michelangelo tells his questioning companion Tomasso de' Cavalieri that he has come to the Colosseum to "learn" from "the great master of antiquity" who designed it. He sees the structure as "the great marble rose of Rome," its petals torn by the wind and rain of centuries, yet still opening itself to the constellations that hang above it like a swarm of bees. To this image Cavalieri opposes Dante's white rose of Paradise, whose petals were saints, while the thousands who once filled out the Colosseum's design "came to see the gladiators die" and "could not give sweetness to a rose like this." But Michelangelo speaks "not of its uses, but its beauty." Even to this, Cavalieri argues that "the end and aim" of a work constitutes its nobility. This arena once served "people / Whose pleasure was the pain of dying men," and even now, as a ruin, it serves robbers and "the ghosts / Of murdered men." For Michelangelo, however, as a ruin it has been reclaimed by its thousands of wildflowers and birds, which are also capable of teaching the artists lessons in beauty.

Yet Longfellow does not stop there, with this summation of the questions about the building's identity—its definition by its various historical uses, by its inherent beauty of design, by its eventual reclamation by nature, by its accumulated associa-

tions. With astonishing eloquence he goes on to a deeper lesson in which Michelan-
gelo converts the Colosseum into a philosophical symbol; implicitly it becomes the
image of the skeletal remains of the world:

> All things must have an end; the world itself
> Must have an end, as in a dream I saw it.
> There came a great hand out of heaven, and it touched
> The earth, and stopped it in its course. The seas
> Leaped, a vast cataract, into the abyss;
> The forests and the fields slid off, and floated
> Like wooded islands in the air. The dead
> Were hurled forth from their sepulchres, the living
> Were mingled with them, and themselves were dead,—
> All being dead; and the fair, shining cities
> Dropped out like jewels from a broken crown.
> Naught but the core of the great globe remained,
> A skeleton of stone.[1]

This reading of the Colosseum, which has distant connections with the cosmic
mysteries that surrounded it in the Middle Ages, had been adumbrated by Haw-
thorne at the end of the Colosseum scene in *The Marble Faun*, where he too passed
beyond the questions of the classical measure of man and the atmosphere of the
Gothic ruin toward an apocalyptic vision: his little quartet of artists strolls away
from the Colosseum, past the Arch of Constantine, and then along the Via Sacra
beneath the Arch of Titus, with the Palace of the Caesars in the background, and
Hawthorne imagines a "Roman Triumph, that most gorgeous pageant of earthly
pride," coming along the same way. Then he adds quickly:

> It is politic, however, to make few allusions to such a Past; nor, if we would create
> an interest in the characters of our story, is it wise to suggest how Cicero's foot
> may have stepped on yonder stone, or how Horace was wont to stroll nearby, mak-
> ing his footsteps chime with the measure of the ode that was ringing in his mind.
> The very ghosts of that massive and stately epoch have so much density, that the
> actual people of today seem the thinner of the two, and stand more ghostlike by the
> arches and columns.

This diminishment of the contemporary world reaffirms the stature of the classical
one. But then Hawthorne takes the further step into historical nihilism. He has
Miriam suggest finally that everything—classical as well as contemporary—is
ultimately reduced to insignificance. Kenyon has just cited the heroic act of Curtius
riding his horse into a fissure in the earth to save the city, and she replies: "It was a
foolish piece of heroism in Curtius to precipitate himself there, in advance; for all
Rome, you see, has been swallowed up in that gulf, in spite of him." Into that abyss
of Time have gone the Caesars and their palaces, the temples, the statues, the
armies, "all the heroes, the statesmen and the poets!" Hawthorne's four characters
then turn their backs on the moonlit Colosseum and stride off across the Forum

toward the Tarpeian Rock where the tragic crisis of the book will occur. As they go along the Via Sacra they sing, somewhat shrilly, "Hail! Columbia!" Theirs is a desperate triumphal march of the present over the past, a march that replaces the earlier American Republic's imaginative wish to join in the ancient procession. They trample the proofs of tragic history underfoot, a defiance of Time by the representatives of Columbia, the New Republic and the Empire to be.[2]

3

Reading the Campagna: "Silence Made Visible"

In the spring of 1833 America's first "foreign correspondent" stood on the "lofty turrets" of the Tomb of Cecilia Metella and saw before him the original of "one of the finest landscapes ever painted"—Thomas Cole's "picture of the Roman Campagna": "the long aqueducts stretching past, . . . forming a chain of noble arches from Rome to the mountains of Albano."[1] The oil was hardly dry on the work that N. P. Willis so confidently rated; it had been painted the year before. Willis had seen Cole's paintings in Florence, where he had moved into the apartment Cole was vacating.[2] A second version of the same scene (fig. 17), painted by Cole in 1843 after another visit to Rome, is described by William Cullen Bryant in his funeral oration for Cole in 1848 as one of the pictures "which we most value and most affectionately admire . . . with its broad masses of shadow dividing the sunshine that bathes the solitary plain strown with ruins, its glorious mountains in the distance and its silence made visible to the eye."[3]

As Bryant suggests, the painting's initial impact comes from the abstract impression of broad bands of dark and light, projected downward to the right from the sweeping but broken diagonal of the aqueduct, itself composed of vertical stripes of light and shadow separated by the dark line of the entablature from the luminous sky that envelops the hills in its atmosphere. The earlier painting, which became familiar through an engraving by James Smillie that was also used as the frontispiece to Henry T. Tuckerman's popular *Italian Sketch Book* (1835), is nearly a negative of this one, the Campagna at sunset instead of dawn, with the aqueduct in full light, making a brilliant stripe across the middle of the canvas while the sunken marshland in the foreground falls into deep shadow. This reversal indicates Cole's sense of the scene's primary significance to him. His vision of the Campagna is fundamentally the same as that in all of his most characteristic landscapes, both imaginary and real. They express a moral universe of light and dark, whether divided by the gates of Eden, by a looming rock in the morning light over the

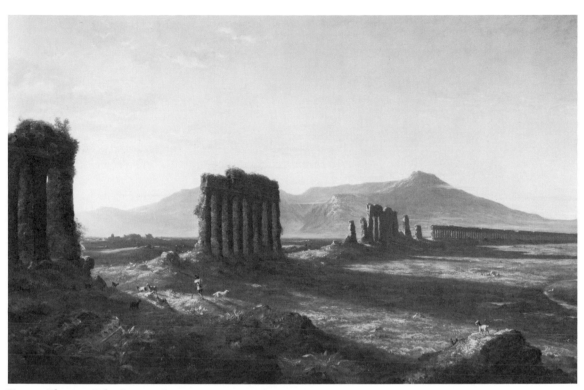

Fig. 17. Thomas Cole. *Roman Campagna*. 1843. Oil on canvas. 32¾ ×
48⁵⁄₁₆″. Courtesy Wadsworth Atheneum, Hartford. (See plate 2.)

Hudson, or by a slanting edge of storm clouds passing over the Oxbow of the
Connecticut River valley.

The Claudian aqueduct was the ruin on the Campagna most popular with Ameri-
can artists who stopped in Rome in the nineteenth century. But the paintings by
George Loring Brown (1842–43), Jasper Cropsey (1848), Sanford Robinson Gifford
(1859), John Rollin Tilton (1862), and George Inness (1858 and 1871) all lack this
drama of light and dark. Other things they necessarily have in common, with the
Coles and with each other. Inherently pictorial qualities are provided by the dimin-
ishing perspective of the aqueduct, the vertical thrust of its arches in opposition to
the wide undulating spaces of the Campagna, and the rough texture of the plain
contrasting with the softly glowing sky that typically occupies nearly half the
canvas. From Thomas Cole through George Inness (in a tradition that went back
through Richard Wilson and others to Claude Lorrain), a fundamental appeal of the
Campagna lay in its light and in the simple, shadowed geometries of forms—
aqueducts, tombs, towers, and trees—defined by that light against the low straight
horizon of the sea or the gently swelling cones of hills. Equally important, those
forms and those hills and the very ground itself had inherent historical and literary
value, which was further dignified by the long aesthetic tradition. Most of the
nineteenth-century artists who went to Rome did so in the belief that a painter was
a poet and a historian and a moralist, and that Rome was the inspiration and school

for this humanistic tradition in art. For over half a century Americans joined other landscape artists from the North in the task of representing the beauty and interpreting the meaning of the Campagna and its adjacent hills. In their company were American writers of all kinds who in their own medium participated in the final representation of the Campagna before it lost forever the appearance that had made it seem a symbol of time, itself become timeless.

Whatever the Campagna's inherent aesthetic potential, the essential point is that it was not just any landscape. In Mme. de Staël's celebrated Roman novel *Corinne* (1807), widely read by Americans going to Rome, they found a clear assertion of the prevailing view: the "singular charm" of the Campagna was owing to its having in abundance precisely what America lacked. "The most beautiful countries in the world, when they bring to mind no recollections, when they bear the stamp of no remarkable event, are stripped of interest." A landscape dotted with ruins inevitably bore associations and became an edifying symbol: the ruins "present the image of time, which has made them what they are."[4] In the works and careers of these American artists arguments over the relative values of American and Italian landscapes are a constant source of ambivalence. The "unspoiled"—even divine—character of the American landscape was asserted as an opposing value, while—somewhat contradictorily—historical and legendary "associations," even though of recent date, were also being eagerly inscribed. Moreover, "potentiality" could also be a theme: the future was an "image" of time just as much as the past. All these conflicting views are expressed, for example, in Cole's own "Essay on American Scenery" (1836).

The ambivalence, however, was a problem for artists only when resident in America, trying both to meet the demands of patrons and to satisfy their own aesthetic. In Rome, there was no question which side had the greater weight. All around them lay what Henry James described in a letter of November 1869 as the "great violet Campagna, stretching its idle breadth to the horizon . . . a wilderness of sunny decay and vacancy."[5] That sunlight, that decay, and that vacancy were their inspiration and their challenge. For the silence made visible in these paintings is not the silence of the virgin American wilderness that most of these artists also painted. It is a silence that recalls dead voices, just as the "vacancy" of the Campagna is a reminder of lost plenitude. In the paintings of the Claudian aqueduct by Cole and Gifford and Cropsey, the marvelous engineering feat of the Roman civilization that carried the sustaining water of life into the great city *seems* to be, like time itself, without beginning or end as it enters into the picture on one side and disappears on the other; but the reality lies in the ravages at the center of the scene and in the utter desolation that spreads around them. James calls the Campagna a "wilderness"—the common word for *American* nature; and so, like the savage state of the American landscape, it required the artist to give it expressive form. There was a vacancy to be filled and a silence to be made eloquent.

Painters and writers responded by evoking two contradictory visions. One is melancholy and moralistic, the other pastoral and transcendent. On the one hand, they present the wasteland of former civilizations, what George Hillard called a "historical palimpsest" in which nature has nearly covered over the ruins of one civilization, the Roman, which had conquered and buried another, the Etruscan. As

such it is a place of "desolate and tragic beauty," "inseparably connected with the ideal image of Rome," "populous with so many visionary forms from the regions of history and poetry, vocal with so many voices of wisdom and warning."[6] In this view, the Campagna is essentially an emblem of mutability and a memento mori. On the other hand, the primitivism of the present scene—the shepherds with their dogs, the goats and the sheep and the buffaloes, the inducements to mirthful idleness on picnics in the verdant villas of Albano, or the evocations of rural serenity at Horace's farm near Tivoli, with the Campagna below stretching toward Rome or to the sea—all these images and ideas stirred writers and painters toward an exactly opposing vision: the illusion of an accessible Arcadia beyond the city walls, as in Vergil's poetry, a bosky place beyond the actions of time. Thus the Campagna was read both as historical desert and as eternal garden. Generally these antithetical images are kept as distinct from each other as Eden from the fallen world, but as contraries they inevitably suggest and confront each other. Even in Vergil, Arcadia is violated by dispossession and death.

The Wasteland: "Mighty Associations and Confused Emotions"

For Melville's Ishmael, the "mortal man" who "has more joy than sorrow in him" is untrue, or "undeveloped." The wiser man is one who has realized the significance of the fact that even "the natural sun . . . hides not Virginia's Dismal Swamp, nor Rome's accursed Campagna, nor wide Sahara, nor all the millions of miles of deserts and griefs beneath the moon." He it is who is "fitted to sit down on tomb-stones, and break the green damp mould with unfathomably wondrous Solomon," author of "the truest of all books," Ecclesiastes—"the fine hammered steel of woe."[7]

While tramping across "Rome's accursed Campagna" in 1845, the twenty-year-old Bayard Taylor was learning his first lessons in Solomonian wisdom. Afterward he wrote bluntly that "the country is one of the most wretched that can be imagined. Miles and miles of uncultivated land with scarcely a single habitation extend on either side of the road, and the few shepherds who watch their flocks in the marshy hollows look wild and savage enough for any kind of crime." As for the great aqueduct, its "broken and disjointed arches" suggested "the vertebrae of some mighty monster. With the ruins of temples and tombs strewing the plain for miles around, it might be called the spine to the skeleton of Rome." Finding that there "was nothing peculiarly beautiful or sublime in the landscape," Taylor nevertheless concluded that "few other scenes on earth combine in one glance such a myriad of mighty associations or bewilder the mind with such a crowd of confused emotions."[8]

For writers early in the century—still within the worldview of neoclassicism and with classical educations securely ingrained—the "mighty associations" could be quite specific. While in Rome in 1817–18, the conscientious young scholar George Ticknor wrote in his journal a long historical sketch of the Campagna, of which the concluding two paragraphs were published by his editor, George Hillard. The first

renders succinctly but explicitly one manner in which meaningful associations could be read from the vacancy:

> The present situation is that of a boundless waste. . . . Nothing can be more heart-rending than the contrast which the immediate and the present here form with the recollections of the past, gilded as they are by the feelings and the fancy. Here lived the brave and hardy tribes of the Albans, the Fidenates, and the Coriolani; here were the thirty-four famous cities, of which every trace was lost even in the time of Pliny; here was the crowd of population that found no place in Rome in the time of the Republic; here was the splendor of the Empire, when Honorius, from the magnificence of the buildings and monuments, seemed to be at the entrance of Rome when he was still fifty miles from its gates; and, finally, here resided the strength and rose the castles of the proud barbarism of the Middle Ages, when the contest remained so long doubtful between the ecclesiastical usurpation within the city and the rude chieftains without, *Haec tunc nomina erant, nunc sunt sine nomine campi.*[9]

Few Americans were so learned as Ticknor to begin with, and fewer became so even in the course of long residences in Rome. Most were content in their relative ignorance. The "somber pleasure of a melancholy heart" that Stendhal (quoting La Fontaine)[10] experienced in the Campagna was entirely accessible without facts. As Mme. de Staël had observed, the "mighty associations" that arose most readily from the Campagna could conveniently be abstracted into one: time. But for Melville's "mortal man" who sits on a tombstone reading—if not Ecclesiastes, then a guide-book—time is really a euphemism for death, and it is the idea of death—the death both of individuals and of entire civilizations—that most haunted the Roman landscape in the nineteenth century. All writers speak of its "sadness," even while trying to throw up defenses against outright morbidity. On his first visit to Rome in the 1860s, even William Dean Howells yielded to the mood:

> Away before us stretched the Campagna, a level waste and empty, but for the umbrella-palms [*sic*] that here and there waved like black plumes upon it, and for the arched lengths of the aqueducts that seemed to stalk down from the ages across the melancholy expanse like files of giants, with now and then a ruinous gap in the line, as if one had fallen out weary by the way.

On his second visit, forty years later, he was even less inclined to regard the Campagna with the "realistic" detachment that he exercised in the Forum. He found the land "desolate" and "lonesome," the evening sky "sad," the wind "mournful," and even the buffaloes seemed "gloomy." But Howells counteracted this pleasantly depressing pathos with a contrary sentimentality. He decided that the Campagna reminded him of the Ohio of his boyhood, in spite of his realization that *this* is a "many-memoried ground." "Nature," he comfortably asserted, "where history was so august, was perfectly simple and motherly, and did so much to make me feel at home."[11]

The gloomy, lonesome, and mournful Mother is less hospitable in other repre-

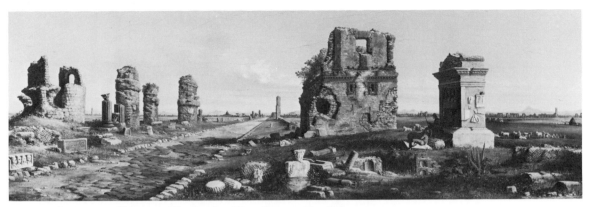

Fig. 18. John Linton Chapman. *The Appian Way, Rome.* 1880. Oil on canvas. 29⅞ × 71". Courtesy Childs Gallery, Boston.

sentations. In fact she seems to be making very few accommodations, casting only the thinnest veil of ivy over the memento mori that is the Campagna. The tomb-bordered Via Appia—"the 'stop traveller' of antiquity," as James Fenimore Cooper calls it[12]—expresses harsh lessons unbeautified by Nature. Theodore Dwight describes the fear that seized him as he was overtaken by nightfall one evening in 1821 after he had ventured too far out on the Via Appia. With self-consciously fashionable gothicism (even alluding to the sensational novelist Mrs. Radcliffe), he mentions a shaggy shepherd of apparently "deranged" mind who "seemed like a barbarous outcast from the world"; otherwise Dwight was alone:

> The setting sun was shining very bright, and strongly illuminated the ruins on one side, while the opposite parts were thrown into a deep shade. Their appearance varied every moment as I passed on; and their sad, though fantastic forms, seen against the pure sky, and suddenly assuming some unexpected aspect or expression at almost every step, seemed like a mysterious assembly of gloomy spirits. . . . What mortal could have the audacity to raise his voice against the deep and long drawn silence which has settled upon a scene once so filled with promises of Roman immortality? . . . Who could long endure the chilling presence of these frowning strangers?[13]

One of the few American paintings of this forbidding road (fig. 18) comes very late among those from the Campagna. Rendered in several versions in the 1870s by John Linton Chapman, the unhappy son of a painter better known to history, it is almost surreal in its exclusive focus on the sun-baked and misshapen remains of ancient tombs along a road that seems endless. The tiny men and animals to the right have collapsed in midday exhaustion, and the slight vegetation—painted with the abnormal clarity of the Pre-Raphaelites—consists of weeds and desert growth, brightened by scattered blood-red spots of poppies. Only a few atypical paintings by George Inness also done in the 1870s approach a similar sense of depletion, of minimal persistence of life under a too-hot sun and upon a barren ground among bleached ruins that are not so much picturesque as grotesque (fig. 19).

Outside the Porta San Sebastiano, where the Via Appia begins, lie the Christian

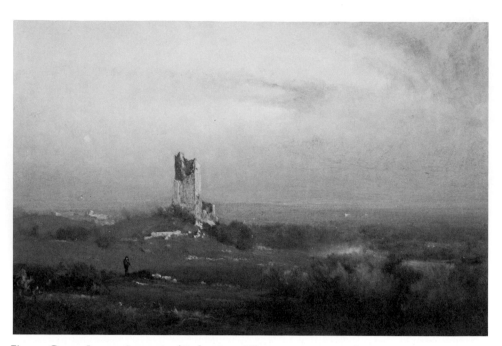

Fig. 19. George Inness. *Souvenir of Italy.* 1874. Oil on canvas. 20 × 30".
Collection of Boston University.

catacombs, certain to provide a "gothic" experience to anyone who descended into them. Those of San Callisto are the setting for the third and fourth chapters of Hawthorne's *Marble Faun:* "Subterranean Reminiscences" and "The Specter of the Catacomb." By reversing the chronology of his story, Hawthorne is able within a few pages to take the reader quickly from the heights of the Capitol, where his romance begins with a scene of superficial social chatter, underground into tomb chambers and the haunted mind of Miriam, his "dark" heroine. The party of artists

> went joyously down into that vast tomb, and wandered by torchlight through a sort of dream. . . . On either side were horizontal niches, where, if they held their torches closely, the shape of a human body was discernible in white ashes, into which the entire mortality of a man or woman had resolved itself. Among all this extinct dust, there might perchance be a thigh bone, which crumbled at a touch; or possibly a skull, grinning at its own wretched plight, as is the ugly and empty habit of the thing.[14]

Hilda and Donatello, Hawthorne's representatives respectively of Christian and pagan innocence, share a hate for this "dismal" place. Tombs and grinning skulls are alien to both Eden and Arcadia; it is the fallen Miriam who has led them into a place of death. But also foreign to their sunny sensibilities is Hawthorne's own evident delight in macabre humor, which is another sort of defense against the morbid, like the sentimentality of Howells.

Pagan tombs were usually preferred to the Christian catacombs by most nine-teenth-century writers. They excited more interest and their "associations" sug-

gested more heroic and congenial—and perhaps less chastening—thoughts than did the largely nameless martyrs, whose pious evocation usually made them seem merely pathetic and grim. In 1833 N. P. Willis worked up two equally conventional passages for the readers of the *New York Mirror*, but one is written with more evident enthusiasm. Of the niches in the Catacombs of St. Sebastian he says (in part):

> What food for thought is here, for one who finds more interest in the humble traces of the personal followers of Christ, who knew his face and had heard his voice, to all the splendid ruins of the works of the persecuting emperors of his time! . . . Of those that are left we saw one. The niche was closed by a thin slab of marble, through a crack of which the monk put his slender candle. We saw the skeleton as it had fallen from the flesh in decay, untouched, perhaps, since the time of Christ.

Willis does not necessarily include himself among those who find all this rich "food for thought." In contrast, while on an excursion in the summery weather of late March to the pagan Fountain of Egeria in the Campagna, he and his party stop at "the beautiful doric tomb of the Scipios" and refuse a boy's offer of candles to see the interior of "the damp cave from which the sarcophagi have been removed." They prefer to sit "upon a bank of grass opposite the chaste façade, and [recall] to memory the early-learnt history" of the Scipios. This time Willis clearly takes the stage himself:

> One feels . . . as if the improvisatore's inspiration was about him—the fancy draws, in such vivid colors, the scenes that have passed where he is standing. The bringing of the dead body of the conqueror of Africa from Rome, the passing of the funeral train beneath the portico, the noble mourners, the crowd of people, the eulogy of perhaps some poet or orator, whose name has descended to us—the air seems to speak.[15]

Silence and vacancy have been more satisfyingly overcome than at the dreary catacombs.

Beyond the catacombs is another monumental classical tomb even more popular than the Scipios'—that of Cecilia Metella—"'the wealthiest Roman's wife,'" as Willis identifies her, quoting Byron from his guidebook, and then adding the alternative, "according to Corinne," that Cecilia was his "unmarried daughter."[16] Tuckerman in his *Italian Sketch Book* quotes the appropriate passage about Cecilia from Byron, and then goes on for three whole pages of supplementary moralizing. He justifies this with words that might apply to the whole Campagna as well as to Cecilia Metella's tomb, since for most authors uncertainty as to the facts is sometimes a real convenience: "The obscurity which veils the history and character of her whose ashes it once contained, renders it, to one at all given to vague imaginings, more eloquent than if it were the concomitant of a more interesting and elaborate chronicle. . . . For free scope is thus given to a species of conjecture, which it is mournfully pleasing to indulge." Tuckerman's own "vague imaginings" see Cecilia as the Type of Woman in both of woman's roles—as daughter and as wife,

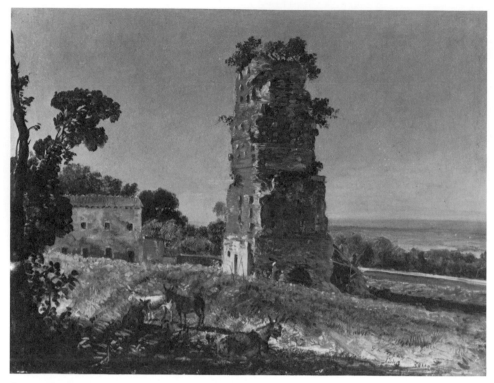

Fig. 20. George Loring Brown. *Ancient Tomb at the Entrance of Albano.*
1849. Oil on canvas. 10⅝ × 13⅝″. Herbert F. Johnson Museum of Art,
Cornell University.

commend her contribution in both capacities to the production of "that obsolete
and wonderful being, a Roman citizen!" and remind us of the main "lesson" to be
learned from the most ostentatious tomb of a person of uncertain identity: that of
"the rapid flight and levelling influence of time."[17]

Similarly Cooper, admitting that he can find in Cecilia's tomb "food for useful, as
well as agreeable reflection" upon the luxurious civilization of which this is a
significant product, observes that the mind "scarcely turns" at all to the wife of "a
mere triumvir, a *millionaire* of his day," except "to distrust her merits; for pure
virtue is seldom so obtrusive or pretending as may be inferred from this tomb.
Insignificance is ill advised in perpetuating itself in this manner."[18] But George
Hillard infers a different sentiment altogether, which shows how conveniently
blank were the tombs of the Campagna, even those inscribed with names. After
merely referring to the Christian catacombs as "much visited," Hillard commends
this tomb for having been "reared by the gentlest and purest of feelings—the
affection of a husband for the memory of a wife" (he wants no daughter to confuse
matters). He then moves on to an entire page celebrating the heroic classical figures
and tragic scenes with which one might fill one's mind's eye while strolling onward
along the Via Appia: Coriolanus, the Horatii, the Curiatii—what does it matter if
the scholarly German Niebuhr has established that they are mostly legendary?
They are essential to the beauty of the Way. But to lend some factual basis to one's

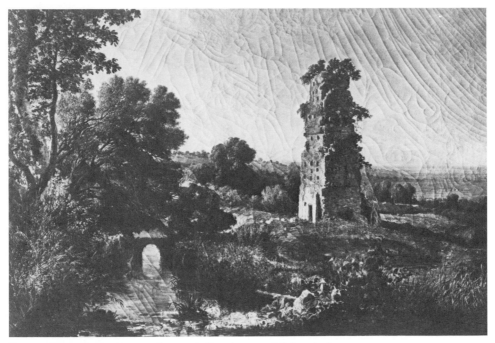

Fig. 21. George Loring Brown. *Pompey's Tomb*. 1850. Oil. Lee Anderson
Collection, New York City.

mournfully pleasant musings, Hillard does cite from Professor Nibby and from Sir
William Gell, who actually counted all the tombs.[19]

Cooper's approach to Rome had been from Naples through Albano. Impatient
with the slow *vetturino*, he had hastily swallowed his breakfast and "hurried on
alone." As he passed through a gateway, his first view of the Campagna opened
before him. "Such a moment can occur but once in a whole life," he wrote. "That
plain! Far and near it was a waste, treeless, almost shrubless, and with few buildings
besides ruins. Long broken lines of arches . . . and here and there a tower rendered
the solitude more eloquent."[20] An oil sketch by George Loring Brown of the so-
called Pompey's Tomb (fig. 20), which stands on the Via Appia just inside the gate
below Albano through which Cooper so eagerly passed, suggests the mute elo-
quence these tomb towers owed to historical and philosophical associations, and
made them effective subjects for the mute medium of painting that yet wished to be
poetic: even the greatest and wealthiest die, and even their monuments decay; their
culture is destroyed, and beautiful nature survives, by its unchanging action con-
verting all remnants of the past into symbols of time. For these ideas, in which the
age found a pleasing combination of the edifying and the sublime, Pompey's Tomb
is a more satisfactory wreck than Cecilia's, not only because she was merely
wealthy, but also because, ironically, one of the facts about her tomb, as George
Hillard noted, is that it is actually a "striking image of solidity and endurance. . . .
Time has not even brushed or roughened [its stones] in the lapse of nineteen
centuries, and the courses of masonry are as smooth and bright as on the day on
which they were laid."[21] Perhaps that is one reason it was relatively neglected by

artists, since nostalgia is not conveyed by an image of survival. And nostalgia is the purpose of these paintings. But whether the nostalgia is for a dead Republic, a vanished Empire, or a lost Arcadia is not always clear. For Brown's patrons, it was simply for "Italy."

Frequently the second component of the ruins-and-nature combination required a deliberate enlargement, as is evident in the finished painting Brown based on his sketch in oils (fig. 21). Here we see that an entire vale with water, bridge, and umbrageous trees has been imported from Claude Lorrain into the foreground, the tomb has been diminished, and the barren plain confined to a misty distance. This revision perfectly illustrates the competition between the complementary visions of the Campagna as wasteland or garden. Understandably, neither vanitas vanitatum nor memento mori was a preferred association for a "souvenir of Italy."

About two and a half miles beyond the Porta Maggiore on the west, along the tomb-bordered ancient Via Praenestina, there is another ruin whose associations are even vaguer than Cecilia's because it may have been either a tomb or a temple. Happily for artists, however, it had kept a striking form while becoming decidedly a ruin. Its site, moreover, related it to Campagna and hills most attractively. A landscape with ruins must be a landscape above all, and only the Colosseum managed to be both, but the Torre de' Schiavi (or Tor, or di, or dei, or de, or simply Slaves' Tower, depending upon the writer's or artist's Italian) was, after the Claudian aqueduct, the most popular ruin on the Campagna. It has now been engulfed and belittled by the expanded city and is entirely unknown to tourists and even to most Romans. Like the aqueducts, and unlike all the other ruins of the Campagna except the tomb of Cecilia Metella, the Torre has some formal interest of its own. The most prominent of a complex of ruins, it is architecturally related to the Pantheon. But in paintings it is invariably placed in its broad setting, the value of which for artists and other visitors is evident in a full-circle description by Hillard, worth quoting at length because it could serve as a topographical guide to paintings of the Torre de' Schiavi by Cole (1842), Cropsey (1849), Gifford (1862), Thomas H. Hotchkiss (1864), and Elihu Vedder (1868)—to name just some of the American artists—and also explicates familiar "Views from Tivoli," such as those by Cole and Gifford (fig. 22):

> But though these ruins are not much in themselves, they are so happily placed that they form a favourite subject for artists. They are on the circular summit of a beautiful elevation, and the ground about them slopes and falls away in softly-undulating curves and sweeps, the lines flowing into each other by gentle gradations, like the limbs of a marble Apollo. But the chief charm of the spot consists in the unrivalled beauty of the distant view which it commands; revealing, as it does, all the characteristic features of the Campagna. On the extreme left towers the solitary bulk of Soracte, a hermit mountain. . . . On the right, dividing it from the Sabine chain, is the narrow lateral valley of the Tiber; and further on, the horizon is walled up by the imposing range of the Sabine Hills, whose peaks, bold, pointed, and irregular, have the true mountain grandeur. . . . Conspicuous among them are Monte Gennaro, whose morning shadows fall upon the modest farm of Horace. . . .

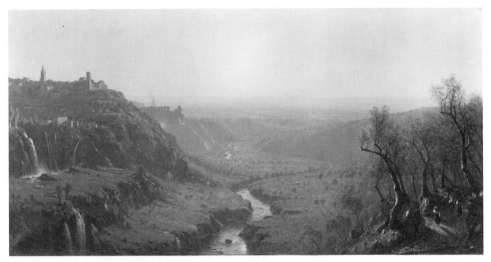

Fig. 22. Sanford Robinson Gifford. *Tivoli*. 1879. Oil on canvas. 26⅜ × 50⅜". The Metropolitan Museum of Art. Gift of Robert Gordon, 1912.

In the foreground, sparkling like a jewel on the giant's breast, is Tivoli, near which the headlong Anio breaks through its mountain gates and bounds into the Campagna. A very narrow plain divides the Sabine Hills from the Alban Mount, whose softer and gentler elevations present, as compared with the sterner and bolder line of the neighbouring range, a certain character of feminine beauty. Still turning to the right, the slopes of the Alban Mount pass into the level surface of the Campagna, along which the eye glides, till the plain blends with the shining mirror of the Mediterranean.[22]

As usual, Cole's painting of the Torre (fig. 23) is wholly unlike any of the others. He has placed the tower near the center of the picture and directly in front of the sun, so that it makes a dark silhouette that projects a pyramidal shadow forward to the lower frame. Subsidiary fragments cast rhythmic shadows into the vale. There are pink clouds in the luminous blue sky, and the Sabine hills are pale purple in the dawn. Cole alone relates himself to the tower in such a way as to allow light to pass directly through a perfectly round oculus high on the wall near the base of the shattered dome. Once more Cole, far removed from the scene where he made his drawings, is able to impose upon it his formulaic drama of light. The later artists are more concerned to paint the scene for its own sake, including the actual character of its light.

Hotchkiss's version (fig. 24) gains additional interest from the way he filled the vacancy of the foreground with arched openings into underground chambers and with an uncovered mosaic pavement of a boy on a dolphin. These are reminders that beneath the surface lie buried the remains of ancient civilizations, including marvelous treasures awaiting discovery. Maitland Armstrong, an artist who served as the American consul general in Rome for some years after 1870, tells how Hotchkiss, whom he has identified as the recently deceased young painter of a "first-rate" view of the Torre de' Schiavi, had actually found some Etruscan vases in a tomb in

Fig. 23. Thomas Cole. *Torre di Schiavi.* 1842. Oil on wood panel. 14¾ × 24″. Private collection. Photo courtesy Sotheby's-Parke-Bernet, New York City.

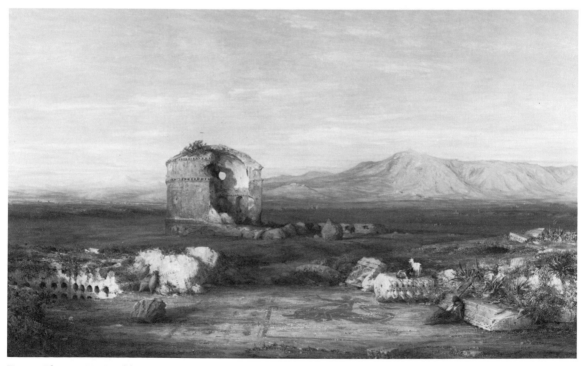

Fig. 24. Thomas H. Hotchkiss. *Torre di Schiavi.* 1865. Oil on canvas. 22⅜ × 34¾″. National Museum of American Art, Smithsonian Institution.

the Campagna. And when Armstrong himself was sketching the Torre, a mosaic pavement of peacocks was recovered.[23] This hidden realm is for the most part merely suggested by the fragments of columns and entablatures which in these paintings abundantly litter the landscape; but no matter how pleasingly beautiful the landscape becomes, as long as there are ruins, there are reminders of something that once was here and is no more. Recovery of further evidence about its existence became such a mania that practically the only exciting news from Rome that William Cullen Bryant had to report to his New York newspaper in March of 1858 concerned the growing "passion for excavation." Throngs of strangers and citizens alike were trooping out into the Campagna, where prostrate Jupiters, placid nymphs, and merry fauns awaited exhumation.[24]

But no matter how diligently archaeologists dug things up, or how luxuriantly Nature covered them over and pushed herself forward in their place, what one beheld remained fundamentally a vacancy suggesting lost plenitude. In *Art and Nature in Italy* (1882), the artist Eugene Benson sums up the image of the Campagna as wasteland: "Something ghostly, phantom-like, great, formless, vague, seems to be a presence by day and by night on the Campagna, oppressing the mind and filling it with melancholy disquiet. It is a homeless space of mighty memories. Fever and death here watch and slay through centuries of life."[25]

In Search of Arcadia

Realization of the Campagna's actual desolation stimulated the search for its opposite. Sometimes the competing images provide the drama within a painting or a passage of prose. The tension is evident, for instance, in two paintings of the Claudian aqueduct by George Inness (both 1858). Except that one is oval, the two are nearly identical, and in both Inness has given over half the space to a white, red-roofed dwelling surrounded and overarched by three distinct kinds of trees, all merging with a highly overgrown part of the aqueduct, the rest of which (the same fragments that we see in Cole's paintings), much diminished and constantly diminishing, reaches toward the Alban hills.[1] It is as though we are on the edge of a barren plain, at the last outpost of reclaimed shade and shelter; all beyond is ruin and waste (fig. 25). The same opposition between wasteland and shady home is evident in writers' descriptions of passages across the Campagna to Tivoli, Frascati, or Albano, where they reach an Arcadia beyond and above the historical desert of death. The most beautiful of these is one in which Eugene Benson records the sensations of a three-hour drive in the evening from Rome up to Lake Nemi. A point midway on the Campagna, and the arrival at Nemi, sufficiently indicate the psychic distance traveled:

> We have passed the old Via Latina, with a few tombs yet standing, but in ruin, and we are now in the midst of the wide waste and beauty and silence of the Roman Campagna, which surrounds Rome like a sea, fixed in everlasting rest. The fires of summer have scorched everything, and at this hour it is pale and gray. Close by us

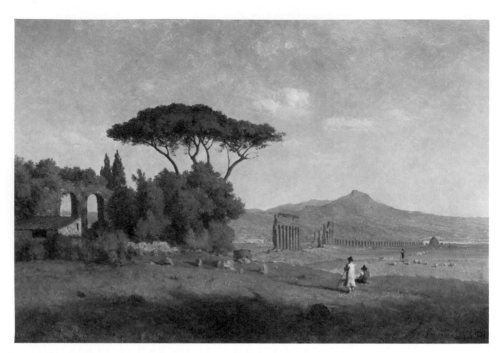

Fig. 25. George Inness. *Roman Campagna.* 1858. Oil on canvas. 20 × 30".
Collection of the New Britain Museum of American Art, Connecticut.
Charles F. Smith Fund.

we see the whitened and withered stalks of the asphodel. . . . The spectral moon rises above Monte Cavo.

. .

We drew rein at Gensano. . . . But within an hour we were at Nemi, having gone around the half-circle of the lake,—an old crater-mouth,—under luxuriant tasselled foliage of chestnut, and beech, and the darker leaved ilex; and on each side of the road we saw ivy of Bacchus, and jessmine, and clematis and honeysuckle vines, which here trail in tangled lavishness, lighted by the moon. The night-owl cried from depths of darkness across the lake, and then the solemn stillness of night seemed deepened. Could it be a fact that great Rome was but three hours away? We were now in the very bosky places of old mythology.

The purpose of this journey, which Benson now reveals, is also in harmony with an aspect of Theocritus, Vergil, and Ovid. Benson's companion, an aging abbé, orders a "good supper," and tells him that it was here that "I spent my 'honeymoon' with my friend. . . . Here we lived together, rode, walked, studied, and played. I must have two pictures—one of Nemi by daylight, the other by moonlight. Make your studies, get your impressions, my dear artist. There is but one Lake Nemi, a man is young but once, and the consecrated hours of our life should be perpetuated in some way." Benson gladly enters into "this novel enthusiasm and devotion of my delightful abbé," and he privately dedicates the commission to his own dead friend, the "poet-artist, Gifford," whose sunset view of Lake Nemi, rendered "in the very flush of his early manhood," was the first by him that he had ever seen. Gifford had painted

Fig. 26. George Inness. *A Bit of the Roman Aqueduct.* 1852. Oil on
canvas. 39 × 53¼". The High Museum of Art, Atlanta.

what they now beheld: the deadly plain below transformed by an "inundation of
light, where Campagna, sea, and sky seem to melt and faint into one vast harmony
of color. What we saw was worth the double enthusiasm of the priest and the
painter."

As they leave the hills the following night, they come to "the last lone, closed
farm-house, on the very edge of the Campagna, looking both deserted and haunted."
Beyond them rise up the "black arches of the Roman aqueduct" in "broken gran-
deur" and "gloomy pomp." Their "bones are not likely to be picked clean by the
archaeologists. . . . Here nature and time have their way with art." The idyll of
Nemi is over.[2]

The opposition between the desolate Campagna and the idyllic woods that we
see in the painting by Inness and the reminiscence of Benson is usually suppressed.
One of Inness's earliest Roman compositions is almost all trees (fig. 26). Someone
appropriately entitled it *A Bit of the Roman Aqueduct* (1852), since the "bit,"
hardly visible in the center distance, is nearly swallowed up by the improbably lush
greenery of a vale out of Claude. In the foreground is one of those ponds, such as did
exist in the springtime, into which have wandered four cattle of nicely diversified
colors—white, brown, and black—while their herdsmen lounge in the shade. To-
ward this extreme all the painters of the Campagna tended, and it is the one to
which the most popular artists adhered. For the general desire of artists and patrons
was not for the real thing, an emblem of historic desolation and death, but for a
vision of an idyllic Arcadia derived from Claude: it was with that vision that they

wished to fill the vacancy. And the effort required not only an emphasis on trees and water and a misty horizon but also the introduction of figures appropriate to the ideal scene. All knew well what it was all supposed to look like. The challenge was to create a plausible contemporary version.

N. P. Willis, in a remarkable paragraph describing his experience of the landscapes by Claude Lorrain, "famous through the world," in the Palazzo Doria in Rome (fig. 27), provides both a convenient catalog of the Claudean elements and their effects and an instance of how easy it was to cross the border between reality and dream:

> It is like roving through a paradise, to sit and look at them. His broad green lawns, his half-hidden temples, his life-like luxuriant trees, his fountains, his sunny streams—all flush into the eye like the bright opening of a Utopia, or some dream over a description from Boccaccio. It is what Italy might be in a golden age—her ruins rebuilt into the transparent air, her woods unprofaned, her people pastoral and refined, and every valley a landscape of Arcadia. I can conceive no higher pleasure for the imagination than to see a Claude in travelling through Italy. It is finding a home for one's more visionary fancies—those children of moonshine that one begets in a colder clime, but scarce dares acknowledge till he has seen them under a more congenial sky. More plainly, one does not know whether his abstract imaginations of pastoral life and scenery are not ridiculous and unreal, till he has seen one of these landscapes, and felt *steeped*, if I may use such a word, in the very loveliness which inspired the pencil of the painter. There he finds the pastures, the groves, the fairy structures, the clear waters, the straying groups, the whole delicious scenery, as bright as in his dreams, and he feels as if he should bless the artist for the liberty to acknowledge freely to himself the possibility of so beautiful a world.[3]

Although Willis says first that the Claudes are like "what Italy might be in a golden age," he ends by claiming that the "possibility" has been realized; the "abstract imaginations of pastoral life" are no longer "ridiculous and unreal" once one has seen the "very loveliness which inspired" Claude.

Claude's Italy (more than that of the Flemish artists who had preceded him) was always an ideal composition, although based on studies from nature in the Roman countryside. It was one flowering of the Renaissance love for the myth of the Golden Age, and in most of the landscapes the figures are from Greco-Roman mythology. These normally provided the painting with its title and theme. Among Americans of the nineteenth century, only Washington Allston included explicitly mythic figures in an ideal landscape, those in his *Diana and Her Nymphs in the Chase* (1805; Fogg Museum), a painting more Alpine than Alban. (Figure paintings with mythological subjects and landscape backgrounds—such as those by Vanderlyn and Vedder—are a different matter and are also uncommon.) Later painters, less close to the neoclassical age than Allston, made do with real country people, passing them off as dwellers in the Italian Arcadia. Allston himself, as we shall see, also preferred idealized human types to gods and nymphs.

Art historians often use a slightly dismissive term for such figures in a landscape,

Fig. 27. Claude Lorrain. *Landscape with Dancing Figures (The Mill).*
1648–49. Oil on canvas. 150 × 200 cm. Galleria Doria-Pamphili, Rome.

whether gods or peasants or St. John himself: *staffage,* a pseudo-French German
word that was imported into English by Bayard Taylor in 1872 while discussing a
ballad by Schiller. Staffage in a landscape is understood as an accessory figure to
indicate scale, to fill up a hole in the composition, to provide a desirable dab of color.
We know that many artists were impatient with them (or, like Cole, knew that they
drew figures badly). The Old Masters often employed assistants to paint them in, we
are told. But the arguments of authorities on the greatest of Renaissance landscap-
ists—Claude and Nicolas Poussin—that their landscapes usually take their very
form and meaning from the subject represented by the figures, seem to me persua-
sive.[4] Whatever may be the case with gods and nymphs, human beings in an Italian
landscape are not mere garnishment; they are certainly more essential than Indians
or woodsmen or artists in pictures of the Catskills or Niagara Falls. Even in the
works of a lesser artist like Jasper Cropsey, where they are often minute details that
clearly have not determined the basic composition of the landscape, they are nev-
ertheless the indispensable final touches. Patrons were right to demand their addi-
tion when the artists sometimes forgot the entire point: what one wanted to see in
the Arcadian version of the Campagna, and in Italy generally, was a perfect harmony
of nature and man. Nature in Italy might be sublime or beautiful; it might even have
turned some of man's works into ruins. Nevertheless, unlike the American land-
scape, without man it was not itself.
 The real pastoral life of the Campagna, and even the life of the peasants as

observed in their hill-town retreats, was anything but idyllic, and it was picturesque only when observed from a distance. Writer after writer refers to the towns as "squalid" and "miserable" and, like Hawthorne, contrasts them with the neat and industrious New England village. Taylor thought the people he encountered on the Campagna were "most degraded and ferocious-looking."[5] One is shocked to learn from tales told by Henry P. Leland, Maitland Armstrong, and James E. Freeman that pistols were a necessary part of the equipment for artists who sketched in the Campagna.[6] But it is George Hillard who supplies us with an extraordinarily valuable and comprehensive paragraph on the actual life of the Campagna:

> Of that life which takes root and is fixed permanently to the soil there is little or none in the Campagna. There are no cottages, with patches of garden-ground, and children sporting round the door; no spacious farm-houses; no sights and sounds of rural toil. The figures which are indigenous to the soil are a few shepherds with cloaks of sheepskin, attended by suspicious-looking dogs of dirty white, and, here and there, a mounted herdsman, or overseer, armed with a long lance, whose locks and cloak stream back upon the wind as he rides, and whose figure, relieved against the distant sky, suggests that of a Bedouin Arab. But, in general, the living forms are only those which are connected, directly or indirectly, with the neighbouring city—an artist with his sketchbook; a fowler shooting birds for the market; a party of equestrians whose fresh complexions and firm seat betray their northern origin; a peasant from Belletri or Gensano driving a cart laden with wine-casks; a ponderous wain drawn by gray oxen; a tumble-down and ague-stricken vettura, abound for Albano or Tivoli, crammed with life like the hold of a slave-ship; and, occasionally, the smart barouche of an English millionaire, or the heavy chocolate-coloured coach of a cardinal, perhaps drawn up by the side of a road, while its owner, in his red stockings, is solemnly pacing up and down, taking exercise.[7]

Very little even of this transitory life of the Campagna is evident in the paintings of it. The artists almost always selected their figures to imply an indigenous pastoral life that conformed to the conventions of what such a life would consist of, as modified by nineteenth-century morality. There would be no impassioned shepherds (let alone aroused satyrs) and no naked nymphs. At the same time, the figures *are* selected from an idealized reality; they are not mythological or even merely imaginary.

The painting that comes closest to suggesting that the Campagna could be seen as something other than either wasteland or idyllic garden is John Gadsby Chapman's *Harvesters on the Roman Campagna*, which exists in at least three versions executed in the late 1860s when, after the Civil War, American tourists began returning to Rome. The earliest and perhaps largest is that at Yale (fig. 28). Remarkably for an Italian landscape, it shows people actively working, engaged not in the pastoral life but in an agricultural exercise unknown to the Golden Age. Chapman, whose most famous painting is *The Baptism of Pocahontas* in the Rotunda of the Capitol in Washington, had been America's most successful illustrator before returning to Rome in 1849, where he preferred subsistence living catering to the tourist trade over prosperity in New York.[8] As an experienced figure painter, he did

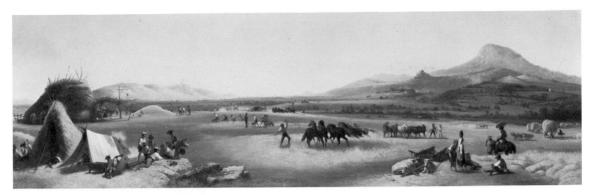

Fig. 28. John Gadsby Chapman. *Harvesters on the Roman Campagna.*
1867. Oil on canvas. 29½ × 71½". Yale University Art Gallery. Gift of
Senator H. John Heinz III, B.A., 1960. (See plate 3.)

genre as well as landscape paintings, and the types are combined in the painting of
the Campagna. Its interest arises equally from the deep extension of the wheat field
to a graceful line of hills beneath an atmospheric sky, and from the variety of
activity in the several groups of clearly contemporary workers (trousered and hat-
ted) in the foreground and middleground, surrounded by their haystacks, tents,
wagons, and other equipment. Of greatest interest, however, and therefore centrally
located, is the primitive image of the man driving horses in a great circle, the actual
means of threshing wheat still employed. Although contemporary, it is the appar-
ently timeless character of the scene that provides its strongest appeal. In his *Book
of the Artists,* Tuckerman quotes a letter from Rome describing Chapman's studio,
where this painting then appeared " 'full of bright light and life, and of the expres-
sion of Italian customs and character centuries behind the age.' "[9] Eugene Benson
describes an actual scene of this type, and in effect Chapman's painting:

> The Campagna is now blond and coppery in color. The vast spaces once covered
> with waving grass and grain are but scorched stubble. The harvesters have done
> their work. Here and there cut wheat is laid in great circles to be beaten out by the
> hoofs of horses. This primitive mode of threshing, very beautiful and inspiriting to
> look at, is still kept up by the cultivators of these great tracts of land. It is already
> sunset. A light breeze blows over the vast spaces of the Campagna. . . . The hills in
> front of us are violet-tinted, dreamlike, and fall in caressing lines of tenderest grace
> to the level of the Campagna. Far to the north the couchant shape of lone Soracte,
> isolated from the cortege of mountains which makes the confines of this amphi-
> theatre of history, is seen in the tender light of a Roman summer evening.[10]

Undoubtedly this is the mood in which one was to regard Chapman's painting; even
the historical sense suggested by the fallen column in the foreground is not here a
melancholy reminder of death but rather an image of the past that is wholly
positive, since it indicates the permanence of the fundamental agricultural life
symbolized by the threshing of the wheat. It *is* "beautiful and inspiriting *to look at.*"
But what was it like for the *contadini?*

Once more we are indebted to Hillard, this time for a chapter almost unique in
American travel books of the period: a discussion of the actual agricultural condi-

tions of the Campagna, based on research in German, French, and Italian authorities. Others—such as Catherine Maria Sedgwick and William Wetmore Story—briefly mar their verbal paintings of a lovely pastoral Campagna by mentioning the misery and injustice of peasant life, but only the lawyerly Hillard allows the full reality to overwhelm the dream. After concluding one chapter with a rhetorically inflated section called "Walks on the Campagna" (such walks are said to be like listening to Schubert or Beethoven), Hillard begins a new chapter by asserting that "we have no right to look upon a landscape only as a picture, or to view it merely as a harvest-field for dreamy emotions or fine visions." The most important considerations for someone gazing from an elevated prospect concern "the relation of humanity to the soil": "For whom are those golden harvests waving? . . . Does this fair landscape support a manly, an intelligent, a virtuous people? or does it yield a miserable pittance to a population wasted by hopeless toil and paralyzed by poverty? . . . Has some enormous capitalist spread his title-deeds over the whole horizon, or is the soil divided into modest proprietorships?"

Although Vergil's First Eclogue actually concerns the entitlement of shepherds to their farms in Arcadia, in the sentimentalized pastoralism of the nineteenth century one is surprised to come upon such questions. After an extensive comparison between Rome and Boston with respect to the interdependency of city and suburbs, Hillard (with one eye on America) launches into the causes for the decline and fall of the Roman Campagna. They begin far back in the Republic and are inseparable from those that led to Empire and imperial corruption. Specifically, "they are to be found in the grasping spirit of the favoured classes; . . . and in the prevalence of a system by which enormous estates were gathered into a few hands." Left "untilled and unoccupied," the Campagna was already desolate in the days of Cicero and Livy; the barbarians of the Middle Ages merely completed its conversion into a wasteland. At the Renaissance, "the Campagna did not share in the general resurrection. Nor has it since been waked into life." Why not? Because vast capitalistic tracts, largely used for grazing rather than for growing of crops, are more profitable than would be the small farms that alone guarantee both the larger social happiness and a healthful soil. Prince Borghese owns fifty thousand acres, St. Peter's Corporation, forty-five thousand, and the Hospital of Santo Spirito, thirty-two thousand, and all these are monopolized by the middlemen, the Mercanti di Campagna.[11]

Who then are these people we see harvesting the cultivated tracts of the Campagna? They are the poor from the hills, especially from the Abruzzo. With their "variety of costumes" and "the vivacity of their movements," they may make a "striking and attractive spectacle," but they are doomed to an early death:

> As a general rule, the harvest-labourers have no shelter provided for them, but upon the very spot of their daily toils they throw themselves down for their nightly repose, their frames bathed in perspiration, and exhausted with the fatigues of the day. Then the chill winds and heavy dews which so often succeed the burning heats of the sun fall upon them with silent, deadly power, and the poison of fever passes into their veins. Each day the number of healthy and able-bodied is dimin-

ished, and, when their task is done and they have received their wages, many have no more strength than enables them to crawl home and die at their own doors.

By the end of the harvest, only half would still be alive. "Such are the cruel and heartless results which ensue, when men act wholly upon the principle that property has rights, and forget that it has also its duties. The beauty of the Campagna . . . is turned to ashes."[12]

In a letter responding to a request from one of his Boston patrons for an explanation of the action in *Harvesters*, Chapman remarks in passing that the workers were mostly boys who received ten cents a day and were always available.[13] The economic reality is not suggested by his painting, which one sees with different eyes after reading Hillard.

Hillard concludes that to convert this wasteland into the Arcadia it might be, the efforts of some well-intentioned popes are insufficient. Someone combining the iron will of a Napoleon with the benevolence of an Oberlin is required. But "that such a man should spring from the exhausted soil of Rome" would be as miraculous as for an angel to descend and "in a single night cover the Campagna with smiling villages and a vigorous population." The comparison with America becomes explicit. Such a "fertile and sickly" region in our own country would be "but a brief obstacle" to the westward advance. Not only has Hillard turned the Roman Arcadia to ashes; he now inverts the very moral conventionally found in its character as a wasteland. For whereas many professed to find the triumph of nature over artificial man, as represented in the Campagna, a beautiful idea, Hillard now asserts the glory of the reverse process: in the conquest of such a region, "man would triumph at last over nature." The true Arcadia is man's achievement, but it is only possible "to the boundless energies of a young democracy like ours."[14]

Few subjected the country life of Rome to such a critique, and, of course, there was little motive to do so. There was no question of disillusionment, because most were conscious of the purely aesthetic character of their ideal to begin with. They sought and wanted only an Arcadia of art or else believed that as a necessity of history the Golden Age was in the future and the "real" Arcadia was in the West. The poetaster, minor painter, and gregarious host Thomas Buchanan Read lived many years in Rome and joined William Ellery Channing the Younger, S. Weir Mitchell, and countless others in writing stupefying poems on the Campagna that give one an entirely new sense of its vacuity. But when he wished to challenge Longfellow if not Vergil in ambitious song, he set his interminable and unreadable poems called *The New Pastoral* (1855) and *Sylvia, or, The Last Shepherd: An Eclogue* (1857) in his native Pennsylvania, making the most of the etymology of that commonwealth's name. The first of these, sung on an "oaten pipe" in Florence in 1854 (while Whitman was writing his *Leaves of Grass* in New York), celebrates the "worthiest theme" from Maeonides to Milton: rural life. From caves of the Susquehanna, "shy nymphs" sing of "that middle life, between the hut and the palace," while a procession of great figures (including Christ) gives blessings on the West. It goes on for thirty-six books. Read returned to American and served in the Civil War on the

staff of the general who would write *Ben-Hur*. He rose briefly to the epic strain in "Sheridan's Ride" (in both verse and paint), and then returned to Rome for the remainder of his life. He loved Italy, but it was not for the rural "middle life" that he lived there.

Arcadia was—or had briefly been—in America if anywhere, but writers nevertheless frequently expressed their pleasure in coming momentarily upon Arcadian scenes in the actuality of present-day Italy: contadini disporting themselves according to the visual and musical conventions of pastoralism. At Viterbo, north of Rome, Willis and his companion

> a half hour before daylight, . . . heard music in the street, and looking out at the door, we saw a long procession of young girls, dressed with flowers in their hair, and each playing a kind of cymbal, and half dancing as she went along. Three or four at the head of the procession sung a kind of verse, and the rest joined in a short merry chorus at intervals. It was more like a train of Corybantes than anything I had seen. . . . They were going out to pluck the last grapes. . . . The whole thing was poetical, and in keeping, for Italy.[15]

What was "in keeping, for Italy" also was for it to be the occasion for the discovery of an aesthetic, psychological, and spiritual ideal, an inward Arcadia. Five particular regions of the mind and senses, regions both found and created by three artists and two writers, we may now explore.

Meditation and Dance: Thomas Cole

As Vergil introduced Theocritean pastoral into Roman poetry, so Cole had the honor of being the "parent of true idyl" in American painting. This was the claim of his pastor, friend, and biographer, Louis Legrand Noble. By "true idyl" Noble does not mean just any pleasant landscape to which men and animals are mere accessories but "those in which they are in such wise actors, that the landscape has, at least, a moral subordination; when all conspires to tell a story, and that a story of rustic life and manners."[1] A "sylvan scene, all American,"[2] showing leisurely human activity or unstressful labor, such as Cole renders in the late works *The Pic-nic* (1846; Brooklyn Museum) and *Home in the Woods* (1847; Reynolda House, Winston-Salem, N.C.), does not seem to belong to this category, although paintings like these, which adapt two aspects of Arcadia to the American reality, might be considered more interesting than the one Noble actually discusses as an example of what he means by the pastoral idyl: the *Dream of Arcadia* of 1838 (fig. 33). This work represents the extreme simplification not only of the pastoral tradition but even of Cole's own thinking about it. It belongs with other "imaginary" or "ideal" paintings related to Cole's study of Claude Lorrain and Nicolas Poussin and to his experience of the Campagna: *Landscape Composition, Italian Scenery* (1833; fig. 29); *The Arcadian or Pastoral State* (1836; fig. 30); and *L'Allegro* (1845; fig. 32). All of these except the *Dream* aspire—through internal oppositions or external dependency and

Fig. 29. Thomas Cole. *Landscape Composition, Italian Scenery.* 1832.
Oil on canvas. 37½ × 54¼". Courtesy New-York Historical Society, New
York City. (See plate 4.)

reference—to a complexity of concept that is at least dualistic. The *Dream*, in
contrast, is as bourgeois parlor art the equivalent to Victorian verse for ladies and
gentlemen. Obviously, that is not what Theocritus invented, what Vergil and Ovid
adapted for Rome, or what Poussin painted for Cardinal Richelieu. Cole not only
gave birth to serious pastoral painting of this sort in America; he also buried it. The
direct line of descent was simultaneously taking its last gasps in France with Ingres's
less complete compromises, but it is worthwhile to observe separately its brief
florescence in this group of works by Cole.

The *Landscape Composition* (fig. 29) is the most comprehensive assemblage of
Italian motifs among Cole's works, and it partially combines the two opposing
visions of the Campagna. Across the center, the broad, sunny vacancy of the plains
reaches to the sea beneath an overarching sky. In the lower half of the canvas is a
clutter of ruins: to the left a version of Tivoli's Temple of the Sybil (half-filled with
earth and overgrown with greenery), in the shadowed center the ivied brick arch of a
collapsed viaduct, to the right a long broken stretch of the aqueduct (improbably
located), and in the foreground the marble fragments of a ruined building. But a
noble stone pine, tall and straight, ascends the canvas from bottom to top at the
extreme left, superimposing itself upon the ruined temple, while a series of three

Fig. 30. Thomas Cole. *The Course of Empire: The Arcadian or Pastoral State.* 1836. Oil on canvas. 39¼ × 63¼". Courtesy New-York Historical Society, New York City.

more distant pines steps gracefully down to a silvery lake. Intense varieties of green in the lower quarter of the painting contrast with the brownish tones of the plain beyond. In the lower left-hand corner a goat (such a goat practically serves as a signature in Cole's more topographical Italianate landscapes) rests in the shade of the tall pine. On the path that curves gracefully down among splendid trees, we see a couple walking along, and a small white sail is visible on the placid lake. But the important human figures are in two foreground areas shaped and illuminated like little stages, one round and one rectangular. They are the sunlit base angles of a triangle that peaks in the tower-pointed bluff thrusting up over the lake at the center of the canvas, the only other broad area in the lower half that is in full sunlight. From this bright center of bluff and tower the eye may move diagonally down across the line of trees to a scene on the left where a brightly costumed peasant couple lift arms and legs in dance to the rhythm of another woman's high-held tambourine. Or, alternatively, the eye moves diagonally down to the right along the shoulder of the bluff to a bright spot of red and white: a cloak thrown over the stump of a column against which a youth leans as he sits and meditates, his image reflected in a small pool of water beside him. The horizontal line that links these balanced images of dance and meditation is made up of marble architectural fragments, which do not fully connect, and a continuous margin of green grass that begins precisely at the youth's extended leg and flows to the left where it broadens into the circular turf of the dancers.

 Landscape Composition is thus twice divided thematically in the lower half

Fig. 31. Thomas Cole. *The Course of Empire: Desolation.* 1836. Oil on canvas. 39½ × 61". Courtesy New-York Historical Society, New York City.

(beneath the sky): horizontally between an upper band of brownish desert Campagna with monumental ruins, and a lower swath of Arcadian green that on the left, with lake and pine, is overcoming the wasteland world; and vertically between the two Arcadian activities of meditation and dance. These two activities as well as some of the same architectural motifs (especially the Tivoli temple) are repeated in painting after painting not only by Cole but by many others. In a collapsed world, the people are happy, without being stupid. No one does anything that might be called work; there are contented cows and goats about, with plenty of grass to graze on, and water always nearby. Nature—the trees and grass and water—is in fact repossessing the world; it is returning man also to his "natural" state. It is as though a humanity both joyful and thoughtful had reentered the scene of *Desolation* that concludes Cole's *Course of Empire* (fig. 31) and found themselves with no less reason to dance than if there had been no past—no *Consummation* and no *Destruction.* Perhaps there is *more* reason; for they seem to have reached a changeless condition: there is no ambiguous sense of *emergence* as there is in Cole's Druidic *Pastoral State* (fig. 30)—the first signs of abstract knowledge (the Pythagorean old man drawing symbols on the ground) and of violence (hunters, and the man with shield and spear). The only possible change suggested by the *Landscape Composition* is further slow decay of what has already become irrelevant to natural life. What the youth can contemplate is what no one in *The Pastoral State* could yet have had reason to know: the lessons of history about the vanity of man's strivings and artificial achievements; it is upon an emblem of these that he rests. The

93

Apollonian attitude is here limited to rational reflection (the pool in which sky and man and compact fluted column reappear is a neatly rectilinear corner of a ruin), while its Dionysian complement (expressed in the irregular circle of greenery associated with the attendant goat and the vine growths on the tree trunk) consists of vigorous but clearly innocent dance. Both intellectually constructive striving and sexual abandon are of the past.

While painting *The Course of Empire* in 1835–36 Cole married and—in consistency with his epic's message—turned his back on the burgeoning harbor metropolis of the Empire State to settle permanently in the rural serenity of Catskill. The famous series, his biographer tells us, had its beginning in its end: the final painting was inspired by the "melancholy desolation" of the Campagna Romana while Cole sat upon a ruined column at sunset after a long walk in 1832.[3] In the entirely unpeopled last scene, the viewer is himself left in meditation, forced to compare what he sees with the four successive images of the same place at earlier periods. Of the two stages that compete as ideals, the *Arcadian or Pastoral State* and *Consummation* (fig. 12), in the earlier we can find the most conspicuous activities of the *Landscape Composition* presented as two among a variety that receive equal stress. In contrast to the balanced thematic design of the earlier composition, a planned randomness of human imagery suggesting multiple and contradictory potentialities characterizes the *Pastoral State*—since, contrary to the usual conception of Arcadia as a timeless place, here it is forced into a narrative and therefore temporal framework. Like all of the other "states" through which the Empire passes except the last, it is necessarily unstable. The very conception of Arcadia as an image of nascent empire is paradoxical. But the old man here does not meditate upon a past, personal or cultural; he externalizes an abstract thought that will lead to intellectual pride and to the artful structures of *The Consummation*. The shepherd with his flock at the center is upstaged by the boy in the foreground below him whose inquisitive posture echoes that of the old man. Descendants of the lightly garlanded couple who dance to the music of the flute player at the extreme right will be among the gesticulating horde that thrills to the blare of trumpets as it raises laurel wreaths to the imperial hero in his triumph. Only after long search does one find in *The Consummation* one or two figures engaged in reflective thought.

In 1845 Cole separated the two Arcadian activities of meditation and dance into a pair of paintings with the Miltonic titles *L'Allegro* (fig. 32) and *Il Penseroso*. They are his last completed pair of paintings of the several accomplished and others projected. Cole was attracted by narrative sequences and thematic pairs as a way to transcend the limitations of his static medium. Claude, too, was fond of pairing, and Marcel Röthlisberger states that nearly half of his oeuvre consists of paintings that have their individual integrity but assume their "full meaning only in connection with a pendant."[4] It is not known whether Cole perceived this; Claude's pairings depend upon subtler and deeper unities of content and form. His complementary use of morning and evening light, of mirrored disposition of middleground trees in relation to the opening onto background hills or harbor, and a reversing of the curving line that leads from foreground to background—all contribute to a more complex development of the relation between the paired subjects than is ever the case with Cole. Subtlety of idea and statement was seldom to Cole's purpose,

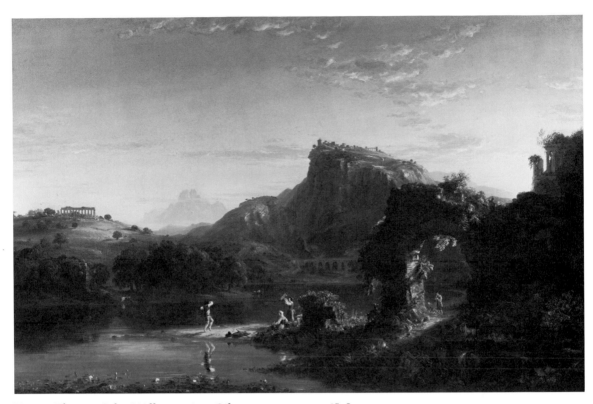

Fig. 32. Thomas Cole. *L'Allegro*. 1845. Oil on canvas. 32 × 48". Los Angeles County Museum of Art. Gift of the Art Museum Council and the Michael J. Connell Foundation. (See plate 5.)

although "reading" his paintings completely requires some care and time. Cole unquestionably intended his paintings to be read thematically, the "fineness of color" (like all other technical elements of his art) being merely "means" to the poetic "end."[5] Among American writers, Cole's admirer James Fenimore Cooper is a directly parallel case. That is what allows Cooper to state that as "a mere artist" Claude surpassed Cole, but "as a poet, Cole was as much before Claude as Shakespeare is before Pope."[6] As a poet, however, Cole tended to think in simple conceptual dualities. Thus within single, unpaired "ideal" paintings from *The Expulsion from the Garden of Eden* (1827–28) on, drastic contraries present a world of absolutes in which there are few moral or emotional gradations. There may be—as there is in Milton—some sense of ambivalence toward the erupting, passionate, and dangerous world from which we look back into the placid lost Garden, but there is no feeling that the two could be reconciled.

In the pair of paintings that alludes to Milton's early pair of highly Italianate poems, *L'Allegro* and *Il Penseroso*, most of the thematic motifs of *Landscape Composition, Italian Scenery* were redistributed and modified. Just after finishing "a view of the Campagna di Roma" in 1844, Cole proposed the pair in a letter to a patron: "In the first, I should present a sunny luxuriant landscape, with figures engaged in gay pastimes or pleasant occupation. In the second, I would represent

some ivy clad ruin in the solemn twilight, with a solitary figure musing amid the decaying grandeur around. I hope the subject will suit your taste, for it is one on which I can work con amore." *Il Penseroso* departed further from this projection than did the first painting. Noble describes it as a view of "Lake Nemi after sunset— expressive of the tender, pensive spirit of the hour, and the pleasing loneliness of shadowy woods and waters."[7] But Tuckerman's description better reflects Cole's shift from the merely pensive pleasures in the earlier part of Milton's poem to the religious emphasis of its conclusion, which encouraged an iconography more medi- eval and romantic than pagan and philosophical: "The shores rise abruptly to a great height, and are covered with dense and shadowy foliage. A dash of Salvator's gloom broods over the scene, and an ancient shrine, before which a single peasant kneels, increases the religious solemnity of the landscape."[8]

Indeed, the rediscovered painting now identified as *Il Penseroso* and reunited with *L'Allegro* in Los Angeles[9] depicts a prostrate religiosity wholly foreign to Milton's poem. Similarly, *L'Allegro* nearly reduces Milton's companion lyric to the single injunction to Mirth that has become most hackneyed: "Come, and trip it as you go / On the light fantastic toe" (lines 33–34). Milton later includes as images of Mirth the nighttime stories told by people in "upland Hamlets" and the activities of bustling dwellers in "towered cities," activities that include theatergoing and lis- tening to sophisticated music: "soft Lydian airs / Married to immortal verse" (lines 136–37). Such activities would not have appealed to Cole in Catskill; he inevitably represented *L'Allegro* by rustic dance. What is more interesting is that *within* this painting there is also an image of one form of meditation, and the "pleasant occupa- tion" that Cole thought of to accompany the "gay pastime" was not that of the whistling plowman or singing milkmaid mentioned by Milton but the one that corresponds to the activity of the poet: that of the artist. The place of the contempla- tive youth in *Landscape Composition* is now taken by a painter who ignores the ruined arch that enframes him, choosing rather to paint a genre scene of the dancing peasant, who is the one here reflected in water—thus completing a neat man-art- nature reiteration of the image of Mirth. Tuckerman suggests that the "picturesque ruins" in this painting that otherwise "sparkles with the buoyant nature of Par- thenope" are meant to remind us that there are " 'finer issues.' "[10] They seem to me rather to reflect the consciousness in Milton's poem that the experience of "heart- easing Mirth" is the result of choice and a willed effort which begins with the rejection of "loathed Melancholy." This is the choice that the artist in the painting has made.

Duality and difficulty are what Cole had set aside when he painted (apparently three times) his *Dream of Arcadia* (fig. 33) in 1838. Explicitly calling it a "dream" was perhaps the excuse for the unrelieved fantasy of this painting. Here there are no contemporary Italian peasants cavorting among ruins, and there are no ruins—only a happy pastoral vale reached by a solid stone bridge and overlooked by a pristine and anachronistic Greek temple (if it is possible to speak of anachronism in what is timeless and a dream; and was it anachronistic for Cole to submit that year a design in the same Doric style for the state house in Columbus, Ohio?). The people, dressed in the simple clothes of antiquity with much exposure of leg and arm and shoulder, serenely do as they please, and what they do is peaceful: they lounge in the shade of

an avenue of ilex trees, they tap on tambourines and play their pipes and dance with garlands of flowers in front of a Pan-herm. On the opposite side is a cascade of white water which descends into a placid stream where children safely wade. Near the center a mother fondles her babe. There is birth and growth, but no death. No storm-blasted trees disfigure the sky or sprawl their rotting trunks across the foreground. There are cattle, sheep, goats, and dogs in abundance and in close relation to man. Two men ride by on noble horses, but they do not seem to be warriors. Up at the temple, against a backdrop of Olympian heights, the gods are being worshiped. Here there is neither emergence nor decay; somehow the bridge, the temple, and the town were built, but no one earns his bread by the sweat of his brow. Sequence and history are unknown; there is only an eternal present.

"Arcadia" is the ideal of a changeless, timeless place. Yet, like everything else, it reflects the time and place in which it is reconceived. When Cole saw the paintings by Nicolas Poussin in the Louvre for the first time in 1841, he wrote with the greatest admiration: "You are always transported by him from the present into the past: you are in Judea or Arcadia: you live in a world—in a time, far removed from this." But one wonders how he could have recognized Arcadia in Poussin from his dream of it three years before. Even in London much earlier, or through reproductions, he must already have known Poussin's early bacchanals and triumphs of Flora and of Pan. The herm in profile in his own *Dream of Arcadia* is like that in *The Kingdom of Flora* (1631; Dresden) and other paintings, but with its beflowered genitalia removed. This mutilation is the more serious in that Pan, the great god of Arcadia, god of gardens and fertility, is identifiable as Priapus when his image is hung with floral wreaths, as it is by Cole.[11]

But Arcadia as a park for genteel peasants is diametrically opposed in every respect to the mythological place of passionate abandon depicted by Poussin. This is true even of relatively "innocent" scenes such as the *Bacchanal before a Herm* (1635?; fig. 34), where the playful turmoil around the satyr on the right, the totally nude male dancing in the center, and the gross-looking infants eagerly grasping for grapes on the left give one plenty to think about. It is even more true of those paintings deeply informed by Ovidian mythology, in which Ajax falls upon his sword beneath the herm, Narcissus gazes forever at himself, and flowers are never merely flowers. Poussin abandoned these fleshy subjects for the classic landscapes that Cole admired and became, as Cole said, "chaste." But Cole, always chaste, made his Arcadia so. Try to align Cole's *Dream of Arcadia* with this description by Professor Harry Levin of Jacopo Zucchi's *O belli anni d'oro*, which Cole must have seen in the Uffizi: "The vista extends from the horticultural foreground to a craggy hill which rises steeply in the distance. At every level the garlanded nudes are enjoying their idleness: dancing, bathing, playing, fondling one another, plucking flowers, gathering their spontaneous nutriment. Two *putti*, male and female, are urinating down stream."[12] The landscape remains the same, but the people behave differently. Of Zucchi's painting of the Golden Age, Nathaniel Hawthorne said that "the charms of youths and virgins are depicted with a freedom that the Iron Age can hardly bear to look at."[13]

What the present age required becomes fully apparent when we look at Cole's painting with the eyes of the Reverend Louis Legrand Noble, who tells us all about

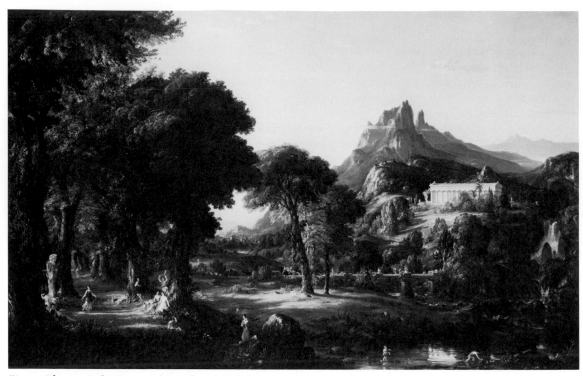

Fig. 33. Thomas Cole. *Dream of Arcadia.* 1838. Oil on canvas. 38¾ × 63".
Courtesy Denver Art Museum.

the humanity in Cole's Victorian Arcadia. Surprisingly, the *Dream of Arcadia*
provoked the longest analysis written by Noble himself (rather than quoted) of any
painting discussed in his book. Evidently he felt that this most explicitly pagan
subject, standing in isolation from any moral narrative, most required interpreta-
tion. The excesses in Noble's several remarkable pages[14] of "pastoral" prose ("pas-
toral" in two senses) should not be blamed on Cole, yet it is arguable that Noble
found the true verbal equivalents for the images and mood of Cole's painting. The
scene is "happily laid in a vale"—rather than at sea or on a mountaintop—since
there we more readily "sink into the embraces of nature." An oblique acknowledg-
ment of pagan mythology is made through the anthropomorphic description of the
natural scene that takes almost two pages. Whereas Cole's painting is merely filled
with light, in Poussin's *Kingdom of Flora* an embodied Apollo soars brilliantly
overhead in his chariot pulled by four horses. But the meaning is the same. Noble
writes: "Earth and atmosphere proclaim that we are on the track of the king of day
in glorious progress. Everything visible seems to have been trampled with a golden
magnificence, and rolled with the wheels of a glowing splendor." The metaphor
remains, but the god—no longer literally shown—cannot be named. Also, "dew-
footed evening will presently steal in for vespers" beneath the "far-reaching arches"
of the trees on the left, "barely twice the flight of an arrow" from where we stand
cooling our feet in the foreground stream. The viewer has entered the picture as a
barefooted Arcadian archer, but he is only dimly aware that Venus as Hesperus, the

98

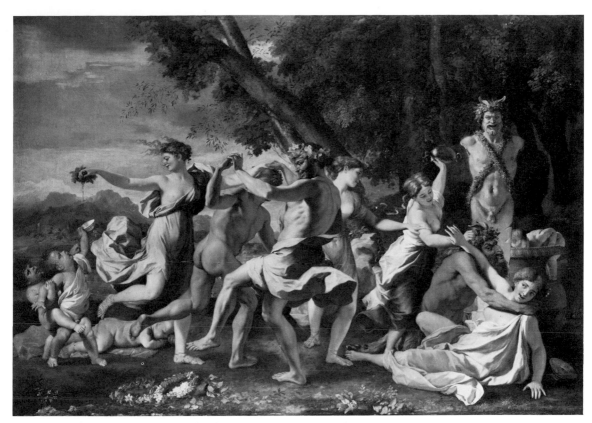

Fig. 34. Nicolas Poussin. *Bacchanal before a Herm.* 1638–39. Oil on
canvas. 0.99 × 1.42 m. The National Gallery, London.

evening star, lurks behind the Christianized "vespers" beneath the "arches." No-
ble's idea of Cole's vision is explicitly infantile, for this vale is the "most luxurious
cradle in which Earth, humming her loving lullaby, rocks the new-born June"
(Juno). Such personification without the force of literal, visualized myth is perva-
sive: "Life and gladness leap and bound about, but ever spring into the embrace of
shadowy repose. Night has sprung her invisible net. . . . Life, joy, and beauty strug-
gle in the dreamy meshes." In Cole's Arcadia, all Poussinesque leaping, bounding,
and struggling are neutralized by repose and dream.

Nature so conceived suggests of itself, says Noble, "the spirit of a pastoral, . . .
[the] happy passages of rural life": "Were there no breathing creature in view, we
should unavoidably feel ourselves looking upon a land in which there must be, at
that instant, hundreds of sheep, shepherds, and peasants, living, loving, and enjoy-
ing." Cole, however, has supplied the humanity as well, though not quite by the
"hundreds." The manner in which he has made the "great central thought" of the
interpenetration of nature and humanity shed "over all a moral radiance" makes the
work "a simple harmonious creation," and proves its maker "both the Artist and
the Poet." In a detailed verbal "reproduction" of humanity and its animals within
the landscape, Noble illustrates his meaning. The "fleecy creatures lie down in their
whiteness, bedded in yielding verdure," while the "full-fed cattle" as they drink are

"breathing balm upon the dimply element." Half a page is given to the "honeyed sensations" of the "drowsy rustic" who lies "within . . . a kid's-cry" in the middle distance, at the foot of a pine tree, where he might be entirely overlooked by a more casual viewer than Noble. Among other things—all specified—that occupy the rustic's mind in a life of smelling, seeing, and hearing is the "breathing and ever-busy chewing of his full-uddered charge," the goats who "ruminate" nearby. The mother in the foreground "finds pleasure less in the loveliness of things, than in the freedom and sportiveness of her children." They, according to their respective girlish or boyish natures, repose upon the "lap of the blossomy bank" or brave the water.

Finally Noble faces up to the challenge of the left-hand side of the painting: "The heart of the picture . . . beats in the breast of the great grove. . . . One could search there for memorials of the fortunate Tityrus," he says. Choosing to forget that Tityrus (in Vergil's First Eclogue) filled the woods with the name of Amaryllis, Noble listens instead for "the strains 'of the dainty Ariel,'" who provides him with some verses that owe more to Fancy than to Eros. This group within the grove, Noble continues, shows "the melody and life, the sweetness, quietness and grace of present enjoyment, irrespective of yesterday or tomorrow." That is a legitimate view of Arcadia and of the escapist—rather than moral—function it serves. But Noble then notices the "patriarch of the shepherds" so stiffly tucked in between the "loving swain with his gentle shepherdess and dog" and the girl with the tambourine. He must be "calmly musing . . . on the experience of age, and the hopes of youth." So there is meditation here in the midst of dance, after all, although it would seem inconsistent with the form of "present enjoyment" that is supposedly the exclusive focus of the scene. Perhaps it is just as well that the old man is hardly visible, for he seems less introspective than Noble suggests: he is looking straight at the dancing girl or beyond her at the image of the emasculated Priapus.

Noble refers to the herm as vaguely as possible: it is "an image of the presiding genius of the grove," and the young people who lounge or dance beside it he reduces to "a group of children." Neither is the "playful kid decked with a necklace of flowers" perceived as more than a pet; the symbolism of the aggressive flower-draped goats of Poussin, both frightening and comic, has become wholly inoperative for Cole and Noble. The "graceful disorder" of the frolic is an "upleaping, sparkling fountain of innocence," which, however, Noble hastens to leave behind, immediately moving on up the grove where he discovers a more convincing image of sobriety than even the old patriarch: "a solitary, half his years in the arms of memory, and half in those of anticipation" who "feeds on the fond melancholy that comes with loneliness and twilight." This is saying much for a figure hardly visible who is in fact approaching the dancers. But Noble's apparent anxiety over the painting leads him to introduce precisely here two lines not from *L'Allegro*, but from its sober pendant, *Il Penseroso*.

All these efforts allow Noble to wind up reading the painting as though it were a representation of the cycle of life, a joyous version of Washington Allston's *Italian Landscape* of 1805 (to which we shall come):

Thus childhood and youth; manhood in the bright kindling of the affections; manhood in the paler fires of intellect; and old age atmosphered with mild serenity, all

unite spontaneously, each according to the laws of its nature, in giving one accordant response to the genial influences of the place and moment: . . . all, health, motion, melody, repose, is one odourous flowering of joy.

This interpretation probably does reflect Cole's intention. Arcadia is adapted to contemporary sensibilities and values. It remains a dream, but one of extraordinary simplicity, innocence, and sexual repression. Probably Noble's arduous efforts to give it some depth, solemnity, and "moral radiance," however, were unnecessary. Given Cole's propensity to think in moral, emotional, and visual complementaries, when the opposing vision is so nearly absent as it is in the *Dream of Arcadia*, one might do better to seek it in another painting.

It was precisely in the late thirties, just after *The Course of Empire* (which can be reduced essentially to the duality of rise and decline), that Cole began to think most persistently in terms of pairs. In 1837 he painted *The Departure* and *The Return*, and in 1838 *The Past* and *The Present*. A passage in his journal for May 22, 1838, describes his current project of painting "a Ruined & Solitary Tower" (which does not quite coincide with *The Present*, but may be it). Cole's concluding words, while incidentally demonstrating that Noble's manner was not alien to Cole, indicate that the painting would make—both conceptually and visually—an excellent "meditative" complement to the dancing *Dream of Arcadia* (painted the same year), even if it is not so designated:

This picture will not be painted in my most finished style; but I think it will be poetical; there is a stillness, a loneliness about it that may reach the imagination. The mellow subdued tone of Evening Twilight, the silvery lustre of the rising moon, the glassy ocean which mirrors all upon its bosom, the ivy-mantled Ruin, the distant Bark, the Solitary Shepherd Boy who apparently in dreams of distant lands suggested by the lagging Sail has forgotten the night approaches & his flocks are yet straggling among the rocks & precipices 'round—these objects combined must surely, if executed with ordinary skill, produce in a mind capable of feeling, a pleasing and poetical effect, a sentiment of tranquility & solitude.[15]

A less obvious and more interesting possibility for the "pendant" to *The Dream* of 1838—if we assume that Cole's dialectic was sequential when not simultaneous—is to be found in the painting that he in fact exhibited with it in the same year at the National Academy—*Schroon Mountain, Adirondacks* (fig. 35). Although I am concerned here more with what would have been for Cole psychological and thematic pendants rather than actual physical pairs, it is worth noting that these two paintings are exactly the same width and vary only two centimeters in height. An unexpected relationship between them (perhaps not consciously realized by Cole) is suggested, to begin with, by a letter to Asher B. Durand on March 20 and a journal entry of the preceding July 8. The second paragraph of the letter reads:

I took a trip to Arcadia in a dream. At the first start the atmosphere was clear, and the travelling delightful: but just as I got into the midst of that famous land, there came on a classic fog, and I got lost, and bewildered. I scraped my shins in scrambling up a high mountain—rubbed my nose against a marble temple—got half suf-

focated by the smoke of an altar, where the priests were burning offal by way of sacrifice (queer taste the gods had, that's certain)—knocked my head against the arch of a stone bridge—was tossed and tumbled in a cataract—just escaped—fell flat on my back among high grass, and was near getting hung on some tall trees: but the worst of all are the inhabitants of that country. I found them very *trouble-some, very*—they have almost murdered me—alas! I am in their hands yet. But I hope to dispose of them one by one, if I have fair play, and have them hung, as a striking example, in the exhibition at the National Academy, by hangmen of our acquaintance.

This jocularity from one artist to another, so refreshing after Noble's rhetoric on the same work, does not hide but rather expresses Cole's relation to the dream: Arcadia is easy to conceive, but difficult to realize, especially the people. The letter then continues:

> Stop!—say you—you began in a dream, and have come down to a dull reality. . . . I am like the little dog at Schroon—you perhaps remember it—that was so glad to see us, it picked up a straw: so I offer you a straw.[16]

Durand—who now received this full report on the difficulties of Arcadia—had accompanied Cole and both of their wives on a "tour in search of the Picturesque" the previous summer. For Cole it was a return to a place partially explored in the autumn of 1835, when it had been found "not very picturesque though rugged and often wild"; the mountains were "generally lumpish," and the weather "cold and disagreeable."[17] Schroon Mountain itself had promised "remarkable beauty," how-ever, and it was a closer realization of this that he and Durand now sought. In the long journal entry,[18] of which Noble published only about half, Cole recorded in detail the enormous difficulties they faced and overcame in order to see the reality of Schroon Mountain as they wished to see it. The view from Schroon Lake, while impressive, was too conventional and too easily won:

> The scene is not grand but has a wild sort of beauty that approaches the grand—quietness, solitude, the untamed, the unchanged aspect of Nature, an aspect this scene has worn thousands of years, affected alone by seasons, the tempest & the sunshine. We stand on the border of a cultivated plain yet can look into the heart of nature. . . . Eagle Point slides out like the side Scene of a Theatre & exposes to the eye a glorious picture. . . . I do not remember having seen in Italy a composition of mountains so beautiful or pictorial as this glorious range of the Adirondack, whether from land or water, at sunset or sunrise.

Of America, however, they expected something different, not merely in degree, but in kind. Going further toward the mountain they reached the point where beyond all was *"terra incognita."* Pursuing their way on boat and by foot, they passed through gorges, climbed steep hills, scrambled through burned-out regions, and skirted the lakes through swampy forests while being eaten alive by "musquitoes & gnats." Stopping often to sketch the unfolding scenes, they were never quite satis-

fied: "the cleared hills beyond the pond and nearer the great mountain promised such an opportunity for a more complete view of the Mountain that we could not resist the temptation. . . . This would be glorious, we thought, & hope & enthusiasm drew us on." When they climbed the "topmost knoll" of the clearing they "eagerly looked towards the west—and were disappointed." A forest ridge hid the anticipated view, and "for once I wished the woodsman's hand had not been stayed." But they persevered, and when they emerged from the forest, "our eyes were blessed; we were rewarded. . . . Here we felt [the] sublimity of untamed wilderness and the majesty of the eternal mountains."

Cole then composed a poem spoken by the spirit of the mountain who on its forest-darkened peak in solitude has witnessed over the centuries "the dislocating floods" and destructive fires, and has lived with earthquake and thunder. He lives where "silence is most deathlike, / And darkness deepest cast." It is as though nature were everywhere essentially a Campagna—a scene of solitude, silence, destruction, and death. After sketching the scene "amid the blackened stumps & mutilated trees," Cole and Durand descended to seek information from the "half civilized inmates" of a log cabin. They ended up for a time in the swampy margin of a pond among gray trees of "pallid hue" which added "seeming death to solitude. The imagination might easily conjure up dread spirits from the deathlike waters, and take the mists that flit among the hoary trees for beings of fearful birth that dwell like guardians of this dismal lake." Attempting to be active in sketching what they chose to name "Grisly Lake" rather than indulge in such "dreary speculations," they are soon defeated by nature. The mosquitoes "sought with ravenous appetite the blood of man" and drove them back toward civilization.

How Cole's personal associations with Schroon Mountain, and all the qualities he attributes to it, would have made it for him the complementary subject for a pendant to the *Dream of Arcadia* hardly requires explication. But it is worth observing that the autumnal season (which he chose after all), the storm-threatened sky, the conspicuous blasted trees, the extreme smallness and near-invisibility of the human figures, the difficulty of access to the mountain (from which we are separated by thick forest slopes and a mysteriously obscure waterway), and our perilous suspension in air as we view the scene—all these elements are in specific opposition to the *Dream of Arcadia* and result in complementaries of colors and textures as well as mood and meaning. Here is the inhuman reality of nature, more easily painted than the dream, but forbidding, almost beyond knowing. Arcadia, in contrast, was easy to imagine—or to find in its essential parts in paintings from the past—but impossible fully to realize.

Yet at least the *dream* of Arcadia was necessary. Sounding like Melville himself, Cole had written in his journal in 1836, the year of *The Course of Empire:* "I often think that the dark view of things is the true one; we could not live if such truth was always present & heaven has granted us a sunshine of the heart that warms up the barren & cold reality & dazzles & deceives that we may enjoy & live."[19]

If it is true that Cole moved between the alternatives of dazzling deception and cold reality, not always placing the dance of hope in the same painting with the melancholy meditation, then it is possible to consider, finally, that the true pendant to the *Roman Campagna* (fig. 17), with which we began, is not another of the Italian

Fig. 35. Thomas Cole. *Schroon Mountain, Adirondacks.* 1838. Oil on canvas. 39⅜ × 63". The Cleveland Museum of Art. Purchase Hinman B. Hurlbut Collection.

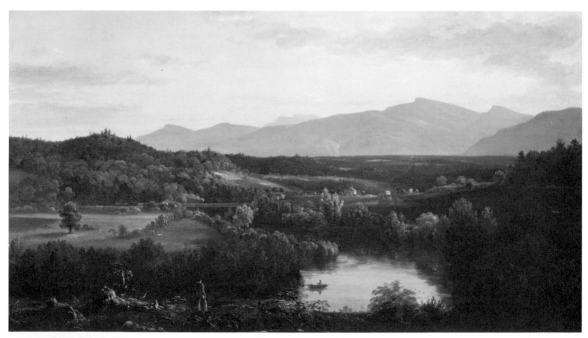

Fig. 36. Thomas Cole. *River in the Catskills.* 1844. Oil on canvas. 28½ × 41¼". Courtesy Museum of Fine Arts, Boston. Gift of Mrs. Maxim Karolik for the Karolik Collection of American Paintings.

scenes painted in 1844 but the *River in the Catskills* (fig. 36), also of that year. As solitude and thoughts of death were in Cole's mind at Schroon Lake, so were they as he painted the Campagna. And as the dreams of a purely felicitous life are at the heart of Arcadia, so the meditative woodsman with his dog, exactly duplicating the thoughtful shepherd and his dog on the Campagna, looks across a gentle stream toward newly created Arcadian fields where a boy is at play. The stump of a tree in one painting is located where the stump of a column (bearing Cole's name and the date) lies in the other. Light, sky, and clouds are similar in the two, but an active railroad viaduct and a town have been built where in the Campagna aqueducts rise up in crumbling magnificence before similar hazy hills. The paintings thus compose another Colean pair, in which we gaze alternately into the future and into the past, knowing that in the course of time one will take on the image of the other.

The Romance of Truth and a Possible Ground: Washington Allston

But there are some hearts that never suffer the mind to grow old. And such we may suppose that of the dreamer. If he is one, too, who is accustomed to look into himself,—not as a reasoner,—but with an abiding faith in his nature,—we shall, perhaps, hear him reply,—Experience, it is true, has often brought me disappointment; yet I cannot distrust those dreams, as you call them, bitterly as I have felt their passing off; for I feel the truth of the source whence they come. They could not have been so responded to by my living nature, were they but phantoms; they could not have taken such forms of truth, but from a possible ground.
 —*Washington Allston*, Lectures on Art

Over thirty years before Cole, an ideal vision of Italy had already been realized for American art by its first great romantic artist, Washington Allston. That vision contained no historical Campagna, no desert of death; it also entirely excluded sheep, cows, and dancing peasants. Whereas Cole's habitual dualism led him naturally to explore with others the common alternative or complementary readings of the Campagna as Wasteland or Arcadia, Allston's aesthetic idealism engendered an entirely different response to Rome. It recognized the "real" Roman landscape of his experience only to the extent that the Campagna made a sensuous contribution to a transcendent spiritual reality—to the superior "forms of truth" rendered by Claude and Poussin, and now by Allston himself. This harmonious aesthetic realm was indebted to the Campagna as a source of imagery and atmospheric light, but it did not "represent" the Campagna. No external referent, but only the soul's validating response, established its truthfulness. Briefly to define the extremity of Allston's romantic vision will help us see more clearly both the troubled ambivalences of Hawthorne's less confident idealism and the originality of different solutions found by George Inness and Henry James. They, as "realists," did directly "represent" the Campagna, but found their own means of making it signify an ideal faith equal to Allston's.

If Allston's vision has little to do with the actual landscape of Rome, it has everything to do with the art that he observed in Italy, and earlier in London and

Paris, and with the theory of art that was developing in accordance with his own temperament and idealism. Art itself was the separate ideal place, but Rome had fostered its realization by artists. Almost thirty years after he had left Italy, Allston wrote in a letter that he still dreamed of it continually, visiting it in imagination "once a month":

> It is there only where you will find the existence of invisible Truth proved palpably. At least, I cannot well conceive how any imaginative man can return from Rome and Florence, without having felt that there are other Truths besides such as are begotten through the senses. And then, perhaps, he may wonder why he catches elsewhere such rare glimpses of the Ideal world he has left.

Allston's own answer is in the tradition of the succession of ages that had always made the myth of the Golden Age serve a contemporary critical function:

> I do not believe in the influence of Climate; for I am unwilling to admit a material agency in this matter. Why we have so little of this ideal revelation *now* is, perhaps, explained in the matter-of-fact character of the present age. Men are too busy with the palpable useful to open their minds to those higher influences which in other times were considered as the natural cravings of an immortal spirit.[1]

The Italian Renaissance, then, had been the Golden Age for Allston, and it was to this that he returned in his dreams and through the practice of his ideal art.

Allston lived four years in Italy (1804–08), mostly in Rome, but painted "Italian" scenes before that and for long afterward. Almost a quarter of the nearly two hundred known works by Allston are in some sense related to Italy in subject; all are related to it by aesthetic tradition. The later works probably owe something as well to the most important friendship he formed in Rome, that with Samuel Taylor Coleridge. "To no other man," he wrote, "do I owe so much, intellectually, as to Mr. Coleridge."

> He used to call Rome the silent city; but I never could think of it as such while with him; for . . . the fountain of his mind was never dry, but, like the far-reaching aqueducts that once supplied this mistress of the world, its living stream seemed specially to flow for every classic ruin over which we wandered. And when I recall some of our walks under the pines of the Villa Borghese, I am almost tempted to dream that I have once listened to Plato in the groves of the Academy.[2]

From these walks within the Borghese groves in the spring of 1806 Allston must have gained immeasurable confidence in the relation between the imagination and truth in the poetry of art.

While still a student at Harvard, Allston painted bandits in wild landscapes after the manner of Salvator Rosa and according to Anne Radcliffe's gothic tales (themselves pictorial images of an Italy taken from Salvator).[3] But the year after graduating, he went to London and painted there a *Romantic Landscape* (c. 1803; fig. 37) which differs strikingly from a remarkably complex *Italian Landscape* (c. 1805;

Fig. 37. Washington Allston. *Romantic Landscape.* ca. 1803. Oil on
canvas. 33 × 42". Courtesy Concord Free Public Library, Concord, Mas-
sachusetts.

fig. 38) painted two years later in Rome. The Italian landscapes of later decades tend
toward simplification and achieve a greater unity; ultimately their quintessence is
expressed in a pair of "landscapes" of meditating shepherd boys (figs. 41, 42). But
what all the paintings that follow Allston's arrival in Rome have in common is their
creator's absolute belief in the truth of his vision. Allston's experiences both of the
external world of Italy and of his own varied but sure responses to its idealized
image in art convinced him that the forms of romantic truth rested upon plausible
grounds. Cole's beginning in topographical scenes, his rise to a narrative of histor-
ical myth, and his end with the isolation of the Arcadian dream as the antinomy of a
mysterious and melancholy reality—none of these phases was anticipated by All-
ston. Ideal "composition" from traditional imagery such as Cole had also achieved
once in *Landscape Composition, Italian Scenery* (fig. 29) was Allston's exclusive
and constant aim. Even that ideal composition differed from Cole's as one of
harmonies rather than antitheses. And the harmonies were approached through
several stages of effort.

The *Romantic Landscape* (fig. 37) is the last of Allston's landscapes to contain a
sinister narrative element. This and the medieval architecture no doubt determined
its designation (by someone) as "romantic." For there is nothing particularly wild—
which is what "romantic" then most suggested when applied to landscape—about
the landscape itself; it conforms closely to Allston's later observation that Claude's

compositions consist of "the simple combination of the parabola and the serpentine," in contrast to Salvator Rosa's "rapid, abrupt, contrasted, whirling movement" of line.[4] In a generally dark-toned painting a soft Claudean light suffuses a gray-clouded sky, is reflected from a still lake, and lights up the Poussinesque roadway that curves in a broad C in the lower right quadrant, repeating the shape of the pale blue opening in the clouds directly above. More than any roadway leading from foreground to middleground in Claude, Allston's resembles that in Poussin's *Landscape with a Man Washing His Feet at a Fountain* (1648; National Gallery, London), on which there is also a woman in motion with an arm lifted to the basket on her head. But on Allston's roadway an obscure drama is being enacted. The peaceful scene in which various types of humanity have been going about their business in a felicitous natural setting has just been interrupted by a violent act. The beautiful figure of a woman just off center in the foreground is not the statuesque and stable classical figure she would have been a moment before. She reaches up to balance the large basket covered with white cloth that she carries on her head, as she turns to witness something even as she walks on—a fact emphasized by the highlighting on the leg that rises, its foot turned up on its toes. This instability in the most prominent figure relates to the confusion of the others: in a darkly shadowed triangle to the left are three men at whom she is looking. They are a group out of Salvator Rosa, closely resembling the three middle figures in Salvator's *Landscape with a Lake, Mountains and Five Soldiers in the Foreground* (Ringling Museum, Sarasota).[5] In Allston, one man is a half-kneeling soldier with armor and sword, who partially hides a man lying on his stomach, his legs awry, who raises his head in lamentation while another man with a knapsack, sitting close by and leaning on one arm, looks at the soldier and points toward two tiny figures going away near the center of the canvas. One is a man on horseback who turns to watch a man walking closely after him making pleading gestures. Above them—at the end of, or along the road they are following—the light illuminates a complex of medieval fortress towers and castellated walls.

The way in which the beauty of the scene conflicts with the troubled humanity within it, and the way in which the two together appeal to feeling rather than idea, distinguish the work from the *Italian Landscape* painted in Italy (fig. 38). Now Claude and Salvator have given way to the exclusive example of Nicolas Poussin. A resemblance to Poussin's *Landscape with Orpheus and Eurydice* (c. 1650; fig. 39), for example, is evident not only in this work's general character but in its specific disposition of figures and Roman architecture around a lake crossed by a treble-arched bridge.[6] More abstract and intellectual in form than the *Romantic Landscape*, and philosophical rather than narrative in theme, this is the most complex of Allston's ideal landscapes. A fine city extends across the center of the canvas, its highest temples lit up by the soft light of dawn. As many as two dozen figures can be distinguished, and there are many more on the parapets of the populous town. Two hunters are passing down the road, while another man seems to ask directions of a woman with a basket on her head, who is pointing the way. Elsewhere we see a woman on a donkey, several others with baskets on their heads, a few men on the shore, and two men in a small boat on the lake that separates the town from the country road of the foreground. It is here that the most important human figures are

Fig. 38. Washington Allston. *Italian Landscape*. ca. 1805. Oil on canvas.
39 × 51". Addison Gallery of American Art, Phillips Academy, Andover,
Massachusetts. (See plate 6.)

to be seen. Their being universal human types rather than mythological or even
biblical figures is a significant departure from Poussin and from the "historical
painting" Allston also aspired to.

In a triangular composition Allston has clearly displayed the cycle of life that
Noble desperately sought in Cole's *Dream of Arcadia:* at one base is a brown-robed
old man with a pilgrim's staff who is sitting on some rocks (not ruins) in meditative
rest. At the other base is a subsidiary triangle consisting of two women and a child.
The woman in the center, elegantly and colorfully dressed, stands calmly holding
the large basket of grapes on her head with one arm, while the other woman kneels
to adjust the grapes in her basket. The child peers curiously from behind his mother.
At the apex of the triangle, a youth, his back to us, is setting off along the path with
determined stride, his walking stick planted firmly and his cloak flaring out in an
agitated outline against the water silvered by the light of dawn. He is taking a last
look back at the Ideal City reflected in the waters, even as he moves on. Yet the
bridge at the left center, which circles back across the lake, suggests that the Ideal
City is also his destination and the place occupied by the minds of all. The painting
is noble, containing a noble vision executed with care down to the carefully dif-
ferentiated small plant life in the extreme foreground. It is Allston's own dream of
an ideal world, one where there is work to do, a journey to take, and an old age to
endure. It is neither an Arcadia where peasants dance nor a Campagna of death.

In the decades after Allston's return to America, the paintings that he relates by

Fig. 39. Nicolas Poussin. *Landscape with Orpheus and Eurydice*. ca. 1650. Oil on canvas. 1.19 × 1.76 m. Louvre, Paris.

title to Italy become ever simpler and even more quiet, the harmonious inventions of memory and imagination, original offshoots of a long cultural tradition. A beautiful *Italian Landscape* of 1814 (fig. 40) is nearly as complex as the one of 1805. It uniquely includes some ruins on either side of the central scene. This place is not timeless; the ruins establish its antiquity and the relative modernity of the scene, for the medieval town at the center is prosperous and well kept. People are passing in and out of its gates, and laden carts are being pulled in the morning light toward its markets. But the primary mood is set by the three figures in quiet contemplation facing toward the water that jets from a sculptured lion's mouth into a marble basin, as though listening to its plash. In the *Italian Landscape* of 1828–30 (Detroit), there are only four figures, three women (one standing in the characteristic pause on a food-bearing journey) who listen to a handsome youth playing his lute—the Keatsian motif of sweeter "unheard music" that was a frequent subject of Allston's figure paintings. Thus Allston moves from the heavily populated *Italian Landscape* of 1805, with its diversity of interests and obviousness of emblematic elements, toward both a more unified mood and a more intuitively grasped meaning. Poetic feeling (as distinct from allegory) as a means to truth is more confidently relied upon. Such feeling was not, Allston insisted in his *Lectures on Art*, to be confused with the fanciful, which may be totally devoid of such feeling. It is nothing less than "sensibility to *harmony*"—an alertness to "all existing affinities" and an ability to "supply the deficiency" of experience. The Artist (Allston always capitalizes the word) must have this sensibility from which proceeds his "romance of Truth." The

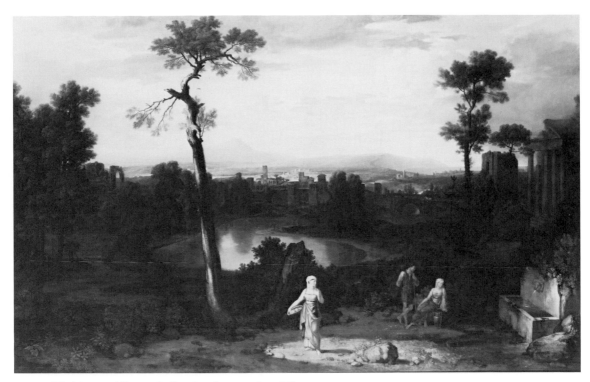

Fig. 40. Washington Allston. *Italian Landscape.* 1814. Oil on canvas. 44
× 72″. Toledo Museum of Art, Ohio. Gift of Florence Scott Libbey. (See
plate 7.)

phrase is not paradoxical because "it is impossible that the mind should ever have
this perpetual craving for the False." Idealism is validated by its origin in an internal
necessity of mankind.[7]

A harmonious relation between man and nature is not necessarily one of the
"existing affinities." Yet it is a truth that can be imagined; it has a "potential
existence," but *only* a potential one until it becomes "manifest" in an "objective
correlative" (Allston's phrase) made from the forms and colors of art, where the
"deficiencies" are supplied. The "master Principle" of man's nature is harmony;
conceptions of beauty, truth, and holiness are but its physical, intellectual, and
moral phases. And mankind is eternally active, hoping, seeking an end—a satisfying
state, a perfection beyond what nature provides. It remains to be realized.[8] For
Allston, insofar as the romance of truth was to be "realized" in forms of "land-
scapes-with-figures," it required less and less, so long as the landscape was Italian.
(Amusingly he remarks, apropos the artist's natural propensity always to seek out
the truly beautiful, that Italians do not go to Holland for their models, but the
reverse.)[9] His memory and his drawing papers having been stocked with figures
from Italian art and a few nude children from Italian life, he had no need to look
about him at Yankees. For it is a fact that people are essential to his landscape, as are
even the structures—bridges, towers, fortresses, temples, palaces, and city walls—
that conspicuously modify that landscape. In a few paintings the figures and struc-
tures may be reduced to the minimum—as in both the early Titianesque *Morning in*

Fig. 41. Washington Allston. *Italian Shepherd Boy.* 1819. Oil on canvas. 21 × 17". Detroit Institute of Arts. Gift of Dexter M. Ferry, Jr.

Fig. 42. Washington Allston. *Italian Shepherd Boy.* ca. 1819. Oil on canvas. 47⅜ × 34¼". Brooklyn Museum. Dick S. Ramsay Fund.

Italy (c. 1808, Shelbourne Museum, Vt.), in which there are merely a bridge, the outlines of a distant town, and a single walker on the road, and *Landscape, Evening (Classical Landscape)* (1821; IBM), where only a boy and his dog rest beside a clear stream in the foreground, while between the dark silhouettes of great trees against the sunset sky one dimly makes out the towers of a town overlooking a vast Campagna that stretches toward Albano-like hills.

The ultimate condensation of this human and natural material, however, had occurred two years before in two works, both called *Italian Shepherd Boy* (figs. 41, 42). They are Allston's only truly pastoral paintings, and they most simply unite moods of interiority with significations of the external world of nature to convey a principle of harmony between the two, and to elicit a harmony between the sensuous ground of the painting and the viewer's soul. One shepherd is hardly more than a child; the other is adolescent; both sit in deep woods alone holding their flutes at rest. They are in deep thought as though listening to an inner music, and their beauty is illumined by a fall of sunlight through the foliage that surrounds them. But they are also distinct from each other, as are their respective forest retreats. The forest whose darkness defines the still-developing shape of the younger shepherd is itself sublimely primitive, as inchoate as the boy's presexual soul, a luxuriant, quiet chaos closed off by the blank peaks of a mountain. But for his well-formed adolescent Allston has provided a woods through which one could move, with openings to a world and a sky beyond. Both shepherds in conjunction with

their backdrops express—and, Allston hoped, would evoke in the spectator—the "sovereign principle of Harmony," to experience which is to experience an inner Arcadia. Dreamers themselves, the shepherd boys are also dreams, but dreams are not phantoms. Like Allston's other Italian landscapes, they present themselves as "forms of Truth."

Golden Light and Malarial Shade: Nathaniel Hawthorne

In the early pages of Nathaniel Hawthorne's *The Marble Faun*, the faun of Arcadian mythology is characterized in terms that might make us think of Allston's shepherd boys:

> All the pleasantness of sylvan life, all the genial and happy characteristics of creatures that dwell in woods and fields, will seem to be mingled and kneaded into one substance, along with the kindred qualities in the human soul. . . . And, after all, the idea may have been no dream, but rather a poet's reminiscence of a period when man's affinity with Nature was more strict, and his fellowship with every living thing more intimate and dear.[1]

At first glance the older of Allston's shepherd boys could be taken for a mirthless brother to Hawthorne's faun, Donatello. In the pioneering study to which we are largely indebted for the rediscovery of Washington Allston, E. P. Richardson suggested that among the early American writers, it was not his traveling companion in Italy, Washington Irving, who was closest in feeling to Allston but rather Hawthorne, the great romancer of the next generation.[2] Hawthorne's appeal to dream life, his introspection, and his intention (simply stated) to create a world where the imaginary and the actual may meet and modify each other (the points to which Richardson was speaking) do make him seem close to Allston. But the comparison ultimately will indicate greater differences than similarities, owing partly to the differences between the arts of painting and fiction, but even more to temperamental and intellectual differences between Allston and Hawthorne.

In Allston's art, the "poet's reminiscence" or ideal possibility is actualized as vision and is dependent for its effect upon the relative simplicity of a static form. One can speculate upon the shepherds' thoughts, but such speculations cannot go far with any legitimacy and can hardly arrive even at the perturbations of the passionate shepherds of pastoral poetry. Both the paintings and the lyric poems achieve any degree of interesting complexity solely in formal and technical aspects specific to the visual and verbal media, not in their content. A poem attempting to render nothing but the literary content of an Allston painting would be only less intolerable than one providing this service for Cole's *Dream of Arcadia* (fig. 33). If proof were necessary, the poems inspired by exhibitions of these artists or the verses written by Allston and Cole themselves (since both wished to be poets in all senses) would amply serve. As much could be said for some of Hawthorne's static "sketches," it is true, but even in the slightest of his tales the genre itself requires some complication

of plot and therefore of theme beyond what is possible in painting without reference to a literary source for extension and interpretation of the moment depicted.

In Hawthorne this complication is always in a direction opposed to the essentially ennobling humanism of Allston's art. This is the second reason for his radical difference from Allston. And the irony and skepticism that result from the development of his plots through dialectical opposition of characters and viewpoints and through reversals in the action are supported also by his narrative voice. The "poet's reminiscence," rather than being recaptured, as with Allston, is continually undercut by two opposing stylistic tendencies that have the same effect: one a sarcastic, even cynical tone that assures us of Hawthorne's mature and essentially realistic grasp on life, whatever his fictions may suggest, and the other an occasional indulgence in fanciful thought and language that always seems aware of its own puerility. Paintings, lacking an easy means of conveying irony or self-doubt even if those attitudes were desirable, have the advantage of complete conviction. No amount of historical evidence or reference to "actualities" can affect their validity when they aspire frankly to visionary reality. This is the case also in romance as practiced, for example, by Spenser, a favorite poet of both Allston and Hawthorne (Allston beautifully painted "The Flight of Florimel" from *The Faerie Queene,* and Hawthorne named a daughter Una). But in Hawthornian romance there is a constant capitulation of the visionary to the sober facts of "reality," characteristically accompanied by halfhearted rationalizations about the even greater beauty, truth, and superior happiness enabled by this miserable world, whose fallen state necessitated the promise of Christian redemption.

In his preface to *The Marble Faun,* Hawthorne characterizes Italy as "a sort of poetic or faerie precinct, where actualities would not be so terribly insisted upon, as they are, and must needs be, in America." He claims that America lacks the shadows, antiquity, mystery, and "picturesque and gloomy" wrongs that make Italy suitable for romance and that his "dear native land" has nothing but "a commonplace prosperity, in broad and simple daylight." He concludes that "romance and poetry need Ruin to make them grow."[3] The preface, written in December 1859 on the eve of the Civil War, is deliberately disingenuous and constitutes a satire on America's self-conception. Hawthorne seeks—as always in his prefaces—to excuse improbabilities and ambiguities which he thinks essential to romance, and he pays lip service to the "commonplace" reality of "broad and simple daylight," for which he has really no sympathy at all. But he also satirizes his own genre by reducing it to a question of the "picturesque and gloomy." It is more than that. What Hawthorne believes to be the real "actualities" are the powers of darkness within individuals, in their social relations, and in their mortal destinies. These essential actualities, then, are what he finds in Italy—not a pastoral retreat from the rational and commercial daylight life of America but ruin; not a "faerie precinct" but a malarial shade. It is in an attempt to escape spiritually troubling *realities* that his hero and heroine, Kenyon and Hilda, finally return "home" to America.

When, in response to complaints from readers who felt cheated of a full revelation of mysteries at the conclusion of *The Marble Faun,* Hawthorne added a postscript in March of 1860, his exasperation with those who take the final coherence of plot for the essence of a fiction is apparent and justified. Yet he once more begs the

question of the nature of the imagined reality of his book and unconsciously defines the defect in his method:

> The idea of the modern Faun . . . loses all the poetry and beauty which the Author fancied in it, and becomes nothing better than a grotesque absurdity, if we bring it into the actual light of day. He had hoped to mystify this anomalous creature between the Real and the Fantastic, in such a manner that the reader's sympathies might be excited to a certain pleasurable degree, without impelling him to ask how Cuvier would have classified poor Donatello.[4]

This, however, is beside the point. Hawthorne himself constantly shifts poor Donatello into "the actual light of day"—the light of a narrative voice both skeptical and consciously whimsical—and renders him merely quaint if not grotesque, instead of enlisting "the reader's sympathies" in Donatello as an Arcadian being with "faun-blood." The key to the problem is in Hawthorne's opposition here between the "Real" and the "Fantastic," rather than his more usual distinctions between the "Real" and the "Ideal" or between the "Actual" and the "Imaginary." For the "Fantastic" is conceived as a realm wholly unreal, rather than as an abstraction or extension from or idealization of the "real," that is, the natural.

Allston, in contrast, held that in *all* art there is "an insuperable difference" from nature, because the natural is always modified by the personal element contributed by the artist. This is as true of Ostade as it is of Raphael. Yet it is equally true that all works of art "so far as they are recognized as true, are to be considered an extension of Nature," and this is as true of Shakespeare's Caliban as it is of Sir Joshua Reynolds's Robin Goodfellow and the Apollo Belvedere (his examples coming readily from several arts). There are two great divisions of truth, the actual (the probable and natural) and the imaginary (the possible or ideal), but both *are* truth, and both are "extended Nature."[5] Allston clearly holds to classical conceptions as given redefinition by Goethe and Coleridge. But Hawthorne draws upon a different, gothic distinction between "the Real and the Fantastic."[6] For Allston the artist's creation *must* lie in an intermediate realm, for nature provides the "sensuous ground" for all true ideas. But when Hawthorne attempts to find that realm between the Real and the Fantastic, he falls into an ontological chasm. Henry James has been criticized for imposing his own realistic prejudices upon Hawthorne's romance when he said that its "lunar element is a little too pervasive." The doomed attempt to cross two different verisimilitudes James perceived most acutely in the character of Donatello, the faun: "His companions are intended to be real . . . whereas he is intended to be real or not, as you please. He is of a different substance from them; it is as if a painter, in composing a picture, should try to give you an impression of one of his figures by a strain of music."[7]

James was right. The question is not how Cuvier would classify Donatello, Hawthorne's faun, but whether Hawthorne himself can believe in the life he represents. And he cannot. Like a proto–D. H. Lawrence he professes an attraction to the "honest strain of wildness" that Donatello might represent and for the "regions of rich mystery" into which it might lead—partly restoring "what man has lost of the divine."[8] But he continually neutralizes the attraction with whimsy instead of

following its lead into an idealized and mysterious naturalism. Hawthorne is, after all, no Lawrence, but neither is he the Shakespeare of Caliban or the Spenser of the Garden of Adonis or—far less—the Bower of Bliss. The direction open to him (*The Scarlet Letter* proves it) was that of "real psychology" rather than "picturesque conceit," as James noted: "Among the Italians of to-day, there are still plenty of models for such an image as Hawthorne appears to have wished to present in the easy and natural Donatello."[9]

Apparently from a kind of fear, then, Hawthorne surrounds his presentation of Donatello with the disclaimers of a mocking style, with conventional diction that relates him to the wearier pastoral artifices of neoclassicism, with gratuitous asides (ranging in tone from the coyly sentimental to the sarcastic), and, finally, with the condescending attitude—itself defensive—of the "world-worn" Miriam. The point of view of the faun himself is entirely absent.

The attenuation of Donatello's reality and characterization reflects Hawthorne's awareness that they implied a vital and innocent sexuality that is as discomforting to him as it would have been unacceptable to his readers. For Donatello is neither a passive shepherd lost in thought like Allston's boys, nor even Vergil's Tityrus sublimating his love sorrows into song. He is not a shepherd at all. He is a faun. Fauns are sensual and playful, even in the humanized version attributed to Praxiteles that provoked Hawthorne's first thoughts about the book (fig. 43). Their kind in Ovid keeps company with Pan, with nymphs, and with goats. In fact, as minor deities of the woods, they are usually goats themselves, in their lower half. Hawthorne thought their race "the most delightful of all that antiquity imagined," but complimented Praxiteles on confining the faun's "animal nature" to his pointed, downy ears and a tail "probably hidden under his garment": "Only a sculptor of the finest imagination, most delicate taste, and sweetest feeling, could have dreamed of representing a Faun in this guise." Like an Allston shepherd boy, he contains an entire landscape: "trees, grass, flowers, cattle, deer, and unsophisticated man" all in one. In his portrayal of Donatello, Hawthorne was faithful not only to Praxiteles' "delicate taste" and "sweet feeling," with the "animal nature" unstressed, but also to the fig leaf that was then firmly in place, hiding something more essential than the tail.

In his original notebook observations Hawthorne certainly was conscious of *The Faun*'s sensuality. On his first visit he thrilled himself with the idea of a "young lady!" who possessed "the moral instincts and intellectual characteristics of the faun." When he returned the next week for a more minute consideration of *The Faun*'s possibilities, he noted that it was actually "the image of a young man" whose "garment falls half way down his back, but leaves his whole front, and all the rest of his person, exposed, displaying a very beautiful form, but clad in more flesh, with more full and rounded outlines, and less development of muscle, than the old sculptors were wont to assign to masculine beauty." The face was "beautiful," the mouth "voluptuous." In short, "the whole person conveys the idea of an amiable and sensual nature, easy, mirthful, apt for jollity, yet not incapable of being touched by pathos. The faun has no principle, nor could comprehend it, yet . . . might be refined through his feelings."[10]

In the self-criticizing dialogue of the frame narratives in Hawthorne's *Wonder*

Fig. 43. *Faun in Repose,*
known as "The Faun of
Praxiteles." Roman copy
of Greek original of 350–
30 B.C. Marble. H: 1.705
m. Capitoline Museums,
Rome.

Book, in which he retold many of the stories from Ovid for children, a neighbor advises Eustace Bright (the youthful narrator) to keep his hands off these "classical" stories—his "Gothic" imagination distorts and demeans them. But the fact is that Ovid's *The Metamorphoses* contains as much horror as wonder, as much blood as beauty. The "transformation" of Donatello into a sinful human being is not more terrible than many of which Ovid tells. Hawthorne's Bright avers that these tales from the childhood of man's race had been somehow distorted in a corrupt age (evidently meaning by Ovid himself, in the Age of Augustus). What Bright is doing is returning them to their original childlike innocence, for the children of our time. This argument obviously conflates two kinds of innocence—the sexual innocence of early mythic man (not of the gods!) and the innocence of Victorian children. To Hawthorne guiltless animal sexuality is indistinguishable from late classical "corruption" with its tales of nymphs and satyrs—and their attendant fauns. In writing *The Marble Faun*, although obviously attracted to what is essential about the creature as well as what is fanciful, Hawthorne could not free himself from this inhibited view of pagan innocence. Donatello is created as though for children, while his function in the romance from the beginning depends upon his representing a spontaneous and happy sexuality that opposes his essential being to both the guilt-ridden sexuality of Miriam and the angelic asexuality of Hilda. If this is not so, then Donatello might as well have been merely a lovelorn "Arcadian" shepherd from the Campagna, and not a faun at all.

In an early sequence of four chapters (8–11)[11] Hawthorne locates his action in "the Suburban Villa"—as he calls the Villa Borghese—"just outside of the Porta del Popolo." In this border region between the walls of Rome and the deserted Campagna he wishes to create the illusion of an Arcadia, and it does fulfill the convention that Arcadia is a middleground between city and wilderness. Here Donatello is free to be himself—not in the places where we have previously seen him: among the artifices of the Capitoline Museum, in the deathly atmosphere of the catacombs, and in Miriam's studio with paintings expressing sexual revenge. "The scenery, amid which the youth now strayed, was such as arrays itself in the imagination, when we read the beautiful old myths, and fancy a brighter sky, a softer turf, a more picturesque arrangement of venerable trees, than we find in the rude and untrained landscapes of the Western world." Hawthorne devotes an exuberant page to the ancient ilex trees, the stone pines, the cypresses—all of whose shapes, colors, and textures were celebrated by the painters of this villa (fig. 44).[12] Here, says Hawthorne, there has been "enough of human care . . . bestowed long ago, and still bestowed, to prevent wildness from growing into deformity; and the result is an ideal landscape, a woodland scene, that seems to have been projected out of a poet's mind, . . . pensive, lovely, dreamlike, enjoyable, and sad, such as is to be found nowhere save in these princely villa-residences, in the neighborhood of Rome."

This is how Hawthorne *describes* it, not how Donatello *experiences* it. The trees are not vitalized by any authentic mythic feeling. They have only the artificial life of conventional poetic anthropomorphism and conventional aesthetic categories. They conform to "a picturesque arrangement" and compose "an ideal landscape": the ilexes have no dread of the axe; the attack of the Gauls has "passed out of their dreamy old memories." These "leafy patriarchs" strive to diffuse a sweet sunshine

Fig. 44. George Inness. *Barberini Villa, Italy [Villa Borghese, Rome?]*.
1872. Oil on canvas. 9 × 13¹⁄₁₆″. Courtesy Art Institute of Chicago.

over the lawns. The "final charm" that Hawthorne finds "piercing, thrilling, delicious" in this "Eden" is that it is infested with malaria: "Fever walks arm in arm with you, and Death awaits you at the end of the dim vista."

Having indulged himself in a characteristic Hawthornian irony and shudder, he reminds himself that "Donatello felt nothing of this dreamlike melancholy." On the contrary: as the faun, "bred in the sweet, sylvan life of Tuscany," passed beneath the trees, "the mouldy gloom and dim splendour of old Rome" so alien to him lifted from his consciousness, and "in a sudden rapture, he embraced the trunk of a sturdy tree, . . . as a Faun might have clasped the warm, feminine grace of the Nymph, whom antiquity supposed to dwell within that rough, encircling, rind." Even here, Donatello's feeling comes at one remove, not as he felt it, but according to the quaint suppositions of "antiquity." When Donatello throws himself upon the "genial earth, with which his kindred instincts linked him so strongly," and kisses it, feeling the response of flowers and lizards to "his buoyant life," a powerful alternative to the life within the walls of natureless Rome is suggested; Donatello is the lost child representative of a denatured humanity, who "finds himself suddenly in his mother's arms again." But Hawthorne trivializes this by stating that "it was pleasant to see" the lizards scrambling over him (so it is merely a picturesque scene for a hypothetical observer); and when the birds perch on the "nearest twigs" to sing "their little roundelays, unbroken by any chirrup of alarm," the sensibility is closer to Disney than to Vergil or Ovid. The reader, who might be very willing to suspend his disbelief if that were the way Hawthorne wished to go, is frustrated by the author's cautious persistence in being merely fanciful.

The subsequent chapter, called "The Faun and Nymph," establishes the relation-

ship between Donatello and Miriam, and here Hawthorne's defensive strategies against the sexual implications of Arcadia become even more troublesome. "He gave Miriam the idea of being not precisely a man, nor yet a child, but, in a high and beautiful sense, an animal—a creature in a state of development less than what mankind has attained, yet the more perfect within itself for that very deficiency." Is this to remain merely theoretical? Even if we are not to enter the mind of this animal with the perfection of his defects, how is Miriam to respond to the possibility of the rare relationship he offers?

Miriam asks him to call forth a dryad or a water nymph, and adds: "Do not fear that I shall shrink, even if one of your rough cousins, a hairy Satyr, should come capering on his goat-legs . . . and propose to dance with me. . . . And will not Bacchus—with whom you consorted so familiarly of old, and who loved you so well—will he not meet us here, and squeeze rich grapes into his cup for you and me?" But this is mere talk. When Miriam asks Donatello why he is so happy, and he replies "Because I love you!" she hears his confession "without anger or disturbance, though with no responding emotion. It was as if they had strayed across the limits of Arcadia, and come under a civil polity where young men might avow their passion with as little restraint as a bird pipes its notes, to a similar purpose." But that purpose is instinctive. The sort of spontaneous relationship (however troubled or woebegone at times) that was possible in the classical and Renaissance Arcadias is literally unimaginable here. Hawthorne completely inverts the idea by suggesting that Miriam would have to have been even more worldly than she was to have "found it exquisite to slake her thirst with the feelings that welled up and brimmed over" from the fresh fountain of Donatello's heart. "She was far, very far, from the dusty mediaeval epoch, when some women had a taste for such refinement." Are Arcadian nymphs then indistinguishable from the dissolute dames of the Middle Ages? Miriam's conscious scorn for Donatello's intellectual "simplicity" fortifies her against the effect of his phallic energy. (Hawthorne's concern that the wind may expose the ardent faun's "furry pointed ears" as he lopes through the woods is clearly a displacement.) Miriam thinks him both a "wild, gentle, beautiful creature" and a "simpleton." Having taken pleasure in reminding him (as Hawthorne has already been at pains to remind the reader) that the atmosphere they breathe in this apparently Arcadian place is actually "malarial," Miriam claims to be equally "dangerous" herself and warns Donatello not to follow her. But his simple certainty that his love will last "forever" persuades her to accept the illusion that "for this one hour" she can be "as natural as himself."

They play together "like creatures of immortal youth," running races and pelting each other with flowers, and making garlands for their heads: "It was a glimpse far far backward into Arcadian life, or, further still, into the Golden Age, before mankind was burthened with sin and sorrow, and before pleasure had been darkened with those shadows that bring it into high relief, and make it Happiness." Even at the moment of Arcadian climax—jejune as it is—Hawthorne cannot let it be. He must recite the Christian comfort that says "good riddance" to the superficialities of sensual pleasure. The "ideal" truth of Hawthorne's fiction is fundamentally different from that of Allston's paintings. It is not the purification and perfection of the physical world according to a Platonic ideal; it is rather a sense of the general or typical truths abstracted from the historical, psychological, and moral worlds.

These truths include the actuality of the painful, the grotesque, the ugly, and the sinful as conceived by Victorian Protestant Christianity, but also the promise of a redemption that will transcend even the myths of ideal worldly place (Arcadia) and time (the Golden Age). Pleasure must be *darkened* to become "Happiness."

The sound of music leads Donatello and Miriam deeper into the grove; the metamorphosis of Miriam into a nymph is, to all outward appearances, complete. "You would have fancied"—says Hawthorne, maintaining a fictive distance—that she had emerged from a tree or a fountain. When they join the band of musicians, Donatello snatches up a tambourine and strikes the pose of another famous statue—the *Dancing Faun* of the Capitoline—but he nevertheless produces "music of indescribable potency"—indescribable, that is, in Victorian romance. When a crowd gathers, "all gone mad with jollity," Hawthorne paints an Arcadian landscape containing strangely incongruous figures, one in which the harsher accents dim the golden light of vision into the common daylight of "reality":

> Among them were some of the plebeian damsels, whom we meet bareheaded in the Roman streets, with silver stillettos thrust through their glossy hair; the contadinas, too from the Campagna and the villages, with their rich and picturesque costumes, of scarlet and all bright hues. . . . Then came the modern Roman, from Trastevere, perchance, with his old cloak drawn about him like a toga. . . . Three French soldiers capered freely into the throng, in wide scarlet trowsers, their short swords dangling at their sides; and three German artists, in gray flaccid hats, and flaunting beards; and one of the Pope's Swiss Guardsmen, in the strange motley garb which Michel Angelo contrived for them. Two young English tourists (one of them a lord) took contadine-partners, and dashed in; as did also a shaggy man in goat-skin breeches, who looked like rustic Pan in person, and footed it as merrily as he. . . . There was a herdsman or two, from the Campagna, and a few peasants in sky-blue jackets and small-clothes, tied with ribbons at the knees;—haggard and sallow were these last, poor serfs, having little to eat, and nothing but the malaria to breathe; but still they plucked up a momentary spirit, and joined hands in Donatello's dance.

The only person incapable of joining in this supposed manifestation of "the Golden Age come back again" is an American, "who sneered at the spectacle, and declined to compromise his dignity by making part of it." That American is one part of Hawthorne himself, who cannot go on to describe the bacchanalian procession that develops without likening it to the reliefs on a sarcophagus, which invariably—according to him—end up with a reference to "doom and sorrow." This suggests for a moment the more complex tradition of "Death in Arcadia." It is Hawthorne's cue for getting on to what engages his belief more fully. For in the midst of the "madness and riot" of the "wild dance" appears the Model, the Spectre of the Catacomb himself, and the illusion of Arcadia vanishes. The Villa Borghese instantly becomes nothing but "an old tract of pleasure-ground, close by the people's gate of Rome; a tract where the crimes and calamities of ages, the many battles, blood recklessly poured out, and deaths of myriads, have corrupted all the soil." Death brings in the daylight of truth.

A new vigor enters into Hawthorne's language with the reentrance of the Model.

But the Model, too, is a character wrapped up in pagan mythology, and he made his first appearance, as we have seen, in the catacombs of the Campagna. He is another creature from Donatello's world:

> The stranger was of exceedingly picturesque, and even melodramatic aspect. He was clad in a voluminous cloak, that seemed to be made of a buffalo's hide, and a pair of those goat-skin breeches, with the hair outward, which are still commonly worn by the peasants of the Roman Campagna. In this garb, they look like antique Satyrs; and, in truth, the Spectre of the Catacomb might have represented the last survivor of that vanished race, hiding himself in supulchral gloom, and mourning over his lost life of woods and streams.[13]

The Model, as a descendant of satyrs, embodies an even more potent amoral sexuality than does the faun. But he differs from the start by representing a tragic pagan fatalism that contrasts with Donatello's initial happy and inconsequential abandon. Mysterious as the Model is to all the friends of Miriam and the gossips of Rome, they ultimately conclude that "the most reasonable" account is the one that identifies him as Memmius, the Man-Demon who was a spy upon the Christians in the service of the emperor Diocletian and who refused the "single moment's grace" granted him to convert to Christianity, thereby placing himself forever beyond salvation.

In the chapter of "Fragmentary Sentences" which follows the Model's disruption of the Arcadian dance, the medium of language itself becomes a heap of ruins, of broken and failed communications between both Miriam and the Model and Hawthorne and the reader. Had he wished to be conventional, here was Hawthorne's opportunity to clarify Miriam's past. But he gives us instead passionate exchanges that are as vaguely allusive as inscriptions on those shattered tombs whose full meaning we can never know. Similarly Miriam and the Model, their past unexplained and unexplainable even to each other, can come to no understanding. Miriam's suggestion that he find hope in his Catholicism simply horrifies him. It is precisely his eternal doom—which he insists links him and Miriam together—that gives him his identity. The past they share—unspecific as Hawthorne is willing to be about it (the silences between the fragments are pregnant)—is one obviously characterized by sexual guilt and is one that Hawthorne sympathizes with deeply. In the Model he combines elements from both male protagonists of *The Scarlet Letter*, Chillingworth's fatalism with Dimmesdale's sense of guilt. This chapter of *The Marble Faun* is written in the same key of tragic drama found in those successive chapters of *The Scarlet Letter* in which another "dark" heroine passionately argues with her antagonists beyond the city limits and within a dark wood. The garland of flowers Donatello made for Miriam is now replaced by something metaphorical, but more real to Hawthorne—Chillingworth's "iron chain of necessity." Of the relation between Miriam and the Model, Hawthorne writes: "That iron chain, of which some of the massive links were around her feminine waist, and the others in his ruthless hand—or which perhaps bound the pair together by a bond equally torturing to each—must have been forged in some such unhallowed furnace as is only kindled by evil passions and fed by evil deeds."

Miriam had persuaded herself to engage in Donatello's Arcadian illusions "for one hour" by momentarily questioning whether her personal past was any more "real": "My reality! What is it? . . . Is the dark dream, in which I walk, of such solid, stony substance, that there can be no escape out of its dungeon?" Hawthorne has her find her answer when she confronts the Model. The dark dream—not Arcadia—is reality, and the only escape from it is "death! Simply, death!" But the Model says, "It is not our fate to die, while there remains so much to be sinned and suffered in the world. We have a destiny, which we must needs fulfil together." At the end of the chapter, Miriam and the Model "strayed onward through the green wilderness of the Borghese grounds, and soon came near the city-wall." The Arcadian grove has been transformed into a "wilderness" indistinguishable from the lawless American forest in which Hester Prynne wished to persuade Dimmesdale that they could be free of their past and of sin, and in which they enjoyed an illusory hour of freedom. The tragic, irremediable violation of Puritan "civil polity" is something that Hawthorne understands far more than the guiltless pleasures of Arcadian life proposed by Donatello. Until he murders the Model and thus becomes like him in guilt, the faun is wholly alien to Hawthorne.

The Marble Faun is structured so that Arcadia is introduced as an alternative reality—or dream—twice more, at the middle of the romance and at the end. At Donatello's ancestral estate in Tuscany we learn that they drink a wine called "Sunshine" that was developed by Bacchus himself; and on the walls of the castle hang faded frescoes of the Golden Age. Now that Donatello has been brought totally within the world of sin, sexual guilt, and death, Hawthorne not only can portray his character with more conviction but can allude to the possibilities of an Arcadian inheritance in man's temperament and inclinations with less fancifulness and irony. He cheerfully traces "The Pedigree of Monte Beni" (chap. 26) back to prehistoric times into the legends of Arcadia and fables of the Golden Age that "enriched the world with dreams"—"those delicious times, when deities and demigods appeared familiarly on earth." The "progenitor" of the race, a "sylvan creature" "not altogether human . . . loved a mortal maiden" and won her "by subtle courtesies . . . or possibly by a ruder wooing." The most notable feature of their "vigorous progeny" was their resistance to the "trammels of social law. . . . Their lives were rendered blissful by an unsought harmony with Nature."[14] This harmony had been evident in Donatello's youth, when he had communicated with animals freely, and had been "the soul of vintage festivals." That "merrier world" of Monte Beni is now lost because of the change in Donatello, and it is a world that (through his character Kenyon) Hawthorne for once regrets. Following the Vergilian and Ovidian tradition, he contrasts it this time not with the promise of Christian salvation but— like Allston in his complaint about our obsession with the "palpable useful"—with the dreary moral purposiveness of the modern world, this Iron Age:

> The entire system of Man's affairs, as at present established, is built up purposely to exclude the careless and happy soul. The very children would upbraid the wretched individual who should endeavour to take life and the world as (what we might naturally suppose them meant for) a place and opportunity for enjoyment. It

is the iron rule in our days, to require an object and a purpose in life. It makes us all parts of a complicated scheme of progress, which can only result in our arrival at a colder and drearier region than we were born in.[15]

Thus the inexorable facts of temporal existence—mutability and mortality—do not in themselves render the Arcadian vision totally irrelevant; man-made social laws needlessly repress natural desire. Yet, even here, such a concession is partly undercut by attributing it to Kenyon, in his attempt to explain Donatello's "transformation." The explanation necessarily seems superficial when placed beside our knowledge of what Donatello has done, of which Kenyon is ignorant. Murder is not only contrary to Christian and social law; it is, of course, contrary to the life of Arcadia as well. The animals now flee from Donatello, just as the Nymph of the Fountain at Monte Beni never returned after the knight of the legend stained his hands with blood.

Near the end of the romance, Kenyon takes "A Walk on the Campagna" (chap. 46), and although fully conscious of the way strewn with tombs and the sense that under every field there are columbaria, catacombs, and buried villas, he takes satisfaction in seeing that the tombs have rarely preserved the names of those they were to memorialize, that even in February the violets, daisies, grass, shrubs, and even some trees cover all. He walks beside the broken Claudian aqueduct in brilliant sunshine, a buffalo calf gamboling beside him, and in spite of his sorrow and worry he feels his spirits reviving. A breeze caresses his cheek: it is "sweet, fresh" weather that belongs only to Paradise and Italy, spiritual and sensual at once.

When Miriam and Donatello, now joined in passion and in guilt, arrive at the place of meeting, they are disguised as "The Peasant and the Contadina" (chap. 47), a clear parodistic echo of "The Faun and the Nymph" (chap. 9). But here they are not in the Arcadian Villa Borghese, but out on the desolate Campagna of Death, wearing its mask of flowers. Nor are they eighteenth-century aristocrats playing at being shepherds with light hearts and guiltless sexual pleasures. Miriam—in a reversal of the situation of the earlier chapter—cries to Donatello. " 'let us live a little longer the life of these last few days! It is so bright, so airy, so childlike, so without either past or future! Here, on the wild Campagna, you seem to have found, both for yourself and me, the life that belonged to you in early youth: the sweet, irresponsible life which you inherited from your mythic ancestry, the Fauns of Monte Beni.' "[16] This is the final effort to maintain the illusory "irresponsible" life of Arcadia. Miriam goes on to propose to Kenyon the theory that he himself had proposed to Hilda—that Donatello's story reenacted the Fall of man, that it demonstrates how fortunate was that Fall, since through crime man fell only to rise to a higher state of knowledge, humanity, and spirituality, in contrast to the animal contentment and stupidity of the Edenic state. Kenyon rejects that view of crime, as had Hilda, but he too has been struck by the way in which Donatello has changed from faun to man. In the loss of his pagan innocence he has been ennobled by guilt and sorrow.

The two penultimate chapters of *The Marble Faun* have as their setting the Carnival, during which the Corso "was peopled with hundreds of fantastic shapes, some of which probably represented the mirth of ancient times, surviving, through

all manner of calamity, ever since the days of the Roman Empire." The bacchanalian revelries of the Carnival are, however, an anachronism in the modern world. The world has grown sad, and such a festival is merely factitious, "traditionary, not actual." In the crowd of strident merrymakers Kenyon meets Miriam and Donatello for the last time. Masked as peasants of the Campagna, they cannot hide from him the tragic reality of their lives. The Christian innocence of Hilda, however, is maintained to the end. Strangely, it is she who now emerges intact from "a Land of Picture" onto a balcony of the Corso to be reunited with Kenyon. The most refined aspect of the aesthetic Arcadian vision is transferred to her. Hilda was from the beginning the most fervent believer in Donatello as the innocent faun, and now, without irony, the reader is invited to believe that she has been "straying with Claude in the golden light which he used to shed over his landscapes, but which he could never have beheld with his waking eyes, till he awoke in a better clime."[17]

The Sacred Groves of George Inness

No. 89. It must be understood that the natural world springs from and has permanent existence from the spiritual world, precisely like an effect from its effecting cause. All that is spread out under the sun and that receives the heat and light from the sun is what is called the natural world; and all things that derive their subsistence therefrom belong to that world. But the spiritual world is heaven; and all things in the heavens belong to that world.

No. 111. Trees, according to their species, correspond to the perceptions and knowledges of good and truth which are the source of intelligence and wisdom. For this reason the ancient people, who were acquainted with correspondences, held their sacred worship in groves.
—*Swedenborg,* Heaven and Its Wonders and Hell

Like Hawthorne's Hilda, George Inness saw a celestial light. In the theology of Emanuel Swedenborg, in which he became a fervent believer, the sun of this world corresponds to the Sun of Heaven, that divine love which is the source of the light of divine truth and the heat of divine good. All natural things have their existence from the sun of the world, and all spiritual things from the Sun of Heaven.

The objects our sun illuminates also have their corresponding objects in Heaven; but there space and place have no meaning. And for George Inness the question of place was inessential. The result is that a few of his Italian landscapes are indistinguishable from American scenes and bear alternative titles (*Milton on the Hudson or Perugia*). Also, in the beautiful painting to which someone (if not Inness himself) gave the title *View of Rome from Tivoli* (1872; Dallas), Rome is not visible. When asked to identify the landscape in one of his paintings, he angrily replied, "Nowhere in particular. Do you think I illustrate guide books? That's a picture."[1]

In the 1870s, however, American patrons and dealers did still care as much about the "subject" as the "picture." For that reason Inness contracted with his dealer in Boston—a city that had proven more receptive to his art than had New York—to go to Italy in search of salable subjects. In his famous landscapes of the two preceding decades, the specific scene had greatly mattered: *Lackawanna Valley* (1855; Na-

tional Gallery)—commissioned by the owner of the railroad it depicts—and *Peace and Plenty* (1865; Metropolitan)—celebrating the end of the Civil War. But precisely because he was himself now indifferent to the worldly location of his landscapes, he could go anywhere. So he and his family spent the years 1870–75 in Italy. About a dozen paintings derive from two summers in Perugia, and there are a few from the Tyrol as well. But the bulk of his production from these years consists of over 125 landscapes from the Campagna Romana and the associated hills of Tivoli and Albano. Their titles show all degrees of indefiniteness: *Italy, or Landscape, Souvenir of Italy, Italian Landscape, In the Italian Hills, View near Rome, Olive Grove, or Alban Hills, Twilight in Italy, Twilight (Campagna, Albano), In the Campagna, Glimpse of the Campagna, Storm in the Campagna, Campagna from the North, or Perugia!*

The relatively uneducated Inness apparently had little or no interest in the old classical associations of the landscape that had excited earlier generations and were still assumed by some to be indispensable to the meaning, beauty, and dignity of landscape art. Almost no ruins appear in his Italian paintings of the 1870s (although not unique, *Souvenir of Italy*, fig. 19, is atypical). This removes one element of their specific Roman identity. Nevertheless—and partly as a consequence—Inness produced in these years the most original American paintings to come from the Roman Campagna and its neighboring hills. Purchasers could use the vagueness of the titles as an excuse to make what associations they pleased, whether of Tivoli with Horace, or of Nemi with strawberries they had eaten. And if in one sense it did not matter to Inness whether the scene itself was Massachusetts, New Jersey, or Italy, it is also true that the Roman landscape was deeply sympathetic with his essentially pastoral and religious art. He had been to Rome on three previous occasions, and from the last of these (1850–52)—a visit abruptly terminated by Inness's arrest for refusing to tip his hat to the pope—there are about a dozen paintings of some beauty, although fussily finished in detail and relatively conventional in composition. But on this fourth visit—with his art matured under the influence of the Barbizon painters he had studied in France in 1853, and with his soul informed by the theology of Swedenborg to which he had devoted himself since 1865—he produced some of his finest paintings.

Both elements of his maturity are evident in an anecdote from the Campagna reported by Maitland Armstrong:

> I was one day sketching one of these ruins, a small temple or tomb, the stucco a delicious yellowish tint, with a bright spot of white in the centre of the apse-like top. An almond-tree in bloom hung over it, and beyond was a jumble of delicate flowers and a touch of tender blue sky. I was busily absorbed when I looked up and saw George Inness and T. Buchanan Read. They had just finished lunching together and were in good spirits. Inness remarked, "Your high light in the arch is not bright enough." So handing him my palette and brush, I said, "Do it yourself then," and without taking off his kid gloves he took the brush, mixed up some Naples-yellow and white, steadied himself and gave one dab just in the right spot. . . . He was a small, nervous man, with ragged hair and beard, and a vivacious, intense manner,

an excellent talker and much occupied with theories and methods of painting, and also of religion. I once met him in the White Mountains and we spent several hours talking together, or rather he talked and I listened, about a theory he had of color intertwined in the most ingenious way with Swedenborgianism. . . . Toward the latter part of the evening I became quite dizzy, and which was color and which religion I could hardly tell![2]

Inness himself often testified to the inseparability of his religious conviction and his mastery of painting. His closest friend of his last years, the Reverend Dr. J. C. Ager, said in his eulogy for Inness at a memorial service in 1894:

> To him all nature was symbolic—full of spiritual meaning. He prized nothing in nature that did not stand for something. That was the secret of his theory of art. He cared for no picture that did not tell a story; not necessarily to common minds by this kind of symbolism, but telling a story to the feelings which it suggested, and to the thought to which it gave expression.[3]

This is not a very lucid statement, and Inness's mature paintings have neither crudely allegorical nor narrative content. But it is certain that for Inness they did "stand for" something. In the almost ecstatic act of painting in the studio, he gave expressive form to motifs from the natural world that were inherently meaningful correspondences to spiritual facts. What he "represented" was not nature or historical place but the feeling for and thought of another reality. "The paramount difficulty with the artist," he wrote, "is to bring his intellect to submit to the fact that there is such a thing as the indefinable which hides itself that we may feel after it. But God is always hidden, and Beauty depends upon the unseen—the Visible upon the invisible."[4]

In Swedenborg, objects of this world often have correspondences of surprising but seldom arbitrary specificity. Olive trees, for instance—one of Inness's favorite Italian motifs—"correspond to affection for good and its uses" (*Heaven and Hell*, no. 520). Rocks—so plentifully strewn across Inness's landscapes in preference to ruins—correspond to faith, clefts in rocks to falsities, and hills to spiritual love (no. 188, no. 488). Probably Inness had some sense of these significations, but they are not what convey the meaning of his pictures. Instead, he relies upon the formal element of his art, which he found confirmed in Swedenborg's sense of the abstract truth of science, an objective reality, the perception of which was paradoxically dependent upon uniqueness of personality. In Heaven, Swedenborg had learned, even the angels are infinitely various. But everything in this world, said Inness, including art and religion, tends to become dogmatic, so that one fails to see "the other side." Therefore, "you must find a third as your standpoint of reason. That is how I came to work in the science of geometry, which is the only abstract truth, the diversion of the art of consciousness." In a statement that makes us think of Cezanne, Inness defined "landscape" as "a continued repetition of the same thing in a different form and in a different feeling." Art, science, and religion became synonymous, but "science" for Inness had nothing to do with naturalism, which he

Fig. 45. George Inness. *Italian Landscape*. 1872(?). Oil on canvas. 26½ ×
42¾". Courtesy Museum of Fine Arts, Boston. Bequest of Nathaniel T.
Kidder. (See plate 8.)

despised as materialism, or with the optical studies of impressionism, which he
called "the original pancake of visual imbecility."⁵ It was the purely intellectual
science of geometry that revealed the invisible hidden within the visible.

Inness's landscapes typically contain representatives of all three of the kingdoms
of nature—mineral, vegetable, and animal—to which Swedenborg continually re-
fers. But trees above all were the objects of his affectionate study. On his visits to
Heaven, Swedenborg often delighted in the trees, but they were invariably planted
with mathematical precision in long avenues or in formal gardens. Inness's trees are
never so; his paintings are his formal gardens. On the surface of the canvas, and
within the depths of its perspectives, order is created from motifs recalled from
nature. The spatial relations of what is seen in nature can be altered by one's own
movement or in one's memory in order to discover the abstract truth. In this way,
returning again and again to the groves of olives, pines, and ilexes of Italy, Inness
constantly discloses an ideal world.

In the olive groves—especially those that clung to the slopes rising from the open
Campagna toward Tivoli—Inness found a favorite image. Planted and pruned for
the needs of humanity, they assert a vital irregularity as a part of their dependable
shape, color, and texture. Their inherent form is made to contribute to a geometrical
reality that for Inness underlies the landscape. In *The Olives* (1873; Toledo), the
shadowed horizontal sprawl of the olives in a declivity to the left breaks against a
rigid vertical thrust of poplars on the right. In the sun-filled *Italian Landscape* of
about 1872 (fig. 45), the olives form the dark and continuous top stripe of the lower

Fig. 46. George Inness. *Pine Grove, Barberini Villa, Albano, Italy.* 1874.
Oil on canvas. 30¼ × 45⅜". Virginia Museum of Fine Arts, Richmond.
(See plate 9.)

half of the painting, the dominant band in an alternating series of dark and light greens that rises to a pale blue sky. Where the plateau of the horizon slopes downward at the right of the canvas, a small flat-bottomed cloud continues the straight line and fills in the space. The trees themselves are widely spaced and recessional toward the right; yet their lower branches, cultivated for ease of harvest, seem (from the chosen angle of vision) to spread outward to join in an unbroken line. The stout trunks that support this fruitful growth punctuate the sunny green stretch of grass visible below it, where we see also an isolated human figure and a flock of sheep. On the brilliantly lighted hillside above and beyond, there is an outcropping of rough white stones; below this is a square white farmhouse, while to the left and directly on a line with the stones are blockish white buildings. In this group of images, we see the mineral "kingdom" in both its natural state and (in Swedenborg's view) as reshaped by intelligence and science. By analogy this is what Inness has done with the landscape, building it around his olive grove. The painting is a comprehensive and orderly display of "all that is spread out under the sun and receives the heat and light from the sun."

In the celebrated pine groves of the Villa Barberini at Albano, Inness found another feeling entirely. In the several paintings for which they provided the leading motif, the pines are composed into somber presences that rise from a shadowed earth into otherworldly evening skies. In the version at the Virginia Museum of Fine Arts (1874; fig. 46), they congregate darkly over a row of olive trees whose tops are silver-tipped in the last light of day, a light that also glows softly on a white flock of sheep. The mass of pines slopes downward toward the cubic structures of a town on the left, whose rectilinear rooflines are symmetrically continued on the right by a

Fig. 47. John Gadsby Chapman. *Pines of the Villa Barberini.* 1856. Oil on canvas. 27 × 21". Courtesy Museum of Fine Arts, Boston. Gift of Mrs. Maxim Karolik for the Karolik Collection of American Paintings.

wall. This stony line parallels the white band of the horizon that sharply separates the flat spread of the Campagna from the brownish-golden sky; although the Campagna like a sea reflects the light of heaven and takes on its color, they are not one. That which joins them in this painting is the looming silhouette of the pines.

The pines as seen by Inness hardly seem to be of the same species as those in John Gadsby Chapman's *Pines of the Villa Barberini* (1856; fig. 47), let alone the very same trees. In Chapman's view, the pines are gracile creatures in a park enclosed by a smooth white wall and formal gate, where peasants lounge in the shade and calm ladies recline in the mild light. Here our world is itself of ideal prettiness, with everything smoothly glazed over, including a picturesquely crumbling wall of ancient ivy-draped brick. Browns in the foreground blend into grays, and a lavender Campagna blurs into a misty sky-blue. In the illusion of such souvenir art, the terrestrial paradise is a place we briefly knew in Italy.

How differently Inness felt toward these pines can be seen even more in another of his paintings that they inspired. In *The Pines and the Olives* ("*The Monk*") (1873; fig. 48), the dense mass of the grove is placed on the far right, and from it the spreading crowns of widely separated trees join to form a black peninsula that invades the entire width of the sky. Enough light still falls from above to show a white wall, high, straight, and static, where it appears from behind the opposingly turbulent growths of olive trees. It is in opposition as well to the irregularly extended outline of the pines, which it parallels in the diagonally contrary quadrant of the canvas. On the dim horizon, the gray Campagna meets colorless clouds, separated by a bar of red from the golden sky above, the gold itself both broken by the

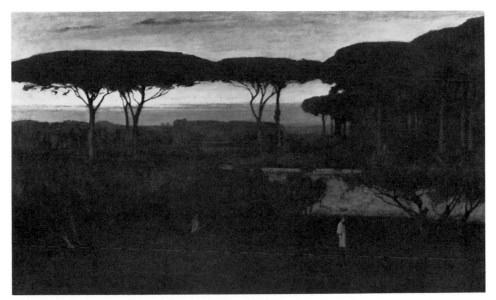

Fig. 48. George Inness. *The Pines and the Olives* (*"The Monk"*). 1873. Oil on canvas. 38½ × 64½". Addison Gallery of American Art, Phillips Academy, Andover, Massachusetts. (See plate 10.)

dark streak of the trees and pierced above them by an elongated eyelet of pale blue-green.

Something of what Inness may have said to Armstrong about the theological meaning of color at their meeting in the White Mountains may be suggested by a passage from Swedenborg concerning that light in Heaven which is "Divine truth, . . . the source of all intelligence and wisdom":

> The planes of that light, in which variegations like those of color exist, are the interiors of the mind; and these variegations are produced by confirmations of Divine truths by means of such things as are in nature, that is, in the sciences. For the interior mind of man looks into the things of the natural memory, and the things there that will serve as proofs it sublimates as it were by the fire of heavenly love, and withdraws and purifies them even into spiritual ideas. (no. 356)

This passage may explain to us the conspicuous presence of the white-robed monk who with hooded head and shadowed down-turned face walks *away* from the sunset he has no further need to observe. The colored planes of light are correspondences to the interiors of his mind, and the olives and the wall, the pines and the natural light itself, are objects of opposing qualities selected from his natural memory—withdrawn, purified, and sublimated by the "fire of heavenly love" into "spiritual ideas." The monk thus corresponds to the artist, and what the painting "stands for" is the profound union of art, science, and theology.

There was another grove, however, isolated upon the bare Campagna not far from the walls of Rome, that drew Inness's attention and arose in his memory more than any other. This was the Sacred Grove of evergreen ilexes, long visited by pilgrims in

the eighteenth and nineteenth centuries as the very place where King Numa Pom-
pilius, successor to Romulus, paid visits by night to the nymph Egeria, one of the
Camenae who had migrated from Arcadia with Evander. The legend is variously
told by Livy, Juvenal, Ovid, and Plutarch, but the essential point is that it was Egeria
who gave the instructions to Numa that determined the forms of Roman religion.
Even after archaeologists in the late 1860s definitively relocated Egeria's nymph-
arium at a place within the present walls, guidebooks still quoted Byron's sophisti-
cated reinterpretation of the story in relation to the site on the Campagna:

> Egeria! sweet creation of some heart
> Which found no mortal resting-place so fair
> As thine ideal breast; whate'er thou art
> Or wert,—a young Aurora of the air,
> The nympholepsy of some fond despair;
> Or, it might be, a beauty of the earth,
> Who found a more than common votary there
> Too much adoring; whatsoe'er thy birth,
> Thou wert a beautiful thought, and softly bodied forth.
> —*Childe Harold's Pilgrimage*, 4:115

When Thomas Cole exhibited his painting (now lost) of the site, Byron's verses were
appended.[6] Because the ardent young Bayard Taylor assumed that this and the four
succeeding stanzas had "cast the sunbeam" of Byron's mind over Egeria's natural
fountain, keeping it eternally fresh, he sought it out to drink of her "Elysian water-
drops." Alas, they were bitter. George Hillard forewarned travelers of disappoint-
ment, but did not deign even to mention Byron, since to him the true legend of Egeria
"is one of the most genuine flowers of poetry that ever started from the hard rock of
the Roman mind," and it signifies—he sententiously and curiously averred—the
need of all great leaders for periods of withdrawal into "solitary self-communion."[7]
 Now it is unlikely that Inness cared for Byron either (even though James Jackson
Jarves called him "the Byron of our landscapists"),[8] and certainly not for his account
of Egeria's "immortal transports" with her "mortal lover." In his six or seven
paintings that show the grove, he gives no indication of the "cave-guarded spring"
with its broken statue at all, as Cole undoubtedly had, along with the American
painter Robert W. Weir, who also painted it in the 1830s. (Paintings by both Claude
and Poussin with the Egeria-Numa myth as subject are of course "historical"
landscapes showing an architecturally elaborate nympharium; Claude's is of Egeria
mourning for her consort, the action that according to Ovid caused her to be turned
into a fountain.) But Inness cannot have so interested himself in this grove without
knowing of the tradition associated with it, working and traveling as he did in the
company of people like Thomas Buchanan Read who possessed a cultivated curi-
osity about mythological "facts."
 At the heart of that legend of Egeria, which takes us back to the very foundations
of Rome, is the acquisition of supernatural insight by a mortal king through union
with a deity. At the same time, she is a sort of fertility goddess, who assured safe
childbirth to those who sacrificed to her. Moreover, in *The Golden Bough* Frazer

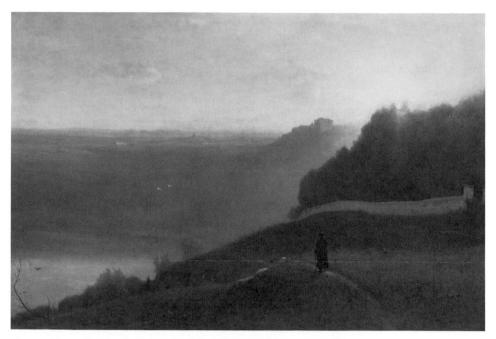

Fig. 49. George Inness. *Lake Nemi.* 1872. Oil on canvas. 30 × 45″. Courtesy Museum of Fine Arts, Boston. Gift of the Misses Hersey.

suggests that Egeria as a nymph of water and woods is an aspect of Diana, or a local Roman version of her. Inness, in living a summer at Albano and painting Lake Nemi several times, would have known the water's serene surface as "The Mirror of Diana," and would have learned that Apollo's sister had been worshiped in ancient times in a sacred grove at Nemi. Such a grove darkly occupies a wedge of space the same size as—and directly counterbalancing—the translucent water of the "mirror" itself in his paintings. In one of two versions in the Boston Museum (1872; fig. 49), water and grove are separated by a pure white wall. Below the point where wall and grove terminate as the hill falls away to the water, a meditative priest walks alone toward the deep space opening before him. Its vast extension out over the Campagna is accentuated by birds flying in midair above the lake; birds, Inness knew from Swedenborg, "correspond . . . to the intellectual things of the natural mind or the spiritual mind" (no. 110).

Pagan belief in the relation of the supernatural to the natural world (short of outright pantheism) was not unsympathetic to Swedenborg; he reports that he was often allowed to converse with the "ancient peoples" (he "had reason to believe" that one was Cicero), and he says of them, "the knowledge of correspondences was the chief of knowledges. By means of it they acquired intelligence and wisdom. . . . The most ancient people, who were celestial men, thought from correspondence itself, as the angels do" (no. 87). Probably, then, Inness returned so many times between 1872 and 1875 to the motif of this pagan grove, not with a thought specifically of Egeria (her name is omitted in the titles) but with a generalized yet real sense of its sacredness. Sometimes it is centrally located on the slopes over its stream-fed vale with Campagna and low hills beyond. Its density makes it a myste-

Fig. 50. George Inness. *In the Roman Campagna.* 1873. Oil on canvas. 26
× 43". Courtesy The St. Louis Art Museum. (See plate 11.)

rious oasis in the open expanse of rock-strewn green fields that swell above the
occasional small and crumbling ruins from the ancient world. A plowman or a
herdsman works alone with his sheep, his oxen, or his cattle—all very small in a
spacious world in which the presence of the dark grove is felt to be the only
immutable thing. In contrast to the groves of olives and pines, no single tree ever
separates itself from the others; all merge into one entity. The Sacred Grove is
something one would enter as into a church.

The most complex reading of the Sacred Grove arises in the three versions that
establish it in relation to the most ancient of Christian basilicas, St. John Lateran.
The second and largest version is now in the Art Museum of St. Louis (fig. 50). As in
all three, the Sacred Grove is seen at a distance on the horizon line just below the
middle of the canvas and left of center. Exactly on a line with it at the center of the
right-hand side, more distant yet but also forming part of the horizon, the gigantic
white façade of St. John Lateran rises over the walls of Rome. At this distance all
baroque detail disappears; façade, church, papal palace, and the neighboring build-
ings are reduced to pure rectangles defined by white light and blue shadow. The
painting is thus evenly balanced between two simplified images—one of natural
vitality, the other of geometrical transformation—which are significant in them-
selves but enhanced in meaning by their specific associations with the two religious
traditions of great antiquity, paganism and Christianity, that are inextricably a part

134

of the identity of Rome. The city is mistily indicated all along the horizon and blends into the sky itself. In Inness's other paintings of the Sacred Grove not only is the Grove central but the earth from which it arises occupies two-thirds of the canvas. In these versions where it shares the natural world with the spiritualized stones of St. John, the kingdoms of rocks, animals, and vegetation take less than half the space. Above all that is "spread out under the sun" in this bright painting looms a blue heaven dotted with flying birds and measured off by perfectly horizontal striations of clouds.

Yet the natural world of *this* Campagna, which spreads indefinitely beyond both sides of the canvas and behind us as we look toward Rome, is one of sufficient abundance for natural man. Just below the Sacred Grove is a strip of green of a different shade, indicating a cultivated field, and at the far left on the horizon are what appear to be huge square stacks of hay. (Just below them three arches of dark grottoes—perhaps parts of the nympharium—open mysteriously into the earth.) At the exact center, just below the horizon, is a single shepherd, and his grazing flock is strung out along the curve of a grassy sunken meadow. Far to the right in a sunny lower vale is a herd of white cattle. Nearer to the foreground a vigorous small tree rises beside the fallen trunk of a large one that has died. In the extreme foreground on the left, a contadina kneels beside an ancient culvert, cooking over a small fire, from which smoke rises as from a sacrifice. Near her are some sheep, which—says Swedenborg—correspond to "the affections of the spiritual mind."

The Roman pastoralism of Inness then is filled with religious feeling and allusive thought. It is not retrospective or nostalgic, but seeks suggestion of the eternal and spiritual in the present and natural. When buildings appear, as they usually do, typically as a part of the horizon line, they are seldom ruins and almost never monumental ones. They are works of strong and simple geometrical force, and they are made to function in the design of the painting in relation to the usually more dominant trees. The presence of St. John Lateran in the paintings of the Sacred Grove reminds us too how often the buildings in Inness's Italian works have religious significance. The walls of abbeys and the towers of churches and convents occur frequently, as does the dome of St. Peter's in the distance against the sky. But just as notable is the way in which roads and walls follow straight lines or swerve in natural curves, as though defining the abstract squares and spheres inherent in the shape of the earth.

Hidden within the visible is the invisible reality of mind and spirit. The artist perceives and reveals it—using, paradoxically, the art of the visible. Evil is, of course, a part of the natural world, as there is also a Hell which has its correspondences here. But it is not this all too evident reality with which the artist occupies himself. He is concerned instead with the correspondence of the mind to the reality of Heaven. In Heaven Swedenborg learned a new version of Ovid's Golden Age. It was then that "the most ancient people on earth . . . thought from correspondences themselves, the natural things of the world before their eyes serving them as the means of thinking." With this capacity, they talked with angels, who were their friends (no. 115). For an artist like Inness, with the natural things before his eyes serving as a means of thinking, that Golden Age is now.

The "Illimitable Experience" of Henry James

During the years that Inness was resident in Rome, the young Henry James made his second and more extended visit, from late December 1872 until mid-May of 1873. He was in Rome again in April of 1881, the year in which he completed *The Portrait of a Lady*. As we have seen in an earlier chapter, a sequence of Roman settings symbolically related to his heroine's experience and deepening character included the Campagna as well as the Forum and the Colosseum. A distinction between walks in the desolate Campagna and carriage rides in the sociable Villa Borghese is established early after Isabel Archer's marriage to Gilbert Osmond. The Campagna becomes an almost daily habit with Isabel, while the villa is the natural preference of her still-innocent stepdaughter Pansy (chap. 40). Later, immediately after Isabel's discovery of the deep duplicity of her friend Madame Merle and Osmond, it is to the Campagna that she naturally turns. The view from the "low parapet which edges the wide grassy space before the high, cold front of Saint John Lateran"—a reversal of the direction of Inness's painting (fig. 50)—is "across the Campagna at the far-trailing outline of the Alban Mount and at the mighty plain, between, which is still so full of all that has passed from it." Everywhere Isabel feels "the touch of a vanished world." Leaving the carriage,

> she strolled further and further over the flower-freckled turf, or sat on a stone that had once had a use and gazed through the veil of her personal sadness at the splendid sadness of the scene—at the dense, warm light, the far gradations and soft confusions of colour, the motionless shepherds in lonely attitudes, the hills where the cloud-shadows had the lightness of a blush.

In such a place Isabel can contemplate the possibility that "the great historical epithet *wicked*" could apply to an intimate friend of hers. After all, she had complacently assumed ignorance of wickedness while at the same time desiring "a large acquaintance with human life." In the vast extension of that acquaintance now forced upon her, she must accept that Madame Merle has been "deeply false." Yet, as she looks out upon the ghostly plain where almost nothing of human life remains, she is moved to compassion. She ends her "silent drive" with the "soft exclamation: 'Poor, poor Madame Merle!'"[1]

This scene is the last in a series of "views of the Campagna" written by Henry James. The series charts the efforts of a great writer to find a vision and a style that can encompass both romantic idealism and historical realism, both free invention and disciplined representation, both the beautiful reality of innocence and the fact of its inevitable loss. James's self-conscious awareness of the alternatives available to him is evident in the neatly opposed characterizations of "Adina," a tale written not long after his second visit to Rome, but before *Roderick Hudson*. A character named Scrope exists to undercut the affected romantic attitudes of the narrator: "If we met a shepherd on the Campagna, leaning on his crook and gazing at us darkly from the shadow of his matted locks, I would proclaim that he was the handsomest fellow in the world, and demand of Scrope to stop and let me sketch him. Scrope would confound him for a filthy scarecrow and me for a drivelling album-poet."

Naturally, when they come upon the person—called Angelo, of course—who is to be the central figure of the story, sleeping beneath a tree, "it was not more than I owed to my reputation for Byronism," says the narrator, "to discover a careless, youthful grace in the young fellow's attitude. . . . 'An American rustic asleep is an ugly fellow,' said I, 'but this young Roman clodhopper, as he lies snoring there, is really statuesque.'" While the artist gazes at the "rustic Endymion," Scrope the antiquarian connoisseur spots a gem in his hand. When the young man awakes, the narrator finds his smile "very simple,—a trifle silly," but he has "the frame of a young Hercules; he was altogether as handsome a vagabond as you could wish for the foreground of a pastoral landscape."[2] Within this superciliously composed Arcadian framework, James tells the story of the transformation of a true innocent into a man driven to revenge. Cheated by Scrope, he in effect is moved to entrap Adina, Scrope's fiancée, who is herself an embodiment of American innocence. He loses a genuine Arcadian simplicity as a result of his encounter with the grasping modern world. Ironically, the American intruders into the Campagna, by treating Angelo as either a filthy scarecrow or as the silly provoker of aesthetic clichés, have themselves produced the reality that justifies their skepticism.

James's own exhilarated experience of the Campagna in the winter of 1869 and the spring of 1873 is directly memorialized in a lyrical essay called "Roman Rides," first published in August 1873 in the *Atlantic Monthly* and much later collected in *Italian Hours*.[3] It is his equivalent to a series of paintings, and the analogy with art is an explicit motif. When it was first published, he wrote apologetically about these "Italian scribbles" to Mrs. Sarah Butler Wister, who had befriended him in Rome. He justifies "the rather high-falutin *Atlantic* Rides" by saying "I had to make up for small riding by big writing. But what's the use of writing at all, unless imaginatively? Unless one's vision can lend something to a thing, there's small reason in proceeding to proclaim one has seen it."[4]

In fact, James's vision added substantially to the Campagna, and the essay is a beautiful achievement, far more complex than his letter would suggest. A major theme of "Roman Rides" concerns precisely one's capacity to *envision* the totality of an experience and to hold it in an "after-vision." Gazing into the "remoter distances," he "measured the deep delight of knowing the Campagna. But I saw more things than I can easily tell." Yet to convey that wider knowledge, *to tell* what he saw, was the point of the essay. Thirty years later, while revising his novels of this period, *Roderick Hudson* and *The American*, James was moved to define as "romantic" the "things that can reach us only through the beautiful circuit and subterfuge of our thought and our desire." Romance is not unreality, he insisted; it is "experience liberated."[5] So, in "Roman Rides," he had claimed that for someone in Rome, a ride on the Campagna was "the most romantic of all your possibilities,"—"an illimitable experience."

"Roman Rides" is filled with crosscurrents of perception, opposing tendencies of thought and sensibility, upsurges to rhetorical sublimities and descents into ironic moderations. Its long paragraphs stride forward through almost imperceptible associative shifts in observation and comment; yet there is much backtracking to earlier organizing reference points, and the whole follows a discursive route that covers all the ground and even points out certain pitfalls to be avoided. It concludes safely back among the sociable paths of the Villa Borghese.

The imagery of the opening sentences introduces the essay's two primary thematic oppositions. James reaches the Campagna by crossing the Ponte Molle, "whose single arch sustains a weight of historic tradition." The light of the Campagna is "full of that mellow purple glow, that tempered intensity, which haunts the after-visions of those who have known Rome like the memory of some supremely irresponsible pleasure." Ponderous didactic historicism on the one hand, and pure purple aestheticism on the other, are not so easily separable, however. Significantly, James cannot speak simply of "supreme pleasure"; the echo of Hawthorne requires the word "irresponsible," pronouncing a judgment even while cherishing a memory. What drives the essay on, in fact, is the wish to come out somewhere onto a high prospect that validates an *imaginative* mode of perception as *serious,* as the true means to "illimitable experience." Within the imaginative mode itself, framed and given sensuous specificity by its aesthetic qualities, one can synthesize the meanings implicit in the facts of what one observes—whether facts of ruin and of degraded life or of resurgent nature and of urban sociability. One can discover the full resources of both one's personal vision and one's medium of expression. This thesis, of course, is itself more implicit than manifest in an essay that, superficially read, seems merely descriptive and evocative rather than reflective and argumentative. But it is there.

The initial perspective is one that sees the Campagna as the complement to the Rome within the walls. The two together make possible a "double life." Within the walls is the "world" with its shops, theaters, cafés, "balls and receptions and dinner-parties, and all the modern confusion of social pleasures and pains"; and beyond "the great gates," half an hour away, where the city seems "a hundred miles, a hundred years, behind," there is this:

> the tufted broom glowing on a lonely tower-top in the still blue air, and the pale pink asphodels trembling none the less for the stillness, and the shaggy-legged shepherds leaning on their sticks in motionless brotherhood with the heaps of ruin, and the scrambling goats and staggering little kids treading out wild desert smells from the top of hollow-sounding mounds.

James is so impressed by the mutual accessibility of these two regions of experience that he invents a friend to elaborate for two pages on "this mingled diversity of sensation." A day that begins with a long ride to a castellated farmhouse sometimes seen in the paintings of Claude Lorrain ends with a dinner party at a Roman villa where he observes "flounces of Worth" trailing over the "rare antique mosaic" in the hall leading to the drawing room. Although there is a play upon the name of the fashionable Parisian couturier whose "flounces" are weighed by the "rare antique mosaic," the "world" is not denigrated. After all, it and not the Campagna will be the primary ground for James's imaginative investigations. The breadth of possible experience is precisely what James appreciates about Rome. But for this essay he is willing to claim that the Campagna is "the larger half," implicitly because it is the more romantic half—that is, unlimited by the contingencies of historic and social experience, which belong to the province of realism. His designation of the experience within the walls as "the world," moreover, clearly assigns the experience of nature and ruins beyond the walls primarily to the spirit.

That experience begins with the fact and character of the walls themselves:

> City walls, to a properly constituted American, can never be an object of indif-
> ference. . . . A twelvemonth ago the raw plank fences of a Boston suburb, inscribed
> with the virtues of healing drugs, bristled along my horizon: now I glance with idle
> eyes at a compacted antiquity in which a more learned sense may read portentous
> dates and signs—Servius, Aurelius, Honorius. But even to idle eyes the prodigious,
> the continuous thing bristles with eloquent passages.

Nearly half a century earlier, the great romancer James Fenimore Cooper had felt
the same emotion. But he had conscientiously circled the entire city on horseback,
going from gate to gate, in an active attempt to cultivate the "more learned sense"
that James eschews. In *Gleanings in Europe: Italy,* Cooper reported both his obser-
vations and his researches (chiefly into Mariano Vasi's elaborate guidebook), in two
"Letters" (xxii–xxiii) which might also have been entitled "Roman Rides." But his
pedantic prose plods along at a weary pace:

> The gate beyond is the Porta Salaria. Alaric entered the city at this point; and the
> Gauls, more remotely, penetrated by the Porta Collina, which was the counterpart
> of the present gate, in the wall of Servius, though necessarily less advanced than
> this. Hannibal is also said to have manifested an intention to attack the town on
> this side, whence it is inferred it was the weaker quarter.

Such writing makes one grateful that James was content to remain archaeologically
ignorant. But Cooper does rise occasionally to a certain playfulness:

> One might almost fancy himself on a prairie of the Far West, such is the wasted as-
> pect of the country, as well as the appearance of the rapid, turbid Tiber. Diverging
> from the stream, which inclines north again, taking the direction of the mountains
> where it rises, we next enter some fields imperfectly fenced, among which a
> Tityrus or two are stretched under their *patulae fagi,* not playing on the oaten reed
> it is true, but mending their leather leggings.

But the only thing for which Cooper shows real enthusiasm is the white horse he is
riding, a "fine beast" of the princely Chigi breed, with "great powers of endurance,
as well as foot and fire."[6]

Cooper and James faced the same challenge: how to fill up a blank money-
making page with an emptiness called the Campagna. Cooper met it by borrowing
archaeological facts from Vasi. But James accepted the challenge as though his very
life as an artist depended upon it. Just before returning to Rome the previous
December he had defended himself from the accusation of "over-refinement," an
accusation lodged by his brother William and by Howells, by saying that "writing
not really leavened with thought" (like Cooper's letters) was "unprofitable" for
him. To "work one's own material closely is the only way to form a manner on
which one can keep afloat," he said. "I have a mortal horror of seeming to write
thin—and if I ever feel my pen beginning to scratch, shall consider that my death-
knell has rung."[7] Consequently, while writing about the Campagna James can find

the "luxury of landscape" visible on a mere wall—"as little as possible a blank partition," but richly expressive as it crumbles "grain by grain, coloured and mottled to a hundred tones by sun and storm, with its rugged structure of brick extruding through its coarse complexion of peeling stucco, its creeping lacework of wandering ivy starred with miniature violets, and its wild fringe of stouter flowers against the sky."

James evokes as well as anyone the wasteland Campagna, the "far-strewn wilderness of ruins—a scattered maze of tombs and towers and nameless fragments of antique masonry." He sees its oppositions of brightness and sadness and hears how though "so still" it is "yet so charged, to the supersensuous ear, with the murmur of an extinguished life." And since he is writing in 1873, just after the fall of that papal Rome which he had visited in its last days in 1869, he is conscious of what seems a new feature in the Campagna's surfeit of historical loss: the Church, belonging now among the "vanished powers," is being assimilated into the general ruin of Rome. While riding beneath the wall of the Villa Doria, near Porta San Pancrazio, James finds "monumental consolation" for the "meagre entertainment of this latter Holy Week" in a visit to the "pompous ecclesiastical gateway of the seventeenth century, erected by Paul V to commemorate his restoration of the aqueducts. . . . One can hardly pause before it without seeming to assist at a ten minutes' revival of old Italy—without feeling as if one were in a cocked hat and sword and were coming up to Rome, in another mood than Luther's, with a letter of recommendation to the mistress of a cardinal."

If the Church now shares in "that forlornness which lurks about every object to which the Campagna forms a background," the dilapidated villas and vineyards along the roads just beyond most gates to the city have clearly sunk into that state long ago. "Rusty cypresses" border avenues that lead to "a couple of acres of little upright sticks blackening in the sun, and a vast sallow-faced, scantily windowed mansion, whose expression denotes little of the life of the mind beyond what goes to the driving of a hard bargain over the tasted hogsheads." The "asker of curious questions" is likely to find the "life of the mind . . . the very thinnest deposit of the past." A "mythological group in rusty marble—a Cupid and Psyche, Venus and Paris, and Apollo and Daphne" is "the only allusion savouring of culture that has been made on the premises for three or four generations." By what mental effort does one keep in perspective such depressing realities, without wholly repressing them as an important part of the truth? How can one simply admire the "fine eyes and intense Italian smile" of the "rabble of infantile beggars" one encounters at the primitive taverns along the way, without recalling that the victory of Porta Pia three years before "had no direct message for Peppino's stomach—and you are going to a dinner-party at a villa"? Or that when you toss him a copper, you confirm him in his vices, and he grows up a beggar?

These questions are only indirectly formulated in the essay. But although James characterizes himself as merely the curious asker and recorder, he is actually searching for the right attitude to be assumed by the imaginative observer of life whose medium is unlimited either by scientific discipline or by political engagement. He suggests that the sensitive have their own forms of insensitivity, and are liable to both self-indulgent fantasies and an excessive valuation of creature com-

forts. Competing attitudes are rendered and acknowledged in a curiously shifting passage far along in "Roman Rides." Writing as a connoisseur of sensations, James tells the reader that in going cityward at twilight, he can see the Campagna "to the last point its melancholy self," and the "landscape has details of the highest refinement, . . . 'effects' of a strange and intense suggestiveness":

> Certain mean, mouldering villas behind grass-grown courts have an indefinably sinister look; there was one in especial of which it was impossible not to argue that a despairing creature must have once committed suicide there, behind bolted door and barred window. . . . Every wayside mark of manners, of history, every stamp of the past in the country about Rome, touches my sense to a thrill, and I may thus exaggerate the appeal of very common things. This is the more likely because the appeal seems ever to rise out of heaven knows what depths of ancient trouble. To delight in the aspects of *sentient* ruin might appear a heartless pastime, and the pleasure, I confess, shows the note of perversity. The sombre and hard are as common an influence from southern things as the soft and the bright, I think; sadness rarely fails to assault a northern observer when he misses what he takes for comfort. Beauty is no compensation for the loss, only making it more poignant. Enough beauty of climate hangs over these Roman cottages and farm-houses—beauty of light, of atmosphere and of vegetation; but their charm for the maker-out of the stories in things is the way the golden air shows off their desolation.

James winds up here seriously enough, explicitly claiming for himself the point of view of the "maker-out" (not the pure inventor) of stories. Nor should the word *charm* mislead us; it is used as it is by Hawthorne, in the sense of what casts a spell; and as with Hawthorne, the spell is cast by the ironic function of nature's "golden air" as the revealer of human desolation. What is "perverse" in the passage is that immediately after having accepted the risk of seeming perverse in taking pleasure in "sentient ruin," James immediately trivializes the famous sadness of the Campagna as perceived by northerners by suggesting that it is largely an effect of beauty perceived in *discomfort*. That this is his point becomes clear when he turns to specifics and to humor: when you find yourself sitting under "an arbour of time-twisted vines . . . with your feet in the dirt," you may "remember as a dim fable that there are races for which the type of domestic allurement is the parlour hearth-rug." James concludes the passage with a declaration of vocation that finally does admit to limits of expressibility ("apparent or otherwise," "beyond expression"), and uses another word—*amuse*—that like *charm* apparently trivializes unless its stronger suggestion of enchantment is recalled: "For reasons apparent or otherwise these things amuse me beyond expression, and I am never weary of staring into gateways, of lingering by dreary, shabby, half-barbaric farm-yards, of feasting a foolish gaze on sun-cracked plaster and unctuous indoor shadows."

At this point James abruptly remounts his horse (so to speak) and changes directions, reminding himself that in the Campagna the preceding considerations are mere "wayside effects," incidentals, genre scenes. What the great artist seeks is something more general: "the strong sense of wandering over boundless space, of seeing great classic lines of landscape, of watching them dispose themselves into

pictures so full of 'style' that you can think of no painter who deserves to have you admit that they suggest him." In the ensuing (and penultimate) two paragraphs of the essay James brings to culmination and justification two strands of thought and feeling, which through their conveying imagery give "Roman Rides" its unity. One is a celebration of pure sensuous pleasure, which is achieved through direct particular images of the colors, smells, and textures of nature. The other relies upon metaphors of art and is a tribute to the ways in which actual experience and aesthetic-literary traditions are interdependent and mutually enhancing.

The first strand makes "Roman Rides" remarkable for its color effects. In the first paragraph alone we move through the "mellow purple glow" of an opening light toward the checkered "blue and blooming brown" of the slopes and dales, observe the "alternation of tones" of sapphire and amber in the lights and shadows "at play on the Sabine Mountains," and make out at a distance "among blue undulations," "some white village, some grey tower." The ramparts of the city glow "in the late afternoon with the tones of ancient bronze and rusty gold." But the chief accents of color in the Campagna come from the flowers, which are particularized: the tufted yellow broom, the "pale pink asphodels," the white daisies and narcissuses, "pale anemones," scarlet poppies, honeysuckle, wild roses, cyclamen, and violets. The ground for all this brilliance is the grass, brown or green according to season, or the sky—seen through loopholes in the ivy-draped walls—fading from purple to violet and from blue to azure according to the time of day. The profusion of flowers scattered through the essay makes the absence of trees the more conspicuous; James mentions only the "dusky cypresses." (In contrast, "Roman Neighbourhoods," a companion essay, pays separate tribute to the oak, the ilex, and the olive, as well as the cypress in the landscape of Albano.)

In a Campagna strewn equally with Arcadian flowers and Wasteland ruins, the latter are finally submerged in the consciousness of spring through which this sensuous strand reaches its climax:

> Far out on the Campagna, early in February, you feel the first vague earthly emanations, which in a few weeks come wandering into the heart of the city and throbbing through the close, dark streets. Springtime in Rome is an immensely poetic affair; but you must stand often far out in the ancient waste, between grass and sky, to measure its deep, full, steadily accelerated rhythm.

Spring proclaims its achieved reality by filling the desert air with the "disembodied voice of the lark":

> It comes with the early flowers . . . and makes the whole atmosphere ring like a vault of tinkling glass. You never see the source of the sound, and are utterly unable to localise his note, which seems to come from everywhere at once, to be some hundred-throated voice of the air. Sometimes you fancy you just catch him, a mere vague spot against the blue, an intenser throb in the universal pulsation of light.

This sense of natural triumph is pure but brief. The fact is that the sense of nature elsewhere is tempered with a note more reminiscent of Keats than of Shelley.

"Roman Rides" begins in "mild midwinter, the season peculiarly of colour on the Roman Campagna," and the first mention of spring (in the interpolated statement by a "friend") characterizes it as "spring with a foreknowledge of autumn, . . . to be enjoyed with a substrain of sadness, the foreboding of regret." And immediately after spring arrives, in the same paragraph one begins to feel "the dead weight of the sun." The "Roman air" ceases to be "tonic" or exercise "exhilarating." "It has always seemed to me indeed part of the charm"—that word again—"that your keenest consciousness is haunted with a vague languor":

> Occasionally when the sirocco blows that sensation becomes strange and exquisite. Then, under the grey sky, before the dim distances which the southwind mostly brings with it, you seem to ride forth into a world from which all hope has departed and in which, in spite of the flowers that make your horse's footfalls soundless, nothing is left save some queer probability that your imagination is unable to measure, but from which it hardly shrinks.

Approaching the unknown limits of imagining despair and death as the end experience of the sensuous life, experience against which spring and flowers are powerless, James *does* shrink back through the use of colloquial language and distancing laughter: "This quality in the Roman element may now and then 'relax' you almost to ecstasy; but a season of sirocco would be an overdose of morbid pleasure."

The other strand of the essay that implicitly develops a theme is one composed of allusions to the art of painting as a means of shaping experience and giving it imaginative extension. "One's rides," James asserts at the beginning, "give Rome an inordinate scope for the reflective—by which I suppose I mean after all the aesthetic and the 'esoteric'—life." An extended passage at the middle of the essay displays this "inordinate scope" in relation to the Claudian aqueduct:

> It would be difficult to draw the hard figure to a softer curve than that with which the heights sweep from Albano to the plain; this is a perfect example of the classic beauty of line in the Italian landscape—that beauty which, when it fills the background of a picture, makes us look in the foreground for a broken column couched upon flowers and a shepherd piping to dancing nymphs. At your side, constantly, you have the broken line of the Claudian Aqueduct, carrying its broad arches far away into the plain. . . . It stands knee-deep in the flower-strewn grass, and its rugged piers are hung with ivy as the columns of a church are draped for a festa. Every archway is a picture, massively framed, of the distance beyond—of the snow-tipped Sabines and lonely Soracte.

After describing the flowers "in the shifting shadow of the aqueducts" and the ivy that hangs with "light elegance" from the "empty conduits," leaving clear the "mighty outlines," James concludes that they seem "the very source of the solitude in which they stand; they look like architectural spectres and loom through the light mists of their grassy desert, as you recede along the line." It is true that you have applauded these and other ruins in "many an album. But station a peasant with sheepskin coat and bandaged legs in the shadow of a tomb or tower best known to

drawing-room art, and scatter a dozen goats on the mound above him, and the picture has a charm which has not yet been sketched away."

That peasant, however, is more of a problem for James than he was for the more conventional painters, since there is no excuse for him to be only staffage. In his initial description of a typical scene offered by a ride, he places in "the foreground a contadino in his cloak and peaked hat" jogging along on his ass. The perception a little later of a "motionless brotherhood" between the "shaggy-legged shepherds" and the "heaps of ruins" seems to be meant merely as a felicitous visual figure. The "friend," in describing his typical day, includes a genre scene perceived at the very farmhouse sanctified by Claude Lorrain, a "handsome child swinging shyly against the half-opened door of a room whose impenetrable shadow, behind her, made her, as it were, a sketch in bituminous water-colours." But without a sense of damage to the picturesque, the friend goes on to describe her father as "a handsome, pale, fever-tainted fellow," while a "ragged shepherd, driving a meagre straggling flock" is "a perfect type of pastoral, weather-beaten misery. He was precisely the shepherd for the foreground of an etching." Fever, rags, misery: these are not the usual elements of pastoral landscape; yet there is no tone of conscious irony here. But at the culmination of this strand of thought at the end of the essay, James brings it to a suggestive point; he reaches a limit to what is possible in the genre he is working in, while suggesting limitless thought and experience beyond.

Looking across the Campagna at Soracte, admiring how it "rises from its blue horizon like an island from the sea and with an elegance of contour which no mood of the year can deepen or diminish," James—following in the footsteps where we have seen that earlier aesthete N. P. Willis, but extending his thoughts—writes:

> You know it [Soracte] well; you have seen it often in the mellow backgrounds of Claude. . . . A month's rides in different directions will show you a dozen prime Claudes. After I had seen them all I went piously to the Doria gallery to refresh my memory of its two famous pictures and to enjoy to the utmost their delightful air of reference to something that had become a part of my personal experience. . . . Claude must have haunted the very places of one's personal preference and adjusted their divine undulations to his splendid scheme of romance, his view of the poetry of life.

A sketch James was shown was "almost startling in its clear reflection of forms unaltered by the two centuries that have dimmed and cracked the paint and canvas." Forms that establish continuities in human sensibility and experience, the splendid scheme of romance that defies contingencies and shapes a new reality, the infusion of poetry into life—do these require defense? Is not to "tell all" to tell of these too? James concludes by emphatically affirming the richness, the imaginative "limitlessness" that Rome thus makes possible. There is "an intellectual background of all enjoyment in Rome," he argues. Your "sensation rarely begins and ends with itself; it reverberates—it recalls, commemorates, resuscitates something else."

One thing that the Campagna "resuscitates" is Arcadia. The place can be found an hour's ride from Porta Cavalleggieri:

The exquisite correspondence of the term [Arcadia] in this case altogether revived its faded bloom; here veritably the oaten pipe must have stirred the windless air and the satyrs have laughed among the brookside reeds. Three or four long grassy dells stretch away in a chain between low hills over which delicate trees are so discreetly scattered that each one is a resting place for a shepherd. The elements of the scene are simple enough, but the composition has extraordinary refinement.

But consider more closely one "simple element":

By one of those happy chances . . . a shepherd had thrown himself down under one of the trees in the very attitude of Meliboeus. . . . Lying thus in the shade, on his elbow, with his naked legs stretched out on the turf and his soft peaked hat over his long hair crushed back like the veritable bonnet of Arcady, he was exactly the figure of the background of this happy valley. The poor fellow, lying there in rustic weariness and ignorance, little fancied that he was a symbol of old-world meanings to new-world eyes.

This shepherd lends himself to the Arcadian fantasy by being neither feverish nor conspicuously ragged. Yet James can see that he is probably more truly an emblem of "rustic weariness and ignorance" than of Arcadia. In suggesting that he is nevertheless "a symbol of old-world meanings to new-world eyes," James opens up a prospect of thought even as he draws a limit to his own reading: how was it that, in the course of the nineteenth century, Arcadia had become again only an "old-world meaning," and the "new-world eyes," their own innocence lost, now sought its aesthetic and imaginative relevance with a nostalgia formerly borrowed, but now their own?

Death and Arcadia

In 1908 the aging William Dean Howells roared out into the Campagna in an automobile, cheered on his way by joyfully shouting children and barking dogs. Along the rough road to Tivoli there lay a new tram line, and he also saw signs of agricultural reforms. But there were still the aqueducts, and the humps of "turfed-over chunks of antiquity," and in general an unvaried impression of the dead: "Once we came to a battlemented tomb of mighty girth and height, as perdurable in its masonry as the naked, stony hills that in the distance propped the mountains fainting along the horizon under their burden of snow." As Howells rises into the olive groves of Tivoli, however, the image and feeling change: "The olive is a tree which, of all others, is the friend of civilized man; it is older and kinder even than the apple, which is its next rival in beneficence." The resemblance between apple and olive allows the thought that "this boundless forest of olives around Tivoli offered an image of all the aggregated apple-orchards in the world. . . . You felt a racial intimacy with the whimsical and antic shapes which your brief personal consciousness denied in vain; and you rose among the slopes around Tivoli with a sense of home-coming from the desert of the Campagna."[1]

This is by now a familiar opposition between desert and grove. We have seen it, for example, in some paintings by Inness, and it is curious that when Howells arrives at Tivoli he finds it, in spite of the "long tumult of its history, beginning well back in fable, as peaceable as Montclair, New Jersey."[2] Montclair was the place where George Inness (whom Howells must have known in the early 1890s as a fellow member of New York's Century Club) finally settled, and where his paintings included groves of apple trees that do recall his olive groves of Tivoli. Whether or not Howells's reference to Montclair constitutes an allusion to Inness, there is a shared sense of "home-coming" to a "peaceable" kingdom of trees with which one has even a "racial intimacy." This is a feeling for Arcadia, from which the tomb is excluded. It is not that tranquillity mixed with sadness which Erwin Panofsky found to be the Vergilian resolution to the conflict between human suffering and a "superhumanly perfect surrounding."[3]

In a well-known essay Panofsky traced the initial permutations of the *Et in Arcadia ego* theme. To consider that theme is to think about the meaning of Arcadian shepherds (which we are not), of terrestrial happiness (which we might intermittently know, perhaps in Italy), of our mortality (which is certain), and the relation among these as represented in art and literature. As Panofsky shows, the conception of "Et in Arcadia ego" was apparently invented by Guercino in 1621–23 as a memento mori in a painting (fig. 51) now in the Galleria Nazionale d'Arte Antica, Rome. It shows a death's-head asserting his presence in Arcadia to two solemn shepherds. The concept was first modified by Poussin in the following decade by the addition of a disheveled young woman and a tomb, the inscription on which the shepherds excitedly try to decipher (fig. 52; Chatsworth). In a second version by Poussin (fig. 53; Louvre), the new meaning—that it is the dead Arcadian and not Death itself that speaks—is even clearer, for the skull has been omitted, and three shepherds and a woman meditate upon the phrase, to which one points while another traces its letters. Poussin has in effect altered the tense, so that the phrase no longer means "I am even in Arcadia," but rather "I too lived in Arcadia," thus beginning its long decline into simple nostalgia. For Goethe it would mean simply "I was also once in Italy," for Evelyn Waugh, "I too was once young and at Oxford," and for Faulkner's drunken Mr. Compson in *The Sound and the Fury*, nothing very coherent at all.[4]

Panofsky overstates the difference between the two sentiments as represented by Guercino and Poussin ("we can observe a radical break with the mediaeval, moralizing tradition"), since a memento mori is strongly implicit even in Poussin's second version. Panofsky writes: "The Arcadians are not so much warned of an implacable future as they are immersed in mellow meditation on a beautiful past. They seem to think less of themselves than of the human being buried in the tomb."[5] It is not at all clear that this generalization is true. Does the troubled face of the youth who turns to the full-bodied woman who places a comforting hand on his shoulder (and whom Panofsky calls a "lovely girl") express "mellow meditation on a beautiful past"? Surely not. The woman herself gazes at neither tomb nor inscription, but at the earth; it has been said that she is not a "shepherdess" at all, but a "telluric" emblem.[6] In any case, these intelligent-looking shepherds are capable of drawing an inference and giving it personal application. Why should they study the monument's portentous phrase (not the name of the defunct shepherd), if they are pri-

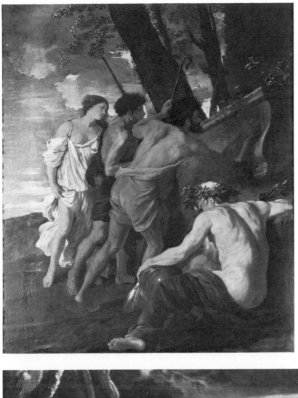

Fig. 52. Nicolas Poussin. *Et in Arcadia Ego.* ca. 1630. 1.00 × 0.81 m. Devonshire Collection, Chatsworth.

Fig. 51. Guercino. *Et in Arcadia Ego.* 1621–23. Oil on canvas. 82 × 91 cm. Galleria Nazionale d'Arte Antica, Rome. Photo from Istituto Centrale per il Catalogo e la Documentazione, Rome.

marily absorbed in the "memory of one who had been what they are"? The realization that they will lose the felicity that someone else has lost is not a merely subordinate idea. Moreover, the realization itself constitutes the first step in the loss. The idea in Poussin as well as Guercino is that Arcadia's illusion of total happiness is destroyed or at least deeply shadowed by the consciousness of mortality.

Panofsky identifies two differing responses to this consciousness, the moralistic and the elegiac, depending upon whether the consciousness is taken as a "warning" or as an occasion for "sweet, sad memories."[7] For our purpose, which is to conclude upon the subject of American responses to the Campagna as both Arcadia and Wasteland, it is important to consider how the condition and mood of the Arcadians in Guercino and Poussin and in later paintings including those by Americans relate to the situation of the viewer and to the mood or message supposedly conveyed to him. It is also necessary to consider the specific images employed to convey the condition, the mood, and the message. By and large American paintings and writings that employ the elements of the "Et in Arcadia ego" theme—Arcadia and death—separate them or join them with other considerations, with the result that they neither moralize to the same point nor elegize about the same loss.

As we have seen, the images of tombs in American painting and writing related to the Campagna are not of shepherds' tombs, and they are not given an Arcadian setting. Byron asked of Cecilia Metella, "how lived—how loved—how died she?" and we may answer, definitely not as a shepherdess. Nor were Pompey or the Scipios shepherds. The images in the younger Chapman's painting of the Appian Way (fig. 18) are of aristocratic tombs which seem wholly irrelevant to the peasants, who ignore them. Panofsky observes the less sensational, more intellectual effect that results when in Poussin's works a classical tomb finally replaces a human skull as the sole image of Death. A change in reference and effect is even greater when paintings show monumental ruins of aqueducts and temples instead of tombs, as in Claude and Cole. An entire civilization is implicated in the doom. The elegiac tone employed in evoking the famous "sadness" of the Campagna has nothing to do with the loss of Arcadia; it has to do with the loss of the very opposite: wealth, power, and empire. It is with this sort of loss, individual and national, that Americans, and the British before them, can identify. If the aristocratic and clerical patrons of Guercino and Poussin could identify their own happiness with that of simple, happy Arcadians in need of a sobering message, few Americans or British did so. But what they perhaps did need to think about was "the course of empire," the futility of riches, the limits to individual ambition, and the vanity of tombs.

Although the English artist Richard Wilson painted a *Shepherds in the Campagna* (1755; Earl of Strafford) that directly employs the "Et in Arcadia ego" motif, I believe he is alone in associating it with the Campagna. He, in any case, imported not only large trees but also columns from the Forum to frame his senatorial shepherds. Moreover, since the inscription now reads *Ego fui in Arcadia* (omitting the *Et* and adding the *fui*), these shepherds have no reason to think that Arcadia is where *they* are. This painting is nonsense. In American paintings, the shepherds are either still dancing (there being no visible tomb to come upon in their Arcadia) or standing in lonely isolation in a world of ruins, a condition that doubly places them

Fig. 53. Nicolas Poussin. *Et in Arcadia Ego.* ca. 1650 (Blunt); 1639–40 or
1642–43 (Friedlaender). .85 × 1.21 m. Louvre, Paris.

outside of Arcadia to begin with, since Arcadia is a community of two (at least) and
it is characterized by the shade of trees, not ruins. If in a painting by Cole a shepherd
pauses among ruins to meditate, the tenor of his thought is indefinable. He simply
represents thought itself—such sober thought as might be induced by incompre-
hensible ruins from an age of grandeur, totally foreign to the life he has known.
There is nothing either moralistic or elegiac about such paintings, nor about the
Dream of Arcadia (fig. 33), in which no one thinks of ruin or death. Nor can the
viewer experience as lost what was never more than a dream.

Allston and Hawthorne are special cases. Allston might make us think of Pous-
sin's second version, and Hawthorne might make us think of his first, or even of
Guercino's original more "gothic" interpretation. Allston's ideal worlds are im-
mensely serious, but they are not sad. They do not seem to depend upon the elegiac
mood at all, for to Allston nothing of the ideal can ever be lost. One critic has
correctly noted that the basin in the Toledo *Italian Landscape* (fig. 40) has the shape
of a sarcophagus and is inscribed with Allston's name and date.[8] This is the tomb in
Allston's Arcadia, he would suggest. But Allston, as I have argued, never painted an
Arcadia in any meaningful sense of the word. His people, who are not living in
thoughtless felicity to begin with, could be neither startled nor dejected by the
knowledge of death. The sarcophagus, if it is one, has been converted into a basin
forever filled with the water of life, and the woman sitting closest to it has taken her
"measure" of it in a beautifully wrought and precious golden urn.

Allston's shepherd boys (figs. 41, 42), however, would not be out of place in either

Guercino's or Poussin's second *Et in Arcadia ego*, which with respect to the attitude of the shepherds, resemble each other more than either resembles the Chatsworth Poussin. In spite of Panofsky's argument that "the element of drama and surprise" is merely retained "to some extent" in the Chatsworth Poussin, it seems to me much more emphatic than in the Guercino.[9] Guercino's Arcadians in fact appear in the identical attitude in another of his works, where they are watching Apollo flay Marsyas alive; and they are learning more than a lesson in mortality from that incident.[10] But in both works what they observe seems to evoke more solemn wonder than shock or horror; there is no "surprise," and the only "drama" is in the death's-head. Walter Friedlaender rightly noted that even in Poussin's more dramatic first version, the shepherds are not "deeply disturbed" and manifest more "curiosity than awe."[11] Allston's shepherds are anything but giddy and would be at home in these paintings. Yet it is significant that their creator has given them no skull or tomb to motivate their sobriety, any more than he has thought such props necessary to any of his other ideal figures or in his portraits of relatives and friends (including Coleridge), all of whom are shown as deeply thoughtful people. Ideality is not in itself any more concerned with death than it is with birth; existence is sufficiently mysterious, and Allston's two shepherds, in their state of *becoming*, do not think of (and should not make us think of) death.

Both Nathaniel and Sophia Hawthorne comment on many paintings in their journals, but neither mentions the Guercino *Et in Arcadia ego*, although they visited the small gallery of the Palazzo Sciarra (where it hung until 1896) at least twice. Neither Murray's guidebook nor their friend Hillard's told them to take notice. Although the Hawthornes did not always let guidebooks limit their curiosity, this painting suffered disadvantages besides going unlisted. Throughout the century it was misattributed to Bartolommeo Schidone, and at the Sciarra it had to compete in the same room with a Leonardo, a Raphael, Caravaggio's popular *Cheating Gamesters*, and not one but two Guido Reni *Magdalenes*, the sort of thing Sophia liked to contemplate from her portable chair "for hours." In fact, only the earliest of the English guidebooks used by Americans—that by Mariana Starke— had mentioned the painting (with the inscription mistranslated in a footnote), and she refused to give it even one of her exclamation-mark ratings (!, !!, or !!!). Nevertheless, N. P. Willis (who used Starke) not only described the painting for his *New York Mirror* readers (the shepherds are "gazing . . . in attitudes of earnest reflection," he rightly said) but also commended the "poetical thought, . . . wrought out with great truth and skill."[12] But I have not discovered anyone else who thought it worth mentioning.

One can easily imagine Hawthorne liking it. He is given to such juxtapositions of felicity and death in his tales and sketches, and we have seen him in *The Marble Faun* finding the image of Death waiting for us at the end of an Edenic vista to be "piercing, thrilling, delicious." This is a nearly explicit use of the theme as invented by Guercino, since Hawthorne has already identified the Villa Borghese as an Arcadian place. But there are differences. First of all, what thrills him is not the sudden discovery of mortality by the innocently happy but the fact of deception: nature here is not what it appears to be. The same idea had been inspired by the Campagna in the mind of George Ticknor when he arrived in Rome in November

1817. It produced a journal entry which in its building periods and dramatic inversion anticipates not so much Hawthorne as Melville in both style and point:

> The heavens are of such an undisturbed and transparent blue, the sun shines with so pure and white a light, the wind blows with such soft and exhilarating freshness, and the vegetation is so rich, so wantonly luxuriant, that it seems as if nature were wooing man to cultivation. . . . But when you recollect that this serene sky and brilliant sun . . . serve only to develop the noxious qualities of the soil, and that this air which breathes so gently is as fatal as it is balmy, and when you look more narrowly at the luxuriant vegetation and find it composed only of gross and lazy weeds, such as may be fitly nourished by vapors like these,—when your eye wanders over this strange solitude, and meets only an occasional ruin, . . . or at most, a few miserable shepherds, hardly more civilized than Tartars, decrepit in youth, pale, haggard, livid, . . . it is then you feel all the horror of the situation.[13]

In their descriptions of the Villa Borghese and the Campagna neither Hawthorne nor Ticknor is concerned to place death in Arcadia, or to achieve a sad tranquillity. Instead they show that Arcadia is the appearance, death the reality. Not merely convention, but this conviction, is the reason we always find something "sad" about Arcadia in the descriptions of Hawthorne and other Americans. It is—in Cole's words—a dazzling deception.

Hawthorne's relating of his characters to Arcadia is consistent with the view that a tomb in Arcadia is superfluous, because only the tomb is real. The Model as Spectre of the Catacomb (where all consciousness of Arcadia was excluded; there was only death) may in a sense be a walking death's-head, and his intrusion into the Borghese idyll has something of the dramatic force of the Chatsworth Poussin. But neither Donatello nor Miriam reacts to him as a reminder of their mortality. Miriam on the contrary is moved by him to *wish* for death as a welcome oblivion, and Donatello is moved not to meditation but to murder. The result is that a few chapters later the Model is indeed a memento mori, lying on a bier in the Capuchin church whose cellars are filled with skeletons grotesquely displayed. When Donatello returns to his Arcadian ancestral home in Tuscany, it no longer has reality. Consciousness of death does not merely darken the dream into a vespertinal light; it ends it. The dream itself dies.

In "Roman Neighbourhoods" Henry James describes a visit to the Capuchin convent at Albano. He sees a "cowled brother standing with folded hands profiled against the sky, in admirable harmony with the scene." In "the expiring light" James looks down into the volcanic crater and remarks that "though stone-blue water seems at first a very innocent substitute for boiling lava, it has a sinister look which betrays its dangerous antecedents." Its

> deep-bosomed placidity seems to cover guilty secrets, and you fancy it in communication with the capricious and treacherous forces of nature. Its very colour is of a joyless beauty, a blue as cold and opaque as a solidified sheet of lava. Streaked and wrinkled by a mysterious motion of its own, it affects the very type of a legen-

Fig. 54. Arthur B. Davies. *Evening among the Ruins.* 1902. Oil on canvas.
11 × 16″. Courtesy Art Institute of Chicago.

dary pool, and I could easily have believed that I had only to sit long enough into the evening to see the ghosts of classic nymphs and naiads cleave its sullen flood and beckon me with irresistible arms.[14]

The world-renouncing brother is the one "in harmony" with this scene, for nature's beauty is not to be trusted. If the lovely creatures of pagan legend attached to the spot should reappear, they would themselves be ghosts beckoning one not to Arcadia but to death.

Perhaps the latest and most telling of images from an American artist using these classic materials was painted by Arthur B. Davies, whose hamadryads, maenads, nymphs, Daphnes, and even bacchantes, Venuses, and Silenuses often seem spectral indeed. One may question the efficacy of his attempt to give classical outline and friezelike form to naked men and women with modern physiques, and to present them as embodiments of pagan life and belief for the twentieth century. But the attempt—which involved frequent trips to Greece and to Italy, where he himself died in 1928—clearly succeeded at least once, in his *Evening among the Ruins* (fig. 54). For this subject at this time, Davies's style was perfect. It justifies James's description of shepherds in "motionless brotherhood with the ruins." For these sad and ghostly shepherds and their goats are indistinguishable from the ruins; they are themselves a dream wrecked by time, and dead. They look in three directions, and everywhere (their faces show it) they see a vacancy, with nothing to fill it up.

The Campagna as a theme, a resource for art and literature, had been exhausted, even as the Campagna as a place was being progressively altered and obliterated by

152

the building of modern Rome: the meadows bulldozed and built over with apartment blocks and Cinema City, the marshes paved with airstrips, the lower hills crowned with transmitters and exposition towers, the monumental ruins surrounded by power lines and oil tanks, the golden air filled with the smoke and exhaust that hides Albano, Soracte, and Tivoli except on the sharpest of winter days. In 1873 Henry James had a premonitory vision:

> As you follow the few miles from Genzano to Frascati you have perpetual views of the Campagna framed by clusters of trees; the vast iridescent expanse of which completes the charm and comfort of your verdurous dusk. I compared it just now to the sea, and with a good deal of truth, for it has the same incalculable lights and shades, the same confusion of glitter and gloom. But I have seen it at moments— chiefly in the misty twilight—when it resembled less the waste of waters than something more portentous, the land itself in fatal dissolution. I could believe the fields to be dimly surging and tossing and melting away into quicksands, and that one's very last chance of an impression was taking place.[15]

That is the ultimate reading of the Campagna, and—for an impression of the Campagna as it had been known, painted, written about, and remembered for centuries, whether as wasteland of death or Arcadian dream—James was nearly right, for the chance was soon gone.

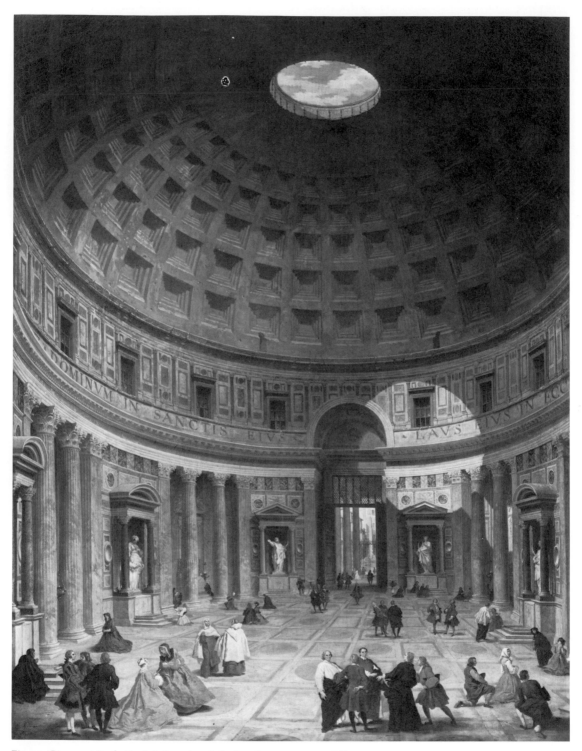

Fig. 55. Giovanni Paolo Panini. *Interior of the Pantheon.* ca. 1740. Oil on
canvas. 50½ × 39″. The National Gallery, Washington, D.C. Samuel H.
Kress Collection.

4

The Pantheon:
The Gods in Twilight

The gods themselves walk on earth, here in the Italian spring.
—Margaret Fuller (Rome, April 1848)

In his walk on the Campagna near the end of *The Marble Faun* (1860), Hawthorne's artist-hero, the rational idealist Kenyon, comes upon an antique marble statue of Venus, which has just been discovered by Miriam and Donatello. "Forgotten beauty had come back, as beautiful as ever," he thinks; "a goddess had risen from her long slumber, and was a goddess still."[1]

The intricate plotting of Roman imagery that characterizes the design of *The Marble Faun* gives emphatic significance to the revival of this particular goddess at this moment in the story. Her resurrection was necessarily the work of the two passionate "pagans" of the book, and it occurs during the Carnival that is itself a commemoration of the cyclical Bacchanalia of ancient days. It thus completes the pattern of allusions to pagan myth that began in the first chapter when Miriam identified Donatello as a faun from Arcady. Between these events the Spectre of the Catacomb has—like Venus at the end—emerged from underground as the legendary Memius who had persisted in his paganism. The return of this repressed spirit led to the permanent psychic union of Miriam and Donatello, a triumph of Venus and Eros, whose effects are sometimes madness and murder. Their power was demonstrated in the obsession that drove Donatello to murder Miriam's persecutor, and in the mutual passion that has possessed the fated pair since that moment on the Tarpeian Rock. Even Bacchus (Dionysus), whose wild adherents satisfied their need for symbolic ritual long after, in the length of empire, the colder gods of reason had disappeared, might be seen in the embrace of Miriam and Donatello immediately following the murder: "the horror and agony of each was combined into one emotion, and that, a kind of rapture." Before the chapter ends Hawthorne has piled upon his pair a sufficient sense of guilt—but a guilt fated and ambiguous, more Greek than Christian. But first he allows them an ecstatic sense of release and of union as a result of the bloody sacrifice they have made:

> As their spirits rose to the solemn madness of the occasion, they went onward—
> not stealthily, not fearfully—but with a stately gait and aspect. Passion lent them

(as it does to meaner shapes) its brief nobility of carriage. They trod through the streets of Rome, as if they, too, were among the majestic and guilty shadows, that, from ages long gone by, have haunted the blood-stained city.[2]

They are specifically given the pathos and the dignity of figures on a Dionysian relief. Then Hawthorne allows Miriam to identify their act with that "high deed" of Brutus, as they pass Pompey's Forum where Caesar was slain. The deliberate and rational are joined with the instinctive and passionate—the extremes of human nature embodied in the ancient gods.

Hawthorne thus suggests in *The Marble Faun* what is hinted at occasionally in many confessions to the higher consciousness of the pagan gods that resulted from a visit to Rome: that the entire mythological group from Jupiter down to the merest naiad more coherently and comprehensively related to human needs and behavior than does either Judeo-Christian theology and ethics or modern atheistic material- ism. Of course, many Americans possessed a prior literary acquaintance with the classical gods; but in Rome, where they bore their familiar Latin names, they seemed more present than in the Athenaeums of America—present in the land- scape with which they had long been identified, present in the consciousness and the breathing language of the people, present in the columns from pagan temples that now sometimes supported Christian roofs, present in the seasonal rituals, the saints' days, and the images of heavenly fathers, great mothers, and dying demigods that belonged to a religion almost as alien to Protestant Americans as paganism itself. Finally, the gods were present as themselves—as embodiments of ideal beauty and truth—in the great galleries of Rome, where they could be contemplated at length and receive homage from strangers. The land, the atmosphere, the people, the religion, and the classical art of Rome thus combined to force on Americans, as on others, some feeling, however feeble and discontinuous, that the gods in their power survived, simply because as images of beauty and truth they could not die. Before long even the hands of Protestant artists busied themselves in the multiplica- tion of their graven images.

Venus was the most troubling of the classical gods. Much effort was expended in attempts both to exclude her and her son and cohorts from that pantheon and to find acceptable alternatives to her. But Venus was emphatically present in the museums of Rome where artists went to study her ideal beauty and where others tried to deny—or learned to acknowledge—it. Encounters with the gods and other ancient images of beauty in the Capitoline and Vatican galleries, and the art that flowed from them, are the subjects of chapter 5. But we turn first to the Pantheon itself, the Temple of All Gods (fig. 55).

"Reverberations of Pagan Worship": Hawthorne to Vidal

In the Pantheon, best-preserved and noblest of ancient Roman temples and the one in which adaptation to Christian worship was least successful, thoughts often turned to the meaning of the entire circle of gods. Moreover, the incrustation of

Christian altars and symbols (including even fake sculptural angels hanging in the dome) meant that more than any other place in Rome it stimulated thought about the differences between paganism and Christianity. In some visitors, only the most conventional reactions were possible. The humorist known as "Aguecheek" found the Pantheon "the embodiment of heathenism, the exponent of the worship of the old, inexorable gods,—of justice without mercy, and power without love." He took great satisfaction in seeing how "the images of the old revengeful and impure divinities had given place to those of the humble and self-denying heroes of Christianity."[3] But Grace Greenwood found that the "stern simplicity" of the Pantheon's "sublime" architecture made one resent the "theatrical" accessories of Catholic worship as one would "some monstrous anachronism in poetry or art." The "ghosts of the dead deities" nevertheless made their presence felt and stirred a sympathy with the "stalwart followers of Mars and manly worshippers of Jove."[4]

Because the great simplicity of its beauty was preferred to the baroque elaborations in form and decoration of St. Peter's, architectural comparisons favored a fair hearing for paganism in the Pantheon as nowhere else. In the ecstasy of his first experience of Rome, Henry James expressed the view emphatically in a letter to his sister, Alice (1869):

> By far the most beautiful piece of ancientry in Rome is that simple and unutterable Pantheon to which I repeated my devotions yesterday afternoon. It makes you profoundly regret that you are not a pagan suckled in the creed outworn that produced it. It's the most conclusive example I have yet seen of the simple sublime. . . . The effect within is the very *delicacy* of grandeur—and more worshipful to my perception than the most mysterious and aspiring Gothic. St. Peter's, beside it, is absurdly vulgar.[5]

Nearly a century later (in 1961), the same view was still being expressed, even more forcefully, by Lewis Mumford in *The City in History:*

> The Pantheon, the finest single monument Rome has left, symbolizes the power and aspiration of Rome at its best. The interior, with its dome open to the sky, conjures a depth of religious feeling that turns St. Peter's into a monument of spectacular vulgarity, unredeemed by the Sistine Chapel. Here the gods from the countries and cities Rome conquered were placed on view: in its day, a sort of living museum of comparative religions, some of which, like the cult of Isis and Serapis, or the Mithraic religion of salvation, proved more attractive than Rome's gods, before Christianity swept them away.[6]

Hawthorne chose to bring his Roman romance to an end in the Pantheon. In the final scene Kenyon and Hilda enter, she to pay tribute to Raphael, whose tomb is there, he to pay his respects to the architecture. "The world has nothing else like the Pantheon," wrote Hawthorne. The pasteboard Christian statues, the "crowns and hearts," the "dusty artificial flowers, and all manner of trumpery gew-gaws hanging at the saintly shrines," do not disturb its grand effect, its solemnity superior to that of St. Peter's. Kenyon (directly echoing Hawthorne's notebook entry after his first

visit) attributes its distinctive effect to the opening in the dome: "It is so hea-
thenish, . . . so unlike all the smugness of modern civilization!" Hilda, charac-
teristically resisting the pagan view (and also repeating the fanciful thought of her
author on a later visit to the Pantheon),[7] imagines angels peeping in above the
"sloping cataract of sunlight" that descends from the opening.

Following the shaft of light down to one altar, they go to see if a Christian
painting thus illumined has any merit. It does not. What is noticeable is the cat
sitting on the altar in the sunlight, like an Egyptian idol, receiving the apparent
worship of a kneeling peasant. They then observe a veiled woman kneeling on the
pavement "just beneath the great central eye," her face upturned. They recognize
Miriam, and, as if unconsciously struck by the paganism of the place she has come
to pray in (it is not clear that she has come to repent), Hilda suddenly asks whether
Donatello was really a faun. Kenyon, having seen him at his ancestral estate, Monte
Beni, and having heard the legends of his pedigree, no longer doubts it: "It seems the
moral of this story, that human beings of Donatello's character, compounded espe-
cially for happiness, have no longer any business on earth. . . . Life has grown so
sadly serious, that such men must change their nature, or else perish." This is a
judgment against modern life, not against that "sweet, irresponsible life" imputed
to early paganism. Shocked, Hilda will not accept this moral, nor the next one—that
of the *felix culpa*—offered by Kenyon. So he seizes the occasion to take Hilda for his
guide; they will go home to theological security in America. Miriam, rising just
then from her prayer at the center of the Pantheon, makes a gesture of benediction
toward them without apparent desire to receive their blessings in return. Instead,
her extended hands "even while they blessed, seemed to repel, as if Miriam stood on
the other side of a fathomless abyss, and warned them from its verge."[8] That abyss is
not only the abyss of guilt; it is the abyss that separates Paganism from Protestant-
ism, a world that recognizes all the gods from one of exclusion, repression, and
restraint.

An early story by Henry James with close affinities to *The Marble Faun,* "The
Last of the Valerii" (1874), reaches its turning point with a scene in the Pantheon.
The latent paganism of a Donatello-like character has reemerged when his Hilda-
like American wife, who is directing the excavations on his ancient family villa,
turns up a Juno of extraordinarily powerful presence. In *The Marble Faun* Haw-
thorne made a point of the fact that the coolly rational Kenyon could not be very
deeply affected by the recovery of a Venus because his mind was preoccupied by
Hilda, a real woman of ideal refinement. James in effect works out the question of
what would have happened if Hawthorne's faun had fallen in love with the Ameri-
can Protestant Hilda instead of with the darkly ambiguous Miriam, and she with
him, and then a real goddess had entered the picture. He makes the goddess a Juno
instead of a Venus to avoid any reductive suggestion that Count Valerio's problem is
one of sexual frustration only. Juno is of a feminine magnificence equally un-
American, and she evokes the entire Olympian assembly which she heads with
Jove. Having given himself over to the extravagant conceit of his fable—the survival
of a thoroughly pagan sensibility into the present age—James follows it through
with far more conviction than we found in Hawthorne.

Count Valerio has, even before his marriage, declared himself indifferent to his

wife's Protestantism, since he is a poor Catholic whom his confessor regards as "a good boy but a *pagan!*" The atmosphere of St. Peter's stupefies him. The countess's American godfather (the narrator) doubts that Camillo has a soul and regards him as a pretty, simpleminded animal—the way Miriam initially regards Donatello: "He's the natural man!" "Happily, his nature is gentle." The count at first objects to the search for buried statues: "Let them lie, the poor disinherited gods, the Minerva, the Apollo, the Ceres. . . . What do you want of them? We can't worship them. . . . If you can't believe in them, don't disturb them. Peace be with them!" He warns the others that he is "an old Italian," superstitious, deeply affected by the ancient statues—he won't answer for his wits if they dig up more. But his wife is "of another race," as he says, and she takes this as a joke. When a Juno is in fact unearthed—just as the count, in true pagan style, had dreamed a Juno would appear—he has her set up in his casino and begins to worship not only her but the other old gods that stand about his villa. He wholly neglects his wife, and when her godfather remonstrates with him, suggesting that he is "unhappy," he declares himself, on the contrary, happy beyond imagining. The Hermes in his garden "seems to me the friendliest, jolliest, thing in the world, and suggests the most delightful images. . . . He knew the old feasts and the old worship, the old Romans and the old gods."[9]

Shortly thereafter the narrator is driven by a sudden spring shower into the Pantheon—"the great temple which its Christian altars have but half converted into a church: No Roman monument retains a deeper impress of ancient life, or verifies more forcibly those prodigious beliefs which we are apt to regard as dim fables. The huge dusky dome seems to the spiritual ear to hold a vague reverberation of pagan worship, as a gathered shell holds the rumor of the sea." Near the center, "beneath the aperture of the dome," just where Miriam had gazed upward, stands the count, "an indefinable expression of ecstasy" on his face as he watches the sunlight mixed with rain descending. When the narrator catches his attention, the count declares the Pantheon "the best place in Rome—worth fifty St. Peters'":

> "Ah! you must *feel* it,—feel the beauty and fitness of that great open skylight. Now, only the wind and the rain, the sun and the cold, come down; but of old—of old . . . the pagan gods and goddesses used to come sailing through it and take their places at their altars. What a procession, when the eyes of faith could see it! Those are the things they have given us instead! . . . I should like to pull down their pictures, overturn their candlesticks, and poison their holy-water! . . . There's been a great talk about pagan persecutions; but the Christians persecuted as well, and the old gods were worshipped in caves and woods as well as the new. . . . It was in caves and woods and streams, in earth and air and water, they dwelt. And there—and here, too, in spite of all your Christian lustrations—a son of old Italy may find them still!"

Such a view simplifies matters for the countess's godfather: the count is plainly mad. When later he sees him lying prostrate before the moonlit Juno and the next day, with the countess, discovers blood on the altar in front of the statue, they resolve to reinter the goddess. "She must go back, she must go back!" cries the American countess. This act of deliberate repression effects the desired cure.[10]

Hawthorne and James entertained the notion of paganism's persistence into the modern day. The revival and suppression of the ancient gods in earlier Christian ages is a subject that has attracted other American writers resident in Italy, as well as some who merely read their Bible at home. Without using the Pantheon as a setting, they are similarly concerned with the meaning and effects of pagan belief. They include, of course, writers of popular historical Roman romance from Lew Wallace to Lloyd C. Douglas, with their simple propagandistic oppositions of good Christians to wicked pagans, and of the chaste Prince of Peace to Venus and Mars. More sympathetic treatments of paganism to be found in other writers are also more important indicators of the sorts of awakenings—whether frivolous or deeply felt— that the encounter with Rome itself might encourage.

Two years before James published his little entertainment about Count Valerio and his American wife, Sarah Loring Greenough (the wife of Richard S. Greenough, an American sculptor) had published among her tales of the supernatural one called "Domitia." More amusingly conceived and competent than most of the performances of this genteel romancer (whom we shall encounter again), "Domitia" is a first-person narrative vaguely set in the Middle Ages and told by a woman whose father was of "the great house of Savelli" and her mother Geltrude of Milan. She is the elder of two daughters who were followed by a son, whose birth caused much rejoicing since he would keep "so ancient a house" from becoming extinct. The beloved mother and her children go to spend the summer at the family castle in Gondolfo, built on the ruins of the emperor Domitian's palace. One day when Geltrude is out riding, she is thrown from her horse when malicious birds attack it. When she "recovers," she finds herself possessed by the soul of the empress Domitia. She steals a statue of Mercury and begins to worship it. She restores an ancient lyre and plays upon it with a strange cadence. She adopts antique fashions in dress and will eat nothing but lampreys. She addresses her children as "little apes," and assumes an imperious attitude toward everyone. After days of tapping on the walls in search of something, she goes to meet an old hag of a sorceress so she can communicate with the ancient gods. Her daughter (the narrator) follows her, however, and is able to save her mother from the pagan powers by lifting a stone on which there is a Cross. The abrupt ending is unsatisfactory (one assumed the precious heir would at least be threatened), but the superstitious medieval mood to which it is a legitimate conclusion is effectively evoked as is the exotic attractiveness of the earlier age. In the true manner of Poe, Mrs. Greenough even provides the obligatory note of authenticity by appending a reference to a scholarly British study.[11]

James's and Greenough's tales are largely sports, although James took his theme seriously. This theme eventually underlay one of his greatest achievements, *The Ambassadors* of 1902, in which his "Golden Pagan" Chad Newsome must be saved by New England puritanism through the sacrifice of a life of beauty and sensuality to a career in manufactured appearances: advertising. As this suggests, the theme implicitly may exist in many novels where the setting is not Rome or its empire. It is precisely in Rome, however, where William Carlos Williams's autobiographical novel, *A Voyage to Pagany* (1928), reaches a turning point. The medical doctor's search for a primitive antipuritanical freedom promised by "the wild gods" reaches its greatest moment of intensity with his vision of Venus in the Museo Nazionale:

Rome filled him to overflowing with riotous emotions seeking intelligent expression. . . . He was too conscious of the old; to-day slipped too much from him or was too near. Or being alone, he had penetrated too far the veil of dust the gods had thrown up about their secrets to protect them. Thus Rome escaping him, he half sees it as a burning presence under the veneer of today. . . . Rome, undeceiving, living—shedding fig leaves. Rome starting alive from the rock. He felt it, he could touch the fragments. There is the Venus. . . . There, crouching at the top of the stairs. But that is a stone. No, it is Venus! . . . The presence is over the stone.

Dr. Evans feels himself "possessed, bewitched, or else he saw the god." The very word "Rome," which he repeats obsessively, seems to him "full of a motion, a motion of crumbling monuments, himself crumbling, loosened at the base, the motion of the sun itself a stream of light, insuppressible among the ruins." A "quiet happiness" commences with this divine "loosening" of the "stalled sinews" of his body. The Church is renounced as a benighting force: "There must be in Rome a greater thing, inclusive of the world of love and of delight; unoppressive—loosening the mind so that men shall again occupy that center from which they have been avulsed by their own sordidness—and failure of imagination." But these realizations cannot effect a permanent change; to the end Dr. Evans senses that his "modernity" prevents him from possessing the "reality of beauty" and from experiencing more than passing moments of "pagan wonder."[12]

The most serious and the finest American novel since Hawthorne's to treat the pagan-Christian conflict of values in a specifically Roman context went back to the point when the dust and the veils descended. In Gore Vidal's *Julian* (1964) the struggle of the so-called Apostate emperor to revive paganism in the fourth century of the Christian era is presented in a manner that engages several viewpoints and gives a profound sense of how deep and lasting has been the cultural impact of Julian's failure. What is not presented is any argument in favor of Christianity; it is satirized by all three of the narrative voices. Vidal undoubtedly redressed somewhat the imbalance of historical fiction of the last century and a half. But he did not resort to a cosmetic enhancement of paganism to do so. Through the early stages of the work Julian's arguments with himself and others make paganism appear as the older Attic tradition he and his philosophic mentors would wish to preserve: attractively rational and humane, admirably pluralistic rather than dogmatic, understanding and tolerant of human behavior—everything, in fact, that Christianity is not. As Julian himself becomes more desperately fanatical in his cause, and more committed to the stranger Mithraic mysteries, however, the dark distortions of personality and restrictions of life of which paganism was also capable are fully expressed, as is the charlatanry of the priests in their rivalry with the highly organized Christians. Julian himself was never in Rome (his uncle Constantine the Great having founded a new Christian capital in the East), and the ancient city exists in the novel as a remote, luxurious, and corrupt place from which the old Stoic virtues of pagan belief at its best have departed. (This novel is of as much contemporary relevance as Vidal's *Washington, D.C.*)

Maximus, a Mithraic priest crucial in Julian's conversion to paganism and himself in the end a charlatan, is eloquent on one of the subjects to which thought would sometimes turn in the nineteenth century when Americans contemplated

the meaning of the Pantheon—the relation of the Many to the One. In creating one temple for "All Gods" had the pagans (as their best philosophers seem to have done) imagined the essential unity of the godhead? Maximus says:

> "How can the many be denied? Are all emotions alike? or does each have characteristics peculiarly its own? And if each race has its own qualities, are not those god-given? And if not god-given, would not these characteristics then be properly symbolized by a specific national god? In the case of the Jews, a jealous bad-tempered patriarch. In the case of the effeminate, clever Syrians, a god like Apollo. . . . The early Romans were absorbed by lawmaking and governing—their god? the king of gods, Zeus. And each god has many aspects and many names, for there is as much variety in heaven as there is among men. Some have asked: did we create these gods or did they create us? . . . Though one may not know for certain, all our senses tell us that a single creation does exist and we are contained by it forever. Now the Christians would impose one final rigid myth on what we know to be various and strange. No, not even myth, for the Nazarene existed as flesh while the gods we worship were never men; rather they were qualities and powers become poetry for our instruction. With the worship of the dead Jew, the poetry ceased."

When Maximus scorns the Christians for the contradictions they have fallen into, Julian asks what of the contradictions of Hellenism? There is a convincing reply: " 'Old legends are bound to conflict. But then, we never think of them as *literally* true. They are merely cryptic messages from the gods, who in turn are aspects of the One. We know that we must interpret them. . . . But the Christians hold to the literal truth of the book which was written about the Nazarene long after his death.' "

After his conversion Julian contemplates the world around him suspended between the Hellenists and the Galileans ("the new death cult," as he now calls it). Most people are on neither side, yet the Galileans—still a minority—are gaining in strength. At this point his own thought is still as philosophical as mystical:

> The old gods do *seem* to have failed us, and I have always accepted the possibility that they have withdrawn from human affairs, terrible as that is to contemplate. But mind has not failed us. Philosophy has not failed us. From Homer to Plato to Iamblichos the true gods continue to be defined in their many aspects and powers: multiplicity contained by the One, all emanating from truth.

Much later, at the height of Julian's military power and success, he says that it is not this that he has desired. His one wish is "to restore the gods." When he fiercely states his belief in their existence, his companion replies: "Then they exist. But if they exist, they are always present, and there's no need to 'restore' them."[13]

In the end, after Julian has had a dream of "the Genius of Rome" leaving him and has been fatally wounded by his Christian bodyguard, Vidal does not have him die speaking the famous phrase that Christian tradition attributed to him: *"Vicisti Galilaee"* ("Thou hast conquered, O Galilean!"), as though the gods died with him. Instead he is shown calmly discussing Plato's dialogue on the soul with the two

mentors who represent the philosophical and the mystical sides of paganism. Afterward a Christian preacher proudly claims the victory, but the philosophical narrator tells him that it is the victory of death; paganism had for "a thousand years . . . looked to what was living." Like the priest who sings Swinburne's "Ode to Proserpine" (1861) also in the fourth century, he takes comfort in the fact that "nothing man invents can last forever, including Christ, his most mischievous invention." As the book ends with "the barbarians" (Christians) "at the gate," the narrator himself faces death hoping "for a new sun and another day, born of time's mystery and man's love of light."[14]

The terms of the debate in Vidal's dramatization of this definitive moment in cultural history not surprisingly echo those used in discussing Greco-Roman myth in the nineteenth century, but the historical distance of his fiction actually allows them to be stated with greater urgency, as though we were on the threshold of a possible recovery. Also, Vidal shows no rhetorical deference to Christianity such as the earlier Americans commonly made to their homegrown Unitarian or humanistic versions, if not to Catholicism. But even in this attitude he was anticipated by the Transcendentalists and by the rare avowed nineteenth-century atheist like Robert Ingersoll, who, however, rejoiced as much in the deaths of Venus and Jove as in those of Mary and Jehovah and called for "a temple of all the people" to replace the "temple of all the gods."[15] As they contemplated the Pantheon's sublime architectural image—or the all-too-inclusive theological idea of the "Pantheon"—Americans were sometimes moved to question their own myths.

Temple of All Gods: E Pluribus Unum

For all its fame in guidebooks and its familiarity through reproductions from Piranesi and Panini, the Pantheon is mentioned only briefly or not at all by our earliest visitors to Rome. In comparison with the Forum, the Colosseum, or St. Peter's, it evoked few associations. Before the romantic revival of a more complex sense of myth, the gods were largely thought of as simple personifications, the thought of whom created little resonance within the vault of the Pantheon. Besides, there was little to describe. As Stendhal remarked in 1828, "The Pantheon has this great advantage: it requires only two moments to be penetrated by its beauty. You stop before the portico; you take a few steps, you see the church, and the whole thing is over."[1]

In 1835 H. T. Tuckerman dismissed the Pantheon as "disagreeable" because modern buildings and a filthy marketplace encroached upon its exterior, and the interior was entirely "marred by the emblems of the popular faith." In 1845 Bayard Taylor was exhilarated by the fact that he could see the Pantheon from a cheap room in the attic of the Trattoria del Sole (where perhaps his beloved Goethe had also stayed), but he never mentions entering it. So elaborate a work as George Hillard's *Six Months in Italy* (1853), of course, provided a summary of what were then supposed to be the historical and architectural facts about the building. Hillard cited the Scottish traveler Joseph Forsyth, whose *Remarks on Antiquities, Arts, and*

Letters during an Excursion in Italy in the Years 1802 and 1803 still served as a compendium of aesthetic judgments, as the authority on its "perfection." The most frequent criticism of the building (still heard today), that the portico is ill joined to the domed body, was implicitly refuted by Hillard's observation that the "masculine" entrance to the "feminine" cell made "a perfect union." But in 1833 N. P. Willis had already summarily stated that "this wonder of architecture has no questionable beauty. A dunce would not need to be told that it was perfect." Willis, however, gave no thought to the gods in whose honor the perfection had been achieved; he converted the Pantheon into a temple of art by remarking only that "Annibal Carraci" and "the divine Raphael" were "worthy" of the place in which they lie buried.[2]

James Fenimore Cooper was the first who considered the pagan religious meaning of the Pantheon. But—dunce or not—he began his account of his visit in 1830 by finding some aspects of the Pantheon of questionable beauty. He concurred in the pre-Murray guidebook opinion (a common one) that the exterior left much to be desired. Pretending not even to have recognized the Pantheon (whereas Willis prided himself on instant recognition), he wrote that in a dirty and unattractive little square he happened to notice an edifice possessing "a strange mixture of beauty and deformity." The portico was "noble" but its tympanum was "altogether too heavy." It had "two little belfries" that were "like asses' ears." (Cooper's comparison—hardly an obvious one—was stolen from the popular Roman epithet for Bernini's additions, which were removed after 1870.) They "make a spectator laugh, while he wonders that the man who devised them did not stick them on his own head." (Hillard was less amused. According to him, Bernini "should have gone to the stake" for "as wanton and unprovoked an offense against good taste as ever was committed.") Cooper, making a conspicuous show of his sham learning, finally recognized the Pantheon from the inscription to Agrippa on its façade. "The inscription speaks for itself" as to date, he declared. Ironically, the one exterior thing he accepted has turned out to be the building's most misleading attribute, indicating construction more than a century too early (27–25 B.C. instead of A.D. 120–125).[3]

The defects of the exterior were forgotten when he went inside, Cooper admitted, for "this idea is one of the most magnificent of its kind that exists in architecture":

> The opening, a circular hole in the top, admits sufficient light, and the eye, after scanning the noble vault, seeks this outlet, and penetrates the blue void of infinite space. Here is, at once, a suitable physical accompaniment to the mind, and the aid of one of the most far-reaching of our senses is enlisted on the side of omnipotence, infinite majesty, and perfect beauty. Illimitable space is the best prototype of eternity.

In venturing an original interpretation of the religious effect of the interior, Cooper significantly ignored the Christian accretions entirely and turned directly to the question of pagan worship. Noting that the number of niches is insufficient for *all* the gods, he hypothesized that the place was actually dedicated to a few—those "in whom *all* or many of the divine *attributes* are assembled." After all, he concluded, "the gods themselves, it is fair to presume, represented merely so many different attributes of infinite power and excellence."[4] Cooper understood the gods as person-

ifications, but that did not reduce them to merely literary rather than theological significance. Just as he had seen in the "spacious vault" and the opening of the dome essentially unifying visual effects, so he imagined the several gods as the many attributes of one "infinite power and excellence." The sense of the divine—omnipotent, majestic, and of "perfect beauty"—evoked by the pagan architecture was by no means alien to him. He had just published *The Prairie*, in which Natty Bumppo, his frontiersman hero for a new American mythology, expressed the same conception while looking at the dome of heaven in the night.

Such a deistic understanding of pagan belief contrasts with conventional writers of Cooper's time who could not get beyond the Puritan horror of what they saw as idolatry, and found in Greek and Latin mythology the most disgusting proofs of divine depravity. Theodore Dwight in 1821 expressed deep pity for the Roman people since, unlike Christianity, their religion not only offered them no solace but consigned their dead to the company of the "Immortal Gods": "The virtuous, the decent would blush at their characters even on earth, how then could they even look on the sky with complacency?"[5]

Yet classical mythology, if not the gods themselves, found defenders among Christian scholars of Greek and Latin literature (hardly disinterested), among Transcendentalists who discovered in it (as in everything else) profound symbolic messages, among teachers of English literature whose texts were incomprehensible without it, and among artists and art historians and critics, for obvious reasons. In the present century the gods metamorphosed into the property of psychologists and anthropologists to be reborn in poetry (in strange company) and in painting and sculpture (in strange shapes). The subject is a very large one, independent of Rome or even Athens, and has occupied many people in the tracing of its various ramifications. All that concerns us at present, however, is the variety of attitudes toward the pagan gods that Americans going to Rome in the nineteenth century took with them or adopted while there. That variety may be sufficiently appreciated by listening to a scholar of Greek literature, a Puritan writer of fiction, the American Victorian compiler of the most popular mythology, a Transcendentalist poet, and a neoclassical sculptor-writer. To the extent that they regard the gods as something more than entertainments from the childhood of the human race, or historical curiosities that would be useless knowledge if they were not embedded in our literary and artistic traditions, these writers sometimes consider the relation of the multiple divinities of the pagans both to Christian monotheism and to life as it is experienced. Clearly the sexual behavior of the gods—the very conception of sexuality as an aspect of divinity associated with beauty—is the most troubling feature that has to be dealt with. In the next section two of the stronger writers of the century—Margaret Fuller and Herman Melville—will receive separate consideration on this subject.

Classical scholars sought to save the gods by emasculating them. Cornelius C. Felton, a year after he became Eliot Professor of Greek at Harvard in 1834 (when Thoreau was his pupil), published a long and often eloquent essay in the *North American Review* defending the teaching and study of classical mythology, especially that of the pure-minded and truly pious Greeks. Felton was the editor of Greek texts for school use, and the gods for him had purely textual existence. Parts of texts can conveniently be expunged, and divine essences easily altered. Felton's

posthumously published *Familiar Letters from Europe* is one of the dullest of its genre because it indicates that for him the Continent provided no sensuous education and no surprises. If the professor of Greek felt anything at all when he saw in Rome the naked marble bodies of the Greek gods and athletes whom he celebrated in his classroom, he did not choose to write home about it. He had long been satisfied with them in their more malleable verbal form. This allowed him to aver that only a depraved imagination could "discover food for the passions . . . in the sculpture of Greece" or in Greek descriptions of the gods. In contrast, and without distinguishing among Vergil, Ovid, and Horace, Felton claimed that Roman poetry was "the growth of a dissolute and ribald age":

> From every side arose the sound of revelry and debauch; not yet degraded to the vulgar wantonness of Messalina, but warbling in the delicious and ensnaring lays of Horace and Catullus, as, crowned with garlands and redolent of perfumes, they reclined through the live-long day in the shades of the luxurious gardens of Maecenas, or on the banks of the rushing Anio. By such minds as these, the fair religion of Greece . . . was easily perverted to the channel of their licentious dreams.

In a less tumescent style Felton concludes: "To the scholar we would say, then, expurgate your Horaces and your Ovids, till not an obscene thought shall stain their pages; and you may be sure that nothing will be lost in your inquiries respecting the classic religion."

Even if it were possible to believe this, the focus on religion as the sole interest suddenly narrows Felton's justification for the study of mythology. He had proposed it as an essential source of knowledge about literature, art, and history, and ultimately about oneself. In the end what he argues for is another version of Ovid moralized, in which every myth worth our attention tells us of the investment of matter by mind, and of the one divinity behind the multiplicity of nature. But Felton's sense of that multiplicity is restricted. The Greek poets, he says, never ministered "at the altars of indecency and wantonness." They saw in the natural world only emblems of "the Soul" and of "God."[6]

The year after Felton's essay appeared, and in the same year that saw the publication of Emerson's *Nature*, which taught its own lessons about the symbolic nature of material reality, Nathaniel Hawthorne published a story indicating how Felton's puritanical expurgation of ancient texts corresponded to a forcibly achieved narrowing of New England culture itself. The fateful opposition in America between puritan and pagan temperament and behavior which Hawthorne dramatized in "The Maypole of Merrymount" was as old as the complementary pages of William Bradford's *History of Plymouth Plantation* (1630) and Thomas Morton's *New English Canaan* (1637). Bradford wrote that the people of Merrymount with their Maypole were guilty of "dancing and frisking together like so many fairies, or furies, rather; and worse practices. As if they had anew revived and celebrated the feasts of the Roman goddess Flora, or the beastly practices of the mad Bacchanalians."[7] Morton on his part delighted to admit as much, and to observe how they danced "hand in hand about the Maypole, whiles one of the Company sung [a song to Hymen's joys], and filled out the good liquor like Gammedes and Jupiter."[8]

Hawthorne's attitude toward these opposing views of life is ambivalent. Morton's revels are presented with a sense of delight, while the Puritans are frankly introduced as "most dismal wretches." Yet Hawthorne did not conclude with anything like Vidal's regret about the repressive outcome of one of history's decisive moments or with a suggestion that pagan pleasure in life would ever return. The phallic Maypole is cut down and the flowers are scattered. Whatever the loss in earthly happiness, the Puritans deserved the victory because theirs was the more profoundly realistic view of mortal man. When James used a parallel opposition between New England and pagan Paris in *The Ambassadors,* and again gave the victory to the forces of repression, the loss felt was hardly compensated for by any sense of a gain in ethical realism; it was simply the loss of life itself. Not a spiritual but a mercantile puritanism triumphed over earthly beauty and desire.

Hawthorne later wrote two of the three books published in the 1850s that would perpetuate the puritan version of classical myths in the popular understanding. His tales of the gods and heroes of Greece for children in *The Wonder Book* (1851) and *Tanglewood Tales* (1853) were joined in 1855 by Thomas Bulfinch's celebrated *Age of Fable,* which would permanently identify mythology itself with Bulfinch's name. Readers discovering the gods through this work did so in a prose medium devoid of the sensuous vigor of Ovid's verse. Bulfinch also moderated the scandalous behavior of the gods as much as he could while still having the tales make any sense. Totally without humor, he was strenuously apologetic about his compilation of myths concerning the "so-called divinities of Olympus [who] have not a single worshipper among living men." The book was justified by its *usefulness* for understanding *Christian* poets from Spenser through Milton to Longfellow. Himself a teacher of Latin to the youths of Boston, Bulfinch nevertheless recognized that "in a practical age like this" even the young could not be expected to turn their attention from "so many sciences of facts and things" to languages that relate "wholly to false marvels and obsolete faiths." Finally, his preface assured readers that "such stories and parts of stories as are offensive to pure taste and good morals are not given. But such stories are not often referred to [by English poets], and if they occasionally should be, the English reader need feel no mortification in confessing his ignorance of them."

Hawthorne's task was in many ways easier than Bulfinch's, since entire liberty in retelling the tales was possible to one engaged not so much in transmitting an expurgated classical heritage as in renovating and purifying it for its only possible modern audience—children. Hawthorne's enchanting reductions suggest Whittier's reminiscence in *Snow-Bound* of the country schoolroom in which one heard

> mirth-provoking versions told
> Of classic legends rare and old,
> Wherein the scenes of Greece and Rome
> Had all the commonplace of home,
> And little seemed at best the odds
> 'Twixt Yankee pedlars and old gods.[9]

Hawthorne's version of "Baucis and Philemon," for instance, transfers the story from Greece to "the pleasant land of Italy," but the landscape is recognizably that of

Stockbridge Bowl in the Berkshire Hills where Hawthorne was living; and the unidentified Jove and Mercury when they arrive at the old folks' home are indeed like loquacious—and finally crafty—peddlers. All the other tales are framed by the New England atmosphere, and in those where the Ovidian version is strongly sensual, the metamorphoses performed by Hawthorne are themselves marvelous. Ovid's Proserpine is the victim of Venus's desire to extend her sway even to the Underworld and to prevent Ceres' daughter from preserving the repugnant virginity of a Diana or a Minerva. In Hawthorne she becomes a flower-picking little girl who is kidnapped by an avuncular old bachelor named Pluto (he is in fact her uncle) who only wants to see a playmate at his hearth and to hear the sound of little feet on his subterranean stairs.

So chastened and transformed, the gods and goddesses found in Bulfinch's and Hawthorne's books—more than in the expurgated texts of Felton—the chief literary vehicles by which they survived at all on a popular level in America. In countless editions, and remaining continuously in print to the present day, they assured some familiarity with the gods among the vast majority who never learned Latin or Greek, and they contributed even to the revival of the classics as a creative force in this century. The Imagist poet Hilda Doolittle (H. D.), for example, whose works eventually included a classical Roman closet drama and translations of Greek tragedies, recalled that Hawthorne's versions had stimulated her first interest in myth.[10] There were perhaps others in whom Bulfinch and Hawthorne prepared the ground for an interest in Frazer's *The Golden Bough*. But in the nineteenth century they both reflected and encouraged a puritan-Victorian version of the myths ill suited to the experience of Greek sculpture and Italian Renaissance painting in Rome. In comparison with the verbal divinities of mere fable, these gods shamelessly flaunted their naked sensuality. Beyond the affixing of a fig leaf, expurgation of visual art is difficult.

Insofar as a deep acquaintance with classical mythology is reflected in their works, Emerson and Thoreau also indicate an expurgated understanding of its essence. Thoreau, who worshiped Aurora every day by taking a cold bath in Walden Pond, certainly did not believe that either Christianity or science had successfully "driven the Hamadryad from the wood" or "torn the Naiad from her flood," as Poe had lamented in a famous sonnet of 1829. Friends liked to think of Thoreau as Pan reincarnated, and it has been claimed that he was in effect a worshiper of Pan.[11] But (the qualification is crucial) it was Pan unsexed, a perversion in itself. Granting all the natural vitality of Thoreau's sense of life, and the authenticity of his belief that our own age is as "fabulous" as any, one still may feel a connection between his neutered mythology and Hawthorne's New England versions for children. Yet there can be no doubt that Transcendentalism opened American thought to a more tolerant pagan sense of nature. When Bronson Alcott, whom Emerson so greatly admired, was called for a time to practice his educational experiments in Philadelphia, one of the nine-year-old children with whom he read Spenser's *The Faerie Queene* was Charles Godfrey Leland. A Germanist, Leland became one of the most famous balladeers of the century under the name of "Hans Breitman," but he also wrote *Etruscan-Roman Remains in Popular Tradition* (1892), a fascinating compilation of what he had learned through many years of association with Gypsies and

other country people about the survival of the most antique Italian gods (and their Greek equivalents) in the language, songs, dances, superstitions, and seasonal rituals of the people. Recalling Alcott in his *Memoirs* of 1893, Leland said that when he first arrived in Rome in 1846, it had been the "Poly-Pantheism" of his boyhood exposure to Transcendentalism that had given him the capacity to enjoy life among the ruins with their lizards and ivy.[12]

A sensibility more genuinely pagan than Alcott's or Thoreau's, precisely because it was joyously open to the full multiplicity of natural experience, is evident in another writer indebted to Emerson's liberating vision. In the same year—1855— that Bulfinch enbalmed his safely dead and sanitized gods in the distant *Age of Fable*, Walt Whitman was singing a genuinely renovating song of multiplicity and unity: "Magnifying and applying come I, . . . Lithographing Kronos, Zeus his son, and Hercules his grandson." When Bronson Alcott in 1856 journeyed to Brooklyn especially to meet this new poet, he found Whitman to be "a modern pantheon" in his own person.[13] In *Leaves of Grass* neither self-conscious reenactments of ritual patterns nor learned allusions to Greek or any other myths are employed to establish the authenticity of Whitman's faith, but rather a language invigorated by a pluralistic sensibility responding to the newness, freedom, variety, and wholeness of a nation, its people, and its land. Whitman's accommodating catholicity did not find even Christianity beyond belief; nothing was. But the core of his faith is a reverential recognition of essentially mysterious forces—sensuous and supersensuous—that unite in the always metamorphosing Self. Eros and Thanatos are realized in the *Leaves* as nowhere else in American poetry, and no one else experienced more fully the relation of the Many to the One.

Of the Transcendentalists who went to Rome, the one who visited the Pantheon and worked out a theory of the pagan gods on the spot was Thoreau's walking companion, the poet William Ellery Channing, namesake and nephew of the great Unitarian and brother-in-law of Margaret Fuller. In his *Conversations in Rome: Between an Artist, a Catholic, and a Critic* (1847), Channing boldly argued for the superiority of pagan to Christian theology, even though (oddly) he first thoroughly secularized the Pantheon and trivialized antiquity. That was no doubt because to a Transcendentalist buildings were incongruous places in which to worship the god of Nature, and history was without spiritual relevance. The Artist (who speaks for Channing against the other two interlocutors, a carping and cynical Critic and a conveniently tongue-tied Catholic) sees a "kind of visionary pathos" in the Pantheon. It is "representative of some of the pleasantest thoughts of the Romans, in their best times":

> It is not stern, silent, and commanding like the Coliseum; it is not strange and colossal, like the Baths of Caracalla; it neither reminds me of Jupiter, Venus, or Apollo, but is a good Roman building, which I can fancy may have been useful, unlike those extraordinary piles that sprang into existence, like architectural diseases almost, of Emperors, when Rome was no longer in sound health. How strongly Roman citizens would stride about on the solid floor, in their togas! How fitly the light falling from above would display the folds of their ample draperies, the playing muscles of their thoughtful and manly countenances!

This fantasy—which sees no gods descending, and would seem to occur in a bath rather than a temple—completes itself by perceiving in the Pantheon "the rounded characters of those Roman women, whose costly names" have come down to us. In conclusion, "old Rome has done her maternal duty in tossing the moderns, through many slippery ages, this complete holiday toy."[14]

Channing's domestication of the past and absurd reduction of the greatest dome in the world to the dimensions of a toy hardly prepares one for his defense of the gods—not in their marble form, or as allegorical representations of superhuman attributes, but as psychologically valid symbols of human experience. The attractive idea that the "religion of ancient Rome was a symbol" is developed in a statement that comprehends several important points:

> Is Venus, or Cupid, or Mars, or Diana, less significant today than when their temples were erected upon these hills? What is our quarrel with the ancients? Not that they symbolized some Natural Influences, which attend us from birth to the grave; but that they saw the figure of the Poet's dream step forth from airy regions, and sculpture itself solid as granite in every tinker's shop. It was an obtuse idolatry; it was a gross worship of carvings. . . . Does the modern believe . . . that these figures of Beauty and Grace were intellectually more important to the ancients than to us? The sculptor placed the figure of his beaming Mistress in the chaste embrace of the lasting marble, which neither grows old nor decays, and christened his statue Venus; the friend cut the handsome features of his Friend in pure stone, and named it Antinous. Those nations felt the pressure of the divine necessity which each nation feels, to melodiously utter the faith of man in the Beautiful and Heroic in permanent words. As a man, so the collected nation worships the best expression of itself for this is the best expression of the general sense of Beauty and Order; at whose entrance it becomes refreshed.

Channing's not entirely coherent argument here gives some evidence of what Thoreau called his "sublimo-slipshod" style. But its distinction for its time lies in its admission that Venus and Cupid were within the "pantheon" of gods and symbolized "Natural Influences" that were still operative. Moreover, Channing holds that the motive for creating an image of a Venus or an Antinous was entirely personal rather than ideal or religious; this notion definitively separates the *idea* of the gods from the *images* in art that would make them idols. Finally, that the "collected nation" worships "the best expression of itself" in its art ("Beauty and Order") is an idea more or less consciously behind the American art movement down to World War II.

Before concluding his discussion of the gods, Channing introduces still another idea that would be sounded with some frequency (but little volume) by visitors to Rome who sometimes stumbled into the novel subject of comparative religions. Like Emerson in his journals, Channing explicitly attacks the sect-ridden Christian faiths of modern times for their intolerance, doctrinal pettiness, and generally depressing effect on life: "The nations who follow us will laugh as gruffly at our Divinities, as we do now at the fallen gods. . . . The old religion was not superficial or perplexing, but productive and profound. They enjoyed it, which is better than

can be said of religion with us."[15] Channing's "Artist" summarized his position later in the *Conversations* with a poem about the Campagna, in which he anticipated (felicity of expression aside) the Swinburnian lament of the "Hymn to Proserpine" (1861):

Was something blighting in the fevered eye
Of Christian martyrs that befooled old Rome,
And brought the second dear delusion in,
Than worship of old Gods more difficult,
The reverence for something past belief?[16]

Transcendentalists characteristically veered between reducing Christianity to the status of another "myth" and arguing for the religious and psychological validity of all myth, as Robert D. Richardson has admirably shown. Some classically educated American intellectuals not given to Transcendental enthusiasm arrived at the essential equation of the Christian and the pagan by another approach. They liked to think of the most elevated pagan thinkers as Christians in all but name. Since their own religion had become primarily a matter of vague belief in a rather remote Creator somehow associated with the ethics enunciated and practiced by Jesus of Nazareth, it was not difficult to set Christ aside when Father-God and ethics seemed otherwise identical. The argument not only made pagan thought acceptable but served as a vehicle for attacking the unattractive aspects of Christianity. "A Conversation with Marcus Aurelius" (1891) by the sculptor and writer William Wetmore Story is a good example of this late Victorian version of an Enlightenment position (in which the Creator now masterminds an organic evolutionary process instead of a machine). It is significant, however, that Story cast his deliberations in the form of a dialogue which allowed him to present himself as unshakeably orthodox while putting the more persuasive points in the mouth of the sainted pagan author of the *Meditations*.

Story begins with an atmospheric description of his own late-night meditations in a spacious room of the Palazzo Barberini, where he had been living for thirty years. The bell of the neighboring Capuchin convent sounds through the quiet air of Rome, and Story, contemplating his cast of the "Capitoline bust" of the emperor, evokes an image of him far away in his army camp writing the *Meditations*. Next imagining the great man's ghost lingering among the manuscripts in the Vatican Library, he thinks how his "rules for the conduct of life . . . might shame almost any Christian." Yet he believed in strange gods: "How could they satisfy a mind like his? How could these impure and passionate existences, given to human follies and weaknesses, to low intrigues, to vulgar jealousies, to degraded loves, satisfy a nature so high, so self-denying, so earnest, so pure?" When Story concludes that Aurelius died "believing in purity, and in impure gods," a mild voice suddenly says, "No! . . . I did not believe in impure and unjust gods." The philosopher-emperor has entered the room.

After some exchange of courtesies, information, and evidence in the manner of any two Victorian gentlemen, the patient pagan explains to Story that his "reverence to the gods that were" constituted simply recognition of "a power above and

beyond us; recognition of divine powers and attributes. This lay as the corner-stone of our worship, as it does of yours." To which Story makes the standard puritan reply: " 'Almost,' I cried, 'it seems to me worse to worship such gods as yours than to worship none at all. Their attributes were at best only human, their conduct was low and unworthy, their passions were sensual and debased. Any good man would be ashamed to do the acts calmly attributed to the divinities you worshiped.' " Marcus Aurelius "calmly answered" that an elevating deification of man is commonly accompanied by a certain degrading humanization of God in all religions, including the Christian. The Christian God is represented as being "inspired with anger and cruelty beyond anything in our system." His scheme of compensating for his own miscreation of man—involving the crucifixion of his own son—is simply "abhorrent." Christianity possesses "a noble and beautiful truth, which sheds a soft lustre over life," in the "pure and philosophic spirit of Jesus of Nazareth," which the emperor claims to have recognized and reverenced, in spite of the fact that Christ's followers were the seditious communists of their day, completely intolerant of all other faiths and modes of life, and determined to destroy them. The superiority of Jehovah to Jupiter, however, he cannot see. Jupiter, even in the "lowest popular notions, whatever were his passions, was at least placable; who, whatever were his follies, was not a demon" like the Hebrew God. Jupiter was a "large and inclusive idea," the "Father and Mother of us all." Divine power is actually a mystery, and the "love of the unintelligible" is at the root of all religions. Incapable of comprehending the one God that encloses him, he "vaguely magnifies his own powers, and calls the result God. . . . In our own reason is the best that we can imagine—that is, our own selves purged of evil and extended."

Story can only repeat the puritan obsession: "Ay, but your gods were not the best you could conceive. They were lower of nature than man himself in some particulars, and were guilty of acts that you yourself would reprove." In reply, the philosopher then adopts one of the standard interpretations of the origin and meaning of classical mythology: the allegorical. The "common ignorant mass" may have taken the legends literally, but it is not to be supposed that Plato, Epictetus, Seneca, and Cicero did, any more than Christian philosophers believe in the popular Catholic superstitions and saints' miracles—all quite as incredible as anything pagan. Through "the outward garment, by which the Universal Deity is made visible," through the personifications of philosophic ideas of the Divine, through the allegories of the multiple forces and processes of nature, the greatest Greeks and Romans recognized God "as one and indivisible." The "divine powers" were but "half hid":

> "Everywhere they peered out upon us, from grove and river, from night and morning, from lightning and storm, from all the elements and all the changes and mysteries of the living universe. . . . Apollo was the life-giving sun; Artemis, the mysterious moon; Ceres and Proserpine, the burial of the grain in the earth, and its reappearance and fructification. So, on another plane, Minerva was the philosophic mind of man; Venus, the impassioned embodiment of human love, as Eros was of spiritual affections; Bacchus, the serene and full enjoyment of nature. We but divided philosophically what you sum up in one final cause; but all our divisions look back to that cause."

Evidently finding this eloquent summation of pagan theology (gracefully defining even Venus, Cupid, and Bacchus in acceptably genteel fashion) unanswerable, Story wisely turns to purely historical puzzles about the campaigns of Marcus Aurelius. In effect he concedes the superior humanism and dignity of pagan religion; and to make this point must have been his motive for writing his dialogue.[17] In it we perhaps hear some echoes of his conversations with one of his closest friends, Robert Browning, and of the high-minded amateur philosophizing that characterized the Anglo-American social gatherings of poets, artists, intellectual actresses, and senators in the Palazzo Barberini. The gods were there around them in Rome; their temple the Pantheon was greater than St. Peter's. As dogmatic Christianity adjusted itself to the new evolutionary thought, the door opened to a reconsideration of the old myths as well.

But the increasing secular realism of the later decades, represented most articulately by William Dean Howells, found the arguments of both Transcendentalists and liberal Christians concerning the status of myth irrelevant to the present and future. On visiting the Pantheon in the winter of 1864, Howells regretted that after floods it was always repaired: "Nothing vexes you so much in the Pantheon as your consciousness of these and other repairs. Bad as ruin is, I think I would rather have the old temple ruinous in every part than restored as you find it." The Pantheon apparently offered only many degrees of vexation; at least Howells has nothing else to express, except the "sense of wildness everywhere lurking about Rome" exemplified by the peasants who had built a fire "almost within the portico of the Pantheon" to cook their supper.[18]

Forty years later he returned in what at first seems a different mood induced by the superlatives of Murray and Hare. The Pantheon is in "good repair," its "porch" is "glorious," the sight of it "does mightily lift the heart." In fact, "it seems too great to be true, standing there in its immortal sublimity, the temple of all the gods by pagan creation, and all the saints by Christian consecration, and challenging your veneration equally as classic or catholic." But Howells is equal to the challenge of both. In a sudden shift of attitude, he tells the potential traveler not to grieve if he arrives when the doors are shut. "There are many sadder things in life than not seeing the interior of the Pantheon," he asserts:

> The gods are all gone, and the saints are gone or going, for the State has taken the Pantheon from the Church and is making it a national mausoleum. Victor Emmanuel the Great and Umberto the Kind already lie there; but otherwise the wide Cyclopean eye of the opening in the roof of the rotunda looks down upon a vacancy which even your own name, as written in the visitors' book, in the keeping of a solemn beadle, does not suffice to fill, and which the lingering side altars scarcely relieve.[19]

Stendhal made the extent to which one was "carried away" by the Pantheon a measure of one's aesthetic sensitivity, and claimed that he had never met anyone "absolutely devoid of emotion" while viewing it.[20] But he would never know the committed realists of a later age, of whom William Dean Howells was a prime example. In spite of his early years in Renaissance Venice and a lifetime of watching

Boston and New York grow, Howells remained as unresponsive to classical architecture as he was insensible to myth, whether pagan, Christian, or Transcendental. As in St. Peter's, where there was space he saw only vacancy. Where there had been two millennia of religious expression and now a great national symbol, he was—wryly, one hopes—concerned only with the inadequacy of his own name to fill the void. A brilliant recorder of social fact and psychological nuance, he was incapable of symbolic thinking. It could not have occurred to him, for instance, that the burial of Kings Emmanuel and Umberto in the Pantheon was the symbolic consecration of the new United Italy, a concept entirely consistent with the original meaning of a building where the sacred unity of the Roman world transcended and assimilated all other gods.[21]

The Chastity of Minerva:
Margaret Fuller and Herman Melville

When Margaret Fuller visited the Gallery of the Palazzo Borghese in 1848 she was captivated by Titian's painting "absurdly" called *Sacred and Profane Love* (fig. 56). The celebrated work depicts two women, one splendidly nude, the other luxuriously clothed, both poised, imposing, and calm. Fuller wrote that "one of the figures has developed my powers of gazing to an extent unknown before."[1] She does not say which. The clothed figure returns the viewer's "gaze"; the beautiful nude perhaps compels it. But Fuller's fascination must have owed more to the painting as a whole than to the education in the art of gazing that "one" of the figures gave her. Her refusal to believe that the two figures are allegories of the sacred and the profane is suggestive. The woman supposedly representing profane love does not lack intellectuality and sobriety; the naked figure said to express the purity of sacred love, on the other hand, is physically related to the sensual Venuses of other works by Titian. Fuller's image of herself selectively gazing at Titian's complex allegory—whichever half fixed her attention—catches her at a moment when her own identity as a woman with settled ideas on the gods of life, on sexuality, and on her freely chosen destiny was severely to be challenged. Her own Roman encounters with Mars and Eros determined her fate in ways unforeseeable.

An intimate knowledge of classical mythology was one of the benefits of the education imposed on Fuller by her father; she began to study Latin simultaneously with English at the age of six. In her autobiography she wrote: "Ovid gave me not Rome, nor himself, but a view into the enchanted gardens of the Greek mythology. This path I followed, and have been following ever since; and now, life half over, it seems to me, as in my childhood, that every thought of which man is susceptible, is intimated there."[2] Certainly the path that led to the politically disturbed Rome of 1848 led to no enchanted garden. Yet the time and place needed someone responsive to "every thought of which man is susceptible," not someone with a diminished circle of gods. She found in Rome a social revolution with which she actively sympathized, and soon experienced a psychological and physical change in her private life as she gave herself for the first time to a man and conceived a child out of

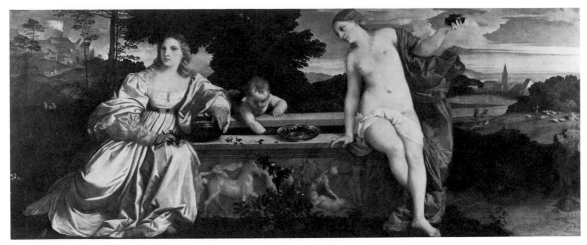

Fig. 56. Titian. *Sacred and Profane Love*. ca. 1515. 3'11" × 9'2". Museo Borghese, Rome. Photo from Istituto Centrale per il Catalogo e la Documentazione, Rome.

wedlock. In retrospect from these events and the deaths by drowning of herself, her husband, and her child off the coast of America the next year, her confidence in a possible future for herself and all women expressed in *Woman in the Nineteenth Century* assumes a poignancy that goes even beyond that inherent in a feminist idealism so deeply aware of historical inertia.

The Transcendentalist circle of Concord-Cambridge-Boston in the 1840s had made study of Greek mythology an important part of its activity. Elizabeth Peabody found the texts important keys to Greek religion and education, and Margaret Fuller translated Goethe's romantic reinterpretation of the myths.[3] In the winter of 1839, Fuller held a series of "Conversations" upon the mythology of the Greeks. The series was repeated for five years thereafter at the Peabody home in Boston or that of the Reverend George Ripley. As many as thirty women attended, including Sophia Peabody (the future wife of Nathaniel Hawthorne) and her sister, Mrs. Horace Mann, with Elizabeth serving as recorder. In 1841 Hawthorne himself was participating in Ripley's Arcadian Brook Farm experiment, where he cared for an ill-tempered "transcendental heifer" belonging to Miss Fuller and was shot in the hand during a birthday picnic by someone masquerading as the goddess Diana. Such was the fame of Fuller's classes in 1841 that an evening series was initiated so men might attend. Hawthorne does not seem to have seized the opportunity, but a twenty-three-year-old lawyer named William Wetmore Story did, and on one occasion so did Emerson, who had long considered that there was "somewhat a little pagan" about Margaret, with her belief in a fate and a guardian genius, and her special reverence for the planet Jupiter.[4]

Emerson's account suggests that the mixed-sex "conversations" did not go so well, since the men "fancied" that on "such a question" as mythology, "they, too, must assert and dogmatize." Fuller had had some difficulty even with a few of the women—those "who could not bear, in Christian times, by Christian ladies, that heathen Greeks should be envied." Fuller's response was that "she had no desire to go back," yet believed the ancients deserved respect: "These fables of the Gods were

the result of the universal sentiments of religion, aspiration, intellectual action, of a people, whose political and aesthetic life had become immortal; and we must leave off despising, if we would begin to learn." In Fuller's "Conversations" the gods seem to have served primarily as convenient allegorical introductions to large topics such as "Pure Reason," "Will," "Genius," or "Beauty," upon which she could then deliver an inspired monologue (with some interruptions) in the manner of a Corinne.[5]

Fortunately it is not in the records of these conversations but in a few pages of *Woman in the Nineteenth Century* that we discover Fuller's most valuable and personal view of the classical gods. There she found that they helped her define Woman and Man (ideal concepts, always capitalized). This was the view she took to Rome with her. In its day it was comparable in its sexually liberating intention only to that of Whitman. Its understanding of the Olympian deities as a symbolically bisexual unity went radically beyond the idea of the gods articulated by any other American who went to Italy, although it is interesting to recall that years later Story would have his Marcus Aurelius refer to Jupiter as "the Father and Mother of us all." Yet ironically Fuller is more thoroughly of her time than Whitman precisely because of her fear of Venus. Like so many other New Englanders, but for different reasons, she wished to exclude that goddess from the circle of the gods.

Venus is conspicuously absent from Fuller's first survey of "the idea of Woman" as "nobly manifested" in ancient mythology.[6] She proudly observes that in India the goddess Sita was "a form of tender purity," and in Egypt Isis was unsurpassed "divine wisdom," while the Sphinx had the "calm, inscrutable beauty of a virgin's face." As for the Greco-Roman myths, Ceres and Proserpine, "significantly termed 'the great goddesses,' were seen seated side by side"—an image of mother and daughter, "prepared for all things." Diana, Minerva, and Vesta differed "in the expression of their beauty," but "were alike in this,—that each was self-sufficing." "Other forms" were merely "accessories" to "one like these." Apollo might be the companion of his sister Diana, but they merely "set off one another's beauty"; she did not need him. Rome, "ruder" than Greece, knew only one form of good man— "the always busy warrior." He "could be indifferent to Woman," yet Rome confided "the permanence of its glory" to the Virgins of Vesta, while "her wisest legislator [Numa] spoke of meditation as a nymph [Egeria]." Fuller conveniently fails to recall that Venus, who probably shared with Mars one of the two chief niches in the Pantheon, was the goddess of Rome.

The actual life of women in ancient Greece and Rome is said to have been deplorably restricted, Fuller knows, yet that fact cannot efface the symbolism on the zodiac she sees before her eyes: "busts of gods and goddesses, arranged in pairs. . . . Male and female heads are distinct in expression, but equal in beauty, strength and calmness. Each male head is that of a brother and a king,—each female of a sister and a queen. Could the thought thus expressed be lived out, there would be nothing more to be desired. There would be unison in variety, congeniality in difference." The notorious incestuous relations among some of these brothers and sisters, fathers and daughters, are obviously not part of the "thought thus expressed" that Fuller has in mind. The fact that they are seen only as brothers and sisters is itself significant. For Fuller's noble aim—like Whitman's—is to establish

an absolute equality between men and women while preserving their differences. Yet as Fuller knew to her pain, differences of equality necessarily exist between father and daughter. The zodiacal circle "breathes the music of a heavenly order," says Fuller; and her silence about Venus must express a sense of how disrupting that powerful goddess and the random arrows of Eros have been to the orderly equality she envisions, how much they have been responsible for ambiguities of dominance and restrictions of being.

Later in the argument Fuller tries both to define the characteristic differences between Man and Woman and to deny that they are binding on the individual. "There are two aspects of Woman's nature," she says, "represented by the ancients as Muse and Minerva." Woman is less analytical and less creative than Man: "More native is it to her to be the living model of the artist than to set apart from herself any one form in objective reality; more native to inspire and receive the poem, than to create it." This tendency may be "Femality" itself, but it is not in "the order of nature" that it should exist "incarnated pure in any form." "Masculine" energy may be mixed with it in any given case. There is a "radical dualism" of male and female in nature, but "they are perpetually passing into one another. . . . There is no wholly masculine man, no purely feminine woman."

> Nature provides exceptions to every rule. She sends women to battle, and sets Hercules spinning; she enables women to bear immense burdens, cold, and frost; she enables the man, who feels maternal love, to nourish his infant like a mother. Of late she plays still gayer pranks. Not only she deprives organizations, but organs, of a necessary end. . . . Presently she will make a female Newton, and a male Syren. Man partakes of the feminine in the Apollo, Woman of the masculine in the Minerva.[7]

And it is to the idea of Woman as Minerva that Fuller is attempting to call her sisters of the nineteenth century—virgin goddesses with an intermixture of the masculine traits necessary for their time. The ideal for the future is wholeness for both Man and Woman, each containing the four powers distributed among the twelve "spheres": the *"demiurgic and fabricative,"* represented by Jupiter, Neptune, and Vulcan; the *"defensive,"* Vesta, Minerva, Mars; the *"vivific,"* Ceres, Juno, Diana; and the *"elevating and harmonic,"* Mercury, Venus, and Apollo. Here for the first time Fuller mentions Venus, saying that in her sphere beauty dominates, in that of Jupiter, energy—as though Fuller would place the question of sexual energy as far from Woman as possible and removed from beauty. Immediately she asserts that "only in the present crisis" is "preference given to Minerva." For "the power of continence must establish the legitimacy of freedom, the power of self-poise the perfection of motion." While male-female relations are "incalculably precious," only a Minerva can experience the losses and changes that attend them without "dull discord." How aware Fuller was of the effects of Eros is evident when she writes: "If any individual live too much in relations, so that he becomes a stranger to the resources of his own nature, he falls, after a while, into a distraction, or imbecility, from which he can only be cured by a time of isolation. . . . [Therefore] we shall not decline celibacy as the great fact of the time."

Sexual relations without subordination of the woman and without restriction of her being will be possible after a great change. "Union is only possible to those who are units. To be fit for relations in time, souls, whether of Man or Woman, must be able to do without them in the spirit." In the meantime, "a sister is the fairest ideal," she writes, innocently adding, "and how nobly Wordsworth, and even Byron, have written of a sister!" Also, there "is no sweeter sight than to see a father with his little daughter. . . . At that moment, the right relation between the sexes seems established." But fathers eventually want for their daughters husbands like themselves—protective, confining. Men of the nineteenth century cannot be relied upon to see from a woman's point of view. For a time Woman must free herself from Man, assuming herself the necessary defensive and energetic powers, leaving aside those of Venus, of Ceres, and of the Muse: "Grant her, then, for a while, the armor and the javelin. Let her put from her the press of other minds, and meditate in virgin loneliness."[8]

Later Fuller discusses another aspect of the question—the sexual attractiveness and behavior of men as it affects Woman by turning her into an imbecilic bride or a prostitute. She has scorn for the former and pity for the latter. The only solution is continence or chastity on the part of men, and it is mere cynicism to suppose that Man is incapable of these. Although in Greco-Roman mythology there are no male Vestas, Minervas, or Dianas, nor even a fatherly Ceres to whom she can appeal, Fuller is sure that "Man is not of Satyr descent." Every young woman must insist upon the purity of her husband, if husband she must have. When she sees "fair Woman carried in the waltz close to the heart of a being who appeared to her a Satyr," and is told all men are helplessly submissive to the desires of their brutish bodies but "women should know nothing about such things," she must not believe in this difference between the sexes. She must neither accommodate herself to "Woman's lot" nor acquire "a taste for satyr-society, like some of the Nymphs, and all the Bacchanals of old." Men are capable of purity and must be subjected "to the same laws they had imposed on women." The bachelor "demi-gods" Michael Angelo, Canova, and Beethoven had "kept themselves free from stain." They prove that the spirit can dominate even the male body.[9]

Fuller's freedom for Woman thus comes about by a more severe repression of Eros for both men and women than even her Victorian contemporaries required or supposed possible. The painful division between her temperament and her convictions was manifest. On the wall of her study beside a copy of an Andrea del Sarto *Madonna* was a drawing of the antique sculpture of *Silenus with Infant Pan*. In admiration of George Sand she called her a bacchante, yet William Henry Channing described Fuller herself as a bacchante who spent her time scrubbing a statue of Minerva.[10] In all this Fuller and other Transcendentalists like Thoreau, otherwise so liberating, actually intensified puritan inhibitions. Whitman, who also owed much to Emerson, thus becomes more singular in his program of sexual liberation. Beneath the elms of Boston Common, Emerson urged him to abandon his erotic "Children of Adam" poems, but he would not. His attitude toward the "fall" of Margaret Fuller would have been quite different from that of a non-Transcendentalist like Hawthorne, whose puritan attitude toward sexuality was nowhere more evident than when he welcomed the fact that Fuller had finally proven herself to be

made of flesh like the rest of us, despite her proud and pretentious claims to ideal intellectuality and freedom.[11]

Herman Melville saw such a case far more tragically and sympathetically than Hawthorne. In a late poem called "After the Pleasure Party" (1891),[12] set in Italy, he imagines with a fine intensity the emotional torment of such a woman as Fuller or of any would-be idealist like himself. In the verse that serves as an epigraph to Melville's poem, erotic power issues a direct challenge:

LINES TRACED UNDER AN IMAGE OF AMOR THREATENING

> Fear me, virgin whatsoever
> Taking pride, from love exempt,
> Fear me, slighted. Never, never
> Brave me, nor my fury tempt:
> Downy wings, but wroth they beat
> Tempest even in reason's seat.

The poem is the monologue of a female astronomer called Urania who comes to Italy from a chilly northern country. In an Italian villa by the sea she experiences the terrible revenge that Love is taking upon her for her years of exclusive devotion to science. It is "Vesta struck with Sappho's smart," almost sufficient to drive her, like Sappho, to suicide. She identifies her problem explicitly as that of sexual repression; now that her sexuality is aroused, the man toward whom it is directed ignores her, flirting with a "radiant ninny." Her entire character is being destroyed not only by sexual longing but by "envy and spleen." She now aspires to pierce "Pan's paramount mystery." The poem then shifts to a later date to show Urania in Rome ("For queens discrowned a congruous home") staring at a colossal antique goddess on the porch of the Villa Albani. She regards it religiously:

> Yet far, how far from Christian heart
> That form august of heathen Art.
> Swayed by its influence, long she stood,
> Till surged emotion seething down,
> She rallied and this mood she won:

The "mood" is one of conversion. Against the Virgin Mary, who had tempted her to enter a convent, is placed Minerva:

> But thee, armed Virgin! less benign,
> Thee now I invoke, thou mightier one.
> Helmeted woman—if such term
> Befit thee, far from strife
> Of that which makes the sexual feud
> And clogs the aspirant life—
> O self-reliant, strong and free,
> Thou in whom power and peace unite,
> Transcender! raise me up to thee,
> Raise me and arm me!

Melville ends by declaring this prayer for successful sublimation to be useless against the vindictive Amor, too long scorned. But his poem, in its complexity, shows, among other things, not only paganism opposed to Christianity, but the rivalry of gods and goddesses among themselves as realities and alternatives within the complex human psyche they collectively express.

The Pantheon, not the ethically compromised and originally too ostentatious Colosseum, was the building that set the standard of human aspiration and achievement in architecture that corresponded to the political standard of the Roman Republic evoked by the Forum. As we have seen, the Pantheon was commonly regarded as a rare embodiment of "perfection." Cooper saw in it the noblest of all ideas and the most perfectly realized. In the politically turbulent year of 1848, William Ware felt that one could not enter the Pantheon "without emotion," for the "genius of the place" reminded us that our horror of "the bloody and savage Roman people" was based on a half-truth. The peace and unity conferred by Rome upon the Empire for long periods—a peace and unity felt in the Pantheon itself—contrasted with the constant strife of the Christian Middle Ages that warned us what *"our disunion"* would be like, "were the golden band once broken that now holds the states together."[13] What Channing said of pagan worship of the gods was true of the Pantheon: "the collected nation worships the best expression of itself" in the particular manifestations of its "general sense of Beauty and Order." What Story's Marcus Aurelius said of the unity of the many gods in the one God also applies: it "encloses" all; "our own reason" is projected as "the best that we can imagine— that is, our own selves purged of evil and extended." Thomas Jefferson's use of the Pantheon as the model for the central building of his University of Virginia campus was a profoundly considered act.

Visitors to the Pantheon in the nineteenth century sometimes attempted to imagine ancient statues of the gods standing in their niches all around the room. Superimposing the Apollo and the Venus and the Minerva they had seen in the galleries of the Vatican and the Capitoline upon the reality of Christian images, they envisioned those icons of art within a place of worship. The Pantheon further encouraged the association of religious feeling and art because it contained the tomb of Raphael, whose classicism caused him to be more revered even than Michelangelo and nearly as much as the ancient sculptures. Raphael was a reminder, moreover, that the pagan gods had inspired the greatest art ever achieved. Their Renaissance rediscovery and re-creation in new images, and their exhibition on the most prestigious hills of Rome—the Capitoline and Vatican—made possible the new religion of Beauty.

Story makes clear the association between the gods of the Pantheon and the only possibility for Beauty when he begins an essay on Michelangelo with these words: "The overthrow of the pagan religion was the deathblow of pagan Art. The temples shook to their foundations, the statues of the gods shuddered, a shadow darkened across the pictured and sculptured world, when through the ancient realm was heard the wail, 'Pan, great Pan is dead.'" Story then equates the loss of the gods with nothing less than the loss of "Beauty, happiness, life, and joy." "Religion and Art, which can never be divorced," disappeared together. But after the long dark ages,

"the marble gods, which had lain dethroned and buried in the earth for so many centuries, rose with renewed life from their graves, and reasserted over the world of Art the dominion they had lost in the realm of Religion."[14]

The belated American participation in that veneration of the marble gods is our next subject.

5

The Capitoline and Vatican Sculpture Galleries: Temples of Art and the Religion of Beauty

John Singer Sargent's Roman sketchbook of 1869 contains—besides a pale gray wash of the Colosseum and a drawing of the white oxen of the Campagna—studies by the sixteen-year-old artist of the *Laocoon* and the *Apollo Belvedere* in the Vatican, and of the *Faun*, the *Antinous*, and the *Hercules* of the Capitoline Museum.[1] More than half a century later (in 1921), Sargent's painting of *Apollo and the Muses* would be unveiled as part of the decorations for the rotunda in the Museum of Fine Arts, Boston. The American painter's image of Parnassus constituted a far-flung link to one of the most famous paintings of neoclassicism, Anton Raphael Mengs's *Apollo and the Muses* on the ceiling of the grand salon in the Villa Albani in Rome (1760), itself a work of conscious rivalry with Raphael's *Parnassus* in the Vatican *Stanze*, painted 250 years earlier. Rembrandt Peale had managed to see Mengs's painting in 1829, calling it "one of the best works of the last great painter in this style"[2]—a significant statement, since Mengs had been considered by his friend the art historian Johann Joachim Winckelmann and others as the *first* great painter in a new style, whose novelty derived from its being very old. It was the pure style of the ancient Greeks revived in the light of greater knowledge than the Renaissance masters had possessed.

A solitary American, Benjamin West, was among the young painters who had directly witnessed this rebirth. Mengs began to paint his Parnassus in the summer of 1760, at the same time that West received Mengs's advice about his education and made the acquaintance of Cardinal Albani, the patron of both Winckelmann and Mengs and the collector at the center of the new inspiration. Naturally West was taken to see the Vatican *Apollo* (fig. 115), which Winckelmann—in one of the most influential passages of art criticism ever written—placed at the summit of art. The Quaker primitive (as he was considered by his Italian hosts) surprised everyone—so the familiar story goes—by detecting a close resemblance between the divine Apollo and a Mohawk warrior. Following Mengs's advice, West began his "higher education," as Sargent and countless others were to do, by filling a notebook with sketches of the *Apollo* and other famous antique statues in Rome.[3]

From West's first sketches in the Capitoline and Vatican in 1760 to the unveiling of Sargent's Parnassus in Boston in 1921, there is a continuous tradition that places intimate knowledge of antique sculpture at the center of formal training for painters and sculptors. Of the Vatican Gallery Rembrandt Peale wrote that it was like "a delicious dream, but a dream that must be repeated by the artist until its impressions are confirmed into records of truth and usefulness." The pilgrimages of many dedicated apprentices are rendered in fictional synthesis by Hawthorne in *The Marble Faun,* by James in *Roderick Hudson,* and by lesser writers in other tales. Young Roderick, James tells us, drew sketches from the antique in the Capitol and the Vatican "till his head swam with eagerness and his limbs stiffened with the cold."[4]

Painters and sculptors led the way, since those galleries were the schools as well as the temples of their crafts, but writers and the general tourist also felt impelled to contemplate the ancient art. The more thoughtful of them attempted to understand its meaning for them as Americans, democrats, and usually nominal Christians. At least through Sargent's friend Henry James—but not for their contemporaries Howells and Mark Twain—the ancient statues seemed necessary to one's development as a civilized human being. Embodiments of ideal beauty and truth, they did not exist to be criticized; they challenged one to rise to their level. After wandering through the "wilderness of marble" in the Vatican on March 28, 1833, the young Emerson called it "the wealth of the civilized world. It is a contribution from all ages & nations of what is most rich and rare. He who has not seen it does not know what beautiful stones there are in the planet, & much less what exquisite art has accomplished on their hard sides for Greek & Roman luxury. . . . It is vain to refuse to admire. . . . You must in spite of yourself. It is magnificent."[5]

The note of resistance is strong in Emerson, but since Winckelmann the prestige of the long-famous statues of Rome had been increasing steadily. He had shown how they offered something more than archaeological knowledge or sculptural delight, something equivalent to what Emerson three years after his visit to Rome would say could be found in nature: a transcendent religious experience. The ecstasy occasioned by works of ancient art and architecture had been persuasively versified by Byron, whom neophytes found a convenient attitudinal guide. The religion of Beauty for more than two centuries has filled a void created by the absence of adequate ritualistic and aesthetic satisfactions in Protestant and Jewish faiths, or by the total loss of traditional religious beliefs (not always admitted). It underlies aesthetic commentary from Americans (as from others) beginning with Allston's *Lectures on Art,* continuing through the histories of William Dunlap and H. T. Tuckerman, perhaps climaxing in the several works of James Jackson Jarves from 1855 to 1869, and reverberating well into this century in the commentary of critics and historians like Royal Cortissoz and Bernard Berenson, and artist-educators like Kenyon Cox and Eugene Savage. Even the interpretations of Abstract Expressionism, although divorced from the classical source, frequently use the language and hold out the promises of mystical transcendence: the uplifting and transforming moment of contemplation and a visionary contact with the universal and eternal.

Winckelmann had frequently but vaguely defined something called Taste. Like Grace, not everyone had it, but the divine statues could help. "The Minerva Medica [fig. 83] revealed herself to me today," wrote Hawthorne in his notebook after a visit

to the Vatican on Monday, April 12, 1858. The fifty-four-year-old author of ex-quisitely wrought tales and romances humbly continued: "I am partly sensible that some unwritten rules of taste are making their way into my mind; that all this Greek beauty has done something towards refining me, who am still, however, a very sturdy Goth."[6] One suspects he intended to remain one; yet his equation of refinement with receptivity to the antique ideal is a notion he genuinely accepted. Most journalistic accounts of visits to the sculpture galleries do not admit, like Hawthorne's, that such revelations were difficult or rare. These reports are te-diously similar attempts to prove that the writer had not failed to experience at the shrine what was promised by the paraphrases from Winckelmann and extracts from Byron found in the guidebooks. One hopes their ecstasies were real and recognizes the difficulty of finding an original language for such experience, a difficulty the writers often confessed. Sometimes Byron's inventive powers and verbal gifts re-ceived as much praise as the statues. Not merely the lesser essayists and poets, but Cooper, Hawthorne, Melville, and James all witness to the debt that both the initiates and the icon-statues owed to Byron as the intercessory priest and composer of hymns for the new religion of Beauty.

More interesting than these testimonials to Taste are the occasional troubled realizations of an actual preference for the realistic Roman art that Winckelmann ranked lowest. Sometimes a writer also observed that the "perfect" ideal works were strangely defective in some particulars and hard to reconcile with the guide-book views. The *Laocoon* especially (fig. 142) often seemed unreposeful; it even reminded George Hillard of Bernini, the chief exponent of Bad Taste in sculpture.[7] Other supposedly immortal works bore disfiguring bruises of time so difficult to ignore that several observers ventured to find more pleasure in pristine modern works—as long as they were classically inspired. Finally, and most important, these images were, after all, heathen: gods and goddesses, nudities, and mere myths. They represented idolatry, indecency, and lies. How could they be ideal?

Those visitors to the galleries who were not content merely to verify fulfillment of promises, but whose thoughts moved most actively between idea and object and between the general and the particular, returned most persistently to the questions of realism versus idealism, paganism versus Christianity, and the importance of the nude to the ideal. These were the three stumbling blocks on the way to Beauty both for those who merely wished to worship and for those Americans who hoped also to create new images for new temples in the New World. Inspired by images of old gods, our art would someday equal or surpass them. As the ideal of the Republic had been realized once more in finer form, so could the ideal of Beauty embodied in the ancient sculptures be achieved again.

History and Transcendence

February 18, 1821, being one of the days on which "the great Museum" of the Capitoline was open to the public, Theodore Dwight returned to absorb its treasures further, intending at last to give an account of it. But what he thought worth recording, finally, was nothing of the *Venus*, the *Faun*, the *Antinous*, or even the

Dying Gladiator. What preoccupied him were the sepulchral fragments brought from the Appian Way, whose only claim to interest was

> as the memorials of unknown and humble individuals who lived and died so many centuries ago. . . . Wherever the eye turned it glanced on such broken expressions as these: . . . "Optimi filii," . . . "Carissimae conjugis," . . . "Juliae sorroris amatae, hoc saxum, cum multis lachrymis, posu"—["In memory of the best of sons,"—"To my dear wife," . . . "In memory of Julia, our dear sister, we have placed this stone, with many tears"].

These memorials moved Dwight to "a more affectionate interest in . . . the fate of Rome" than "distant and general reflections on her greatness and glory" ever had. They reminded one, he felt, that the famed armies and proud emperors brought to others suffering, injustice, and war: "Here we learn to despise what our old Roman instructors taught us to admire: the splendour of an empty name; and begin to sympathise . . . not with the descent of an empire to the dust, but with the real distresses of the helpless, unoffending individuals who were involved in its ruin." Moved by these "real distresses" of the humble, Dwight had neither patience nor space even for the also real emperors ("those monsters"), real philosophers, and real poets, whose busts are grouped in the following three rooms. And the "remaining apartments [containing the too-famous ideal sculptures] need scarcely be mentioned."[8]

Sophia and Nathaniel Hawthorne interested themselves intensely in the "monsters." The portrait sculpture of Roman emperors, ladies, philosophers, and poets offered them an incomparable opportunity for psychological analyses. Sophia, who had been reading Quatremère de Quincy, was anxious to see—of all people—the emperor Commodus, whose "marvelous beauty" the French scholar had described. In fact, she wanted to get acquainted "with all these potentates, who ruled the world, but not themselves." In the *Julius Caesar* of the Capitoline (fig. 57), Nathaniel observed the ugly physical details precisely—"wrinkled, puckered, shrunken"— and then drew his inference: "he had fought hard with life, and had suffered in the conflict."[9] Melville's interpretation in his lecture "Statues in Rome" was less sympathetic:

> The head of Julius Caesar fancy would paint as robust, grand, and noble; something that is elevated and commanding. But the statue gives a countenance of a businesslike cast that the present practical age would regard as a good representation of the President of the New York and Erie Railroad, or any other magnificent corporation. And such was the character of the man—practical, sound, grappling with the obstacles of the world like a giant.

"Magnificent corporation" and "like a giant" still concede an elevated status, but realistic portraiture primarily encourages a realistic—that is, deflationary—estimate of emperors. The reductive possibilities are meant to be nearly complete when Howells, as an old man, detects in this same bust of Caesar a resemblance to "the finer sort of Irish-American politician."[10]

What all these reactions have in common is the pleasure of feeling that one can

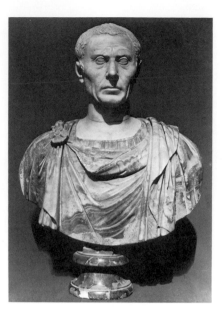

Fig. 57. *Julius Caesar.*
Antique bust. Capitoline
Museums, Rome.

"know" a historical figure—what he "really" was like. William Wetmore Story
wrote in *Roba di Roma* that to anyone who lived in Rome, the emperors of the
Capitoline became as familiar as Pius IX and Napoleon. According to Melville, the
ancient sculptors had performed "a task which was considered beneath the dignity
of the historian," comparable to that of the modern writer of memoirs: "Here are
ancient personages, the worthies of the glorious old days of the Empire and the
Republic. Histories and memoirs tell us of their achievements, whether on the field
or in the forum, in public action or in the private walks of life; but here we find how
they looked, and we learn them as we do living men." And, as with living men, one's
own preoccupations determine which to look at, which to know, and what to think
of them. Hawthorne's Augustus is a philosopher saddened by his realization of the
worthlessness of being "at the summit of human greatness."[11] For both Nathaniel
and Sophia Hawthorne the value of the individualizing realism of these Roman
portraits is precisely in its showing that the originals are not reducible to a common
type; each is unique, the victim or beneficiary of an extraordinary destiny from
which, however, psychological and ethical principles may be inferred.

Howells, in contrast, prefers to see the satirical type and the social condition.
Thus he takes no notice of an Augustus, but expresses amazement at the freedom of
the original sculptor to reveal so vividly the "chubby idiocy" of the young Nero.
Melville combines Hawthorne's close scrutiny and psychological study with How-
ells's search for a contemporary analogy that proves universal typicality. His ambiv-
alence is evident in his admiration for the remarkable individual and his reductive
suspicion that the fundamental truth is in the familiar type. "Standing face to face"
with Demosthenes, whose "strong arm, . . . muscular form, [and] large sinews, all
bespeak the thunderer of Athens," he nevertheless sees "a modern advocate" to
whom "a glorious course of idleness would be beneficial" (cf. an American copy of
the head, fig. 58). Socrates, closely observed, becomes the "simple-hearted, yet cool,

Fig. 58. Augustus Saint-Gaudens. *Demosthenes* (bust after the head of an antique statue in the Vatican Museums, Rome). 1873. Marble. H: 21". Formerly in the Evarts Family Collection. Photo courtesy Saint-Gaudens National Historic Site, Cornish, New Hampshire.

sarcastic, ironical" character he truly was, even though at first he reminds one "of the broad and rubicund phiz of an Irish comedian." Seneca, known to be "avaricious and grasping," although his philosophy was almost Christian, seems "pinched and grieved," with a face that is "ironlike and inflexible, and would be no disgrace to a Wall Street broker." In certain cases—Vespasian, or Tiberius, "the most wicked of men"—the failure of the face to reveal all is ironically apt: "'That Tiberius?' exclaimed a lady in our hearing. 'He does not look so bad.' Madam, thought I, if he had *looked* bad, he could not have been Tiberius."[12]

The Roman portrait sculpture in the Capitoline and Vatican galleries was attractive to those with an interest in the ancients—and everyone had at least an idea of Socrates and Julius Caesar—because they established a common humanity between the American viewer and people whose celebrated status in history and poetry had left them faceless and remote. They did not test one's capacity for exalted feeling, but rather encouraged a familiarity, even a sense of equality. They permitted a realistic democrat like Howells to condescend even to Caesar. (He had nothing to say of Apollo.) N. P. Willis called the *Apollo Belvedere* (fig. 115) the "greatest statue in the world," but said that he would rather have possessed the *Young Augustus* (fig. 59) than "all the gods and heroes of the Vatican." Such works "made me realize that the Romans of history and poetry were *men*" and brought them "familiarly to my mind." The late Napoleon, Willis imagines, must have looked something like this Augustus in his youth.[13] There was, of course, a tendency to take greatest interest in portraits of the more exalted or admired ancients, so that romantic hero worship is not inconsistent with the appreciation of "realistic" portraiture. The Vatican *Demosthenes* that Melville saw as a muscular lawyer in need of a rest cure, Henry James (reminding his sister that she could see a cast of it at the Boston Athenaeum) described as "a fine wise old man . . . so perfect and noble and beautiful that it amply satisfies my desire for the ideal." James agreed with

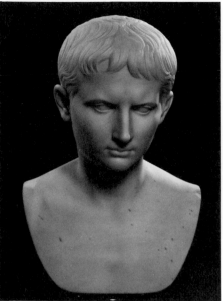

Fig. 59. Horatio Greenough. *Young Augustus* (copy of original in the Vatican Museums). 1836. Marble. H: 53.9 cm. W: 29.2 cm. Courtesy Museum of Fine Arts, Boston. Bequest of Charlotte Greenough.

Willis on the "ravishing little bust of Augustus as a boy. . . . He may have been an arrant knave but he had a sweet most interesting intellectual visage. All the Roman portraits give a deep desire to plunge into Roman history—so that yesterday I narrowly escaped paying 22 frs. for an English publication on the subject."[14]

Realistic Roman portraiture and the interest in history are reflected in the works of American sculptors in Italy in the nineteenth century, both in the reproductions they made of classical works and in the character of their own portraits of American politicians, orators, and others. The Vatican *Demosthenes* was copied in marble by Thomas Crawford in 1837, by Paul Akers in the late 1850s, and by Augustus Saint-Gaudens in 1873 (fig. 58). The Vatican *Young Augustus* was copied by Horatio Greenough in about 1836 (fig. 59), three times by William Henry Rinehart in 1867, and by Saint-Gaudens in 1872. Replicas of the *Cicero* of the Capitoline were made by both Akers and Saint-Gaudens, who also copied its *Marcus Junius Brutus*.[15] The realistic tendency in American male portrait sculpture is evident even in works modeled in America before they were executed in Italy. The close relation between the *John Adams* of Greenough (1829), the *Andrew Jackson* of Hiram Powers (1835) (fig. 3), and the busts of Roman senators and emperors owes more to the expressively modeled and believably individualized physiognomies than to togas or bared breasts.

Their genuine delight in realistic portrait sculpture, both ancient and modern, did not prevent most nineteenth-century visitors to the Vatican and Capitoline galleries from honoring scrupulously the neoclassical hierarchy: realistic portraiture, then ideal portraiture, and at the top those images of "heroes and divinities" that possessed "an air of majesty worthy of the 'land of lost gods and godlike men.'" Generally, they conserved their energies for the gods and heroes. Like Bayard Taylor (whose words these are), they knew that when faced (as at the Vatican) with "hundreds upon hundreds of figures—statues of citizens, generals, emperors and

gods, fauns, satyrs and nymphs, children, cupids and tritons," even when many were of "matchless beauty," they had to "keep their eyes unwearied" until they reached the *Antinous* or the *Apollo Belvedere.*[16]

The ideal achievements Taylor saw in the Vatican made him wonder what hope there was for American art. The Greeks and Romans had already attained "perfection" in this field:

> I should almost despair of such another blaze of glory on the world were it not my devout belief that what has been done may be done again, and had I not faith that the dawn in which we live will bring another day equally glorious. And why should not America, with the experience and added wisdom which three thousand years have slowly yielded to the Old World, joined with the giant energy of her youth and freedom, rebestow on the world the divine creation of art? Let Powers answer![17]

Hiram Powers certainly tried—and so did all the others from Horatio Greenough on, those pioneers of American sculpture on whom Hawthorne's Kenyon and James's Hudson are based. In Rome only could each find, as James calls it, the "sufficient negation of his native scene" in the positive presence of ideal beauty.[18] The often-expressed opposition between Rome and Greece, as representing respectively the Real and the Ideal, now became an opposition between America and Rome. It was America (the new Rome) that insisted on endless realistic copies of its unbeautiful heads, whereas Rome inspired the sculptor to ideal efforts for which there was little demand. Yet behind this apparent disloyalty to America was in fact the desire to create beauty for the New World—a faith that the old fire could flame again in the new dawn. And it was assumed that the new art would be virtually indistinguishable from the original: "what has been done may be done again" was often understood all too literally. Sometimes, fortunately, the beauty or heroism of the subject, or the exalted allegorical intent of a monument, allowed the real to partake of the ideal. Thomas Crawford's bust of his wife, Louisa, who was famous for her beauty, was rightly known first as an ideal *Portrait of a Lady,* and in his colossal *Armed Liberty* atop the dome of the American Capitol he had a subject hardly to be distinguished from a *Minerva* or a *Juno.*

James dramatized the conflict and occasional reconciliation between historical factuality and transcendent beauty in *Roderick Hudson.* While sketching the *Juno* of the Villa Ludovisi (which Hillard called "the only goddess I have ever seen"),[19] Roderick catches his first sight of Christina Light, whom he sees at once as "transcendent perfection," "beauty's self," "a revelation." He is therefore certain she cannot be American. When he finishes the sketch of the statue, Juno has "the eyes, the mouth, the physiognomy" of Christina. Since, according to Roderick, the living girl alone has provided him with his one "glimpse of ideal beauty," there seems at first no contradiction between the real and ideal. So rare and rightly placed, however, is Christina, that Roderick has had to come to classic Rome to see her as well as Juno. "She's a daughter of this elder world," he rightly perceives. Late in the book, after two years have passed, Roderick's sponsor Rowland Mallet stands with Mary Garland, the sculptor's fiancée from Massachusetts, in the sculpture gallery of the

Vatican. They are contemplating the *Demosthenes* (in which, we recall, James himself found the ideal in the real), when Mary suddenly expresses her pride in Roderick's work, a man's profession. But at that very moment Roderick is creating his final work, a realistic "Roman" bust of his mother. His "Greek" idealism has been eroded by his frustrated passion for the "ideal" Christina. It is possible, however, that the statue of his mother is his best work. This irony emerges also when one contemplates the works of Greenough, Powers, and Crawford and their successors. Some of their commissioned busts are remarkable studies in character. For Americans who have an interest in their own history and literature, such a work as Powers's *Andrew Jackson* provides those pleasures of recognition and familiarity that the Roman portrait sculpture gave to classically educated nineteenth-century visitors to the Vatican. It is about the "ideal" works that one often has doubts.

Whether or not ideal beauty should even be the aim of modern sculptors is debated by the artists and patrons in James's novel. The strongest advocate against it is the worldly—and immensely successful—sculptor Gloriani, who argues for the ugly and the expressive, and happily detects increasing signs of the un-ideal in Roderick's art. In the bust of Christina, however, the issue is ambiguously stated, since Christina's beauty causes it to be mistaken for "an ideal head . . . one of the pagan goddesses—a Diana, a Flora, a naiad, a dryad." Some viewers are confounded to discover that the representation of "an American Christian maiden" could resemble "a pagan goddess." A later statue of a drunken *lazzarone* is, according to Roderick, "an image of serene, irresponsible, sensuous life"—an "ideal lazzarone," not a "real" one, who is a "vile fellow." (James's satire here parallels Howells's on Real and Ideal Grasshoppers in *Criticism and Fiction*.) A Mr. Leavenworth, who has commissioned a statue of "Intellectual Refinement" (finally abandoned as unrealizable), detects a resemblance in pose between the lazzarone and *The Dying Gladiator* of the Capitoline (fig. 144). He transfers to an image of drunkenness the standard neoclassical criticism of that statue (perhaps he had read Kenyon's criticism of it in *The Marble Faun*): "Sculpture shouldn't deal with transitory attitudes." To which Roderick replies, "Lying dead drunk's not a transitory attitude. Nothing's more permanent, more sculpturesque, more monumental." By this time Roderick, always more Dionysian than Apollonian in his private life, has gone far toward the more baroque style of the later neoclassicists who were his true contemporaries in the 1860s. (Roderick epitomizes two generations of American sculptors in his two-year career.) Initially, after producing his Adam and his Eve, he could say:

> "I mean never to make anything ugly. The Greeks never made anything ugly, and I'm a Hellenist. . . . I care only for the beauty of Type. . . . It's against the taste of the day, I know; we've really lost the faculty to understand beauty in the large ideal way. . . . The thing that there was is the thing I want to bring back. . . . I want to produce the sacred terror; a Hera that will make you turn blue, an Aphrodite that will make you turn—well, faint."

Roderick is not intimidated by Gloriani's protest that Canova has already exhausted these "poor old academic bugbears." His versions will be "more than mortal. They will be simply divine form. They shall be Beauty; they shall be

Wisdom; they shall be Power; they shall be Genius; they shall be Daring. That's all the Greek divinities were." "To crown all" he will make an image of his Native Land. Miss Blanchard objects that his conceptions are rather abstract; Gloriani, that the only thing divine is to be twenty-five years old. "My colossal 'America' shall answer you!" he replies. But everyone gathered in the studio is looking at a photograph of his first work, *Thirst*, done in Northampton, Massachusetts: an ideal nude youth eagerly drinking from a gourd. Singleton, an artist himself but a sympathetic critic, says, "one might say that really you had only to lose by coming to Rome."[20] What Singleton does not know is that Hudson's practical options as a sculptor in America had been represented by a bust of the shrewd Yankee lawyer, Mr. Barnaby Striker, which Roderick had destroyed. Miss Blanchard's criticism is more to the point, for Roderick's grandiose notions of what it would mean to be the great sculptor of America had been voiced before he ever left its shores. To start with the idea and increasingly fail to find the image is what brings Roderick to despair. Only when he finds the compelling face first in reality—whether the ideal face of Christina or the careworn face of his Yankee mother—is he still able to create.

The parallel dialogue on sculpture that Hawthorne had provided in *The Marble Faun* (chaps. 13–15) does not urgently arise from the tensions of any of his characters, as with James. Instead he distributed among them his own contradictory and vacillating views (and some he had picked up during conversations in Roman studios). These indicate doubts not only about materialistic realism in sculpture but also about the existence of an eternally true ideal "reality." The old myths may be outmoded, misleading, fraudulent, or immoral. Their sculptural embodiment then is an instance of Beauty *not* being Truth, and therefore no longer a joy. In an extended paragraph obviously referring to John Gibson (although the British sculptor is mentioned by name only elsewhere), Hawthorne stated: "He had spent his life, for forty years, in making Venuses, Cupids, Bacchuses. . . . Gifted with a more delicate power than any other man alive, he had foregone to be a Christian reality, and perverted himself into a Pagan idealist, whose business or efficacy, in our present world, it would be exceedingly difficult to define." It was "a sin and shame to look at his nude goddesses." Tinted flesh color, they were simply "naked women."[21] Upon reading this, Sir Henry Layard wrote to the American sculptor Harriet Hosmer (a disciple of Gibson) that he could not understand a man of Hawthorne's "refinement objecting to the colored Venus" on moral grounds rather than those of good taste.[22] His point was well taken. Hawthorne's selection of Venus, Cupid, and Bacchus from among many less sensual of Gibson's subjects, and his diction—"perverted," "sin," "shame"—indicate clearly enough that his objections were ethical rather than aesthetic. Hiram Powers encouraged that attitude by referring to a Gibson statue as the *Tainted Venus*.[23]

Hawthorne had previously made Miriam voice his objection not merely to goddesses stained with coffee or tobacco juice but to *all* nudity in contemporary sculpture. Argued primarily on the grounds of realism (nobody is ever *seen* nude any more, as they were in Greek days), it was also motivated by his moral squeamishness (the artist "is compelled to steal guilty glimpses at hired models"). Fidelity to contemporary life was an odd position for Hawthorne to be taking, and in fact he was not for realism in sculpture, either. He scorned the "nice carving of button-

holes, shoe-ties, coat-seams, shirt-bosoms, and other such graceful peculiarities of modern costume." No. A modern sculptor for Hawthorne should have been neither a pagan idealist nor a materialistic naturalist, but a Christian realist and a poet (something, in short, like the writer of *The Marble Faun*). Hawthorne made his sculptor-hero Kenyon the direct heir to Antonio Canova by placing him in the neoclassical master's own studio. But, like James's Roderick, Kenyon could have shown Canova "how," at least in subject matter. His works include an idealized Milton (whose features have been deduced from his poetry), a drowned pearl-fisher, Hilda's hand, and a great Cleopatra. All were taken from works Hawthorne saw in American studios in Rome and Florence, a theft he acknowledged in his preface. His ambivalence toward even these works—although there are no nude goddesses and no buttons—is expressed in a dialogue between the cool, respectable sculptor Kenyon and the antipathetic painter Miriam. Both express their self-contradictory author's own views. Miriam objects to the art of sculpture itself as being incapable of representing the agitation and difficulty of life, yet she comes to Kenyon's studio precisely to find the "calm and coolness" of his marbles. She even criticizes his *Dead Pearl-Fisher* because "the form has not settled itself into sufficient repose"— in other words, some expressive tension remains (see fig. 131). She declares that except for portraiture, which Hawthorne has already dismissed as an egotistical imposition on posterity, there is nothing for sculpture to do in the modern world. "There is never a new group nowadays," she says, "never even so much as a new attitude":

"Greenough (I take my examples among men of merit) imagined nothing new; nor Crawford either, except in the tailoring-line. There are not—as you will own— more than half-a-dozen positively original statues or groups in the world, and these few are of immemorial antiquity. A person familiar with the Vatican, the Uffizi gallery, the Naples gallery, and the Louvre, will at once refer any modern production to its antique prototype—which, moreover, had begun to get out of fashion, even in old Roman days."

Kenyon vigorously replies that as long as there is Carrara marble, "and while my own country has marble mountains, probably as fine in quality, I shall steadfastly believe that future sculptors will revive this noblest of the arts, and people the world with new shapes of delicate grace and massive grandeur." In his unconsciously Americanized paraphrase of Winckelmann's famous formula ("noble simplicity and *calm* grandeur"), Kenyon sounds like Roderick; and in fact this is his own similar declaration of faith in himself, his country, and the future to achieve the ideal beauty of the past—if only, he adds, "mankind will consent to wear more manageable costume!" His practical reply, however, is to unveil his Cleopatra. Hawthorne's lengthy description—whether or not it corresponds to anything we can see today in William Wetmore Story's original (fig. 87), or whether anyone, even Hawthorne, could see it in the 1850s either—expresses ideal combinations of "repose" and "latent energy," "tenderness" and "passion," womanly beauty-of-type and Egyptian particularity. It is, says Hawthorne, "one of the images that men keep forever"[24]—keep, at least, in storage.

Until recently, museum storage is exactly where most neoclassical American paintings and sculptures (when not part of permanent monuments) ended up in the twentieth century. However, entirely apart from the fact that a few of them merit a better fate simply because they possess a beauty we have begun to perceive again, they remain interesting as the new nation's attempt to become a contributing part of the Western tradition it inherited and to equal what many thought its highest achievement in art. Nationalism might be expressed through the subject matter— *Washington*s and *Liberty*s—but pride of American accomplishment on the ancients' own level would be equally effective, as the quotations from Bayard Taylor, Hawthorne's Kenyon, and James's Hudson suggest. By definition, in fact, the subject of the highest art was never merely national, but universal. Therefore, for American painters and sculptors as for others, classical mythology and the nude were inevitable studies. The nude was central to the humanistic tradition of Beauty, and found its most justifiable excuse for being in the now timeless ancient myths. Pagan beliefs and nudity—two things alien to American taste—thus seemed essential to the production and worship of Beauty in the new world.

Pagans and Christians: Bodies and Souls

Around 1730 a Swedish immigrant painter named Gustavius Hesselius, who had made a living in America for twenty years by painting portraits, decorating coaches, and making spinet pianos, essayed a *Bacchanalian Revel*, to no recorded acclaim.[1] In 1811 another Swedish immigrant, Adolf Wertmüller, tried again. He had brought with him from Paris a *Danae*, showing Jove descending upon the nude in a shower of gold. This work was considered "dangerous even for a woman to look at."[2] Wertmüller's wish to display it at the Pennsylvania Academy disgusted both Charles Willson Peale and Benjamin Latrobe. Peale wrote to Thomas Jefferson that "we should guard against familiarizing our Citizens to sights which may excite a blush in the most modest." When the artist exhibited his *Danae* independently and made money from it, other artists had to be warned not "to rake, from the filth of mythology, a disgusting portrait of miserable licentiousness."[3] Tuckerman, who saw it many years later, described it as "one of the most exquisite pieces of flesh-painting which has emanated from the French school."[4]

On visits to the Vatican in 1816–17, James Sloan was moved to consider the pernicious influence of Paris in perpetuating the worst aspects of classicism. He had seen "those unrivalled masterpieces, the Apollo, the Laocoon, and the Antinous" four years earlier in the Louvre, where they had been taken by Napoleon. Now he was pleased to see these "matchless forms" restored to the chaster atmosphere of the Vatican, where their potentially dangerous pagan attractiveness was counteracted by images that encouraged "the higher feelings of moral and religious enthusiasm." The student who might "become so enamoured of the works of the ancients, as to believe that the religious ideas and fictions of heathen mythology furnish the happiest subjects for poetry and painting" had only to step into the adjacent St. Peter's to have that notion refuted by the works of Canova, Guido,

Domenichino, Raphael, and Michelangelo (Bernini is not mentioned): "However happy they [the ancients] were in seizing those ideal forms of beauty, that seduce the senses and the imagination, and however noble and perfect those specimens are, which they have left of their skill in portraying the external forms of matter, the true sources of the moral sublime are to be found in the christian scriptures."

At the Vatican this truth was evident: at the Louvre it was not; and the consequences were obvious in contemporary French painting. At the Louvre "sacred, gay, and voluptuous subjects were promiscuously mingled together," and anyone with a "delicate and refined taste" was as shocked to find "the Jupiter and Leda of Coreggio in the same company with the transfiguration of Raphael" as he was disgusted to see the "sublime performances" of Rubens and Rembrandt next to "the ale-house frolicks of Teniers." The degeneracy of taste in France since Poussin was further encouraged by the unsuitableness for the "study of the fine arts" of the Louvre's location between the "crowded and tumultuous quays" of the Seine and "the mountebanks and marionettes of the place Carousel." In contrast, "no sounds are heard near St. Peter's, but the accents of prayer; a sacred stillness pervades these beautiful receptacles of art, and the murmur of its fountains is in harmony with that freedom from meaner cares, and that intellectual repose, so necessary to the success of the higher efforts of the imagination."[5] This is merely the most explicit of several nineteenth-century testimonials to the superiority of the Vatican to the Louvre as a Temple of Art. Not the least of its advantages was that its Christian—even if Catholic—ambience redeemed the experience of pagan art, an impossibility in the curiously mixed (monarchist and populist—equally earthy) atmosphere of the Louvre.

The Christian paintings at the Vatican were seen by others, however, not as a prophylactic against the corrupting sensuality of pagan art, but as a foil that ironically established the superiority of heathen to Christian mythology. At the Vatican even William Dean Howells was moved to unwonted appreciation of the gods, since they provided a "refuge from the cruel visions of Christian art" that he first had to endure in the adjacent galleries:

> It was such relief, such rest, to go from those broilings and beheadings and crucifixions and flayings and stabbings into the long, tranquil aisles . . . where the marble men and women, created for earthly immortality by Greek art, welcomed me to their serenity and sanity. The earlier gods might have been the devils which the early Christians fancied them, but they did not look it; they did not look as if it was they that had loosed the terrors upon mankind out of which the true faith has but barely struggled at last, now when its relaxing grasp seems slipping from the human mind.[6]

The most thoughtful nineteenth-century considerations by an American of the relation of art to pagan and Christian religions, and of nudity to the ideal, were written by the art historian and critic James Jackson Jarves. He went over the ground no fewer than three times: in *Art Hints, Architecture, Sculpture and Painting* (1855), *The Art-Idea* (1864), and *Art Thoughts, the Experiences and Observations of an American Amateur in Europe* (1869). Jarves was a pioneering collector of early

Italian painting whose long residences in Italy made him familiar with all the great galleries. His views are important, not only because they were influential (reinforcing the Ruskinian influence steadily growing in American aesthetic thought), but because they articulated tendencies to identify art with religion that are implicit in the commentaries of many other Americans who contemplated sculpture in the Vatican, Capitoline, and Uffizi galleries, and in the studios of American sculptors in Rome and Florence.

The history of art proved, Jarves believed, that works of the greatest beauty are born of religious belief and feeling. In arguing this connection, he frequently makes the terms *religion* and *art* virtually interchangeable. In distinguishing science from art, for instance, he says that the former is "the material expression or image of Wisdom," whereas art is "the spiritual representative of Love." Art lifts us "above the ordinary laws of matter, into the world of spirit," the brilliant "effulgence" of which would blind us except for the intermediary of "material beauty." It "brings down the incomprehensible, by a species of incarnation, to the range of finite faculties." Art-as-Christ could hardly be more explicitly suggested. In the fact that art is the ideal "made flesh," however, lies its danger. For its "sensuous proclivity" may become an end in itself, obscuring the "soul's vision" with "carnal instincts" and directing the viewer toward the "external life" rather than the "divine origin." Therefore the artist must remember that his talent is sacred. "By the exercise of [his] indirect creative faculty the artist partakes of a divine function, insomuch as Divinity delegates to him the infinite talent by which he represents the creative principle, and, by its stimulus, is trained for a loftier being." Elsewhere Jarves asserts that the "end and aim" of beautiful objects is "spiritual and eternal"; "unselfish fervor" is therefore required of those who would "serve Art." The "scope and direction of Art" is "GODWARD."[7]

Precisely because Jarves assigns to art the character and functions of religion, he strongly resents the historical subordination of art to dogmatic religion and "priestcraft." Only in escape from such "vassalage" can art be free to fulfill "the aesthetic principle of its own being," to "assert its proper dignity and beauty." A liberated art appears to be the same thing as a liberated religion. "Poet-artists are the prophets and messengers of truth in the garb of beauty," he asserts. "The art of a nation is at once its creed and catechism." In the highest period of Greek art, it was not only "wholly emancipated from priestly servitude, but, through its inherent intellectual force," had "won for itself the position of teacher. Art and religion were indeed, in one sense, identical." The "mind was unshackled, and left to its normal action," so that artists and poets were able to become the creators of a "beautiful, refined, and natural mythology. . . . The *word* was indeed made flesh."[8]

Naturally Jarves, like Hawthorne and his Hilda, hastened to add that the word's merely "sensuous, aesthetic sense" in Greek religion was "inferior by far to the Christ-love which descended later upon men, to elevate them to a still higher phase of life." His conviction that the greatest pagan sculpture is more beautiful than even the best Catholic art therefore troubled him, since it defied notions of cultural progress and his constantly reiterated faith in the superiority of Christianity. He tried to believe that Protestantism—purified Christianity, or the "religion of humanity"—would inspire the highest art of all in the current "democratic-progres-

sive" phase of history. But he had to admit that it had not yet done so. The "best Christian art" shows "lofty idea and great naturalistic vigor of treatment," but "it is a relief to turn from the school as a whole to the antique Isis, Minerva, Flora . . . fashioned in the principles of beauty." The ancient artist had *two* sources of inspiration: his "intense love of the beautiful" as well as "a faith, which, like that of Fra Angelico, by prayer and devotion, opened up to him celestial visions and special manifestations of the favor of *his* gods and their delight in his work. . . . Ecstatic inspiration has not been confined to the Roman Catholic artist. His Pagan and Protestant brethren have been likewise favored." William Blake, with his vision of the "human form divine," exemplifies the possibility of a Protestant mysticism freed from puritanical asceticism.[9]

Equal in spiritual revelation, the Greek artist surpassed the Catholic in the aesthetic manifestation of what was revealed. Superior art was encouraged by the nature of the gods as he understood them. Greek religious art contrasts both with the "passive and petrified sublimity of the Egyptian" that preceded it and "vulgar violence and coarse suffering" of Catholic realism that followed. What it had was a profound humanity: it "delighted in joyous, sensuous life, and brooked no restraint upon the will or actions of its divinities, for what was happiness and possibility to them was likewise joy and possibility for humanity, only in an inferior degree." This explained its superiority: "Greek art is in so great a degree an aesthetic idealization of the higher faculties of man as the climax of nature and seed of divinity, every man having latent within him the capacity of a god, that even its fragments continue to be viewed as the noblest specimens of true art yet produced." More specifically:

> Examples of female loveliness, of manly strength, of heroic action, and of the faculties of head and heart, and beauty of form, that most worthily represent man or woman under the guise of a Juno, Minerva, or Venus, a Hercules, Jupiter, Mars, or Bacchus, and other personages of a populous Olympus . . . [in] their virtues and vices . . . are alike human, and, in consequence, upon our own level of motive and action, or within the range of our own capacities.

If the gods are known as human, a man is also shown as "on his way to divinity." This is exemplified by the *Athlete of the Vatican*, who is shown "scraping the sweat from his arm"—a most "vulgar" action. Yet "the attitude and expression, independent of its pure anatomical detail and superior execution, are such as to suggest, in the classical sense, the 'godlike.'" There are, however, limits. Both the *Old Hag* and the *Drunken Woman* of the Capitoline show that even the Greeks could lapse into "disgustingly correct realism." Our sense of what is "loveliest and best" in the female sex makes these works repellent, wrong in both subject and treatment. A "jollily tipsy" Bacchus might, however, be permissible, "despite the sage axioms of temperance."[10]

Since human suffering is so ceaselessly the favored topic of Christian art, it is worth noting how rarely the Greeks treated it, and how finely when they did. In the *Laocoon* (fig. 142), "bodily pain" is made "subordinate to aesthetic taste," and "moral beauty [evident in the facial expressions of the father and his sons] . . .

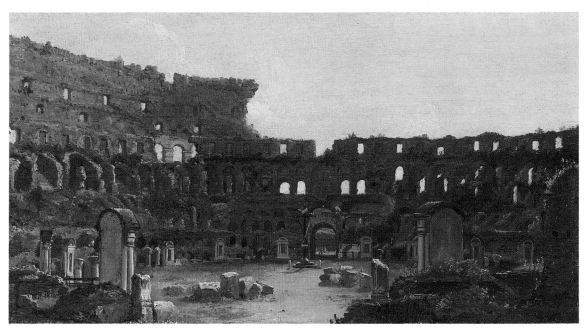

1. Thomas Cole. *The Colosseum, Rome.* ca. 1832. Oil on canvas. 10⅛
× 18⅜". Collection Albany Institute of History and Art.

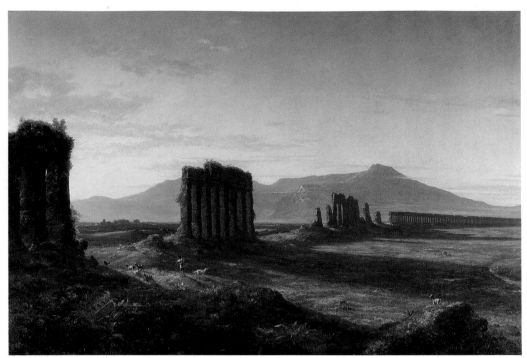

2. Thomas Cole. *Roman Campagna.* 1843. Oil on canvas. 32¼ ×
48⁵⁄₁₆″. Courtesy Wadsworth Atheneum, Hartford. Bequest of Clara
Hinton Gould.

3. John Gadsby Chapman. *Harvesters on the Roman Campagna.* 1867.
Oil on canvas. 29½ × 71½″. Yale University Art Gallery. Gift of
Senator H. John Heinz III, B.A., 1960.

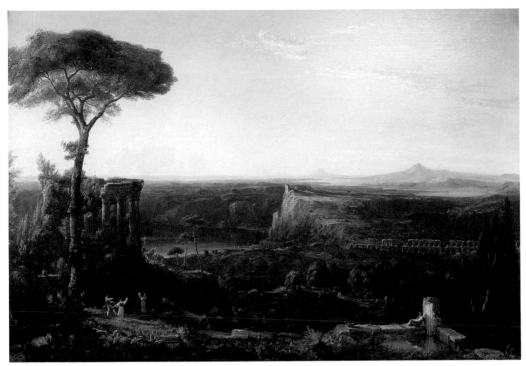

4. Thomas Cole. *Landscape Composition, Italian Scenery*. 1832. Oil on canvas. 37½ × 54¼". Courtesy New-York Historical Society, New York City.

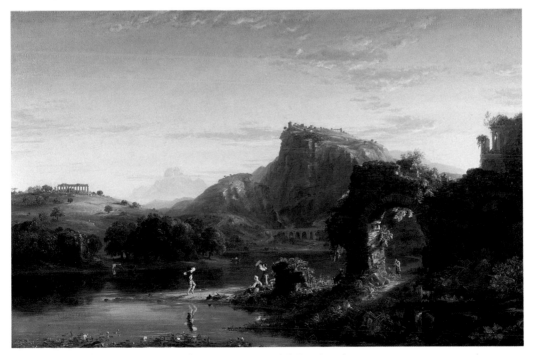

5. Thomas Cole. *L'Allegro*. 1845. Oil on canvas. 32 × 48". Los Angeles County Museum of Art. Gift of the Art Museum Council and the Michael J. Connell Foundation.

6. Washington Allston. *Italian Landscape.* ca. 1805. Oil on canvas. 39 × 51″. Addison Gallery of American Art, Phillips Academy, Andover, Massachusetts.

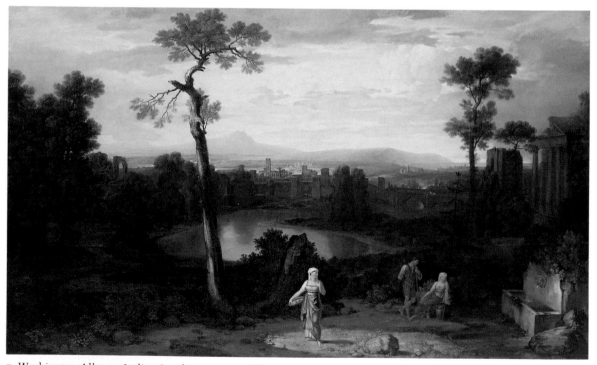

7. Washington Allston. *Italian Landscape.* 1814. Oil on canvas. 44 × 72″. Toledo Museum of Art, Ohio. Gift of Florence Scott Libbey.

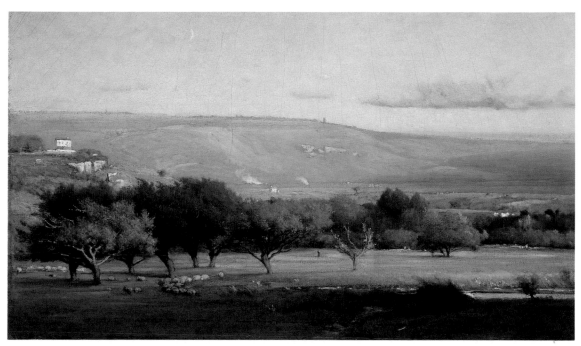

8. George Inness. *Italian Landscape*. 1872(?). Oil on panel. 26½ ×
42¼". Courtesy Museum of Fine Arts, Boston. Bequest of Nathaniel T.
Kidder.

9. George Inness. *Pine Grove, Barberini Villa, Albano, Italy*. 1874. Oil
on canvas. 30¼ × 45⅛". Virginia Museum of Fine Arts, Richmond.

10. George Inness. *The Pines and the Olives* (*"The Monk"*). 1873. Oil
on canvas. 38½ × 64½". Addison Gallery of American Art, Phillips
Academy, Andover, Massachusetts.

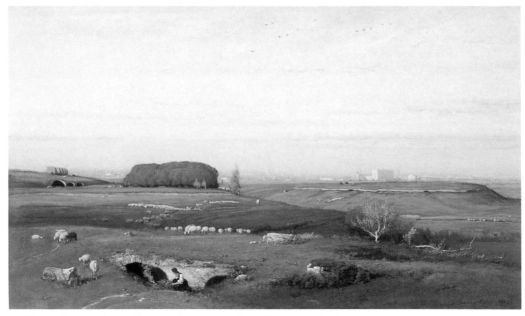

11. George Inness. *In the Roman Campagna*. 1873. Oil on panel. 26 ×
43". The St. Louis Art Museum.

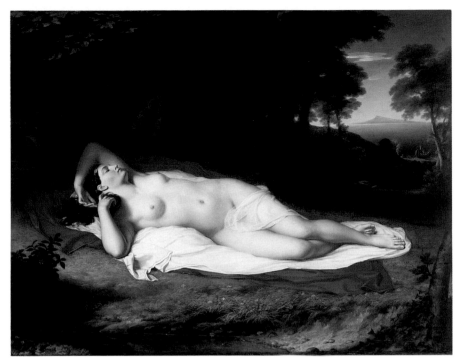

12. John Vanderlyn. *Ariadne Asleep on the Island of Naxos.* 1809–14.
Oil on canvas. 68½ × 87″. Courtesy The Pennsylvania Academy of the
Fine Arts. Gift of Mrs. Sarah Harrison (The Joseph Harrison, Jr.
Collection).

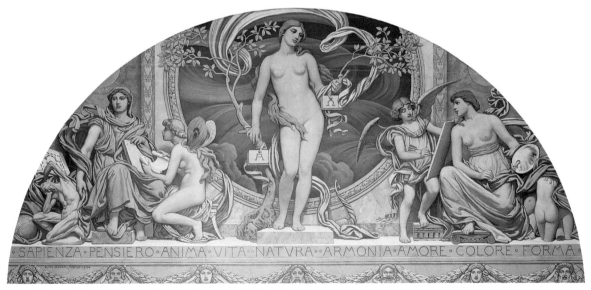

13. Elihu Vedder. *Rome, or The Art Idea.* 1894. Oil on canvas. 12 ×
24′. Bowdoin College Museum of Art. Gift of the Misses Walker.

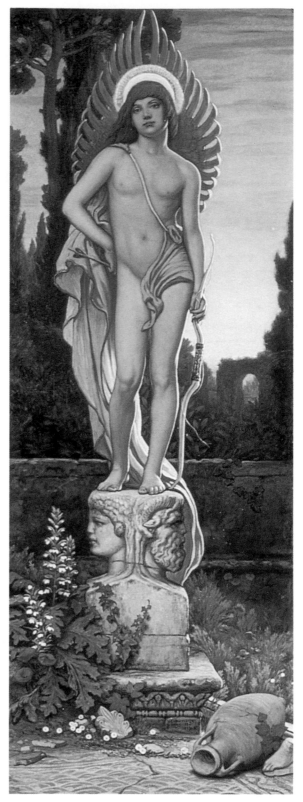

14. Elihu Vedder. *Love Ever Present,* or *Superest Invictus Amor,* or *Amor Omnia Vincit.* 1887–99. Oil on canvas. 34¼ × 12½". The Brooklyn Museum. Lent by James Ricau.

overpowers the sense of physical agony." Jarves gives the standard Winckelmannian view of the *Laocoon:* in spite of its "violent and convulsive action, . . . we feel, above all else, its deep quiet." Across the city on the Capitoline, *The Dying Gladiator* (fig. 144) provides another example of the elevation of the painful subject into "ever-living art." Jarves sees it as "an incarnation of the spirit of the universal brotherhood of men in their common heritage of suffering and death."[11] In his journal Herman Melville similarly remarked that this statue "shows that humanity existed amid the barbarians of the Roman time, as . . . now among Christian barbarians." When he elaborated this idea for his lecture on "Statues in Rome," he dropped the ironic parallel, saying that the artist who created *The Dying Gladiator* had not joined in the "pitiless hiss" of the crowd at the Colosseum, for he was obviously a "Christian in all but name."[12] Interestingly, George Hillard for the same reason found *The Dying Gladiator* the greatest of all statues, judged subjectively, while insisting that it was impossible to enter into the spirit of the *Laocoon.* Only the Greeks who actually believed in the myth of Laocoon could see the "ideal" in such a painful subject, just as only Roman Catholics can see the "ideal" in *their* "repulsive forms of martyrdom."[13]

For Jarves, however, both of these statues still express the neoclassic ideal and form the basis for a contrast with the "repulsive forms" of Catholic art. A Christian artist—such as those who have provided us with our St. Sebastians bristling with arrows and our St. Lawrences sizzling on a grill—might well have left the sword stuck in the side of the Gladiator, "his limbs violently disturbed by the muscular distortion of gaping wounds." The "common fashion of Christian art is to appeal to the coarser sympathies, by exaggeration of physical sufferings, emaciation, or the tokens of poverty and asceticism." In its "unwise abhorrence of sense" it paradoxically plunged into "the meanest and most cowardly materialism," whereas Greek art, with its sense of "sensuous enjoyments," achieved the highest "intellectuality." The Hell that Catholicism misconceived to frighten people into virtue is "a perpetual lake of flaming brimstone, dense with lewd and blood-lusting demons . . . gloating in the foulest wickedness and quivering with unmentionable horrors, . . . finding in . . . agonized flesh and mangled bodies the most savory morsels of their quenchless appetites,—in short, a future more prolific of material horror than the maddest Pagan imagination had ever conceived." The opposing imagery of Heaven is also uninviting: "a sort of purified Olympus, swept clean of its sensuous enjoyments," where the redeemed in "quaint, uncomfortable clothes" chant monotonously forever.[14] Passing over Calvinism's fondness for the same images of Heaven and Hell (especially Hell), Jarves trusted that modern Protestant art might yet free the Christian imagination from these horrors and puerilities, and—with its loftier sense of both divinity and humanity—achieve an ideal beauty surpassing even the Greek.

Jarves, in spite of his perception of the unity of the human and divine in Greek art, had convinced himself that the Greeks were beautiful bodies with no souls. In *Art Hints* he wrote:

In the bloodless strifes and mental displays of their Olympic games, they found the originals of their Venuses, Minervas, Apollos, and all those wondrous forms of hu-

man beauty with which they have delighted the world. But there is no saving grace in them. They fully perform their mission to the intellect and merely human emotion, but the teaching to the soul is no portion of their inspiration. The nation which merely revives these forms, will revive their dangers with them.

That is what the Italy of the late Renaissance had done. Its artists illustrated the "fabulous histories of heathen gods and goddesses in all their scandalous details of lewdness and nudity for the edification of the inhabitants of Christian edifices." Classical history and mythology provide "legitimate" subjects for the Christian artist only as historical illustrations. The "innate refinement" of a Raphael made it possible for his classical works to exist in the Vatican "side by side" with his "noblest works of Christian faith," equally "pure and sincere in spirit." Lesser artists, however, joined with musicians and poets in making their works "vile instruments for the promotion of universal depravity in this miscalled golden age." Since Raphael, art has been declining exactly as it had in the Roman Empire, when "Jupiter had degenerated into a Heliogabalus, and Venus into a Messalina." The Parisian school is the modern hindrance in the "great work on hand to get back in taste and morality to even where Raphael left Art." Our hope lies in the best tendencies of modern English and American artists.[15]

The prevalence of nudity in the highest art—the Greco-Roman—encouraged modern artists to misuse mythological subjects, Jarves believed. "Much doubt exists as to the propriety of rendering the nude figure." In sculpture, however, "it is universally admitted," because in sculpture we look "for form alone," and form appeals only to the "intellect," not to the "senses." Add color, however, and "feeling is at once touched." Jarves is here repeating a commonplace at least as old as the Ninth Discourse of Sir Joshua Reynolds (1780). Hiram Powers pontificated to the same effect for Hawthorne's benefit in Florence, while attacking his fellow sculptor John Gibson. Hawthorne characteristically put the case in its extreme puritanical form, finding that "whiteness removed the object represented into a sort of spiritual region, and so gave chaste permission to those nudities which would otherwise be licentious."[16] In spite of Jarves's anxiety to liberate Protestantism from puritanical asceticism, his own formulation shows its persistence in his own thought: "Intellectual pleasure diminishes in the degree that pure white is departed from" even in sculpture; how much more dangerous then is a painted nude. "Art" as practiced by Titian could redeem the natural body; but there has been "but one Titian." Other artists have only displayed their own corruption. The nude finds "its legitimate province" even in sculpture only when "it wishes to represent *men* or *women* as created for Paradise, perfect in form and pure in feature. The power, action, and beauty of the human figure can in no other way be adequately presented. . . . We are to look upon the creation of the sculptor as God looked upon Adam when He pronounced him 'good.' If he fail to awaken in us this feeling, there is a taint of foulness about him or in ourselves." Although pure white Adams and Eves encourage the right attitude, even their form alone, without color, can excite the miseducated to the wrong ideas: "The majority of men associate vulgar ideas with the human form, simply because they have debased their own minds by sensual thoughts

or actions. . . . Were their own natural instincts of purity left free to act, they would see only in human beauty the power and wisdom of the Creator."[17]

In the same year that these words appeared—1855—Walt Whitman first published the poems that would form the core of the "Children of Adam" cluster in his completed *Leaves of Grass*. Whitman's poetry as a whole was an attempt to liberate humanity from the repressions and horrors of the Christian imagination, restoring not only the "serenity and sanity" that Howells saw in pagan art but the "joyous, sensuous life" and the divine status of humanity that Jarves perceived in the Greek revelation. What Jarves wrote of the Greek gods and goddesses perfectly describes the vision of human possibility expressed in *Leaves of Grass*. But for Whitman this did not leave men and women merely beautiful bodies without souls; the Soul and the Body were one.

The Human Form Divine: Venus and Apollo

The love of the body of man or woman balks account, the body itself balks account,
That of the male is perfect, and that of the female is perfect.

—Walt Whitman

The return of the marble gods to Rome in 1816 from their eighteen-year captivity in Paris was reported by James Sloan:

> When their arrival near the city was announced, its artists and amateurs accompanied by the principal ecclesiastical and civil dignitaries of the Roman state, and a great concourse of spectators, marched forth beyond the walls, to hail these exiled divinities, and to conduct them in all the pomp of a triumphal procession, back to their native shrines, on the banks of the Tiber.[1]

Apollo resumed the position he still occupies in naked splendor as the central icon in the Belvedere courtyard of the Vatican (fig. 115). Across the Tiber, within sight of the elevation upon which the emperor Hadrian built the Temple of Venus and Rome, Venus—also naked—reigns as the most important pagan divinity on the Capitoline (fig. 60). During the nineteenth century, however, the goddess was confined to a "reserved cabinet" open only on "nonpublic" days; and one had to pay a paul to see her. Her dangerous connotations were enhanced by the company she kept: the two smaller works enclosed with her were a *Leda and the Swan* and the passionately embracing nudes *Cupid and Psyche*. The differing arrangements for display of the *Apollo* and the *Venus*, both among the chief sights of Rome, reflect a difference in attitude toward male and female nudity and their significance. Supposedly both expressed ideal beauty. Yet, while few admitted to perceiving more in the fig-leafed Apollo than a symbol of sublime intellectual enlightenment, there was no avoiding the fact that Venus suggested something else. In the Papal City one was made particularly conscious of this, while in Florence the *Venus de' Medici*

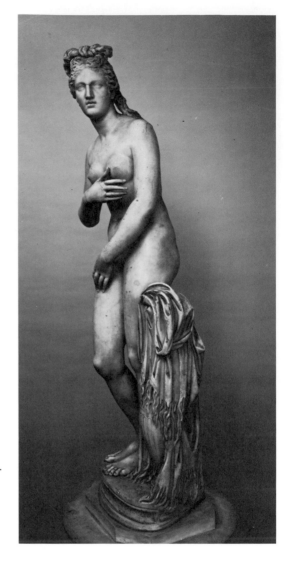

Fig. 60. Capitoline *Venus*.
Roman copy of Greek
original ca. 320–280 B.C.
Marble. H: 1.87 m.
Capitoline Museums, Rome.

more boldly received worshipers in the Uffizi's place of honor (figs. 61, 62). For this
reason among others (although not everyone granted her superior beauty), the
Medicean *Venus* was far more extensively discussed, even by writers in Rome, in
spite of the Capitoline *Venus*'s fame and the presence of other notable (but more
damaged) Venuses in the Vatican as well. The most celebrated of these was the so-
called *Knidian Venus* of Praxiteles (fig. 63), which—as Murray's guidebook said—
had been "covered with bronze drapery by one of the Popes from a fastidious feeling
of modesty."[2] After 1834 the newly discovered and partially draped *Venus de Milo*
in Paris began to take precedence over all others as the model of female beauty.[3] But
Venus in whatever form was to be problematic for Americans.

What the *Apollo Belvedere* and other nude gods, heroes, and athletes of the Ro-
man and Florentine galleries, together with various Venuses, Graces, and nymphs,

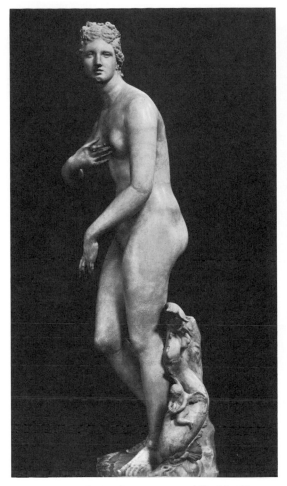

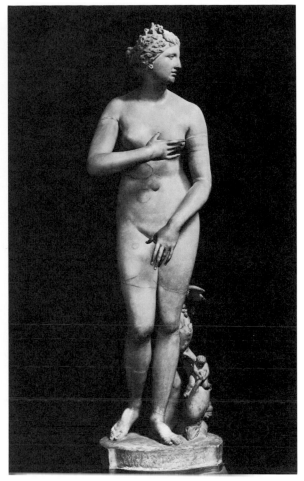

Fig. 61. *Venus de' Medici.* ca. 100 B.C. Marble. H: 1.53 m. Uffizi, Florence. Photo: Alinari/Art Resource, New York.

Fig. 62. *Venus de' Medici.* ca. 100 B.C. Marble. H: 1.53 m. Uffizi, Florence. Photo: Alinari/Art Resource, New York.

provided the artist or merely interested visitor was a catalog of physical types conforming to the different possible conceptions of human beauty. In 1809 Benjamin West wrote to his early pupil Charles Willson Peale concerning the art education planned for one of Peale's sons. After recalling how in 1760 he himself had been dazzled by the "stupendous" works in Italy, he concluded:

> And as an artist I hope he will bear in his mind, that correctness of outline, and the justness of character in the human figure are eternal; all other points are variable, all other points are in a degree subordinate and indifferent—such as color, manners and costume: they are the marks of various nations: but the form of man has been fixed by eternal laws, and must therefore be immutable. It was to those points that the philosophical taste of the Greek artists was directed; and their figures produced on those principles leave no room for improvement, their excellencies are eternal.[4]

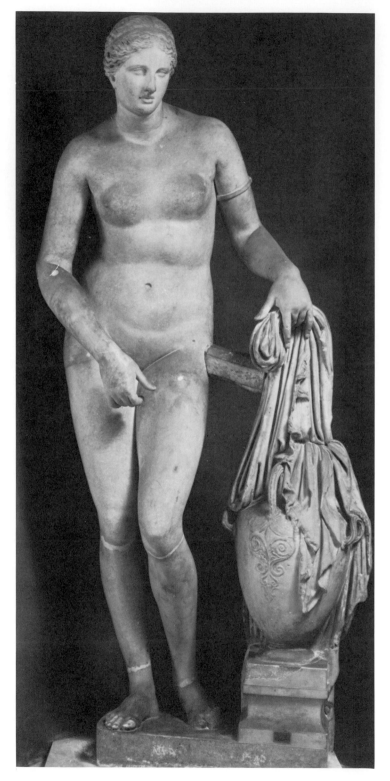

Fig. 63. *Knidian Venus* after
Praxiteles. Roman copy of
Greek original of ca. 350 B.C.
Marble. H: 2.50 m. Vatican
Museums, Rome.

The year after West left Rome (1764), Winckelmann published his complete survey of the "conformities" to various ideal types thus "eternally fixed." With Winckelmann's systematic approach to both period styles and ideal types in mind, Goethe proposed to himself in February of 1788 two projects to accomplish while in Rome. The first was to work out a "history of styles" beyond the "little spade-work" so far done; the other "line of inquiry" would focus exclusively on Greek art: "What was the process by which these incomparable artists evolved from the human body the circle of their god-like shapes, a perfect circle from which not one essential, incidental or transitional feature was lacking?"[5] In the following century, Americans also were moved to explore this "circle of god-like shapes." The artists among them—particularly the sculptors—selected from the circle models for their own nude figures. Their collective production leaves several gaps interesting to observe (the avoidance, for instance, of mature male types), but even more instructive are their positive choices and the variations upon their models. All were made in full awareness of the two supreme ideals of male and female beauty. In his Royal Academy discourses of 1794 and 1797 West recommended specifically the *Apollo Belvedere* and the *Venus de' Medici* as furnishing artists with the "general measurement or standard for man and woman."[6]

Americans who did not go to Italy could also become familiar with ideal beauty as represented by Venus and Apollo. Casts of both voyaged across the Atlantic even in the eighteenth century (Venus appeared in both her Florentine and Capitoline manifestations). Venus had been imported to Boston (probably in a reduced version) by the painter John Smibert as early as 1729, but when she arrived in Philadelphia in 1784, it was her fate alone to be shut up in a cabinet once more. William Dunlap, looking back over half a century of "progress in civilization," quotes a correspondent's sarcastic observation that "a public exhibition of such a figure" was not possible "*at that time*," whereas in the 1830s "our people now flock to see the naked display of a Parisian hired model."[7] The prudery of the earlier time (and of the northern states) had not prevented Thomas Jefferson, planning his personal sculpture gallery for Monticello in 1771, from listing as the first two items the "Venus of Medicis. Florence" and the "Apollo of Belvedere. Rome," to be followed by dancing fauns in a circle that would end with a *Diana Venatrix*. Second thoughts did not displace Venus, but proposed tripling the number of nude males: the *Farnese Hercules* and an *Antinous* might join the *Apollo*, or *Hercules* might even replace him.[8] Jefferson did not acquire any of these works, but another American collector in 1794 offered Canova whatever price he asked for copies of the *Venus de' Medici* and the *Apollo Belvedere*.[9] In 1803 "the most enlightened citizens of New York" founded an Academy of Fine Arts for the explicit purpose of "introducing casts from the antique" into America, "with a view to raising the character of their countrymen, by increasing their knowledge and taste." Robert R. Livingston, the treasurer, sent twenty-six casts of classical statues and busts from Paris, where he was the American minister. They included the *Apollo Belvedere* and the *Venus of the Capitol* (both at that time in France). Their recipients promptly spent $12.50 to affix fig leaves to Apollo and the other males. They then exhibited them all in the "Rotunda of the Pantheon in Greenwich Street (near the Battery)," setting aside Saturdays for "ladies only."[10]

By 1829 the westward movement of Venuses and Apollos (the two indispensable ones) in the company of others (especially the *Laocoon* and *The Dying Gladiator*), produced a sight so comically appalling as to unhinge the syntax of James Fenimore Cooper:

> Walking through the streets of Leghorn, a shop filled with statuary, Venuses, Apollos, and Bacchantes, caught my eye, and I had the curiosity to enter. If I was struck with admiration on first visiting the tribune of the gallery of Florence, I was still more so here. On inquiry, I found that this was a warehouse that sent its goods principally to the English and American markets: I dare say Russia, too, may come in for a share. Where the things were made I do not know, though probably at Carrara; for I question if any man would have the impudence to display such objects in the immediate vicinity of the collections that contain the originals. Grosser caricatures were never fabricated: attenuated Nymphs and Venuses, clumsy Herculeses, hobbledehoy Apollos, and grinning Fauns, composed the treasures. The quantity of the stuff had evidently been consulted, and, I dare say, the Medicean beauty has lost many a charm for the want of more marble.[11]

Apollo and Venus and the others served two purposes in America. They inculcated Taste in all who saw them, and they fostered native talent along the right classical lines. During the 1820s they "fed the eyes" of the hungry young Ralph Waldo Emerson in the Boston Athenaeum, which offered Venus in both her Medicean and her Capitoline appearances, while with Apollo were assembled the *Antinous of the Capitol*, the *Gladiator Borghese*, the *Discobolus*, the *Torso of Hercules*, the *Little Apollo*, the *Hermaphrodite*, and the *Laocoon*, altogether a considerable display of nudity, both male and female.[12] Not everyone was ready for such revelations of Taste; at the Pennsylvania Academy in 1811 a similar display of naked gods and goddesses was removed so that ladies would feel free to attend the exhibition of paintings.

Among the students feasting their eyes on naked beauty in the Boston Athenaeum was America's first professional sculptor, Horatio Greenough. Yet he later wrote to Dunlap that it was only in Rome in 1826 (when Greenough was merely twenty) that he began to *study* art; at Harvard and in Boston he had "lived with poets and poetry. . . . I *gazed* at the Apollo and the Venus, and *learned* very little by it. It was not till I ran through all the galleries and studio[s] of Rome, and had had under my eye the genial forms of Italy that I began to feel nature's value." Greenough rested the beauty of the *Apollo* and the *Venus*es he saw in Italy on a point even finer than Cooper's when he wrote to Washington Allston from Carrara in 1828: "Let any man ask me where the beauty, the glory of the Venus and Apollo lie—I say in answer that I'll not define it but I'll say that it lies within the thickness of [a] dollar in every part of their bodies and I will engage by reducing it that much in one part and increasing it in another to make them ordinary figures—."[13]

Such was the faith in the perfection of the Greek ideal of the human form for most of the sculptors who followed Greenough to Rome and Florence for the next half-century, and also for those worshipers of Beauty who measured the new American works by the ancient images of Venus and Apollo. In 1897, exactly a century

after Benjamin West's second discourse asserting the classical ideal of the human figure, William J. Stillman published a sumptuous folio of photographic reproductions called *Venus and Apollo,* intended to reconfirm the now threatened images of female and male. Four decades earlier Stillman had been one of the founding editors of the *Crayon,* America's first art journal, and afterward had lived many years in Rome, first as an American consul and later as a journalist for the London *Times.* In his preface to *Venus and Apollo* he now declared his opposition to Darwinism, Realism, and Impressionism—all modern movements that denied the existence of an essential and eternal form of man and universal and objective standards of beauty. Art, Stillman argued, would maintain a dignity equal to that of science not by imitating it in its neutral descriptions of evolving varieties and transient forms but by demonstrating its capacity to perceive "the Ideal innate and unalterable." Realism, concerned only with "anatomical fact," provided nothing but "the parrot's evidence," whereas the ancient Greeks and the Italians of the early Renaissance had known that nature was merely "the means"; "pure Beauty was the end." They turned "to types of Mythology, in which the search of pure Beauty has been unhampered by any secondary consideration; and especially in the two types we have selected, Apollo and Venus, has the purest form of male and female human beauty always been aimed at."[14] Stillman's book naturally includes photographs of the *Venus Capitolinus* and the *Apollo Belvedere.* To the two ideals that these statues preeminently embodied in Rome, and to the American effort to repossess them in art and thought, we now turn.

Venus—and Eros

This is the female form,
A divine nimbus exhales from it from head to foot,
It attracts with fierce undeniable attraction,
I am drawn by its breath as if I were no more than a helpless vapor, all falls aside but myself
 and it,
Books, art, religion, time, the visible and solid earth, and what was expected of heaven or
 fear'd of hell, are now consumed,
Mad filaments, ungovernable shoots play out of it, the response likewise ungovernable,
Hair, bosom, lips, bend of legs, negligent falling hands all diffused, mine too diffused,
Ebb stung by the flow and flow stung by the ebb, love-flesh swelling and deliciously aching.
 —Walt Whitman

Walt Whitman is looking at—or imagining—a goddess whose divinity he recognizes, but she is of flesh, not marble. In fact, "art" is one of the mundane matters wholly "consumed" by the sexual reality of the "female form." It would never occur to Whitman, however, to make the art historian's distinction between the "naked" and the "nude," which assumes in its extreme form that none of the feelings that might be aroused, or the ideas that might occur, in an encounter with the "naked" would in any way propose themselves while one contemplated a "nude," even one called Venus, the goddess of love. That the distinction is real is essential to the belief that art is never pornographic; yet the nineteenth-century recognition of the

erotic power of the "nude," demonstrated by the need either to suppress it entirely or to neutralize it through moralistic narrative, may be more honest than the pretense that it exists only for the unsophisticated viewer.

That Whitman's uninhibited celebration of the "female form" is entirely from a man's point of view is also important. It quickly (and narcissistically) becomes an appreciation of the effect of that form on the male body. The fact that the ways of looking at Venus and of bodying her forth in paint and marble were the creations of men naturally affected the new art as well as commentaries on both that art and the "masterpieces." The conventionally masculine sexuality that Whitman's voice assumes here, limiting as it is, contrasts usefully with the indirections of other artists and writers, even while it explains them. The very urgencies he explicitly acknowledges necessitated the assumption of "feminine" or asexual attitudes by others. His exuberant rendering of a materialism entirely infused with idealism rather than opposed to it, a pagan naturalism that rejoiced in its own divinity, serves as the perfect foil for the confusions, evasions, and strategies for accommodation made by puritanical idealists in Italy who encountered sensuous naked forms on façades and fountains, in every artist's studio, and even (it seemed) in every church—and sometimes recognized them as beautiful.

FIGURE, FACE, AND EFFECTS OF VENUS

Hawthorne, who thought his own *Scarlet Letter* too "adult" in theme for his own children to read, nevertheless took his daughter Una (aged fifteen) to see the Capitoline "Venus in her secret cabinet" (fig. 60). She was, after all, an "ideal" figure, and a work of "art." In fact, neither of them enjoyed her, "perhaps because a sirocco was blowing," perhaps because the Capitoline museum was depressingly dusty in comparison with the immaculate halls of the Vatican. At any rate this celebrated Venus, whom he had "greatly admired" on a previous visit, offered them a view of "the lower part of her back" which was "exceedingly unbeautiful." Hawthorne retaliated by judging her "heavy, clumsy, unintellectual," and "common-place."[1] The experience epitomizes a pattern of rejections of Venus characteristic not only of Hawthorne.

Hawthorne's relationship with the *Venus de' Medici* in Florence (figs. 61, 62) produced one of the most comical sequences in his notebooks. He achieved in a few weeks a neutralization of this image of the goddess that had taken Ruskin five years.[2] Hawthorne recorded his first visit to the Uffizi on June 8, 1858, as a narrative of desire long delayed and then overwhelmingly satisfied. The delay was caused by the confusion of rooms and profusion of art, but also by his fear of disillusionment. Having gone the length of the long outer gallery, thinking constantly of the Venus ("the mystery and wonder" of the place) and seeing her nowhere, he then sought her in the maze of rooms, hardly glancing at the superabundance of Italian art. For a while he was refreshed by some works from the hands of northern painters—a Claude, a Rembrandt, "fat Graces ('greases,' rather) and other plump nudities, by Rubens; brass pans and earthen pots, and herrings, by Teniers and other Dutchmen; . . . all of which were like bread, and beef, and ale, after having been fed too long on made-dishes." Somewhat satisfied by these lowly diversions, he yet "could

not quite believe that I was not to find the Venus de Medici; and still, as I passed from one room to another, my breath rose and fell a little, with the half-hope, half-fear, that she might stand before me."

At last, in a movement implicitly allegorical, he came "from among the Dutchmen" and "caught a glimpse of her, through the door of the next room." The appreciation that follows typifies the admiration and personal regard expressed by countless visitors before him:

> She is very beautiful; very satisfactory; and has a fresh and new charm about her, unreached by any cast or copy that I have seen. The hue of the marble is just so much mellowed by time as to do for her all that Gibson tries, or ought, to try, to do for her statues by color; softening her, warming her almost imperceptibly, making her an inmate of the heart as well as a spiritual existence. I felt a kind of tenderness for her; an affection, not as if she were one woman, but all womankind in one. Her modest attitude—which, before I saw her, I had not liked, deeming that it might be an artificial shame, is partly what unmakes her as the heathen goddess, and softens her into woman. There is a slight degree of alarm, too, in her face; not that she really thinks anybody is looking at her, yet the idea has flitted through her mind and startled her a little. Her face is so beautiful and intellectual, that it is not dazzled out of sight by her body.

The "mishaps" suffered by "the poor little woman" do not "impair the effect" of her "naked grace" because "the idea is perfect and indestructible." Hawthorne is "glad to have seen this Venus, and to have found her so tender and so chaste," all the more that in the same room, "and to be taken in at the same glance, is a painted Venus by Titian, reclining on a couch, naked and lustful" (fig. 64). Hawthorne's concerns for Venus's "modesty" (expressed by the placement of her hands), for her "alarm" at being thus viewed, and for the "intellectual" character of her face are to be concerns of many in viewing and creating female nudes. The contrast with Titian's *Venus of Urbino* is also common: it proved one's capacity to make the crucial distinction between ideal and erotic art.[3]

On a second visit three days later, Hawthorne became ecstatic and openly worshipful. This Venus was "one of the treasures of spiritual existence":

> Surely, it makes one more ready to believe in the high destinies of the human race to think that this beautiful form is but Nature's plan for all womankind, and that the nearer the actual woman approaches to it, the more natural she is. I do not, and cannot, think of her as a senseless image, but as a being that lives to gladden the world, incapable of decay and death; as young and fair to day as she was three thousand years ago, and still to be young and fair, as long as a beautiful thought shall require physical embodiment.

From this Keatsian rapture Hawthorne descends to attack the impertinence of Gibson and Powers and all those "who people the world with nudities, all of which are abortive as compared with her." The Venuses and Greek Slaves and Eves of these moderns should be "burnt into quick-lime, leaving only this statue as our image of

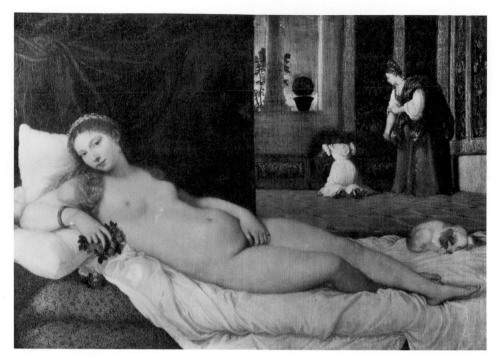

Fig. 64. Titian. *Venus of Urbino.* 1538. Oil. 119 × 165 cm. Uffizi, Florence. Photo from Istituto Centrale per il Catalogo e la Documentazione, Rome.

the beautiful." With her look of "depth and intelligence," she is a "miracle" undoubtedly "wrought religiously," and beyond commentary. Hawthorne vows to say no more of her, especially since further acquaintance was certain to elevate his taste and make expression of his "sense of its excellence" even more impossible. "If, at any time, I become less sensible of it, it will be my deterioration, not any defect in the statue."[4]

This deterioration was rapid, and the vow of silence soon broken. At first the vision of the ideal sustained him through the visit to the Museum of Natural History that immediately followed. There he saw wax models "of all parts of the human frame." Only the fresh memory of "the wholeness and summed-up beauty of woman" could counteract the morbidity induced by this naturalistic and very unbeautiful display of "the details of her system," including the digestive and reproductive. What natural history could not do, however, a visit to the studio of Hiram Powers did. Powers had established his studio between the Pitti Palace and the Uffizi on the main tourist route of Florence and had prospered as a sculptor amazingly. "Wife and I," wrote Hawthorne, went there on June 13 to leave Rosebud to play with the Powers children. In the studio Powers himself, "in his dressing-gown and slippers, and sculptor's cap, smoking a cigar, which by the way was none of the best," showed them his two "genuine casts" of the *Venus de' Medici*, and seized the opportunity to deliver "a quite unexpected but most interesting lecture" on her faults. Her face was "that of an idiot." The sculptor who made her " 'did not know what he was about.' " Her eyes, to begin with, were totally unlike any made by

nature. Hawthorne began to crumble: indeed the eyes were "very queer," more like half-worn buttonholes than human eyes. As for her ears (Powers continued remorselessly), they were too low, giving a portion of her head an "artificial and monstrous height." The forehead and mouth were "altogether wrong." When Powers ceased battering the poor face to pieces, Hawthorne was so convinced of its demerits that he dared not "urge in its defense" that "this very face had affected me, only the day before, with a sense of higher beauty and intelligence than I had ever till then received from sculpture." Powers then directed the attention of the Hawthornes to his own creations: busts of Proserpine (fig. 92) and Psyche, conveniently at hand. Hawthorne's capitulation in his notebook entry is complete: in "beauty, intelligence, feeling, and accuracy of representation," these "two faces" were beyond comparison with the Venus. While Powers emphasized the soulful light in the eyes of his ideal heads, so superior to the stupid eyes of the Venus, he "turned up, and turned inward, and turned outward, his own Titanic orb (the biggest by far that ever I saw in mortal head) and made us see and confess that there was nothing right in the Venus, and everything right in Psyche and Proserpine."[5]

Not surprisingly, the faithless Hawthorne did not appear before his goddess again for three months. And when he did, she refused to reveal herself as other than a "piece of yellowish white marble. How strange that a goddess should stand before us absolutely unrecognizable, even when we know by previous revelations that she is nothing short of divine! . . . one of the most tedious and irksome things in the world; . . . an old lump of stone, dusty and time-soiled, and tiring out your patience with eternally looking just the same." When the time came for the Hawthornes to leave Florence, they paid last visits to the great masterpieces that they might never see again. But what Hawthorne felt was simply "utter weariness": "I threw my farewell glance at the Venus de Medici, today, with strange insensibility."[6]

Ironically, thirty years earlier as a twenty-three-year-old mechanic back in Cincinnati, Hiram Powers had made his first attempts in sculpture by modeling a copy of this same *Venus de' Medici*'s head.[7] His present attack on it, however, was nothing new. Winckelmann himself had disliked it, but nevertheless found that the body of the Medicean *Venus* resembled an unfolding rose, or a fruit almost ripe: "all the vessels of the animal system are beginning to dilate, and the breasts to enlarge, as her bosom indicates,—which, in fact, is more developed than is usual in tender maidens."[8] Defects in the head did not prevent sensuous observation of the body, as important as Winckelmann believed facial expression was to the highest beauty. Powers had in fact found great advantage in receiving permission from Maria Antoinetta, the grand duchess of Tuscany (of whom he executed a bust), to make a plaster cast of the *Venus* for his own studio. However imbecilic her face, her body was to be a constant standard for the female nudes he would call by other names. But it is obvious that for Hawthorne there was nothing to be said once the "intellectual" and "spiritual" aspects of *Venus*—which resided entirely in her face—were no longer perceptible. Commentary on the size of her breasts, or her other proportions, would have been legitimate only after her ideal status had been established by her expression, which had to be that of an intelligent and ethical woman. For this reason (and the fact that they were so much cheaper), "ideal heads" of females were very popular, even when they were severed from the bodies of full-length statues. The

facial "expression" was always sufficiently ethereal to permit the exposure of one or both breasts (very amply developed), lower parts being relegated to a literally "ideal" existence. Certainly no one ever thought of ordering a mere torso, although there were occasional requests for feet.

The size of Venus's head and the expression of her face were important to Victorians for an excellent reason. The tendency to identify Venus not simply as the ideal of Feminine Beauty, but of Womanhood itself, meant that her face should be as "intellectual" as Hawthorne at first thought it. In 1855 William Cullen Bryant made the mistake of allowing a quotation from Horace, in which his mistress was praised for her "low forehead," to be printed in his *New York Evening Post* as a definition of the true beauty of women. The pioneering art journal the *Crayon* attacked this notion as "rubbish," saying that Roman standards didn't apply to Christians. Raphael's Madonnas and Dante's brainy Beatrice were "nearer perfection" than Venus. Horace had lived in an age of "sensualism and utter moral degradation," and his Lycoris was clearly a "cyprian." Besides, unlike the Romans, the Greeks had three ideals of woman. The best image even of the "sensuous" ideal—the *Venus* of Milo—in fact has a "medium forehead," while Dianas have "rather more," although they represent the "purely physical" ideal, and Minerva, the "intellectual," in her "best" representations shows "a head which any nineteenth century woman would acknowledge as fine and noble." Readers were reminded that Minerva "is the only embodiment of pure and perfect wisdom which the Greek artist ever conceived"; no *man* was ever thought of as the "type of absolute intellect."[9]

When it was necessary to speak of the body of a Venus, even to amateurs and students of art, the utmost decorum was exercised. This is evident in four lectures on "The Antique Statues" delivered by Charles L. Edwards to the "gentlemen" of the National Academy of Design in New York in 1831. Pointing to the casts beside him, he begins his analyses of particular works with the two naked *Venus*es, in order "to smack somewhat of gallantry." He says nothing about the mythological meanings of Venus or about her behavior in Vergil or Ovid, but he indicates his awareness of some aphrodisiac anecdotes about the statues themselves. With some other mildly titillating gossip, he retails an edited story concerning the *Venus de' Medici* and the English poet Samuel Rogers. Its certain source is a woman, Mrs. Anna Jameson, who in her widely read *Diary of an Ennuyée* (1826) had reported that Rogers was to be seen every day gazing at the goddess in the Tribune of the Uffizi, probably—she wryly added—in hope "that the statue might animate *him*." Edwards has sufficient masculine loyalty to omit that remark, and skips to the conclusion: a friend of Rogers finally planted between *Venus*'s fingers a verse epistle in which the goddess commanded the poet to cease his "*ogling.*"[10]

Turning briefly to concerns that presumably were of more use to the academicians, Edwards becomes as impersonal as possible, citing the opinions of "physiognomists and physiologists" who "generally agree" that *Venus*'s head is that of a "weak, silly woman" whose only "distinctive mark" is "imbecility of mind." As for *Venus*'s figure, the authority of "the late eminent surgeon Dr. John Bell" was necessary to establish that "this statue is exquisite in all its forms and proportions; in symmetry, in slender, round, finely tapered limbs, in the joining of the haunch-

bone in the loins—all perfect." Poor *Venus* lies etherized upon a table. "There is said"—Edwards timidly continues—"to be something inconceivably delicate in the back and loins of this statue." Edwards himself evidently hadn't looked.[11] In the eighteenth century, Jefferson had been able to enjoy a pre-Winckelmannian English clergyman's description of the Medici *Venus* that dared not only to appreciate the "wantonness" of her pretty face (little caring that it lacked intellectuality!) but even to "insist particularly on the beauty of the breasts, ... small, distinct, and delicate, ... with an idea of softness, much beyond what any one can conceive, ... yet with all that softness, they have a firmness too."[12] Sensual clergymen once could express tactile pleasures forbidden to a Victorian surgeon.

There is, however, little reason to think that nineteenth-century art devotees of either sex were more capable of a complete idealization of the nude than we are, now that idealization is no longer a desideratum. The confusion and conscious circumspection of their language indicates otherwise. Sculptors were not unaware that female nudes sold better than male nudes (men being the primary purchasers), or that busts with both breasts on view sold better than those even partially draped.[13] William Henry Rinehart, who settled in Rome in 1858, carved an "ideal head" called *Penserosa* in 1865 which was repeated in many copies; her breasts are lightly draped, but a self-caricaturing drawing by Rinehart shows him scraping away at her bosom while she indignantly bends her head to watch.[14]

In Henry P. Leland's *Americans in Rome* (1863), the artist Caper pays a Sunday visit to the studio of a sculptor named Chapin. Chapin seems to be an amalgam of Hiram Powers and Randolph Rogers, creator of the best-selling *Nydia, Blind Girl of Pompeii*. The sculptor has intended to go to church, but when he hears that Caper's rich uncle may drop by, he changes his mind. He begins a discourse on his popular *Orphan*: "You see, I've made her accordin' to the profoundest rules of art. You may take a string, or a yard measure, and go all over her—you won't find her out of the way a fraction. The figure is six times the length of the foot; this was the way Phidias worked, and I agree with him." After explaining his patented machine for ensuring accurate proportions, he interprets *The Orphan*: "You see, she's sittin' on a very light chair—*that* shows the very little support she has in this world. The hand to the head shows meditation, and the Bible on her knee shows devotion; you see, it's open to the book chapter, and verse which refers to the young ravens." Caper interrupts with a question: "But may I ask why she has such a *very* low-necked dress on?" Chapin replies, "Well, my model has got such a fine neck and shoulders, that I re-eely couldn't help showing 'em off on the Orphan; besides, they're more in demand—the low neck and short sleeves—than the high-bodied style, which has no buyers."[15]

"Ideal heads" avoided the major problem of full-length nudes: how to establish their modesty. For the nudes there were two possibilities: strategic placement of the arms and hands, or else contrivance of a swath of drapery coming from somewhere. The Capitoline *Venus* and the *Venus de' Medici* are in essentially the same posture, that of the *Venus Pudica*, or Modest Venus; although totally nude, they make some effort to cover their breasts and pudendum. The resultant closing-in gives a desirable compactness to their essentially ovoid form, as Kenneth Clark pointed out, but it must be admitted these "modest" gestures also serve as pointers to the specifi-

cally female parts of the body. Moreover, they rarely succeed in actually hiding the parts; as incomplete barriers they rather challenge than prevent scrutiny. Yet when the hands of Venus actually cover by touching, more disquieting effects result.

A passage in Hawthorne's notebooks concerning the unearthing of a new Venus near Rome in the spring of 1859 amusingly indicates that where the goddess placed her hands was carefully observed. Hawthorne and Sophia drove out to a vineyard with the sculptor William Wetmore Story and his wife to view the discovery. They all agreed that the new statue was far more beautiful than the *Venus de' Medici* and was perhaps the Greek original of which that was an inferior copy.

> Both arms were broken off (at the elbow, I think) but the greater part of both, and nearly the whole of one hand, had been found; and these being adjusted to the figure, they took the well known position before the bosom and the middle, as if the poor fragmentary woman retained her instinct of modesty to the last. There were the marks on the bosom and thigh, where the fingers had touched; whereas, in the Venus de Medici, if I remember rightly, the fingers are sculpted quite free of the person.[16]

The point was developed with emphasis when Hawthorne adapted this experience for *The Marble Faun.* Story, who had wiped the dirt from between the beautiful lips of the disinterred goddess, became Kenyon, who not only performs this service but reassembles the broken body. Venus had "perished" with her "modest instincts" intact, and now "snatched them back at the moment of revival. For these long-buried hands immediately disposed themselves in the manner that nature prompts, as the antique artist knew, and as all the world has seen, in the Venus de' Medici."[17]

The promptings of nature are more ambiguously suggested by Titian's *Venus of Urbino* (fig. 64), which shares the Tribune of the Uffizi with the Medici *Venus* and which, for Hawthorne (as we have seen), served to emphasize by contrast the chastity of the statue. The reaction to Titian's *Venus*es (there are actually two in the Tribune) was usually very strong. To a purely vulgar writer like Joel T. Headley, who viewed them in 1843, they could be dismissed as "disgusting pictures" of "almost beastly sensuality," which must have been painted by a drunk using "models from a brothel." "I have no patience with such prostitution of genius," he adds. (The reviewer of Headley's book in the *Knickerbocker* condemned his "presumption" in discussing art at all, which he'd promised not to do.)[18] Mark Twain similarly confessed to ignorance of art and then proceeded to dogmatize, but he was far more ambivalent about the various Venuses of the Tribune than either Headley or Hawthorne. In *A Tramp Abroad* (1880), the disturbance the *Venus of Urbino* caused him provoked one of the most revealingly incoherent of his comments on art and sex:

> Without obstructing rag or leaf, you may look your fill upon the foulest, the vilest, the obscenest picture the world possesses. . . . It isn't that she is naked and stretched out on a bed—no, it is the attitude of her arms and hand. If I ventured to describe that attitude, there would be a fine howl—but there the Venus lies, for anybody to gloat over that wants to—and there she has a right to lie, for she is a

work of art, and Art has its privileges. I saw young girls stealing furtive glances at her; I saw young men gaze long and absorbedly at her; I saw aged, infirm men hang upon her charms with a pathetic interest. How I should like to describe her—just to see what a holy indignation I could stir up in the world—just to hear the unreflecting average man deliver himself about my grossness and coarseness, and all that.

But the world will not permit a verbal equivalent of "Titian's beast," and that is Mark Twain's real complaint. His friend Howells also lamented that contemporary manners denied to literature one-half of a man's existence. As a wholehearted realist and a halfhearted moralist, Mark Twain finds the fact that artists have greater license than writers even more intolerable than the Titian: "The brush may still deal freely with any subject, however revolting and indelicate," whereas "the privileges of Literature" have been "sharply curtailed" since the days of Fielding and Smollett. They could "portray the beastliness of their day in the beastliest language," but the contemporary writer, with "plenty of foul subjects" available, can't even treat them in "nice and guarded forms of speech." Mark Twain is disgusted equally by sexually explicit paintings and by prohibitions upon writers to match them. The general absurdity of the situation is increased by the "fig-leaf mania" of the preceding "fastidious generation," which destroyed the "innocent nakedness" in which the statues of Rome and Florence had stood "for ages." "Nobody noticed their nakedness before, perhaps; nobody can help noticing now, the fig-leaf makes it so conspicuous." The last stupidity lies in the fact that fig-leafing "is confined to cold and pallid marble" which does not need "this sham and ostentatious symbol of modesty, whereas warm-blooded paintings which do really need it" go unsupplied.[19] Mark Twain is probably basing this contrast between the effects of marble and painted nudes upon his own experience rather than the theories of Reynolds and Jarves: the Titians "do really need it," but it would be even better if literature didn't

Grace Greenwood wrote the most interesting and representatively equivocal comments by a woman on the various Venuses. That of the Capitoline was "a beautiful, soulless, voluptuous creature, an exquisite animal," she declared in late 1852. But in Florence the next spring the "simpering" *Venus de' Medici* did not "strike" Greenwood as being even "voluptuous," precisely because she *lacked* "all strength of passion and noble fulness of development, all *soul*; for paradoxical as it may seem, a soul of wild depths and passionate intensity must lie beneath the alluring warmth and brightness of a refined and perfect sensuality." During the winter in Rome Greenwood seems to have arrived at a bolder idea of the union of body and soul than any man dared express. But she can go only so far with this, and Titian's *Venus of Urbino* marks the limit. It is a "great painting" of "wonderful beauty," but Greenwood "cannot even tolerate it." It has a "dangerous character" because it shows a woman (not a goddess) whose "voluptuousness" is "gorgeous, undisguised, yet subtle, and in a certain sense poetic." This woman, consciously "free from the obligations of morality and purity," "proudly and quietly revels in her own marvellous beauties." With "inexpressible . . . relief," Greenwood turned from this intolerable vision of excessively liberated womanhood to Titian's nearby paintings of a *Bella Donna* and a *Flora*.[20]

In the third edition (1848) of his *Italian Sketchbook,* Tuckerman attacked the "untenable" view of Italian art that condemned Titian's Venuses in particular "on account of their voluptuous character." He explained that the "intent embodied in the Medicean Venus and those of Titian is totally diverse." Whereas the aim of the Greeks for "ideal form" made even a Venus a "creature of the mind," the Venetians had wished to show "physical loveliness, the object of passion." Both aims, be it known, were "legitimately artistic." Besides (he added somewhat irrelevantly), passion and beauty were not the only aims of Italian art; Guido Reni's *Cleopatra* and his *Beatrice Cenci* both show "elevated thought and conscious greatness."[21] Jarves, in his *Art Hints* (1855), maintained the Art worshiper's premise with more conviction, devoting several pages to the argument that Titian's genius had transformed the *Venus*es of the Tribune into wholly ideal beings. As for the Greek statues of Venus, he explained in *The Art-Idea* (1864), they had originally a "sacred significance" much above that indicated by the obscene Roman objects recently disinterred in Pompeii and rightly consigned to "a new darkness." "The worship of Venus" was not "a scandalous exhibition of sensual passions" but a recognition of the "divine mysteries" of "generation." The obelisks now admired in Rome are themselves phallic symbols. Besides, although Christianity now "rightly puts out of sight" "acts and objects . . . then held in public esteem," the Christian Cross is itself "a union of the most ancient signs of the male and female organs of generation," given "the still loftier significance of the regeneration of the soul."[22]

There is no evidence that this argument was widely appreciated. But its very extremity shows how urgently the true believer in Art wished to save it from attacks that found corrupt icons at its center: the sculptured Venuses of the Greeks and the painted ones of the Old Masters. The two had been the standard for painters in America ever since John Smibert brought both a copy of Titian's *Venus and Cupid* and a cast of the Medici *Venus* along on the visionary voyage of Bishop Berkeley to America in 1728. Copies of Titian's *Venus*es and copies of copies had been a source of inspiration to American painters ever since, but had almost always met with reprobation from the public.[23]

The problem with Venus derived not merely from an inadequately spiritual and intellectual face, or the exposure of her parts, but also from the company she kept. All three made her meaning and intended effect obvious to anyone who saw with their earthly eyes instead of through the spectacles of the new religion of art. Here the common desire for a narrative context worked against her, since when she stood as an isolated figure she could more easily be perceived simply as Ideal Beauty than when she was given a companion or, in paintings (and even Canova's sculptures), allowed to recline upon a couch.

The association of Venus with Eros most explicitly defined her meaning, but her comportment with either Mars or Adonis, and her preening before Paris in triumph over far more virtuous goddesses—Minerva and Ceres, wisdom and motherhood— were intolerable. The radical Roman sculptor Giuseppe Ceracchi had known what republican virtue required when he arrived in Philadelphia in the winter of 1790–91 and went to work on his *Minerva as the Patroness of American Liberty* and on a terra-cotta model for an even larger monument that included, besides Apollo singing the glories of America to a secretarial Clio and Neptune urging Mercury to help

American commerce, another group in which Mars was being restrained from war, not by Venus, but by "Policy." (All this was to surround an equestrian statue of Washington.)[24] An essay in the *American Museum* in 1790 entitled "Wit and Beauty: An Allegory" boldly claimed that "Venus always appeared to her greatest advantage when accompanied by Wit."[25] What the writer overlooked was that she had never so appeared.

Venus's defining companions are Amor (who may be clever but is no embodiment of Wit, by which the writer meant Intelligence) and those lovely Hellenistic creatures, the Three Graces. The Graces, even in the earliest and most Neoplatonist phases of the Renaissance, were (according to Pico della Mirandola) "Verdure, Gladness, and Splendor; and these three Graces are nothing but the three properties appertaining to ideal Beauty." Nothing is said of Wit, nor is it present in Marsilio Ficino's analysis of Venus as the nymph Humanitas: her "soul and mind are Love and Charity" only, while other attributes express Dignity, Magnanimity, Liberality, Magnificence, Comeliness, and Modesty, the whole comprising "Temperance and Honesty, Charm and Splendor": "Oh, what exquisite beauty!"[26] The emphasis is on character, not intellect and not sexuality. In none of the phases of neoclassical art is the *ethos* of the early Renaissance recaptured. Generally speaking it moves from an eroticism continuous with the art of the immediately preceding generations to the puritanism of the later Victorian period without ever expressing the elevated joy in human qualities made visually manifest by Botticelli. Canova's *Three Graces* (1812–16) take such a caressing interest in the attributes of each other's bodies that one forgets to think what else they might "stand for."

The counterclaims of pagan eroticism and puritan idealism are most evident in the career of Benjamin West, although oddly his development goes in the direction opposite that of the general historical movement. His interpretation of the *Venus de' Medici* is indistinguishable from that of Victorians down to Hawthorne: she expressed "the peculiar excellencies of women: . . . a virtuous mind, a modest mien, a tranquil deportment, and a gracefulness in motion."[27] One hears a distant echo of the Florentines, but where have Verdure, Gladness, and Splendor gone? For painters and sculptors "tranquil deportment" is a poor substitute for Magnificence in both goddesses and women.

When West first defines Venus in relation to one of the objects of her passion, in *Venus Lamenting the Death of Adonis* of 1772 (fig. 65), she appears as an ideal matron, fully clothed, while Adonis is conventionally nude, although he has been killed while hunting. The composition so unavoidably recalls the *Lamentations* over the body of Christ that the painting is infused with Christian feeling. Syncretic mythologizing in the Renaissance had long since established a death-and-resurrection parallel between Christ and Adonis. In the 1630s, for example, Poussin had painted both of the popular Venus-and-Adonis scenes—their lovemaking and her grief over his dead body. As Anthony Blunt pointed out, the Christian parallel is perceptible in Poussin's composition of the second subject.[28] In West's painting, the emphasis is reversed: the painting is Christian first, and through that imagery—prompted by the title—one detects Venus, Adonis, and Amor. The need for the pagan gods to break through a Christian overlay will be evident in much that follows.

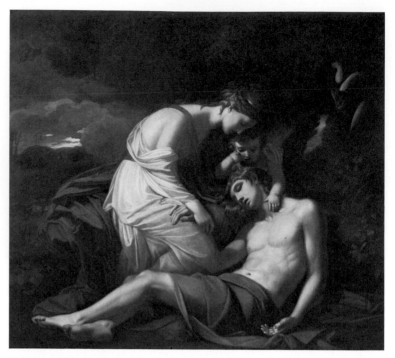

Fig. 65. Benjamin West. *Venus Lamenting the Death of Adonis.* 1768 (1771?). Oil on canvas. 64 × 69½". Museum of Art, Carnegie Institute, Pittsburgh.

That West chose this scene, rather than Venus and Adonis after lovemaking, is itself symptomatic. It allowed Venus to be shown capable of the most "tranquil deportment" even on the most sorrowful occasion. She neither cries out against blind fate, as in Ovid, nor seems to be performing the miraculous act that will turn the blood of Adonis into anemones, as she is in the comparable painting by Poussin. The only exotic—and identifying—element is the pair of swans who have transported Venus to the scene. Cupid, whose carelessness while kissing his mother had allowed a dart to scratch her and thus is the original source of her present grief, is unrecognizable as the tender and benevolent boy who caresses Adonis's neck. He looks even less like his chubby self than do many of the cherubic mourners who customarily hover around the dead Christ. This painting is at an extreme remove not only from the exuberant, fleshy treatments of the Venus-and-Adonis myth by Rubens but also from the classical Poussin's version of the companion scene that West ignored. Poussin's *Venus and Adonis* (fig. 66) is more explicit about the sexual relation of the goddess to the youth than even Ovid. Venus, naked, lies open to the partially clothed Adonis, who rests his face against her breast. They sprawl near sleep, sated from love, surrounded by the flesh-filled turbulence of earth and sky and watched over by a dispassionate river god. West's painting, by shaping its central trio into a lovely spheric unity, substitutes sentimentality and moralism for passion and mystery. Venus and Eros have been defeated by being transformed into creatures not themselves.

Since such transformations will become common in the nineteenth century, it is

216

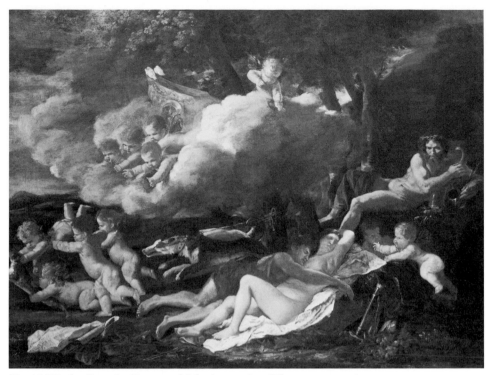

Fig. 66. Nicolas Poussin. *Venus and Adonis*. ca. 1630. Oil on canvas. 29¾
× 39½". Museum of Art, Rhode Island School of Design, Providence. Gift
of William H. Kimball, Georgina Aldrich, Mary B. Jackson, Edgar J.
Lownes, and Jesse Metcalf Funds.

interesting to note that West's much later version of the same subject (1803;
Rutgers) shows Venus completely nude and tearing her hair with grief. Adonis is
still a dead rather than love-sated body, but Amor is not only fleshier, he is supple-
mented by a chorus of gesturing nymphs and putti. West's increasing romantic
emotionalism has actually effected a return of something like rococo imagery. In
1808 West painted an even more sensual *Cupid and Psyche* (Corcoran), and by 1811
the power of Venus and Eros together received full acknowledgment in *Omnia
Vincit Amor* (fig. 75).[29]

West's career was pursued in an aristocratic milieu, and not primarily for Ameri-
can viewers. Dunlap records that a little known painter "of vulgar appearance and
obscure manners" named Jeremiah Paul, who in the 1790s branched out from
portraiture by making copies of West's pictures from prints, was induced by the
success of Wertmüller's *Danae* to exhibit in Philadelphia in 1811 a painting adver-
tised as "a 'Venus and Cupid nine feet by seven feet,' 'taken from living models.'"
Dunlap was induced to look at it, but "not long." Anyway, it was not a financial
success, since Venus and Cupid scared people off: "Our ladies and gentlemen only
flock *together* to see pictures of naked figures when the subject is Scriptural and
called moral." As Dunlap remarked elsewhere, if the names "Adam and Eve" were
used, people would eagerly look at "an English prostitute in the most voluptuous

attitude, without a shade of covering enticing the man to sin; a perfect Venus and Adonis."[30]

A painter's ability to shield the defensive viewer from the erotic charge implicit in the stories of Venus is evident also in the mythological works of Henry Peters Gray at mid-century. Like his first teacher, Daniel Huntington, Gray went to Rome for the mature study of his art. Along with hundreds of portraits and popular genre pieces, including illustrations of new American legends by Washington Irving, there is a large number of works with paired pagan males and females, often nude: *Proserpine and Bacchus, Cupid Begging His Arrows,* and *The Judgment of Paris* (1861; fig. 67). Tuckerman says that these paintings were bringing to American homes "those memorable forms that make the galleries of Italy attractive." Yet one notes that Cupid has been made the subject of a coy genre painting, in which, significantly, he has been rendered impotent. In *The Judgment of Paris,* it is only too obvious that we are not looking at a warm-fleshed goddess but at an antique marble torso carefully drawn by Gray in some gallery, and here demarcated by a high-placed bracelet, an arm-hiding fold of cloth, and some drapery obligingly held up by a pretty-faced Cupid, whose instincts for modesty exceed those of his mother. Not Venus herself, but a work of antique art will receive the golden apple. Tuckerman admits that Gray was criticized for "renewing obsolete mythological subjects," and he apparently could on occasion "renew" the nude in a sufficiently exciting manner, since one was such a "triumph of color and form" that he hung it face-to-wall in his own studio. Yet one cannot help but wonder if there is not more genuine pagan feeling in the contemporaneous animal paintings of William H. Beard. Tuckerman describes one: "two rabbits are making love, and a third stands on his hind legs and peers over a cabbage-leaf, with an expression of jealous surprise in his fixed and fierce eyes." Surely this is a *Venus and Mars Observed by Vulcan*! (Beard in fact did the century's only American *March of Silenus,* a picture of intoxicated goats.)[31]

In sculpture the pairing of Venus or any other female nude except sinful Eve with any male nude except remorseful Adam was entirely avoided. Canova's libidinous misuses of marble in this way were well known. And the fact that Bertel Thorwaldsen, the Dane whom Victorians preferred to Canova since he was (in the words of Hillard) "at once the most Classic and the most Christian,"[32] had also done an intensely sensual and intertwined *Mars and Venus* did not license any American to do so, particularly since no American could have displayed such a piece. A crouching Venus-like *Hero* (fig. 96), who was in fact a priestess of Venus and according to Marlowe's famous poem looked just like her, was created in the 1850s by William Rinehart to go with his heroic nude *Leander* (fig. 138), but the point of their tragic story *required* them to be on separate pedestals, far apart, and doomed to remain so. In the 1860s William Wetmore Story dared to match a handsome, fleshy (but not corpulent) Bacchus with a totally nude and sugary Venus who is actually smiling. But they are a pair of statuettes, hardly imposing icons of Love and Wine such as might have engendered Priapus. As for Cupid, he is even more frequently deprived of his mother in sculpture than in painting. And his passion for Psyche, so boldly displayed in the antique statue in the Capitoline, and intensified in versions by both Canova and Thorwaldsen, is denied him in American sculpture. Psyche commonly remains a butterfly and he a child, and their union is entirely Christian. When he appears as *Cupid with Hope,* one can sympathize.

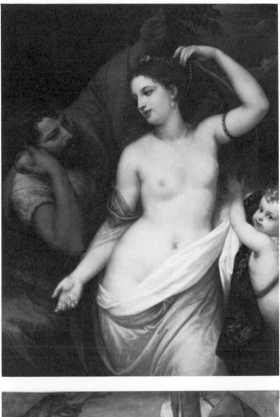

Fig. 67. Henry Peters Gray.
The Judgment of Paris. 1861.
Oil on canvas. 50⅞ × 41".
Corcoran Gallery of Art,
Washington, D.C. Museum
Purchase, 1877.

Fig. 68. Henry Oliver
Walker. *Eros et Musa.* 1903.
Oil on canvas. 72¼ × 54⅛".
National Museum of
American Art, Smithsonian
Institution. Gift of William
T. Evans.

The atmosphere for Venus and Eros and company changed somewhat with the emergence of French classicism as the dominant influence in the last quarter of the last century, and their forms and associations changed even more in this century. How these developments help define the character of the nineteenth-century Roman experience of pagan icons we shall later consider. Just now the conservative academic treatment of Venus and Eros may be observed reaching its most completely intellectualized state in a painting by Henry Oliver Walker called *Eros et Musa* (1903; fig. 68). The female figure is draped even more heavily than was Venus in West's first *Venus Lamenting the Death of Adonis,* and Eros might feel himself even more mismatched with Thought than with Wit, were he not himself so completely metamorphosed into a pretty child, a Jesus or Saint John with feathery wings instead of a furry lamb to set off the smoothness of his flesh. This Muse does not dance, neither does she sing. She is face only, without figure or parts. What effect has she? What does she inspire? Merely a passive thoughtfulness in untroubled association with a purely platonic Love. Eros grasps his bow, but surely it will never be used randomly, mischievously, vengefully, as Cupid was wont to do. His mother Venus has vanished, and his foster mother the Muse has made an angel of him. Both the ferocity and the delight of Roman mythology are absent.

From the vantage point of this extreme negation of the effects of Venus and Eros we may more readily appreciate the efforts of other American artists of the nineteenth century to convey the reality of physical beauty and its mythic force. This effort, however obscured by necessary deceptions, sought something more than the arbitrary manipulation of figures in simple allegories of no felt significance. The effort more often arose from a sensuous feeling for the beauty of the human figure as it may be realized in paint and marble. As a result, through the veils of an unsexed classicism the old gods do occasionally both glimmer and glower.

DECEPTIONS OF VENUS

After graduating in 1868 from the Virginia Medical College in Richmond, Moses Ezekiel followed his family to Cincinnati, where they had gone to escape the postwar "political horrors." He had already expressed a wish to go to Rome and become a sculptor, so when he went to the room prepared for him in his grandparents' house, he found that his grandmother had placed in the four corners of the room plaster copies of the four most famous statues of Venus: the *Venus of Milo,* the *Venus de' Medici,* the Capitoline *Venus,* and Thorwaldsen's *Venus,* in the hope that their presence would keep him at home. She had, however, draped them all with white gauze.[1] In time Ezekiel went to Rome and remained there the rest of his life, working in vast studios in the ruins of the Baths of Diocletian.

In America, Venuses had been literally or metaphorically veiled for a long time. Nevertheless the best artists and sculptors interested in the female nude developed several strategies for depicting feminine beauty that reconciled Anglo-American taste and ethics with the tradition that found its source in pagan life, mythology, and sculpture, and its most exuberant expression in Renaissance painting. Some of the strategies were compromises so total as to defeat the purpose; others were so successful as to incur the charge of hypocrisy from our own age of candor. Raphaelle Peale's *Venus Rising from the Sea: A Deception* (1823; fig. 69) is a witty representa-

Fig. 69. Raphaelle Peale. *Venus Arising from the Sea: A Deception (After the Bath)*. 1823. Oil on canvas. 29 × 24". The Nelson-Atkins Museum of Art, Kansas City. Nelson Fund.

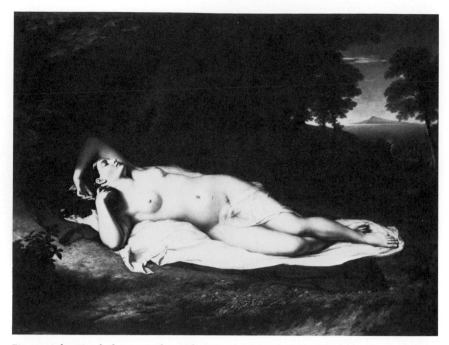

Fig. 70. John Vanderlyn. *Ariadne Asleep on the Island of Naxos.* 1809–14. Oil on canvas. 68 × 87". Courtesy The Pennsylvania Academy of the Fine Arts. Joseph and Sarah Harrison Collection. (See plate 12.)

tion of the artist's consciousness of the problem. A beautifully executed trompe l'oeil painting of a napkin hangs before a painting of Venus. Art veils not nature, but itself, its own representation of Beauty. The shapely arm that lifts Venus's wet hair just rises into sight at the top, while below we see her naked feet. To the male observer are left many possible reactions: shock at what he imagines lies behind the napkin; a prurient desire to snatch it away; or simple happiness in the joke. Perhaps he might even suspect that a pleasure as satisfying as that offered by one more traditional Venus may be found in the shades of white light refracting angularly from the various napkin folds. But the joke was possible only once, and a leap ahead into the aesthetics of pure abstraction hardly to have been expected. (In this century Peale's *Venus* was itself deceptively mistitled *After the Bath.*)[2]

Other artists practiced their own "deceptions," thinking of the nude Venus, but providing diversions and talking of many things. The propaganda that accompanied the most famous American painting of a female nude in the nineteenth century was one of the bolder strategies, as the nude was one of the most beautiful. The money made by Wertmüller through display of his *Danae* did not escape John Vanderlyn's notice in Paris. He made copies of both Correggio's *Antiope* and his *Leda and the Swan* and of Titian's *Danae* precisely because he believed unchaste nakedness "may attract a great crowd if exhibited publickly."[3] The fond purchaser of the *Antiope* did not dare to hang it in his home, since he knew it to be "altogether indecent."[4] But as an artist Vanderlyn cannot have found copying these paintings merely an act of cynical commercialism; he clearly learned from them. In 1809 he began painting his own masterpiece, the opulent *Ariadne Asleep on the Island of Naxos* (fig. 70). Vanderlyn had been in Rome for two years, 1805–07, but the

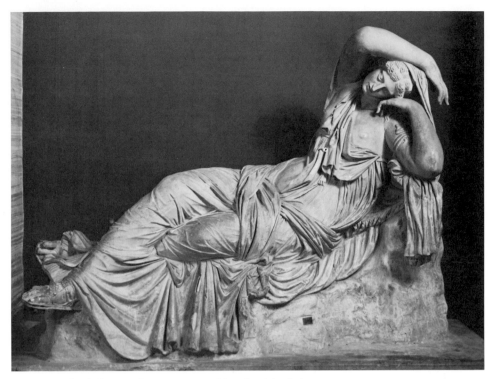

Fig. 71. *Ariadne* (*Cleopatra*). Roman copy of Greek original of ca. 240 B.C.
Marble. H: 1.62 m. L: 1.95 m. Vatican Museums, Rome.

celebrated sculpture of Ariadne from the Vatican collection on which his Ariadne's
pose is ultimately based (traditionally called a Cleopatra, although Winckelmann
thought she was a Venus) was at that time directly at hand as part of the Napoleonic
loot in the Louvre; after 1816 it was again admired in Rome (fig. 71).[5] The lush and
more recumbent Venuses of the Venetians lie even more conspicuously behind this
painting, but the sharper outlines of contemporary French neoclassicism and the
serenity of the sleeping face (like that in its classical source) somewhat moderate
the sensual appeal found in Titian's palpably round and frankly gazing goddesses.
Moreover, while Titian's Venuses prefer their boudoirs, Ariadne (like the Venuses of
Giorgione and Correggio) is wholesomely framed by nature.[6]

Vanderlyn's *Ariadne* is, however, emphatically a celebration of glowing flesh and
curvaceous form, and even her face expresses desire satisfied, like that he had copied
in Correggio's *Antiope*, which it closely resembles.[7] Nevertheless, it had a less
sensational reception than he had hoped for when it was exhibited in New York in
1819 together with his *Panorama of Versailles*. Perhaps a frankly named "Venus,"
even a "Sleeping Venus," would have incited more profitable outrage. In a new
version of 1837 Vanderlyn did try adding a Cupid and moving Ariadne indoors; but
he also pulled some blankets up just below her breasts.[8] But *Ariadne* in any version
was wrapped up in a veil of sentimental narrative. You were supposed to see both
more and less than met the eye. The title focused thoughts that otherwise might
have run wild.

A pamphlet published at about the time of Vanderlyn's lonely death in 1852, in

the last of many attempts to exploit his *Ariadne,* still gave a complete justification for viewing *this* female nude. Appeals to "nature's God," the artist's obvious genius, the love of landscape, and the laudatory opinions of "our truly eminent artists STUART and ALLSTON" and the "great departed critics and amateurs NAPOLEON and JEFFERSON" were all felt to be necessary. Most essential, however, was that one recognize the innocence of Ariadne and view her situation with the proper sentiment. Whatever she may look like, Venus she is not. "Little did she think . . . that the man [Theseus] for whom she had sacrificed her all, could ever prove forgetful— she lay down by his side in perfect serenity." We are assured that when the "rosy morn" opened her lids, and she discovered her "wretched situation," her grief would bring on "a premature death." The happy alternative ending in ancient mythology is suppressed. In that version Venus herself arrives on the scene and consoles Ariadne with the promise of a divine husband—Bacchus, no less, who eventually transforms her into a diadem of stars. But Venus and Bacchus were precisely the wrong associations for an American female nude. The pamphlet, while protesting too much, nevertheless served its end: to enable the viewing of a superb nude without shame. Within the statement are buried the simple truths of the artist's own real interest and intention: to show "all that is lovely in the loveliest," and to "display" the artist's "talents in depicting female excellence." Perhaps inevitably, the painting was purchased by another painter, Asher B. Durand, who made from it a beautiful engraving. Since Botticelli and Correggio there had been no higher aim in secular painting than what Vanderlyn had sought here. The question was how American taste would come to participate in the artists' pleasure.

One of the stranger deceptions was attempted by whoever gave Thomas Crawford's *Venus as Shepherdess (after Thorwaldsen)* (1840; fig. 72) its title. When Crawford arrived in Rome in 1835, he entered the studio of Thorwaldsen himself, who had inherited Canova's position as the leading neoclassical sculptor in Rome. Crawford's work is simply the direct copy of a relief made by his master in 1831. But Thorwaldsen's is known simply as *Shepherdess with Loves.* It was in its own way a deception, however, since it imposed the innocuous masquerade of eighteenth-century pastoralism upon an image derived from a truly salacious fresco discovered in the Vesuvian ruins at Stabia. An engraving of the fresco, known as *Il Mercato degli Amori* or *The Cupid-Seller,* was published in 1762 and became the source for works by many artists and sculptors before Thorwaldsen. Some artists even heightened its eroticism. Joseph-Marie Vien, a disciple of Winckelmann, had one cupid make an obscene gesture, and Fuseli's version has been characterized as pornographic by Robert Rosenblum, who finds "something sexually grotesque and disquieting in the transformation of a Roman vendor of loves into an old, witchlike hag who thrusts a cringing Cupid at a coolly serious lady."[9]

That transformation is not, however, so great as the one effected by Thorwaldsen in the opposite direction, primarily by the removal of any love-buyers. His and Crawford's fat-cheeked shepherdess has no sheep either, simply a crook and a dog, who would seem to have a dangerous interest in the bite-size cupids that bulge from the basket in sweetly amorous play. The traditional eroticism of the theme remains just beneath the surface here, but that surface is sufficiently veiling to permit the shepherdess to be proposed as a Venus. Crawford's title resumed the erroneous

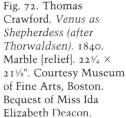

Fig. 72. Thomas
Crawford. *Venus as
Shepherdess (after
Thorwaldsen).* 1840.
Marble [relief]. 22¾ ×
21⅛". Courtesy Museum
of Fine Arts, Boston.
Bequest of Miss Ida
Elizabeth Deacon.

assumption made by the discoverers of the Stabian painting—if these are Loves, that must be Venus—which, however, had not been perpetuated in the reprints or imitations.[10] Now the tough-looking little Love who is sent flying (not in the original, but adapted from Vien or Flaxman) may be thinking all sorts of things as his pudgy arms move toward the phallic gesture introduced by Vien; but he looks back worriedly at his "mother," as though not certain of his powers to fly, let alone take venereal action. A buried source in conflict with a sentimental surface, to which is added a misleading title sanctified by the inclusion of a Christian artist's name—all combine to render Crawford's *Venus as Shepherdess (after Thorwaldsen)* naively absurd, the work of an apprentice in a wholly foreign world.

The two American artists of this period who interested themselves in Venus as the nude goddess herself were the sculptor Horatio Greenough and the painter William Page. But whereas Page boldly proclaimed the healthfulness of the natural female body, Greenough approached it cautiously over many years and through several stages. He resisted his first opportunity, a request from his Baltimore patron Robert Gilmor that he do an adaptation of Botticelli's *Birth of Venus.* He counterproposed figures that would have been more fully draped, two of them men. Gilmor then suggested a smaller partially draped female, so Greenough proposed a girl, aged nine. This not being what Gilmor meant at all, the sculptor finally settled upon *Medora,* the partially nude but safely dead heroine of a poem by Byron. Greenough wrote that he hoped it would "interest and charm the eye and mind with a female form without appealing to the baser passions, what has not been done in Italy for many years." He succeeded. The Greek scholar (and expert expurgator)

Cornelius C. Felton, of all people, hailed the work as displaying "the highest excellence of soul and sentiment."[11] Yet it was at first thought necessary in the Boston of 1833 to segregate by sex the thousands who paid to see *Medora*. At least one woman was more conscious than Felton of there being something besides "excellence of soul" on display, for she said she was "horrified at the size of what Moore calls woman's loveliness which actually took my eye so that I could not see the face."[12] Perhaps she was merely singular in admitting as much.

The success of the *Medora* was such that in an excited letter to Washington Allston of 1838 Greenough was able to describe his progress on an actual *Venus* for John Lowell of Boston—his "first female figure entirely naked" (fig. 73). He was trying "to combine symmetry with expression and beauty with innocence taking the more poetic sense of the character and considering the mother of Beauty and the patroness of the graces as simply such"—in other words, *not* as the Goddess of Love and mother of Eros. How the perception of the viewer could be so limited—blinking the merely terrestrial aspect of an "entirely naked" female—was not explained, although Allston perhaps understood the self-deception. Greenough admitted that he was "examining Nature pretty widely" and "scrutinizing" the antique models as well—especially the *Venus de' Medici*. He assured Allston that if "but one statue of a female could be saved," that would be it. Yet (this is twenty years before Hawthorne's lesson from Powers) "the head is scarce worth speaking about," "the length from the *nates* to the heel" is "too great by far," the "pubis" is "superficial," with the result that "the muscles of the inside of the thigh" go "to a false insertion considerably *outside* the real one," while the thighs, legs, ankles, and feet, though "exquisite" and "beautiful," are all flawed in one particular or another. This is obviously shoptalk of a sort not meant for general consumption. Greenough said that the model of his own *Venus* was ready for casting, yet "this class of figure" was interesting him so much that he might remodel it "while my ideas are awake . . . to try a few experiments."[13] The result was a perilously forward-leaning figure of bewildering dimensions. Not meant to be life-size, she is still as large as a little woman—not how one thinks of Venus. Her iconography is also confusing. There is a relief of *The Judgment of Paris* carved on the base of the statue; and that this *Venus* is the *Victrix* is indicated by the tiny apple nearly hidden in one hand. Yet she absentmindedly twists some hair on top of her head with her other hand, as though she wanted to be a *Venus Anadyomene* as well. As a result she is very far from being a *Venus Pudica*; her breasts, much less developed than those of *Medora*, are fully exposed when viewed from her right, and so is her "pubis," one less "superficial" than that of her Medicean sister.

Greenough's interest in "this class of figure" was now thoroughly aroused, however, and his thinking about it—and about nudity—also developed. In 1846 he sent a brief essay from Italy to New York called "Do Not Be Afraid of Grace and Beauty!" It described the pleasure he took in watching acrobats, strongmen, and especially dancers like Taglioni, Fanny Elssler, and Cerito. "To me there is a devotional feeling attached to such appreciation of our bodies," he wrote; he loved to behold the "marvelous capacities of this noble frame." Defensively, he confessed that "the senses have their full share in this pleasure," but it is as innocent as one's gratitude for "sun in winter" and for shade and the "sound of spouting water" in the

summer. He is as disgusted as anyone by "the gymnastics of the brothel," but he will not for that reason deny the "charm I find in the poetry of motion." Fanny Elssler's ability to reveal "female attractions" far surpassed that of Catullus, Tibullus, Moore, and Byron. Greenough now saw "the full power of womanhood revealing itself to man—strongly, for it is the origin of all strength—gracefully, for it is natural—innocently, because it is just what God made it." Fanny Elssler gave a "drunken thrill" to his blood, quite different from the effect produced by the *Apollo Belvedere*—a "sober stir" accompanied by a "soaring of mind." The opposition between the intellectual male and the sensual female is reestablished. It is not necessary for Venus to be the "poetic . . . patroness of the graces," for Fanny has made Greenough see that female sensuality is simply "humanity not ashamed of itself." The Greeks "took the world as they found it. . . . They did not flinch from fact." Venus is not "incompatible" with the Graces, but neither is she "inseparable" from them.[14]

By 1850 Greenough completed the modeling of a *Venus Vincitura*, this time larger than life. It was highly praised by many worthy judges; Robert Browning hoped that it would appear at the Crystal Palace Exhibition the next year. But this *Venus* was never to be put into marble. The model, made of a new plaster invented by Hiram Powers, disintegrated during shipment to America in 1853, the year of Greenough's death.[15]

American Venuses who went by their proper name perhaps were jinxed. Of the four bold and life-size versions painted by William Page later in the 1850s, three soon fell from their canvases as a result of their creator's transcendental indifference to the facts of chemistry. They were among Page's major productions of the decade that followed his settling in Rome in 1852 and excited the highest interest among his friends. The Brownings had lived in the same palazzo on Via Bocca di Leone with the Pages and regarded him as "that noble Page." In a letter from Paris in 1856 Robert inquired of Harriet Hosmer about the progress of the "Venus," to which Elizabeth added a postscript saying "I long for the Venus, is it finished?"[16]

Since he was known as "the American Titian," it was perhaps inevitable that Page should attempt to rival his master in one of Titian's preeminent subjects. He had taken his Transcendentalist beliefs—to which he had added Swedenborgianism under the tutelage of Hiram Powers in Florence from 1850 to 1852—beyond the vestigial sexual puritanism that remained in Emerson and Thoreau. For his self-portrait that is a pendant to the painting of his third wife in front of the Colosseum, Page chose to appear before the so-called *Dionysus* of the Parthenon. He had long since (1843), in America, painted a half-length close-up double nude of *Cupid and Psyche* kissing in impassioned embrace, a work of intense sensuality based upon the celebrated antique group that shared the reserved cabinet with *Venus* in the Capitoline Museum. It was banned from the 1843 exhibition at the National Academy in New York, but was shown at the Boston Athenaeum the same year. Page was a successful genre painter and a fine portraitist; Mrs. Browning considered his portrait of her husband to be second only to God's gift to her of Browning himself.[17] But a man with Page's pretensions and respect for the classical heritage measured himself by the Renaissance. Moreover, he felt he understood the true significance of Venus. She was to him "health and nature," and anyone who saw her differently was

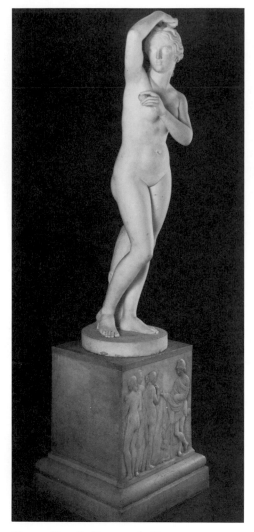

Fig. 73. Horatio Greenough. *Venus Victrix.* 1837–41. Marble. H: 145.3 cm. Boston Athenaeum.

Fig. 74. William Page. *Venus Guiding Aeneas and the Trojans to the Latin Shore.* ca. 1857–62. Oil on canvas. 85¾ × 55". National Museum of American Art, Smithsonian Institution. Gift of Frederic C. Page and Lowell B. Page, Jr.

"either grossly ignorant or vulgarly and morbidly corrupt," claimed a promotional pamphlet of 1860, perhaps written by Mrs. Page.[18]

The *Venus* of Page that survives shows a goddess who refuses to cover any part of herself (fig. 74). She is not, however, reclining seductively upon a couch as Titian showed her, or even reclining upon the bosom of nature, like the Venuses of Giorgione and Correggio and the Ariadne of Vanderlyn. As in Botticelli's *Birth of Venus,* she floats toward us standing upon a half-shell. Page also made a concession to contemporary desire for a justifying narrative by claiming that she is in the act of "Guiding Aeneas and the Trojans to the Latin Shore." If Vergil and the founding of

228

Rome itself could not establish Venus's dignity as a pagan goddess in the eyes of the Victorians, nothing could. Unfortunately Page defeated himself by painting an exceptionally unattractive Venus. Her self-conscious half-smile is the antithesis of an expression of majestic and triumphant beauty that one might expect of her on this occasion. She holds the delicate fingers of her left hand near her face in what she knows is their prettiest pose, while balancing herself on her shell like a novice surfboarder. She makes a wobbling effort to bend her torso at the angle in which Page had found it in an antique fragment. This torso demonstrates exactly the classically equal distances between points of breasts, between nipple of lower breast and navel, and between the navel and what Hawthorne called Venus's "middle." But her waist is somewhat pinched, the visible result of having worn a corset, according to a critic who questioned how that showed "nature and health."[19] For Page, however, any concessions to either classical precedent or current fashion would have been subordinate in his mind to an elaborately evolved theory of human proportions based upon certain verses in the Bible.[20] Browning advised Hosmer in 1854 to listen to Page closely "for it is real life blood you will get out of him, real thoughts and facts, nothing like sham or conventionalism. I carry in my mind all I can of his doctrine about the true proportions of the human figure, and test it by whatever strikes me as beautiful, or the reverse."[21]

Whether or not Page's Venus demonstrated the biblical proportions for the beautiful, she was rejected in 1859 even by the Salon in Paris, reportedly on grounds of indecency. (Ingres's own *Venus Anadyomene* was of 1848, his *Le Bain Turc* would appear in 1862, and Manet's *Olympia* in 1863—not without inciting protests.) Page's *Venus* was rejected again by the Royal Academy in London and finally by the National Academy in New York. But it was otherwise shown and even toured, although described by the *Crayon* in New York as a "disgusting insult to Christian delicacy" which proved Page's moral derangement.[22]

In *The Art-Idea* (1864) Jarves, in a general condemnation of Page's plagiary from other painters, turned to the *Venus* in particular:

Even his Venus bears a close resemblance to that of the Frenchman Peron. It is sensuous and graceful in idea, but bilious in color. In avoiding the meretricious daintiness of his prototype, he has fallen into a repellent realism, which not even his intense dinginess of hue can sufficiently veil. It is an apotheosis of the animal woman, suggestive of sportive wantonness and conscious seductiveness. Seldom, indeed, do modern painters of the naked woman lift her out of the mire of the sensual. To paint a good portrait requires a master's hand; much more the entire woman, as the highest type of divine creation, morally, intellectually, and physically. The religion of the pagans demanded this of art, and theirs was equal to the call. But the religion and taste of the moderns both condemn it. Hence these pictures are exceptional, and are apt to excite exceptionable curiosity.[23]

The "power" of the "mature" artist Jarves defines as a "veiling" of the physical reality of the female nude through a mysterious idealizing process. Evidently the "animal woman," sportive and seductive, inevitably exemplifies "repellent realism" and falls outside the realm of "pure art," which somehow serves as Peale's

white napkin. But Jarves further implies that even a depiction of the "entire woman," when this is attempted through the nude, is so alien to contemporary religion and taste that it inevitably arouses "curiosity" of the wrong kind. Apparently a naked woman will tend *always* to be seen as "animal woman," even though she is meant to be "the highest type of divine creation." Finally, in wisely observing that the difference between ancient Greek and nineteenth-century religion inevitably causes a different response to the nude, Jarves does not indicate how the masters of the Renaissance, with whose works he compares Page's, could be certain of an elevated response in their patrons. Titian must have credited viewers with extraordinarily acute powers of perception if he relied upon them to find any "moral" and "intellectual" component in his Venuses.

Jarves cannot resolve the general problem he has raised because his analysis shies away from the questions implied by the several factors involved: Are the great artist's idealizing powers inherent in his technique and style? Is the nude an inherently "realistic"—and therefore inferior—subject? Can the same thing that was "ideal" in the classic antique be too "real" for the modern world? How then can we speak of beauty as being "universally" recognizable, and as having its highest expression in Greek art? Why is a change in contemporary or future religion, such as would permit the nude once more to be seen purely, assumed to be impossible? Fortunately for Jarves, the particular case of Page's *Venus* was unlikely to prove either the power of personal technique and style to idealize a subject or the inherently ideal beauty of the female nude. Both could be left in the past, with Titian and Praxiteles.

Even H. T. Tuckerman, usually disposed to praise all American efforts toward high art, placed Page's *Venus* among those works that had posed "art-problems" by giving simultaneously the impressions of "grandeur and grotesqueness." As is often the case with Tuckerman, he shields himself by quoting a less discreet contemporary to convey what he thinks. In this case the voicer of his judgment is Paul Akers, an American sculptor resident in Rome. Akers, by pleasant indirection, tears Page's *Venus* to shreds and then throws it away:

> The "Venus" of Page we cannot accept—not because it may be unbeautiful, for that might be but a shortcoming,—not because of any technical failure, for, with the exception of weakness in the character of the waves, nothing can be finer,—not because it lacks elevated sentiment, for this Venus was not the celestial,—but because it has nothing to do with the present, neither is it of the past, nor related in anywise to any imaginable future.[24]

Irrelevance could hardly be more complete. But that had not prevented a group of Bostonians, headed by Charles Eliot Norton, from organizing to purchase one of Page's *Venus*es for the Boston Athenaeum, where she is said to have been sent promptly to the cellar.[25]

VENUS AND EROS ENCHAINED

The title of Benjamin West's *Omnia Vincit Amor* (1811; fig. 75) is taken from Vergil's Tenth Eclogue, but its image calls to mind the powerful figure of Eros in

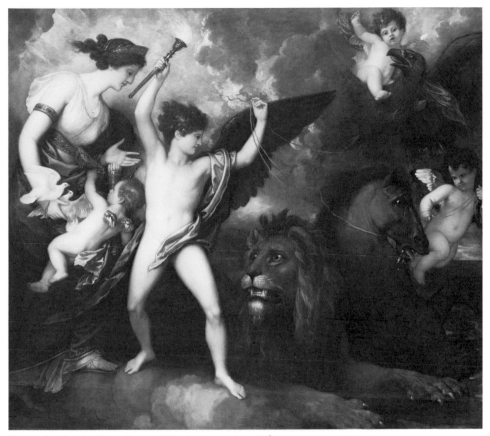

Fig. 75. Benjamin West. *Omnia Vincit Amor.* 1811. Oil on canvas. 70⅛ × 80½". The Metropolitan Museum of Art. Maria De Witt Jesup Fund, 1923.

Petrarch's *Trionfo d'Amore.* West's Amor, like Petrarch's, is the cruel nude youth ("garzon crudo . . . tutto . . . ignudo") who has in thrall all the mighty of the earth—the lions, the eagles, the stallions (I:23 -27). Even Venus herself (fully clothed) is being bound by one of his assistant *amorini.* Three years later (1814) Thorwaldsen created an *Amor Triumphant* who is also an embodiment of Petrarch's "superb leader" (*somma duce*), like those who formerly led their captives in "great glory" to the Capitol in Rome. This Love would be capable of tying *"Venere bella"* to her Mars, of placing Mars himself in "iron chains—feet, arms, and neck," of entrapping Pluto and Proserpine, Jove and "jealous Juno," even *"'l biondo Apollo"* (I:151–60). But when Horatio Greenough read his Petrarch (which he also advised Cooper to do, now that Cooper knew Italian), he skipped over this first and longest of Petrarch's *Trionfi,* preferring the *Trionfo della Pudicizia* (*Castitá*) and the *Trionfo della Morte*—Chastity and Death. The god Love was not only diminished into an impotent infant but himself put in chains. Venus and Eros—and the sexual power of Woman—were thus controlled, and not for the last time in American sculpture.

Greenough's first opportunity to create a *Venus* eventually resulted, we have

seen, in the large-breasted but dead *Medora*. The "spirit" of this work, Greenough told Cooper, was to be found in two lines of Petrarch's *Trionfo della Morte*. In 1835 he was at work on *Love Captive* (fig. 76), also supposedly "embodying a conception of Petrarch," this one from the *Trionfo della Castitá*. But in Petrarch's poem Amore necessarily remains a powerful figure as he appears in terrible combat with Chastity (Laura). He loses some feathers from his "great wings of a thousand colors," but only by great effort on Chastity's part can his energetic form be bound to a "beautiful jasper column" by a "chain of diamonds and topaz" that had been dipped in the waters of Lethe (lines 120ff.). In contrast, Greenough imagines him as a petulant boy with paltry appendages, inherently impotent. He described him in a letter thus: "His godship stands chained to a rock on which the bird of wisdom stands centinel [*sic*]. His arrows lie broken at his feet, his hands are crossed behind him in the attitude of helplessness—in his face I have attempted to mingle lurking mischief with shame."[1]

One might wonder how it was to the credit of Chastity to have her mighty enemy so reduced. But undoubtedly both his nudity and his nature required it. Cooper, in giving Greenough his first commission for ideal sculpture with the *Chanting Cherubs*, had explicitly encouraged him to abandon a heroic nude male which represented his Michelangelesque "bias" (and which Emerson thought was modeled after Greenough's own body), in favor of "the more graceful forms of children and females," since these were closer to "popular taste."[2] Naturally the boy-Cupid of Roman tradition would therefore be preferred by Americans to the adolescent and frequently androgynous Eros (child of Hermes and Aphrodite = hermaphrodite) who had been reborn in the Italian Renaissance. Edgar Allan Poe alludes to him when he imagines a heaven in which a poet might sing a truly impassioned song—where "a bolder note than this might swell" from his lyre—as a place "where Love's a grown-up God" ("Israfel," 1831). Melville's "Amor Threatening" in the epigraph to "After the Pleasure Party" must also have looked more like the god of Petrarch and West than that of Greenough. One also doubts that Margaret Fuller would have been satisfied with Greenough's ludicrous little bird as the emblem of Minerva.

Petrarch's white-gowned Laura is, however, close to the American Victorian ideal of Woman. She defends herself from Amore's arrows with the shield given to Perseus by Minerva. The poet thus implicitly grants that she possesses Wisdom, and he explicitly mentions all the traditional feminine virtues as well, including those of the Graces. He makes her in effect a Venus with one crucial difference: she is "Supreme Beauty united with Chastity," "a rare concord" (lines 90–91). The *Trionfo della Castitá* ends in Rome with visits to the Temple of Suplizia, formerly dedicated to Venus, where one was cured of the madness of passion, and then to the Temple of Pudicizia. The final verse concerns a young woman who veiled her "bellezza" to protect her own chastity and that of those who saw her. All this painters and sculptors would have liked to envision, but to show the beauty it was necessary to remove the white gown and the veil. The significance—particularly the chastity—of female beauty thus revealed, however, was difficult to express. Sculptor and viewer as well as the nude herself found themselves in equivocal situations.

The most drastic and successful solution to the problem again involved chains.

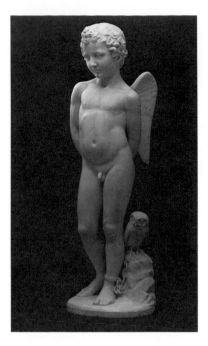

Fig. 76. Horatio Greenough. *Love Captive (Love Bound to Wisdom)*. 1835(?). Marble. 42 × 13". Courtesy Museum of Fine Arts, Boston. Bequest of Mrs. Horatio Greenough.

The *Greek Slave* of Hiram Powers is a Venus conveniently draped in sentimental narrative, which enabled her to make a notorious tour of America in 1847, to appear within a curtained booth at London's Crystal Palace Exhibition in 1851, and eventually to exist in eight marble copies (fig. 77). Her perfect nudity, her classical proportions, and the fact that her pose is adapted from those of the *Knidian Venus* and the *Venus de' Medici*—all caused her to be seen as a Venus, since her beauty was to be compared only with that of other Venuses. The Reverend William Ware frankly saw in her the "sort of beauty that makes a Venus," and wished that she had looked more "downward" with "eyes a little more depressed."[3] Her resemblance to the goddess of love therefore made it the more necessary in her public relations to insist upon her chastity. By means of her chains, a small cross, and a blank "expression," Powers constructed a screen that made her an emblem of Christian fortitude and resignation in the face of Turkish barbarians during the recent (but already historical) Greek war for independence.

A pamphlet by the Reverend Orville Dewey, who like Ware was one of those Unitarian ministers who were trying to find richer sensuous lives through the arts,[4] assured viewers whose eyes might have misled them that the "voluptuousness of the antique" was totally lacking here; what they saw was "chasteness." Only the purest of motives were evident in both artist and nude. Dewey's assumption that physical beauty by itself is inherently dangerous to morals is apparent in his insistence that didactic realism and uplifting sentiment were necessary to render it innocuous: "There ought to be some reason for exposure *besides* beauty; like fidelity to history, as in the Eve, or helpless constraint, as in the Greek Girl." The Reverend Mr. Dewey's metaphorical description indicates how thoroughly physical beauty had to be thought of as obscured when placed directly before one's eyes: "It was clothed all over with sentiment, sheltered, protected by it, from every profane

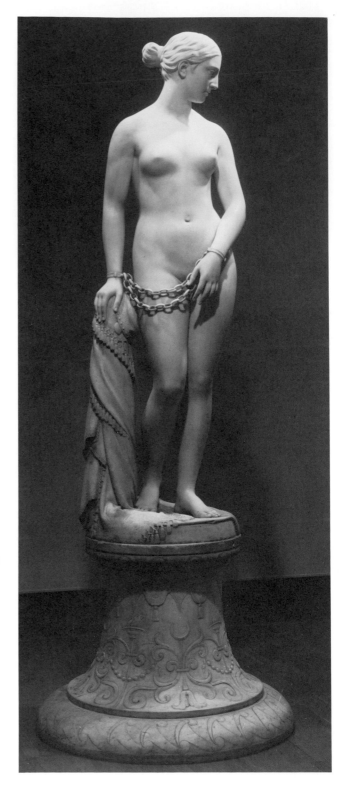

Fig. 77. Hiram Powers. *The Greek Slave.* 1843. Marble. H: 65½" (not including pedestal). Yale University Art Gallery. Olive Louise Dann Fund.

eye. Brocade, cloth of gold, could not be a more complete protection than the vesture of holiness in which she stands."[5] The "protection," however, worked both ways: the girl from the "profane eye" and the viewer from the girl's erotic power. Instead of Raphaelle Peale's resplendent white napkin, a "vesture of holiness" more impenetrable than brocade was hung between Venus and viewer. The brocade, like the napkin, was a deception, but in this case belief in the reality of the fabrication rendered it transparent so that the Venus behind it could happily be seen.

The propaganda generated on behalf of the *Slave*—which included essays, stories, and poems (including sonnets by Elizabeth Barrett Browning and H. T. Tuckerman)—has obscured even from modern commentators her real reason for being. The fact that beauty itself was not admitted as a self-sufficient excuse indicates that display of beauty was the real purpose, the narrative merely serving as the enabling device. The Reverend Mr. Dewey's assertion that there must be something *besides* beauty leaves the "something" as the indifferent variable, while "beauty" is the essence and the object. But what is most peculiar about the disguised Venuses of Powers—which include his *Eves*—is that the narratives that justify their nudity invariably focus the mind on sexuality more than an autonomous Venus so identified would do. The narratives, whether of the *Slave* or of *Eve*, make it difficult to contemplate the female nude simply as an expression of Beauty or even Woman. She is made to express Female Sexuality. Ironically, the contexts provided for the nude, which were meant to turn thoughts away from the amoral sexual power of physical beauty that is always implicit in a *Venus*, focused on supposedly morally superior thoughts of sex as the violation of beauty (the *Slave*) and as the emblem of man's fallen animal nature (*Eve*). In both the *Slave* and the beautiful *Eve Tempted* (fig. 78), sexual innocence is the conscious prelude to sexual degradation. Eve is an emblem of Female Sexuality conceptually bound by chains of original sin and guilt.

Since the excuse for display of nude beauty in the instance of the *Slave* required the naked girl to have her wrists bound in chains which accentuate her vulnerability to sexual attack, she became more provocative than the relatively modest classical Venuses, who usually made some effort to cover themselves or rose from their baths or received the prize apple for beauty with such self-assurance as to make it clear they were as much the agents as the objects of desire. The chains placed the *Slave* within the hand-cuffed Adromeda type, forcing her to expose her breasts. The male viewer is in the position of a sexually attracted Perseus, a voyeur, or even a buyer, and the sympathetic female viewer is the object of these attentions. The opinion of Kenneth Clark in his fine study *The Nude*, that Victorian marble females such as the *Slave* can never have been thought of as objects of desire, was based upon his own wide basis for discrimination. It is not so clear that the masses in the Crystal Palace or in the small cities of America would have looked upon the naked *Slave* with Clark's coldness, not themselves having seen the *Knidian Venus*.[6]

The *Slave*'s chains serve not merely as instruments of subjection, but as means of controlling this Venus's own potency. To the same extent that she is perceived as the constrained object of sexual desire, she is seen as provoking that desire. She is not just your average female slave, who ought equally to evoke pity; a body as beautiful as hers is itself a threat to the chastity of others and ought to be veiled. Hence the chains did not merely expose female beauty to violation; they also

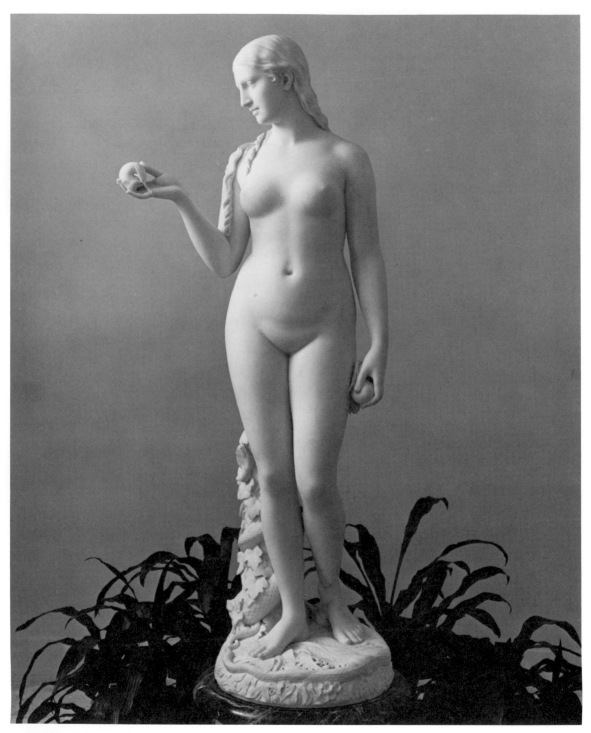

Fig. 78. Hiram Powers. *Eve Tempted*. 1839–42. Marble. 68⅞ × 29⅞ ×
20½". National Museum of American Art, Smithsonian Institution. Mu-
seum purchase in memory of Ralph Cross Johnson.

inhibited its own aggressive capacity. The *Slave* is then not merely "Chastity Threatened," as officially presented, but also "The Goddess of Love Enchained," or another version of the Triumph of Chastity: *Venus Captive*. A *Venus* isolated from any narrative that excited and directed the imagination, a *Venus* existing simply as Female Beauty, as though she were no more than a *Standing Nude* of our own century, would have been less provocative of sensual ideas, and in less need of control. The narrative intent thus doubled back upon itself. In positing a context of sexual desire and possible possession, it simultaneously necessitated an image of impotence in the physically attractive female.

The interesting letters written by both Powers and his patrons, published by Donald Martin Reynolds, sufficiently indicate that the central interest of both creator and buyer was not in the moral narrative but in the beauty of the female nude—in Venus. As with any Venus, the problems here centered around the expression of the face, the disposition of the hands, and the significance of accessories. Powers's first and central motive was always to create a "female figure"; only secondarily was he concerned with who she might be or what she might express other than her womanly beauty. He thought of making an Eve "reflecting on death"—a sufficiently pious diversion—but this not surprisingly proved to be difficult to convey in the face, so he tried *Eve Tempted*. That meant she could be seen before the Fall, hence both entirely naked and wholly chaste. At the same time the fact of being tempted would inevitably associate her physical beauty with sexual activity in the mind of the viewer. Powers was flippant and heavily ironical about the necessity for justifying her nakedness. *"Eve* might shock the sensibilities of many who found the *Slave* quite as much as their moral feelings could bear," he wrote the purchaser, Colonel Preston, "for *Eve* is quite 'naked,' and she does not appear in the least 'ashamed.' It was very wrong to make her so." As for the "error" of omitting a fig leaf, he "forgot" it until "too late in the season to get any." He hopes that *Eve* "will not corrupt the morals of her more perfect and less sinful descendants," since she insists upon wearing her hair in a natural style and leaving her waist uncorseted, her feet unpinched, and her buttocks unpadded; she has never seen "the enormous developments" in the rear characteristic of the chaste daughters of modern times.[7]

To Joel T. Headley, Powers had demonstrated that only "an American or an Englishman could conceive a proper idea of Eve." Frenchmen and Italians could do "passion and beauty" well enough, but they had not even "the most dim conception" of "moral character" and "high purpose."[8] *Eve*'s naked beauty mattered more than her scriptural status, however, when the townspeople of Albany heard that the naval officer Robert Townsend wished to purchase the first version of the statue. His brother wrote Powers that everyone was disconcerted by Robert's intention to distinguish himself by becoming the "Master" of "the first of American beauties," never before having shown any "hankering womanwards." The order was canceled. Similarly, when Captain John Grant became the first purchaser of the *Slave*, he expressed no specific appreciation of its moral sentiment or its concord of Beauty with Chastity, but explicitly stated that since seeing her he had visited all the *Venus*es of Rome and Naples without seeing "a figure which combines so much feminine beauty as the *Slave*. No, not even the *Medici* with all its beauties." His

considered judgment was that he now owned an image "nearer the *beau ideal* of feminine beauty" than "a goodly number of what are called Venuses." In other words, she deserves the name more than they. For Powers himself the *Slave* was literally the fulfillment of a recurrent dream of his childhood. When he heard that she had made an appearance in his native town of Woodstock, Vermont, he recalled that dream: he had seen a beautiful white female figure standing upon a pedestal, and "his strong desire to see it nearer" had always been frustrated by an intervening river "too deep to ford."[9] His *Slave* was now the realization of this *Venus Anadyomene* of the Vermont wilderness.

Powers, thanks partly to his Swedenborgianism with its easy spiritualization of the natural world, went about the central task of sculpture—the study of the nude—less troubled than some others. When his fellow-American sculptor in Florence, Thomas Ball, was engaged upon his own *Eve*, he suffered a grotesque dream that she disappeared from his studio. Searching for her everywhere, he finally spotted "a knee protruding from the imperfectly closed door of a closet." When he tried to open it, she desperately held it shut with both hands. When at last she relented, he saw her "crouching in the corner, cracking at every joint." She then explained to him that she "was afraid" and "ashamed, because I was naked." Ball realized then that she was not the Eve he intended, who was not to have known that she was naked. He learned that a nude's ignorance of what everyone can plainly see is not something sculpture can easily convey. Just like her creator, deep down an *Eve* knows that she will be looked upon as a *Venus*. On the other hand, there was no predicting what some viewers would see. Moses Ezekiel was informed in his studio in Rome by the princess of Sayn-Wittgenstein that *his* Eve had a thumb "bent too far back," a characteristic of women of "immoral character." She also objected that Ezekiel (a literalist) had deprived Eve of an umbilicus.[10]

The placement of their hands, and the character of their accessories, tended to emphasize the naked sexuality of Powers's nudes rather than to distract from it. The sculptor assured Colonel Preston that the *Slave*'s hands would be "bound and in such a position as to conceal a portion of the figure, thereby rendering the exposure of the nakedness less exceptionable to our American fastidiousness." What he did not mention, but was obviously aware of, was that this left her breasts exposed, while the enchained hand that unsuccessfully attempted wholly to hide the pudendum merely focused attention on it. *Eve Tempted*, being still innocent, is therefore without the modesty of most classical Venuses, so she makes no effort to cover herself. Like a *Venus Victrix*, she holds in one hand an apple, but in the other are two similar spheres—these an innovation in iconography which, Powers explicitly stated, constituted an allusion to Adam; lower down is the erect and obviously phallic head of the Serpent. In the *Eve Disconsolate* of thirty years later, this Serpent has fallen limp to the ground, and the long index finger of Eve's left hand that points toward the serpent extends directly over her genitals, establishing a strong visual linkage. Her left hand "is pressed against her bosom," as Powers said, blandly adding that "by this arrangement of the hands, the statue, though naked, becomes sufficiently modest by accidental concealment, to admit of mixed company standing before it without offense to sensitiveness" (as had not always been the case with the *Slave*).[11]

All of Powers's nudes are similarly equivocal. The *California*, which Hawthorne thought "naked as Venus," but not "capable of exciting passion,"[12] holds an eye-compelling divining rod (an exotic metallic instrument with an ovoid opening) directly over her genitals and a bunch of thorns behind her. She is the only one explicitly called by Powers "voluptuous," yet she is physically not notably different from the partially draped *America*, who was supposed to represent the important influence of "womanhood" on the Republic, and "all that is lovely, pure, and fascinating." Wrote Powers, "I have shown as much of a woman's form as possible," since after all "it is the form and not the drapery that claims the beholder." His worries over whether a scepter beneath the foot of *America* would offend his British patrons, or whether the substitution of broken chains would offend wealthy southern Americans, show that he also wished that the eye of the beholder could be held by the form, not the accessories, which were largely nuisances of extraneous "meaning." The perception of "form" could be thought of as an experience of the ideal, as Powers insisted to Elizabeth Barrett Browning in iterating the old saw about spiritual beauty being evident in form, and material beauty in color. His pure white women were thus wholly spiritual beings. Yet this contradicted another aspect of Powers's art that he highly appreciated: its tactility. Both in the selection of his marble and in his invention of processes for extraordinarily realistic finishing of the surface he aimed at close approximation of human skin, a sensuous stimulation and invitation considerably modifying one's perception of "pure form."[13]

Artists and viewers alike thus judged the female nudes produced by American sculptors and others primarily as "Venuses," no matter how much ancillary narrative comment they excited, all of which was largely diversionary. Margaret Fuller was one of those upset by the *Slave*'s sensational success, because she questioned not her nakedness but her beauty. If her beauty were in doubt, then the elaborate rationale for looking at her was pointless, however moral. In the very year of the statue's American tour Fuller could barely refrain from judging "the adorers of the Greek Slave" themselves, only reminding them that "they have not kept in reserve any higher admiration for works . . . which are, in comparison with that statue, what that statue is [when] compared with any weeping marble on a common monument." The *Slave*, she asserted, was no more than "a form of simple and sweet beauty, but . . . neither as an ideal expression nor a specimen of plastic power is it transcendent."[14] George Hillard also cautioned those not privileged with a basis for comparison not to get carried away: "From one who has seen the swarms of naked nymphs and goddesses in the galleries of Rome, [Powers's] Greek Slave will not receive the enthusiastic praise which has been lavished upon it in England and America."[15] It did not occur to Hillard that a chaste Christian maiden automatically deserved higher praise than nymphs and goddesses; in the selection of icons for the religion of Beauty, only Beauty mattered.

Both Fuller and Hillard did seem to grant that the *Slave* was at least an inferior version of the transcendent classical type to be seen in Italy and was therefore to be measured against it. Jarves, in *The Art-Idea*, scathingly placed the *Slave* completely outside the canons of true beauty, both those defined by the Greeks and those applicable today (which, as we have seen, Jarves held to differ precisely with respect to nudity). Jarves seems actually fearful that the *Slave*'s success might make nudity

respectable, so incoherent and vicious is his attack. After having charged that the *Slave*'s face lacked character, since it is indistinguishable from those of *Eve*, *America*, and *California*, Jarves arbitrarily reads into her face a character wholly at odds with what Powers intended in order to destroy any moral excuse for looking at her. She is, he claims, "a feebly conceived, languid, romantic miss, under no delusion as to the quality and value of her fresh charms viewed by the carnal eye, and evidently comforted by them, naked and exposed though she is to the lustful gaze of men! We need have no pitying pang; the bought and buyer will soon be on speaking terms, for a coquette at heart always has her price." Jarves, too, takes a Venus as the proper comparison—the now preeminent (and partially draped) *Venus de Milo:*

> This statue [is] the incarnation of the Greek ideal of womanhood; "the goddess-
> woman;" a mother of nations, and the perfect companion of the perfect man.
> Nothing sensuous, weakly sentimental, or immodest in her, and yet no charms
> that sexually attract are wanting, but they are subdued to a greater expression of
> the virtue and intelligence that assert the true woman's prerogative to the homage
> of man. The most carnal eye can detect no consciousness of nakedness in the fault-
> less grace, dignity, tenderness, and majesty of that figure, whose conception and ex-
> ecution are alike lofty and harmonious.[16]

Jarves bravely ascribes even greater morality to a Venus than to Powers's Christian maiden and allows her as a woman what was never even thought of in the defenses of the *Slave*—intelligence. His expressed ideal of a greater wholeness in Woman, with no antipathy between Venus and Minerva or Ceres, indicates what would now seem admirable about the Victorian resentment of imbecilic expression in the *Venus de' Medici*, if that resentment had not also entailed a complete repression of what made Venus Venus.

But Jarves's reading of the *Slave* is as arbitrary as the official one; he simply constructs his own vicious narrative screen to invalidate her as an expression of Beauty, while reading into the *Venus de Milo* the attributes of character he admires. No more than the official interpretation does his permit seeing the *Slave* as the remarkably sensuous form that she is, or admiring her for being simply that. And we are still somewhat blinded by the propaganda, failing to look at the form (ignoring if possible the chains). What Powers said of the *Venus de' Medici*, whose body he thought unmatchable in spite of his contempt for her head, was the evident primary aim of his *Slave*, an aim achieved: "There is not an angle in it. From head to foot, all the movements are curves and in strict accordance with Hogarth's line of grace."[17] We tend to think Victorian sculptors were primarily concerned with narrative, but John Rogers, creator of the famous "Rogers Groups" of American genre scenes, was unhappy in Rome in 1859 because the artists all put such an emphasis on the "classical idea" of form, scorning "all the little odds and ends" that he liked to put in his works. He amusingly claimed that the popularity of Powers's *Slave* was entirely owing to the chains. *They* told the "story."[18] Conversely, the chains were seen as an irritating distraction in England.[19] Since Tuckerman's discussion of Powers's other female nudes is almost exclusively thematic, we should take seriously his assertion that the *Greek Slave* owed her popularity to the fact that she was "a type of

the beautiful," a "harmonious expression in form,—the legitimate ideal of sculpture."[20]

Jarves's contempt for another American female nude—also captive—of 1857 was expressed through the brevity of an exhortation to Venus herself. May "Venus forbid," he cried, that the popular *White Captive* (fig. 79) of Erastus Dow Palmer of Albany "should ever be taken for the ideal standard of form of the women of America." She had been called "an indigenous American type," but she is "a petulant, pouty girl, vulgar in face and form," suggesting "*meat* and immodesty." Palmer, to Jarves, was himself the emblem of "American art in bondage"—to "materialism and inexperience." So proud of being a sculptor without benefit of the Vatican, the Capitoline, or the Uffizi, Palmer would do better to remember that "the study of classical art profited Michel Angelo."[21] In fact, Palmer's *White Captive* is of a type that can also be found in antique sculpture (she resembles, for example, the *Esquiline Venus* in the Conservatori Museum on the Capitoline). What is peculiar here is simply the preference for a nonidealized image, and for a different "ideal"— that of the robust adolescent over a fully mature woman. The transference of the captivity narrative to home ground, with Indians replacing Turks as barbarian threats to Christian maidens, is also less important (since extraneous to the form) than the fact that this time the girl's hands are tied *behind* her so that she must stand exposed in every part.

In 1855 Whitman used the image of the slave at the auction block—an image after all familiar in the America of his day—as a realistic device that allowed him to appraise and praise the human body in anatomical detail, as though he had to "sell" the beauty and value of each part to the doubting Americans. But ironically the purpose of his slave image in the nascent "Children of Adam" cluster of poems was to liberate the body through a return to a spiritually Edenic way of regarding its beauty of form and function—including generative function. Wholly lacking the uncomfortably combined prurience and piety that characterized the narratives supplied for the bound nude females of Powers and Palmer, his own program for a healthy eroticism was perhaps abetted in the (very) long run by the public emergence and final acceptance of these nude ideals of feminine beauty (however different from each other and however shrouded at first in diversionary moral narrative). Whitman's views were at one with those of Powers when the sculptor wrote in defense of his nudes that "the body of man is always innocent, for it only operates the command of His will," and when he said that the Creator cannot have intended "when he made us naked, that his most beautiful creation of all, and his most precious gift to Adam should be forever veiled . . . from his sight."[22] The growth of an aesthetic appreciation of beauty seems allied to a more liberal attitude toward sexuality than America had previously known, and in this double development the native antipuritan movement was fostered by some of the practitioners of the Italian-centered religion of Art.

Bound Cupids and Enchained Females interested other American sculptors, including women, as well as Greenough, Powers, and Palmer. Edmonia Lewis, the part-black, part-Indian member of the Roman circle of American women sculptors, created an excessively tortured Cupid caught in some kind of animal trap,[23] and Harriet Hosmer modeled a proudly defiant *Zenobia* (fig. 7), heavily garbed in

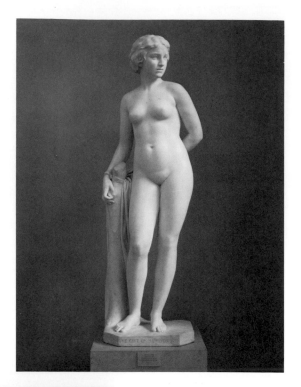

Fig. 79. Erastus Dow Palmer.
White Captive. 1859.
Marble. H: 66″. The
Metropolitan Museum of
Art. Gift of Hamilton Fish,
1894.

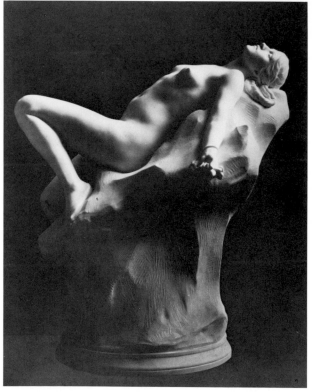

Fig. 80. Daniel Chester
French. *Andromeda*. 1929–
31. Marble. H: 51¾″.
Chesterwood Museum,
Stockbridge, Massachusetts.
A property of the National
Trust for Historic
Preservation.

queenly costume, but with chains linking her wrists as she is paraded toward the Capitol in a Triumph of Emperor Aurelian. Hawthorne, who greatly admired the *Zenobia*, saw a resemblance between her and that *Minerva Medica* of the Vatican who had revealed herself to him (fig. 83), of which there was a cast in Hosmer's studio. This suggests that Hosmer shared Margaret Fuller's preference for Minerva over Venus. Hawthorne's description of *Zenobia* interestingly resembles the standard view of Powers's *Slave*, emphasizing her inviolable dignity and her spiritual ability to transcend her captivity; she is "self-sustained and kept in a sort of sanctity by her native pride."[24]

In the quite different atmosphere of the twentieth century, Mary Abastenia St. Leger Eberle effectively made a different sort of feminine counterthrust by exhibiting at the famous Armory Show of 1913 a group called *White Captive* which included, besides the humiliated nude female, a grotesque male huckster who is selling her. In 1929–31 the French-trained octogenarian Daniel Chester French completed a long career more than ever convinced that "the beauty of woman is beauty at its best and highest," a belief he chose to commemorate by the creation of a sensual *Andromeda* (fig. 80) recumbent upon a rock, her arms chained back and her legs spread open with one knee raised. Oddly he saw this as a celebration of the fact that the modern woman physically achieved the "perfection" of the ancient Greeks because she was "the first free woman of many centuries." She had both intellectual and physical freedom, and "her figure has improved marvelously since she got out of stays."[25] So why was it desirable to put her back in chains?

Perhaps the real conclusion to the Petrarchan theme of love, beauty, and chastity begun by Greenough, however, is to be found in the conceptual confusions and equivocations surrounding the twelve-year effort of the Kentucky sculptor Joel Hart to complete a group of a nude female and a cupid together (fig. 81). After settling in Florence in 1860, he first made a copy of the *Venus de' Medici*, as had his friend Powers, whose works he obviously also studied. In 1865 he began work on the group to be called *The Triumph of Chastity*, which he changed, as Lorado Taft wrote, "with better taste, if not better sense," to *Woman Triumphant*.[26] The first title was of questionable taste, presumably, because the figure of "Chastity" was totally nude and of playful expression. The second title actually does make "better sense," since it directly opposes the idea to the "Amor Triumphant" tradition, showing Woman defeating Amor by withholding his arrows and—in Hart's words—resting "her left foot on his exhausted quiver." Hart said that he gratified his "passion in modelling a life-size virgin and child . . . not a Christian virgin, however. The figures are nude— Beauty's Triumph." How a nude female's virginity and religion were to be inferred from her pose and form, he did not explain.

According to Wayne Craven, the group was also frankly known as *Venus and Cupid*.[27] That is certainly what its mere appearance would naturally have brought to mind. Hart, however, was pleased to think that "the idea is modern and my own." Yet the image—if not "the idea"—related to several Renaissance paintings of Venus and Cupid in teasing exchanges (sometimes Mars got into the act). It also inevitably recalled the famous *Venus Felix* group in the Vatican (fig. 82), in which Cupid, standing next to his mother, similarly stretches up and back (although for what is not known, since his arms and one of hers are missing). But once again there is a

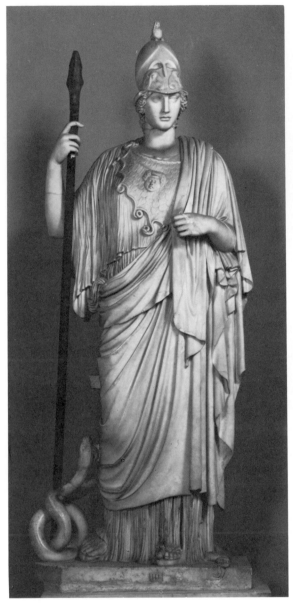

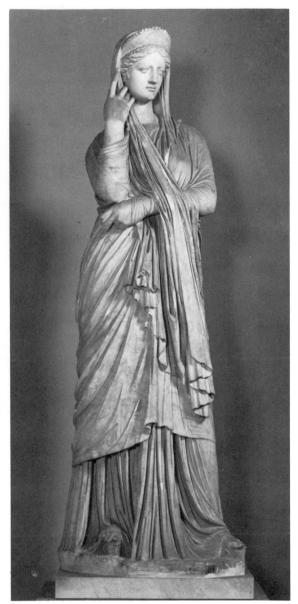

Fig. 83. *Minerva Medica (Minerva Giustiniani)*. Roman copy of Greek original of ca. 350 B.C. Marble. H: 2.23 m. Vatican Museums, Rome.

Fig. 84. *Pudicitia (Livia)*. ca. A.D. 75. Marble. H: 2.09 m. Vatican Museums, Rome.

Throughout Story's long and enormously productive life in Rome, he attempted to fill gaps in the historical archives and sculptural legacy of the ancient world in two ways: he created verse letters and dramatic monologues written or spoken by Phidias, Praxiteles, Marcus Aurelius, Cleopatra, Mark Antony, and Cassandra (who, in his version, has a vision of Medea slaying her children), and he sought to revivify through his sculpture our image of great historical and literary characters—particularly women. The starting point of these last would seem to have been the *Seated Agrippina* of the Capitoline. The repertoire of characters he produced was complemented by those of other American sculptors who also resided for decades in Rome, such as Harriet Hosmer with her *Zenobia* (fig. 7), and Joseph Mozier, Franklin Simmons, and William Henry Rinehart, with their remarkable women ranging from *Penelope* to *Pocahontas*, from *Sappho* to *Virginia Dare*.

All these works have in common an indebtedness to a tradition of antique sculpture alternative to that represented by Venus and the ideal beauty of the nude. They define the difference between the traditions and enlarge the definitions both of Woman and of Beauty for the new religion of Art. The difference may conveniently be expressed as a difference between Greek and Roman traditions, but the realism of the Roman portrait sculpture is here elevated by a notion of literary and historical figures as having an "ideal" character. In them history merges with myth. The bestselling writer Lydia Maria Child, keenly attuned to popular taste as she was, wrote in the *Boston Transcript* in 1864 that the fifteen thousand people who had paid to see Hosmer's *Zenobia* in the first three weeks of its exhibition had beheld not a "purely ideal" woman but an actual "portrait" based upon historical research. Zenobia was a relative of Cleopatra and had inherited the same beauty; but her "character" was entirely different, lacking all "voluptuousness and coquetry." Her "womanly modesty, manly courage, and intellectual tastes" were the traits of Miss Hosmer herself. "Like a genuine artist, Miss Hosmer aimed at a true marriage of the real and the ideal." The democratic poet Whittier said the *Zenobia* was exactly "what historical sculpture should be." In rendering the "shadowy outlines" of William Ware's popular romance "fixed and permanent (a joy forever)," Hosmer had in Rome rendered a service to the nation equal to that of the soldiers then dying in defense of the Union.[4]

The obvious formal distinction between the two traditions lies in the preference for the draped over the nude human body as the primary means of expression. A limitation of the nude is that it can hardly be forced to express an idea beyond itself, however valiantly both artist and viewer try to see something else. Moreover, nudity is a form of eternal present. Only realistic and abundant accessories and draperies surely place the figure in a romantically remote and heroic time. Such works offer the weighty brocades of historical costume, under which the body largely disappears, although sometimes the exposure of one or both breasts serves precisely to signify what is otherwise shrouded. The disguise of Venus is, however, no longer the point. Nor is there any interest in the union of Chastity with Beauty. By entirely circumventing the ambiguity of response presented by the nude, this romantic realism could the more readily provide occasions for indulgence in amoral aesthetic experience stimulated by sculptural allusion to dramatic situations familiar to literate viewers.

These situations, to which a woman is usually central, may seem today merely sentimental or sensational when isolated from their transforming rhetorical context in Sophoclean or Shakespearean tragedy. But both sculptors and their appreciators in the second half of the nineteenth century saw them as vehicles for uplifting, refining, humanizing emotion—as providing, in short, the occasion for experience of the Beautiful, more largely understood than it had been by the strict neoclassicists. Sculpture, it was thought, could achieve in its own three-dimensional reality something equal to historical painting, which similarly relied upon a viewer's knowledge of literature for its complete understanding. Ideal narrative sculpture removes itself from the unbeautiful and passionless present, which all too persistently made its demands on the noble art in the form of portrait busts and commemorative statuary. It also achieved the irrelevance to contemporary political and social affairs necessary to an experience of Beauty for its own sake. But this beauty is a function of concept and of technique, not of plastic form. Consequently, in spite of its more candid aestheticism, this sculpture seems more remote from that of the twentieth century than do the earlier neoclassical works. In them the angles, curves, hollows, rotundities, and textures of the nude form in marble asserted themselves through the veils of moralizing narrative as the true essence of beauty in sculpture. Such beauty can survive the loss of both moral and fable. In contrast, with works like Story's, when the narrative is ignored or unknown, nothing much remains but the technical ingenuities of carving.

The function of the artist in this romantic tradition seemed much greater than mere imitation of either nature or the Greek ideal of beauty. His genius had a twofold character: he was first of all a Poet, the powerful conceiver of the Idea, and second, the Creator, the almost miraculous craftsman who could carve out the physical expression of the Idea in realistic historical detail, down to the last tassle on the finest fringe. A testimonial from Senator Charles Sumner in 1864 concerning his pleasure in the *Zenobia* defines the attributes specifically appreciated in both the work and the artist:

> The statue tells its story most successfully. . . . Character and drapery are both given with consummate skill. I know enough of the sculptor's art to recognize the labor, as well as talent, which Miss Hosmer must have brought to this masterpiece, not only in its original conception, but in the details of its execution. I rejoice in such a work by an American artist, as in a new poem.[5]

Since Story most famously enjoyed the dual reputation in the historical genre and was also the one who actually wrote poems, he may represent the whole group. He was moreover the only one to receive the tribute of two early full-scale biographies, one a work of hagiography by an adoring Miss Mary E. Phillips, the other an "official" family-authorized two-volume work by one of the most prestigious authors of the day, Henry James.

James, engaged in his delicate task in 1903, was obliged to look back forty years to explain the enormous success of Story's *Libyan Sibyl* (fig. 86) and his *Cleopatra* (fig. 87) in London's great exhibition of 1862. He did so by comparing the two traditions of nudity and drapery. He observed that Story brought sculpture in the

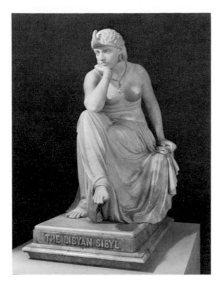

Fig. 86. William Wetmore
Story. *Libyan Sibyl.* Modeled
1860–61. Marble. 57¼ × 31
× 43⅜″. National Museum
of American Art, Smithso-
nian Institution. Gift of the
Estate of Henry Cabot Lodge.

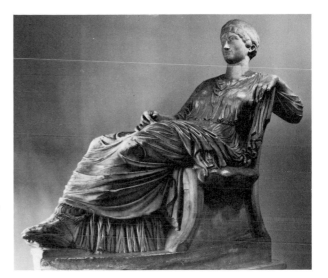

Fig. 85. *Seated Agrippina.* ca.
A.D. 325. Marble. H: 1.21 m.
Capitoline Museums, Rome.

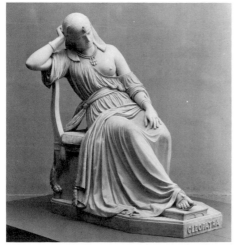

Fig. 87. William Wetmore
Story. *Cleopatra.* Dated
1869. Marble. H: 54½″. The
Metropolitan Museum of
Art. Gift of John Taylor
Johnston, 1888.

Anglo-American world to an entirely new level of romantic storytelling which made the works of the earlier period seem feeble indeed: "Strange, starved creations glimmer before us in that early Victorian limbo . . . ; meagre maidens, nymphs and heroes equally without temperament or attitude." In contrast, Story's historicism provided abundance itself, massive in exotic narrative interest, curious and exact in detail. Yet from the *Sibyl* and *Cleopatra* on, James thought, one might question his "fondness for the draped body and his too liberal use of drapery." This raises the question "of what, in relation to the public, was possible and not possible." Nothing is more obvious than Story's shrewd awareness of his public, James observed, and what his works say about that public is perhaps already the most interesting thing about them. Why, "in the mid-Victorian time," was there a "felt *demand* for drapery"? There was no case against either sculpture or painting as arts, "yet there presumably both was and is a presentable case (though never presented) against the nude, to which these arts are of necessity beholden for so much of their life." Story's acceptance of the "interdict" may have deprived us of unimaginable "revelations of shockability" in his public and therefore of "precious lights on significant abysses." Nude sculptures from the eminently respectable Story might have forced into the open the full "case against the nude." Story, in fact, "loved the nude, as the artist, in any field, essentially and logically must." But, as a romantic and not a classic, he loved drapery more:

> Drapery, that is, folds and dispositions of stuff and applications, intimations of or-nament, became a positive and necessary part of his scheme from the moment that scheme was romantic; nothing being more curious than the truth that though the nude may have a dozen other convincing notes it is eminently destitute of *that* one—or possesses it only when conscious, contrasted or opposed.

A naked Saul or Medea (two of Story's subjects) were no more imaginable than "an Apollo protected from the weather or a Venus rising from the sea in a bathing-suit." The "story" is not in Andromeda, "isolated and divinely bare, but in the mailed and caparisoned Perseus, his glorious gear, his winged horse and helmet and lance." James thus arrived at a devastating conclusion about his recently deceased genius: since Story was more charmed by "the figure for which accessories were of the essence," one must conclude "that he was not with the last intensity a sculptor" at all.[6]

James noticeably shifted the ground of his argument from Story's calculated response to public demand to Story's innate romantic preference. The second mo-tive seems more probable. Story (who was independently wealthy) in the early 1860s considered abandoning sculpture because of the initial lack of interest in the monumental draped females he had created for his own satisfaction. Yet James is correct in stating that Story showed a genuine interest in the classical nude. What is more, although as a lawyerly young man he had found Canova's *Venus* "detestable" because she was obviously "a lascivious courtesan,"[7] he seems to have developed a more liberal feeling for the erotic aspects of mythology during his years in Rome. Among a list of works (many now lost) one finds the intriguing entries "1877—Eros—Went to America," and "1881—Centaur and Nymph." This last may have

had some correspondence to his dramatic monologue called "Pan in Love," although one suspects that he could not have gone so far in marble as he did in words, where he could emphasize Pan's grasping lewdness and his excited contrasts between the nymph's smooth white limbs and his own "hairy neck" and "shaggy knee," between her "tender feet" and his own "horny hoofs."[8]

Story's classicism is also evident in a complex illustrated treatise on the *Proportions of the Human Figure* published in 1866, following his completion of two nude statuettes, the *Bacchus* and its apparent pendant, the *Venus Anadyomene*.[9] He wrote worshipful poems to and on both Phidias and Praxiteles and was sufficiently self-confident to carve his own statue called *Phryne* (1874), after the woman whose celebrated beauty was immortalized in Praxiteles' *Knidian Venus*. Story's poem celebrates their love. Yet what he has Praxiteles see in the "silent face" of his marble goddess is the "youth," "grace," and "serenity" of Phryne, now rendered "perennial," "unfading," and "sealed." He stops short of admiring the notorious beauty of form that made her preeminent as a model for Venus. The Greek idealization of the face, with its impassive expression of "serenity," to which Story seems to be applying the standard Keatsian appreciation, actually was a major irritant to nineteenth-century artists who sought to imitate it while believing that character and feeling were the true subjects of art. One of Story's couplets expresses both respect and frustration:

> Where is the voice that in the stone can speak
> In any other language than the Greek?[10]

He complained that the human face appeared in modern sculpture as though it had no part "in the expression of passion and character, because the Greeks so treated it. We have a thousand Venuses but no women." This may explain the unclassically full smile of his own *Venus*. Phillips in her biography of Story refers vaguely to the *Venus* as an indication of "what his idealization of this subject was meant to be," and then hastens in the next sentence to say that it is "in striking contrast" to his "'Little Red Riding Hood,' with her wee face full of sweet, wondering surprise."[11] One should think so. Little Red Riding Hood, however, would not provide Story with his true alternative to Venus, although her type largely satisfied some others.

Harriet Beecher Stowe described Story's turn to Egypt as a search for "a type of art which should represent a larger and more vigorous development of nature than the cold elegance of Greek lines." In Rome she had watched him "working out the problem" of his "glorious" *Cleopatra*: "all that slumbering weight and fullness of passion." In the *Libyan Sibyl*, inspired by the story of the slave Sojourner Truth that Stowe herself had related to the sculptor, he went even further into the "recesses of African nature—those unexplored depths of being and feeling, mighty and dark as the gigantic depths of tropical forests." In these works, asserted Mrs. Stowe, Story created "a new style of beauty, a new manner of art."[12] Clearly it was a "style of beauty" in which the beauty of the sculpture could not be confused with (or seem to be dependent upon) Greek forms of female beauty. Story described his *Libyan Sibyl* as "full-lipped, long-eyed, low-browed and lowering," with the "largely-developed limbs of the African." Since he made her "upper part" nude, it gave him "a grand

opportunity for the contrast of the masses of the nude with drapery, and I studied the nude with great care." The *Sybil's* "massive figure, big-shouldered, large-bosomed," had "nothing of the Venus in it," yet was "luxuriant and heroic."[13] Story does not go so far as to claim that this form is itself beautiful (that belongs to Venus). He is proud of taking a conscious risk, "not at all shirking the real African type." But he knows that the terrible grandeur of his theme—"Slavery on the horizon"—provides the requisite conceptual beauty that will move the viewer in the manner of great art.

The allusion to contemporary history here is exceptional in Story's work; but giving the figure an "ideal" classical title rather than naming it *Sojourner Truth* was a deliberate act of "elevation," inevitably associating the work with the Sibyls of Michelangelo in the Sistine Chapel and those of Raphael in Sta. Maria della Pace. Similarly Elihu Vedder's "Idealized Portrait" of Jane Jackson, a former slave whom Vedder had known in New York, was already seen as that of a woman "Sibylline, yet benign" by Herman Melville when he wrote a poem about it after attending the National Academy Exhibition of 1865. In Rome eleven years later Vedder used the face for a heroic canvas in which Jane Jackson was in fact transformed into *The Cumaean Sibyl*, striding across the Campagna looking anything but "benign" as she angrily goes to reveal the destiny of Rome.[14] The Cumaean Sibyl, besides figuring importantly in Vergil, had been depicted by Domenichino in one of the most admired paintings in the Capitoline Museum. Story himself had created a version of this Sybil, too, three years before Vedder.

In the *Libyan Sybil* and in many later works Story's declared interest in how the "masses of the nude" contrast with drapery is plain to see. The contrast is more one of surface textures than of outline, however, and relates to the tactile variety meant to be a major feature of all the historical figures. Less frequently the contrast is made sensuously expressive. Phillips commended Story for substituting, in his group with a centaur, a nymph for the cupid who customarily expressed "the usual ideals of that people of Thessaly." She supposed the artist wished thus to show "the gentler and more refining influences of the human over animal nature"—a large supposition to make about a nymph. For substantiation, Phillips happily quoted Story as saying that "women should be made of swan's-down and velvet, and nothing else."[15] This opinion offers rather more proof of Story's sense of his auditor's vanity than it does of woman's nonanimal refinements. But if the remark is anything more than an instance of vapid studio banter of the sort that makes Story's late dialogues (*He and She*, 1883; *Conversations in a Studio*, 1890) such dismal reading, it oddly conflicts with the heroic and somber women of Story's sculptures, whose varied textures of skin and drapery as rarely suggest swan's-down or velvet as their characters express gentility and refinement. Nothing in the appearance of his ponderously sitting *Sappho* (1863) contradicts the concluding quatrains of the poem he wrote to accompany it:

> Curses on her who stole my love!
> Curses, Lesbos, light on thee!
> False to her! O! Phaon prove,
> As to me.

There is the necklace once he gave!
 Take it, false and changeful sea.
There is the harp for the treacherous wave;
 Now take me.[16]

Over a twenty-five-year period the succession of Story's women after Cleopatra, the Libyan Sybil, and Sappho includes Judith, Medea, Delilah, Cleopatra again, Salome, Helen, Semiramis, Electra, the Cumaean Sibyl, Alcestis, Clytemnestra, Cleopatra once more (reclining), and Canidia the Sorceress. This is a remarkable list of women. Many of them are notable for using their sexual power for political purposes or for purposes of personal vengeance, and almost all are associated with war, murder, or suicide. *Canidia*, the subject of Horace's vengeful poem on his faithless Gratidia, was—to judge by Phillips's description—an exercise in the ugliness of "wrinkles of the brow, face, neck, and skinny arms, the veins swollen with very fright at their own disfigurement." Nothing could indicate more clearly how far beyond Winckelmann's notion of beauty—which forbade wrinkles even in portraits—the new notions extended, even to the inclusion of the visually ugly if the concept was sufficiently interesting. More commonly, of course, Story and the others chose women of whom conventional beauty could be assumed, even though that was never the main point about them as far as the sculpture went. Even with Cleopatra, her physical beauty is merely the starting point. Story's reclining *Cleopatra* of 1884–85 derived her pose from the *Ariadne* of the Vatican Gallery (fig. 71), then usually still thought of as a *Cleopatra*. But where Vanderlyn had stripped off what drapery the model possessed (fig. 70), Story greatly added to it. Phillips's description of this work is an excellent index to the literary conception and pictorial details of sculpture that were of primary interest:

> The second Cleopatra is as beautiful as creative genius and the pure white marble can make this sovereign and woman. Egypt's queen is represented by a glorious female figure half reclining in languid grace upon a couch of slender design, delicately finished with lotus flowers in low relief. A tiger's skin is half thrown across its center, the fine head and claws lying flat on the floor as foreground. A soft, full cushion of Eastern stripes and silken texture supports the elbow of her superb arm, upon which is the serpent-bracelet that bars "with a purple stain." Her head, entwined with the mystic *uraeus* or basilisk of sovereignty, rests upon her folded hand. Her face is full of beauty, intelligence, and sorrow, while passion seems fairly to ebb and flow through the splendid form, across which some priceless gauze is thrown.[17]

There was, of course, no "purple stain" on Story's marble, and Phillips's quotation is not from Shakespeare but from Story's own "Cleopatra," which begins, "Here, Charmian, take my bracelets." The poem is companion to another dramatic monologue spoken by "Marcus Antoninus." The existence of these and other poems written by Story to go with his works indicates his sense of sculpture's limited capacity to tell the story, to give its color, or even to vivify the character portrayed. They also indicate a need to give a more contemporary expression to tales

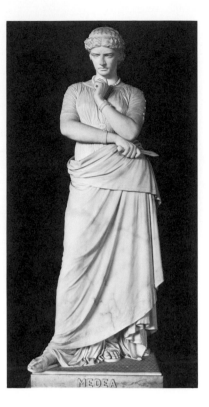

Fig. 88. William Wetmore
Story. *Medea.* 1868, after the
original of 1864. Marble.
76½". The Metropolitan
Museum of Art. Gift of
Henry Chauncey, 1894.

that ought to have been familiar to everyone, since he employs a conversational idiom allied to that of his intimate friend Robert Browning. Its textures, both flattened and roughened in comparison with the charged rhetoric and melodic beauty of Shakespeare's Roman plays, are allied to the "realism" of his sculptures.

The poems and verse dramas, however, also point up by contrast an aspect of relative conformity to classical "decorum" in Story's marble narratives. In Winckelmann's discussion of "The Expression of Beauty in Features and Action," he notes that "in women, particularly," Greek artists "followed the fundamental principle" taught by Aristotle and observed in all ancient tragedies, "never to represent women in such a way that they shall violate the characteristics of their sex, or appear excessively daring or fierce." Even Medea, dagger in hand, must be shown "as if still hesitating," her "fury . . . mingled with compassion."[18] In his *Medea* (fig. 88) Story strictly followed this injunction, although the specific mixture of emotions in her face may be difficult to define. (Story's break with classical "serenity" of expression provoked Mrs. Henry Adams to remark that all his women looked "as if they smelt something wrong.")[19] Of his *Judith*, Story proudly observed that whereas painters traditionally turned her into a mere criminal by showing her after the act with Holoferne's head in her hands, he showed her during prayer before her "great patriotic act," filled with "religious enthusiasm" and still "poetically and artistically grand."[20] The same could be said for his *Delilah*.

But in spite of this "decorum," James rightly observed that Story's real interest was in crime itself. That was the "special turn of Story's artistic imagination . . . as sculptor and poet. . . . It was in their dangerous phases that the passions most

appealed to him," and this obsession was fostered by living in Italy: "a country where the breath of the centuries of violence was still in the air and where the fancy could still so taste it."[21] For the full expression of this interest, Story had to turn to poetry and verse drama in which there was no need to limit oneself to the single moment before the crime or to show woman only at her noblest. In another context we have already considered the exotic sexual atmosphere of Story's drama *Nero* and its self-justifying aestheticism. In *Stephania* (1876) he wrote the "tragedy" of a woman who disguises herself as a man with the intention of murdering her captor, the early Roman emperor Otho, who had murdered her husband, the Consul Crescentius, after promising him free passage. Seized by ambition, she becomes Otho's mistress instead of his executioner, expecting to be crowned empress. But Otho (evidently a classicist) marries a Greek princess and then dies. Stephania gets neither throne nor revenge. According to Story the principals were "filled with the intensest and most contrary passions, and these, with the occasion given for their exercise, give the dramatist a fine field."[22] The field is obviously wider for the dramatist than for the sculptor. Yet in both arts Story's interest is in the expression of grand passions for their own sake as long as they have a densely historical context realizable in exotic detail. This combination constitutes the Beautiful, no matter how troubling or even ignoble the passions.

Story for many years filled a role important to the religion of Art in Rome, that of the multitalented Michelangelesque genius. (Michelangelo, who seemed a wayward creature from the point of view of neoclassicism, became increasingly a romantic hero. Story, who worshiped him, derived his own seated *Saul* from the *Moses*.) A poet of sexually charged closet dramas centering on powerful women, and a sculptor of female forms enveloped in the accoutrements of archaeologically fascinating costumes, Story was also a notable mimic who built his own theater in the Palazzo Barberini where the great actresses and actors of the day could join him in spirited readings. His *Medea* was inspired by the performance of the actress Adelaide Ristori, whom he adored.[23] He was a musician as well, but it would have taken the creative genius of a Verdi (*Aida* is of 1871) to provide the music that might have transfigured the thin libretti of his dramatic verse and the elaborate designs of his ponderous sculptures into the high operatic art with which his, in their fragmented parts, have affinities of both subject and intention. In a poem on Raphael the artist proclaims that

> Each art is, so to speak, a separate tone;
> The perfect chord results from all in one.
> ... 'tis in the means alone
> The various arts receive their difference.

"All Arts are one," Story claimed in a couplet: "Verse, tone, shape, color, form, are fingers on one hand."[24] Thus even his two arts were inadequately complementary, and he worked with a sense of their respective deafnesses or mutilations. One may imagine that even more than opera, cinema would have satisfied Story, that what he wished to do for the ancient biblical and Roman world of the Mediterranean only became possible with the multiple resources of film commanded by a Cecil B.

DeMille. Both men found entertainment and grandeur in the simplified passions and the exotic decor and costume of history-as-myth. Theirs was an essentially amoral and sometimes lurid fascination with the sensual and material forms of history through which there protruded now and again the tantalizing breast or leg of Woman.

In spite of Story's romantic realism and his frustration with the expressive limitations of the medium of sculpture, he remained a theoretical adherent to classical orthodoxy in the religion of Art. During a visit to America in 1877, Story delivered a "Lecture on Art"[25] to an overflowing crowd of the faithful in New York's Chickering Hall. The lecture was repeated by request in New Haven and Syracuse. It amounts to an evangelical sermon on the tenets of the true faith. Story began by promising to transport his audience from America's "world of work" into a transcendent world, the world of art—specifically to the Greece and Rome ("These names are the symbols and watchwords of art") not of historical fact but of the imagination. Art alone has given meaning to history. And it is the "enthusiasm" of the artist with his vision of ever "nobler heights," his "indomitable will," and his "severest training of work" that makes the discovery of meaning through beauty possible. The artist's revelations of the ideal are "never false, but scrupulously true." There is no "nobler" or "higher" calling than that of the artist: "What better object in life can a man have than an occupation that lifts the soul, transfigures nature, and makes beauty a daily friend, while it adds to the pure enjoyment of one's fellow-men?" In his Apollonian peroration Story concluded that true art "has the face and shape of an angel and the form of the gods. It is the sister of religion. It calls its followers to a great mission. It is the interpreter of the high and pure. Its material is humanity."

Naturally this sermon did not fail to define the false, Plutonian religion—"of the earth earthy." "God save us from such art!" he cried. "A servile imitation of nature results in nothing. The great vice of modern art is its overfidelity to literal details." In rejecting the naturalists and an aspect of the Pre-Raphaelites, possibly Story was thinking also of some of his fellow-American sculptors in Italy who, after all, found occasion for plenty of "literal detail" even in their historical "ideal" subjects, as though helplessly recapitulating the ancient evolutionary sequence that Winckelmann had described as going from noble simplicity of form to the decadent imitation of drapery folds and jewelry designs. Mozier's success as a clothing merchant in New York had enabled him to move to Italy to become a sculptor, but he largely continued to work in stuffs and stitches. Simmons's *Jochebed, the Mother of Moses* (1873; MFA, Boston) is a bravura display of a carver's ability to achieve the appearance of embroidery on a wide waistband that loops behind into a half-bow, and to give the effect of two different textures of cloth in the stripes of a headdress. All this "literal detail" is trivial distraction from Jochebed's haunted expression of maternal dilemma and the innocent dependency of Baby Moses (about to be abandoned among the bullrushes) which supposedly provide the "ideal" subject of the piece. The theme of such a work is much more sentimental than those of Story, and the execution makes his seem almost restrained and classically simple by comparison. Yet even of Story it was possible for the acerbic Mrs. Adams to say, "He'll take to worsted work soon."[26]

Fig. 89. Jo Davidson.
Gertrude Stein. 1920.
Bronze. 31¼ × 23¼ × 24½".
Whitney Museum of
American Art, New York
City.

Only by superimposing the image of Jo Davidson's *Gertrude Stein* (1920, fig. 89) upon Story's succession of ponderously seated women can one imagine that somewhere within the marble there yet resides a form more classic even than that of the *Seated Agrippina* of the Capitoline. Drapery and accessories hammered away, what might emerge would of course not be Venus, but an image of self-assurance and intellectual curiosity, a Woman such as Margaret Fuller had called for, not a Muse but a Minerva, a Maker in her own right. Story's draped women remain very far from that. Although not Venuses, their partially obscuring but provocative drapery merely reinforces one's impression that they exist primarily as symbols of sexual power—not sexual power as source of pleasure and human fruition, but as a means to material gain, and as the frequent cause of conflict, violence, and death. To these women we chiefly owe all that is—in Story's words—"fierce, restless, human," the "scandals" and "crimes" that make the history of the ancient Mediterranean an endless resource for the myths of Art.

THE FRENCH DECEPTION: VENUS AS DIANA

In his *History of the Rise and Progress of the Arts of Design in the United States* (1834), William Dunlap concludes his account of Jean Antoine Houdon's creation in the 1780s of a statue of George Washington for the Capitol in Richmond, Virginia, with two pages discussing the remainder of the sculptor's career. They begin:

> On his return to Paris, M. Houdon produced a statue of Diana [fig. 90], a copy of which was made in bronze. The original, in marble, was ordered by the Empress Catherine, of Russia, for the Hermitage. It is said that this Diana is more like one of the followers of Venus than the goddess of Chastity. M. [Quatremère] de Quincy, with great *naiveté*, wonders that the artist should so represent Diana. He forgets that the statue was destined for Catherine of Russia. That she should order a Diana is the wonder.[1]

Dunlap could not have imagined that late in the century his own countrymen would wholeheartedly adopt Houdon's solution to the problem of uniting Supreme Beauty to Chastity. The athletic and puritanical virgin goddess became by far the most popular American goddess, and the fact that she usually appeared in the nude was owing primarily to sculptors whose training was French rather than Roman. As Dunlap suggests, her nudity indicates a deception, that of Venus passing as Diana. But both the French tradition and the American results suggest something more: the erotic attractiveness of a beautiful female nude was actually enhanced by her presumptive virginity. This may have been true of the *Greek Slave* and the *White Captive* as well, but image and effect are quite different when the virgin is not only free but armed.

Winckelmann asserted, and Jarves repeated, that Venus was the only goddess who ever appeared nude in Greco-Roman art (and even she was often draped).[2] In his great work on the papal collection of art published in 1818, however, Ennio Quirino Visconti mentioned that he had seen two antique nude Dianas in Rome, but one of them "would have seemed a Venus" if she hadn't had a crescent moon on her forehead. What Visconti wished to establish in any case was that the Vatican's version of the crouching *Venus nel bagno* is definitely *not* Diana. When he discussed two statues in the Vatican that are of the virgin goddess (one in which she is "short-clothed" for hunting, as Ovid describes her, and one in which she is draped to her toes), the distinctive nature of her clothing was of major importance.[3] Diana traditionally makes a sartorial compromise between Venus's ideal nakedness and the long-gowned, helmeted, shielded Minerva. She is so seen in the most celebrated antique statue of Diana, which is not in Rome, but in the Louvre, where it has been since 1798. The *Diane Chasseresse* (fig. 91) wears a two-part knee-length tunic with a thick cincture around her waist. A deer leaps beside her as she withdraws an arrow from the quiver on her back. This statue was considered nearly the equal of the *Apollo Belvedere,* and to have been created originally as its sisterly companion. It is the only conspicuous work of sculpture included in Samuel F. B. Morse's famous painting of American artists studying in the Louvre (1833). Inspired by a cast of the statue in the Boston Athenaeum, Margaret Fuller declared: "It has the freshness of the woods, and of morning dew. I admire those long lithe limbs, and that column of a throat. The Diana is a woman's ideal of beauty; its elegance, its spirit, its graceful, peremptory air, are what we like in our own sex: the Venus is for men."[4] Thus in spite of Visconti's obscure examples of ambiguous cases, in the classic image of Apollo's chaste sister she was very distinct from Venus, and never nude.

Diana in her own character had considerable popularity among Americans. Washington Allston characteristically chose Diana as the only major goddess he ever painted, depicting her and her nymphs properly clothed in *Diana and Her Nymphs in the Chase* (painted in Rome in 1805). *Apollo and Diana, Diana, Diana Hunting,* and *Hercules Arrested by Diana* are all listed among the lost works of Thomas Crawford. Paul Akers, whom we have heard denouncing Page's *Venus* as an irrelevant creature, himself carved a *Diana* in Rome. Hiram Powers considered both Diana and Minerva to be relevant models for the image of "America" on the chair of his proposed Washington Monument,[5] and he carved a bust of Diana (c. 1863) which boasts the most heavily draped bosom of any of his ideal females. The 1876 Centen-

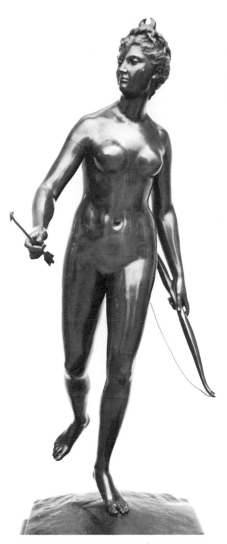

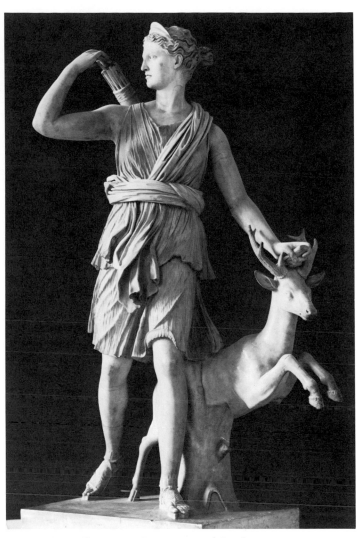

Fig. 90. Jean Antoine Houdon. *Diana.* 1782. Bronze. The Huntington Library and Art Gallery, San Marino, California.

Fig. 91. *Diane Chasseresse.* Roman copy of Greek original of ca. 325 B.C. Marble. H: 2.00 m. Louvre, Paris.

nial Exposition in Philadelphia was graced by a *Diana Transforming Actaeon* sent from Florence by Pierce Francis Connelly, who had begun his study in Rome thirteen years earlier.

The nymphs and devotees of Diana were more popular with the Italian-based American sculptors than the severe goddess herself, apparently because the image of those who had been compromised by Venus and Eros, in spite of (or because of) their vows of chastity, was equivocal: their purity was given some edge by their sensual experience. This allowed them to be shown in the nude, which signified either purity or sensuality, as one chose. Hiram Powers's draped bust of Diana did not sell well, but his bust of *Proserpine* (fig. 92), conceived in the early 1840s and eventually

Fig. 92. Hiram Powers.
Proserpine. 1844. Marble.
24^{15}⁄₁₆ × 19⅙ × 11⁵⁄₁₆".
Cincinnati Art Museum.
Gift of Reuben R. Springer.

developed in three versions, was the best-selling bust of the century, being repli-cated over one hundred times. Not coincidentally, a wreath of acanthus leaves serves not as a veil but as a highly textured foil to the smooth swell of *Proserpine*'s magnificent breasts, which rise beneath a much blander face. They belonged, how-ever, to an innocent and divine girl, beloved daughter of Ceres, whose devotion to Diana had angered Venus. Since the Goddess of Love also wished to extend her realm to the Underworld, she sent Eros to cause Pluto to abduct the perverse girl from her field of flowers. Proserpine thus remained virginal in soul while becoming experienced in body; moreover, her annual return from Hades brings us the spring. She could safely be allowed in one's parlor.

So could *Daphne* as carved in Rome by the twenty-four-year-old Harriet Hosmer in 1854, the same year in which she vowed herself to be a "faithful worshiper of Celibacy" for life.[6] It is perhaps significant that Hosmer's first work of sculpture was of the man-petrifying *Medusa*, and *Daphne*, her second work, was a nymph who enjoyed all the attributes of Powers's *Proserpine*, while having sworn (thanks to Cupid's leaden arrow) to imitate Diana by taking neither lover nor husband. When Apollo called Cupid a "lecherous boy" who merely played with bows and arrows, he was hit in revenge with a golden dart. Daphne eluded his hot pursuit by turning into a tree, thus preserving her vow of virginity. The nymph Clytie provided a titillating reversal of this story, since like Daphne she was eternally a virgin, but unwillingly so. Disappointed in her love for the sun god, she was metamorphosed into a sun-flower, doomed to turn her face longingly toward him forever. William Henry Rinehart in 1872 modeled a superb classical nude and gave her a sunflower to hold (fig. 93), thus indicating that she was locked into frustrated virginity by the refusal of a god. Finally, Egeria, a famous Roman nymph or priestess of Diana, was carved in the nude by Chauncey Bradley Ives in 1876 when the sculptor was sixty-six. Ives, a former farmboy from Connecticut, had arrived in Rome in 1854 and was to die there in 1894, and he perhaps wished to pay tribute to a local deity. Egeria's reputation as the consort of King Numa, one of the founding kings of Rome, was somewhat ambiguous, but generally interpreted as of religious significance, and therefore

Fig. 93. William Henry Rinehart. *Clytie.* 1872; original modeled 1869–70. Marble. H: 62½". The Metropolitan Museum of Art. Gift of Mr. and Mrs. William H. Herriman, 1911.

acceptable; she was replicated ten times. Among all these nymphs of Diana memorealized by Americans, Callisto, the one who actually became pregnant (by Jove, who had disguised himself as Diana!), is notably absent. She is the center of interest, however, in paintings by Titian and Rubens.

A poem by Dr. T. W. Parsons, dentist and Dante-ist (he made the first extended American translations of the *Inferno*), spells out the basis for Diana's acceptability, and by extension that of her chaste followers. "To a Lady" was written to accompany the gift of "a Head of Diana" found in a "dim shop" in Rome where it had been carved by the "cunning hand" of an American. "Great is Diana!" he had cried when making his purchase, justifying his "pagan feeling" by the thought that "By various paths religion leads / All spirits to a single end":

> The goddess of the woods and fields
> The healthful huntress, undefiled,
> Now with her fabled brother yields
> To sinless Mary and her child.
>
> But chastity and truth remain
> Still the same virtues as of yore,
> Whether we kneel in Christian fane
> Or old mythologies adore.

Parsons then expressed his hope that the recipient of his gift might live in her rural retreat like Diana, "Thrice blest! in being seldom seen."[7]

Such simplification of Diana into an essentially Christian allegory of "natural" feminine chastity prettifies one of the more jealous and vindictive goddesses of ancient poetry, and in its last line inaptly recalls the most famous episode in which she *was* seen in the *Metamorphoses* of Ovid—by the unfortunate Actaeon, who came upon her bathing naked with her nymphs. In this event many artists—from the maker of the sarcophagus on which Visconti saw one of his examples of a nude Diana down to Crawford's master Thorwaldsen in a relief—found the excuse to show her so. Even Allston painted a small *Diana Bathing* (now lost) in London. But the point of the myth is precisely the virgin's outrage at being seen naked. It is so great that she turns Actaeon into a stag to be hunted down and gnawed upon by his own dogs, even though his sight of her was entirely accidental. Consequently a certain masculine defiance is displayed by artist and patron in the depiction and enjoyment of this scene. Diana herself may represent chastity, but that is not what is promoted by the contemplation of her nudity—and that of her nymphs, whose presence so conveniently increases the varieties of female exposure that can be included in one painting. From Titian's *Diana and Actaeon* of about 1550 down to Corot's Poussinesque work of the same title in 1836, and a thoroughly academic English painting of 1846, William Edward Frost's *Diana and Her Nymphs Surprised by Actaeon*, painters exploited this opportunity to re-create (without adverse consequences) a masculine intrusion into Diana's exclusive world of women, a world literally overflowing with curvaceous flesh. The extreme anger of the goddess is invariably indicated, which adds to the fun and allows one to appreciate her magnificently uplifted arm.

French sculptors and painters, however, from the beginning perversely extended the occasions for Diana's nudity to include her hunting expeditions. The resultant incongruities no doubt added to the piquancy of her image. The clear ancestress of Houdon's *Diana* is a painting in the Louvre of about 1550 from the School of Fontainebleau which shows the goddess striding along with her eager hound. She holds in one hand her bow and in the other an arrow, and her quiver hangs by straps over her shoulder. She is off to the hunt, entirely nude. But unlike her dog, her mind is not on her business; she coyly turns her head in our direction and looks us in the eye with no sign of alarm. This is not the classical Diana described by Winckelmann who "appears to be unconscious" of the fact that she is "endowed with all the attractions of her sex," and whose "look" is "turned towards the source of her enjoyments, the chase, ... it is directed straight forward, and away into the distance, beyond all near objects."[8] Another work expressing what Clark calls the "stylish eroticism" of the time and place,[9] and equally remote from the spirit of the goddess whose name she bears, is the sculptured *Diana of Anet* (Louvre) of uncertain authorship but created in the early 1550s, which shows a flat-breasted, wide-waisted courtesan with fashionable coiffure who reclines against (and partially embraces) a couchant stag, while her hound rests between her legs. One can well believe that the French conception of a shamelessly nude "Diana" arose in response to the position of Diane of Poitiers as mistress to Henry II.[10] In any case it is still vital in the eighteenth century in the *Diane Sourtant du Bain* (1742; Louvre) of Boucher, whose patron was Madame de Pompadour: no Actaeon is in sight, but one does not feel that this Diana would be alarmed if there were.

The fact that the French Diana possesses a body unlike that of the classical Venus does not make her less erotic. Winckelmann accepted the theory enunciated by Giovanni Pietro Bellori in 1672 that different ideal types were encompassable within the general "idea" of the beautiful. Bellori's "soft Venus" and "tender Bacchus" on the one hand and his "archeress Diana" and "quiver-bearing Apollo" on the other were all beautiful. But the differences in contour, expression, effect, and meaning were important and to be kept distinct. Winckelmann therefore complained of the "Frenchified air" of some so-called Venuses of his time, such as that of the sculptor Pigalle.[11] What Winckelmann could not recognize was that the gothic tradition in its "Eves" and in its own version of Renaissance "Venuses" had developed what Kenneth Clark later identified as the "alternative convention," a different ideal of feminine beauty.[12] In its elegant elongations, its diminution of breast and extension of stomach, it conformed to a nonclassical standard without loss thereby of erotic appeal to those of nonclassical taste. The coincidence of some physical traits of the Diana type with those of the northern Venus therefore made the French merger of their identities plausible on visual grounds, at whatever risk to Diana's essential character. Houdon's *Diana*, barefooted and bare-breasted, is fundamentally absurd as she lopes along with only a crescent moon on her head and a bow in her hand, but these accoutrements, rather than establishing her identity as a virgin goddess, primarily signify her conformity to an athletic ideal of feminine physical attractiveness quite different from that of the voluptuous but idealized classical Venus. Houdon so far forgot the ideal that he violated the convention that the vulva was not external; "corrections" had to be made to remove indecent indications to the contrary at "le bas du ventre" on his *Diana*.[13]

The American sculptors who in the 1880s and 1890s received their fundamental training in Paris followed their instructors in acknowledging this French Diana-Venus rather than the classical virgin. Various so-called Dianas came from the hands of all of the leading American alumni of the French ateliers: Olin Levi Warner (1883; Metropolitan), Frederick MacMonnies (1889; Metropolitan), Augustus Saint-Gaudens (1892; Philadelphia), Frank Edwin Elwell (1893; Chicago), and Daniel Chester French (1896; Chesterwood). All of these associated themselves for a time with Jean Alexandre Joseph Falguière, whom Lorado Taft calls "something of a specialist in Dianas."[14] The American succession of nude Dianas varies in pose more than in physical type. But equivocations as to her significance abound.

Warner's *Diana* (fig. 94), which Taft thought so representative that its image was imprinted on the binding of his *History of American Sculpture*, is ultimately derived from the antique *Nymph with a Shell* (fig. 95), as were, it would seem, the *Oenone* (1855) of Harriet Hosmer and the *Hero* (1869) of William Henry Rinehart (fig. 96). Several versions of this *Nymph* emerged from the soil of Rome in the eighteenth century, but the one that had been familiar since the seventeenth century was by 1811 in Paris, where she was known as *Vénus à la coquille*.[15] The antique figure is lightly draped and seated sideways upon the ground, leaning on one hand and holding a shell (a modern addition) in the other. Warner's *Diana*, similarly posed, is totally nude, holds an arrow instead of a shell, and has a slightly glum expression. This image of the huntress Diana could be Venus after a tussle with Cupid, whose arrow she has captured. In her bronze incarnation, the skin of her

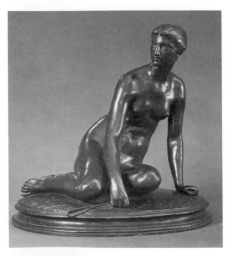

Fig. 94. Olin L. Warner. *Diana.* Dated 1887. Bronze. 23½″. The Metropolitan Museum of Art. Gift of the National Sculpture Society, 1898.

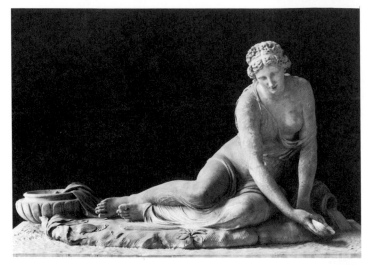

Fig. 95. *Vénus à la Coquille (Nymph with a Shell).* ca. 150 B.C. Marble. H: 0.60 m. Louvre, Paris.

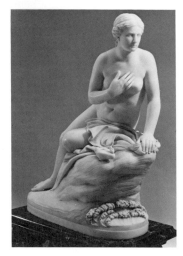

Fig. 96. William Henry Rinehart. *Hero.* 1869. Marble. H: 34″. Pennsylvania Academy of the Fine Arts. Bequest of Henry Gibson.

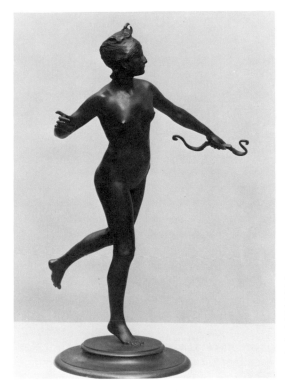

Fig. 97. Frederick MacMonnies. *Diana.* 1890. Bronze. 30¾". The Metropolitan Museum of Art. Gift of Edward D. Adams, 1927.

large and spreading hips and of her full breasts and belly glisten as though oiled. Warner had studied in Italy as well as France; this nude is French only in being called *Diana,* but the abandonment of pure white marble as the medium for sculptors of this period also distinguishes them from their neoclassical compatriots in Italy.

MacMonnies's *Diana* (fig. 97), which was in effect his "graduation" piece at the Salon of 1889, was a by then conventional image of a running nude female outfitted with crescent and bow. It owes much to both Houdon and Falguière.[16] The "liberating" effect of Paris was even more conspicuous in later works by MacMonnies, such as his cheerfully sexy *Venus and Adonis* (1895), a life-size work in red granulated Numidian marble, and his notorious bronze *Bacchante with Infant Faun* (1897). The courtesanlike Venus and her attentive naked lover, upon whose shoulder she invitingly leans, had to be draped as late as the 1920s when they attempted an appearance in New Rochelle, New York. Afterward they disappeared altogether until resurrected by MacMonnies's widow for Brookgreen Gardens in 1959. The exuberant *Bacchante,* intended as a gift to the Roman Renaissance Boston Public Library from its architect Charles McKim, was recognized as nothing more than a naked drunken Frenchwoman. She was driven from the courtyard by a public outcry in which some of the most eloquent braying came from Charles Eliot Norton, who thirty years earlier had welcomed Page's *Venus* to the Athenaeum.

Elwell oddly provided a lion to go with his *Diana,* and they appeared together at the Columbian Exposition in Chicago in 1893 claiming even more oddly to represent *Intellect Dominating Force.* It was evidently understood that calling a nude

"Minerva" would be going too far. Even Diana, one hundred years after Houdon, was still having troubles as a nude goddess. The year before, when Augustus Saint-Gaudens conceived his only nude in the French image of Diana (fig. 98), he went Houdon one better by having her actually drawing her bow to let fly an arrow. The absurd pose made her a beautiful figure atop Stanford White's new Madison Square Garden, besides making her useful as a windvane. It also made her instantly recognizable as a virgin rather than the French Venus she certainly might have been mistaken for. She was attacked for indecency anyway. Originally eighteen feet tall (Ovid's "tall goddess" indeed), she was reduced to thirteen feet for reasons of scale, but her naked beauty continued to make *Diana* the object of protests that persisted until the building was demolished in 1925, and then resumed when she was given to Philadelphia in 1932.[17] She became known as the "chased Diana."[18]

We would stray too far afield if we pursued all the female nudes with classical names that emanated from the studios of French-trained American sculptors, or tried to discover any relation to Rome in the academic mythological scenes painted by other Americans from the schools of Munich and Dusseldorf as well as Paris in the last two decades of the last century. *Ariadnes, In Arcadias,* even *Judgments of Paris* were common enough, but none to my knowledge had the distinction of either the brilliant artificialities of Bouguereau's female nudes or the joyous natural rotundities in warm pink flesh of Renoir's. The women of even a woman artist, Mary Cassatt (herself a Maker and not a Muse), far from either throwing off their gowns and girdles or putting on the helmet and lifting the javelin as called for by Margaret Fuller, wrapped themselves in restrictive fashions, sank themselves into sofas, and found their primary happiness in giving baby a bath. The Madonna still prevailed. That John LaFarge did an *Anadyomene,* not called a Venus perhaps because she is (in William Gerdts's words in *The Great American Nude*) a "small and delicate young woman";[19] that Whistler did both a *Phryne the Superb* and a *Venus Rising from the Sea;* that even Albert Pinkham Ryder painted a nude *Diana* on gilded leather— these are interesting facts only because these artists are otherwise interesting; their connections to the classical tradition are remote, and by different routes than through modern Rome.

The story of the American Diana-Venuses, however, would not be complete without acknowledging those of this century, particularly since the most famous of them was made in Rome by a Roman-trained sculptor (the most popular of the 1930s), and because the emergence of a constantly more androgynous and younger physical type relates to a tendency toward an ideal of the puerile and infantile that was evident in the nineteenth century in both America and Rome. The nude *Dianas* created by more than twenty American artists (including several immigrants) beginning in the 1890s and reaching a climax of popularity in the 1920s, have three implicit rationales for their appropriation of the goddess's name: Diana's healthy athleticism and her independence from men suggest a physical and ethical ideal not only northern but "modern"; her physical activity and attenuated physique lend themselves to the more stylized forms emerging in sculpture; and her virginity made her an eternal "girl," easily identified with the tomboyish type some women sculptors and their patrons found appealing.

The athletic, naturalistic modern woman, firm-breasted, long-waisted, lean-mus-

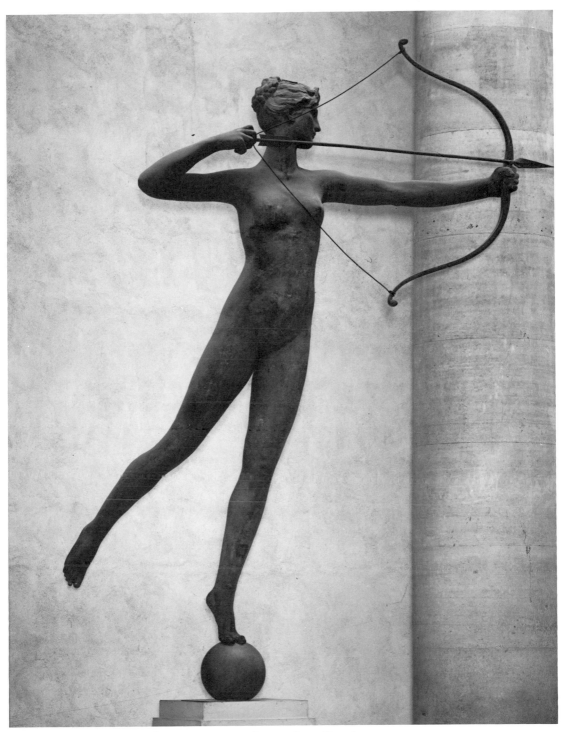

Fig. 98. Augustus Saint-Gaudens. *Diana*. 1892. Copper sheet. H: 14'.
Philadelphia Museum of Art. Given by the New York Life Insurance
Company.

Fig. 99. Karl Bitter. *Diana.*
1909. Bronze. H: 16".
Collection Mr. and Mrs.
Walter Abel. Photo by James
M. Dennis.

cled, and proudly defiant, is evident in two *Diana*s by the Austrian immigrant Karl Bitter. One was a deeply modeled relief he made in the 1890s for W. K. Vanderbilt's Long Island mansion (destroyed), where her identity with the goddess justified the sensuous thrust of an arm and the muscular torsion of her body. The other is a short-haired and high-breasted nude of 1909 (fig. 99) who stands with lifted chin in a pose reminiscent of the *Greek Slave* (and through her the Medici *Venus*); but what links her hands *behind* her (so that they cover nothing) are not chains but her weapon.[20] The same ideal was evident also in contemporaneous works by Henry Hering (*Diana Running*) and by the Armenian immigrant Haig Patigan (who also did an *Apollo Hunting*). This type found its finest expression in the two *Diana*s by Edward McCartan. The first was full-bodied and mature but thoroughly French in her long limbs and sloping shoulders.[21] The second, better known, appeared in the National Sculpture Society Exhibition of 1923 (fig. 100). This svelte young woman, while taking a long stride forward, leans tautly backward to hold in check the similarly slender hound who strains at his leash. To the critic Royal Cortissoz it inevitably recalled Houdon's *Diana,* a work he valued so highly that he wondered at Houdon's own dissent from the view that it was equal to the *Apollo Belvedere.* McCartan was "a child of Houdon," wrote Cortissoz, having "no traffic with either the earth power of Falguière or the supersensitive virtuosity of Rodin." In rhetoric that would not have been out of place in the nineteenth century, Cortissoz exclaimed, "How spare and refined the lovely figure is!" Diana is here "purged of merely sensuous elements." The "ideal of form set forth, and the technical mode . . . are chastened, clarified, given a certain keenness and elevation."[22]

The stylized Diana is evident in works by F. Lynn Jenkins (born in England), Gleb W. Derujinsky (born in Russia), and above all, Paul Manship (born in St. Paul, Minnesota). Jenkins's *Diana* also appeared at the National Sculpture Society Exhibition of 1923, and she is even leaner than McCartan's, her breasts hardly protuberant. But instead of the dynamic flow of line that this physique produced in McCartan's striding nude, it here is exploited for rectilinearity of profile; geometric outline is more important than naturalistic force. Similarly Derujinsky's more

Fig. 100. Edward McCartan. *Diana*. 1923. Bronze, details gilded. H: 24″. The Metropolitan Museum of Art. Rogers Fund, 1923.

Fig. 101. Paul Manship. *Diana*. 1921. Bronze. 37⅞ × 27¼ × 9″. Museum of Art, Carnegie Institute, Pittsburgh.

complex group of about 1925 frames a body of flat planes within the outline of a square standing on an angle by having the diagonal of a descending hound on one side symmetrically correspond to that of a leaping deer on the other.

The precedent for both of these had been created by the much more famous *Diana* of Paul Manship (fig. 101). Manship had been in Rome as a student at the American Academy from 1909 to 1912, but he discovered his inspiration less in the classical works his predecessors of the nineteenth century had idolized than in geometric Archaic Greek works he saw not only in Rome but also in Greece. His *Briseis* of 1916 and his *Atalanta* of 1921 both still have elements of strong naturalistic and classical modeling.[23] Atalanta, the champion female race-runner of mythology, is naturally of the same type as Diana and was in fact devoted to chastity until Venus interfered to cause her marriage. Manship's image of her balanced on one foot as she races forward recalls both Saint-Gaudens's *Diana* and Giambologna's *Mer-*

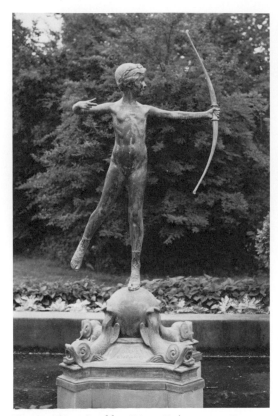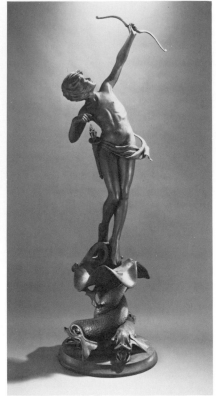

Fig. 102. Janet Scudder. *Diane Enfant.* 1911. Bronze. H: 7′6″. Private collection. Photo by Laurie Adams.

Fig. 103. Anna Hyatt Huntington. *Young Diana.* ca. 1923. Bronze. 92 × 28″. Courtesy Museum of Fine Arts, Boston. Harriet Otis Cruft Fund and Partial Gift of M. Virginia Burns.

cury. But the *Diana* of 1922, executed in Rome where Manship had returned as a professor at the academy, sacrifices everything to design as she extends one arm in a horizontal line, and crooks the other in just the necessary angle to define the diagonal that descends from the tip of her bow to the forefoot of her hound, whose elegant flat flight through space forms the base of the pyramid. Within this there is a dynamic complexity of lines: the inverted pyramid of Diana's chest, the sharp angle of her bent left leg, the turn inward and backward of the hound's head. That the pose is complete nonsense (are naked huntress and hound being pursued by their prey?) does not matter, since the work owes next to nothing to any genuine mythic idea. The essence of Venus, the irrational goddess of Rome, lies in her curves, volumes, and mysterious recesses; and she is meant to be seen in the round. Diana, goddess of America, in the hands of Manship and his imitators, became a matter of flat planes and acute angles, to be seen only straight on. Nude though she is, Diana is no longer a Venus in masquerade, and no erotic overtones emerged when, after Manship settled in Paris the next year, he mated her with an agonized *Actaeon* (fig. 121).

Ironically, by that time Manship's former assistant, the French immigrant Gaston Lachaise—who had been impelled by the power of Eros to abandon his "dream

Fig. 104. Mary Callery. *Young Diana II.* 1952. Bronze. 60 × 96". Private collection. Loaned in loving memory of Ted Weiner. Photo courtesy Museum of Fine Arts, Boston.

of Rome" and cross the ocean in pursuit of a married Bostonian lady[24]—had more than sufficiently returned Magnificence to the female nude. He would even make sculptures—*Breasts with Female Organ Between, Large* (1930–32) and *Dynamo Mother* (1933)—wholly inspired by the vulval folds eradicated from Houdon's *Diana.* To call a *Standing* or *Striding* or *Reclining Woman* of Lachaise—with her massive breasts and buttocks so proudly carried in perfect equilibrium—"Venus" would be superfluous. And they are far from being even French "Dianas." They wear no disguise.

The third category of twentieth-century Diana was predominantly the invention of women, and it takes to an extreme Margaret Fuller's relinquishment of Venusian beauty to the taste of men. Although there is something girlish in the relatively flat physiques of the *Diana*s of McCartan and Jenkins, they were at least pubescent. The *Young Diana*s of Janet Scudder and Anna Hyatt Huntington, echoed thirty years later by Mary Callery, are naked children. Scudder, who had gone from Indiana to Chicago to be a sculptor's assistant at the Columbian Exposition in 1893, was so dazzled by the contributions of MacMonnies that she followed him to Paris to work in his studio. She found her own specialty, however, in 1908 when she saw Donatello's *Singing Boys* and Verrocchio's *Boy with a Fish* in Florence. With some assist from the earlier *Puck*s of Harriet Hosmer, it was she who engendered the race of cavorting infants (sometimes called *Cupid*s or *Faun*s) that has since populated the public and private gardens of America. One of the more charming and less coy of these is her clean-lined little archer of 1911 (fig. 102), a vast reduction in all senses of Saint-Gaudens's monumental windvane. Anna Hyatt Huntington of Massachusetts, creator of two *Joan of Arc*s for New York, had become so thoroughly French that she was made a citizen of Blois in 1922, the same year in which she produced a

Fig. 105. Erastus Dow Palmer. *Infant Flora.* ca. 1855. Marble. Walters Art Gallery, Baltimore.

mature *Diana of the Chase*, who in shooting her arrow upward twists in a sensuous spiral to which a leaping hound contributes by wrapping himself partly around her legs. More popular (and reproduced in five casts) was the *Young Diana* that immediately followed (fig. 103). A sleekly boyish girl with bobbed hair, she strangely stands upon two of Venus's iconographical signs: dolphins and a shell. Young as she is, perhaps Diana's identity is not yet settled.

Thirty years later the motif was resumed by Mary Callery, an intimate friend of Picasso who lived in France from 1930 to 1946. In the early 1950s, back in America, she began the early studies for her *Young Diana II* of 1952 (fig. 104), in which the girl and her dogs are combined into a composition of sinuous attenuated ropelike forms which look limp and malleable even in bronze. At this stage they relate wittily to the unformed girls of Scudder and Huntington, but the fact that they strongly resemble wholly abstract works by Callery which after 1960 are simply called *Compositions* and given a number, makes us see that here too, as with Manship, what matters most is design (best viewed from one angle). Manship's work remained in an intermediate stage that exploited both a reminiscence of mythic and naturalistic mimesis and an appreciation for abstract form. Callery finally went wholly over to abstraction, and the thin lines of a young Diana and her lank hounds were one of the rope bridges by which she crossed.

These *Young Diana*s, however, return us to the nineteenth century, where we may find a less agreeable interest in childish bodies posing as juvenile goddesses in the work of Erastus Dow Palmer of Albany. Not content with his *White Slave* alone, in 1856 he put on display in a church his *Infant Flora* (fig. 105). The Roman goddess is usually conceived as a more mature version of Proserpine, who similarly brings us spring (we see their relation clearly in Botticelli's *Primavera*). Nevertheless, a childish version may be just imaginable, although Palmer's bold-faced and remarkably homely little girl, exhibiting the buds of her as yet unbloomed breasts, is not all one might wish her. But the idea of an *Infant Ceres*, which he also embodied in marble, is oxymoronic, a conceit like the *Wounded Diana* and the *Tired Mercury* of

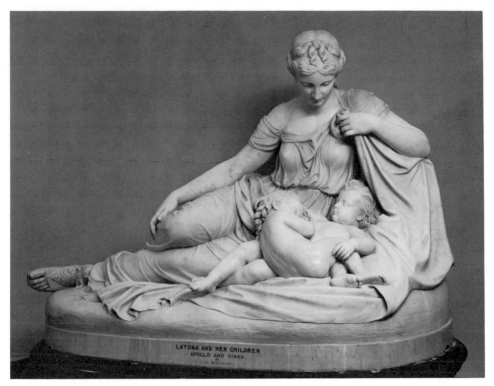

Fig. 106. William Henry Rinehart. *Latona and Her Children, Apollo and Diana.* 1871–74. Marble. H: 46″. The Metropolitan Museum of Art. Rogers Fund, 1905.

Robert Ingersoll Aitken or the *Toy Venus* of John Gregory in the twentieth century. These are all symptomatic of the arbitrariness or superficiality of understanding with which ancient myth (even as it had persisted in the post-Renaissance iconography of sculpture and painting) was borrowed upon to give the creative impulses and decorative needs of a different age some relation to tradition.

The transformation—or, from one point of view, the deformation—of gods and goddesses into the obsessions or banalities of the age did not occur merely in Paris or Albany. In Rome itself, William Henry Rinehart, a resident classicist from 1858 on, went to an extreme in the direction of infantile nudity when in the year of his death, 1874, he completed *Latona and Her Children* (fig. 106). Familiar with the *Sleeping Infant Eros* of antiquity, and already celebrated for a work called *Sleeping Children* (ideal for tombs), he showed the great goddess Latona, daughter of a Titan and second in Jove's favor only to Juno, dressed in clothing that does not so much hide as outline her matronly form, watching like any Victorian Madonna over her divine babes, who cuddle together in the naked innocence of Christ-children of both sexes. They are Diana and Apollo. Nothing in Rinehart's group suggests either of Latona's two most notable legendary characteristics: the harried anxiety she experienced while fleeing from jealous Juno (the way she appears on a sarcophagus relief at the Villa Borghese in Rome and in a work by Thorwaldsen), and her own cruel jealousy, which would one day lead Apollo and Diana to slay the offspring of Niobe because of

273

that mother's overweening pride in the number and beauty of her children. This was the subject of one of the most famous of antique sculpture groups and of many paintings, but Rinehart, secure in his quintessentially Victorian Myth of Mother-hood (for which his work became justly celebrated), surely did not mean us to recall Latona's classical behavior, even ironically, as we contemplate a gently protective mother and the sweetly sleeping babes, Apollo and Diana.

During the years when Story was creating his historic and literary heroines of Mediterranean myth, and Diana was undergoing her equivocal French metamor-phoses, Walt Whitman's friend Thomas Eakins was engaged in the approach to what might be called a myth of realism, similar to that of Whitman himself. This rested on the idea that beauty was a quality of existence itself—not necessarily in the behavior or condition of what existed, and certainly not in its appearance as judged against a supersensuous "idea," but inherent in the wonderment of simply being. Eakins heartily disliked the "silly, smirking goddesses of many complexions" that he saw in the Paris Salon.[25] Yet that he wished to think of the reality he envisioned and painted as mythic is indicated by his use of titles such as *In Arcadia* for landscape scenes in which naked youths play at being Pan, flute in hand. This too can seem puerile and artificial, but it was a way of saying with Thoreau "Olympus is but the outside of the earth everywhere." Here is a real landscape and these are real Americans, so *we* are the divinities of an ideal realm.

More effectively, and more pertinently to the manifestations of Venus in Amer-ica, Eakins worked out a series of paintings that simultaneously paid tribute to the first American efforts at sculpting the female figure directly from a model, those of the woodcarver William Rush, and also created his own myth of the ideal and the real in art. Rush's works, executed in the 1820s, were strictly allegorical. There is a *Charity* group of mother and children that strongly resembles Rinehart's *Latona*. Better known are his river allegories, that of the Schuylkill River being the one to which Eakins alludes. Rush's figures ended up with draperies through which female form was very evident, yet it is primarily their noses and coiffures that are classical. Eakins, however, painted a double image in the first two versions of the subject, showing both the naked model and the emerging work of art. The sculptor is intensely at work, while the model's chaperone sits close at hand to remind us of what might have happened in her absence. But in Eakins's last version (c. 1908; fig. 107), both work of art and chaperone have disappeared. The artist proudly, gently, and respectfully helps the model down from her pedestal. We now see her frontally, with nothing hidden by a convenient fall of cloth or by a well-placed arm or hand. She is no classical Venus in her proportions and she has no conventional beauty of face. But her strong sexuality, her naturalistic wholesomeness of body, and her confidence of bearing—the elements of Whitmanian beauty—are most apparent. There is not the slightest suggestion of lascivious intent in the sculptor (or in the painter), and no incitements to either prurience or indignation for the viewer. In conveying at the same time a sense of sexual power and guiltless ease in the mature female body, and in suggesting both the artist's imaginative possession of natural beauty and the respectful detachment of his worshipful regard for it, Eakins came far closer to the essence of the classical Venus than did many laboring too close to the marble models in Paris, Florence, and Rome.

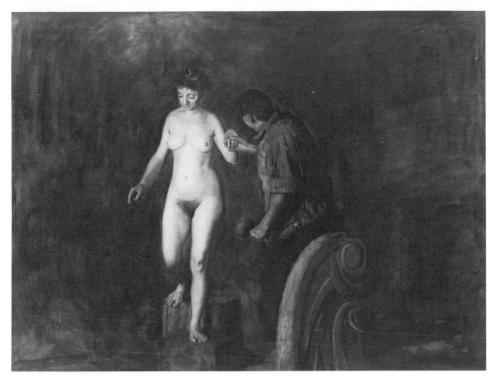

Fig. 107. Thomas Eakins. *William Rush and His Model.* 1907–08. Oil on canvas. 35¼ × 47¼". Honolulu Academy of Arts. Gift of the Friends of the Academy, 1947.

AMOR / ROMA: ELIHU VEDDER

Omnia vincit Amor: Et nos cedamus Amori.
—Vergil, Eclogue X:69

The long career of one American painter who gave himself wholly to Rome synthesizes all the tensions and achievements related to the accommodation of Venus and Amor in the new religion of Beauty by artists on both sides of the ocean. The female form nude or draped, purity versus sensuality as the significance of the female nude, the relation of Beauty to Eros, Venus versus Diana or Minerva as the highest image of Woman, Eve as Venus, the living model versus the "Idea" of Woman, the gods in the service of decoration or didacticism, the classical icon revived as self-justifying aesthetic image or as still-vital mythic symbol—all these conflicting tendencies are evident in the art created by Elihu Vedder from the time he settled in Rome in 1865 until his death in 1923. Still other issues that we have encountered are reflected in Vedder's highly eclectic art: Christian versus classical subjects, the visual abundance of romantic historical realism (in Vedder's case focusing on the Italian Renaissance) versus the simplicity of classical idealism, realistic impressions of the Italian landscape versus symbolic inventions, and the extension of the sense of beauty to include the ugly.

Vedder had gone first to Paris to study in 1856, where he drew from casts of the antique sculptures. There followed three years in Florence, where James Jackson

Fig. 108. Elihu Vedder. *The Little Venetian Model.* 1878. Oil on canvas. 18 × 14⅞". Columbus Museum of Art, Ohio. Museum Purchase, Schumacher Trust Fund.

Jarves stimulated his interest in the Italian "primitives" that Jarves was collecting. On his later sketching trips through Umbria with Thomas Hotchkiss, "the artist of the Campagna," Vedder kept his eye out for old things in obscure places that Jarves might like to buy.[1] Jarves, whose animadversions upon the work of many contemporary artists we have heard, in *The Art-Idea* (1864) wrote hopefully about Vedder on the basis of his early symbolic paintings and, five years later in *Art Thoughts*, still saw his works as "a favorable symptom for ideal art" in America.[2] Such works were to be only a part of Vedder's oeuvre, but they seemed to illustrate the exalted conception of art's "meaning" that Jarves looked for.

Another side to Vedder, however, indicates how that conception could be turned around: if art was the central vehicle for the expression of religious idealism, art—Beauty itself—could be the ideal and the religion. During the years 1861–65 when Vedder was back in New York, he frequented the notorious Bohemian circle at Pfaff's restaurant, where Walt Whitman was also to be seen until the Civil War removed him to Washington in 1862. The talk of this circle was as filled with the art gossip of recent returnees from Paris and Italy as any club in Boston, but it welcomed into its midst a failed actress with her Paris-born illegitimate child (fathered by a prominent American musician), and it delighted in attacking the "respectability" of Boston, the city that most fully concurred in the ethical idealism of Jarves's art theories and most eagerly purchased Vedder's early symbolic paintings.[3] In Vedder, Pfaff's Parisian New York married Jarves's Boston, and moved to Rome. Consequently not everything that emerged from Vedder's studio during nearly sixty Roman winters answered to the aesthetic ideal as Jarves defined it or conformed to

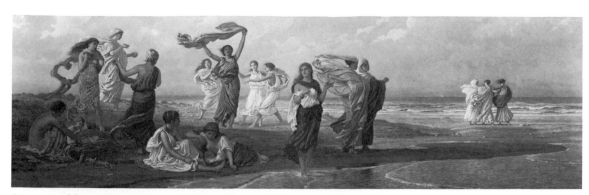

Fig. 109. Elihu Vedder. *Roman Girls on the Seashore.* 1877. Oil on canvas. 18¼ × 58¾". The Metropolitan Museum of Art. Arthur H. Hearn Fund, 1958.

the classical icons on the Capitoline and Vatican hills that Vedder could see from the high windows of his home on the Pincio. Yet the work of no other American artist of permanent Roman residence evinces a more complete devotion to Beauty for its own sake or a firmer belief in art as an end in itself. Vedder became a prophet in the new religion long fostered by the sensuous classical city that he loved.

Vedder's Eakins-like artist's love for his naked female models was from the start only less obvious than his love for the folds and swirls of drapery. His elaborately costumed women and girls of the late 1860s and 1870s stand in their satins and brocades upon rich oriental rugs and in front of intricately woven tapestries. There is, however, a full nude, *The Little Venetian Model* of 1878 (fig. 108), whose shapely but unclassical body is observed without idealization as it sits in a side-view pose, defining itself against the highly textured wall and furnishings of the studio. Something of the grave honesty of Eakins is here, as also in the *Roman Model Posing* of 1881. Although this model's legs are swathed in richly patterned drapery, the atmosphere is perhaps even more sensuous, owing partly to a mirrored reflection to one side; yet she lacks the vanity of Venus to gaze into it.

Vedder's opposing tendency to idealize is evident in an elaborate earlier painting with a classical theme created for J. P. Morgan (a frequent resident of Rome). Closely related to a work by the English painter and Roman friend of Vedder, Frederick Leighton, called *Greek Girls Picking up Pebbles by the Sea* (1871),[4] Vedder's work is known both as *Greek Girls Bathing* and *Roman Girls on the Seashore* (1877; fig. 109). It includes seventeen female figures, most of whom are engaged in enjoying the effects of the sea breeze on their swirling draperies. Bare legs are much in evidence, and the outline of a breast is here and there exposed. One girl, sitting as though sunning her back while amusing a little girl, is bare to her buttocks; she would be comfortable bathing with Diana and her nymphs. This painting rests between reminiscence of a Greek frieze and an exhilarated abandonment to nature. Yet the flying drapery of antique Greek figures usually imparts motion to the bodies and outlines their forms. Here the women are stationary, literally "statuesque" in their exhibition of a variety of poses. An embracing trio on the right must be the most heavily robed *Three Graces* in art history. Only the drapery is alive, dominating over flesh and form even at the seashore. In *The Pleiades* (1885; Metropolitan),

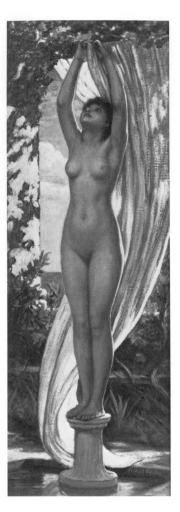

Fig. 110. Elihu Vedder. *Nude Girl Standing on a Pedestal.* ca. 1890. Oil on canvas. 20 × 7½". Courtesy Museum of Fine Arts, Boston. Bequest of William Sturgis Bigelow.

the seven sisters similarly exist primarily to swirl their enveloping thin bolts of cloth into decorative arabesques as they circle quite solemnly, bare arms lifted high, in some kind of rope dance. The abundance of material makes the naked bosoms and thighs the girls unconsciously expose rather more titillating than classically "nude." Ironically, the paintings of single nude models, "realistic" and surrounded by historical bric-a-brac, are essentially more classical in feeling than these purely decorative "ideal" paintings with classical names.

In *Nude Girl Standing on a Pedestal* (1890; fig. 110), however, Vedder effectively separated the drapery from the nude, and also reconciled the real and the ideal. In a reversal of Raphaelle Peale's *Deception* (fig. 69), a curtain, which would hide the girl who is hanging it if it fell straight down, drops instead in a curve *behind* her. Physically she is younger sister to Rush's model in Eakins's paintings, but instead of being seen in the act of stepping *down* from the pedestal, which makes breasts and belly more pendulous, she is stretching her arms upward in a movement that lifts her bosom high and flattens her abdomen. She thus assumes a form more classical than might naturally be hers, and is wittily placed "on a pedestal." Her unself-

consciousness of exposure is characteristic of both the Venus Naturalis and the healthy real model.

When Vedder amused himself (like Story with his *Canidia the Sorceress*) by taking as a subject the ugliest image he could find in Latin literature, he sketched out in pencil and then in oil Ovid's *Phorcydes* (1868), the three sisters who had only one eye to pass among them. They appear as wrinkled hags who clutch at one another as the very antithesis of the Three Graces, like Dürer's *Four Witches* (1497). But in the large painting of 1878 commissioned by a patron who had taken a surprising interest in the subject as sketched, the sisters metamorphosed into quite different creatures from the horrors originally envisioned. With drapery swirling in the wind, they have become pretty girls on the seashore again, but three who happen to have one unfortunate flaw. Their five sightless eyes, however, appear to be more closed than vacant, and the beautiful bosoms now fully exposed (the hags had kept their withered dugs mercifully covered) draw one's attention. To the patron Vedder explained-that he had attempted to preserve the wildness admired in the sketch, but "could not find it in my heart to spoil the group by making them old and ugly." They were now "more in harmony with the Greek idea from which they were drawn," and "the element of beauty enters more largely into them than into the small drawing from which they were ordered, which is pretty gothic." Vedder hoped the purchaser would consider that upon the parlor wall they would "be present to the eye continually."[5] Clearly Vedder believed not only that classical beauty is sure to wear better over time than gothic expressionism but also that it alone constitutes true "beauty."

Strangely, Vedder's classicism at first emerged most fully in the composition of visual "accompaniments" (he did not call them "illustrations") for an Englishman's translations of Persian poetry. The wonderful edition of Edward FitzGerald's *Rubaiyat of Omar Kháyyam* (1886) that finally made Vedder financially secure is filled with nudes more fully reflecting the environment of sculpture and painting in Rome than any of his works before the late murals. As Jane Dillenberger has said, "the youths are Praxitelean in their grace and nudity, the nude females are related to Venus and the Fates, and the allegorical youth that appears in a number of plates is distinctly identifiable as Eros."[6] In the image accompanying verse 81 (fig. 111), called *In the Beginning,* the Eros is as emphatically present as the Serpent, so that the Woman becomes simultaneously Eve being tempted by the apple and Venus receiving it in acknowledgment of her superior beauty.

In the 1890s Vedder, too, was caught up in the excitement over the World's Columbian Exposition in Chicago and the decoration of the Boston Public Library. Although requested to apply his Roman spirit and skill to these projects, in the end he contributed to the decoration of neither. He produced, however, sketches of various nude women purporting to have astronomical signification (even his own nude Diana floating before the moon), and he did win commissions for murals in the Collis P. Huntington mansion in New York, in the new Walker Art Building for Bowdoin College, and in the Library of Congress. These murals are all of classical inspiration, both in subject and in style.

Vedder's ceiling panels for the Huntington mansion distinguish themselves clearly from the diaphanous semidraped nudities provided for other ceiling spaces in

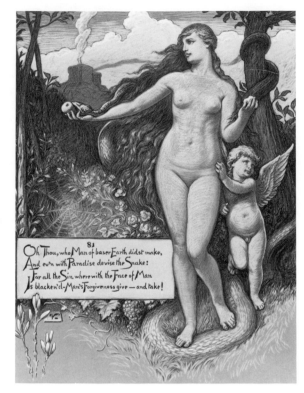

Fig. 111. Elihu Vedder. *In the Beginning* [verse 81, *Rubaiyat of Omar Kháyyam*]. 1883–84. Chalk, pencil, and watercolor on paper. 17¹¹/₁₆ × 13⁵/₁₆". National Museum of American Art, Smithsonian Institution. Museum purchase and gift from Elizabeth W. Henderson in memory of her husband, Francis Tracy Henderson.

the same building by Edwin Blashfield and Francis Lathrop. Vedder's gods and goddesses signifying the "Abundance of the Days of the Week" are all defined in sharp outline. Although in a study for a lunette showing *Diana at the Hunt* he sensibly returned to her the tunic of which Frenchified Americans deprived her, his lunar Diana (lunedi; Monday) in the ceiling is nude, but cannot be confused with Venus (venerdi; Friday) because that goddess rides buoyantly on her half-shell in the opposite panel, with Apollo (Sunday) in the central sphere between them. In the corners Mars (martedi; Tuesday) and Mercury (mercoledi; Wednesday) are also nude, while Jove (jovedi; Thursday) and Saturn (Saturday) are clothed in classical conformity (as Winckelmann observed) with their greater age and lesser beauty. All of this is embedded in more elaborate zodiacal symbolism like that which Vedder, while painting these works in Rome, would have been recalling in Raphael's supreme decorations for the Farnesina across the Tiber. What after all was the difference between Agostino Chigi and Collis P. Huntington as patrons, or between their houses as palaces of pleasure? Vedder tried to revive a tradition of sober elation amounting almost to nobility in the genre of luxurious domestic decorations. Over the fireplace of the dining room Vedder rendered a nude *Fortuna* as the object of a pagan prayer (in Italian rather than Latin; why not English?): *Dea Fortuna Resta Con Noi.*[7] (The sculptural frieze around the main hall below Vedder's paintings, created by the Austrian immigrant Karl Bitter, appealed to a different level of the tradition: it consisted of a Bacchanalia of babies!)

In Vedder's contributions to decorations for the Library of Congress the ambig-

uous significations of nudity are most apparent. In his five panels on varieties of government, *Government* herself in the center is heavily draped, even wearing an underbodice. To her right, *Corrupt Legislation* has let the straps of her gown slip so far down her arms that her voluptuous shoulders and the top half of her breasts are exposed, while she has crossed her legs in such a way as to thrust one leg, bare from the thigh down, into whorish prominence. The last panel on that side shows a female sprawling in naked abandon with minimal covering of her "middle." She is *Anarchy.* The figure in the inner panel on the opposite side, called *Good Administration,* is sartorially indistinguishable from *Government* herself. But next and last is *Peace and Prosperity,* a blonde more nude even than *Corrupt Legislation.* She sits square-shouldered and straight on, however, displaying classically harmonious proportions, while some drapery decorously covers her legs. Her hands are not grasping, but rather extend wreaths to youthful artist and farmer alike. Thus female nudity can be made equally to mean sensual depravity, selfishness, and self-degradation on the one hand, or purity, generosity, nourishment, and reward on the other. Physical beauty in itself is neutral and always attractive. These didactic murals were not motivated by a religion of Art for its own sake, but one in which beauty is forced into the service of the good. When, as here, nudes are clearly not only *ideas* but *right ideas,* they can (unlike the French *Bacchante* for the Boston Public Library) appear in public places and be paid for by the people.

An additional commission from the Library of Congress allowed Vedder to conceive the design for a mosaic. He chose to create a *Minerva*—a true Minerva, not a "Liberty" or an "America." Margaret Fuller would no doubt have admired his original study (1896) in which the commanding helmeted figure drives the horses of her chariot toward us. This goddess sketchily suggests the force of some of the great antique *Minervas* and *Athenas* in the galleries of Rome. But in the final version she has lain aside her helmet and aegis, and abandoned horses and chariot in favor of a flowery knoll within a villa park. Still imposing but far more "beautiful," she has nevertheless become something of a Muse. Perhaps wisely, she holds onto her javelin while thoughtfully consulting the subject catalog of the library's contents— from "Agriculture" to "War." At least the subjects are not merely "feminine," since they also include "Medicine" and "Finance."

Vedder created the equivalent of an altarpiece for the religion of Art in one of its new temples when he painted the mural called *Rome* or (perhaps after Jarves's book) *The Art Idea* (fig. 112) for McKim, Mead, and White's Walker Art Building at Bowdoin College. The entrance hall was to receive four murals by four artists, each allegorically representing one of the great creative centers: Athens, Rome, Venice, and Florence. Beneath them were casts of the most famous antique statues and over them soared a Renaissance dome. Rome was Vedder's city, and his identification of it with art was complete—which is to say, it was identified with all that matters in life. Across the bottom in modified Roman lettering we read "SAPIENZA • PENSIERO • ANIMA • VITA • NATVRA • ARMONIA • AMORE • COLORE • FORMA." The outer pairs of concepts are associated respectively with Michelangelo and Raphael, who were constantly opposed as geniuses by nineteenth-century visitors to Rome, to the advantage of Raphael in the earlier neoclassical decades. Here antique fragments of the Three Graces—the companions and attributes of Venus—rest above FORMA on

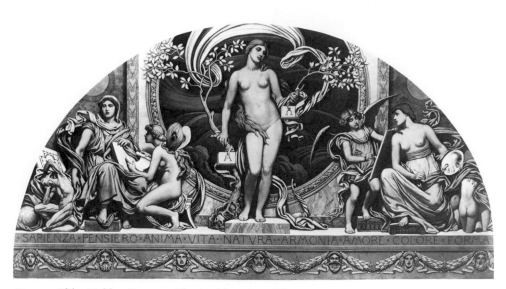

Fig. 112. Elihu Vedder. *Rome, or The Art Idea*. 1894. Oil on canvas. 12 ×
24'. Bowdoin College Museum of Art. Gift of the Misses Walker. (See
plate 13.)

Raphael's side. ANIMA (Psyche, or Soul) counterbalances AMORE (Cupid, or Love), on
either side of the central figure of NATVRA, who is none other than Venus herself
enveloped in images for Life and Harmony. Her stance and appearance recall both
the so-called *Knidian Venus* of the Vatican (fig. 63) and Botticelli's more celestial
vision. Her hands, however, are otherwise occupied than in the service of modesty.
Religious icon that she is, she holds the Greek letters Alpha and Omega, the
Beginning and the End. Vedder himself said that this referred to the fact that Nature
is the "beginning and end of art," but the reference is to the Platonic conception of
Nature that informed the entire tradition to which Vedder was now adding one of
the ultimate images. Nature is perfected through Art in accordance with the spir-
itual ideal the Artist perceives.

 Vedder also drew attention to a second attribute: NATVRA touches with one hand
a Tree of Life and holds in the other a "detached branch with its fruit." This
indicates that "an art having reached its culmination never lives again; its fruit,
however, contains the seeds of another development."[8] "Another development"
had clearly been the Renaissance, and Vedder and all his fellow artists of the so-
called American Renaissance believed that theirs was still a third, one that recog-
nized its ancient and its Renaissance roots, yet differed from both. It was not a dead
and sterile imitation, but a vital and fruitful growth. The Art of the Beautiful lived
again in a new form and a new land, and her temples were being built with reference
both to origins and to the new soil. But the transplantation in this case was directly
from Rome.

 The most interesting of Vedder's revived gods, however, is not Venus, or Venus-
as-Rome, but her child Amor. His appearance in angelic Raphaelesque form in *The
Art Idea* at Bowdoin College is not Vedder's distinctive image of him. There he has
been adapted to specific allegorical intentions. Through symmetry he assumes a
traditional opposite relation to Psyche, and through proximity he mediates between
Nature on one side and Ideal painting (Color and Form) on the other. He is thus both

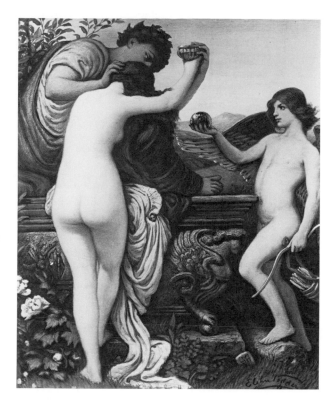

Fig. 113. Elihu Vedder. *The Cup of Love.* 1887. Chalk, gouache, and gold on paper. 10⅞ × 8¹⁵⁄₁₆". Courtesy Mrs. E. P. Richardson, Philadelphia.

Body and Love, which defines well enough his fundamental meaning, but here his corporeality has been subordinated to his service to the ideal. The infant Cupid whose presence assures that Eve will be read as Venus in *In the Beginning* (fig. 111) is also not Vedder's fully developed conception. Much more his own is an adolescent Eros added to *The Cup of Love,* an accompaniment to verses 46–48 of the *Rubaiyat,* when he re-created it as a small painting (1887; fig. 113). Eros here is the completion of the Venus figure to the left who offers the Cup of Love: they are complementary halves of the same ovoid form. We see his front, and her back, visually unified by the color of their flesh and by the curvaceously flowing lines of their bodies. Brought close, they would fit together, the convex curve of his pubescent belly fitting into the inward curve of her more mature form, created by her forward-bending stance. Both lift their right arms, she with the Cup of Love, he with the sphere of the world. The scene, however, in the spirit of Omar, is enacted around a sarcophagus, and the aura of melancholy around the heads of the lovers, and the Cup itself, link the painting to Vedder's *Cup of Death,* which accompanies the subsequent verse. They obviously convey the themes of *Et in Arcadia ego* and *carpe diem.*

Eros's solicitude that the lovers not lose the world he has to offer, expressed by pose and expression in *The Cup of Love,* is replaced by seductive and saucy confidence in a painting begun at about the same time, *Love Ever Present,* or *Superest Invictus Amor,* or *Amor Omnia Vincit* (fig. 114). The last version of the title is Vergilian and takes us back to the work by Benjamin West of the same title (fig. 75). The others emphasize not so much Love's omnipotence as his omnipresence and his

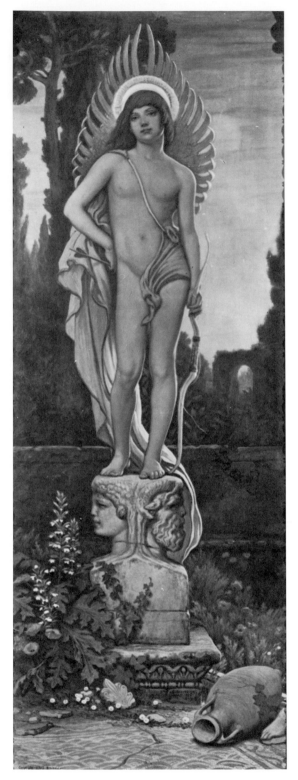

Fig. 114. Elihu Vedder. *Love
Ever Present*, or *Superest
Invictus Amor*, or *Amor
Omnia Vincit*. 1887. Oil on
canvas. 34¼ × 12½". The
Brooklyn Museum. Lent by
James Ricau. (See plate 14.)

ability to survive whatever would destroy him. Other gods may have died in the long centuries of Christendom, but in the late nineteenth century Amor lives. The painting is of the present, for the triumphant structures of the pagan past, to which the spiritually proud would have relegated him, are visible ruins in the background among the ever-living cypresses and stone pines of Rome. Eros rises from the mosaic pavement and broken columns of the ancient world, and stands upon the Janus-head of a Pan-Psyche,[9] Male/Female and Body/Soul, as a personification of conscious sensuality within the villa park of the present. This Eros has no need to assume the stance of "Amor Threatening," like the statue in the Roman villa of Melville's poem. From his mother Venus—and from the marble *Faun* of Praxiteles (fig. 43)— he has learned a more potent pose. Framed by folded archangelic wings such as Petrarch described, his body, soft and smooth, and his full-featured Caravagesque face convey the androgynously inclusive character of his appeal. Resting his bow, he presents himself as the agent of physical desire by posing as its object. The painting is expressively ambiguous in another way as well. Here is Eros the living god, blood-warm and breathing, playing "statue" upon a fragment from the past. Invincibly immortal as an aspect of human nature, he yet owes his identity and survival also to his existence in Art, to the devotions of painters, sculptors, and poets who have never ceased to make his images and write his hymns. As with Venus his mother, the religion of Art is unimaginable without him. But after enduring captivity, disguises, and denials, he managed in the puritanical new world to make Art serve the religion of Love. *Superest Invictus Amor.*

Apollo

The male is not less the soul nor more, he too is in his place,
He too is all qualities, he is action and power,
The flush of the known universe is in him,
Scorn becomes him well, and appetite and defiance become him well,
The wildest largest passions, bliss that is utmost, sorrow that is utmost become him well,
 pride is for him,
The full-spread pride of man is calming and excellent to the soul,
Knowledge becomes him, he likes it always, he brings every thing to the test of himself, . . .

Gentlemen look on this wonder,
Whatever the bids of the bidders they cannot be high enough for it. . . .

In this head the all-baffling brain,
In it and below it the makings of heroes.

Examine these limbs, red, black, or white, they are cunning in tendon and nerve,
They shall be stript that you may see them.

Exquisite senses, life-lit eyes, pluck, volition,
Flakes of breast-muscle, pliant backbone and neck, flesh not flabby, good-sized arms and
 legs,
And wonders within there yet.

 —*Walt Whitman*

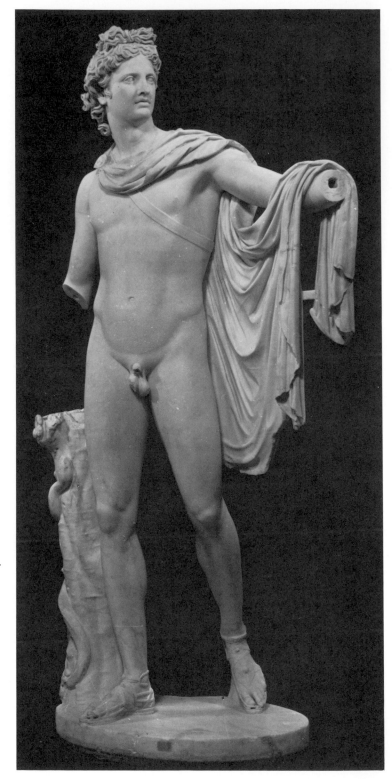

Fig. 115. Apollo Belvedere.
Roman copy of Greek
original of ca. 350 B.C.
Marble. 2.24 m. Vatican
Museums, Rome.

In 1856 the "Orphic" poet Bronson Alcott and his friend Henry David Thoreau (whom he called "Sylvanus") sought out the new poet Walt Whitman at his home in Brooklyn. Alcott observed three pictures on the wall of Whitman's bedroom: a Bacchus, a Hercules, and a satyr. Noting certain physical resemblances, Alcott inferred that Whitman took "the virtues of the three to himself unreservedly." In contrast, Nathaniel Hawthorne's study in the Old Manse at Concord contained a bust of the *Apollo Belvedere*—to whom Sophia sometimes compared her husband—and a picture of Endymion, the moon goddess Diana's beloved shepherd boy.[1] The choice of one's gods is not always so conspicuously displayed, but preferences as well as omissions (like Margaret Fuller's suppression of Venus) are—as Whitman would say—indicative.

Unlike Christianity, Greco-Roman mythology does not offer men any real choice of gods or heroes noted for their chastity or continence. There are no male Dianas or Minervas, nor even a fatherly Ceres. Adonis and Hyacinthus are transformed into flowers not to escape the embraces of the infatuated Venus and Apollo but to be immortalized as their lovers. Petrarch with great difficulty found two men to bring up the rear of his *Triumph of Chastity*. One was from the Old Testament, and the other was Hippolytus, whose character and fate, in spite of the interventions of Diana, do not inspire emulation. Nor does the bloody end of Orpheus, dismembered by the Thracian women for repelling their advances.

So chastity is not an important male virtue, and total nudity in gods and heroes is commonplace in Greco-Roman sculpture. The nineteenth-century worshipers of Art, and of the nude *Apollo Belvedere* (fig. 115) who embodied the highest expression of that art, never admitted any association between the naked male body and physical desire, an association they found nearly inevitable for the female nude. Women seem to have acquiesed in contradictory assumptions that can have originated only with men: women are spiritually higher than men, less given to animal appetites, and therefore too pure to be affected by male nudity the way some men are affected by female nudes. At the same time, women are the daughters of Eve, weak creatures susceptible to Satanic temptations. When naked they are Venuses, inciters of erotic fantasy unless veiled in a narrative that establishes their innocence and preoccupies a man's thoughts. Yet while man is intellectually superior to woman, his more insistent sexuality means that chastity cannot as a rule be expected of him (an assumption Margaret Fuller attempted to refute). Certainly chastity is not the virtue most essential to his honor, as it is for a woman. Therefore nakedness does not jeopardize the character of a god, hero, or athlete, since his chastity is not the main concern about him. On the contrary, in the case of males the Platonic assumption that beauty of form expressed nobility of character was understood. Hence male nudity was appropriate even in Christian art, especially if the nude man was being baptized, whipped, crucified, grilled, or shot full of arrows.

Participants in the religion of Art were thus simultaneously obliged to admire male nudity in classical sculpture while knowing it in actuality to be a disgusting reminder of man's animal nature and compelling sexual weakness. The result was symptomatic of the radical division between art and life. The experience of art was a transcendent moment that was *essentially* distinct from actual experience even of something superficially resembling what the art represented. Male nudity in sculp-

ture belonged to art; sexuality belonged to life. This was not a distinction that Walt Whitman would allow in his attempt to idealize life without relegating his poetry to the effete realm of high art. Just as he insisted upon the wholesomeness of the naked female as a sexual being, he simultaneously had to insist that man had a soul as well as a body (the two being one) and that his nonintellectual passions were to be celebrated. After him, William Dean Howells, Mark Twain, and the early James, with no concern to idealize biology, nevertheless were acutely aware of how the nonrecognition of man's sexual life limited contemporary Anglo-American fiction in comparison with both the French novel and the visual arts.[2] Their efforts (about which all three were ambivalent) toward a "realistic" dissolution of the division between art and life help define the constraints imposed both upon the commentators on male beauty in the galleries of Rome and upon those who wished to create new images of it.

When Charles Edwards delivered his series of lectures on the antique sculptures in the National Academy of Design (1831), he began, as we have seen, with the two *Venus*es for motives of "gallantry," not primacy of beauty. But he did not continue with the other two women available to him: *Niobe* and *Ariadne* (*Cleopatra*) (fig. 71), both draped. From those "gentle beauties" the *Venus*es, he turned next in the same lecture to the "masculine vigour" of the *Fighting Gladiator* and to "the body of the beautiful Bithynian boy," the *Antinous* of the Vatican (fig. 137), whose beauty as a *man* (as distinct from the *divine* beauty of the nearby *Apollo*) was generally acknowledged to be supreme. Edwards evidently felt but did not recognize an affinity, based upon the physical beauty of the nude, between the *Venus*es and the *Gladiator* and *Antinous*, but, of course, he did not speculate about the relation between the Emperor Hadrian and his "favorite," in spite of his penchant for gossip and anecdote. Next came Praxiteles' *Faun in Repose* of the Capitoline (fig. 43), a softly languorous type whose stance renders Hogarth's "line of beauty" even more sensuous than it is in the *Antinous*. Edwards, however, chattered on about the probable origin of these statues and provided their subjects with historical and mythological contexts filled with charm, sentiment, and respectability. Most of his commentary on *The Faun* is taken up with a wholly irrelevant joke that Phryne played upon Praxiteles. Almost all the remaining statues upon which he commented were male nudes, among the most celebrated statues of Rome (only one, the *Farnese Hercules* of Naples, was elsewhere). Their anatomy, however, was apparently of very little interest, even when—as with the *Belvedere Torso* (fig. 146) and the *Farnese Hercules* (fig. 140)—there was little else to think about. Edwards's longest commentary, of course, was on the *Apollo Belvedere*. It consisted of a heap of generalized praise, questionable facts, and snatches of history and legend.[3]

This lecture on the *Apollo* to the "gentlemen" of the academy is indistinguishable from most of the commentary written by visitors to the "originals" in Italy, except that nearly everyone but Emerson naturally insisted on the inferiority of all casts and copies, so as to justify the long journey to Rome. Cooper, for instance, was so disturbed by the rumor that the statue at the Vatican might itself be a copy that he discussed little else. He concluded by insisting "for your comfort" that "the casts and copies of this statue that are usually seen in America bear some such resemblance to the original as a military uniform made in a country village bears to the

regulation suit ordered by government and invented by a crack town-tailor."[4] The surprising analogy seems to have been inspired by an acute reaction to Apollo's nudity, which is otherwise unobserved. Indeed, the amazing variety of physiques— of "ideas" of male beauty presented in the Vatican and Capitoline like so many satellites around the supreme "divine" form of the sun god *Apollo* at the center— was almost studiously ignored by Americans, or acknowledged only behind the blandest of general and comparative terms.

This self-editing among the romantic classicists contrasts with the elaborate catalog of different physical "conformities" worked out by Winckelmann, who even remarked upon the specific beauty of testicles. Among later "realistic" writers, the French critic Hippolyte Taine (admirer of Howells and admired by him) provided equally particularized formal and anatomical observations, which define by contrast the reticence and vagueness of the Americans. The focus of Taine's writings on the statues of Rome in 1864 makes them wholly antithetical to Edwards's lectures of 1831. Such conscious acknowledgment, with highly specific definition, of the repertory of nude human forms available for contemplation in Rome was left to the sculptors and painters themselves. They naturally illustrate I. A. Richards's edict that the best response to a poem is to write another.

WORSHIPING IN THE BELVEDERE CHAPEL

The prestige of the *Apollo Belvedere* was already centuries old when it was viewed by Benjamin West in 1760, but Winckelmann's appreciation of it, just then being written, was to dominate the way it was seen for the next century. Winckelmann's description and that of Byron in *Childe Harold's Pilgrimage* (1818) have affected the presentation of the *Apollo* in most guidebooks down to our own day. Until mid-nineteenth century, Americans assumed the "right" attitudes and adapted the received ideas to their own expressions of delight and awe in their journals, letters, travel books, and art criticism. When, in 1834, the New England parents of the young John Lathrop Motley received a long letter describing their son's passionately imaginative response to the *Apollo*, perhaps the knowledge that it was directly plagiarized from Winckelmann (with some spice from Byron) would have come as a relief.[5] The original passages in Winckelmann and Byron, often said to coincide, are actually quite different in everything except their subjectivism. Together they encouraged five components of the experience: (1) the *Apollo* is a means to religious ecstasy; (2) he may be understood allegorically; (3) he either represents the human image of the divine or suggests the divinity of man; (4) he is a supreme proof of man's capacity for ideal artistic creativity; and (5) there is, after all, something sensuous if not erotic about him.

For Winckelmann the *Apollo* was "a purely ideal figure" of a god, not a man:

> His stature is loftier than that of man, and his attitude speaks of the greatness with which he is filled. An eternal spring, as in the happy fields of Elysium, clothes with the charms of youth the graceful manliness of ripened years, and plays with softness and tenderness about the proud shape of his limbs. Let thy spirit penetrate into the kingdom of incorporeal beauties, for there is nothing mortal here, nothing

which human necessities require. Neither blood-vessels nor sinews heat and stir this body, but a heavenly essence . . . seems to fill the whole contour of the figure.

Despite Apollo's incorporeality, Winckelmann could not describe him without resorting to both physical detail and sensuous metaphor:

Scorn sits upon his lips, and his nostrils are swelling with suppressed anger, which mounts even to the proud forehead; but the peace which floats upon it in blissful calm remains undisturbed, and his eye is full of sweetness as when the Muses gathered around him seeking to embrace him. . . . The soft hair plays about the divine head as if agitated by a gentle breeze, like the slender waving tendrils of the noble vine; it seems to be anointed with the oil of the gods, and tied by the Graces with pleasing display on the crown of his head.

This combination of divine subject and sensuous imagination precipitates an aesthetic religious rapture:

In the presence of this miracle of art I forget all else, and I myself take a lofty position for the purpose of looking upon it in a worthy manner. My breast seems to enlarge and swell with reverence, like the breasts of those who were filled with the spirit of prophecy, and I feel myself transported to Delos and into the Lycaean groves—places which Apollo honored by his presence.[6]

Winckelmann concluded by declaring this bravura passage to be his own offering to be placed at the feet of the god. As early as Hegel it was acknowledged to reveal an entirely new mode of aesthetic perception. In the words of Hugh Honour, Winckelmann "had replaced the mimetic with an expressive theory of art." Thereafter "impressionistic verbal evocations" became the normal form of discourse.[7] Thus one of the founding texts of neoclassicism established an attitude essential to the romantic art of Byron and his followers.

When Byron's Childe Harold arrives on his pilgrimage at the Vatican and stands before the *Apollo*, his gaze is almost wholly inward. In the first stanza (IV:161) his indifference to actual observation of the statue makes Winckelmann seem relatively objective. Instead of Winckelmann's notations of superhuman stature, bloodless and sinewless body, and specific hairstyle, Byron offers only notions of conventional personification: "The God of life, and poesy, and light— / The Sun in human limbs array'd." The arrow that has just been shot "bright / With an immortal's vengeance" is purely imaginary, and is less intimately related to the visual experience than are Winkelmann's Muses, Zephyr, and Graces—all of whom are imagined as having contributed in a tactile way to his appearance. Winckelmann's Apollo is also far more complex: he has just exercised physical power but he expresses intellectual beauty; his brow shows "disdain" but his eye "is full of sweetness." In Byron, the "brow" is "radiant from his triumph in the fight," while in his eye and nostrils not only "beautiful disdain" but "might / And majesty, flash their full lightnings by." That is not an image one cares to visualize. In any case, sweetness is evident nowhere. In the next stanza (162), Apollo's "form" does become "delicate" in order

to introduce a "dream of Love, / Shaped by some solitary nymph." This strain of worldly but frustrated eroticism, which in an earlier chapter we saw Byron introduce as the rationale for the religious legend of the nymph Egeria, is completely contrary to the spiritual ecstasy of Winckelmann, whatever degree of sublimated desire may seem to us to have been involved in Winckelmann's view of the *Apollo*. Byron oddly completes the stanza with some vacuities about "ideal beauty" and some cloudily fanciful figurative language, none of it related to any solitary nymph's dream or to the actual statue. In the third and final stanza Byron's concern is equally typical of him: to pay tribute to the supernally inspired Genius who gave "eternal glory" to the marble. Byron's invocation to *Apollo* is less the lyric record of his experience of the statue (as Winckelmann's at least was) than a dual exercise in literary abstraction and pure self-expression. Until the privilege of commenting on statues at all was entirely assumed by "objective" scholars, American writing inspired by the *Apollo Belvedere* ranged between Byron's two extremes, but by mid-century the subjective values upon which both are based began to change.

In his thoroughly romantic *Lectures on Art* (begun in the 1830s), Washington Allston precedes his discussion of the *Apollo* with a proof that even the muscle-bound *Farnese Hercules* (fig. 140) is an embodiment of "pure Idea," a "visible image of Truth" which has survived all fluctuations in "the manners, habits, and opinions of men." Consequently he finds it relatively easy to establish the ideality of the *Apollo*, in which the "human form" has been made to "assume" and "make visible the harmonious confluence of the pure ideas of grace, fleetness, and majesty," in contrast to the *Hercules'* embodiment of strength. But simple recognition of the ideas personified is not the whole experience. For one is conscious of beholding neither a man nor a statue, but rather a revelation of "celestial splendor," a "vision" from "another world." The religious character of the highest art is defined through Allston's personal experience of the *Apollo:*

> I know not that I could better describe it than as a sudden intellectual flash, filling the whole mind with light,—and light in motion. It seemed to the mind what the first sight of the sun is to the senses, as it emerges from the ocean. . . . But, as the deified Sun, how completely is the conception verified in the thoughts that follow the effulgent original and its marble counterpart! Perennial youth, perennial brightness, follow them both. Who can imagine the old age of the sun? As soon may we think of an old Apollo.

Possibly echoing Winckelmann's "eternal spring," and like him putting the emphasis on the god's shining and celestial qualities, Allston yet eliminates Apollo's pride and disdain and his physicality altogether. He is simply a sublime intellectual experience, free of terror. The *Apollo Belvedere*, reversed, draped in white, and given a gentle face, had long since served Allston for his own image of "light in motion" in the figure of *The Angel Releasing Saint Peter from Prison* (1816; MFA, Boston).[8] Yet in his lecture Allston interestingly acknowledges that the reader may ascribe his experience of the *Apollo* "to the imagination of the beholder" rather than to anything in the statue. But he denies that it can be thus "explained away," because it is to the imagination that every work of genius is deliberately addressed

by being created *"suggestive."* The "false and commonplace" work never excites such thoughts and emotions or fills the imagination with "corresponding images," the "proper end" of art.⁹

An "ideal" art inspired by revelations to the imagination of the artist and appealing to the imagination of the viewer was also the highest ambition of Thomas Cole. Yet Cole's commentary on the *Apollo Belvedere* indicates how his conception of the religious dimension of the aesthetic experience differed from Allston's. In 1847 he also recalled the *Farnese Hercules* as an instructive contrasting image, adding the *Venus de' Medici* when he wished to establish the identity of the true and the beautiful, that is, the absolute dependence of art (the beautiful) upon nature (the true). Whereas Allston argued that the ideal was recognized, and its reality proven, by a psychological response to a work of art that transcended the fashions and prejudices of time and place, Cole made observation of nature the test. Although "all nature is not true," the recognition of truth depends not upon reference to a preexistent Platonic abstraction but upon an understanding of the function evidently implied by the form as it exists in various states of development or imperfection within nature. Perfection of form (or the ideal truth, the beautiful) exists where a specific function is best fulfilled, whether in an *Apollo* or an oyster. "In the human form, the most beautiful is that which is most completely developed for the functions of life, whether modified by sex or age." The artist follows the divine creative principles observable in nature to arrive at images representing the ideal fulfillment of the "functions of life."

> In the Apollo, Dignity, Grace & Agility are embodied. In the Hercules, Force & muscular power. In the Venus, Feminine beauty, in great measure destitute of intellectual expression. These works are true, having their types in Nature. Apollo was the God of swiftness, light & song, Hercules he who wrought such immense physical labors, Venus the voluptuous. The Artist found in Nature the principles & form which constituted these various classes of beauty.¹⁰

Cole arrived, by a more inductive route, at an understanding of these works as personifications similar to that of Byron and Allston. But the works themselves and the experience of them are not seen as transcendent; they are within nature and represent the truth about certain aspects of man in nature, not of the divine. There is no assimilation of the divinity of Apollo or Venus into the religious experience of art. The creation and appreciation of art are religious experiences because art reveals divine intentions and processes within nature. In this sense the subject—oyster or god—is a matter of indifference: "The Fiend as well as the Angel may be beautiful," each "perfect in its kind"; "moral" beauty does not necessarily coincide with "physical" beauty. The superior interest of *Apollo, Hercules,* and *Venus* is owing not to their superhuman ideality but to their creators' success in making them represent the ultimate fulfillment of certain positive potentialities in human nature.

Precisely the power of art to reveal the supernatural is what H. T. Tuckerman, one of the earliest converts to the new religion, appreciated most in the Vatican Gallery. This vast collection, he wrote in 1835, gives a "vivid and elevating concep-

tion of her [art's] power." Above all, "it is when the eye first rests, and the heart first fastens with instinctive eagerness upon the Apollo Belvedere, that we feel the triumph of human art."

> And there springs up a rich sentiment of satisfaction, not only that the poetical in native feeling, the pure in taste, and the exalted in thought, are conscious of unwonted gratification, but because we rejoice in the spiritual nobility of our common nature; we glory in the thought that the senseless marble radiates the beautiful and deep expressiveness of intellectual life at the call of human genius, and we are soothed by the testimony thus afforded to the immortality of what we most love in ourselves and kind; for we feel that such followers of nature are allied to its Author, and may humbly, but legitimately, aspire to yet higher teachings than the ones evolved from the physical universe.[11]

The *Apollo* is here a kind of prophetic scripture, written by an artist-saint, who as a "follower of nature" is yet superior to it, and through his work teaches us of an intellectual realm above the "physical universe." Meditation upon the statue brings out all that is best in us—the poetical, the pure, the exalted—and confirms our "spiritual nobility." Exactly how the *Apollo* manages to do this is not specified, but it is surely dependent partly upon a preconception of him as the god of *intellectual* beauty, the patron of the fine and liberal arts who consorts with the Muses. No one writes this way about the *Hercules* or even after viewing the greatly admired *Antinous*. Simply as sculpture these may have equal excellence, and as nude males they may be even more impressive. But to worship *Apollo* is to worship Art itself in its most refined conception. In Margaret Fuller's "Conversations on the Fine Arts" in 1840, as reported by Elizabeth Peabody, the *Apollo* provided the culminating image in the aesthetic religion's credo:

> The fine arts were our compensation for not being able to live out our poesy, amid the conflicting and disturbing forces of this moral world in which we are. In sculpture, the heights to which our being comes are represented; and its nature is such as to allow us to leave out all that vulgarizes. . . . That was grand, when a man first thought to engrave his idea of man upon a stone, the most unyielding and material of materials,—the backbone of this phenomenal earth,—and, when he did not succeed, that he persevered; and so, at last, by repeated efforts, the Apollo came to be.[12]

The reason for the official preference of *Apollo* over other male images becomes most apparent in Melville's comments on him in his lecture on "Statues in Rome" (1858). In his Roman journal he in fact had recorded no impression whatever of this statue, whereas there are notes indicating special appreciation of Antinous as he appeared at the Capitoline and the Villa Albani: "Antinous, beautiful," reads one note; "Antinous—head like moss-rose with curls & buds" begins another.[13] Melville bought a bust of Antinous, not of Apollo. Nevertheless, in his public lecture, he said nothing of any *Antinous* but testified to a most elevated response to Apollo as a deity. He even referred twice to the alcove in which the statue stands as the

"Belvedere chapel" and said (falsely in his case) that it is the place visited both first and last by every visitor to Rome. The visit is described as an act of worship:

> Its very presence is overawing. Few speak, or even whisper, when they enter the cabinet where it stands. It is not a mere work of art that one gazes on, for there is a kind of divinity in it that lifts the imagination of the beholder above "things rank and gross in nature," and makes ordinary criticism impossible. If one were to try to convey some adequate notion, other than artistic, of a statue which so signally lifts the imagination of men, he might hint that it gives a kind of visible response to that class of human aspirations of beauty and perfection that, according to Faith, cannot be truly gratified except in another world.

Melville in fact claimed that the angel Zephon of *Paradise Lost* IV:844–48 is an "exact counterpart of the Apollo. . . , once the idol of religion and now the idol of art." Milton's description is brief and highly general; but the notion of an essential equivalence between the heavenly worlds of paganism and Christianity pleased Melville so much that he went on to suggest that Milton's entire epic "is but a great Vatican done into verse," the result of Milton's visit to Italy during which he learned "high ideas of the grand in form and bearing" from "these representations of the great men or the gods of ancient Rome." Horatio Greenough had already found that this process could be reversed. In consultation with Allston, he used the *Apollo* as the direct model for the form and attitude of his *Abdiel* (1839; Yale), another angel of *Paradise Lost*. He intended to show "the angel character embodied in a form worthy [of] the words of Milton and alive with kindling and just indignation," like the *Apollo*. He only regretted that the angel could not be nude.[14]

Milton's assimilation of pagan conceptions of the divine into Christian imagery, however, reminded Melville of the problem of Venus, the indigestible goddess. In describing her Medicean version (figs. 61, 62), he found the proof of the *Apollo*'s superiority:

> She is lovely, beautiful, but far less great than the Apollo, for her chief beauty is that of attitude. In the Venus the ideal and actual are blended, yet only representing nature in her perfection, a fair woman startled by some intrusion when leaving the bath. She is exceedingly refined, delicious in everything—no prude but a child of nature modest and unpretending. I have some authority for this statement, as one day from my mat in the Typee valley I saw a native maiden, in the precise attitude of the Venus, retreating with the grace of nature to a friendly covert. But still the Venus is of the earth, and the Apollo is divine. Should a match be made between them, the union would be like that of the sons of God with the daughters of men.[15]

Woman is of the earth; the divine is in the image of man. In "After the Pleasure Party" Melville had recognized distinctions among feminine types—there were the Virgin and Minerva as well as Venus. But here the opposition between Venus and Apollo is made to stand for the difference between the sexes. Thomas Cole imagined that art was limited to showing "the perfection of nature" in Apollo as well as Venus. But for Melville nature perfected can mean only the mixture of the "actual

and ideal" which he has encountered outside of art—in the Fayaways of primitive nature. The very conception of Venus as a goddess is compromised if she belongs to nature; her sexuality makes her a "daughter of earth." Art strives for the altogether supernal and in the *Apollo* has achieved it. The implication of this goes beyond Winckelmann into complete absurdity, since it implies an entire absence of nature in the visible form of the *Apollo*. The consequence would be an art of pure Idea, in other words, an end to painting and sculpture. To a large extent this is precisely the art that *Apollo* was made to serve. In Melville's pursuit of his own idea in the absence of any particular recollection of the statue itself, he surpassed even Byron. He did not refer to a single feature of it, even its stance or expression, let alone its disdainful nostrils and gracefully blown hair. When looking into the face of God, Melville expected and found the blankness of white.

Not everyone was as happy as Melville in the *Apollo*'s unearthly capacity to resolve into a divine abstraction. Hawthorne, for example, acknowledged that the *Apollo* was "ethereal and godlike," and that Canova's *Perseus* in the adjacent alcove was "disgusting" in comparison, "though I could not tell why." He wisely realized that masterpieces speak in the language of their own medium; "and if they could be expressed any way except by themselves, there would have been no need of express-ing those particular ideas and sentiments by sculpture."[16] Nevertheless it is ob-vious that Hawthorne was far more impressed by the nearby *Laocoon* (fig. 142) with its full narrative context and a "moral" congenial to his thought—the helplessness of suffering man in the hands of a superhumanly imposed fate—than he was by *Apollo*.

An urbane means of amplifying commentary upon the *Apollo* was discovered by N. P. Willis. We have seen that he admitted to preferring the "infantine bust" of Augustus to "all the gods and heroes of the Vatican." Yet he owed it to his readers if not himself to see what Byron had seen in the *Apollo*—"breathing, indignant nostrils and lips" as well as the "mingled . . . grace and power." Willis's original contribution, however (perhaps suggested by Byron's notion of *Apollo* as a nymph's dream), was to introduce the question of the comparative attitudes of men and women toward the statue. This involved insisting that the statue although "god-like" is the "model of a man," such a man as has never been seen in nature, but nevertheless one to draw the attention of women as a man, and that of men as well, in rivalry. It shows "truth to nature," yet is "beyond any conception I had formed of manly beauty. It spoils one's eye for common men to look at it." It makes a man "feel what he should have been, and mortifies him for what he is." No wonder "most women . . . adore the Apollo as by far the finest statue in the world." Further-more, while (he incorrectly adds) "most *men* say as much of the Medicean Venus," Willis himself, even as a man, prefers the *Apollo*. "The beauty of the Venus is only in the limbs and body. It is a faultless, and withal, modest representation of the flesh and blood beauty of a woman. The Apollo is all this, and has *soul*. I have seen women that approached the Venus in form, and had finer faces; I never saw a man that was a shadow of the Apollo in either." The comparison parallels that of Melville without going to the extreme of pushing the *Apollo* into a purely divine realm. Willis had already emphasized the expressive corporeal aspects of the statue, and he concluded with an amusing image of Apollo alone in the "room" consecrated

to him, "thronged at all hours by female worshippers" tirelessly gazing up at the god on his pedestal with "open-mouthed wonder." It was enough to make him believe in the famous tale of the girl who died of unrequited love for the *Apollo Belvedere*.[17]

Grace Greenwood's commentary on the *Apollo* goes far toward justifying Willis's picture of female infatuation. Greenwood found the Capitoline *Venus* to be "soulless," whereas the *Apollo* was virtually all soul. He existed for her in "the region of the divine and the eternal," and she shared in the "sigh of unutterable admiration, with which the pilgrims of art" have always adored him. Viewing *Apollo* by torchlight, she "bowed" before the "highest heathen imagining of a God, that the world contains."[18] But for the Reverend William Ware the *Apollo* possessed "mere animal beauty" which, unlike that of the *Venus*, roused "little feeling"; the "world" has never "gone mad" over male beauty, anyway, he oddly averred.[19]

When Tuckerman versified the story of the infatuated girl (whom he identified as French), he emphasized that the passionate liberating dream that sent her speeding across St. Peter's Square and up to the Belvedere was of a god, not a man. She died not because Apollo was not flesh but because he was only marble.[20] Among American men the young Bayard Taylor almost alone confessed to having gone to the Belvedere with something of the eagerness of that girl. His tone may be attributed to his youth, or perhaps to the homoerotic sensibility strongly evident in some of his poems and novels.

> I absolutely trembled on approaching the cabinet of the Apollo. I had built up in fancy a glorious ideal drawn from all that bards have sung or artists have rhapsodized about its divine beauty. I feared disappointment; I dreaded to have my ideal displaced and my faith in the power of human genius overthrown by a form less than perfect. However, with a feeling of desperate excitement, I entered and looked at it.

Like Hawthorne when he finally saw the *Venus*, but unlike the French maiden, Taylor confessed himself completely gratified. "I gazed on it lost in wonder and joy—joy that I could at last take into my mind a faultless ideal of godlike, exalted manhood." The next thought—as always with Taylor the Byronist (he quotes some lines from the poet on the *Apollo*)—was of the artist who created the form: "I would give worlds to feel one moment the sculptor's mental triumph when his work was completed; that one exulting thrill must have repaid him for every ill he might have suffered on earth."[21] Art as compensation for creator and worshiper alike is an article of faith in its religion. Taylor's visit to the Belvedere answered fully to his two main concerns: to worship the ideal form of man and to worship the genius capable of conceiving and executing that form.

What "ideal" the *Apollo* embodied was an important issue, since it reflected one's fundamental religious beliefs and one's notion of pagan and Christian ideas of divinity. In the Unitarian and Transcendentalist advocacy of a "religion of humanity," a definition of the Divine Image was necessary. It was supplied not by Christian but by pagan art. "Greek art expressed immortality as much as Christian art," said Margaret Fuller, but in contrast to Christianity's emphasis on futurity through "the look of aspiration in the countenance of a Magdalen," the Greeks "expressed it

in the present by casting out of the mortal body every expression of infirmity and decay. The idealization of the human form makes a God."[22] In William Wetmore Story's "Conversation with Marcus Aurelius," the emperor is allowed to go even further:

> If you seek the true spirit of religion among any people, you will always find it in the productions of their art. In sculpture, the most ideal of the plastic arts, you will see the real features of the gods. They are grand, calm, serene, dignified, and above the taint of human passion; claiming reverence and love in their beauty and perfection beyond the human. . . . The best personifications of your own divinities in art look poor beside them. . . . Christ in your art is pitiable beside the splendor of Apollo.[23]

By 1853, however, the Elgin Marbles from the Parthenon had thoroughly established themselves as the touchstone of classical achievement in sculpture, so some criticism of the *Apollo* (increasingly believed to be a copy) became possible. The lawyerly George S. Hillard began his presentation of the case with a somewhat peevish statement: "The Apollo Belvedere provokes criticism because it appears to defy it." The problem is that the *Apollo* is not classical *enough*. "It seems to me," says Hillard, avoiding dogmatism on so sensitive a point, that *Apollo*'s creator was the Euripides to the Sophocles of Phidias.

> Beauty is beginning to be divorced from simplicity. There is—shall I speak the word?—a little of the fine gentleman about the Apollo, and in the expression there seems to be a gleam of satisfaction reflected from the admiration which his beauty awakens. There is not enough of the serene unconsciousness of the immortal gods. The disdain and triumph of the countenance are those of a mortal who doubted his aim, and was surprised at his success. And then the attitude, what does it mean? Does an archer ever hold up his right arm after discharging the arrow?

Hillard's reading of the *Apollo*'s expression was as arbitrary as that of any of the faithful. And while "disdain" is one word Hillard's description shares with Winckelmann's and Byron's, by 1853 an air of superiority was no longer admired in either gentlemen or gods. Hillard proceeded conclusively to lower the status of the statue, but in the same breath tried to maintain his credibility as a responsive devotee of Art: "There are, doubtless, finer statues in the world than the Apollo—works proceeding from a deeper vein of sentiment, and breathing a more simple grandeur—but there are none more fascinating." This *Apollo*, "more than any other work in marble," shows "grace and animation of living form"; it has "lightness," "elasticity," "sympathetic charm"; the "chest seems to dilate, and the figure to grow tall, before the spectator's eyes." But Hillard could not conclude without suggesting that the *Apollo* was too popular to be truly great. It is to Phidias's *Theseus* in the British Museum what Dryden's "Alexander's Feast" is to Milton's "Nativity Ode." "The latter is the production of the greater genius, but nine readers out of ten will prefer the former."[24] Hillard's attitude toward the *Apollo* marked a

turning point. The number of those who had now testified to their personal awaken-
ing to *Apollo*'s intellectual beauty had become too large. The connoisseur within
what was becoming a mass religion had to find new tests of orthodoxy in Taste.

Such questioning of the *Apollo*'s perfection is itself satirized by Henry P. Leland
in his *Americans in Rome* (1863) when he puts the criticism in the mouth of the
ignorant and egotistical Yankee sculptor named Chapin, modeled primarily, as we
have seen, upon Hiram Powers, but also upon Randolph Rogers, creator of the best-
selling *Nydia, the Blind Girl of Pompeii.* Powers waited several years before visiting
Rome from Florence and returned from the Vatican and Capitoline galleries the
more convinced of his own supreme genius. Chapin does not know where the
Acropolis is, but does know that Greek sculpture "was all of the religious stripe,"
and intended for the "precious few," whereas he is more interested in "domestic life
and feelin'," and in "layin' open art to the million." Evidently Greek elitism al-
lowed an unnaturalness that modern Americans would find foolish: "Now, there's
the A-poller Belvidary—beautiful thing; but the idea of brushin' his hair that way is
ridicoolus. Did you ever see anybody with their hair fixed that way? Never! They
had a way among the Greeks of fixing their drapery right well; but I've invented a
plan—for which I've applied to Washington for a patent—that I know will beat
anything Phidias ever did."[25]

The voice of Babbitt's friend T. Cholmondeley ("Chum") Frink, author of "Po-
emulations" published daily in sixty-seven newspapers, was heard in the land long
before 1922. In the spread of the religion of Art by patented means of mass produc-
tion and mass communication, the *Apollo* was being squeezed on both sides: too
common for the ultraorthodox and too effete for the masses. In 1874 the son of
General Robert E. Lee visited the Roman studio of the Virginia sculptor Moses
Ezekiel with his sister Mildred, who had been insisting that he admire the *Apollo
Belvedere.* Asked for his opinion, Ezekiel—himself a graduate of the Virginia Mili-
tary Insitute—replied that "I never did have any use for a man who tied up his hair
on the top of his head in a bowknot."[26]

A week after Henry James's first arrival in Rome in 1869, he wrote the long
ecstatic report to his sister, Alice, that I have previously cited. Since the portrait
statue of Demosthenes was "so perfect and noble and beautiful that it amply
satisfies my desire for the ideal," it is not surprising that James could take an
unanxious and unreverential attitude toward the *Apollo,* although he admitted that
his "first movement at the Vatican was to run to the Belvedere" to get the *Apollo*
and the *Laocoon* "off my conscience." "These clever pieces," he continued with a
smile, "don't err on the side of realism. . . . On the whole they quite deserve their
fame: famous things always do, I find. . . . The Apollo is really a magnificent
youth—with far more of solid dignity than I fancied. The Laocoon on the other
hand, strikes me as a decidedly made up affair."[27] While Hillard at least regretted
the *Apollo*'s loss of divinity, James evidently liked it *better* for showing less of the
divine and ethereal—a "magnificent youth" with "solid dignity" was more to his
taste. James amply testifies elsewhere to his belief in the redemptive powers of Art;
his very self-confidence as a practitioner allowed him to make original discrimina-
tions, to find the ideal in the real *Demosthenes* and the real in the ideal *Apollo,*

without fear of sacrilege. He himself would be a lawgiver in a new phase of the religion.

Among James's older French contemporaries was Hippolyte Taine, historian, critic, and friend of Flaubert. James, who reviewed his *Italy: Rome and Naples* (1868) and his *Notes sur l'Angleterre* (1871), frequently and appreciatively referred to Taine's more "scientific" approach to art in his own admittedly impressionistic reviews of exhibitions in London. Yet James felt that—as with Flaubert—Taine's extraordinary power of description was also a liability that hindered the "deeper sort of observation"—by which he meant a "higher" sort of ethical and psychological generalization from the facts of individual cases to ideas and types.[28] Taine's description of physical and social reality—including works of art—became effectively the verbal mode of materialism and sensation, a level of "realism" to which neither James nor Howells was willing to descend. Taine's great gifts, whether limited in this way or not, nevertheless encouraged him in his works on England, Paris, and Italy to *see* more than any American writer saw, or at least wished to report. *Italy: Rome and Naples*, written in 1863, was soon translated into English by John Durand, a former editor of the defunct *Crayon*, and published in America in 1868; by 1889 it was in its fourth American edition. To hear Taine on the Capitoline and Vatican galleries is to hear a different voice from the American and English voices, or even the German of the eighteenth century, although some indebtedness to Winckelmann is still evident. The difference is not merely a question of Taine's specific talents noted by James, nor even his greater commitment to a theory of social evolution. Equally important is his ease with the sensuous forms and textures of both nature and art.

This ease, which Taine shares with his French male predecessors in Rome, President de Brosses and Stendhal (it is less evident in Mme. de Staël), was a gift from the Mediterranean and Catholic culture common to France and Italy. Beyond that, Taine brought with him a more thorough knowledge of Greek literature and history than any American of that period. He was content with the "few Greek books" he had packed in his trunk, for Homer and Plato proved to be "better guides" to the Vatican and Capitoline sculpture galleries "than all the archaeologists, artists, and catalogues in the world." Hillard had said the same thing, but gave no demonstration of the fact. Taine specifies how Homer's eye for visual detail is like Flaubert's, and how the "superabundant" life in Aristophanes vivifies the social context from which Greek art emerged. Such knowledge gave Taine a perspective from which he could appreciate why things are as they are, and not otherwise. But his social perspectivism stopped short of becoming a complete relativism devoid of all personal preferences, just as Winckelmann's sense of the inevitable relation of styles to social conditions did not cause him to abandon an absolute point of reference for aesthetic judgment. Taine's comparative studies are informed by a standard of cultural health and sanity by which he judges deviant styles of artistic expression that he nevertheless first seeks to understand. His commentary is valuable to us because his response to the sculptures of Rome defines by contrast, in ways just suggested, the nature of the American responses. Even more usefully, its greater amplitude and particularity provides what no American did, an introduction

to the *variety* of male nudes observable in the galleries. This variety the American artists, from the very nature of their task, could not overlook, ignore, or reduce to a matter of contrasting allegorical ideas, as the writers did. Taine's close observation of the classical works will make us see more clearly works of the "moderns" who imitated them.

In the Capitoline Gallery, Taine says of *The Dying Gladiator* (fig. 144): "Here is a real and not an ideal statue; the figure is nevertheless beautiful, because men of this class devoted their lives to exercising naked." Although Winckelmann made much of this fact, Americans rarely mention it, or even indicate a particular awareness that the statues—whether real or ideal—are of naked men, let alone suggest that they are beautiful *because* the models for them "devoted their lives to exercising naked." Their commentary focuses always on the "expression" of the face, the statue's "attitude," or the "sentiment" it embodies, never on the torsion of the body, the swell of muscles, or the curve of buttock or breast. Writes Taine of the Greeks: "Personal experience provided them with ideas of a torso, of a full chest displayed like that of Antinous, of the expanded costal muscles of a leaning side, of the easy continuity of the hips and thighs of a youthful form like that of the bending Faun." Hawthorne wrote a whole book inspired by that *Faun* (fig. 43) without once mentioning the "easy continuity" of his hips and thighs, while wondering too often whether he had a tail, something Taine does not concern himself about. The Greeks, he goes on, "had two hundred ideas for every form and movement of the nude." Since gymnastic education continued even into the age of imperial Rome, Rome was simply "another Greece" with respect to physical beauty and its related pleasures. The fauns, "with well-defined muscles and bodies turned half around," show that "physical joy in antiquity is not debased, nor, as with us, consigned to mechanics, common people, and drunkards"; the ancients knew that Bacchus was divine. The interest of a wrestler's "attitude" at the Capitoline is "wholly confined to the backward action of the body, which gives another position to the belly and pectoral muscles. In order to comprehend this we have only the swimming schools of the Seine. . . . And who is not disagreeably affected in our frog-ponds with its undressed bodies paddling about?" Finally, the figures on a sarcophagus have "no dramatic interest"; they do not exist to "represent" an action but the contrary: the action exists to bind together the "six nude young males," two draped females, and two old men, each of whom is "beautiful and animated," and "sufficiently interesting in itself." "To see a body leaning over, an arm upraised, and a trunk firmly planted on two hips, is pleasure enough."

These radical ideas—that mere physical form is "pleasure enough" and that, by implication, mere pleasure in beauty is also "enough"—are further developed when Taine goes to the Vatican, "the greatest treasury of antique sculpture in the world." He is aware that his views, and those he attributes to the Greeks, stress man's animality. This has its dangers as well as its virtues. Both are evident in Plato. Taine quotes two pages from the *Charmides*, in which Socrates expresses his admiration for the competitive beauties of naked young men and refers happily not only to gymnastic education but to eugenics as means to their realization. Taine says that this dialogue is prerequisite to understanding what one sees in the Vatican—such as the discus thrower or the athlete with the strigil: "His head is small, his intellect

being ample for the corporeal exercise which is just terminated; such glory and such occupation suffice for him." The Greeks did not distinguish between human and animal life with respect to the cultivation of physical capacities and beauty. The athlete is *"currying"* himself like a horse. "Consider," Taine exclaims, "what flesh such a life produced, what firmness of tissue, what a tone oil, dust, sunshine, perspiration, and the strigil must have given to the muscles!" Such appreciation of the body for its own sake demolishes the neoclassical hierarchy: "The body of this figure is perfectly beautiful, almost real, for he is neither god nor hero." His little toe on the left foot is imperfect, his biceps rather meager; "the fall of the loins marked; but the legs, and especially the right one, as viewed behind possess the spring and elasticity of those of a greyhound." In spite of the animal status and minor physical flaws of such an athlete (as distinct from a god or hero), Taine finds himself referring to another as having a "divine body"—a phrase he grants seems self-contradictory in the modern age, but is certain expresses a Greek idea.

Perhaps disquieted by his own enthusiastic participation in what he imagines to be Greek modes of perception, Taine suddenly interpolates an unexpected paragraph on the "evil" that attended the "good" of gymnastic education. This "evil"— never mentioned by Americans—"induced" a love that is "a perversion of human nature." Plato was "extravagant" on the subject. The otherwise laudable "respect" for "the animal in man" also tends to "develop" it. On carnal vices Aristophanes was "scandalous," and the proof that we are less corrupt than the Greeks is that we would never stage his *Lysistrate* in our theaters. Taine the cultural relativist has suddenly become as certain of what constitutes "human nature" and "corruption" as any Victorian moralist. "Sculpture, fortunately, shows us nothing of this singular society but its beauty," he concludes, turning abruptly to the statues of draped women. His experience as a medical student had familiarized him with "the articulation of the neck and limbs" and "the mechanism of the muscular system extending from the sole of the foot up the thigh to the hollow of the lumbar region," so he can detect the form beneath the folds in antique drapery, whereas it is all totally obscured by modern female dress. His scientific fingers itching, and his Victorian credentials established, Taine can now return to the male nudes, to admire "the vigorous setting of the thighs" in the *Belvedere Torso* (fig. 146), and to accept the fact that the *Meleager* "is simply a body, but one of the finest I ever saw." To offer it "intellect," as most commentators do, is like offering it "pantaloons and overcoat." Its beauty consists "in a powerful neck and a torso admirably continued by the thigh," no doubt the result of applying the "horse-breeding system" to the human race.

Taine has slowly been approaching the *Apollo Belvedere*, a statue whose reputation for ideality was diametrically opposed to the beauty of animality that he has been admiring. And indeed, when he arrives at *Apollo*'s "oratory," it is clear that he has not come to pray. With the advantage of refinements in the system of differentiating among cultural climates that Winckelmann himself had introduced into art history, Taine can use Winckelmann's own criteria against him and refer the German's judgments to his own time and place. Taine views the *Apollo* as Hillard had done ten years earlier; it "belongs to a more recent and less simple age" than the *Mercury* (fig. 137):

Whatever its merit may be, it has the defect of being a little too elegant; it might well please Winckelmann and the critics of the eighteenth century. His plaited locks fall behind the ear in the most charming manner, and are gathered above the brow in a kind of diadem, as if arranged by a woman; the attitude reminds one of a young lord repelling somebody that troubled him. This Apollo certainly displays *savoir-vivre*, also consciousness of his rank—I am sure he has a crowd of domestics.

Because *Apollo*'s torso and thighs are evidently not worth commenting upon, Taine confines himself to satirical dismissal of the god to the taste of another age. Like James (who may have been recalling him), he next condemns the *Laocoon* as sentimental and sensational. If "these two statues have obtained more admiration than others," he concludes, "it is because they approach nearer to the taste of modern times."[29] The coincidence of his own taste with that of George Hillard and Henry James in their judgment of the *Apollo* indicates that Taine was in some respects himself not peculiar, but was, like Winckelmann, representative of his period while influencing the revolt of the next. Yet for most of the century romantic idealism prevailed in the galleries of the Vatican and Capitoline. By comparison and in retrospect, Taine's taste, in its preference for precisely observed formal beauties and purely aesthetic pleasures over sentiment and narrative in sculpture, seems much closer to what we now call modern.

These shifts in taste were of concern above all to the artists themselves, who had to face changing and conflicting standards, sometimes even within themselves as artists. In the classical world's legacy of such a variety of "types" of nude male beauty, which Winckelmann and Taine observed more sharply than American writers, the American artists found perhaps their most difficult challenge.

APOLLINI: INDIANS AND FAUNS, SHEPHERDS AND FISHER BOYS

A beautiful youthful form in their deities awakened tenderness and love, transporting the soul into that sweet dream of rapture, in which human happiness—the object and aim of all religions, whether well or ill understood—consists.

—*Winckelmann*

First among the different degrees of the "male ideal" in ancient sculpture, wrote Winckelmann, is that of the young satyrs or fauns, characterized "by a certain innocence and simplicity, accompanied by a peculiar grace . . . [and] so shaped, that each of them, if it were not for the head, might be mistaken for an Apollo." American sculptors found occasion for expression of this ideal in two mythologies: the Greco-Roman and the Native American. In their view, Indians and fauns and Arcadian shepherds were all essentially of the same breed, sharing the animal life of nature. Genteel interpretation of their myths focused on the same values and found the same justifications for nudity in their primitivity and youth. Yet their images came into existence not to tell stories but to be icons in the religion of Art, to be admired for their beauty. To contemplate them is to be transported into a happier world. Indians and fauns actually compound the art motive described by Winckel-

mann as serving to spiritualize the sensual image: "To human notions, what attribute could be more suitable to sensual deities, and more fascinating to the imagination, than an eternal youth and spring-time of life, when the very remembrance of youth which has passed away can gladden us in later years?"[1] These young men idealize not only the youth of the individual but the youth of the race: the Greek and the American Arcadias of the imagination. There is, however, a difference: the Indians are agile running figures, lean young male Dianas with (like her) bow and arrows and companion dogs. Fauns and shepherds tend toward recumbency; they are somewhat luxurious figures of soft ease. The contrasting postures represent complementary "ideals" of youthful life, and they allowed distinctive studies of "ideal" physiques within the general type.

Benjamin West's famous comparison of the *Apollo Belvedere* to a Mohawk warrior seems to have haunted—and helped—American efforts to body forth an idea of the American Indian in sculpture. Identification of the Noble Savage with the Greek God pleased many romantics, and the convention that male Indians typically went about nearly naked was a convenience to sculptors. Painters of Indians, contrarily, rejoiced in the natives' highly colored finery. The "naked Apollo" was in fact *opposed* to the "tattooed and feathered and blanketed savage" by Horatio Greenough when he wrote to Emerson to enlist support for a new American aesthetic that would be organic and functional: "this godlike human body has no ornament," he said.[2] Yet by and large Indians were made to be Apollos, or at least Apollini. In Florence in 1843 an American sculptor from Ohio named Shobal Clevenger made the first attempt to see an Indian as Apollo. To judge by the surviving drawing (fig. 116), published in 1844 (Clevenger died before the work was put into marble), this "Indian" was simply the *Apollo Belvedere* with a fancy headdress and slightly slanted eyes, an even more "disdainful" nose, and with arms and bow differently restored. Joel T. Headley, who saw the "great work" in Florence, said that it "showed conclusively that our Indian wild bloods furnish as good specimens of well-knit, graceful and athletic forms as the Greek wrestlers themselves."

In the same year Clevenger's friend and fellow student Henry Kirke Brown also asserted his Americanism by attempting to model an Indian youth instead of a god, to Headley's further delight: "Indians, among the gods and goddesses of Florence, were a new thing, and excited not a little wonder; and it was gratifying to see that American genius could not only strike out a new path, but follow it successfully." William Gillespie, living in Rome in these same years (1843–44), laughed at the sculptors for making the Indians an easy "recipe" for "American."[3] But within the Italian marble there awaited no Indian image in any case; as Brown's boy emerged into the classical air of Rome, where it was finished in 1844, it became an Apollino, like the one Brown had drawn from a classical statue in Florence (fig. 117). The frustrated novice wrote of this development with regret, expressing hope that when back on the soil native to both Indian and artist, he could compensate for his "treachery." Brown believed that such a return was necessary if he was to be for America what a Greek sculptor had been to ancient Greece: an exponent and uplifter of the popular culture. That meant finding (in the words of a contemporary critic) "other subjects than the unclad beauties or the fabulous forms" of antiquity.[4]

Some artists had already found that the Indian provided them with an unequivo-

Fig. 116. Shobal Clevenger. *Indian Chief.* 1843. Photo reprinted from line engraving of statue in *United States Magazine and Democratic Review*, February 1844.

Fig. 118. Henry Kirke Brown. *Indian and Panther.* 1850. Bronze. The Metropolitan Museum of Art.

Fig. 117. Henry Kirke Brown. Drawing of Apollino, Uffizi, Florence. 1843. Brown Sketchbook F, p. 12. Library of Congress, Washington, D.C.

cally native subject that did not require them to sacrifice the "unclad beauties" and "fabulous forms" essential to their art. Like some writers they also realized that the Indians were assuming an ideal mythic status as well. Cooper, helping to create the myth, elevated Natty Bumppo's noble companion Chingachgook by comparing his appearance to the *Apollo*'s. It was the Indian's "high poetical character"—not any thought of him as a near-animal savage, like Cooper's "bad" Indians—that had appealed to Brown in the first place. When he returned to America, he sought out "real" Indians on Mackinac Island in Michigan, trusting that they would displace the insistent Greek images he had studied for four years in Italy. He did not allow the "degraded" appearance of some to disturb his faith in the "real grandeur" of a race so close to nature. He had only to represent them as they were—"fine looking fellows, some of them very powerfully made, others slim, but very elegant in their motion"—in order to achieve what the ancient Greeks achieved through their visits to the gymnasium, a realized image of the ideal: "An Indian is a poetic being, an ideal character," he said. "There is nothing material about him, nothing which can be reduced to practical purposes." In other words, an Indian could serve as well as the *Apollo* in the self-justifying experience of art. He could be the mythology through which the ideal beauty of Rome could find an American realization. Brown's wife was explicit about the matter. An Indian, she wrote, has "as much historical interest and poetry as an Apollo or a Bacchus."[5]

Brown's best-known work is the equestrian statue in New York's Union Square of another "ideal character," George Washington, which has the Father of His Country extending an arm in a benevolent gesture like that of the revered statue of *Marcus Aurelius* on the Capitoline Hill in Rome, which Brown certainly remembered. But away from Rome Brown did succeed in creating various figures of Indians, although a relationship to Apollini was never lost. Even so, the pseudohistorical justification for their nudity did not convince everyone. It merely made Indians as indecent as pagan Greeks. The American Art-Union offered Brown's first bronze statuette of an Indian youth in its distribution of 1849, with the assurance that he was as "beautiful as Apollo," and "armed with bow and arrow, like him as he pursued the children of Niobe." Such a double vision was encouraged by the figure's *contrapposto* stance and leftward turn of the head. Nevertheless a Providence newspaper asserted that "to exhibit a figure like this entirely nude, in our parlours, would be going farther than they would go in France or Italy."[6] Even the Indian's youth could not save him from charges of indecency. In the course of creating a later work, the *Indian and Panther* (fig. 118), Brown changed it from a group showing an Indian father defending his child from a panther, into a single youth attacking one. Brown was thus avoiding the American problem with adult male nudity, yet his youth's total nakedness, defying historical realism but conforming to the classical ideal, was so obviously desired for its own sake that it could hardly be ignored. In the raised and bent right arm, and a stance apparently taken from one of Canova's boxers in the Vatican Belvedere, Brown produced an invigorated American version of the *Apollino*'s languorous pose and a more virile display of the male anatomy.

The *Crayon* in 1855 acknowledged in a review of this statue that such a work was too good to be popular because it required "both knowledge and feeling" in the viewer. The *Crayon*'s editors, W. J. Stillman and John Durand, who evidently

possessed both, welcomed the work enthusiastically precisely because it illustrated "the application of the spirit of the Greek art to common forms." Durand, who was to be Taine's translator, seems already to have possessed some of Taine's values: Brown has studied "the forms of the only people, perhaps, who at the present day show the perfect state of the physique which the Greek athletae possessed." The "whole muscular system" is brought into activity.

> The strongly planted right foot, from which he draws back, resting his weight on the elastic left leg, the left hand, partially clenched, drawn up to the inflated chest, all unite to make the immediate action most powerful and effective. . . . This intensity and unity of *action* exists only in the Fighting Gladiator, and not at all in the Venus or Apollo. . . . Follow the modelling as closely as you will, you can scarcely perceive its delicacy; the divisions, the insertions of the muscles, are so subtly rendered, that there is not an inch . . . which does not contain anatomical truth.

The *Crayon* was not always so appreciative of the beauty of anatomical detail. Earlier in 1855 it had published a letter from Italy praising the *Discobolus* of Myron for having "the anatomy admirably concealed; no distortion of muscle; no attempt to awaken in the mind of the spectator admiration of Science instead of love of Art."[7] But since the review of Brown is developed as an attack on Crawford's use of a moribund Greek mythology in his feeble *Hebe and Ganymede* (fig. 134), just arrived from Rome, the reviewer was rhetorically disposed to find value in the muscular *Indian*, and he did.

One of the *Crayon*'s special missions in fact was the destruction of Greco-Roman mythology as a subject for art, and the substitution of the American equivalent: Indian life. It published a long letter sent by Paul Akers from Rome in May 1855, arguing that the original spiritual and scientific meaning of Greek myths was irrecoverably lost, thanks to the sensuality of the Romans and the fierceness of the early Christians. Therefore they could have no present relevance. A year later the journal published an essay pointing out how artists were still missing their great opportunity with the Indians, who were "fast passing away from the face of the earth." Painters and sculptors had a "duty" to show "the red man" in "the unadorned simplicity of his primitive conditions, . . . the wild freedom of [his] aboriginal manhood." "A naked man, a stump, a few chips, a gun. . . . What attitudes for sculpture . . . unknown in antique sculpture . . . , wholly American."[8]

In all this the editors of the *Crayon* sound in harmony with Henry Kirke Brown's friend and fellow Brooklynite Walt Whitman, whose *Leaves of Grass* was also published in 1855 and was reviewed in the same issue with the essay on Indians. Four months later the journal would praise the latest collection of conventional poems from Bayard Taylor in the highest terms, but Walt Whitman frightened them. Admitting that he belonged to "the class, Columbus," and had "wonderful vigor of thought and intensity of perception," his poetry was nevertheless "barbarous, undisciplined, like the poetry of a half-civilized people," the very thing the *Crayon* editors were trying to prove that Americans were not. They were not Indians! Whitman's preface to his *Leaves* was a "creed of the material, not denying

the ideal, but ignorant of it." The poems were "irreligious" because Whitman thought that "all things in Nature" were "alike good" and "alike beautiful" and all "to be loved and honored by song." Such a notion of equality is false, and dangerous to art as to poetry; it means there is "no order in creation."[9] The Ideal, which applied even to the selection and treatment of Indians, would be lost. What the *Crayon* said of Whitman was all true; yet Whitman did possess discriminating standards. When he reported in the *Brooklyn Daily Eagle* a visit to an exhibition of Brown's work in 1846, not long after the sculptor's return from Rome, he praised his "genius and industry," but thought that a life-size *Adonis*, though "noble," did not "come up to our (perhaps too lifted) ideas of 'Myrrha's immortal son.'" In fact, across Broadway there was something more to his "taste for the Ideal—for the exquisite in form, the gracefully quaint, and the chastely gorgeous." This parody of Winckelmann's definition of the Ideal found its fulfillment in a wonderfully outfitted new saloon: "True Democrat as we are, we did like to look on shapes and things of beauty, ever."[10]

In his old age Whitman recalled with fondness his days of social interchange with artists in Brown's Brooklyn studio, "young fellows" just back from "Paris, Rome, and Florence." He had also appreciated the admiration of Longfellow's brother Sam, a Unitarian preacher in Brooklyn who told Whitman that he was "the most Greek" of modern poets, which Whitman took to mean that the *Leaves* showed an "underlying recognition of facts"—a Greek peculiarity, he thought. But he was not comfortable in Longfellow's circle. It was "literary, polite." The habitués of Brown's studio were "more to my taste."[11] However dissatisfying Brown's *Adonis*, Whitman must certainly have admired his *Washington* (as did the *Crayon*) and his Indians. In "The Sleepers" Whitman's Washington is the same unwarlike father-hero that Brown portrayed; "Song of Myself" and "I Sing the Body Electric" celebrated the beauty of the human form—"red, black, or white"—with the sort of particularized enthusiasm for the revelatory pose that Brown had imbibed in Rome and expressed in his *Indian and Panther*.

One of the young men Whitman met in Brown's studio was his pupil and assistant, John Quincy Adams Ward, who was himself to become a sculptor of ideal Indians to the extent that his official commissions of commemorative statues would leave him time. He too would go west to see the "real" thing, but his most famous Indian youth, familiar to all who have strolled through Central Park, is the *Indian Hunter* modeled first as a bronze statuette in 1860 (fig. 119) and then redesigned in a more erect version (with a bow added) around 1865 for the life-size work. Ward never went to Italy, declaring in 1878 that Rome had a "cursed atmosphere," that its antique statues destroyed a sculptor's "manhood." At the same time he admitted that sculptors remaining in America "suffer from not living in an art atmosphere," and the theory of art he enunciated was thoroughly neoclassical in its principles: "Art means the selection and the perpetuation of the noble and beautiful and free. . . . The true significance of art lies in its improving upon nature."[12] Learning from Brown (whom he can hardly have thought unmanned by Rome), and surely becoming familiar with casts from the antique in New York, Ward in fact did not need to go to Rome to be a recipient of its essential gift: not the names from its mythology but a feeling for myth that engendered formal beauty. The pose of his *Indian Hunter* resembles that of a gladiator more than his features

That Manship's *Diana*s—like those of Huntington—were conceived as domestic bronzes for parlor or garden does not invalidate them; at least a garden is a congenial setting. But the recent erection in America of acquisitive temples of Art called Museums meant that many of his works were immediately given the status of aesthetic icons intended exclusively to furnish occasions for the experience of Beauty. Manship's "Credo"—specifically so called in a booklet of 1947 published by the National Sculpture Society—is a page of generalities in support of the aesthetic religion. Talent and training are not enough; the sculptor depends upon "inspiration" to "turn ideas and emotions into objects of beauty and expression. . . . Of such things is made the Great Excitement and Mystery of Art."[16] But "inspiration" in this "Mystery" arises from Art itself, not from extra-aesthetic religious or political belief, or from nature.

We have already seen, in considering the famous *Diana* executed in Rome, that from the beginning of his career Manship's intention was primarily formalist and decorative, taking its "inspiration" from the form but not the substance of a Greek art that belonged to an earlier period than the one that had inspired his predecessors with an image of Truth as well as Beauty. In 1912, his last year at the academy as a student, Manship read a paper that declared, "Nature is formalized to conform with the artist's idea of Beauty. . . . The entire statue can be considered as a decorative form upon which all the detail is drawn rather than modelled."[17] The supremacy of the Idea of Beauty over Nature is nothing new, although calling the result a "formalization" rather than a "perfection" of nature radically alters the accent of classicism. What is new is the loss of the sense of the statue as a numinous object with the three-dimensional reality of things in nature, a concentration of their mysterious potentialities and significance, something more than an abstracted "form" upon which decorative lines are drawn. In the simpler body planes and the patterned flow of stylized hair and drapery in Archaic Greek statues and in Pompeiian decorative art, Manship's eye saw possibilities of abstract design that made the more developed "ideal" forms of classic art seem comparatively close imitations of nature. To him ancient mythology became only an anthology of conceits suggesting different outlines and visually pleasing contrasts of surfaces. Myth was not meant to lend its own mystery to the "Mystery of Art."

In Manship's earliest works done in Rome, however, the formal intentions and achievements were not devoid of iconographical force. Satyrs leaning over sleeping nymphs (1909; 1912) were experienced *as* satyrs. In 1914 the U.S. Postal Service stopped a magazine showing photographs of Manship's *Centaur and Dryad* (conceived two years earlier in Rome) from going through the mail, finding it (rightly) "bestial."[18] The jury that gave it a prize in 1913, and the curator of the Metropolitan Museum who immediately bought a copy, must have been conscious of more than the compact triangular outline of the group, its suave modeling, and the flowing parallel lines on the drapery and on the centaur's tail. They responded as well to the image of brute power rearing up behind a dryad who seems more to lean with tense anticipation into the centaur's grasp than to resist it. Form here still served an idea of beauty inseparable from an idea of natural force. Even the "decorative" lines flow like a visualized electrical charge between nymph and man/beast.

How that kind of power is largely absent from the *Diana* (fig. 101) and from her made-in-Paris companion piece *Actaeon* (fig. 121) becomes evident when this pair is

compared with another that directly prefigured it: an *Indian Hunter* and the *Prong-horn Antelope* he is shooting (figs. 122, 123; statuettes 1914; heroic versions 1917). In the Indian's metamorphosis into Diana, and that of the antelope into the Actaeon who is himself in the process of becoming a deer, there is more loss of meaning than gain. *Diana* and *Actaeon* are arbitrary and largely nonsensical forms, however attractive as abstractions, whereas the Native American and his antelope (conceived and executed on home ground) possess the mythic power and mystery of Archaic gods. This is owing partly to the totemic quality of their realization in stone and to the *Indian*'s less open form. The bronze *Diana* and *Actaeon,* in contrast, whether patinaed in black, green, or gold, and cast in whatever size (they came in three), seem to have been occasions for bravura exercises in luxurious "pure" forms with dynamic complementary outlines. The classical myth is simply another elegant patina. The dogs do not gnaw upon the ill-fated *Actaeon*'s leg, but interestingly break its line. His is not the body of a beautiful youth caught in its transient perfection, but a form upon which lines have been drawn. True, he suggests the kinetic genius of the animal he is becoming, and his eyes show the horror of his change as his head sprouts antlers and his dogs leap upon him, yet they also seem to look to us for appreciation of the effect of his balletic leap. The names affixed to these statues are presumably tickets to a grander salon of art than a mere Indian could provide. But they are perhaps more tarnished than enhanced by this *chic* citation of once sacred scripture. Manship's *Diana* and *Actaeon* are icons in a religion that is beginning to find traditional literary and other external references extraneous to its needs and purposes but has not yet the courage to dispense with them. A formal and decorative internal coherence is sufficient to effect the aesthetic experience, and any thematic incoherence that remains should be ignored as arising from nonfunctional vestigial remains of outmoded referents. That one is worshiping nothing but Beauty is clearer because one has a simplified sense of what Beauty is.

This, however, gets us ahead of our story, to the point where classical Rome had lost its meaning for art. When we look at Manship's Indians—especially his *Indian Hunter with Dog* (1926; fig. 124) created to run through Cochran Memorial Park in St. Paul (where Manship passed his own childhood)—we still see Ward's Apollino/Diana ideal of beauty reimbronzed in a sleeker, fleeter model, yet relying for its effect not merely upon its formal elegance but also upon its palpable appeal to life. The dog (clearly *Diana*'s dog, the very same) is perhaps more concerned with the extension of his line than with catching his prey, as Ward's quietly snarling beast (hardly to be restrained) so convincingly is. Yet Manship's "idea of Beauty" here still manifests itself as the gift of superior and permanent form to some truth of human experience, less perfectly realized in nature and all too fleeting, but itself a part of the substance and beauty of art, not something extraneous to it. Encounters with Ward's and Manship's Indian youths with their dogs are moments of engagement in an alien and vanished life in which we yet recognize an aspect and a memory of our own.

The sober and intense absorption of the Indians in their own active life is one of the things that defines our experience of them and differentiates them from recumbent fauns and other Apollini, who are made to appeal coyly yet directly to our regard for

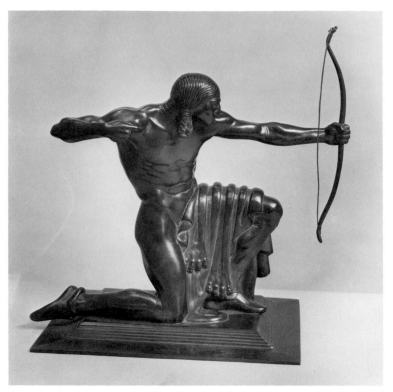

Fig. 122. Paul Manship. *Indian Hunter*. 1914. Bronze. H: 13⅝". The Metropolitan Museum of Art. Bequest of George D. Pratt, 1935.

their beauty. That beauty is softer and somewhat androgynous. A work that Augustus Saint-Gaudens made in Rome in the early 1870s unites Indian and faun in one image. Appropriately, *Hiawatha* (fig. 125) illustrates not a moment in the life of any Indian that Saint-Gaudens ever saw but some lines from Longfellow's highly artificial poem published in the same year—1855—as Whitman's *Leaves of Grass*, and intended like it (with far more initial success) as a contribution to the national mythology. The seated nude youth is "musing . . . on the welfare of his people," the inscription tells us, as a reminder that this is all in a now mythic past when there was an ideal life in the forest. The period of action is over; Hiawatha is a figure of relaxed meditation, more faun than warrior or hunter. He is absorbed within himself, and leaves us to admire his beauty—and to imagine his thoughts if we wish. Since simple regard for beauty is still not "pleasure enough," fauns usually provide us with a thematic distraction from their form.

In 1859 the writer Lydia Maria Child rather presumptuously gave Harriet Hosmer the benefit of her fantasies about what she would create if she were a sculptor. Among them was one of "the young Pocahontas, vigorous and supple, with her twelve years of free, forest life, reclin[ing] on the ground beside [Captain Smith], with the careless grace of a faun."[19] The fauns of sculpture (both antique and modern) usually display more suppleness and grace than vigor, but Child's characterization of a sensuous young Pocahontas-as-faun is not inconsistent with the images Hosmer in fact realized of reclining fauns in the 1860s, which prefigure

312

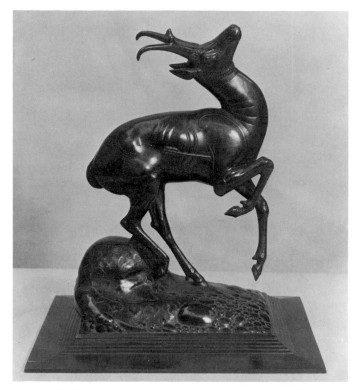

Fig. 123. Paul Manship. *Pronghorn Antelope*. 1914. Bronze. H: 12½".
The Metropolitan Museum of Art. Bequest of George D. Pratt, 1935.

*Endymion*s by William Henry Rinehart, Thomas Ball, Daniel Chester French, and Paul Akers, and also Akers's *Dead Pearl Diver*, all created within a twenty-year span. What these works have conspicuously in common is their reduction of the beautiful male nude to a state of complete passivity: sleeping or just awakening, and in one case, dead.

Harriet Hosmer liked to refer to her *Faun*s and her *Puck* as her "babies." Visitors to her studio in Rome often associated the *Faun*s with *The Marble Faun*, and Hosmer no doubt was influenced by Hawthorne's emphasis on the simple, warm, and charming aspects of the faun idea rather than the more wild and problematic ones, and she would also have been encouraged in this by the statue in the Capitoline he had used as his point of departure (fig. 43). In adding more marble fauns to the world Hosmer was consciously exploiting the fame of Hawthorne's work. She wrote of her admiration for it in 1860, and in 1865 we first hear of the *Sleeping Faun* (fig. 126) as the hit of the Dublin Exhibition. Hosmer's master, John Gibson, said it was "worthy to be an Antique," and others found that they could describe it by quoting from Hawthorne on the Capitoline *Faun*. The work itself, and its reception, perfectly express both the pleasure in nostalgia for the antique that is essential to neoclassical feeling and the illusion that the exact spirit of the antique could be duplicated. Yet Hosmer's *Faun*s are unmistakably Victorian. Certainly the first of them is very far removed from its most famous classical antecedent, the Barberini *Sleeping Faun* (fig. 127), which Winckelmann, while calling it "beautiful," admitted

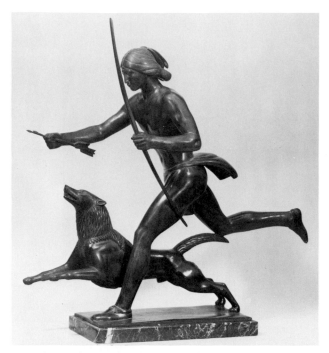

Fig. 124. Paul Manship. *Indian Hunter with Dog.* 1926. Bronze. H: 23¼". The Metropolitan Museum of Art. Gift of Thomas Cochran, 1929.

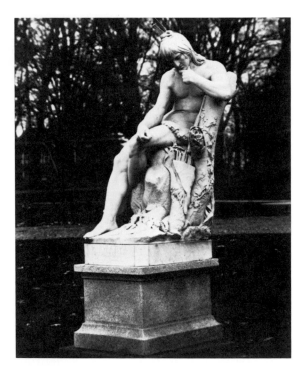

Fig. 125. Augustus Saint-Gaudens. *Hiawatha.* 1872. Marble. 7'9". Private collection. Photo courtesy Saint-Gaudens National Historic Site, Cornish, New Hampshire.

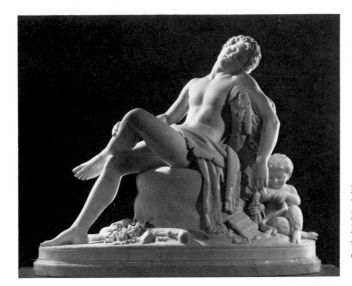

Fig. 126. Harriet Hosmer.
The Sleeping Faun. 1865.
Marble. 34½ × 41". Courtesy
Museum of Fine Arts, Bos-
ton. Gift of Mrs. Lucien
Carr.

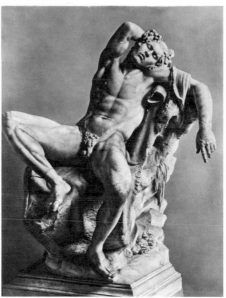

Fig. 127. Barberini Sleeping
Faun. ca. 200 B.C. Marble.
Staatliche Antikensamm-
lungen und Glyptothek,
Munich.

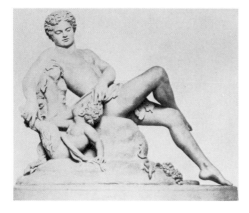

Fig. 128. Harriet Hosmer.
The Waking Faun (lost).
1867. Marble. Photo
reprinted from Harriet
Hosmer, *Letters and
Memories.*

was "no ideal, but an image of simple, unconstrained nature."[20] The statue, though no longer in Rome, was very famous and must have been the source of Hosmer's subject. As late as 1874 William Rinehart was writing to Mr. Walters of Baltimore that a cast of it could be made from "old moulds" in Rome for 450 francs.[21] Moreover, Hosmer prided herself on knowing personally and admiring the artistic interests of the royal family of Bavaria; Ludwig I as Crown Prince had triumphantly carried this *Faun* off to Munich in 1819.[22]

Comparison with the sprawling Barberini *Faun* makes Hosmer's work seem less sensual than it actually is, however, so extreme is the former. The parted lips, the smoothly swelling breast, the utter relaxation of the hanging arm, the improbably raised leg held in place by a hand (is he really sleeping?), the minimum of drapery, create an image of remarkable sensuality, such as any "ideal" faun should possess. Like some creators of female nudes, Hosmer took the precaution of making him distinctly younger than the most celebrated antique fauns, but he is no infant. Moreover, he is of an ambiguous size—perhaps half that of life—but who knows how many sizes fauns come in? In being so small, so young, and sound asleep, he could never—no matter how animal and naked—encourage anything but pure and sweet thoughts in the uncorrupted viewer, which was certainly not true of the Barberini *Faun*.

But anecdotal distraction from too bald a presentation of physical beauty (of a certain type) for its own sake is provided by a tiny satyr. His presence removes the faun, who lacks the "historical" reality that justified Indian nudity, into a self-contained fictional world to which we can relate only as observers from the outside. We are not admiring a beautiful nude youth while he is sleeping; we are "reading" an amusing episode from the world of pure fancy: a mischievous *baby* satyr (not a big lusty one) is binding a faun to a tree stump while he sleeps. The extent to which contemporary viewers made use of this "diverting" stratagem—the parallel to the deceptions we observed with Venus—is evident in the commentaries. A letter written to a Reverend Robert Collyer in 1867, quoted in the Hosmer memoirs, is typical: "I despair of being able to describe to you that beautiful being, from whose lips the soft breath of slumber seems to come, and the mirth of the wicked little satyr who is tying together, around the tree against which he reposes, the tail of the Faun, and the skin of a wild beast, which form his drapery." The writer gets the tails confused, but shows a quick appreciation of having the satyr there to describe as a relief from the first-acknowledged sensual beauty of the faun himself. A second writer remarked that the satyr gave "life" to a "composition" that without him would have been just another beautiful nude boy.[23]

In the *Waking Faun* (fig. 128) the infant satyr becomes much more prominent; the faun cannot awaken to *our* gaze, and boldly return it like the *Faun* of Praxiteles, but must instead take playful revenge upon the satyr, to which his action thus also directs our attention. "He is imprisoned . . . so gently, so tenderly held that we do not fear for his safety," noted a contemporary critic. Miss Hosmer herself was quoted as saying, "You see he takes it cooly. Fauns don't get angry you know." Not physical beauty but mirthful action was the admitted purpose of such a work. Yet according to one visitor Miss Hosmer had found "the chisel of Praxiteles": "Under her hand the beautiful old myths live again, and all her works are suggestive of noble

meaning, not only expressive of genius themselves, but so full of an exquisite fancy that they would inspire genius in others."[24] Surely a chapel would be the only place suitable for such works. The "noble meaning" of Hosmer's pubescent fauns and infant satyrs, however, is not very apparent. The faun awake reclines even farther than when he was sleeping, swells his breast out even more, and shows a more extended length of leg. The genre still lives (chiefly in photography), but it no longer inspires comparisons with Praxiteles.

The year after Hosmer completed her *Waking Faun*, William Henry Rinehart conceived his *Endymion* (fig. 129), which was completed in marble in 1874. In April of 1875 the young Daniel Chester French visited Rome from Florence, and would have seen the reclining youths of both Hosmer and Rinehart on his visits to their studios. Within a few months he was creating *The Awakening of Endymion* (fig. 130) in the studio of Thomas Ball, who is reported to have been working on the subject himself at this time.[25] Now Endymion was not a faun, but a shepherd, yet he also served very well as an excuse to model a recumbent nude youth. Precedents existed in antique reliefs in the Capitoline, in Renaissance frescoes in the Farnese, and in a work by Canova. Furthermore, unlike the inherently sensual faun, he had the advantage of being thought of as the very type of the dreamy poet (Keats, who wrote a long poem on Endymion, was much in the minds of Anglo-American Romans, who every day passed the house where he died). Endymion was loved by Diana in her celestial form as Luna, yet he was famous for nothing *but* his repose. Ovid tells his story in the *Amores*, but as Bulfinch remarked in a rare moment of humor, "Of one so gifted [with eternal youth and eternal sleep], we can have but few adventures to record." The sensuous aspects of his story—Diana being warmed to love by the shepherd's extraordinary physical beauty (she somehow bore him fifty daughters)—are qualified by the complete passivity and unawareness of the youth in his dreamland. His nudity is enveloped in a cloud of innocence.

Rinehart, nevertheless, has taken further precautions. The amorous presence of Diana is not suggested, as it often was in antique and Renaissance representations, where she is sometimes accompanied by Cupid. The youth himself is also made much younger than Canova had imagined him. Rinehart's *Endymion* is so childlike, and his slumber so deathlike, as to suggest a certain perversity in the goddess. Rinehart's model is reported to have been "just developing into manhood after having served as a child model for several years."[26] This *Endymion* is indeed the successor to the morbid *Sleeping Children* of 1859. Lorado Taft waxed poetic over the figure in 1903, wishing for it a setting of "a trellised arbor or a bosquet where the amorous moonlight might steal in and caress the pale form."[27] A bronze replica of his *Endymion* marks Rinehart's grave in Baltimore.

In contrast, French's *Endymion* is imagined as being awakened by an amorino. In his more upright posture and in the vertical drop of one arm, he is closer to Hosmer's *Sleeping Faun* than to Rinehart's youth. He is also older and more fully developed. By uncrossing his legs he even assumes something like the posture of the Barberini *Faun*, although instead of spreading his legs wide and throwing his arms behind him, he much more modestly uses his left hand to hold in place the piece of cloth at his groin. The line of that arm and the curve of the hand, however, are reminiscent of Titian's *Venus of Urbino* (fig. 64) in Florence, where *Endymion* was realized in

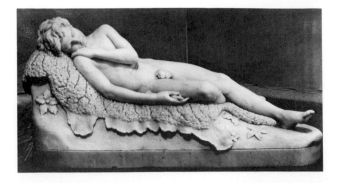

Fig. 129. William Henry Rinehart. *Endymion.* 1874. Marble. Corcoran Gallery of Art, Washington, D.C. Museum Purchase, 1875.

Fig. 130. Daniel Chester French. *The Awakening of Endymion.* 1875–79. Marble. 36 × 58 × 25". Chesterwood Museum, Stockbridge, Massachusetts. A property of the National Trust for Historic Preservation. Original photo by French.

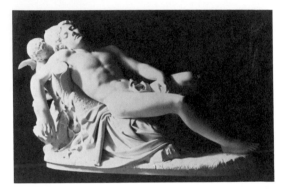

Fig. 131. Benjamin Paul Akers. *Dead Pearl Diver.* 1858. Marble. 27 × 28 × 67". Portland Museum of Art, Maine. Gift of Elizabeth Akers Allen et al., 1888.

plaster. By thus enhancing the moment of Endymion's possible awakening into a sensuous life, and locating the legend's meaning clearly there, the young French has dared to exploit the tension between the actual image and the poetic theme that protected its innocence. In spirit his treatment is closer to Keats's than to either Rinehart's or Canova's. Possibly—in spite of the cute baby cupid—it owes most to the famous erotic painting in the Louvre by Girodet-Trioson, *Endymion's Dream* (1791), in which a naked Eros (no infant he) holds back the foliage to let the lunar light flood down upon the full-bodied semirecumbent sleeper, a Danae of the male sex.

At the other extreme among these American recumbent nude youths is the first to have been created, and the last work of its sculptor, Paul Akers's *Dead Pearl Diver* (1858; fig. 131), made famous like Story's *Cleopatra* through its attribution to the sculptor Kenyon in *The Marble Faun*. Its pose relates to several *Dead Abel*s popular in the period, the classical antecedent for which is one of the beautiful Niobids slain by Apollo and Diana. But Akers (whom we have heard objecting to mythological names) looked about for a contemporary subject. He found his justification for "modern" nudity where others did, among the Italian lower classes, so popular with visitors and artists from the North for their picturesque simplicity. The assumed natural innocence and cheerful charm of boys of this class assimilated them, like Indians, to the fauns and shepherds of pastoral poetry and made their nakedness permissible.

Instead of showing one doing something quaintly useful, however, such as trampling on grapes like a little Bacchus (subject of a work by Lorenzo Bartolini in 1842–44), Akers chose to show one dead from drowning. If a social criticism of the wealthy who bribed the poor to take such risks for the sake of feminine luxuries was intended, the *Crayon* in 1860 failed to perceive it, and the lachrymose tale Akers provided to accompany the statue did not help. The journal confessed to have "no sympathy for subjects of this class" (meaning death), since they were too "negative"; art was supposed to be uplifting. This reviewer, unlike the one of Brown's *Indian* a few years earlier, also claimed to be too ignorant of anatomy to judge its accuracy in this case, but deemed that the *"feeling"* of the sudden conversion of an active youthful life into "the silence and repose of death" had been successfully rendered. When he observed bluntly that the pose "could only be admissible in a figure deprived of life," he touched upon what is most striking about Akers's work.[28] Contrary to the leg-crossing and cloth-clutching attempts of other sculptors to make the genital area obscure or recessive, the diver's position thrusts the pelvis into prominence. The viewer, looking down upon the youth, finds the eye attracted by the intricate carving of the open meshwork intended as a covering. William Gerdts has even referred to it as a "see-through fishnet" illustrating a "peek-a-boo" device adopted as a tease by other sculptors of would-be nudes.[29] Akers himself wrote that "there would have been no need of fig leaves, if the significance of the marble gods had been excavated with them."[30] Does part of the significance of his work lie in the centrality of its ambivalent fig leafing? The absence of any anecdotal side action (such as a sorrowing dog) forces a direct contemplation of a youthful body subsiding into death. This still-transient state is what Hawthorne's Miriam complained of to Kenyon. But it is the meaning of this moment, not deathly repose,

that Akers formally expressed. The second half of Winckelmann's sense of what is beautiful in the Apollino faun form—simultaneity of ripeness and potentiality—is canceled.

Many other Apollini besides athletic Indians and recumbent youths were created by American sculptors in the century between Horatio Greenough's lonely arrival in Rome in 1825 and Paul Manship's return as a teacher in the fully established American Academy in 1922. Shepherd boys, fisher boys, boys at play, and various "Geniuses" of this or that were made to stand, lean, kneel, and prance in the studios of Italy and the parlors and exhibition halls of America. They far outnumber adult male nudes, and the infantile ideal prevails even over the juvenile. The Connecticut sculptor Edward Sheffield Bartholomew, who had given up dentistry "in disgust" (as Tuckerman reports), was inspired to become an artist by reading Cellini's autobiography and to become a sculptor when he discovered he was color-blind. Among the works Bartholomew created in Rome in the 1850s Tuckerman lists a *Campagna Shepherd Boy*, an *Infant Pan and Wizards*, and an unimaginable *Ganymede and Infant Jupiter*. Chauncey B. Ives, also from Connecticut and resident in Rome at the same time as Bartholomew, executed a *Cupid with His Net*, a *Shepherd Boy and Little Piper*, and (when he returned to Rome after the Civil War) a *Fisher Boy*. From all this breed of boys we need consider only three from the decade 1842–53 that have particular but representative significances: Story's *Arcadian Shepherd Boy* (1853), Powers's *Fisher Boy* (1848), and Crawford's *Ganymede* with Hebe (1842).

All these youths are in the first instance academic exercises, necessary explorations of one of the ideal classic forms—the male nude. Powers, having triumphantly demonstrated his ability with the female nude in his *Eve Tempted* (fig. 78), wished to see—and show—what he could do with the other sex, and did so with his *Fisher Boy*. Crawford, having already studied single figures in a life-size *Bacchante* of 1836 and in his *Orpheus* of 1838–43 (which we shall consider in a different context), wished to assay a more ambitious group with two figures, male and female. Beyond these purely sculpturesque concerns, however, the choice of specific subjects is significant. The choices of Story and Powers represent opposite responses to American skepticism about the value of sculpture and all ideal art, and the choice of Crawford represents the neutralization of the erotic component of the Greek tradition in mythology and the art of the male nude.

Story's choice of an *Arcadian Shepherd Boy* (fig. 132) as the subject of his second work of sculpture and his first ideal piece, a choice that seems timid and conventional, may be seen as a symbolic act of defiance, representing nothing less than his choice of vocation. Having been commissioned at the age of twenty-seven to carve a memorial to his father, the potent Judge Story of Massachusetts, William had set off for Rome to learn the art. In the years between 1847 and 1852 he not only did this but also—on returns to Boston—wrote important legal textbooks and a two-volume biography of that same father. Henry James wrote sympathetically of the strain that Story came under in having discovered an alternative life to the brilliant but conventional one that lay open to him in New England. James imagined Story remembering all his life that when he chose sculpture over law, his mother had called him the greatest fool she had ever known. There must always have been a "a voice in the

air" saying, "You would have made an excellent lawyer."[31] So, while honoring his paternal embodiment of the legal system in both print and marble, the most anti-thetical image the aging aesthetical son could simultaneously conceive to negate the one of his father was that which said to him, "You would have made an excellent Arcadian Shepherd Boy: forever young, forever playing your pipe, never hearing of Treatises on Contracts and Property." By creating this other-worldly image of unheard music as a marble counterweight to the prudential father of mundane success, Story released himself to indulge in the historical fantasies of an aesthetically self-justifying intermediate world where he could dispassionately con-template the crimes of famous women and the madness of King Saul. The Boston ideal of Washington Allston (figs. 41, 42) prevailed over the Boston ideal of Judge Story.

"Story's Choice," as James called it, was typical of many of the artists resident in Rome whose conscious repudiation of an alternative life in America was sometimes greater than their talent. But Powers of Florence represents the contrary case. His *Fisher Boy* (fig. 133) was made to serve what it apparently opposed, like the money-making *Greek Slave.* It represents the creation of "useless" and unself-conscious beauty as a commodity. Powers was as skilled as a Yankee mechanic and business-man as he was as a sculptor (which was considerable), and he succeeded in an evident ambition to prove that the "practical" ideals of America were expressible through the profession he had chosen, not alien to it. What he needed in Italy were workmen, marble, and live models, such as were not available in America. What he did not need or expect was a world of art, much less an Arcadia. The fact that Florence was in every way cheaper than Rome was more important than the greater abundance of classical statuary offered by the Vatican and Capitoline galleries, which he waited nine years to visit. Before he got around to the male nude as a subject, he had modeled nearly seventy different realistic busts, his ideal heads of *Proserpine* were going as fast as his workmen could turn them out, and the prospects for profitable exhibition and multiple sales of his first *Eve* and the *Slave* were promising. So it is not surprising that the subject Powers chose for his male nude had already proven its popularity in both sculpture and genre painting. An ideal fisher boy was sure to sell, and Powers wrote that it "should realize $2000."[32]

A notable recent precedent was François Rude's *Neapolitan Fisherboy with Tortoise* (Louvre) of 1833. Seated on a net, he is as picturesque as his single article of clothing—a "funny" cap—can make him. Such a fisher boy is timeless, and there-fore contemporary. In a letter expressing the difficulty of finding a contemporary subject that would "justify entire nudity," Powers stated of his own *Fisher Boy*: "This figure is a kind of Apollino, but the character is modern, for I hold that artists should do honor to their own times, and their own religion instead of going back to mythology to illustrate, for the thousandth time, the incongruous absurdities and inconsistencies of idolatrous times."[33] Powers engaged in an apparently necessary self-delusion. The entire and unself-conscious nudity of a "modern" boy who is obviously no longer a child was probably not justified by a visit to the seashore. Originally conceived with greater plausibility as a boy of eight or nine, the figure developed into a boy of about twelve, possibly as a result of Powers's choice of a model. This model may have been a youth in the Porta della Croce quarter who

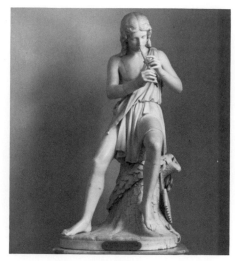

Fig. 132. William Wetmore Story. *Arcadian Shepherd Boy.* 1852. Marble. Courtesy Trustees of the Boston Public Library.

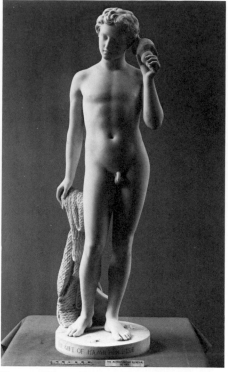

Fig. 133. Hiram Powers. *The Fisher Boy.* 1848. Marble. H: 57". The Metropolitan Museum of Art. Bequest of the Honorable Hamilton Fish, 1894.

possessed an hermaphroditic beauty that Powers admired. It is the type of beauty that Winckelmann placed highest of all in its synthesis of forms, its "commingling" of the best features of the two sexes in "an image of higher beauty," often to be seen in Apollo and Bacchus.[34]

Powers, as he realized, had created an Apollino, and his main interest was not in "modern character" but in an ideal of beauty. Joseph Mozier, a rival sculptor who often made Powers the target of his malicious gossip, even told Hawthorne that the work was copied from the *Apollino* of the Uffizi.[35] In fact there is slight physical resemblance to that youth, and none to his seductive and languorous attitude. Powers's *Fisher Boy* possesses a more classical remoteness than either the *Apollino* or Rude's seated "Neapolitan" boy with his winning smile. The columnar pose that makes him younger brother to the *Greek Slave*, his solemn, foggy-eyed expression as he listens to his conch shell, and the absence of any ethnic or temporal detail in face or accessories, such as partially localized Rude's boy in time and place—all contribute to his remarkably iconic quality. Although some legends of the conch shell have had its sound convey visions of another world, Powers showed his characteristic practicality by stating that it foretold changes in weather. Yet this mundane purpose is not inferable from the statue itself, which in any case gives a more poetic effect than does the teasing of a tortoise. And there is nothing about the

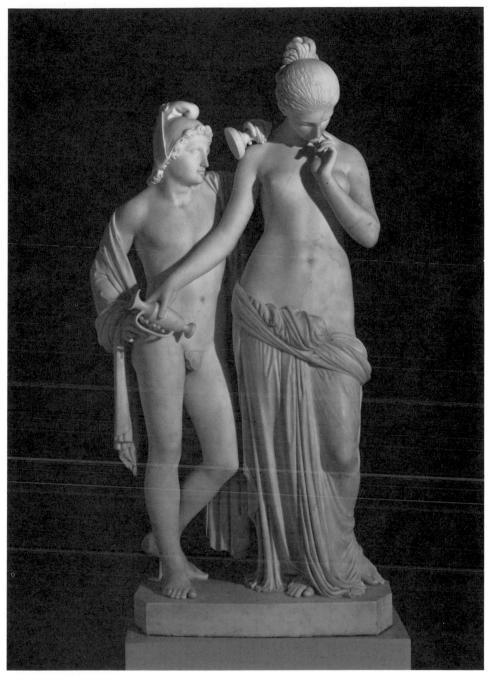

Fig. 134. Thomas Crawford. *Hebe and Ganymede*. 1842–44. Marble.
68½ × 32″. Courtesy Museum of Fine Arts, Boston. Gift of Charles C.
Perkins.

image that "honors" Powers's "own times" and "own religion," other than the growing religion of Beauty. The *Fisher Boy* is a piece of finely carved and finished marble, an object that exists only as art, without significant social context or function, without, in fact, "meaning." Craftsmanship and the profit motive were entirely compatible with the new religion. The demand for the statue was so immediate and so insistent that Powers at first refused to sell, knowing that his price could only rise.[36] He was right; eventually the ideal boy found five buyers, each usually paying more than the last. In 1861 Powers sold still another of his *Fisher Boy*s in London. The French sculptor Jean-Baptiste Carpeaux was in Italy until 1862, and the next year created his own *Neapolitan Fisherboy*. He made him kneel, supplied him with the sharp teeth and eyes of a Neapolitan pixy, and gave him back the cap, the happy smile, the physical vitality and immediacy of which Powers had deprived him. But he let him keep the shell with its charming legend.[37]

The homoerotic appeal of the youthful male nude, which was, as Taine reluctantly recognized, an aspect of the Greek cultivation of this ideal of beauty, oddly surfaces in Crawford's choice of *Hebe and Ganymede* as a subject (fig. 134). It is odd for two reasons. First, the shepherd Ganymede figures importantly in mythology only because his beauty was so extraordinary that it provoked the passion even of the notoriously heterosexual Jupiter, who abducted him in the form of an eagle after Juno's daughter Hebe had stumbled as cupbearer to the gods. Jupiter's infatuation established an association that could hardly be repressed. In Ovid it is the subject of one of Orpheus's songs about the love for pretty boys. It just precedes the song about Apollo and Hyacinthus, whom Benjamin West had painted in 1770 in his most sensuous study of male nudes. The abduction of Ganymede had inspired highly erotic imagery in several well-known Renaissance paintings. In his *History of Ancient Art* Winckelmann included two line drawings of antique works illustrating the subject. One is of a statue in the Vatican that shows a fully developed Ganymede being lifted "tenderly" by an enormous eagle. The other is of a life-size painting showing the "entirely naked . . . favorite of Jupiter" kissing the god (not as an eagle) while he serves him. Winckelmann calls him "one of the most beautiful figures which antiquity has left us"; in his face "such an expression of voluptuousness is diffused that his whole life seems to be merely a prolonged kiss."[38] This picture, the drawing of which was included in all editions including the American translation by George Henry Lodge, was actually a forgery by Anton Raphael Mengs, who fooled his friend Winckelmann, knowing his proclivities. In short, Ganymede was still a known quantity in the nineteenth century. Since the nymphs and maidens whom Jupiter loved were avoided by Americans, why should Crawford have turned to the shepherd boy?

The second reason Crawford's choice was odd was that paired figures (except for Adam and Eve in distress) were also to be avoided, as we have already seen; they were too likely to suggest erotic possibilities. But in the oddity of Ganymede, Crawford found his way around this second prohibition. Ironically, in his invention of an unrecorded sentimental meeting between them on the occasion of Ganymede's succession to Hebe's Olympian duties, there was no possibility that the nude youth and the seminude goddess (affianced to Hercules in any case) would be

taken as a loving couple. Thorwaldsen, under whose direction and in a corner of whose studio Crawford had begun his Roman studies in 1835, had sculpted separately a *Ganymede* in 1804 and a *Hebe* in 1806. They stand in nearly identical poses, holding a pitcher in one hand and raising a drinking cup in the other. A version of Thorwaldsen's *Ganymede*, owned by the Bostonian William Appleton, was exhibited at the Athenaeum in 1839–40, where it was much admired by Margaret Fuller.[39] It is a totally nude figure, appropriately of the Bacchus type, wearing only the Phrygian cap that Winckelmann says identifies that god. A large eagle stands erect against his left leg, looking up at him, as in an antique restored by Cellini in the 1540s. Thorwaldsen's lightly draped *Hebe* stands with downcast face and is clearly the source for Crawford, being entirely different from Canova's cheerful-looking, buoyant goddess. In 1817 Thorwaldsen invented an original group in his *Ganymede with Eagle.* This shows the beautiful nude youth kneeling to offer a drink from his cup to a rather ferocious-looking eagle, as though the youth, not the god, were the seducer. (Thorwaldsen told an American that while he himself modeled the youth, the eagle was entirely the work of an assistant, since he "knew nothing about the bird.")

It therefore seems impossible that Crawford was unaware of his displacement and repression of explicit erotic content as he modeled his mournful pair, the more so in that their side-by-side stance is reminiscent of two other works of paired nudes. One is Thorwaldsen's fondly embracing *Cupid and Psyche*, in which Psyche bends her left arm upward with a cup in hand, and whose hairstyle and drapery (confined to lower hips and legs) closely resemble those of Crawford's Hebe. The other is the antique so-called *Castor and Pollux*, a cast of which remained in the French Academy where Crawford spent many evenings drawing. It shows two nude and melancholy youths, one of whom leans lightly but affectionately upon the other, crossing one leg behind his other and resting his left arm on his companion's shoulder. The pose of Crawford's Ganymede appears to be a slight adaptation of this figure. Ganymede, the sculptor blandly explained, "offers his consolation to the virgin" while "leaning carelessly upon her shoulder."[40] But there was an image behind this image, and there was a more thrilling episode in Ganymede's story behind this event.

The *Crayon* attacked Crawford's *Hebe and Ganymede* as being devoid of all "motive" or "intellectual and moral worth." It was "nonsense, unworthy of serious contemplation," an "abuse of the antique," an "idle freak," and so on at great length.[41] In the same year (1855), however, Thomas Bulfinch turned with obvious relief to Crawford's group (by then in the Boston Athenaeum) as his point of departure for mentioning Ganymede at all in the *Age of Fable.* Simply stating that Jupiter "carried Ganymede away" as the solution to a servant problem, he was able to subordinate that relationship to Crawford's innocuous image of Ganymede and Hebe. He dutifully quoted Tennyson's lines from "The Palace of Art" on "flushed Ganymede, his rosy thigh / Half buried in the eagle's down" (an apparent allusion to a painting by Correggio), since to explain poetic allusions was his purpose, but the context was neutralizing. And Crawford's own Ganymede, in comparison with Thorwaldsen's, is not a sensual figure in spite of his nudity. The expression of his

face is lugubrious, the muscles of his smooth limbs are not articulated, and—more significantly—his stature has been distinctly reduced in comparison with that of Hebe. The group nevertheless received Thorwaldsen's praise, and Crawford might well have imagined himself as soon to receive the neoclassical cup from that Olympian, but as yet unstumbling, demigod of Rome. Certainly Crawford's was not the most enfeebling treatment of the Ganymede story. Bartholomew's, created in the mid-fifties, is described as showing him as a little boy "seated on the back of the eagle, and thus being carried off actually riding, . . . holding on the edge of the eagle's wing—a manifest impossibility in flight."[42] Perhaps it was this work to which Tuckerman referred as the *Ganymede with Infant Jupiter,* reversing their roles more completely than Thorwaldsen had done. But Richard Greenough, a younger brother of Horatio, in 1853 created in Rome a *Boy with Eagle* (Boston Athenaeum) that achieved a complete subversion of the myth. Not love but enmity is represented by a ferocious eagle's attack upon a knife-wielding but highly classical shepherd boy. Nearby, the head of a pathetic dead eaglet droops over the pedestal's edge.

The Apollino figures of Story, Powers, and Crawford, different as they are, should be contrasted with later nude youths painted by Eakins, back in America. Whitman's friend persisted in a belief that the anatomical study of the naked human form was the basis of beauty. The Greeks themselves, after all, had not studied the antique; their works were "modelled from life."[43] The Americans in Italy, of course, did both, but undoubtedly their imposition of the antique image upon the living model was a different process, with different results, from Eakins's own idealization of the real. While photographing his male students naked at the old swimming hole, he could see what the Greeks had seen in their gymnasia. In reordering the images for a painting, he could make them assume all the variety of poses he wished, in order to study the noble contours that the human body is capable of revealing through extension or relaxation of muscles, through turns of torso, through its ever-shifting achievements of equilibrium (fig. 135). Like Crawford, Eakins also affirmed through imitation the values of poses found in antique works, which he did not need to go to Rome to know. Like Story, Eakins sought an Arcadian ideal and, like him, could place a primitive flute in a naked boy's hand (as in *Arcadia;* 1883; Metropolitan). Another antique ideal—that of the hero-athlete—is superimposed through its title upon *Salutat!* (fig. 136), in which the nearly nude wrestler lifts his arm in victory, facing the crowd in the Philadelphia Coliseum. The allusion to the ancient world is also reached through another allusion, that to the gladiatorial paintings of Gérôme (fig. 10), the teacher whom Eakins deeply admired in Paris. *Salutat!* is closer to Whitman than Eakins's Arcadian charades, for when the poet celebrated "lads ahold of fire-engines . . . no less to me than the gods of antique wars," he left them firmly in their contemporary city. Independent and "realistic" as he was, Eakins spoke only for a long tradition—Greek, Renaissance, and neoclassical— when he said that a naked woman "is the most beautiful thing there is . . . except a naked man."[44] Living, like Whitman, in a world less congenial than Rome to such a notion, he wished all the more to make others see what they saw.

In the first years of the twentieth century, the thoroughly Romanized Elihu Vedder, whom we have already seen returning sensuality and mystery to the figure

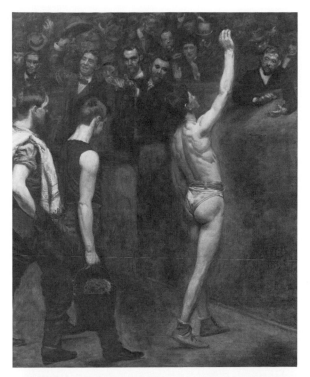

Fig. 136. Thomas Eakins. *Salutat!* 1898. Addison Gallery of American Art, Phillips Academy, Andover, Massachusetts.

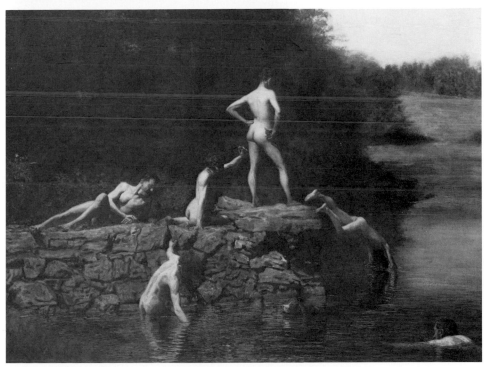

Fig. 135. Thomas Eakins. *The Swimming Hole.* 1883–85. Oil on canvas. 27 × 36″. Fort Worth Art Museum. Purchased by the Friends of Art.

of Eros, modeled a statue of a nude boy for a fountain. *The Boy* (1900–02; Art Institute of Chicago) is a graceful and vital ideal figure in the act of balancing an enormous bowl upon his head as he walks upon an uneven surface and holds his arms outward to keep steady. Vedder had not lived among the fountains of Rome for nothing—especially such a one as the *Tartarughe* with its elegant mannerist youths. Vedder's study for his *Boy* was enlarged and cast in bronze by a new American sculptor in Rome named Charles Keck, himself among those who would go on creating fauns with very twentieth-century physiques and faces and shaggy bronze goatskins around their loins. In conformance with Vedder's sense of the fitness of things, his own *Boy* was entirely nude. Nevertheless, possibly as late as 1929, it was provided with a ridiculous strip of bronze cloth to hide the boy's genitals.[45] Little had changed since Greenough's first sculpture—the *Chanting Cherubs*—had arrived a century earlier to confront demands that they should wear little aprons.

In a country where even the nudity of infants was considered a threat to decency, not much was to be expected from attempts to discover beauty in the adult nude male. While the image of the Apollino—even nude—was obviously one of innocence, that of the heroic male nude was mostly beyond the sculptors' daring and their public's comprehension or tolerance. Perhaps this last is why the mature male nude never interested Powers at all (for that matter, he found no further use for Apollini either). The adult figures that came into existence were usually shown dying or—in this century—sublimated into already dead allegories for world's fairs or the pediments of government buildings.

But on the borderline between the naked youth and the little-explored genre of the heroic male there emerged from the hands of one nineteenth-century American permanently settled in Rome, a singularly beautiful image of noble but melancholy manliness. With the line of its form disfigured by an inevitable fold of cloth across one thigh to the shameful genital zone, William Henry Rinehart's *Leander* (1858; fig. 138) was nevertheless obviously intended to rival the *Antinous* (fig. 137) of the Vatican, the *Meleager*, or even the *Apollo* seen not as god but as perfect man. *Leander* needed his companion piece *Hero* (1869; fig. 96), as she needed him, only to satisfy demands for superfluous narrative. Rinehart, that producer of sleeping marble babes, here came closer than most to proving that the ancient beauty was not irrecoverable and could itself be "enough." His work is the fond embodiment, visual and tactile, of the "Amorous Leander, beautiful and young," of Christopher Marlowe's famous poem:

> His body was as straight as Circe's wand,
> Jove might have sipped out Nectar from his hand.
> Even as delicious meat is to the taste
> So was his neck in touching, and surpassed
> The white of Pelop's shoulder. I could tell ye,
> How smooth his breast was, and how white his belly,
> And whose immortal fingers did imprint
> That heavenly path, with many a curious dint,
> That runs along his back.

BACCHUS, HERCULES, JUPITER:
INFANTS, CHIEFS, AND FATHERS

As fauns or Apollini are more youthful versions of the "ideal male beauty" embod-
ied in Apollo, who unites the "strength of adult years" with "the soft forms of . . .
springtime," so Mars and Mercury are simply Apollo in "maturer years." Except in
Rinehart's *Leander*, nineteenth-century Americans almost entirely avoided cre-
ation of these maturer images of Apollonian male beauty as defined by Winckel-
mann. Some uses were found for the more distinctive variations within the class,
represented by Bacchus and Hercules (who, we recall, were Whitman's gods) and, in
one famous case, for the larger and older image of Jupiter, the father of the gods,
deep-browed but without wrinkles.[1] Conveniently for American taste, both Bac-
chus and Hercules figured importantly as infants in ancient mythology and sculp-
ture, but in America they tended never to grow up.

Winckelmann soundly attacked the erroneous notion that Bacchus is a gross god,
and the several images of him in the Vatican conclusively demonstrated his beauty.
In modern times, however, he was sometimes confused with his teacher Silenus or
even with his son (by Venus) Priapus, which further compromised a reputation
already suspect in temperate America. He could be sufficiently abstracted into
allegory for the purposes of one of Margaret Fuller's "Conversations" in 1839, when,
in opposition to the "celestial" Apollo, he represented "terrene inspiration, the
impassioned abandonment of genius."[2] That idea required no specific image, which
might prove unpleasant. In 1855 the *Crayon* said of Michelangelo's *Bacchus* that
it deserved failure because of its subject—drunkenness. Yet Longfellow actually
wrote a "Drinking Song" (which Bulfinch happily quoted) that described Bacchus's
brow as "supernal / As the forehead of Apollo," and in 1854 it had been possible for
Dr. Parsons to recite a dedicatory ode at the opening of the Boston Theatre in which
he recalled the time when "Bacchus was divine" and went on to equate the rites of
the "rude revellers" who followed him with "the savage dramas of the Indian
bands" who had once performed on the very site where the theater now stood.[3] Thus
were the Native Americans used once more to naturalize a pagan god—one less
likely than Diana—not far from the Merry Mount where two centuries earlier he
had been driven away by the Puritans, along with Jupiter and Ganymede. Yet
although the *idea* of Bacchus as the god of drama and even as the god of wine may
have been becoming acceptable, the *image* of him lagged behind even that of his
Bacchantes.

Surprisingly, the fourteen-year-old Horatio Greenough chose Bacchus as the
subject of his first effort in sculpture, in 1819 in Boston. It conformed perfectly with
Winckelmann's idea of his beauty.[4] But it was only a head with no body. William
Story's *Bacchus* (1863; MFA, Boston), voluptuously full-bodied but not corpulent,
also strictly followed Winckelmann's description of the ideal. The speaker in
Story's poem "A Primitive Christian in Rome" admits that there resided in the old
myths "Something of good— . . . / Of beauty and delight," including "the gracious
joy, / The charm of nature" that "Bacchus represents."[5] But Story's image is only
forty inches tall. In 1858 Story had purchased for the Boston Athenaeum a Roman
cast of the celebrated *Silenus* cradling the infant Bacchus in his arms.[6] Five years

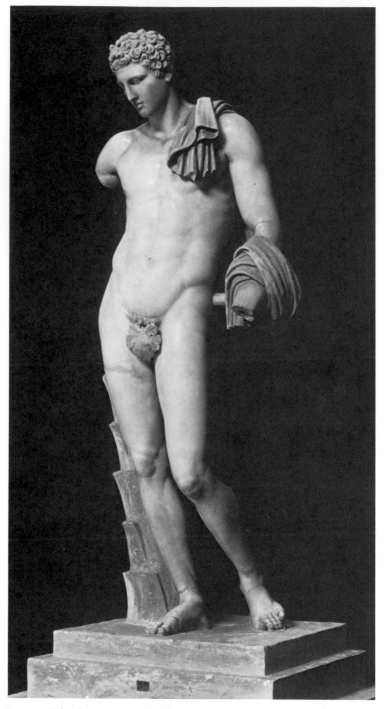

Fig. 137. Belvedere Antinous (Meleager, Mercury). Roman copy of Greek original of ca. 350 B.C. Marble. 1.95 m. Vatican Museums, Rome.

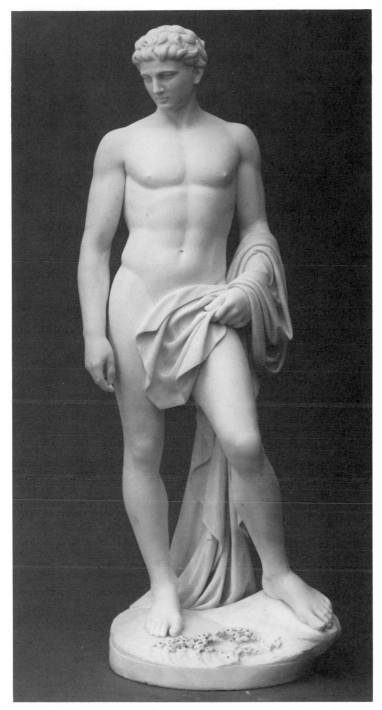

Fig. 138. William Henry Rinehart. *Leander.* ca. 1858. Marble. H: 40″. The Newark Museum.

later he completed not only his statuette of the mature god, but his own *Infant Bacchus on a Panther* (MFA, Boston), a charmlessly chubby child whose fat cheeks, however, do resemble those in the antique work. The Centennial Exposition in Philadelphia in 1876 was honored by the presence of the infant Bacchus with his aunt Ino (who disguised him as a girl after jealous Juno destroyed his mother), sent from Rome by Chauncey B. Ives. But Bacchus full-grown, life-size, and beautiful never really settled in America until Edward McCartan created him in gilt bronze, curled a panther behind his legs, thrust a thyrsus in his hand, and put vine leaves in his hair (fig. 139). Ironically, that was in 1923, during Prohibition. And by then he was no longer Roman in origin or name; he was once again Dionysus.[7]

The prestige of the fatigued and muscle-bound Farnese *Hercules* (fig. 140), whom we have heard Allston and Cole admiring, was not sufficient to make many artists wish to imitate it closely. Harriet Hosmer thought it had been "modelled on the principle of the Fat Boy in Pickwick, only doubly fat and trebly sleepy."[8] But in most antique images of Hercules his physical development has fewer knots and bulges, although remaining distinctly powerful, and Christians had always found his character attractive. The ease with which his labors could be read as moral allegories had helped him to survive even through the Middle Ages when other ancient myths were suppressed; and he had been easily politicized in the "Republican" Florence of the Renaissance. In the eighteenth century the American Puritan divine Cotton Mather found Hercules usefully analogous to New England clergymen. Also, Hercules had performed heroically as an infant. Allegorical thinking and infantilism being familiar American tendencies, Hercules appropriately appeared as an emblem of the Infant America on the side of the chair in which Horatio Greenough's Washington-as-Jupiter sat, an idea good enough to be copied by Harriet Hosmer when she was designing another Washington monument. And America as the Infant Hercules was reasserted as an imperial idea, this time with reference to the future of art, in Paul Manship's fountain in the courtyard of the American Academy in Rome itself.

Thomas Crawford, faced in 1840 with the problem of the excessively developed and notoriously nude Hercules when making another of his Thorwaldsen-like reliefs, solved the problem as he had with his much less imposing Ganymede. According to George Washington Greene, American consul in Rome, Hercules was shown as both colossal and godlike, yet effectively diminished by the female figure who was made to tower over him. In this case she was none other than Diana, "chaste sovereign of the woods," properly clothed.[9]

Hercules could be treated as a grown-up demigod only by painters working in the atmosphere of the first two neoclassical generations. Benjamin West in 1764 composed an academic study called *The Choice of Hercules* (Victoria and Albert Museum), which strictly followed the detailed prescriptions of the Earl of Shaftesbury in an essay called *The Judgment of Hercules* (1712), a work that had influenced Winckelmann.[10] West's Hercules, carefully combined from antique sculptures including the *Meleager* of the Vatican, is seen at the moment when he inclines toward the beautiful and fully draped Virtue instead of the buxom and partially exposed Pleasure. Both high moral allegory and imitation of the antique, as prescribed, were thus achieved. More interesting as going beyond apprentice work is the *Dying*

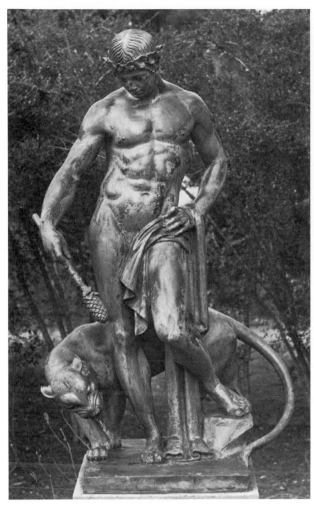

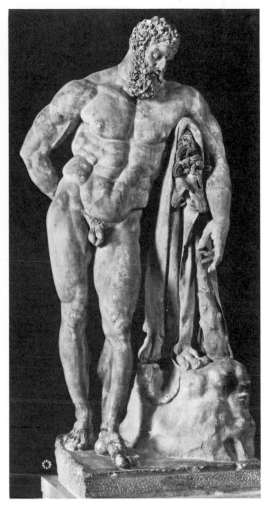

Fig. 139. Edward McCartan. *Dionysus.* 1923. Gilt bronze. Brookgreen Gardens, South Carolina.

Fig. 140. Farnese Hercules. Roman copy of Greek original of ca. 300 B.C. Marble. H: 3.17 m. Museo Nazionale, Naples. Photo: Alinari/Art Resource, New York.

Hercules (1813; fig. 141) of Samuel F. B. Morse, created while he was in London receiving the artistic advice of both West and Allston, and—by mail—the practical advice of his puritanical father, a clergyman who only wished him to come home to New England to earn a Christian living (which he eventually did when he turned to telegraphy). In the meantime he continued his careful drawings from casts of the Borghese *Gladiator*, the Farnese *Hercules*, the *Laocoon*, and other antique figures.[11] When he attempted his own *Hercules*, he first modeled it in clay to aid in the execution of the monumental painting. The sculpture itself was so impressive that it won a prize, and later six copies were made.[12] Morse's is the most "herculean" of all the nineteenth-century American male nudes, but it is actually the central figure of the *Laocoon* (fig. 142)—the father himself in a more recumbent position—given

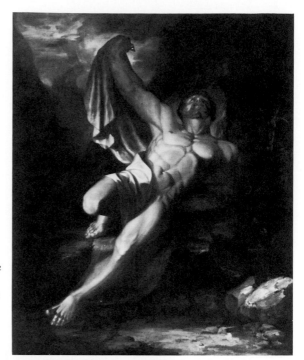

Fig. 141. Samuel F. B. Morse. *The Dying Hercules.* Oil on canvas. 96¼ × 78⅛″. Yale University Art Gallery. Gift of the artist.

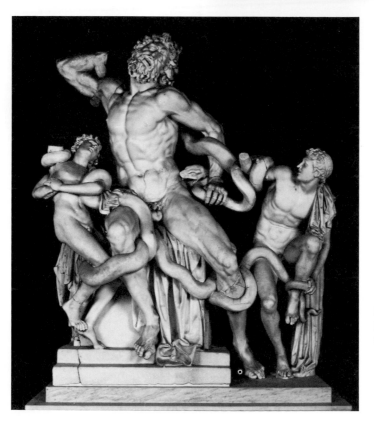

Fig. 142. *Laocoon.* ca. A.D. 50. Marble. H: 2.42 m. Vatican Museums, Rome.

the pectoral development of the Farnese *Hercules*.[13] Its theme—taken from one of the most intense passages in Ovid's *Metamorphoses*—is the agony and anguish of the great hero as he seeks his death on the burning pyre, which would result in his deification. For such a romantic image both the body of Laocoon and the expression of his face were the inevitable authorities; Morse has even imitated the position of the mistakenly reconstructed right arm (now removed).

For the most part, not Hercules himself but dying Indians—and in one instance a liberated black man—provided the chief opportunities for Americans of the nineteenth century to study the male nude whose mature physique connoted great strength—an image that assimilated the more realistic antique statues of warriors and of athletes (wrestlers, gladiators, and discus throwers) to the ideal of the muscular god. In 1804, when Indians were still a powerful threat on a not-distant frontier, John Vanderlyn painted a historical episode of 1777 for Joel Barlow's *Columbiad*, showing Jane McCrea being killed by two Indians who possess the classical bodies and poses of the ancient statuary he also had assiduously drawn in Rome, Paris, and London.[14] By mid-century, however, it was the Indians themselves who had to be shown subdued and dying. Horatio Greenough's *Rescue Group* (fig. 143) for the Capitol in Washington, conceived in 1839 and finished in 1851, placed a nearly nude and murderous savage firmly in the grip of a heavily clothed and classically headed pioneer. The wiry-muscled and almost emaciated figure of this Indian was intended to express his racial inferiority through its departures from the antique ideal. In Boston Peter Stephenson, Harriet Hosmer's first teacher, created a realistic *Wounded Indian* (1850), which, like the semirecumbent wounded Indian in a group called *The Last Arrow* (1880; Metropolitan) modeled in Rome by Randolph Rogers, was a variation upon *The Dying Gladiator* of the Capitoline (fig. 144).[15] In contrast, a seated *Indian Chief* (fig. 145), designed in the mid-1850s by Thomas Crawford in Rome for the *Progress of American Civilization* group on the east pediment of the Capitol, was given a full-bodied classical development and a nobly meditative expression. He is in fact far more Greek than Crawford wished him to be, but the sculptor found that even the realistic portrait busts of Indians with which he was provided could not counteract the ennobling influence of Rome.[16] This Indian chief might well be the image of antique beauty, for he is contemplating his own demise; in the pediment version Crawford placed an open grave not far behind him.

The obvious source for the torso and pose of Crawford's Indian was the *Belvedere Torso* (fig. 146), as it was also for John Quincy Adams Ward's *Emancipated Slave* (or *Freedman*) of 1863 (fig. 147).[17] The *Torso*, often assumed to be that of a Hercules (like Crawford's Indian, it sits upon an animal skin), had excited the admiration of sculptors from Michelangelo on, but it received little comment from visitors who saw it while on their visits to the *Apollo*. After all, there was not much to remark upon except the marvels of its musculature and the size of its thighs. Sculptors, however, could provide it with a context and a theme that released one to admire its physical beauty. Thus Jarves, viewing Ward's *Freedman*, could write: "The negro is true to his type, of naturalistic fidelity of limbs, in form and strength suggesting the colossal, and yet of an ideal beauty, made divine by the divinity of art."[18] Tuckerman quoted another writer who commended the image for representing a real black man, "no abstraction," yet promptly went on to praise Ward for using the classical

Fig. 143. Horatio Greenough. *The Rescue Group.* 1837–51. Marble. Courtesy Architect of the Capitol, Washington, D.C.

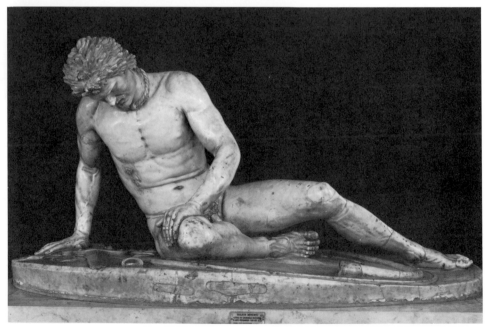

Fig. 144. The Dying Gladiator. Roman copy of Greek original of ca. 240–200 B.C. Marble 0.93 m. × 1.865 m. × 0.89 m. Capitoline Museums, Rome.

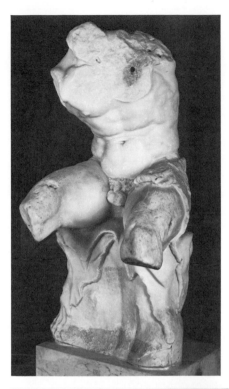

Fig. 146. Belvedere Torso. ca. 150–50 B.C. Marble. H: 1.59 m. Vatican Museums, Rome.

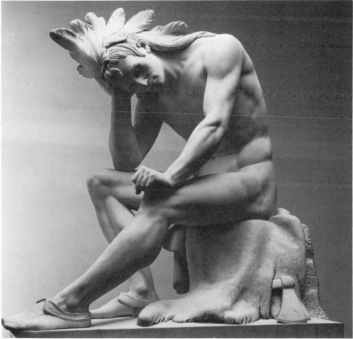

Fig. 145. Thomas Crawford. *The Dying Indian Chief Contemplating the Progress of Civilization.* 1856. Marble. 55". Courtesy The New-York Historical Society, New York City.

procedure for arriving at an ideal type: "He is all African. With a true and honest instinct, Mr. Ward has gone among the race, and from the best specimens, with wonderful patience and perseverance, has selected and combined, and from this race alone erected a noble figure—a form that might challenge the admiration of an ancient Greek. . . . Thanks to the courage and genius of the artist," this "mighty expression of stalwart manhood"—a Hercules, in effect—can now "assert in the face of the world's prejudices, that, with the best of them," the black man "has at least an equal physical conformation."[19] Such recognition of a naturalistically modeled black male as an icon in the religion of Beauty was an important step forward—one long since urged by Ward's friend Whitman when he described a "picturesque giant" with the sunlight falling "on the black of his polish'd and perfect limbs." That the freedman's obvious physical power contributes to the expression of his spiritual aspiration is also impressive. But this statuette, unlike Ward's *Indian Hunter*, was never recast in heroic or even life-size.

Some ambiguity, in fact, must be recognized in this mid-century willingness to expand the repertoire of powerful nude males to include Indians and blacks along with muscular infants, but not white adults. Nowhere in America could there have been erected a public statue of a white man anything like the Herculean and totally nude *Achilles* by the Rome-trained British sculptor Richard Westmacott, unveiled in 1822 at Hyde Park Corner, London. It was from the creation of just such an *Achilles* that Cooper discouraged Greenough with his promotion of feminine and infantile forms. American ambivalence about the meaning and effect of heroic male nudity in art is most evident in the career of Dr. William Rimmer of Boston, for whose most personal works there was no public demand whatever. His powerfully expressive nudes, idiosyncratic as they are in their time and place, are nevertheless related to perfectly conventional attitudes toward the ancient world and toward the body—even the beautiful body—as constituting man's bestial "lower" being. Rimmer revered the classic images as profoundly as any of his contemporaries, and there was nothing revolutionary about his attitude toward them or about the anatomical theories he enunciated in his lectures on art and illustrated in his *Art Anatomy* (1877). These theories, typical of the period, are thoroughly racist in their assumption that the "lower" forms of man are proportionately more animal as they depart from the intellectual Greek ideal. Rimmer's art expresses the anguished conflict between a belief in man as an aspiring intellectual and moral being and the fact that the highest beauty art can know finds its only reality in man's animal form. The high development of that beauty in the male anatomy is, paradoxically, nothing but the perfection of his bestiality.

Rimmer knew the antique images from the casts in the Athenaeum, which he had studied carefully and sometimes lectured upon, and from illustrations in books, including Winckelmann's. In showing the "conformations" of different types of male nudity in his own book, Rimmer produced diagrammatic drawings of the *Apollo Belvedere*, the Farnese *Hercules*, and other antique models, clearly indicating the "ideal" proportions of head and body in different types. The perfect *Apollo*, he noted, is eight and one-half heads high. In his lecture on proportions he explained further that proportions vary with the skulls; the "lowest human types" have skulls resembling those of apes, the opposite extreme from the "classic head": "As a

countenance approaches either one of these types, we call it animal or intellectual." In women there is an "arrest of development," which causes them to retain "child-like and infantile peculiarities." This, however, means that they are "the highest representative, not only of emotion and sentiment, but of intellect also," since in men the continued development of shoulders and limbs and the growth of a beard results in a proportionately smaller brain and an increase of "the animal." Conse-quently, Rimmer preferred to teach only women and to draw and model only men. In men only was there sufficient development of animal form to achieve the highest physical beauty that challenged artistic perception and power, and led to such a realization as: "The thigh is the noblest part of the body."[20]

Physical variations and the moral developments they imply are national and even regional, not merely racial in the broadest sense. The similarity between the American and the ancient Roman seems to have been a factor in Rimmer's great interest in Roman subject matter. "The aggressive or conquering races have convex faces, retreating foreheads, Roman noses, and prominent chins, as the English, old Roman, and the majority of Americans." Julius Caesar had a "head of the highest type," and he looked "like an Americanized Scotchman." Faces of modern French-men and Italians, in contrast, belong "to the very worst type," in which "intellec-tual and emotional" lines of expression exist upon an animal structure, indicating the "fickle, insincere, artistic—in short, Mephistopheles." "All artistic races have concave faces." "Faithfulness and integrity" are commonly found in "a certain lower order of anatomical structure," represented by a drawing of Uncle Tom. And so on. Interspersed in all this are allusions to ancient works—the *Apoxymenes* (*The Scraper*) and the *Laocoon* of the Vatican, the *Illissus* from the Parthenon, the *Fighting Gladiator* of the Louvre. The *Belvedere Torso,* which "represents the disembodied Hercules," is commended for "the relation of the chest to body," and the Farnese or *"Vulgar Hercules"* is found to be a confused mass of "parts."[21]

Rimmer turned to Roman imagery and the Herculean-gladiatorial form in many of his own works. In a drawing called *Emperor, Warrior, and Poet, or Roman History* he combined three masculine images of "human dignity and power" to be subjects of "his contemplation and admiration," according to his biographer, the sculptor Truman H. Bartlett, who knew him. Ancient Roman history "formed a large part of his enjoyment, and one of his most serious studies."[22] Its mythology inevitably appealed to him also as a source for the male nude; he created a *Chaldean Shepherd* and an *Endymion* (both destroyed). But he was most attracted by the anatomical forms associated with the Rome he never saw. In the convergence of these inter-ests—Roman history, myth, and form—he found the motives of his finest works.

When Rimmer was only fourteen he created a small seated male nude called *Despair* (c. 1830), which is said to represent his father, a strange man who had been raised to believe himself the heir to the French throne and who was to die in alcoholic madness. This earlier image is inevitably recalled by the *Falling Gladiator* (c. 1861; fig. 148), an image of heroic defeat created thirty years later, when Rimmer began seriously to work as a sculptor. He also made a related painting called *Lion in the Arena,* obviously derived from Gérôme, which shows a gladiator in the Colos-seum as the antagonist of a magnificent lion (such as Rimmer also sculpted). The sturdily developed human can achieve his heroism only by slaying the noble beast.

horses across the sky of dawn, Rimmer envisioned the sun as the perfect nude (winged but neutered) falling helplessly toward the horizon, dragged down by his animal body, a beautiful but deadly weight.

If the fate of the Dionysian and Herculean types of manly beauty was—with one exception—to be rendered infantile, violent, agonized, or dying, the type of the Father of the Gods was virtually ignored. As a subject he was impossible: on the one hand his sexual forays among humans, which had made him such a delight to the Renaissance, made him deplorable to Americans, besides usually depriving him of human form. On the other hand, Jupiter's nobler image had been assimilated to that of Jehovah in Roman Catholic painting. He was, in any case, a redundancy in the emergent American mythology, since his place had been taken by George Washington, the Father of His Country. The deification of the virtuous and heroic general and president that characterized much of the first part of the century culminated in Horatio Greenough's colossal statue of Washington as the Phidian Zeus with a reversed Roman sword in one hand (fig. 151). Although he is nude only above the waist, that was enough to make even this aspect of the work controversial, both during the decade of its design and execution and after the statue finally arrived in Washington in 1841. Charles Sumner warned Greenough that he should publish his essay in defense of nudity in advance of the installation, but even that would not have prevented the reaction that followed. Both decency and common sense were offended. A confusion of other classical images was produced in the mind of Philip Hone, the former mayor of New York:

> It looks like a great herculean Warrier—like Venus of the bath, a grand Martial Magog—undraped, with a huge napkin lying on his lap and covering his lower extremities and he is preparing to perform his ablutions in the act of consigning his sword to the care of an attendant. . . . Washington was too prudent, and careful of his health, to expose himself thus in a climate so uncertain as ours, to say nothing of the indecency of such an exposure on which he was known to be exceedingly fastidious.[24]

Commenting on Powers's difficulties with a Washington in modern dress a decade later, Hawthorne asked, "Did anybody ever see Washington naked! It is inconceivable. He had no nakedness, but, I imagine, was born with his clothes on and his hair powdered, and made a stately bow on his first appearance in the world."[25] (In editing the notebooks, Sophia Hawthorne changed the word *naked* to *nude.*)

But Hawthorne and others missed the point as Greenough saw it. The form of his *Washington*, he asserted, was determined by its intended position within a domed rotunda.[26] It was to be the central icon in an American Pantheon, and as such could not be like a portrait statue for a public square. Representing an idea that transcended history, it had to be treated "poetically." Sartorial fashion, Greenough held, was no part of the essence—the "natural and permanent." An injury is done to the dignity of heroes by the amusement that later generations find in their outmoded dress. Greenough expected that viewers, coming to his image with their own prior knowledge of the man, would be glad to find in it the idealization of that "complex

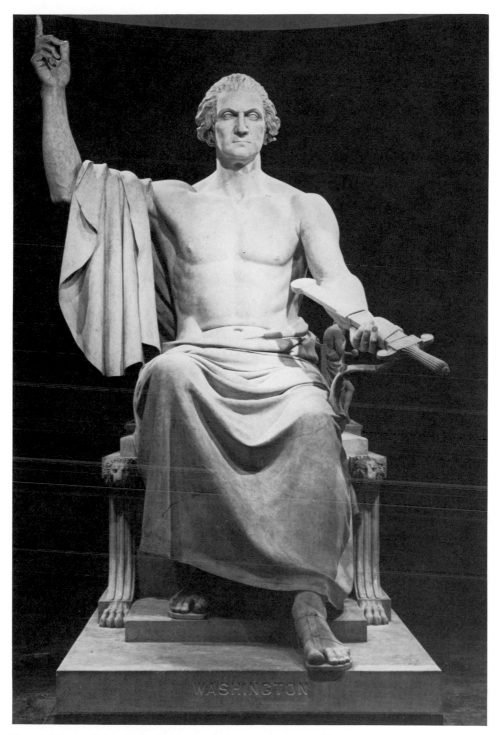

Fig. 151. Horatio Greenough. *George Washington*. 1832–40. Marble. 136
× 102 × 82½". National Museum of American Art, Smithsonian Institu-
tion. Transfer from the U.S. Capitol.

of qualities" that set him apart, not those accidents he shared "with other gentle-men of his day."[27] In such sentiments Greenough showed himself in complete agreement with Canova, who had given Napoleon an entirely nude ideal body in the first decade of the century, and with an older French contemporary, David d'Angers, who modeled a fully clothed *Jefferson*, but nevertheless claimed that even the "foot of a distinguished being has in no way the same form as the foot of a common being"; from the merest fragment we should be able to tell that the original was of a god or hero. "The form of the nude indicates perfectly the morality of the person represented, if the artist has understood that the exterior form of the body expresses very well the moral state of the man."[28] From this point of view nudity could not be exclusively the condition of pagan gods. The dignity of the new democratic and imperial gods—Washington and Napoleon—equally required it. And Greenough was consciously presenting Washington as the American demigod, "a conductor between God and Man."[29]

That, however, placed him even beyond his identity as the Father, in which supremely human capacity Americans had come to worship him. The cult of Washington was more popular and less exalted in feeling than the religion of Beauty. Only those who belonged to the religion, like Tuckerman and Jarves, could see the ideal beauty of Washington's nude breast. It inspired Tuckerman to prayerful verse, and Jarves saw in it a prophecy of the future. Although Greenough had set a unique standard of excellence in this "godlike form" of the "nation's cherished 'father,'" wrote Jarves, it was unfortunately true that by 1864 American sculpture had been "seduced into the facile path of realism by the national bias to the material and practical." But a "new, strong life" was "fast coming upon us," he hopefully went on, sounding like Whitman in the preface to *Leaves of Grass* of nine years earlier. As Americans began to "dignify" their lives with "great ideas and heroic deeds," they would "rise to the level of [Greenough's] sympathies and knowledge," as repre-sented in his heroic and heroically achieved *Washington*.[30]

ORPHEUS IN AMERICA

The sun of Art which glowed in Rome, may rise
To equal splendour in our Western skies.
—*Rembrandt Peale*

Apollo may be seen driving his chariot of the sun westward on one side of the chair in which Greenough's Jupiter-Washington sits. Yet this God of Art was to make relatively few appearances as himself in America. One of Samuel F. B. Morse's student efforts praised by Benjamin West was a *Judgment of Jupiter* (1815; Yale) in which the father of the gods, sitting in his Phidian pose and attended by his eagle, orders the mortal maiden Marpissa to choose between her human hero Idas and Jupiter's divine son Apollo. Apollo reverses the stance he assumes on the Belvedere, and all four figures appear to be inanimate marionette reductions of appropriate antique statues. This painting found no purchaser even in Boston.[1] Allston and Greenough, we recall, simply transformed the *Apollo* into Christian angels, and late in the century in Rome Franklin Simmons followed their example with his *Angel of*

the Resurrection—a work said to be of "incomparable beauty and power ... all flame and force of the utmost exaltation."[2]

Apollo's alert, proud stance and carriage were also to be seen in less obviously divine figures, the new mythical images of the West: the Pioneer—J. Q. A. Ward's *Simon Kenton*; the *Minute Man* of the novice Daniel Chester French, who in 1874 carefully drew the legs of the *Apollo Belvedere* at the Boston Athenaeum before proceeding with his first great work,[3] and the Indian Chief—the *Massasoit* (1922) of Cyrus Dallin, who surprisingly had initiated his student work in Paris in the late 1880s with an *Apollo and Hyacinthus.* The Pioneer, Minute Man, and Indian Chief were successful syntheses of the ideal image with the new national mythology. But William Sydney Mount's witty scene entitled *The Painter's Triumph* (1838; Pennsylvania Academy) indicates the choice that more usually had to be made. It shows a craggy farmer reacting with delight to a painting we cannot see (it might be of his own sharp-featured face), while on the wall the artist's drawing of the *Apollo Belvedere's* head—as disdainful as Winckelmann and Byron thought it—looks the other way. But the third figure is the painter himself, raising his palette instead of a bow as he strikes a triumphantly Apollonian pose and shares his client's simple joy in verisimilitude. Like Marpissa in Morse's painting, the American artist had to choose Idas, not Apollo, unless he found like Whitman that they were one and the same.

There was, however, Apollo's son, Orpheus. Orpheus was the divine Apollo in human form, with an allegorical significance more limited and accessible. The chief episode of his life—his attempt to recover his bride, Eurydice, from Hades—was altogether more appealing than any of the acts of Apollo. A prophet-poet, the founder of a mystical religion of Nature that had puritanic as well as Dionysiac interpretations; the supreme musician, capable with his beautiful harmonies of taming beasts and stopping stones in flight; devoted monogamist, famed for his human courage and grief such as Apollo never knew—Orpheus became the most popular American "god" of the new religion of Beauty, as Diana was the most popular goddess. The details of his post-Underworld misogyny (his "aversion to Venus and nuptial joys," in Vergil's words), his homoeroticism, and his final dismemberment by the enraged women of Thrace did not need to be recalled, any more than did Diana's vindictive cruelty.

The first of the American *Orpheuses* (fig. 152), created by Thomas Crawford between 1839 and 1843, was welcomed to America as a singularly appropriate conveyer of the Greek ideal of beauty from Rome to the West. Its way was paved by the American consul in Rome, George Washington Greene, and by the young patrician and future senator, Charles Sumner, both of whom had watched its realization in Crawford's Roman studio. Even before its arrival, Margaret Fuller gave it an interpretation that incorporated it into Transcendentalism's symbolic systems and demonstrated its modern and American relevance. Afterward, other writers found their own ways of making it at home, and other artists discovered the appeal of Orpheus for themselves.

During his first years in Rome Crawford envisioned extensive exploitations of the mythological world. A series of the seven greatest poets would have begun with Apollo. He also intended to make engravings of nothing less than "the whole of

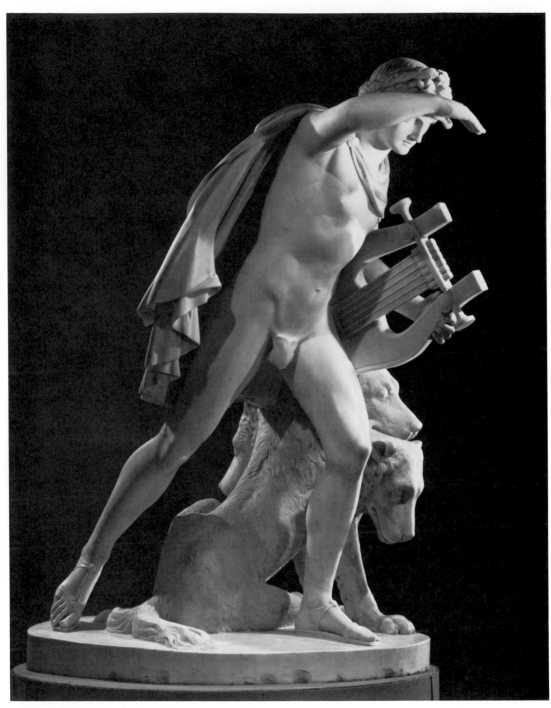

Fig. 152. Thomas Crawford. *Orpheus*. 1839. Marble. 174.5 × 91.4 × 130.8
cm. Courtesy Museum of Fine Arts, Boston. Gift of Cornelius C., III, and
Emily Vermeule.

Ovid," so that customers could choose what they wished him to execute in marble. A bas-relief of six hundred figures showing a *Festa of Ceres* was also projected. All these plans reflect the direct influence of Thorwaldsen, who liked to create related works, and whose vast bas-relief of *The Triumph of Alexander* was considered by Crawford the "great work of modern times."[4] We have already seen the apprentice sculptor's dependency on his master in *Venus as Shepherdess (after Thorwaldsen)* (fig. 72) and *Hebe and Ganymede* (fig. 134). An early plan to sculpt *The Winds* was supplanted by an *Apotheosis of Washington*, which in turn was abandoned for a relief illustrating Anacreon's Ode no. 72 (1842; Boston Athenaeum).[5] This work is nothing but a belated addition to an erotic series Thorwaldsen had created twenty years before in homage to the convivial Greek poet of bisexual love. Crawford's figure of the aged Anacreon was copied almost directly from Thorwaldsen's profile adaptation of an antique statue of Anacreon. But in Ode no. 72 (assembled in Moore's translation from two fragments) the American found one in which the poet simply urges a "virgin, wild and young" to dance to the music of his lyre—a less suggestive lyric than, for example, "Love's Night-walk" (Ode no. 3), which inspired Thorwaldsen's rain-dampened pubescent Amor being warmed and dried by Anacreon as he pricks the old man with his dart. Moreover, the phallic thyrsus and capacious jug of wine that frame the lyre in both of Thorwaldsen's designs— indicating the inspirations for Anacreon's songs—were reduced in Crawford's work to a chastely slim pitcher (probably full of water).

Yet, even though he lacked the assurance with which Canova and Thorwaldsen, as children of the eighteenth century, had been able to celebrate Greek eroticism in white marble without jeopardizing their reputation as Christian sculptors, the uneducated Crawford's interest in myth as integral to a sculptor's intellectual equipment seems to have been genuine, as he read industriously in translations of the Greek poets. Of the lost or unfinished works listed by his biographers, one-third are from classical mythology (twice as many as those of Christian subjects): Apollo, Diana, Ceres, Flora, Vesta, Psyche (in groups with Cupid, Jupiter, and a Bacchante), Cupid (several times, but never with Venus), Mercury, Hercules, Io, Euterpe, Paris, centaurs, and even a Bacchante-as-Autumn (his first life-size work) and a nymph and satyr. Of the relatively few mythological works that were finished and have survived, however, all except the fine *Flora* of 1853 (Newark) were completed before the *Orpheus*. From all this aspiration, only *Orpheus* emerged as an original and convincing achievement and made a personal statement.

The work was conceived after more than three years of arduous study and apprenticework in Rome, during which time Crawford had drawn from the antique statues of the Capitoline and Vatican, from live nudes at the French Academy, and from corpses in the mortuary. His image of Orpheus entering the Underworld was executed with the passionate self-projection of someone who had written home concerning his move to Italy, "I know I am venturing much; it is what few have dared to do."[6] The subject was taken from the tenth book of the *Metamorphoses* and the fourth *Georgic* of Vergil, although in Charles Sumner's promotional article, which was adapted for the official Atheneaum exhibition program, only Vergil— "the sweetest poet of antiquity"—was cited as the source, supplemented by a passage from the less-known Renaissance poet Poliziano.[7] Crawford wrote to his

sister that he showed the moment when Orpheus, having tamed the monstrous Cerberus with the music of his lyre, "rushes triumphantly through the gates of hell."[8] There was neither an antique nor a modern model for this scene; Crawford's choice was intended to be original and personal, and it was significant as a precedent both in what it included and what it avoided. The lyre—Apollo's gift—and the three-headed monster Cerberus (unfortunately comical both in his anatomy and in his music-induced sleep) together convey the allegorical theme of music's power over chaotic nature. This alone would be Orpheus's chief meaning in most later American works. The specific pose of Crawford's hero makes the work popularly appealing on even simpler grounds, since it is readily readable as a universal image that could be called *Searching*, without recourse to myth. Those who know the story can find further satisfaction in recognizing the lover rushing into the Underworld to recover his bride. Crawford "has presented the *rare* husband at the moment of entering hell," Catherine Maria Sedgwick wrote rather pointedly after viewing the statue in Rome.[9] Like most Americans after him, Crawford preferred the image of the young and hopeful Orpheus over the grief-stricken man. Canova's early *Orfeo* is the antithesis of Crawford's: it shows the hero in a tortured baroque twist of the torso as he realizes that his backward look has lost him Eurydice forever. Crawford's preferred moment is that of initial success and high expectation.

But Crawford was not interested simply in his theme. As we by now realize, for most so-called literary sculptors (Story being exceptional), the theme is really a means to the true end. This subject, Crawford said, was "admirably adapted to the display of every manly beauty" and would be "clear of all extravagance in the movement, . . . as nearly as possible in the spirit of the ancient masters."[10] In choosing a partially draped figure in motion, however, he has doubly distinguished his work from that of his modern master, Thorwaldsen, whose ideal male figures are persistently reposeful and always totally nude. In providing Orpheus with a cape Crawford obscured his nudity from the rear, but also fell into the danger of imitating the extravagantly swirling cloaks of Bernini's school. This, he particularly remarked, he would avoid by imitation of the gracefully flowing folds of antique drapery, such as falls from the left arm of the *Apollo Belvedere*.

In one of his "Letters from Rome" published in the *Knickerbocker*, George Washington Greene expressed full appreciation of the statue's narrative interest, but wrote at even greater length of the harmonies and symmetries of Orpheus's physical form. Its "beauties" had to be "of a different order" from those of the *Apollo*; while Orpheus was "endued" with "as large a portion of the divine spirit as ever was granted to mortal man," yet he was "the slave of human passions." Thus his beauty should be as near as possible to the "perfection" of the Greek divinities, "but still distinguished from it, by clear and definite lines." Greene obviously perceived Crawford's Orpheus as the representative Anglo-American young gentleman from a college preparatory school: "The frame is neither powerful, nor slight, but that well balanced medium, which belongs to health, and a perfect command of all the physical powers. His strength is not that of the arena, nor the bone and sinew of daily toil, but such as must gain by healthful exercise in the sunlight and open air. . . . The development of the muscles is carried just far enough." Greene also explained to Americans that sculpture was inevitably classical—the Greeks having

invented the "language" and provided "an appropriate term for every idea, a form of expression for every shade of thought, an ideal beauty for all the varieties of intellectual and physical power. . . . How different the beauty of the Apollo [is] from that of the Gladiator!"[11] Orpheus was the mean between these extremes of divine refinement and animal physicality. In him the beauty of Apollo was moderated to human (yet heroic) proportion, just as Apollo's divine genius was adapted to the experiences and needs of humans in a natural world. Crawford, in fact, stated that only the presence of Cerberus made it possible to distinguish his Orpheus from an Apollo, since "the attributes of lyre and wreath" belong to both.[12]

Although Orpheus's pose recalls that of certain antique running athletes, his body is a smaller version of the *Apollo Belvedere*'s, both in its flat triangular chest with very slight separation of thorax from abdomen, and in smooth modeling of the limbs with little indication of tendons, sinews, or veins. In all this it adheres perfectly to what Winckelmann described as appropriate to the divine body, as opposed to the human. Thus the criticism of the sculptor-historian Lorado Taft early in this century—that *Orpheus*, while "well-proportioned," has an "effeminate and characterless" head and an unarticulated body "smoothed over" with "slight regard for anatomy"—merely echoes the criticism of the *Apollo Belvedere* that had by then become commonplace.[13] The masculine types with highly articulated musculature that Taft preferred had been lamented as vulgarly realistic by Jarves when they had started appearing sixty years earlier. To the painter Thomas Hicks in 1859, Crawford's *Orpheus* had been "heroic manhood inspired by Genius," and to the young Charles Sumner in 1843, he possessed—like all Crawford's works—the "heaven-descended" air, "simple, chaste, firm, and expressive," of the ancients and of their modern successors Canova and Thorwaldsen, to whom now could be added, according to foreigners in Rome, Crawford the American. The *Orpheus* proved that "an American may rival Phidias," said an Englishman, adding, "How such a man can emerge from your back woods into the eternal city I cannot imagine." Sumner quoted such remarks at length, claiming that "the best judges" compared the *Orpheus* with the *Apollo*. A *Knickerbocker* note in 1841 reported that Thorwaldsen "esteems Crawford as his successor."[14] When Thorwaldsen died in 1844, just as Crawford's fame was born with his *Orpheus*, the continuity of the ancient ideal and its westward transmigration seemed assured.

Appropriate as his *Orpheus* was, both as aesthetic demigod nature-tamer and as gentlemanly physical type, to serve as the vehicle for transferring the Greek ideal of beauty to America, Crawford had one worry about his reception: in spite of his cloak, he was nude. Crawford hoped that the beauty of Orpheus would itself be the strongest argument against "the breeches and cock'd hat taste for sculpture," for he meant his musician to be "an advocate for the beauty and purity of nature." Although he provided Orpheus with a small fig leaf, he feared the "maudlin fastidiousness" of "Sunday School mistresses" who would surely propose to make a shirt for him, just as the "old ladies" of Boston had offered diapers for Greenough's *Chaunting Cherubs*. "Many a hearty laugh have I heard in Europe at the expense of these dames and their tailoring specimens." Nevertheless, he could proudly say that "old Thorwaldsen has seen it and is satisfied." And Crawford had dreamed of an even higher approval. One night, when his clay model had first taken its shape in his

studio, he wrote to his sister that he saw it lit up occasionally in the dark corner of his studio by flashes of lightning. "This inanimate creation of mine" seemed to start to life, and the aspiring sculptor recalled the story of how Phidias had asked for a sign of approval for his Jove and saw it in the lightning. "Were we living in that age, or were ours the religion of the Greeks, I too might interpret the sign in my favor."[15]

For the present his own age seemed adequately receptive, and the priests of its new religion of Beauty were interpreting all signs in his favor. Sumner and Greene, with an enthusiasm engendered by watching the *Orpheus*'s long gestation in Crawford's Roman studio, enlisted the aid of all the classicists of Boston—Felton, Everett, Ticknor, Longfellow, Hillard, and Allston—in preparing one of the warmest welcomes a work of art ever received in America. In the spring of 1844 it was unveiled in a building especially built for it on the grounds of the Boston Athenaeum, where it drew appreciative crowds. Nothing Crawford did was ever more acclaimed than this ideal image of beauty, courage, triumph, and eager expectation. In March 1858, four months after the sculptor had died famous, rich, and full of commissions, Hawthorne visited his studio in Rome and concluded that neither had he ever made anything better. Surveying all the works left behind, Hawthorne thought them mostly "common-places in marble and plaster, such as we should not tolerate on a printed page." Among them were certain other characters of American mythology: the ludicrously histrionic and dwarfish *Expulsion of Adam and Eve* (Boston Athenaeum) and the monumental *Equestrian Washington* for Richmond ("a very foolish and illogical piece of work"). Hawthorne then recalled seeing the *Orpheus* "long ago" in Boston. Crawford's premature death, he thought, had deprived the world of nothing of value; he had already "done his best, and done it early in life."[16]

That "best," however, had been gratefully heralded. Margaret Fuller was among those caught up in the preparatory publicity for the arrival of *Orpheus* in Boston. Evidently having seen the engraving of Crawford's early drawing of the work in the *United States Magazine and Democratic Review* in May 1843 that accompanied Sumner's erudite commentary, she meditated on its relevance for "our own day and country." Struck by the coincidence of "the American, in his garret in Rome, making choice of this subject" while some of his countrymen "here at home" showed "such ambition to represent the character, by calling their prose and verse "'Orphic sayings'—'Orphics,'" she thought Orpheus must have special significance. She herself had reluctantly published Bronson Alcott's "Orphics" in the first issue of the *Dial* in 1840. Nothing had subjected that journal to greater ridicule, and Fuller now plainly stated that the "Orphic" poets had not "shown that musical apprehension of the progress of Nature through her ascending gradations which entitled them" to use the hero's name. In fact "their attempts are frigid, though sometimes grand; in their strain we are not warmed by the fire which fertilized the soil of Greece." Yet Orpheus himself is still relevant: "He understood nature. . . . He told her secrets in the form of hymns, Nature as seen in the mind of God. His soul went forth toward all things, yet could remain sternly faithful to a chosen type of excellence. Seeking what he loved, he feared not death nor hell; neither could any shape of dread daunt his faith in the power of the celestial harmony that filled his soul."

Orpheus was then something more than Greene's gentleman with genius, he was

a Transcendentalist. And the Transcendentalists were the avant-garde of America. "Reading" Crawford's sculpture, Fuller felt that it, more than the "Orphics," had caught "the state of things in this country." It showed "the seer at the moment when he was obliged with his hand to shade his eyes," a theme for which Fuller then composed a sonnet which begins "Each Orpheus must to the depths descend; / For only thus the Poet can be wise." The harmonizing, unifying, solacing, and transforming duties of the self-sacrificing poet-musician-lover were successively versified, with the conclusion that "If he already sees what he must do, / Well may he shade his eyes from the far-shining view." Fuller missed the point of the pose (Orpheus shades his eyes to see down into darkness), but she was well on her way to her own point, adapted from Sir Francis Bacon's contrast between Ulysses and Orpheus in relation to the Sirens. The "voluptuous song" of the Sirens was so enticing that Ulysses—knowing his own weakness—had had himself bound to the mast so that he might hear and understand the song without succumbing to it. " 'But Orpheus passed unfettered, so absorbed in singing hymns to the gods that he could not even hear those sounds of degrading enchantment.' " The perfection of Man, claimed Fuller, would arrive when men, like Crawford's Orpheus, unflinchingly faced their heroic challenge and, like Bacon's Orpheus, found in their ecstatic activity their resistance to the degradations of the flesh. Then in a brilliant (if somewhat confused) reversal Fuller found an application more particular to herself and to all women: "the time is come when Eurydice is to call for an Orpheus, rather than Orpheus for Eurydice." Claiming that the "idea of Man" had already been realized, "however imperfectly," more than that of Woman, Fuller yet evidently meant that Eurydice could through her own development be the instrument of an even greater freedom for Man. Facing the "far-shining" view of what lay before her, Woman would come to realize her potentialities for love, courage, and self-redemptive action. She could then summon Man from his own particular Hell.[17]

Fuller's highly idiosyncratic reading of Crawford's *Orpheus* seems to have stirred no responses. Others were content to see him as "The eternal type of constancy," as expressed by Dr. Parsons in his elegy on Crawford, "The Sculptor's Funeral":

Keen Orpheus, with his eyes
 Fixed deep in ruddy hell,
Seeking amid those lurid skies
 The wife he loved so well. . . .
Thou marble husband! might there be
More of flesh and blood like thee!

Parsons identified Crawford himself with Orpheus and declared that his body should have remained in the only place worthy of him:

Lay him with Raphael, unto whom
Was granted Rome's most lasting tomb;
 For many a lustre, many an aeon,
 He might sleep well in the Pantheon,
Deep in the sacred city's womb,
The smoke and splendor and the stir of Rome.[18]

The clergyman Samuel Osgood, to the contrary, emphasized the Western iden-
tity of Crawford, and an American meaning for his *Orpheus*, when he delivered an
address before the New-York Historical Society in 1875 in honor of the gift to that
institution of Crawford's *Indian Chief*. Pointing out that the third centenary of the
death of Michelangelo was being celebrated just as the United States prepared for its
first centennial, Osgood observed that Crawford's *America* atop the Capitol held
out a fairer promise than Michelangelo's dome of St. Peter's in Rome, and his
Washington in Richmond had a far nobler subject than the Medici commemorated
in Michelangelo's tombs in Florence. Both Michelangelo and Raphael had made
antiliberal uses of their art, whereas Crawford was the ally of liberty. Now America
could play the role of the Roman Daughter and "give back the tide of life to her
parent" in art, Italy.

Nowhere was this more evident than in the *Orpheus*. Osgood recalled that in
George Washington Greene's commemorative discourse upon Crawford in 1857, he
had said that while serving as American consul in Rome he had thought of the
Orpheus as an image of Italy itself, "looking . . . into the underworld, and, like him,
vainly trying to recall its cherished past, that lost Eurydice." But Crawford himself
was also the American *Orpheus*, the emissary of the "Land of Hope" to the "Land of
Memory," wishing to raise the dead in "Italy, that mausoleum of humanity."
Crawford's vigorously youthful image contrasted with the "sterility" Osgood had
observed in the work of the contemporary Italian Tenerani. Like Goethe, Crawford
brought gothic blood to the classic ideal and thus settled "the question that sculp-
ture is a modern art": It "allows the modern inward life to show itself with the
antique strengths of form. Orpheus is a Greek and a Christian too, and he faces
toward the Shades of Erebus with limbs trained in the palaestra and with a soul
illuminated by the light that is not of this world. This work is a prophecy of our
coming literature as well as art." Crawford had shown that the American alterna-
tives need not be "spindly pietism" or "muscle and materialism"; "body and soul go
together." At the moment of the gold rush to the west, Crawford's *Orpheus* had
brought "some conspicuous help from the land of art to give America her true
beauty before the world, and to lift her above the materialism that threatened her
life."[19]

Whether for such reasons and with such effects or not, Orpheus continued to attract
American artists over the next century, more than any other classical subject except
Diana. From Rimmer and Story to the abstractions of Mary Callery (1951) and
Richard Lippold (1962), at least twenty artists (including several immigrants) cre-
ated over two dozen *Orpheus*es. During the same period Swiss, Swedish, German,
Italian, and Polish sculptors, along with painters, poets, and filmmakers, were, of
course, also attracted to the Orpheus theme, all with more or less seriousness and
even grimness of symbolic intent. But I have found no American severed heads of
Orpheus, lying upon his lyre, such as exist in French art. American thematic
emphases, which naturally affect the treatment of this particular masculine form,
are primarily three: the tamer of nature, the faithful lover, and the ecstatic musi-
cian. Consequently, works consist of nude-male-with-wild-animal or nude-male-
with-female groups, or the isolated expressive figure. We may briefly consider the

first two groups, and look more particularly at two of the inspired musicians, created by sculptors for whom the experience of Rome predominated over Parisian training and whose other studies of the male nude serve to define their achievement of a golden mean in the Orpheus-Apollo type.

The first group really begins not with Orpheus, Apollo's son, but with Apollo's musical challenger, the audacious satyr Marsyas, whom Apollo eventually flayed alive. As painted in 1876 by Elihu Vedder in Rome (the first of three versions),[20] Vedder's *Young Marsyas* (fig. 153) may be seen as this artist's typically satyr-ic placement of himself at an angle to the Apollonian academic ideal. That ideal had been represented by his friend Frederick Leighton's early and misbegotten *The Triumph of Music* (1855–56), a much-publicized heroic image of Orpheus (playing a modern violin) for which Leighton's other friends, including Robert Browning and Harriet Hosmer, had had great hopes.[21] Vedder, in competitive contrast, created his Marsyas as an unequivocal satyr by giving him a goat's body from the waist down. Squatting on the ground, Marsyas plays his long pipes to a crowd of attentive hares. He is himself half-animal.

Vedder's *Marsyas*, it has been suggested,[22] may have been one influence—along with Gérôme—upon the *Orpheus* painted in 1890 by George de Forest Brush (fig. 154). It constituted a diversion from his French production of beautifully proportioned seminude American Indians before he turned to his next specialty (as a resident of Florence), neo-Renaissance *tondi* of his madonnalike wife and their children. Brush's *Orpheus*, seated upon the ground and clothed only in a laurel wreath and sandals, differs from Vedder's *Marsyas* in showing some loyalty to the academic ideal, yet his model has been painted with enough fidelity to make this Orpheus seem—in spite of his Roman nose—both primitive (hardly different from a musical Indian) and contemporary—rather tough looking, in fact. He strums with a dreamy and rather melancholy air upon a magnificent lyre that rises from his groin, while four charmed hares gaze up into his face. One thinks of Whitman's Messiah, who was both "hankering, gross" and "mystical, nude." In any case Brush's rabbit tamer was imagined not as the carrier of civilization but simply as the mystically natural man, one version of the Transcendentalist ideal. Yet the painting also conveys the amusement of a sophisticated artist depicting a merely instinctual brute—an attitude that would be further evident three decades later in the "classical" paintings of Bryson Burroughs, including his own *Young Orpheus*.

Two sculptors who envisioned Orpheus as the animal charmer were not satisfied with the relatively unsculpturesque forms of hares. John Gregory and Albert T. Stewart chose leopards and panthers (or at least panther cubs). John Gregory conceived the idea of his first *Orpheus* while a student at the American Academy in Rome in 1912–15. The lyricism of his several *Orpheus*es was initially restrained by the contingencies of geometrical design, since Gregory, like Manship before him, was influenced more by Archaic Greek work than by the Hellenistic icons that attracted earlier generations. By 1941 Gregory's realization of the concept had been substantially modified from the relieflike work of 1918, and a more muscular, mature, and monumental Orpheus controlled the behavior of two beasts rather than one (fig. 155). Yet the rigidity of frontal and profile composition—especially awkward in dancing panthers—remained,[23] and so far as an idea penetrated the form, it

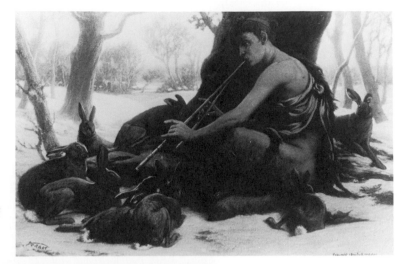

Fig. 153. Elihu Vedder. *Young Marsyas Charming the Hares* (destroyed). ca. 1876. Oil on canvas. Photo from Archives of American Art.

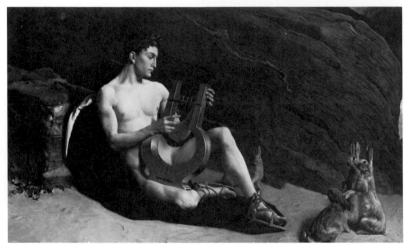

Fig. 154. George de Forest Brush. *Orpheus.* 1890. Oil on wood panel. 12 × 20″. Collection of Jo Ann and Julian Ganz, Jr., Los Angeles.

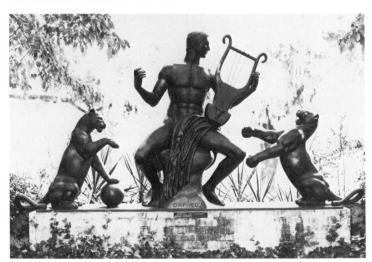

Fig. 155. John Gregory. *Orpheus.* 1941. Bronze. H: 5′7″. L: 9′7″ at base. W: 1′6¾″ at base. Brookgreen Gardens, South Carolina.

was that of a circus performer dangerously nude. The *Orpheus and Tiger* of Albert T. Stewart, a student of Manship's who eventually specialized in animals, is a statuette in which the musician's right-angled kneeling body merges with the ecstatically swooning couchant tiger against which he leans.[24]

Among those who thought of Orpheus in relation to Eurydice was Manship himself, who turned to the theme twice, in 1927 and 1935. In 1954 he created an *Orpheus* alone. Like some of Gregory's versions (with equal reduction in power), Manship's are decorative statuettes, displaying symmetrical opposition of line, but not relating as narrative. *Eurydice* assumes the horizontal pose of a floating naiad, her arms and head raised in what may be either supplication or farewell, while *Orpheus* kneels on one leg and stretches the other behind him to create a long diagonal with his raised chest. He too looks upward like a Guido Reni saint and cuts short the gesture of his strumming arm to terminate the composition in a sharp vertical that echoes the horns of the lyre on the opposite side. Incoherence of subject is again the result of Manship's use of myth.

French-trained sculptors seem to have taken the relation between the lovers more seriously, finding it a challenge to genuinely expressive form. It was the subject of student work by Gutzon Borglum (still far from conceiving the colossal icons for Mount Rushmore's "Shrine of Democracy"), as it was for Bela Pratt. The forcible separation of the loving pair was theatrically interpreted by the Rinehart Scholar Joseph Maxwell Miller in the neobaroque style he learned in Paris under Verlet. A life-size *Orpheus and Eurydice* by Nathaniel Choate—amply embellished with oak branches, squirrels, and owls—is somewhat ambiguous: Orpheus is playing his lyre while a semirecumbent Eurydice may be arising from or falling back into her spectral existence.[25] But Americans generally left the tragic drama of reunion and separation to the French themselves, and Rodin in particular, who not only carved Orpheus and Eurydice emerging from the earth (literally from the rock) but also dared to show Orpheus in his fatal encounter with the Maenads. Coincidentally or not, immigrants to America preferred a happier Orpheus. Most notably, Jacques Lipchitz, the Paris-trained Lithuanian who came to America in 1941, called his work *The Joy of Orpheus* (1945), not "Orphée aux Enfers" or "Orphée Mort," like some of the fellow artists he left behind on a war-ravaged continent. Lipchitz wrote that the statuette expressed "the love of my wife," the two figures merging into the harp with grateful hands upraised.[26]

William Rimmer seems to have been the first American after Crawford to conceive of Orpheus as an isolated figure. Uniquely among Bostonians, he declared that Crawford's statue was "one of the worst examples of modern art," since it typically failed to enhance "all male peculiarities" in the "masculine form." Yet in the next breath Rimmer condemned Ward's *Indian Hunter* for emphasizing "individual peculiarities" at the expense of the "ideal generalizations" required by "high art." In 1867 a British reporter who praised Rimmer's *Falling Gladiator* wrote that he was then "modelling, in the classic style, a full-length figure of ORPHEUS (singing against the Sirens), not unlike in conception to Raffaelle's *Apollo contending with Marsyas.*"[27] This work might have demonstrated Rimmer's attempt to resolve the two equally objectionable tendencies of Crawford and Ward, but its fate is unknown. An *Orpheus*, also unknown, is listed among the works of William Wetmore Story for 1883–84.

oil and dirt from his thigh (Vatican). Here not even ideality of conception (as with Jupiter-Washington) could be pleaded. Only "history"—not the recent revolutionary history claimed for Powers's *Greek Slave* but simply ancient common custom— justified a greater nudity than contemporary sports figures, even boxers, provided. That seems to have been enough. The heftily built *Scraper* (fig. 157) was displayed amid the Roman grandeur of the 1893 exposition in Chicago, where it must have appeared quite in its place. That both of Niehaus's athletes, in their preoccupation with their own activities, show no self-consciousness about their calmly natural display of superb physiques, probably helped. Their physical form is after all what interested Niehaus and still interests all viewers, who yet need suffer no bold-faced return of gaze, and may (if they wish) chatter about the exotic athletic artifacts, just as they had about Harriet Hosmer's little satyrs while looking at her fauns.

The third male nude surviving from Niehaus's Roman period is a potbellied *Pan* who is also thoroughly absorbed—in his piping and his dancing. No beauty, and an exotic in himself, he needed no diverting accessory. Equally intent on a totally different activity is the colossal *Driller,* which Niehaus made at the turn of the century for a monument to industry in Titusville, Pennsylvania. But this kneeling man—no fisher boy or shepherd boy nor even a youth taking a swim, but a mature worker driving a stake into rock—is totally nude. Only his clearly understood status as allegory—a mode of existence that had previously permitted occasional seminudity among gods and goddesses—makes his nakedness acceptable. Yet it does seem to remain nakedness, not nudity, for the image of a beautiful physical form in this sort of muscular exertion inevitably suggests absurdly dangerous exposure. Men at hard labor are not athletes, singers, or gods.

All these male nudes by Niehaus—even the *Pan* in his mythological character— were preparations for the *Orpheus* in Maryland (fig. 158), which, however, as an ideal figure has less muscular—but by no means effete—proportions. Chosen from over one hundred submissions to honor the author of the national anthem, Niehaus's *Orpheus* represents public acceptance of the heroic male nude as something more than an enigmatic allegory crouching beneath a cornice. Relief in fact was expressed that instead of another prosaic portrait of an unfamiliar figure, America had been given a beautiful symbol of "primitive music."[31] In a classical *contrapposto,* Orpheus plucks the lyre held on one hip and gazes outward and slightly upward—perhaps at a banner in Aurora's early light. The Americanization of Orpheus was now final, eighty years after Crawford's image had sailed from Rome. Niehaus's version is closer to his Roman athletes and American laborer than to Crawford's Apollino and may even possess some spirit of the *Pan.* But—with no Cerberus, panther, or Eurydice in sight—he could pass as an American Apollo, for he seems to make a proud and conscious display of his Greek male beauty. He is at least unequivocally the demigod of music, and one suspects that surely he is singing not "The Star-Spangled Banner" but the drinking song from which Francis Scott Key adapted it, "To Anacreon in Heaven."

APOLLO IN BOSTON

A year before the Apollonian Orpheus was unveiled at Fort McHenry, Apollo as himself had appeared in the rotunda of the Museum of Fine Arts in Boston, not once

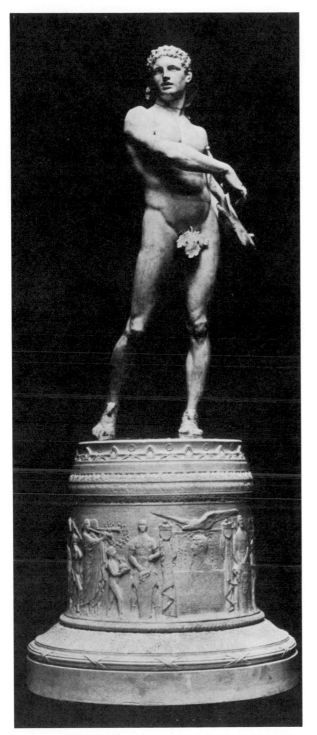

Fig. 158. Charles Henry Niehaus. *Orpheus and the Defenders of Baltimore: Francis Scott Key Monument.* 1922. H: 23'. Fort McHenry National Monument and Historic Shrine, Baltimore. Photo reprinted from National Sculpture Society Exhibition Catalogue, 1923.

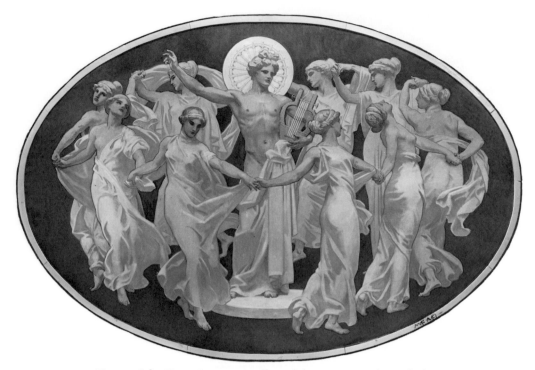

Fig. 159. John Singer Sargent. *Apollo and the Nine Muses* (rotunda deco-
ration). ca. 1916–21. Oil on canvas. Courtesy Museum of Fine Arts,
Boston. Francis Bartlett Donation of 1912.

but twice. Here was a true temple of Art in the New World, in which he could take
his place by unquestioned right. One panel shows him holding his lyre in the crook
of one arm while his opposite hand is held so high as to seem a benedictory gesture
rather than the farthest sweep of an instrumentalist (fig. 159). His messianic stand-
ing is signified by a large aureole of pale gold. His head, although somewhat Gibson-
girlish in its features, is clearly that of the *Apollo Belvedere* whom the boy John
Singer Sargent had drawn so many years before in Rome, and his hair is tied up in a
proper bow. His smooth, lean modern body is chastely draped from the waist down
in the same silky white material worn by the nine elegant and indistinguishable
Muses who circle him in a daisy-chain, their drapery gracefully swirling. There was
never a more genteel or sexless image of any Greek god. In isolation this panel
represents perfectly the attitude toward Apollo as the embodiment of the intellec-
tual and aesthetic refinement and restrained emotion that American visitors to the
Vatican had been cultivating for a century: it is the ultimate in Good Taste.

Such a degree of bland purity Sargent could have achieved only with deliberation
and effort. Among his preparatory drawings for the far more exotic Boston Public
Libary murals are extremely sensuous studies of the male nude in various postures,
charcoals that display Sargent's characteristic marriage of spontaneity and mastery
of line.[1] In these years Sargent was also further developing his distinctive and freely
expressive technique in watercolor, and was ending his celebrated international
career as a portraitist known for a bravura personal style. What the murals for the

Fig. 160. John Singer Sargent. *Classic and Romantic Art* (rotunda decoration). 1925. Oil on canvas. Courtesy Museum of Fine Arts, Boston. Francis Bartlett Donation of 1912.

Boston museum represent then is an effort at complete repression of individuality in the service of a public ideal. In decorating a work of classical architecture designed to reflect a culture's submission to and assimilation of the Greco-Roman ideal of beauty, Sargent committed himself to the virtual anonymity required by the Greek spirit of creativity: the conventional must be treated conventionally; the celebration of tradition is not an occasion for self-expression. The idea behind the other rotunda panel in which Apollo figures (fig. 160), however, may be a comment on this. A parody of the great "choices" made by Mars and Hercules between opposing options in life, it shows Apollo theoretically choosing between Minerva on one side and a shaggy Pan and ecstatic Orpheus on the other. The implied choice between classic and romantic art is not a choice a museum goer has to make; he can have both. Nor was it really a choice for Apollo. Innately classical, he had nothing of Marsyas nor even much of Orpheus in him, though he could be stung on occasion by an angry Cupid's dart. But it *was* a choice Sargent had to make on this occasion. And virginal wisdom and craft clearly won over sensual abandon.

A third panel in fact shows Minerva preempting the central role in this temple. Apollo and the Muses may have inspired and guided the artists, but it is she (evidently personifying a wise Board of Trustees) who is shown protecting Architecture, Sculpture, and Painting from the Ravages of Time. In the religion of Beauty, the gods have their respective functions. What was primarily to be made immutable here was not the work of John Singer Sargent but a representative assemblage of the

361

finest work of all time: that which had proven its ability to offer the viewer the experience of transcendent beauty. The fact that the iconography and style of these murals are clearly derivative, then, demonstrates another sort of decorum. Conscious derivation is a form of allusion. When the Sargent scholar Richard Ormond, in a very brief discussion of these murals and those later placed above the adjoining stairwell, is able to detect specific indebtednesses to Giulio Romano, Michelangelo, Ingres, Botticelli, Raphael, Tiepolo, Tintoretto, and Guido Reni, as well as general references to Renaissance and neoclassical art of the preceding five centuries,[2] we may be certain that Sargent considered such echoes, as catalog and commemoration, appropriate to the building's function. As far as possible this was to be one of America's own Vaticans or Capitolines. If the museum goer who looked up at the stairwell ceiling and saw still a third Apollo, one driving the Chariot of the Sun, and was reminded thereby of the *Aurora* of Guido Reni or of the three Apollos in Raphael's *Stanze*, which had been among his sublime experiences of Rome, how could that help but extend and define the context for what he saw here in Boston? A provincial temple honors those of the sacred city.

Clear as all this may seem, and so consonant with the rationality of classicism, the fourth of the large panels of the rotunda reminds us that at the heart of any religion (and suggested already by the competing claims of Pan and Minerva, Minerva and Apollo), there remain unanswerable riddles, ungraspable realities. It shows the Sphinx and the Chimaera. However plain the dogmas and neat the decoration, some things are unresolvable. And Sargent's choice of subjects for the reliefs that are subordinate to the major painted panels may have expressed the rebellion that their coolly classical execution denied. Here we see not Diana, but Venus with Cupid, Cupid with Psyche, the Three Graces, and gaily dancing figures. In smaller reliefs above these, there are a satyr and maenad, the half-animal Centaur educating Achilles, a figure of "Fame," and the image of Arion, the wandering poet-musician who, when captured with his prize, invoked in song both Apollo and Orpheus before he leaped into the sea and was carried by enchanted dolphins back to his friend (all he wanted in the world besides his lyre, and fame).

In the small painted roundels above everything else are the opposed allegorical figures of Music and Astronomy and two mythological figures. One is Prometheus, Titanic benefactor of mankind and suffering endurer of oppression, a favorite of romantic poets; the other is Ganymede—not with Hebe, but being lifted aloft in the clutches of Jupiter in the guise of an eagle. Surely Prometheus and Ganymede represent the extreme range of Greco-Roman mythology, from the most heroic and benevolent to the amusingly self-indulgent. They are not interpreted or revitalized; they are simply there, as instantly recognizable signs. Yet Sargent made a choice of signs and, in the security of unassailable Good Taste in form and color, allowed himself to allude to a wider range of experience suggested by the mythology than previous Americans had been able to do. He provided not so much a summation as an extension of what had been done since Benjamin West, for a building destined for an inclusiveness necessarily greater than the earlier American imaginative reach.

In the paintings for the staircase ceiling there are, to be sure, decorative banalities of Philosophy, the Unveiling of Truth, Science, and sufficiently vapid Danaids and Winds. But there are also subjects that no restraint of treatment can quite deprive of

color and life: Orestes pursued by the Furies, Hercules and the Hydra, Chiron and Achilles, Perseus slaying Medusa, Atlas and the Hesperides, the fall of Phaethon. All concern male heroes, in several phases of experience: aspiring, learning, acting, suffering, failing. They are surrounded by reliefs of ideal athletes and youths. Sargent painted no Proserpines, Dianas, Hebes, Andromaches, or Antigones here. In the execution of his work, then, Sargent merely observed the canons of good taste in decorative beauty and was self-effacing within this temple of traditional art. But in freely selecting the subjects to fill the void, he found a means of personal expression that distinguished him from his American predecessors. Like them, he made his own choice of heroes and gods.

In the Company of "the Best": The Aesthetic Ideal

The function of a museum of art, not as a school for the artist but as a special place set apart for the experience and worship of Beauty by the ordinary man or woman, is something that could be fully realized by Americans in the nineteenth century only through their visits to London, Paris, Munich, Florence, Naples, and—especially—Rome. From among many literary testimonials to this value of the Capitoline and Vatican galleries, some of which were cited earlier, four in particular—by Melville, Sara Loring Dana Greenough, Hawthorne, and Henry James—effectively provide general summaries of the experience and indicate the range of thought and emotion to which it gave rise. Easily transformed into a self-indulgent occasion for narcissistic Byronic exaltations and banal generalities, a mere recitation of nebulous received ideas unrelated to any personal sensuous experience or actual knowledge, the experience could also be genuinely perceived as morally improving, and as a means to greater knowledge of several kinds, as a stimulus to thought, a regulator of emotions, an extension of experience and a consolation for it, an ideal vision to serve as the measure and complement or compensation for the quotidian and routine.

After Melville returned from his European travels in 1857, he was induced to go on the lecture circuit to make some money. That winter he read a paper on "Statues in Rome" to audiences in small towns and large from New England and New York to Ohio and Missouri. The peroration to this lecture indicates how even a Melville, normally so given to irony, could feel—as he faced the emerging America of money and machinery—that his country could benefit from a reminder of an alternative value. His uncharacteristic simplicity of faith and banality of statement may have owed something to the popular genre he was attempting to master; yet one cannot doubt that he fundamentally believed in his basic message, which was simply in favor of a civilization that fosters the impractical rewards of the beautiful. He had become for a time a roving missionary in the religion of Beauty. The icons he displayed verbally were those of the sacred city of Rome. They were pagan men and pagan gods, and he was willing to use Christian terminology to win converts.

Melville suggests that a gallery of antique sculpture is first of all a refuge from life, a place of tranquillity where even what was vile is transformed into the good

and the beautiful: "Not the least, perhaps, among those causes which make the Roman museums so impressive is this same air of tranquility. In chambers befitting stand the images of gods, while in the statues of men, even the vilest, what was corruptible in their originals here puts on incorruption." But such a place is not merely a refuge from life and an illusory contact with the immortally pure. The "good" and the "wise" have preserved these works of "genius," granting them immortality because contact with them makes us better and wiser. Great sculptures both elicit the best in us and give us a standard of perfection by which to judge our mundane reality. They "appeal to that portion of our beings which is highest and noblest," both intellectual and emotional. They were produced by dreamers, visionaries, and idealists "of old," and they "live on, leading and pointing to good." They are "realizations of soul, and representations of the ideal." Governments and empires have passed away, "but these mute marbles remain—the oracles of time, the perfection of art. They were formed by those who had yearnings for something better. . . . How well in the Apollo is expressed the idea of the perfect man. Who could better it? Can art, not life, make the ideal?"

Melville next applies the experience of ideal beauty and truth to the America-in-progress. Americans are attempting to build a utopia according to some false and naive ideal of their own, he implies, while the utopia of the ancients was expressed more wisely where it could actually be realized—in ideal art. "The Vatican itself is the index of the ancient world, just as the Washington Patent Office is of the modern." Bayard Taylor had already made this comparison, and Mark Twain was to make it as well, with the implication that it indicated a fair trade-off. But Melville emphatically denies that a locomotive can be compared with the *Apollo* or the *Laocoon.* Modern man undervalues art in his insistence on practicality, his pride in progress, energy, and scientific achievement. But "science is beneath art, just as the instinct is beneath reason. Do all our modern triumphs equal those of the heroes and divinities that stand there silent, the incarnation of grandeur and of beauty?" Our "best architecture" rests upon Roman arches, our law upon the Code of Justinian, and our art rather than our politics—if we are wise—will be the repository of our visions as it was with the Greeks and Romans; then we will bequeath to posterity "not shameful defects but triumphant successes." We shall build not Crystal Palaces but Colosseums, reflecting sturdy character and meant to endure.

Melville's satire of the moderns has led him into complete idealization of the Romans, finding in the Colosseum an unambiguously positive reflection of character. Thus he can conclude, somewhat preposterously:

> The deeds of the ancients were noble, and so are their arts; and as the one is kept alive in the memory of many by the glowing words of their own historians and poets, so should the memory of the other be kept green in the minds of men by the careful preservation of their noble statuary. The ancients live while these statues endure, and seem to breathe inspiration through the world, giving purpose, shape, and impetus to what was created high, or grand, or beautiful.[1]

In the uncritical enthusiasm of faith, Melville forgot his own distinction between art and life and idealized the Romans as well as their statues, taking the writings of

their "noble deeds" as scripture. Such a faith, he seems to say, would give purpose and order to the modern world and guide its own achievement of the beautiful.

Melville wished to make an idealization of the past, as represented by its art and literature, function as social criticism of the present. In *Lilian*, a novel by Sarah Loring Greenough published anonymously in Boston a few years later (1863), the ideal experience of antique sculpture is proposed merely as therapeutic for the disturbed individual. Mrs. Greenough, who at the age of nineteen had married the neoclassical sculptor Richard S. Greenough (younger brother of Horatio), had gone to live with him in Rome, and would eventually be buried in the Protestant Cemetery there beneath her husband's statue of *Psyche*, provides us with the extreme presentation of the neoclassical idea as infantile reductiveness, as innocent evasion of life. A review of the events leading up to the heroine's vision of Classic Art in Rome will demonstrate the easy assimilation of Winckelmanniac utopianism into the mindless conventions of genteel romance.

Lilian grows up in America receiving the undivided attention of doting grandmother, manservant, coachman, maid, cook, and dog. Nevertheless her life is periodically troubled by encounters with Italian immigrants, Indians, and the works of Goethe. When still a child, like an Infant Diana she shoots a boy organ-grinder with her bow and arrow because she finds "the little brown Caligula" swinging her cat by its tail while "grinning maliciously with the habitual insolence of foreign vagrants in America." (Her later experience of Italians on their own ground does not alter her attitude toward them.) A new neighbor, Mr. Clinton, arrives on the scene to resolve the situation—the first of many services. He takes to dandling the pretty child on his knee while telling her about the natural wonders of America, asking in return only that she tell him "about God." Perhaps insufficiently enlightened, he marries a woman who proves to be too much of an angel to make a satisfactory wife. Fortunately, when they go on a Mediterranean cruise intended to cure Mrs. Clinton of a madness induced by the vindictive behavior of Rufus, their groom, the ship is sunk by a villainous Neapolitan steamer named *Ercolano*, and Mr. Clinton appears to be the only survivor. After years of lonely wandering through Asia, he returns to America just in time to snatch a copy of *Faust* from Lilian's hands. In her years of loneliness since his marriage, her "white feet" had "trod unscathed among the burning pages of the authors of the Regency," but with Goethe she came close to the "forbidden fruit." The "gates of Childhood's Paradise" would have closed "behind her forever." Mr. Clinton begins to lead Lilian into the realms of "the Good and the Beautiful" by less insidious routes than Goethe's poetry, and—after various difficulties—they get married and go west. While on a hunting expedition Lilian saves an Indian's life. Later, when they are lost and starving, they are attacked by savages, but are saved in their turn by the same Indian. At this point they decide to go to Europe.

Rome, where they settle for the winter, begins at once to preach its silent "mournful homilies." Lilian learns from the ruins "the world's great lesson of the unreality of material things,—the shortness of life, the nothingness of time." The shadows of Death and Desolation give a certain piquancy to her love. "The sad luxury of sentiment and sensation,—which is the breath of Italian existence,— penetrates her whole being." Softening into "pensive acquiescence," Lilian starts

speaking in a lower voice and undulating when she walks. Something must be done.
Mr. Clinton takes her to the Vatican and Capitoline galleries, and introduces her to
the "world of repose, of majesty, of loveliness, awful, ineffable,—the world of
Classic Art":

> And as she reverent stood and gazed, she felt all human passion, all shadow of grief,
> all memory of pain, sink into silence before the unapproachable sublimity, the di-
> vine grandeur, which fill those soundless temples. Stately they stand, and still,
> those ancient godlike forms. A deathless life. . . . Their marble faces look down on
> us as erst on the long-vanished masters of the world. The strifes, the cares, the
> birth, the death of men concerns them not, their life is not as ours,—they, the im-
> mortals of the earth.

A comparable serenity is not to be Lilian's fate, but this vision of a transcendent
world beyond Death and Desolation puts matters in perspective and fortifies her for
further mundane perturbations (such as the reappearance of the first Mrs. Clinton)
which we need not here recount.[2]

Mrs. Greenough gives a noble idea a context and an expression that make it one
more banality among many. It is easy to see why Henry James was distressed by
encounters with the Greenoughs in Rome. Yet, as Nathalia Wright has pointed out,[3]
a scene showing Lilian meditating in the Colosseum resembles the one James
composed twenty years later with Isabel Archer at the site. And the passage from
Mrs. Greenough I have just quoted is a precursor of yet another memorable scene in
The Portrait of a Lady. James's inspiration was of course not *Lilian,* but *The Marble
Faun* and his own visits to the Capitoline and Vatican museums, but a convergence
of idea and terminology indicates the common dimensions of the Roman experi-
ence, while the differences indicate how a cultural cliché can be revitalized by being
made specific, individual, and dramatically functional.

In that now-familiar letter of November 1869 to his sister, Alice, James wrote: "I
saw yesterday at the Capitol the dying Gladiator, the Lydian Apollo, the Amazon,
etc.—all of them unspeakably simple and noble and eloquent of the breadth of
human genius. There's little to say or do about them, save to sit and enjoy them and
let them act upon your nerves and confirm your esteem for completeness, purity
and perfection."[4] Hawthorne's *The Marble Faun* opens by introducing its four main
characters in the room of the *Dying Gladiator* in the Capitoline Gallery, and its
third sentence reads: "Around the walls stand the Antinous, the Amazon, the
Lycian Apollo, the Juno; all famous reproductions of antique sculpture, and still
shining in the undiminished majesty and beauty of their ideal life, although the
marble, that embodies them, is yellow with time, and perhaps corroded by the damp
earth in which they lay buried for centuries." Hawthorne characteristically quali-
fies his evocation of the ideal by bringing in the corrosions of historical reality in the
same sentence. And in his second paragraph he makes us look out the windows of
the gallery at the city that spreads beyond the enclosed ideal chamber like an
emblem of the tragic and incoherent waste of history from which these fragments of
beauty and truth have been salvaged: the "massive foundations of the Capitol," the
"battered triumphal arch of Septimius Severus, right below," "the desolate Forum,

(where Roman washerwomen hang out their linen to the sun)," the "shapeless confusion" of modern buildings, Christian churches, and heathen temples, "the great sweep of the Coliseum." Beneath a blue sky and against the unchanged backdrop of the Alban mountains across the Campagna, lie the decaying signs of the "threefold antiquity." Within, the "world-famous statues" are still shining in the "undiminished majesty and beauty of their ideal life." The aspirations and actions of his four characters will be defined against two realms of being: a vast and absurd historical canvas and art's triumphantly realized images of ideal beauty.[5]

Twenty-five years later James opened the second volume of *The Portrait of a Lady* in the same room and similarly exploited both the general symbolic value of its treasures and the specific reverberations of individual works. The completely abstract nature of Lilian's experience of "Classic Art" was evident in the fact that Greenough failed to place her heroine in any particular gallery, let alone have her observe any particular statues. Lilian did not need actually to *see* them, since the *idea* was everything; their corroded and sensuous presence might actually have interfered with it. The experiences of James's Isabel before her arrival in Rome have been less perilous than Lilian's. Although she has read far more widely in German literature than Lilian was allowed to do, without apparent loss of innocence, her adventures have consisted largely of rejecting "ideal" men—one American and one English—while vaguely aspiring to a greater destiny than that vouchsafed to the ordinary American girl. Without any evident talent or vocation such as Margaret Fuller possessed, she has nevertheless in effect committed herself to Minerva, or perhaps (less presumptuously) to Diana (as her name "Archer" has been said to suggest); Venus and Eros will play no part in her life.

When Isabel enters the room of the *Dying Gladiator,* she finds one of her rejected suitors, Lord Warburton, standing before that figure of vanquished masculinity. Lord Warburton has been represented from the opening pages of the book as one of the most attractive of the several varieties of "ideal" men developed by James in this novel. By character as well as heritage he is entitled to the word *noble.* Following Isabel to Rome has only resulted in a second rejection, so his exchange of words with Isabel at this unexpected encounter is embarrassed and restrained. He says that he is leaving Rome, and she asserts that they are not to see each other again until one or the other is married. Their definitive separation inspires a paragraph worth quoting at length, for in it James realizes a convincing testimonial to the inherent value in the experience of classical Rome. Beautiful objects in a specific enclosed space are seen to have the power of shaping a moment of life that is untroubled, transcendent, and precious; yet the experience of the objects is, through James's narrative voice (like Hawthorne's), opened up to the larger world of history and life beyond the shuttered windows. Shining white figures of gods and men, seen against red walls and reflected on a polished floor in the filtered light of golden sunshine—the ceremonial aestheticism of Rome—emerge from the "void full of names" called the Past in which people saw what we cannot see, and spoke what we cannot hear and could not understand, yet were like ourselves.

> They shook hands, and he left her alone in the glorious room, among the shining antique marbles. She sat down in the centre of the circle of these presences, regard-

ing them vaguely, resting her eyes on their beautiful blank faces; listening, as it were, to their eternal silence. It is impossible, in Rome at least, to look long at a great company of Greek sculptures without feeling the effect of the noble quietude; which, as with a high door closed for the ceremony, slowly drops on the spirit a large white mantle of peace. I say in Rome especially, because the Roman air is an exquisite medium for such impressions. The golden sunshine mingles with them, the deep stillness of the past, so vivid yet, though it is nothing but a void full of names, seems to throw a solemn spell upon them. The blinds were partly closed in the windows of the Capitol, and a clear, warm shadow rested on the figures and made them more mildly human. Isabel sat there a long time, under the charm of their motionless grace, wondering to what, of their experience, their absent eyes were open, and how, to our ears, their alien lips would sound. The dark red walls of the room threw them into relief; the polished marble floor reflected their beauty. She had seen them all before, but her enjoyment repeated itself, and it was all the greater because she was glad again, for the time, to be alone.

But of course Isabel cannot remain alone or long in this transcendent experience of Beauty. After half an hour Gilbert Osmond, who the day before had expressed his envy of Lord Warburton for being handsome, clever, and rich—as well as "a great English magnate," enters and expresses his surprise at finding her without company. She protests that she has "the best," glancing "at the Antinous and the Faun." Osmond doubts that they are "better company than an English peer." Isabel's unequivocal implication that she has rejected that peer raises her in Osmond's estimation. "We know that he was fond of originals, or rarities, of the superior and the exquisite," James comments; "he perceived a new attraction in the idea of taking to himself a young lady who had qualified herself to figure in his collection of choice objects by declining so noble a hand."[6]

James's ironic suggestion of the inhumanity to which the ideal of collecting and preserving "choice objects" such as that represented by the Capitoline and Vatican galleries could be debased is sufficiently obvious in Osmond. Yet Isabel subsequently mistakes him for the supreme example of "the best" in men. She marries him to aid in the realization of that idea of beauty for which he lives. The marriage will alienate her from her cousin Ralph, whose own belief in Isabel as an ideal woman had made her rich, and it will lead to a life of daily misery, humiliation, and dissemblance. In this sense the statues, whose beauty is felt to be somehow continuous with the romantic expectations of Ralph and Isabel, contribute to the simple irony that ideals realizable in marble are not so in flesh. Yet the statues are not diminished by this irony. Isabel's half hour alone with essentially mysterious images of beauty incapable of change or of being other than what they seem remains her finest experience until her reconciliation with Ralph in the last pages of the book.

Unlike Melville, James neither uses the ideal of beauty as an instrument of satire against American values nor implies that it is itself an ennobling instrument of good. Neither does Isabel's mild and vaguely solemn communion with the statues at all correspond to Lilian's indulgence in the rhetorical sublime. The inherent value of the antique art itself—in its "completeness, purity, and perfection"—is

never questioned. Something magnificent achieved and preserved, it is the fulfill-
ment of an ideal of beauty and serves not as a critic but as a friend to modern man.

An experience of ideal beauty such as Isabel's—or even Lilian's—was perhaps not
had by many individuals in the crowds who visited the Centennial Exposition at
Philadelphia in 1876, where they saw more statuary—and more nudity—than had
ever before been assembled on American soil in one place. Yet curiosity was evident
and pleasure was expressed—also pride in the American achievement. Impetus was
given to what Jarves and others had been fostering since before the Civil War, the
desire to create in America permanent temples of Art, our own Capitolines and
Vaticans. The same decade saw the founding of museums in major American cities,
increasing importation of European masterpieces, and acquisition for "permanent"
display of the more celebrated American works. Rivalry in proving possession of
high civilization was manifested not only among American cities but—with an eye
to an imperial future—between them and London, Paris, and Rome for what those
cities had long since achieved. By the time of the New York World's Fair in 1939, the
business of art in America was thoroughly established with schools, galleries, and
innumerable public commissions for murals and monuments.

That Americans in 1876 still had much to learn and much to prove was the
implicit message of a mammoth and lavishly produced *Book of American Figure
Painters* published in Philadelphia in 1886, with an introduction by a new critic
whose voice was to be heard for decades to come. Mariana van Rensselaer wrote in
her introduction that the 1876 Centennial Exposition had turned out to be an
occasion on which works of art from other nations of the world—Asian as well as
European—had "flung their challenge in the face of Yankee steam and steel, and
said (with none to contradict), *You are a means toward living: we are an end to live
for.*" Immediately after the Centennial there had appeared "the new band of native
artists preaching a new artistic gospel," a "gospel of technique": Painting for Paint-
ing's sake. Van Rensselaer's sumptuous book used "the best mechanical means" to
display "the excellence of our Art." The works of forty artists were reproduced, each
accompanied by a poem beautifully printed on a separate page, intended not to serve
as an interpretation of the painting but to be its aesthetic equivalent in verse. To
Americans thoroughly at home with Poetry, but still doubtful about Art, it said: as
the beauty of poetry is self-justifying, so is the beauty of painting.[7]

This book thus consciously established the religion of Beauty upon a dogma that
went further than the propaganda leading up to it had intended. While appealing to
national pride, it presented Art as an object for private delectation by an elite
contemporary cult of aesthetes, a company of "the best" enjoying the company of
"the best." Thus it disposed of two elements the religion had firmly maintained in
its neoclassical form: the belief that Beauty was inseparable from the Good and the
True, and the ambition to achieve a modern democratic culture equaling that of the
ancients in the excellence of its public art. To the old view the Roman experience
had been central; in the new one, which looked toward twentieth-century aes-
thetics, the meaning of Rome and its icons became problematical.

After Thomas Crawford became the first American sculptor to settle perma-
nently in Rome, he wrote to Charles Sumner: "I look to the foundation of a pure

School of Art in our glorious country. We have surpassed already the republics of Greece in our political institutions, and I see no reason why we should not attempt to approach their excellence in the Fine Arts, which, as much as any thing else, has secured undying fame to Grecian genius."[8] This statement was quoted by C. Edwards Lester in *The Artists of America,* published in 1846, from Charles Sumner's article, in which New Yorkers had been urged to support their native son in Rome at least as much as Bostonians had. Lester quoted also the "Autobiographical Account" Rembrandt Peale had sent to him, in which Peale told of passing nine months in Florence copying Renaissance masterpieces and forming a collection which should have become the "nucleus" of an American "NATIONAL GALLERY, or Library of the Fine Arts," for "the improvement and extension of human knowledge—not for the gratification of a selfish and exclusive antiquarian taste." It was to be kept "progressive" by the frequent addition of works by contemporary artists. Peale also recalled his four years devoted to "the introduction of Drawing as a necessary part in the education of every scholar" in the Philadelphia High School.[9] The sculptor Bartholomew, who established himself in Rome in 1850, wrote to the Wadsworth Atheneum in Hartford urging it to keep itself free to all, especially "students of Art." Acknowledging that the Atheneum could not hope to acquire European masterpieces "for our western country," since they were becoming impossible to purchase, he confidently suggested that the museum be filled up with "our own productions" of equal excellence.[10]

Jarves, who was making his own efforts to collect not only masterpieces but historically instructive early Italian works which he hoped would find a home in the Boston Athenaeum (they ended up at Yale), saw the cultivation of art in America as the essential means to "save" the citizenry from the twin dangers of savagery and "Franklinism." Writing in the midst of the Civil War, Jarves nevertheless foresaw the period when, "by the noble conquest of ideas," the entire continent would be one American empire, "the most powerful because the most enlightened, the most peaceful because the most free, and the most influential people of the globe, because having sacrificed the most for justice and liberty." The "art of the intermingling races of a new world" would necessarily be of "new forms, rooted in novel conditions of national being." But it must arise from the "deep and lofty aspirations" that Jarves had expressed in tracing the development of the art of the past. The "BEST is none too good for America to aspire to," and therefore the images of the past that set the standard of achievement must be brought before it. In a paragraph that parallels celebrated statements by Cooper, Hawthorne, and James, Jarves pointed out the absence in America of any "antecedent art," abbeys, ruins, cathedrals, aristocratic mansions, state collections of paintings and sculpture, legends "more dignified than forest or savage life," poetry "lofty and sublime," and "history more poetical or fabulous" than the deeds of men "too like ourselves . . . to seem heroic,—men noble, good, and wise, but not yet arrived to be gods."

By contrast, the European "public is trained to love and know art" involuntarily, since the very streets are "a vast school of art," and citizens of all classes are brought to feel "sympathy with the Beautiful," which is as inescapable there as the weather. Consequently, Jarves was primarily concerned with the establishment of "incentives to art-progress" in the new imperial Republic. He committed himself to the

thankless role of critic, a profession he (like many critics since) declared more difficult than that of the creative artist. He would hold self-praising Americans to the highest classical standards, such as Allston and Greenough had shown they could meet. The "old masters of Greece and Italy will always remain great examples of past styles, and incentives to excellence in ways and ideas of our own." Those "ways and ideas" did not include the degrading of sculptors into tradesmen who "manufacture statuary on the same principle that they would make patent blacking."

> If the ignorance of legislative bodies or the zeal of interested parties, at a heavy outlay of public funds foists upon the people works whose sole effect on the cultivated mind is disgust and ridicule, and on the common simply wonder at mechanical dexterity, bigness, or theatrical display, as in the instance of Clark Mills's equestrian statue at Washington, no protest is too strong, for such abortive work tends to bring all art into disrepute, even with the multitude.

But Jarves concluded that as a result of criticism that insisted upon excellence, and of education that cultivated good taste, and of art schools, exhibitions, museums, and noble public statues and architecture that kept fine art constantly before the eye, the new nation would one day find that it had created its own environment of a beauty unrivaled in history, worthy of its political ideals and its global importance.[11]

Not everyone agreed with Jarves's various points. The *Crayon* had already attacked his *Art Hints* in 1855, resenting among other things the view that art derived from other art rather than from nature, that America had anything to learn from Europe, and that America didn't already have a quantity of great statuary, much of it made in Albany rather than Rome.[12] A decade earlier, William Ware (himself author of *Zenobia, Aurelian,* and *Julian*) had joined others in declaring that in fact there were plenty of "themes from actual life, and incidents of our own history" available to artists; the European example simply led them off onto "Apollos, Dianas, Venuses." Moreover, the ancient statues were debilitating company: "The constant presence of the Antique and a daily worship at her shrine must, as the rule, tend to generate a dull and slavish turn of mind—all within the limits of the most refined taste, but emasculated by the absence of everything like a vigorous originality."[13] Finally, Hawthorne would have agreed with Jarves's judgments, while concluding that his expectations of the new empire were entirely quixotic. In 1858 at Florence he wrote:

> I wish our great Republic had the spirit to do as much, according to its vast means, as Florence did for sculpture and architecture, when it was a Republic; but we have the meanest government, and the shabbiest—and, if truly represented by it, are the meanest and shabbiest people—known in history. And yet, the less we attempt to do for art the better, if our future attempts are to have no better result than such brazen troopers as the equestrian statue of General Jackson [by Clark Mills], or even such naked respectabilities as Greenough's Washington. There is something false and affected in our highest taste for art; and I suppose, furthermore, we are the

Fig. 161. Kenyon Cox. *Tradition.* 1916. Oil on canvas. 41¾ × 65¼". The Cleveland Museum of Art. Gift of J. D. Cox.

Joseph Kiselewski (FAAR, '29), while for the "Court of Peace" Leo Friedlander (FAAR, '16), who had already made his own *Infant Hercules* in the true American tradition, created a colossal totally nude male who would not have been out of place among the circle of bulging brutes that surrounded the new fascist-sponsored Olympic stadium in Rome itself.[6] After the war at least this imagery would fall into disfavor, along with a tradition that in Italy had been made to support an oppressive ideology. The ideal of a renaissance collaboration of artists also ceased to appeal, as architects wanted to achieve their own pure forms, and painters and sculptors wished to be liberated from a primarily decorative function.

In retrospect, of course, it seems ironical that all the activity between 1893 and 1939 so confidently expressing a consensus about what constituted "the best," its value and relevance for a democratic and pluralist society like America's, and a belief in its permanence should have occurred just when the validity of the Greco-Roman tradition was being called into question, perhaps forever. In a world increasingly skeptical, eclectic, and revolutionary, the Rome of classical faith, unity, and continuity moved to the periphery of aesthetic concerns. Neither the American Scene painters of the thirties nor the postwar Abstract Expressionists would seem to have much allegiance to Rome. Yet the academy and the institutionalization of conservative taste and training in America (which made visiting Rome itself less essential) ensured that the idea and to some extent the actual image of Rome (and its gods) would endure. In some ways—in the increasing gigantism of its much-decorated official buildings, in the proliferation of such abstract goddesses as "Justice," "Piety," and "Agriculture" (often labeled in Latin style)—the America of the twentieth century resembled even more the self-deifying Rome of the imperial Republic

374

than it had before. But the most interesting remnants of the ancient nude gods and goddesses were to be found in the metamorphoses—ironical, satirical, regretful, or destructive of the lost ideal though they might be—that one might see in the more expressionistic figurative painting and sculpture. And even abstract art, as it moved to its farthest extreme from the naturalism of neoclassical beauty, often shared with it the ideal of a noble simplicity and sometimes claimed an inspiration from the mythology of Greece and Rome.

Images of contemporary Rome created by American artists and writers in this century are the concern of the next volume. Here I wish only to observe something of what happened to the nude gods, goddesses, heroes, and heroines of Greco-Roman art in the hands of some of the more important figurative artists and to glance at a few of the startling appearances they have more recently assumed. In contrast to most nineteenth-century works, they usually owe little or nothing to the statues in the Capitoline and Vatican galleries. Even when artists have visited Rome, the experience has rarely been definitive for their art, in the way it was for Allston, Crawford, Story, Rinehart, Vedder, Manship, and others. As is the case with modern poets as well, Rome may have merely reinforced one element in the eclectic bag of referents that has characterized twentieth-century thought. Greece itself having become more accessible, and Ovid less familiar than Sophocles, Rome often played a secondary role even in a poet's or artist's classical awareness, and the gods began to lose their Latin names. Any classical source or allusion, moreover, often carried no more prestige than the latest-discovered myth of the Aztecs, Hindus, or Hottentots (how "modern" was Whitman!). The poet or painter reading his Frazer, Freud, Jung, or whomever, picked and chose as he pleased and owed nothing to any one place in the invention of his personal "mythology." Therefore, even though most of our modern poets and painters do seem to have visited Rome, their use of the gods or their exploration of nude forms may have no special indebtedness to it.

That is not true, however, of many painters and sculptors of the first four decades. Since art history of the past thirty years has been written from the viewpoint of triumphant modernism, artists who persisted in traditional representational, illustrative, and decorative tasks have largely disappeared from the record. Of the nearly eighty sculptors who had studied at the American Academy in Rome by 1976, only Paul Manship was included in the Whitney Museum's retrospective of American sculpture in that year purporting to represent two centuries of achievement. No doubt after the neoclassical sculptors of the nineteenth century—although many of those were no less derivative and were often technically less accomplished—a certain redundancy is felt as we regard the works of their "academic" successors. Yet the fact is that in the freer atmosphere of this century even the gods were allowed to achieve a greater vivacity and variety, and they claimed the provinces opened to them with perfect confidence. The innately sculpturesque Hercules in particular was coming into his own. Gutzon Borglum found him a "convenience" in 1904 when he wished to strip a finely built horse thief in order to "show the play of a fine nude figure on a nude horse"; he could call the work *Mares of Diomedes* (Metropolitan).[7] When Franklin Simmons died in 1913, the forty-sixth year of his residency in Rome, he was working on a *Hercules and Alcestis*. During the years 1917–20, among other works created by C. Paul Jennewein while a Fellow

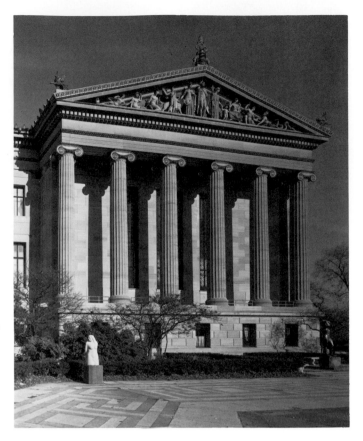

Fig. 162. C. Paul Jennewein.
East pediment sculpture.
1927–32. Philadelphia
Museum of Art. Photo
courtesy Philadelphia
Museum of Art.

at the academy was a *Hercules Taming the Numean Bull*; and Paul Manship in 1918 showed *Hercules Upholding the World.* Other uses to which pagan divinities were put were often less exalted, even demeaning. Was nothing less than a *Zeus* (by Robert Ingersoll Aitken) necessary in 1915 for the American Telephone and Telegraph building in New York? Was it only as the Goddess of Beauty that Venus was employed by Wheeler Williams to encourage the importation of art to Manhattan, on the façade of the Parke-Bernet auction galleries? Was Neptune perhaps misplaced when Gaetano Cecere bodied him forth to guard a mere swimming pool in Rome— New York?

Less equivocally, few new museums of art could be considered complete until pagan divinities were installed, nor could any of the great expositions like the Pan-American in Buffalo (1901) or the Louisiana Purchase in St. Louis (1904) be held without the visible presence of the gods (incarnated in ephemeral matter). For St. Louis, Philip Martiny designed an *Apollo and the Muses* for the entrance to Festival Hall, and Isidore Konti—who had studied for two years in Rome before emigrating to America—created an image of Apollo for the Panama-Pacific Exposition's Temple of Music in San Francisco (1915). To design the pediment figures for the Philadelphia Museum of Art in the late 1920s, two alumni of the American Academy in Rome, John Gregory (FAAR, '15) and C. Paul Jennewein (FAAR, '20), were chosen. Although Gregory's *Pursuit of Wisdom* remains today in plaster, Jennewein's line of

mostly nude mythic personages on the North Wing (fig. 162), completed in 1932 after five years of labor, managed to be something new by being even more remotely old than Crawford's white marbles for the Capitol had been. They are made of terracotta, painted in brilliant colors, and finished with a ceramic glaze. The formerly reviled Jove—of all gods (and weighing a ton)—stands in the center, with Venus—of all goddesses (and with Amor at last beside her)—on his right. Ceres with the child Triptolemus (balancing Eros) is on his left, and they dominate the side said to represent "Divine Love" as opposed to Venus's "Profane Love" (the two apparently meeting in Jove). Probably few could identify the subsidiary figures (even authorities disagree): Daphne as a laurel tree opposes Hippomenes as a lion, Ariadne is opposed to Adonis, and Theseus to Jove once more (as Nous, Creative Intelligence?). But why are Aurora and Minerva's owl on the side of "Profane Love," other than to fill in the narrow point of the pediment? Apollo's python conveniently performs the same function on the other side, but is perhaps a strange stand-in for Apollo himself on the façade of a museum of art. This was, however, far from the first time that the gods became recalcitrant when forced into allegory, while bending more or less gracefully to the exigencies of temple architecture. And they make a cheering sight.[8]

In the realm of domestic decorative art, Jove also emerged for the first time in America—in the form of a bull. Perhaps the way was prepared in 1896 by Isabella Stewart Gardner's importation to Boston of the greatest representation of his Rape of Europa ever conceived: that by Titian. We have already seen how Diana and Orpheus continued their popularity in the America of this period, but they were now rivaled by the Europa myth. This subject, like all of Jove's sexual exploits except that of Ganymede, which was evasively understood, had been entirely avoided in the previous century. In a poem highly responsive to the joyous atmosphere of Veronese's treatment of the event (in a celebrated painting in the Capitoline Museum), William Wetmore Story nevertheless persisted in calling the bull a steer.[9] But now precisely its sensuality and the opportunity for combining animalistic power with the physical attraction of smooth female form made it irresistible in the new sexual climate. Its mythic force and tactile properties relate it to other combinations—Leda with Jove as a sinuous phallic swan, Diana with her deer or dogs, nymphs with centaurs, and—in male variations—Orpheus or Bacchus with panther or tiger, Hercules with bull or lion, and full-grown furry fauns at play with each other. All these became the subjects of American sculpture in this century by artists who had studied in Rome. But none seems to have appealed so persistently as the Rape of Europa.

Paul Manship's *Satyr and Sleeping Nymph*, made in Rome in 1012, and his *Centaur and Dryad* of 1913, thematically and formally prefigured his *Europa and the Bull* of 1924 (fig. 163), which was followed by the breezier *Flight of Europa* of 1925. These statuettes all invite fondling, their sensuality has an intimacy quite remote from Titian's monumental representation of divine power and frightened but rapturous abandon. The 1924 *Europa* is not mysteriously transported, but is herself openly seductive, and that of 1925 is taking a marvelously exciting ride, her hair blowing in the wind. Perhaps the unease the subject could still (rightly) cause is indicated by the critic Edwin Murtha's intended compliment to Manship when he

wrote in 1957 that, in contrast to the "power" of Bourdelle's treatment of the subject and the "drama and nervous movement" in Carl Milles's vibrant version, Manship found "the light touch and restrained humor" the subject "needs."[10] That the myth in fact had purely formal and decorative value for Manship is indicated by his unhesitating redesign of the *Europa and the Bull* as an ashtray!

Perhaps Sidney Waugh's Steuben glassware is a more convincing reminder that illustration of the myths on household objects in such a way as to convert them into works of art is not alien to the Greco-Roman tradition. Waugh at the age of twenty went from Massachusetts to Rome to study at the Scuola delle Belle Arte in 1924 and then to Paris, where he was a pupil of Emile Antoine Bourdelle, who, with Aristide Maillol, was one of the great French adapters of classical myth to the modern idiom. Waugh was in Rome again from 1929 to 1932 as a Fellow at the American Academy. The next year he began his work for Steuben, producing works such as the *Venus Vase* (Toledo), the *Zodiac Bowl* (Victoria and Albert), and the *Europa Bowl* (fig. 164). Both the geometrical stylization of Manship and the expressive muscularity of Bourdelle are evident. In fact Waugh's rather commanding Europa—a Hercules with breasts—does not so much contrast with the bull as partake of its physical characteristics.

The merging of raped rider and divine beast can occur more completely in more abstract forms of the subject. Jacques Lipchitz described his 1938 *Rape of Europa* as an image of "erotic love" metamorphosed from the "conflict and terror" of an earlier *Bull and Condor;* the "bull is caressing Europa with his tongue." But in a later version, made in America, Europa (Europe) is stabbing the Bull (Hitler).[11] Perhaps even more powerful treatments of the theme are those attempted by Reuben Nakian, first abortively in 1938 and then in a series that began with small terra-cottas in 1948 and reached its culmination in the monumental bronze *Voyage to Crete* of 1960–62, installed in the New York State Theater at Lincoln Center (fig. 165).

Nakian is one artist who has developed almost all the mythological themes most popular in this century. In the twenties he was an apprentice in the busy studio of Paul Manship where Gaston Lachaise was the chief assistant, before Manship's removal to Paris. In 1931 Nakian went to Paris and then to Rome on a Guggenheim Fellowship. Of the work he did upon his return, it cannot be said that Babe Ruth's famous figure offered him the best opportunity to model a classical physique (1934), but resemblances to Roman portraiture have been seen in his busts of dignitaries in the new administration of Franklin Delano Roosevelt (1933–35). He then turned, as the poet Frank O'Hara noted, from such "democratic" mythic heroes to classical myth. In Nakian's drawings, wrote O'Hara, "nymphs and Europas and Ledas and Hecubas" are "both goddesses and wantons, at once mischievous and melancholy, voluptuous yet serenely content in their artistic medium." They are "as real as fantasy, as illusory as believed myth (coy Leda, stately Minerva, proud Venus)." How far we are from Powers, Palmer, and Story, and from Dunlap, Tuckerman, and Jarves, in the creation and criticism of the female nude, is indicated by O'Hara's appreciative observation that in the early and more representational mythic works "virtuosity lends candor to the general lubricity of the subject. . . . It is almost impossible to imagine an erotic or abductive act which Nakian's women . . . cannot

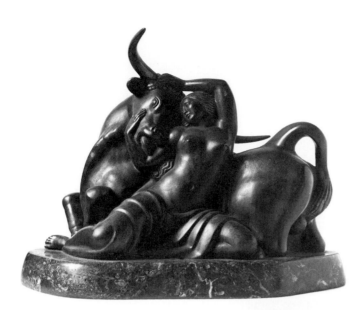

Fig. 163. Paul Manship. *Europa and the Bull.* 1924. Bronze. H: 9¼". Corcoran Gallery of Art, Washington, D.C. Gift of James Parmelee, 1941.

Fig. 164. Sidney Waugh. *Europa and the Bull.* 1935. Glass. 9⁹⁄₁₆ × 11⅜". The Cleveland Museum of Art. Dudley P. Allen Fund.

Fig. 165. Reuben Nakian. *Voyage to Crete.* 1960–62. Bronze. L: 8'. New York State Theatre. Courtesy Lincoln Center for the Performing Arts.

encounter with equanimity and, on occasion, a hint of lofty encouragement. As myths, they have an abstract definition and security; as fantasies, they have an appetite for their own existence." O'Hara spoke of the "necessity of sensuality" in sculpture and appreciatively noted how eroticism serves as allusive content and has importance as a subject.

Nakian's later and more abstract works are called *The Birth of Venus, The Rape of Lucrece, Mars and Venus,* and *The Judgment of Paris.* The monumental welded steel *Mars and Venus* (fig. 166) of 1959–60 conjoins, of course, two images: one a complex of irregularly shaped and darkly shadowed metal fragments, seemingly as chaotic as a heap of broken shields, yet leaning in a diagonal yearning to depart; the other a bright, shining, stably armatured and gracefully curving rectangular span as evocative as white marble or pure flesh. In the *Paris* of 1963–66 O'Hara saw the four misshapen presences that represent the proudly phallic hero and the posturing Venus, Juno, and Minerva as "poised in a fatalistic yet bawdy ritual, waiting for the apple of discord to be awarded and the Trojan war to start." (Nakian's *Hiroshima* was simultaneously in progress.) Even in the *Birth of Venus* of the same years, not so much grace and beauty as force and weight emerge and rise, and in the *Voyage to Crete* the labyrinthine terrain and mysterious rites of the island to which Europa is borne are more present than the satisfied desire of a god. Yet these too are, as O'Hara praised them for being, "libidinous and arousing" works, "for all their esthetic grace."[12] In them one recognizes Venus and Dionysus as perhaps never before in American sculpture.

Across the plaza at Lincoln Center (itself a reminiscence of Michelangelo's Capitoline piazza), in the lobby of Avery Fisher (Philharmonic) Hall, one may see the Apollonian in its true modern form: Richard Lippold's *Orpheus* with—not *Eurydice* but—*Apollo* as great sunbursts and flying fragments from the strings of titanic lyres. In these highly polished bronze rectangles suspended by fine stainless-steel wires, in these pure nonanthropomorphic symbols, and in the mathematical exactitude of sign and execution, we may recognize another of our divinities. Yet Lippold himself has written of them: "Although I did not intend these forms to be figurative, they seem to be acting like people. By their gestures . . . these two figures seem to me like friendly gods (atomically conceived, like all of us), reflecting in their splendor the splendor of man, and identifying it with the spirit of architecture which is in the spirit of music." He added, more casually and amusingly, "I have just named the work *Orpheus and Apollo* after a pair who were more than two good musicians—who had a most tender affection for each other as well as for mankind, since they were son and father."[13]

In painting, too, the gods after a manner survive. Their presence in a painting, whether literal or (as in poetry) through allusion to their myths, relates the work to the great tradition that stems from the art of the Italian Renaissance. We have seen American painters from Benjamin West and Samuel F. B. Morse, William Page and Henry Peters Gray, to Elihu Vedder and John Singer Sargent attempting with more or less conviction to honor this tradition by frank imitation of it. But in the twentieth century, apart from the allegorical mural painting initially fostered by the academy in Rome, almost all such paintings by Americans have been created in a

spirit of irony. And perhaps, of all painters of this century, only Picasso had the ability to renovate the myths—and aspects of classical form as well—in convincing personal terms. In others the note of parody—which in painters of the nineteenth century had been unintentional—is consciously sounded as a defense and a confession. They are like our poets in this, and unlike our sculptors. A work of sculpture is inevitably as much iconic as representational and relates itself to the tradition of its medium simply by being what it is. Its form may be weak or strong, clumsy or elegant, and it may be compromised by a dominating literary referent or an ideological function, but fundamentally it cannot contradict its own nature. Nakian's forms are not alien to those originally assumed by the gods in the earliest Greek art. But painting and poetry have not this inherently mythic character. Except in pure abstraction, painting is always in some sense a deception and like poetry is essentially allusive and representational, even though that is never the whole of either art. Thus paintings of the myths by Americans in the twentieth century may be saying many contradictory things at once: this we would believe and cannot believe; that is what we would paint but cannot paint; here we honor the Renaissance while mocking it, and mocking our own time as well; this is what even the noble Titian would have been constrained to paint if he had worked in our sordid, foolish and despairing age; here are the gods reshaped in the image of our time.

Even in the paganism—intended to be both cheerful and serious—of Arthur B. Davies, from his *Apollo and the Muses* of 1898 to his *Venus* of 1927, there was an unintended element of caricature (as in the modern dance of the time to which his work relates). It was enforced by the artificial gestures and flat linear shapes derived from Greek decorative art. Davies's naked men and women presented under cover of a title like *Idyll* are pretending to be nymphs and satyrs, but cannot quite forget themselves. The sight of Persephone crawling out of a hole beneath a tree like any reborn hibernator induces a smile. The Hamadryads, whose coiffures so happily repeat the foliage, stretch their amusingly elongated "limbs" in the languorous lesbian caresses of 1920. And the year before Davies died in the Florence where Powers and Greenough had so elaborately rationalized nude beauty, Davies made his own mezzotint *Venus*, a creation of spheres presented in bold frontality. Raising her arms above her head the better to display her remarkably large and unclassical breasts, Venus is not so much an Isadora Duncan as a Mae West defying three centuries of restraint.[14]

Now that Venus was readily available to artists as the frankly sensual goddess of physical beauty, it appears that many painters did not know what to do with her under her own name. The greatest American female nudes of the century dispense with mythological nomenclature and present themselves simply for what they are: not goddesses, but sexual beings, often beautiful, more often only powerful corporeal presences in paintings that may be more or less beautiful as paintings. Yet insofar as figurative painters turned to the myths at all, the loves of Venus were their favorite subject, as Europa-and-the-Bull was for modern sculptors. Venus trying to seduce Mars from war; Venus trying to keep Adonis from the hunt; Venus caught by her husband, Vulcan, in bed with Mars; Venus lamenting the death of Adonis; Venus being judged most beautiful by Paris—all these episodes, celebrated

in superb canvases of the Renaissance, challenged the contemporary painter to imitation or incited him to parody. Oddly, only the sculptor Nakian was able to treat two of these episodes in what can only be called the Grand Manner, while Europa-and-the-Bull, so amenable to exuberant sculptural form, in painting is represented most drearily.

No one worked closer to the line between sober classical academicism and modernist parody than Bryson Burroughs. From 1909 until his death in 1934 he was Curator of Painting at the Metropolitan Museum of Art and clearly conceived his painting with the Tradition even oppressively in mind. A list of his numerous works is practically an index to Greco-Roman mythology, with Mary Magdalene thrown in.[15] Naturally Diana, Orpheus, and Europa are included, but not many of the traditional subjects are absent. His gods, goddesses, and heroes are, however, modern Americans playacting. In his *Mars and Venus* of 1928 (fig. 167), his god of war is a sexy suburban bruiser whom the be-crutched and balding old Vulcan has caught between the sheets with Venus, "a real doll." The neighbors from down the beach have been called as witnesses, and they react with prurient disgust, prudish dismay, and moralistic condemnation as they gaze across the railing onto the summer terrace where the adulterous scene takes place, with a landscape of Long Island Sound in the background. This is a thoroughly American and "twenties" updating of the myth. One might think of the world of the semimythic Great Gatsby and his Diana-Venus called Daisy, but the painting's decorative style is not comparable to Fitzgerald's lyricism, and the procedure is actually the reverse: the sordid is not being elevated to mythic status; rather the myth—in this case none too noble to begin with—is being reduced to local terms. One might also think of Eugene O'Neill, yet the fact that Burrough's parody works two ways makes it not melodramatic or—by intention—tragic, as with O'Neill, but unavoidably humorous. The characters have the near-nudity of approximate antique dress, yet they also look like summer vacationers who have hastily wrapped themselves in sheets or towels.

The double vision, fashionable in the poetry of the time, suggests that the universality of the myths makes them adaptable to the experience of every age. But where once classical allusion served to elevate the status of the contemporary subject, when the poets and painters consider theirs to be a trivial and sordid age in which to find oneself practicing a noble art, the effect of allusion is inevitably to debase the myth. The memory of Agamemnon, meant to define the comparative squalor of Sweeney, is itself sullied by the comparison in Eliot's poetry. Painters and poets of great skill not only confess the absence of noble subjects but succeed in lowering the great achievements of the past through association. The contrast between Agamemnon and Sweeney could not be made if there were no point of similarity, which is also stressed. Having encountered Sweeney, we can never think again of Agamemnon without remembering his modern counterpart. When, in a painting in the Metropolitan, Burroughs provided a snake-bitten Eurydice with the equivalent of a Band-Aid he did not so much establish the "relevance" of a symbolic myth to our time as trivialize the classic tradition. Perhaps Wallace Stevens's method in *Harmonium* (1923) was better, when he spoke of the "venereal soil" of Florida but confessed that what he saw rising from the sea was only a "paltry nude."

Burroughs wanted to have it both ways. Other painters more decisively have

Fig. 166. Reuben Nakian. *Mars and Venus*. 1959–60. Welded steel plate.
Albright-Knox Art Gallery, Buffalo. Photo courtesy of the artist.

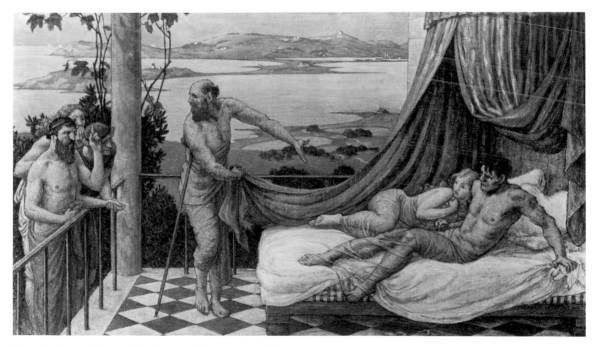

Fig. 167. Bryson Burroughs. *Mars and Venus*. 1928. Oil on canvas. 20 ×
36". Hirschl & Adler Galleries, Inc., New York City.

adopted two possible extreme alternatives to actual renewal of the gods. One is to render them honestly as dead; the other is to use them frankly for satire, since they are dead. Thomas Hart Benton's *Persephone* of 1939, with its two Missouri farmers peeking lasciviously at a naked girl, and his *Apple of Discord* of 1950, are examples of the latter. Paul Cadmus's *Venus and Adonis* (1936; fig. 168) is another. At photography shops in Rome and Florence in 1933 Cadmus purchased hundreds of reproductions of masterpieces.[16] Among them must have been versions of this subject in great paintings by Titian and Rubens, which he adapted for purposes of contemporary satire. Not for the last time Cadmus paid tribute to the union of large compositional simplicity with complex significant detail that is to be found in the Renaissance masters, while finding a contemporary mythic parallel only in a banality of modern life. He has not—like Nakian—chosen the allegory of Mars and Venus, or War versus Love, as the choice facing modern man. Strangely enough, an allegorical understanding of the gods, once thought to be a simplification of them, now would grant them at least the divinity of Platonic ideas, while their presentation merely on the level of story is sure to make them human. Nor does metamorphosis into a flower lie in the future of Cadmus's Adonis. The Venus he scorns in order to go play tennis with the boys is a graceless, clinging, fat-bottomed wife and her Cupid a squalling brat. He himself is no brave masculine hunter, but a pretty-boy whose choice between the fleshy squalor of domestic sexuality and undangerous sport is easy. But neither the obvious satire nor the recollection of myth finally matters. Cadmus himself has written that the myths have no vitality for him; the "important" motives for this painting were "admiration for favorite painters at that time—Boucher, Rubens, Titian, for instance—subjects they dealt with or might have dealt with," and the opportunity the subject offered for nudity: the painting of a Rubensian buttock, a muscular leg, a finely articulated physique.[17] Cadmus's more recent beautiful drawings of male nudes do not usually seek a narrative excuse for being; but it is interesting that the need should still have been felt in the 1930s, as Powers felt it for *The Fisher Boy* a century before. Yet Cadmus is far from Benjamin West, whose nude Adonis, like his Hyacinthus, had to be dead.

In commenting on his painting of Venus's attributes/companions *The Three Graces* (1965; fig. 169), Jack Levine similarly stated that "from a painter's standpoint" the "main point . . . is that the classical allegory is the realm of the nude." Unlike Cadmus, Levine has turned to mythological subject matter frequently since he resumed painting at the end of World War II. One of the first was a gouache called *Mars Confounded* in which Venus leaves Mars—"a bearded bully in armor"—to return to her rightful husband, Vulcan the artificer, "the maker of things." Levine passed a year in Italy, much of it in Rome, where he painted an *Orpheus and Calliope* (1951), influenced by Pompeiian work he had seen. In the 1960s Levine made several versions of *The Judgment of Paris*, the hero of which William Gerdts calls a "beatnik."[18] A small comical etching of 1963 is called *Apollo and Daphne*, and a small oil of 1972 shows a rubbery *Nymph in Pursuit*. According to Levine, since classicism "arises from the Mediterranean," it has never come naturally to northerners. In their hands it becomes "lugubrious": witness, he says, Cranach's *Venus* or the nereids in Rubens's Medici cycle in which a helmeted oarswoman "looks like a middle-aged corsetière." He wonders whether Cranach or Rubens can

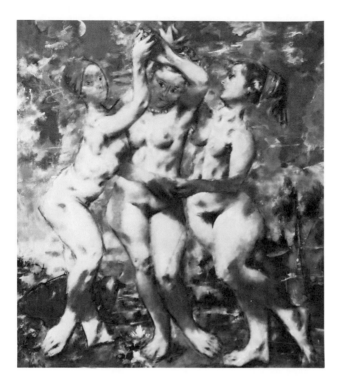

Fig. 169. Jack Levine. *The Three Graces.* 1965. Oil on canvas. 72 × 63″. The William Benton Museum of Art, University of Connecticut. Gift of Louise H. Benton Wagner.

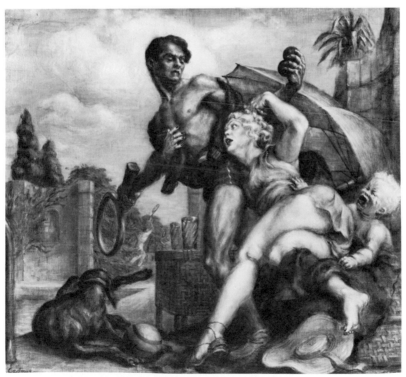

Fig. 168. Paul Cadmus. *Venus and Adonis.* 1936. Oil and tempura. 28⅝ × 32½″. The Forbes Magazine Collection, New York.

have been aware of "the comedic aspect in their treatment of matters classical." Levine is fully aware of it in his own work: "I always knew the classical allegory in my hands would go sideways." His Baltic heritage and boyhood in Boston saw to that.[19]

Levine's awkwardly posturing *Three Graces* rather combine the gothic proportions of a Cranach Venus (high, separated breasts, elongated bellies) with the robuster development seen in Rubens's *Three Graces*. But most interesting is Levine's entire departure—whether conscious or not—from the classical composition. The classical Three Graces are in fact one woman, seen in three of her "aspects." That is why they stand—in antique sculpture and in all faithful visual and poetic imitations since—with carefully balanced symmetry in a linked circle that shows at least one from the rear. Jean Seznec, in *The Survival of the Pagan Gods,* pointed out that the nadir of understanding of Venus and the Graces had been reached in the gothic Middle Ages when they had become merely the illustration of a moral to which their positioning was immaterial. The recovery of the beauty and truth of their original relation was an achievement of the Renaissance.[20] Here in Levine's painting, then, we see again the entire loss of symmetry, harmony, completeness, and meaning. Yet his *Graces* are not Dürer's *Witches.* More than satire there is pathos in the wan and wistful faces of these girls at play, lifting their arms and tipping up on their toes as they strive for a Mediterranean beauty that cannot be theirs. They are, evidently, surrogates for the painter's own art.

The ultimate reach in satirical treatment of classical iconography related to Venus—and this time without a shadow of regret—must come in John Clem Clarke's *Judgment of Paris* of 1969 (fig. 170). Perhaps inevitably Californian, but nevertheless an odd possession for an institution of higher education, this painting was conceived on the grand scale (more than five feet high and ten feet wide) the better to belittle its subject. According to the art critic Sam Hunter, "Even the soft-focus lyricism of John Clem Clarke's contemporary nudes, posed in reenactments of classical mythological themes, comment [sic] wittily on both the new sexual freedom and the irrelevance of a traditional iconography."[21] Certainly the infantile aspect of college students playing "dress-up" (so to speak) is apparent; how "lyricism" is being witty, less so. And what Clarke is saying about the "irrelevance of a traditional iconography" is not clear at all.

The truly irrelevant cannot function as either the object of satire or the standard by which something else is satirized. The triviality of a divine beauty contest from which discord may follow hardly seems irrelevant to contemporary California, any more than it was to Cranach's Germany—and Cranach's Gothic interpretation of the theme, in which pretty girls are posturing for two medieval knights, seems to be a more direct inspiration for Clarke than the versions of the Italian Renaissance. Precisely the traditional title and poses are what facilitate efficient statement of theme no less in our day than in Cranach's. The contemporary association is in either case reductive of the classical myth simply as a narrative. But for us it inevitably brings to mind not merely the myth but the versions of it painted by the Old Masters. They seized the opportunity for imagining varieties of magnificent nudes poised in a moment of dramatic tension that turned precisely on the question of supreme beauty. By contrast, the raw nakedness of Clarke's three buxom girls,

the overt silliness of their posturing, and the vacuous grin of the skinny Paris who presumes to be the knowing judge of beauty must be the measures of a loss. In any case, that the allegedly irrelevant iconography of the Judgment of Paris could be profoundly renovated had already been shown by Nakian in the same decade. What is most striking about Clarke's painting is its suggestion that the release from puritanism—the achievement of the freedom to be naked in the open air that had been proposed by Eakins and Whitman a century before as a celebration of the beauty and purity of the natural body—has meant nothing more than an opportunity for puerile games in both life and art.

What every decade must pronounce to be irrelevant must still possess vitality. Venus and the other gods survive in our time paradoxically by continual dying. Their deaths are but metamorphoses into degraded shapes through which they still assert their power. In the explicitly erotic but austerely nonallusive poetry of Robert Creeley, Venus manages on occasion to be named, even if most conspicuously in a poem called "The Death of Venus" (in the volume *For Love*, 1962). Here the goddess's "sensual proportions" suffer a "sea-change" into those of "a porpoise, a / sea-beast rising lucid from the mist." The poet's attempt to call her closer is answered with a snort before she sinks to the bottom of the sea.[22] Altered, contemptuous, and of an alien element she may be. But dead? Beneath T. S. Eliot's *Wasteland* lie the history and mythology of imperial Rome, fragmented and transposed to our century in the dying British Empire.[23] Its epigraph, taken from the *Satyricon* of Petronius, is the statement of that Cumaean Sybil who foresaw the founding of Rome and to whom Apollo had given eternal life but not eternal youth: "I want to die." But she never dies, nor does the mythology of which she is a part, even if it lives at times only in images of death.

Two final instances of the strangely postmortem survival of the myths may be cited, one of our favorite Diana, the other of our favorite Europa. Alfred Russell, a young and successful Abstract Expressionist painter who had majored in English literature at Michigan and studied Greek art history at Columbia, in the late forties and early fifties made a series of trips to Europe which included visits to the major art centers of Italy. Russell's interest in the classical tradition was revitalized. Realizing that in mid-twentieth-century New York both ancient myth and figurative means of expression were anachronistic, he turned to them in a consciously arbitrary act of freedom: he would "paint the wrong picture in the wrong century and the wrong place."[24] One of Russell's misplaced paintings is his *Diana and Callisto* of 1954 (fig. 171). Diana and her nymphs appear as thirteen nudes standing, sitting, and reclining in an ample repertory of classical poses (like the nudes in Picasso's *The Bathers*). The flat planes and sagging breasts of their heavy bodies are themselves unclassical and, by traditional standards, unbeautiful as well. They are visual echoes of both the realistic nudes of Rembrandt and the geometrized nudes of Cézanne. But what strikes one immediately is the artist's total lack of evident sensual pleasure in them as nudes. Titian and Rubens seized upon both of the Ovidian episodes in which Diana and her nymphs appear as naked bathers—the one in which Actaeon sees them, and the one in which the nymph Callisto, having been seduced by Jove disguised as Diana, has her loss of virginity exposed. Russell chose the second, and interpreted it not as an occasion for Diana's virginal outrage but as

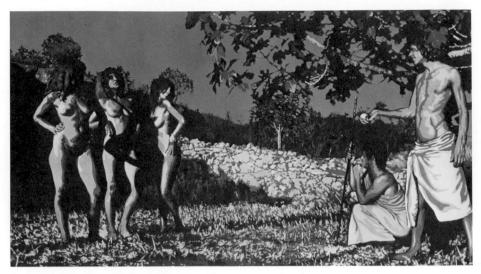

Fig. 170. John Clem Clarke. *Judgment of Paris I.* 1969. Acrylic on canvas. 65 ×
111⅞". University Art Museum, University of California, Berkeley.

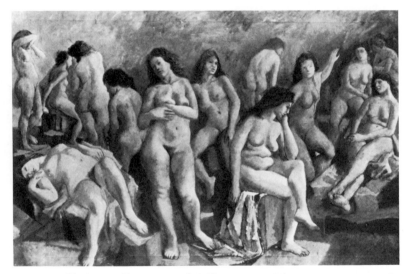

Fig. 171. Alfred Russell. *Diana and Callisto.* 1954. Oil on canvas. 45 × 69".
Collection of the artist.

an event that casts a pall of shame and sorrow over her entire troop. No longer
needing to pretend, like the earlier sculptors, that the Virgin Goddess went hunting
naked in order to show her so, Russell assembled her nymphs at the bath not to give
the viewer pleasure in a sight so rare but to commemorate the sexual pollution of
pure waters. In Ovid the offended Juno transformed Callisto into a bear, and Jove
transformed the bear into a constellation of stars. But in the dejected flesh of
Russell's painting we see only a terminal stasis.

 An even more static and morose image—if possible—may be found in Darrel
Austin's *Europa and the Bull* (1940; fig. 172). The subject that American sculptors

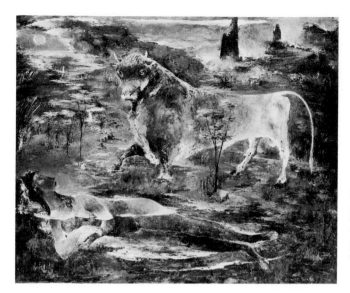

had finally been able to treat with frank sensuality, élan, and mysterious force, Austin reduced to an enigmatic and enervated confrontation. His Europa is one of a series of what John I. H. Baur calls "forlorn maidens lost in swamps with their bulls, foxes, tigers, catamounts, and strange birds." Austin claimed that the subjects of his pictures arose from subconscious promptings during the process of painting them.[25] In this case, an amorphous maiden lying half submerged in the stagnant waters of a marsh, her feet turned out like fins, apparently existing as something like the sea-beast that Creeley's Venus became, must have identified herself as Europa. She has no interest in crowning the beautiful bull with flowers, as in the legend, but awaits his approach passively with no sign of admiration or wonder. Jove himself as the bull lifts a tentative hoof and seems to hesitate as though questioning the monstrous mating with this water nymph that he had desired. Both nymph and bull are deprived forever even of the excitements of seduction, let alone the exhilaration of the flight to Crete.

One might conclude that the release from puritanical inhibitions about nudity in art (not yet complete in popular culture) and the expression of sexual freedom and tolerance that characterize our contemporary poetry, fiction, painting, sculpture, motion pictures, and sex manuals would indicate a thorough revival of one dimension of paganism, a revival to which those first encounters with naked pagan gods by our artists in Rome and Florence made the first contributions. Yet when the pagan myths themselves are brought to bear upon this development, they seem frequently to serve as a basis for criticism, suggesting doubts and fears about the fruits of sexual freedom and about the satisfactions of the flesh. They indicate too the absence, in our conceptions of physical beauty, of any sense of its having a transcendent meaning or a transforming power. Certainly today's nude is not the soul unveiled, as Hiram Powers thought, nor does it show the soul as one with the body; it has no soul. It is not the transcendent Apollo, but strangely enough, neither is it the earthly Venus. It is simply a biological fact, mortal flesh motivated by instinctual drives, the source of our laughter (Clarke) and our sorrow (Austin). For Ovid too it was all this, but more. Contemporary allusions to his fables are reminders that the natural

body was once mysterious. Its urgencies were aspects of divinity which could be imagined as assuming the most beautiful of human shapes in a world where everything was undergoing constant change.

This large sense of Ovid's mythology is evident, however, in a late painting by Peter Blume called *From the Metamorphoses* (1979; fig. 173). Blume, whose paintings often invite elaborate iconographic readings, found in one of Ovid's myths the source for an allegorical painting of comparatively simple lucidity and direct force. "The tale of Deucalion and Pyrrha and how the stones they threw (behind their backs) coalesced into sculpture, then living people, moved me very much," he has written.[26] The stones in the foreground became statues in the middle, while in the distance nudes both male and female rake the once stony fields into the fruitful rectangular plots of agriculture. Man's intellectual reshaping of nature in fact reverses the process: it is he who carves the stones into art, art that in time falls into fragments and then erodes into the stones of the foreground. The interchange of mind and matter and the concurrent, resultant, and constant metamorphoses of the physical world are beautifully rendered. Not accidentally, the figures intermediate between sculptured stones and living beings recall to our mind famous paradigms of beauty, pleasure, aspiration, pathos, and prayer. Imploring Niobids, dying gladiators, sleeping Ariadnes and fauns, bathing nymphs, leaning and bending athletes— the endless company of nude images of human life and beauty such as for two centuries Americans had delighted to encounter in Ovid's Rome are here recalled.

Such a painting—unique even in the career of Peter Blume—can hardly be taken as symptomatic of any revived classical understanding, let alone a specifically greater consciousness of Latin literature or of Rome and its galleries. But Rome is, Blume has written, "a great feast for the eyes which never gets used up." His highly original painting does prove that there are ways that other artists have not realized to "use" what is there, what is in its ancient sources, and what it has inspired in art since the Renaissance. In the resurgence of figurative and even the much-despised narrative painting there may be unforeseen possibilities after all for classical Rome and for the classical nude on which its adopted mythology thrived in two different epochs of Western history, one lasting a thousand years, the other five hundred. In the 1950s more young American artists studying abroad went to Italy than anywhere else, as they had a century earlier.[27] One is nevertheless surprised to read the statement of a new Fellow at the American Academy in 1962 that his "principal aim" while in Rome was "to create monumental sculptural groups based on Christian and pagan mythological subjects."[28] Thorwaldsen and Crawford would have been pleased. Michelangelo and Bernini might have asked, "What else?"

In Jack Levine's letter, previously cited, in which he states that "from the painter's standpoint" the "classical allegory is the realm of the nude," he also remarks that in his view the Spaniard Picasso's rescue of the nude from the French Impressionists and his "implantation" of a classical version of it in modern art was "one of the few good things to happen in the art of this century." He concludes:

There is, of course, the surrogate nude in the academy life class, the studio nude cum canvas cum artist, the voyeuristic nude (Degas), the burlesque show near-nude ([Reginald] Marsh), but I am just back from a dozen days looking at Titian's Bac-

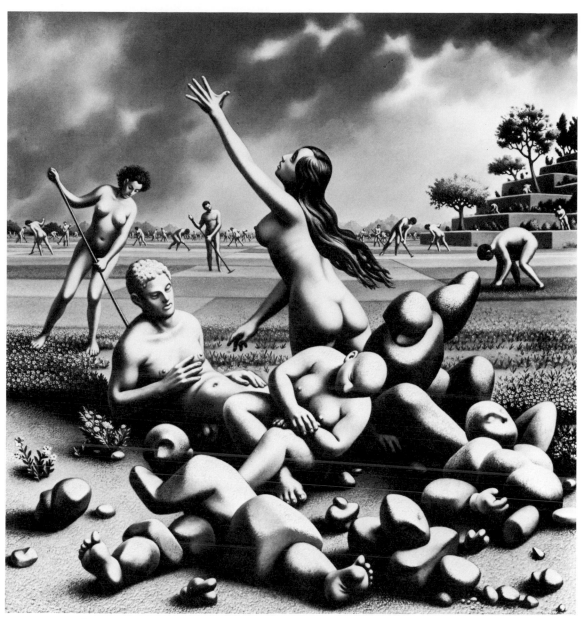

Fig. 173. Peter Blume. *From the Metamorphoses.* 1979. Oil on canvas. 54 × 51″. Photo courtesy of the artist.

chus and Ariadne in London: I am back with the feeling that painting must again become something more like this and less like something else.[29]

More than two centuries have passed since Benjamin West arrived as the first American artist in Rome to study directly the images in the Vatican and Capitoline galleries, at a time when it was being reaffirmed as providing the highest standard of art—and yet an art that could be equaled once more if only it were properly understood and its principles imitated. That was what Bayard Taylor called upon Hiram Powers to prove that an American could do, and what Henry James's Roderick Hudson promised would be his gift to his native land. Nostalgia with hope—the mixed mood of Americans in classical Rome—still speaks: the beauty that once was must come again.

Notes

Preface

1. Norton, *Letters*, 1:349, 410.
2. H. James, *North American Review* 106 (Jan. 1868): 336; quoted in Woodress, *Howells*, p. 71.
3. H. James, *Story*, 1:125.

Chapter 1

INTRODUCTION; THE
SPEAKING FRAGMENTS

1. Lynn, *Howells*, pp. 108, 48; see also Woodress, *Howells and Italy*, pp. 3–10, 44.
2. Howells, *Italian Journeys* (1877 ed.), p. 151.
3. Woodress, *Howells and Italy*, p. 194.
4. Howells, *Roman Holidays*, pp. 94–95.
5. Robert Lowell, *History*, pp. 44, 41.
6. See Reinhold, *Classica Americana*; Eadie, ed., *Classical Traditions*; Miles, "The Young American Nation"; Brown Univ., *Classical Spirit*; Bailyn, *Origins*, ch. 2, and pp. 84–85, 98–99, 136–41; Wills, *Cincinnatus*.
7. Peale, *Notes on Italy*, p. 101.
8. Weir, *Robert W. Weir*, pp. 12, 100.
9. See Tuckerman, *Book of the Artists*, p. 539; Talbot, *Cropsey* (Smithsonian), pp. 16–23.
10. Hendricks, *Bierstadt*, p. 182.
11. Hillard, *Six Months*, 1:234, 220.
12. Ticknor, *Life*, 1:168–71.
13. [Theodore Dwight], *Journal of a Tour*, p. 216.
14. Hawthorne, *Marble Faun*, pp. 164–65; *Notebooks* (Centenary Ed.) pp. 166–67.
15. Goethe, *Italian Journey*, pp. 115–16.
16. Stendhal, *Roman Journal*, pp. 8–9, 20, 95.
17. Greenwood, *Haps and Mishaps*, pp. 166–68.
18. B. Taylor, *Views A-Foot*, pp. 317–18.
19. G. W. Greene, "Letters from Rome," *Knickerbocker* 18 (1841): 371–78; 19 (1842); 293–301, 412–15; 20 (1842); 11–14.
20. W. Gillespie, *Rome*, pp. 26, 30–31.
21. Ware, *Sketches*, pp. 11–14, 18–19.
22. Ware, *Sketches*, p. 39; Tuckerman, *Italian Sketch Book* (1837 ed.), pp. 17, xi; Hillard, *Six Months*, 1:231.

RETRIEVING THE
IDEAL REPUBLIC

1. H. James, *Italian Hours*, pp. 197–99.
2. Sloan, *Rambles in Italy*, p. 298.

3. Hillard, *Six Months*, 1:230–31.
4. DAB; cf. Callcott, *History*, pp. 187–88.
5. S. Eliot, *History of Liberty*, vol. 1, preface (unpaginated); *Liberty of Rome*, 1:xi; 1:264; *History of Liberty*, 1:122.
6. S. Eliot, *Liberty of Rome*, 1:369–73.
7. S. Eliot, *Liberty of Rome*, 1:351; John Adams, *Works*, 4:298.
8. John Adams, *Works*, 4:386.
9. John Adams, *Works*, 4:520.
10. John Adams, *Works*, 4:535, 537.
11. See Somkin, *Unquiet Eagle*, pp. 138–40.
12. Everett, reprinted in Perry Miller, ed., *Transcendentalists*, pp. 20–21.

ROMAN VIRTUE

1. Galt, *West*, 1:97–98.
2. Tacitus, *Annals*, 2:72, 3:1, 4. See Galt, *West*, 2:12, 22–23; Dunlap, *History*, 1:62; Alberts, *West*, pp. 84–86; Dillinberger, *West*, pp. 19–20; Rosenblum, *Transformations*, pp. 42–43.
3. Craven, "The Grand Manner," p. 7.
4. See Bailyn, *Origins*, p. 44.
5. Dunlap, *History*, 2:89–92; Desportes, "Giuseppe Ceracchi in America."
6. Craven, *Sculpture in America*, p. 329.
7. Flexner, "George Washington as an Art Collector," p. 26; Wills, *Cincinnatus*, pp. 8, 133–38.
8. Wendy Wick, *George Washington*, pp. xv, xx; Plutarch, *Lives* p. 214; Amfitheatrof, *Enchanted Land*, p. 140; Craven, *Sculpture in America*, pp. 51–52, 61–64; Henry Adams, *Democracy*, p. 90.
9. As regularized in Emerson, *Journals* (1910 ed.), 3:75. Cf. 1964 ed., 4:71.
10. M. Fuller, *At Home and Abroad*, p. 259. Cf. M. Fuller, *Memoirs*, 2:230.
11. Quoted in M. V. Allen, *Achievement of Margaret Fuller*, pp. 105, 74.

12. M. Fuller, *At Home and Abroad*, pp. 265–66; 358–59.
13. M. Fuller, *At Home and Abroad*, p. 366; letter quoted in Deiss, *Roman Years*, p. 209.
14. M. Fuller, *Memoirs*, 1:18–20.
15. M. Fuller, *At Home and Abroad*, p. 367.
16. S. Eliot, *Liberty of Rome*, 1:355; 2:519–22.
17. See Craven, "Grand Manner," pp. 40–41.
18. See commentary on Tavola V: "La Carità Greca," in *Real Museo Borbonico*, vol. 1.
19. Hosmer, *Letters and Memories*, pp. 145–46.
20. See Waller, "The Artist, the Writer, and the Queen."
21. Ware, *The Antiquity and Revival of Unitarian Christianity*, pp. 3–4.
22. Ware, *Zenobia*, 1:79; 2:87; 1:88–91.
23. Ware, *Zenobia*, 1:196–97.
24. Ware, *Probus*, 1:177–80.
25. John Adams, *Works*, 4:294.
26. See Douglas, *Feminization of American Culture*, p. 116.
27. Lindsay, *Vanderlyn*, p. 72.
28. Tuckerman, *Book of the Artists*, p. 128.
29. Plutarch's *Lives*, "Caius Marius"; Eliot, *Liberty of Rome*, 2:268–85, 344; Lindsay, *Vanderlyn*, pp. 71–72; *Description of the Pictures . . . by Vanderlyn*, pp. 2–3; Craven, "Grand Manner," pp. 16–19.

THE RUBBISH HEAP

1. H. P. Leland, *Americans in Rome*, pp. 12–13.
2. N. Hawthorne, *Notebooks*, p. 54; *Marble Faun*, p. 110.
3. S. Hawthorne, *Notes*, pp. 544–46.
4. Ware, *Zenobia*, 1:241; 2:60.
5. Bancroft, *Miscellanies*, pp. 280–317.
6. Ware, *Zenobia*, 2:70; *Probus*, 1:131–32.
7. Howells, *Italian Journeys*, p. 173.
8. Fast, *Spartacus*, pp. 20, 88.
9. Ware, *Probus*, 1:237–38.

10. See J. W. Johnson, "The Meaning of 'Augustan.'"
11. Norton, *Letters*, 1:399; Vanderbilt, *Norton*, pp. 201–10.
12. Norton, *Letters*, 2:260–69. Cf. Cicero, *Atticus*, 8, 11, D, and Horace, *Carmine*, I:7, 27. I am indebted to Prof. Gerald P. Fitzgerald for this suggestion.
13. Norton, *Letters*, 2:241; Henry Adams, *Education*, pp. 89–92; 499.
14. Henry Adams, *Education*, pp. 90–91.
15. F. M. Crawford, *Ave Roma*, rev. ed. (1902), pp. 1, 3, 12, 13.
16. F. M. Crawford, *Ave Roma*, pp. 76, 23–36, 27, 49–50.
17. F. M. Crawford, *Ave Roma*, p. 394.
18. H. James, *Letters*, 1:353.
19. Story, *Nero*, p. 151.
20. Story, *Nero*, p. vi.
21. Hersey, *Conspiracy*, p. 53.
22. Hersey, *Conspiracy*, pp. 172–73.
23. Riencourt, *Coming Caesars*, pp. 138–39, 245–46, 332.
24. H. James, *Roderick Hudson*, pp. 349–50.
25. S. Hawthorne, *Notes*, p. 288; Howells, *Roman Holidays*, pp. 94–95, 97.

Chapter 2

INTRODUCTION; THE COLOSSEUM AS LANDSCAPE

1. H. James, *Portrait of a Lady*, 2:339–40 (ch. 50).
2. See Colagrossi, *L'Anfiteatro*; Di Macco, *Il Colosseo*; Quennell, *Colosseum*; and Pearson, *Arena*.
3. H. James, *Portrait of a Lady*, 1:413–13 (ch. 27); 2:327–29 (ch. 49).
4. See Röthlisberger, *Claude Lorrain: The Paintings*, vol. 2, figs. 26, 27, 42, 142.
5. See Merritt, *Cole*, pp. 28, 75.
6. In Noble, *Cole*, pp. 115–16.
7. H. James, *Italian Hours*, pp. 201–02; cf. Melville in Sealts, *Melville as Lecturer*, pp. 142–43.

8. B. Taylor, *Views A-Foot*, p. 327. Cf. Goethe, *Italian Journey*, pp. 125, 156, 496–97.
9. Story, *Roba di Roma* (1887 ed.), 1:241, 242.
10. Hillard, *Six Months*, 1:239–41.

THE HISTORICAL ARENA

1. On Gèrôme's Roman paintings see Ackerman, *Gèrôme*, pp. 11–12, 44–45, 62–63, 73–74, 86–87. On Nast, see Boime, "Thomas Nast and French Art."
2. See Story, *Roba di Roma*, 1:243.
3. H. James, *Painter's Eye*, p. 42; H. James, *Parisian Sketches*, pp. 98–99, quoted by Ackerman, *Gèrôme*, p. 74.
4. Crawford, *Ave Roma* (1898 ed.), 2:97–100.
5. See Zafran, "Edwin H. Blashfield."
6. Hadas, ed., *History of Rome*, pp. 137–40; Haskell and Penny, *Taste and the Antique*, pp. 188–89.
7. H. James, *Princess Casamassima*, 2:23 (ch. 22).
8. Cole, *Essays*, p. 140.
9. Norton, *Letters*, 2:218, 169; Henry Adams, *Education*, pp. 340–41.
10. Greenwood, *Haps and Mishaps*, pp. 162, 310.
11. Twain, *Innocents Abroad*, 1:287–96.
12. M. Fuller, *At Home and Abroad*, p. 216.

THE MEASURE OF MAN

1. Shaw, *John Adams*, p. 192 and fig. 2; Henry Adams, *Education*, p. 92.
2. See Ford, "The Grand Tour," figs. 4, 10, 13, 17.
3. On Healy, see G. P. A. Healy, *Reminiscences*; de Mare, *Healy*; and *Healy's Sitters*.
4. H. James, *Letters*, 2:163.
5. Photograph reproduced in *Exhibit 74* (May–June 1976).
6. Flexner, *That Wilder Image*, p. 161.
7. Dr. Trevor Fairbrother kindly brought this photograph to my at-

tention; it has since been published in Dinnerstein, "The Significance of the Colosseum," p. 117. On Page, see Markus, "William Page," and J. C. Taylor, *Page*.

8. Allston, *Monaldi*, p. 65.
9. Byron, *Childe Harold's Pilgrimage*, Canto 4:82, 96, 104, 142.
10. Poe, *Collected Works*, 1:228–30.
11. N. Hawthorne, *Marble Faun*, pp. 153–58.
12. H. James, *Roderick Hudson*, pp. 257–70 (ch. 13).
13. H. James, *Daisy Miller*, pp. 84–93 in 1909 text; quotation partly from slightly differing 1879 text.

THE COLOSSEUM AS
NEGATIVE MODEL

1. See the survey of scholarship by Reinhold in Eadie, *Classical Traditions*, and essays in that book by Aldridge, Cowley, and Kennedy, to which I am indebted.
2. Quoted by Aldridge in Eadie, *Classical Traditions*, p. 115.
3. Timothy Dwight, *Greenfield Hill*, pt. 8, lines 251–78.
4. Tocqueville, *Democracy*, 2:195; W. Gillespie, *Rome*, p. 35.
5. Jarves, *Italian Sights*, pp. 210–11; *Art Hints*, pp. 32–33.
6. See Miles, "Young American Nation," especially pp. 272–73 and n. 62.
7. Henry Adams, *Education*, p. 367.
8. See Jordy, *American Buildings*, pp. 330, 370, 391–92.
9. Quoted by Aldridge in Eadie, *Classical Traditions*, p. 109.

THE ABYSS OF TIME

1. Longfellow, *Complete Poetical Works*, pp. 575–76.
2. N. Hawthorne, *Marble Faun*, pp. 159–63 (chs. 17–18).

Chapter 3

INTRODUCTION;
THE WASTELAND

1. Willis, *Pencillings*, p. 399.
2. Willis, *Pencillings*, p. 308; Beers, *Willis*, p. 120.
3. Bryant, *Orations and Addresses*, p. 21.
4. De Staël, *Corinne*, p. 233.
5. H. James, *Letters*, 1:175.
6. Hillard, *Six Months*, 2:44.
7. Melville, *Moby-Dick*, p. 542 (ch. 96).
8. B. Taylor, *Views A-Foot*, pp. 340, 336, 315.
9. Ticknor, *Life*, 1:168.
10. Stendhal, *Roman Journal*, p. 20.
11. Howells, *Italian Journeys*, pp. 155–56; *Roman Holidays*, p. 172.
12. J. F. Cooper, *Italy*, p. 189.
13. Theodore Dwight, *Journal*, pp. 312–13.
14. N. Hawthorne, *Marble Faun*, p. 24.
15. Willis, *Pencillings*, pp. 398, 397.
16. Willis, *Pencillings*, p. 399.
17. Tuckerman, *Italian Sketch Book* (1837 ed.), pp. 33–35.
18. J. F. Cooper, *Italy*, p. 206.
19. Hillard, *Six Months*, 2:49–51.
20. J. F. Cooper, *Italy*, p. 188.
21. Hillard, *Six Months*, 2:49.
22. Hillard, *Six Months*, 2:52–53.
23. D. Armstrong, *Day before Yesterday*, pp. 188–89, 192, 216; see also p. 230 on Tor degli Schiavi.
24. Bryant, *Letters from a Traveller*, pp. 253–57.
25. Benson, *Art and Nature*, p. 180.

IN SEARCH OF ARCADIA

1. See Ireland, *Inness*, figs. 148 and 149.
2. Benson, *Art and Nature*, pp. 178–88.
3. Willis, *Pencillings*, pp. 384–85.
4. See Blunt, *Nicolas Poussin*, 1:4; Röthlisberger, *Claude Lorrain: The Paintings*, 1:21; and Russell, *Claude Lorrain*, pp. 81–96.

5. B. Tayor, *Views A-Foot*, p. 334.

6. H. P. Leland, *Americans in Rome*, pp. 54–55; Armstrong, *Day before Yesterday*, pp. 215–16; Freeman, *Gatherings* (1877), pp. 100–01.

7. Hillard, *Six Months*, 2:45.

8. See Campbell, *Chapman*; and Chamberlain, *Studies in John Gadsby Chapman*.

9. Tuckerman, *Book of the Artists*, p. 221.

10. Benson, *Art and Nature*, pp. 177–78.

11. Hillard, *Six Months*, 2:57; 2:58–62.

12. Hillard, *Six Months*, 2:70–71.

13. Photocopy in Childs Gallery archives, Boston.

14. Hillard, *Six Months*, 2:75–76.

15. Willis, *Pencillings*, p. 297.

MEDITATION AND DANCE

1. Noble, *Cole*, p. 189.

2. Noble, *Cole*, p. 271.

3. Noble, *Cole*, pp. 111–12.

4. Röthlisberger, *Claude Lorrain: The Paintings*, 1:27.

5. For an example of many such statements, see Cole, *Essays*, p. 61.

6. Cooper, quoted in Noble, *Cole*, p. 166.

7. Noble, *Cole*, pp. 266, 271.

8. Tuckerman, *Book of the Artists*, p. 231.

9. See Parry, "Recent Discoveries in the Art of Thomas Cole."

10. Tuckerman, *Book of the Artists*, p. 231.

11. See Blunt, *Nicolas Poussin*, 1:141–44.

12. Levin, *Myth of the Golden Age*, p. 198.

13. N. Hawthorne, *Notebooks*, p. 321.

14. Noble, *Cole*, pp. 189–94.

15. Cole, *Essays*, pp. 156–57.

16. Noble, *Cole*, p. 188.

17. Cole, *Essays*, p. 137.

18. Cole, *Essays*, pp. 143–51.

19. Cole, *Essays*, p. 142.

THE ROMANCE OF TRUTH AND A POSSIBLE GROUND

1. Letter to James McMurtie, his agent in Philadelphia, written from Cambridge Port, Mass., 2 March 1837. Mss. in the Dreer Autograph Collection, Historical Society of Pennsylvania. I am indebted to Dr. Judithe Speidel for this quotation.

2. Allston quoted in Dunlap, *History*, 2:314.

3. Manwaring, *Italian Landscape*, pp. 214–17. Biographical sources: E. P. Richardson, *Allston*, and Gerdts and Stebbins, "A Man of Genius."

4. Allston, *Lectures*, p. 151.

5. Reproduced in Wolf, *Romantic Re-Vision*, p. 191. Cf. Gerdts and Stebbins, "A Man of Genius," p. 30.

6. For inevitable comparisons with Poussin, cf. Gerdts and Stebbins, "A Man of Genius," p. 47, and Wolf, *Romantic Re-Vision*, pp. 40–52.

7. Allston, *Lectures*, p. 127. Cf. p. 16 in "Introductory Discourse."

8. Allston, *Lectures*, pp. 16, 42ff.

9. Allston, *Lectures*, pp. 30–31.

GOLDEN LIGHT AND MALARIAL SHADE

1. N. Hawthorne, *Marble Faun*, pp. 10–11.

2. E. P. Richardson, *Allston*, pp. 7–8.

3. N. Hawthorne, *Marble Faun*, p. 3.

4. N. Hawthorne, *Marble Faun*, p. 463.

5. Allston, *Lectures*, pp. 79, 93ff., 163.

6. See Panofsky, *Meaning in the Visual Arts*, pp. 265–71.

7. H. James, *Hawthorne*, p. 169.

8. N. Hawthorne, *Marble Faun*, p. 71.

9. H. James, *Hawthorne*, p. 170.

10. N. Hawthorne, *Notebooks*, pp. 178–79, 191–92.

11. N. Hawthorne, *Marble Faun*, pp. 71–98.

12. Although labeled *Barberini Villa, Italy* by Ireland (*Inness*, no. 596),

the painting appears to be of the Villa Borghese, Rome.

13. N. Hawthorne, *Marble Faun*, p. 30.
14. N. Hawthorne, *Marble Faun*, pp. 233–34.
15. N. Hawthorne, *Marble Faun*, p. 239.
16. N. Hawthorne, *Marble Faun*, p. 428.
17. N. Hawthorne, *Marble Faun*, pp. 436, 105, 452.

THE SACRED GROVES OF GEORGE INNESS

1. Cikovsky, *Inness*, pp. 17–18.
2. Armstrong, *Day before Yesterday*, pp. 198–99.
3. George Inness, Jr., *Inness*, p. 218.
4. Dangerfield, *Inness*, p. 54.
5. George Inness, Jr., *Inness*, pp. 175, 174.
6. Baigell, *Cole*, p. 48.
7. B. Taylor, *Views A-Foot*, p. 336; Hillard, *Six Months*, 1:431.
8. Jarves, *Art-Idea*, p. 196.

THE "ILLIMITABLE EXPERIENCE" OF HENRY JAMES

1. H. James, *Portrait of a Lady*, 2:327–29 (ch. 49).
2. H. James, *Tales*, 3:212, 215.
3. H. James, *Italian Hours*, pp. 217–36.
4. H. James, *Letters*, 1:399.
5. H. James, *Artt of the Novel*, pp. 32–33.
6. J. F. Cooper, *Italy*, pp. 203, 213–14, 204.
7. H. James, *Letters*, 1:301.

DEATH AND ARCADIA

1. Howells, *Roman Holidays*, pp. 208–09.
2. Howells, *Roman Holidays*, p. 210.
3. Panofsky, *Meaning in the Visual Arts*, p. 300.
4. Panofsky, *Meaning in the Visual Arts*, pp. 310–11, 317–20, summarizes many of the later stages.
5. Panofsky, *Meaning in the Visual Arts*, pp. 312–13.
6. Russell, *Claude Lorrain*, p. 93, n.

7. Panofsky, *Meaning in the Visual Arts*, pp. 313, 309.
8. Wolf, *Romantic Re-Vision*, p. 52.
9. Panofsky, *Meaning in the Visual Arts*, p. 312.
10. See note to no. 29 in Mahon, *Il Guercino*, pp. 69–72.
11. Friedlaender, *Poussin*, p. 116.
12. Starke, *Travels*, p. 209; Willis, *Pencillings*, p. 387.
13. Ticknor, *Life*, pp. 168–69; ellipses as in original published version.
14. H. James, *Italian Hours*, pp. 248–49.
15. H. James, *Italian Hours*, pp. 249–50.

Chapter 4

INTRODUCTION; "REVERBERATIONS OF PAGAN WORSHIP"

1. N. Hawthorne, *Marble Faun*, p. 424.
2. N. Hawthorne, *Marble Faun*, pp. 174–76.
3. Fairbanks, *My Unknown Chum*, pp. 82–83.
4. Greenwood, *Haps and Mishaps*, p. 165.
5. H. James, *Letters*, 1:164.
6. Mumford, *City in History*, Graphic Sec. 1:15.
7. N. Hawthorne, *Notebooks*, pp. 60–61, 97–98.
8. N. Hawthorne, *Marble Faun*, pp. 457–61.
9. H. James, *Tales*, 3:95–96, 108.
10. H. James, *Tales*, 3:109–11, 120.
11. S. L. Greenough, *Arabesques*, pp. 121–51.
12. W. C. Williams, *Voyage*, pp. 108–10, 112, 116, 125–27.
13. Vidal, *Julian*, pp. 81, 82, 134, 247.
14. Vidal, *Julian*, pp. 430–31.
15. Ingersoll, *The Gods*, p. 89.

TEMPLE OF ALL GODS

1. Stendhal, *Roman Journal*, p. 123.
2. Tuckerman, *Italian Sketch Book* (1837 ed.), p. 39; B. Taylor, *Views A-Foot*, pp. 329–30; Hillard, *Six*

Months, 1:247; Willis, *Pencillings*, p. 305.

3. J. F. Cooper, *Italy*, p. 224; Hillard, *Six Months*, 1:248.

4. J. F. Cooper, *Italy*, p. 225.

5. Theodore Dwight, *Journal*, p. 324.

6. Felton, "Classical Mythology," pp. 330–33.

7. Bradford, *History of Plymouth Plantation*, pp. 48–49.

8. Morton, *New English Canaan*, p. 134.

9. Whittier, *Snow-Bound*, lines 470–75.

10. See Swann, *Classical World*, p. 10.

11. See R. D. Richardson, *Myth and Literature*, pp. 96, 124.

12. C. G. Leland, *Memoirs*, pp. 125, 46–47.

13. Alcott, *Journals*, p. 290.

14. Channing, *Conversations*, pp. 33–34.

15. Channing, *Conversations*, p. 53. Cf. Emerson, *Journals*, 8:196, quoted in Richardson, *Myth and Literature*, p. 73.

16. Channing, *Conversations*, p. 78.

17. Story, *Excursions*, pp. 193–222.

18. Howells, *Italian Journeys*, p. 174.

19. Howells, *Roman Holidays*, pp. 116–17.

20. Stendhal, *Roman Journal*, p. 123.

21. See MacDonald, *The Pantheon*, pp. 76–93.

THE CHASTITY OF MINERVA

1. M. Fuller, *At Home and Abroad*, p. 223.

2. M. Fuller, *Memoirs*, 1:21.

3. R. D. Richardson, *Myth and Literature*, pp. 49–50.

4. M. Fuller, *Memoirs*, 1:219.

5. M. Fuller, *Memoirs*, 1:324–51; M. Phillips, *Story*, pp. 54–55.

6. M. Fuller, *Woman*, pp. 51–55.

7. M. Fuller, *Woman*, pp. 115–16.

8. M. Fuller, *Woman*, pp. 118–21.

9. M. Fuller, *Woman*, pp. 133–37.

10. M. Fuller, *Memoirs*, 2:120, 92–93.

11. N. Hawthorne, *Notebooks*, pp. 155–57.

12. Melville, *Collected Poems*, pp. 216–21.

13. Ware, *Sketches*, pp. 37–38.

14. Story, *Excursions*, pp. 1–4.

Chapter 5

INTRODUCTION; HISTORY AND TRANSCENDENCE

1. The sketchbook is now in the Fogg Museum at Harvard.

2. Peale, *Notes on Italy*, p. 156.

3. Pelzel, *Mengs*, pp. 108–09, 190–92; Dunlap, *History*, 1:52–53, 122.

4. Peale, *Notes on Italy*, p. 137; H. James, *Roderick Hudson*, p. 102.

5. Emerson, *Journals*, 4:150.

6. N. Hawthorne, *Notebooks*, p. 166.

7. Hillard, *Six Months*, 1:188.

8. [Theodore Dwight], *Journal of a Tour*, pp. 321–24.

9. S. Hawthorne, *Notes*, p. 225; N. Hawthorne, *Notebooks*, p. 101.

10. Sealts, *Melville as Lecturer*, p. 132; Howells, *Roman Holidays*, p. 228.

11. Sealts, *Melville as Lecturer*, p. 131; N. Hawthorne, *Notebooks*, p. 102.

12. Howells, *Roman Holidays*, p. 228; Sealts, *Melville as Lecturer*, pp. 131–35.

13. Willis, *Pencillings*, p. 303.

14. H. James, *Letters*, 1:165, 167.

15. Gale, *Crawford*, p. 11; Crane, *White Silence*, p. 97 (on Greenough); Dryfhout, *Saint-Gaudens*, Cat. no. 33, 34, 35, 36; Craven, *Sculpture in America*, p. 283 (on Akers); Ross and Rutledge, *Rinehart*.

16. B. Taylor, *Views A-Foot*, p. 321.

17. B. Taylor, *Views A-Foot*, p. 321.

18. H. James, *Roderick Hudson*, p. 92.

19. Hillard, *Six Months*, 1:302.

20. H. James, *Roderick Hudson*, pp. 300, 116–20.

21. N. Hawthorne, *Marble Faun*, pp. 134–5.

22. Hosmer, *Letters and Memories*, p. 160.

23. Reynolds, "The Unveiled Soul," p. 411.
24. N. Hawthorne, *Marble Faun*, pp. 123, 135, 117–27.

PAGANS AND CHRISTIANS

1. Hoopes, *American Narrative Painting*, pp. 24–25; painting in Pennsylvania Academy of the Fine Arts.
2. John Neal in *Observations*; quoted in Benisovich, "Further Notes," p. 13.
3. Quotations from Neil, *Toward a National Taste*, pp. 75, 82.
4. Tuckerman, *Book of the Artists*, p. 235.
5. Sloan, *Rambles*, pp. 338–39, 333–34.
6. Howells, *Roman Holidays*, p. 183.
7. Jarves, *Art-Idea*, pp. 35, 41, 43, 248, 287.
8. Jarves, *Art-Idea*, pp. 282, 46–49.
9. Jarves, *Art-Idea*, pp. 274–75, 79.
10. Jarves, *Art-Idea*, pp. 52–53, 81, 72, 60–61.
11. Jarves, *Art-Idea*, pp. 66–68.
12. Melville, *Journal of a Visit*, p. 191; *Melville as Lecturer*, pp. 142–43.
13. Hillard, *Six Months*, 1:227–28, 187.
14. Jarves, *Art-Idea*, pp. 68–69.
15. Jarves, *Art Hints*, pp. 32, 232–33, 250.
16. N. Hawthorne, *Notebooks*, pp. 292–93.
17. Jarves, *Art Hints*, pp. 155–56, 160, 158–59.

THE HUMAN FORM DIVINE

1. Sloan, *Rambles*, p. 362.
2. [Murray], *Handbook: Rome*, 3d ed., p. 170.
3. See J. R. Hale, "Art and Audience," pp. 37–58.
4. West, letter cited in Dunlap, *History*, 1:91–93.
5. Goethe, *Italian Journey*, p. 156.
6. Galt, *West*, 2:99–102, 110.
7. Dunlap, *History*, 2:378.
8. S. Howard, "Thomas Jefferson's Art Gallery," pp. 593–94.

9. Vermeule, *European Art*, p. 134.
10. Dunlap, *History*, 2:104–05; Cowdrey, *American Academy of Fine Arts*, 1:11–12.
11. J. F. Cooper, *Italy*, pp. 82–83.
12. Emerson, *Letters*, 1:119, quoted in Wright, *Greenough*, p. 23; Swan, *Athenaeum Gallery*, ch. 8.
13. Dunlap, *History*, 3:226; Greenough, *Letters*, p. 20.
14. Stillman, *Venus and Apollo*, p. xiii.

FIGURE, FACE, AND EFFECTS OF VENUS

1. N. Hawthorne, *Notebooks*, pp. 510–11.
2. See J. R. Hale, "Art and Audience," p. 39.
3. N. Hawthorne, *Notebooks*, pp. 297–99.
4. N. Hawthorne, *Notebooks*, pp. 307–08.
5. N. Hawthorne, *Notebooks*, pp. 309–11.
6. N. Hawthorne, *Notebooks*, pp. 403, 429–30.
7. Crane, *White Silence*, p. 175.
8. Winckelmann, *Ancient Art*, 2:232.
9. *Crayon* 2 (1855): 24.
10. Jameson, *Diary of an Ennuyée*, p. 90; Edwards, *Antique Statues*, pp. 54–55.
11. Edwards, *Antique Statues*, pp. 52–53.
12. S. Howard, "Thomas Jefferson's Art Gallery," Appendix C, pp. 595–96.
13. Gerdts, *Great American Nude*, pp. 91–92.
14. See Ross and Rutledge, *Rinehart*, Plate XLVII.
15. H. P. Leland, *Americans in Rome*, pp. 36–38.
16. N. Hawthorne, *Notebooks*, pp. 516–17.
17. N. Hawthorne, *Marble Faun*, p. 423.
18. Headley, *Letters from Italy*, p. 203; *Knickerbocker* 27 (1846): 158–59.
19. Twain, *Complete Travel Books*, pp. 312–13 (*Tramp Abroad*, ch. 50).

20. Greenwood, *Haps and Mishaps,* pp. 181, 354.
21. Tuckerman, *Italian Sketchbook,* 3d ed., pp. 415–16.
22. Jarves, *Art-Idea,* pp. 55–56.
23. See Gerdts, *Great American Nude,* pp. 20–21, 38–39.
24. See Desportes, "Giuseppe Ceracchi in America," pp. 146–47.
25. Quoted in Neil, *Toward a National Taste,* p. 10.
26. Quotations in K. Clark, *Nude,* p. 97.
27. Galt, *West,* 2:101.
28. Blunt, *Nicolas Poussin* (1967), 1:114–15.
29. See Gerdts, *Great American Nude,* pp. 30–32, and G. Evans, *West,* for reproductions.
30. Dunlap, *History,* 2:103; 1:378.
31. Tuckerman, *Book of the Artist,* pp. 442–44, 498.
32. Hillard, *Six Months,* 2:198.

DECEPTIONS OF VENUS

1. Ezekiel, *Baths of Diocletian,* p. 129.
2. See D. Evans, "Raphaelle Peale's Venus," pp. 63–72.
3. Quoted from a letter in the Archives of American Art by Stebbins et al., *A New World,* p. 217.
4. Dunlap, *History,* 2:162.
5. Haskell and Penny, *Taste and the Antique,* p. 186.
6. Cf. K. Clark, *Nude,* pp. 124–35.
7. For a discussion of Vanderlyn's sources, see Gerdts, *Great American Nude,* pp. 52–57.
8. See Gerdts, *Great American Nude,* pp. 57–61.
9. See Rosenblum, *Transformations,* pp. 3–10.
10. Compare commentary in *Le Pittore Antiche d'Ercolano,* vol. 3, on Tavola VII: Il Mercato degli Amori, pp. 37–39, with that in *Real Museo Borbonico,* vol. 1, on Tavola III: Il Mercato degli Amori, p. 6.
11. Quoted in Crane, *White Silence,* pp. 54–55.

12. Quoted in N. Wright, *Greenough,* pp. 86–88.
13. H. Greenough, *Letters,* pp. 228–29.
14. H. Greenough, "Do Not Be Afraid," pp. 119–20.
15. N. Wright, *Greenough,* p. 253; Crane, *White Silence,* pp. 121–22.
16. Hosmer, *Letters and Memories,* pp. 45, 65, 69.
17. "William Page Papers," *Journal Archives of American Art* 19 (1979):7.
18. Quoted in Gerdts, *Great American Nude,* p. 80.
19. Flexner, *Wilder Image,* p. 162.
20. See A. Davidson, *Eccentrics,* pp. 55–56.
21. Hosmer, *Letters and Memories,* p. 45.
22. *Crayon* 6 (Dec. 1859): 377.
23. Jarves, *Art-Idea,* pp. 179–80.
24. Tuckerman, *Book of the Artists,* pp. 297, 299.
25. Gerdts, *Great American Nude,* pp. 78–79; Swan, *Athenaeum Gallery,* p. 131.

VENUS AND EROS ENCHAINED

1. H. Greenough, *Letters,* pp. 98, 191.
2. Dunlap, *History,* 3:230; Emerson, *Complete Works,* 5:5.
3. Ware, *Sketches,* p. 131.
4. See Douglas, *Feminization,* pp. 21–22.
5. Dewey, pamphlet on *Greek Slave,* 1847.
6. K. Clark, *Nude,* pp. 161–62 and n.
7. Quoted in Reynolds, *Powers,* pp. 158–59.
8. Headley, *Letters from Italy,* p. 197.
9. Quotations from Reynolds, *Powers,* pp. 135, 146, 141.
10. Ball, *My Threescore Years,* pp. 264–65; Ezekiel, *Memoirs,* p. 181.
11. Quotations from Reynolds, *Powers,* pp. 137, 202.
12. N. Hawthorne, *Notebooks,* p. 281.
13. Quotations from Reynolds, *Powers,* pp. 176, 174, 254.
14. M. Fuller, *At Home and Abroad,* p. 372.

15. Hillard, *Six Months*, 1:141.
16. Jarves, *Art-Idea*, pp. 215–16.
17. Quoted in Crane, *White Silence*, p. 195.
18. Quoted in Craven, *Sculpture in America*, p. 360.
19. K. Clark, *Nude*, pp. 161–62 and n.
20. Tuckerman, *Book of the Artists*, p. 279.
21. Jarves, *Art-Idea*, pp. 222–23.
22. Quoted in Crane, *White Silence*, pp. 220–21.
23. See Gerdts, *American Neo-Classical Sculpture*, pp. 80–81.
24. N. Hawthorne, *Notebooks*, p. 509.
25. Quoted by Richman, *French*, p. 196.
26. Taft, *American Sculpture*, p. 102.
27. Craven, *Sculpture in America*, p. 199.

PASSIONATE WOMEN IN HEAVY DRAPERY

1. Ware, *Sketches*, p. 237.
2. See Haskell and Penny, *Taste and the Antique*, pp. 132–34.
3. Story, *Poems*, 1:16.
4. Quoted in Hosmer, *Letters and Memories*, pp. 191–92.
5. Quoted in Hosmer, *Letters and Memories*, p. 204.
6. H. James, *Story*, 2:75–83.
7. Quoted by Ramirez, "William Wetmore Story's *Venus* and *Bacchus*," p. 40.
8. M. Phillips, *Story*, p. 297; Story, *Poems*, 1:123–28.
9. See Ramirez, "William Wetmore Story's *Venus* and *Bacchus*," pp. 32–41.
10. Quoted in Phillips, *Story*, p. 129.
11. Phillips, *Story*, p. 129.
12. Quoted in Phillips, *Story*, p. 131.
13. Quoted in H. James, *Story*, 2:71.
14. See J. C. Taylor, *Perceptions*, pp. 125–27, and Soria, "Some Background Notes," pp. 71–87.
15. Phillips, *Story*, pp. 225–26.
16. Quoted in Phillips, *Story*, p. 147.
17. Phillips, *Story*, pp. 166, 229.

18. Winckelmann, *History of Ancient Art*, 2:252.
19. Mrs. Henry Adams, *Letters*, p. 95.
20. H. James, *Story*, 2:70.
21. H. James, *Story*, 1:194–95.
22. Quoted in Phillips, *Story*, p. 183.
23. Gerdts, "William Wetmore Story," p. 25.
24. Story, *Poems*, 1:168; 2:309.
25. Quoted in Phillips, *Story*, pp. 191–95.
26. Mrs. Henry Adams, *Letters*, p. 95.

THE FRENCH DECEPTION

1. Dunlap, *History*, 1:385–86.
2. Winckelmann, *History of Ancient Art*, 2:232–33; Jarves, *Art-Idea*, p. 90.
3. Visconti, *Museo Pio-Clementino*, 1:59–60 (Tav. X); 1:186–88 (Tav. XXIX–XXX).
4. M. Fuller, *Memoirs*, 1:270.
5. Crane, *White Silence*, p. 227.
6. Hosmer, *Letters and Memories*, p. 35.
7. Parsons, *Poems* (1893), pp. 184–86.
8. Winckelmann, *History of Ancient Art*, 2:235.
9. K. Clark, *Nude*, p. 148.
10. Arnason, *Houdon*, pp. 43–44.
11. See Winckelmann, *Winckelmann: Writings on Art*, pp. 34–36, 45.
12. See ch. 8 of Clark, *Nude*.
13. See Arnason, *Houdon*, p. 111, n. 101.
14. Taft, *History of American Sculpture*, pp. 336–37.
15. Haskell and Penny, *Taste and the Antique*, p. 281.
16. Gardner, *American Sculpture*, p. 82.
17. John Dryfhout in Wasserman, *Metamorphoses*, pp. 201–13; Craven, *Sculpture in America*, pp. 389–90.
18. Chanler, *Roman Spring*, p. 257.
19. Gerdts, *Great American Nude*, p. 132.
20. See Dennis, *Karl Bitter*, figs. 4 and 107.
21. See Proske, *Brookgreen Gardens* (1943 ed.), p. 230.

22. Cortissoz, *Painter's Craft*, pp. 325–26, 420–21.
23. See Murtha, *Paul Manship*, plates 16 and 18.
24. Nordland, *Gaston Lachaise*, p. 1.
25. Goodrich, *Eakins* (1933), pp. 19–20.

AMOR/ROMA

1. Soria, *Vedder*, pp. 33, 92–93.
2. Jarves, *Art-Idea*, pp. 201–02; *Art Thoughts*, p. 318.
3. Allen, *Solitary Singer*, pp. 229–31.
4. See Ormond, *Leighton*, fig. 116.
5. Quoted by Dillenberger in J. Taylor, *Perceptions*, p. 122, where the three versions are reproduced.
6. Dillenberger in J. Taylor, *Perceptions*, p. 131.
7. For detailed readings of Vedder's murals, see the essay by Richard Murray in J. Taylor, *Perceptions*, pp. 206–28.
8. Quoted by Murray in J. Taylor, *Perceptions*, pp. 216–17.
9. See Dillenberger in J. Taylor, *Perceptions*, pp. 146–47.

APOLLO; WORSHIPING IN THE BELVEDERE CHAPEL

1. Alcott, *Journals*, p. 290; Lathrop, *Memories*, p. 192.
2. See Howells, *Criticism and Fiction*, ch. 24.
3. Edwards, *Antique Statues*, pp. 60–95.
4. J. F. Cooper, *Italy*, pp. 239–40.
5. Motley, *Correspondence*, pp. 42–44.
6. Winckelmann, *History of Ancient Art*, 4:312–13.
7. Honour, *Neo-Classicism*, p. 61.
8. See Gerdts, "*Man of Genius*," p. 91.
9. Allston, *Lectures on Art*, pp. 99–101.
10. Cole, *Collected Essays*, pp. 171–72.
11. Tuckerman, *Italian Sketchbook* (1837 ed.), pp. 28–29.
12. M. Fuller, *Memoirs*, 1:343.
13. Melville, *Journal of a Visit*, pp. 193, 195.
14. H. Greenough, *Letters*, p. 229.

15. Melville in Sealts, *Melville as Lecturer*, pp. 138–39.
16. N. Hawthorne, *Notebooks*, pp. 125, 138.
17. Willis, *Pencillings*, pp. 303–04.
18. Greenwood, *Haps and Mishaps*, pp. 181, 179, 271.
19. Ware, *Sketches*, pp. 67–68.
20. Tuckerman, *Poems*, p. 36.
21. B. Taylor, *Views-A-Foot*, pp. 322–23.
22. M. Fuller, *Memoirs*, 1:345.
23. Story, *Excursions*, pp. 208–09.
24. Hillard, *Six Months*, 1:186.
25. H. P. Leland, *Americans in Rome*, p. 37.
26. Ezekiel, *Memoirs*, p. 180.
27. H. James, *Letters*, 1:166–67.
28. H. James, *Letters*, 1:75.
29. Taine, *Italy*, pp. 111–30.

APOLLINI

1. Winckelmann, *History of Ancient Art*, 2:210–13.
2. H. Greenough, *Letters*, p. 401.
3. Headley, *Letters*, p. 199; W. Gillespie, *Rome*, p. 188.
4. Unless otherwise specified, information and quotations relating to Brown here and below are from Craven's two articles, "Henry Kirke Brown."
5. Quoted in Craven, *Sculpture in America*, p. 146.
6. Quoted by Lilian Miller in "Painting, Sculpture, and the National Character," p. 702.
7. *Crayon* 2 (1855): 83; 1 (1855): 102.
8. Akers, "Letter from Italy," *Crayon* 2 (1855): 64; "Indians in American Art," *Crayon* 3 (1856): 28.
9. Review of *Leaves of Grass*, *Crayon* 3 (1856): 31.
10. Whitman, *Unpublished Poetry and Prose*, 1:142–43.
11. Whitman, *With Walt Whitman*, 2:502–03.
12. Quoted in Craven, *Sculpture in America*, p. 249.

13. Whitman, *With Walt Whitman*, 2:278.
14. J. Fairbanks, "American Sculpture," p. 636.
15. Winckelmann, *Writings on Art*, p. 62; *History of Ancient Art*, 2:203.
16. Manship, "Credo," in *Paul Manship*, p. 5.
17. Quoted in Murtha, *Paul Manship*, pp. 11–12.
18. Murtha, *Paul Manship*, p. 150.
19. Hosmer, *Letters and Memories*, p. 146.
20. Winckelmann, *History of Ancient Art*, 2:212.
21. Rusk, *Rinehart*, pp. 42–43.
22. Hosmer, *Letters and Memories*, pp. 273–74; Haskell and Penny, *Taste and the Antique*, p. 202.
23. Quoted in Hosmer, *Letters and Memories*, pp. 223, 210.
24. Hosmer, *Letters and Memories*, pp. 220, 223.
25. Richman, "Early Public Sculpture," p. 103.
26. Rusk, *Rinehart*, p. 53.
27. L. Taft, *History of American Sculpture*, p. 178.
28. "Exhibitions," *Crayon* 7 (1860): 29.
29. Gerdts, *Great American Nude*, p. 94.
30. Akers in *Crayon* 2 (1855): 64.
31. H. James, *Story*, pp. 25–27.
32. Gardner, *American Sculpture*, p. 4.
33. Quoted in Crane, *White Silence*, pp. 206–07, from Lester, *Artist*, 1:85–89.
34. See Reynolds, *Powers*, p. 143; Winckelmann, *History of Ancient Art*, 2:206–08.
35. N. Hawthorne, *Notebooks*, p. 492.
36. Crane, *White Silence*, p. 206.
37. For Rude's and Carpeaux's works, see Licht, *Sculpture*, Color plate II and fig. 58.
38. Winckelmann, *History of Ancient Art*, 3:100.
39. M. Fuller, *Memoirs*, 1:271.
40. Haskell and Penny, *Taste and the*

41. *Antique*, p. 174, Crane, *White Silence*, pp. 281, 314.
41. *Crayon* 2 (1855): 82–83.
42. Addison, *Classic Myths*, pp. 237–38.
43. Quoted in Goodrich, *Eakins* (1933), p. 75.
44. Goodrich, *Eakins* (1982), 1:28. Cf. Gerdts, *Great American Nude*, pp. 122–24.
45. See R. Murray in J. Taylor, *Perceptions*, pp. 232–34 and n. 77.

BACCHUS, HERCULES, JUPITER

1. Winckelmann, *History of Ancient Art*, 2:215–24.
2. M. Fuller, *Memoirs*, 1:331.
3. *Crayon* 1 (1855): 102; Parsons, *Poems*, p. 27.
4. Proske, "Horatio Greenough's Bacchus," pp. 35–38.
5. Story, *Poems*, 1:92.
6. Swan, *Athenaeum Gallery*, p. 157.
7. See Proske, *Brookgreen Gardens* (1943 ed.), p. 231.
8. Hosmer, *Letters and Memories*, p. 75.
9. G. W. Greene, "Letter from Modern Rome," *Knickerbocker*, 15:494–95.
10. G. Evans, *Benjamin West*, p. 41; Winckelmann, *Writings on Art*, pp. 40–41.
11. Dunlap, *History*, 3:90–91; Larkin, *Morse*, p. 30.
12. Tuckerman, *Book of the Artists*, pp. 163–65.
13. Cf. Craven, "Grand Manner," pp. 34–39; Larkin, *Morse*, p. 30; Gerdts, *Great American Nude*, pp. 51–52.
14. See Craven, "Grand Manner," pp. 10–19.
15. See Gerdts, *Great American Nude*, p. 97.
16. See Crane, *White Silence*, pp. 361–63.
17. As noted also by Sharp, "John Quincy Adams Ward," p. 75.
18. Jarves, *Art-Idea*, p. 226.

19. Tuckerman, *Book of the Artists,* p. 581.
20. Quotations from Bartlett, *Rimmer,* pp. 67–70, 103–04.
21. Notes of Providence 1872 lectures reprinted in Bartlett, *Rimmer,* pp. 66–78.
22. Bartlett, *Rimmer,* p. 126.
23. Bartlett, *Rimmer,* p. 124.
24. Quoted in Crane, *White Silence,* p. 83.
25. N. Hawthorne, *Notebooks,* p. 281.
26. Greenough quoted by Tuckerman, *Book of the Artists,* p. 259.
27. H. Greenough, *Letters,* pp. 174–75.
28. Quoted in *Nineteenth Century French Sculpture,* p. 138.
29. Quoted in Crane, *White Silence,* p. 75.
30. Jarves, *Art-Idea,* pp. 210–11.

ORPHEUS IN AMERICA

1. Dunlap, *History,* 3:92–93.
2. See Whiting, "Franklin Simmons," pp. lii–lvi.
3. Sharp, "John Quincy Adams Ward," p. 74; Richman, "Early Public Sculpture," pp. 101–02.
4. Sumner, "Crawford's 'Orpheus,'" pp. 454–55; Gale, *Crawford,* pp. 25–26.
5. Crane, *White Silence,* p. 307.
6. Quoted in Gale, *Crawford,* p. 11.
7. Sumner, "Crawford's Orpheus," p. 452, and Boston Athenaeum archives.
8. Quoted in Gale, *Crawford,* p. 15.
9. Sedgwick, *Letters,* 2:158.
10. Quoted by Gale, *Crawford,* p. 15.
11. G. W. Greene, "Letters from Modern Rome," *Knickerbocker* 15 (1840): 490–93.
12. Quoted in Gale, *Crawford,* p. 15.
13. L. Taft, *History of American Sculpture,* pp. 73–74.
14. Hicks quoted in Gale, *Crawford,* p. 16; Sumner, "Crawford's 'Orpheus,'" pp. 453–54; "Crawford,

the Sculptor," *Knickerbocker* 17 (1841): 174.
15. Quotations from Gale, *Crawford,* pp. 23, 17–18.
16. N. Hawthorne, *Notebooks,* pp. 129–30.
17. M. Fuller, *Woman,* pp. 22–23.
18. Parsons, *Poems,* pp. 51–55.
19. Osgood, *Crawford,* pp. 2–8, 30–37, 15.
20. See Soria, "Some Background Notes," pp. 71–87.
21. Hosmer, *Letters and Memories,* pp. 47, 60, 64, 77.
22. In Troyen, *Private Eye,* and Wilmerding, *American Perspective,* p. 73.
23. See Proske, *Brookgreen Gardens* (1968 ed.), pp. 304–05.
24. See Proske, *Brookgreen Gardens* (1943 ed.), pp. 382–83.
25. See Proske, *Brookgreen Gardens* (1968 ed.), p. 382.
26. Lipchitz, *My Life in Sculpture,* p. 168.
27. Quotations from Bartlett, *Rimmer,* pp. 72, 145.
28. DeKay, "Young Sophocles," pp. 1–3.
29. Winckelmann, *Writings on Art,* p. 64.
30. Gardner, *American Sculpture,* pp. 60–61.
31. Brush, "Francis Scott Key Monument," p. xlvi.

APOLLO IN BOSTON

1. Fairbrother, "A Private Album," pp. 70–79.
2. Ormond, *Sargent,* pp. 93–94.

IN THE COMPANY OF "THE BEST"

1. Melville in Sealts, *Melville as Lecturer,* pp. 150–54.
2. S. Greenough, *Lilian,* pp. 11, 23, 74, 75, 188, 189–90.
3. N. Wright, *American Novelists in Italy,* p. 85.
4. H. James, *Letters,* 1:167.

5. N. Hawthorne, *Marble Faun*, p. 5.
6. H. James, *Portrait of a Lady*, 2:6–9 (ch. 28).
7. Van Rensselaer, Introduction to *Book of American Figure Painters*, n.p.
8. Sumner, "Crawford's 'Orpheus,'" p. 455.
9. Lester, *Artists of America*, pp. 215–18.
10. Quoted in Wendell, "Edward Sheffield Bartholomew," p. 8.
11. Jarves, *Art-Idea*, pp. 149–51, 211.
12. *Crayon* 2 (1855): 101–04.
13. Ware, *Sketches*, p. 133.
14. N. Hawthorne, *Notebooks*, pp. 431–32.

THE GODS IN SUNDRY SHAPES

1. Valentine and Valentine, *American Academy*, pp. 1–11.
2. Quoted in Agard, *Classical Myths in Sculpture*, p. 139.
3. Quoted in Valentine and Valentine, *American Academy*, p. 68.
4. Manship, "Sculptor at the American Academy," pp. 89–92.
5. Quoted in Fink and Taylor, *Academy*, p. 97, from Savage, *On Art Education*.
6. See *American Academy in Rome at the New York World's Fair*.
7. Quoted in McSpadden, *Famous Sculptors of America*, pp. 222–23.
8. *Sculpture of a City*, p. 286; Agard, *Classical Myth in Sculpture*, p. 159.
9. Story, *Poems*, 2:275.

10. Murtha, *Paul Manship*, p. 164.
11. Lipchitz, *My Life in Sculpture*, p. 140.
12. O'Hara, *Nakian*, pp. 9, 16, 19.
13. Lippold, "Projects for Pan Am and Philharmonic," p. 55.
14. See Newlin, *Etchings and Lithographs of A. B. Davies*.
15. See *Index of Twentieth Century Artists 1933–37*, pp. 536–41; *Bryson Burroughs: Catalogue*; Dreishpoon, *Paintings of Bryson Burroughs*.
16. See Eliasoph, *Paul Cadmus*, p. 16.
17. Cadmus, in a letter to the author, 23 Aug. 1983.
18. Gerdts, *Great American Nude*, p. 188.
19. Levine, in a letter to the author, 18 Aug. 1983.
20. Seznec, *Survival*, pp. 208–09.
21. Hunter, *American Art*, p. 310.
22. Creeley, *Collected Poems*, p. 134.
23. E. Cook, "T. S. Eliot," pp. 341–55.
24. On Russell, see Baur, *New Decade*, p. 75, and Rosenthal, "Alfred Russell."
25. Baur, *Modern American Art*; Bird, "Darrel Austin," pp. 18–25.
26. Blume, in a letter to the author, 10 Aug. 1983.
27. Wittman, "Americans in Italy," p. 287, n. 5.
28. Hadzi, "American Academy," p. 117.
29. In a letter to the author, 18 Aug. 1983.

Bibliography

In addition to works cited in the text and notes, a few books that have contributed in a more general way are included here. Standard reference works are not listed.

Ackerman, Gerald M. *Jean-Léon Gérôme (1824–1904)*. Dayton, Ohio: Dayton Art Institute, 1972.

Adams, Henry. *Democracy*. 1880. New York: Farrar, Straus & Young, 1952.

———. *The Education of Henry Adams*. 1908. Edited by Ernest Samuels. Boston: Houghton Mifflin, 1974.

Adams, Mrs. Henry. *The Letters of Mrs. Henry Adams 1865–1883*. Edited by Ward Thoron. Boston: Little, Brown, 1936.

Adams, John. *A Defence of the Constitutions of Government of the United States of America*. (1787–88). Vols. 4–6 of *The Works of John Adams*, edited by C. F. Adams. Boston: Little, Brown, 1850–56.

Adams, Philip R. *Mary Callery: Sculpture*. New York: Wittenborn, 1961.

Addison, Julia deWolf. *Classic Myth in Art*. Boston: L. C. Page, 1904.

Agard, Walter Raymond. *Classical Myths in Sculpture*. Madison: University of Wisconsin Press, 1951.

Akers, Paul. "The Danae." *Crayon* 2 (1855): 63–65.

Alberts, Robert C. *Benjamin West*. Boston: Houghton Mifflin, 1978.

Alcott, Bronson. *The Journals of Bronson Alcott*. Edited by Odell Shepard. Boston: Little, Brown, 1938.

Allen, Gay Wilson. *The Solitary Singer: A Critical Biography of Walt Whitman*. New York: New York University Press, 1955.

Allen, Margaret Vanderhaar. *The Achievement of Margaret Fuller*. University Park: Pennsylvania State University Press, 1979.

Allston, Washington. *Lectures on Art, and Poems*. Edited by Richard Henry Dana, Jr. New York: Baker & Scribner, 1850.

———. *Monaldi*. Boston: Charles C. Little and James Brown, 1841.

American Academy in Rome at the New York World's Fair. New York: N.p., 1940.

American Art in the Newark Museum: Paintings, Drawings, and Sculpture. Newark: The Museum, 1981.

American Paintings. Toledo, Ohio: Toledo Museum of Art, 1979.

Amfitheatrof, Erik. *The Enchanted Ground: Americans in Italy, 1760–1980.* Boston: Little, Brown, 1980.

Amory, Martha Babcock. *The Domestic and Artistic Life of John Singleton Copley.* Boston: Houghton Mifflin, 1882.

The Arcadian Landscape: Nineteenth-Century American Painters in Italy. Lawrence: University of Kansas Museum of Art, 1972.

Armstrong, David Maitland. *Day Before Yesterday: Reminiscences of a Varied Life.* New York: Scribner's, 1920.

Armstrong, Regina. *The Sculpture of Charles Henry Niehaus.* New York: DeVinne Press, 1902.

Armstrong, Tom, Wayne Craven, Norman Feder, Barbara Haskell, Rosalind E. Krauss, Daniel Robbins, and Marcia Tucker. *200 Years of American Sculpture.* New York: Whitney Museum, 1976.

Arnason, H. H. *The Sculptures of Houdon.* New York: Oxford University Press, 1975.

Auser, Cortland P. *Nathaniel P. Willis.* New York: Twayne, 1969.

Baigell, Matthew. *Thomas Cole.* New York: Watson-Guptill, 1981.

Bailyn, Bernard. *The Ideological Origins of the American Revolution.* Cambridge, Mass.: Harvard University Press, 1967.

Baker, Paul R. *The Fortunate Pilgrims: Americans in Italy 1800–1860.* Cambridge, Mass.: Harvard University Press, 1964.

Ball, Thomas. *My Threescore Years and Ten: An Autobiography.* 2d ed. Boston: Roberts Brothers, 1892.

Bancroft, George. *Literary and Historical Miscellanies.* New York: Harper & Brothers, 1855.

———. *Poems.* Cambridge, Mass.: Harvard University Press, 1823.

Barrett, C. Walker. *Italian Influence on American Literature: An Address and a Catalogue of an Exhibition.* New York: Grolier Club, 1962.

Barry, William David. "George Loring Brown: Patrons and Patronage." In *George Loring Brown: Landscapes of Europe and America 1834–1880,* 51–55. Burlington, Vt.: Robert Fleming Museum, 1973.

Barry, William David, and Jean M. Baxter. "John Rollin Tilton." *Antiques* 122 (November 1982): 1068–73.

Bartlett, Truman H. *The Art Life of William Rimmer, Sculptor, Painter, and Physician.* Boston: Houghton Mifflin, 1890.

Baur, John I. H. *Modern American Art.* Cambridge, Mass.: Harvard University Press, 1951.

Baur, John I. H., ed. *New Art in America: 50 American Painters in the 20th Century.* New York: New York Graphic Society and Praeger, 1957.

Baur, John I. H., and Rosalind Irving. *The New Decade: 35 American Painters and Sculptors.* New York: Whitney Museum, 1955.

Beers, Henry Augustine. *Nathaniel Parker Willis.* Boston: Houghton Mifflin, 1885.

Benisovich, Michel. "Further Notes on A. W. Wertmüller in the United States and France." *Art Quarterly* 26 (1963): 7–30.

Benson, Eugene. *Art and Nature in Italy.* Boston: Roberts Brothers, 1882.

Bercovitch, Sacvan. *The Puritan Origins of the American Self.* New Haven: Yale University Press, 1975.

Bertel Thorvaldsen: Skulpturen, Modelle, Bozzetti, Handzeichnungen. Cologne: Museen der Stadt, 1977.

Bird, Paul. "Darrell Austin." *Art in America* 30 (1942): 18–25.

Blunt, Anthony. *Nicolas Poussin.* 2 vols. New York: Bollingen Foundation and Pantheon, 1967.

————. *The Paintings of Nicolas Poussin.* London: Phaidon, 1966.

Boime, Albert. "Thomas Nast and French Art." *American Art Journal* 4 (Spring 1972): 43–65.

Bowditch, Nancy Douglas. *George deForest Brush: Recollections of a Joyous Painter.* Peterborough, N.H.: Noone House, 1970.

Bradford, William. *Of Plymouth Plantation 1620–1647.* Edited by Samuel Eliot Morison. New York: Knopf, 1952.

Brand, C. P. *Italy and the English Romantics.* Cambridge: Cambridge University Press, 1957.

Brooks, Van Wyck. *The Dream of Arcadia: American Writers and Artists in Italy 1760–1915.* New York: Dutton, 1958.

"Brown's Colossal Equestrian Statue of Washington." *Crayon* 1 (1855): 5–6.

Brush, Edward Hale. "The Francis Scott Key Monument at Baltimore." *International Studio* 61 (1917): xlv–vi.

Bryant, William Cullen. *Letters of a Traveller.* 2d ser. New York: Appleton, 1859.

————. *Orations and Addresses.* New York: G. P. Putnam's Sons, 1873.

Bryson Burroughs: Catalogue of a Memorial Exhibition of His Work. New York: Metropolitan Museum of Art, 1935.

Bulfinch, Thomas. *Age of Fable.* 1855. In *Bulfinch's Mythology.* New York: Modern Library, n.d.

Bullard, E. John. *A Panorama of American Painting: The John J. McDonough Collection.* New Orleans: New Orleans Museum of Art, 1975.

Bush, Douglas. *Mythology and the Romantic Tradition.* Cambridge, Mass.: Harvard University Press, 1937.

Byron, George Gordon. *The Poetical Works of Lord Byron.* New York: Oxford University Press, 1946.

Caffin, Charles H. *American Masters of Sculpture.* 1903. Freeport, N.Y.: Books for Libraries Press, 1969.

Callcott, George H. *History in the United States 1800–1860: Its Practice and Purpose.* Baltimore: Johns Hopkins Press, 1970.

Campbell, William P. *John Gadsby Chapman.* Washington: National Gallery of Art, 1962.

Catalogue of the Exhibition of American Sculpture Held by the National Sculpture Society. New York: N.p., 1923.

Chamberlain, Georgia S. *Studies on John Gadsby Chapman: American Artist 1808–1889.* Alexandria, Va.: N.p., 1963.

Chambers, Bruce W. *American Paintings in the High Museum of Art.* Atlanta: The Museum, 1975.

Champney, Benjamin. *60 Years' Memories of Art and Artists.* Woburn, Mass.: Wallace & Andrew, 1900.

Chanler, Mrs. Winthrop [Margaret Terry]. *Roman Spring: Memoirs.* Boston: Little, Brown, 1934.

Channing, William Ellery. *Conversations in Rome: Between an Artist, a Catholic, and a Critic.* Boston: Crosby & Nichols, 1847.

Cikovsky, Nicolai, Jr. *George Inness.* New York: Praeger, 1971.

Cikovsky, Nicolai, Jr., and Michael Quick. *George Inness.* New York: Harper & Row, 1985.

————. *The Paintings of George Inness (1844–94).* Austin: University Art Museum of University of Texas, Austin, 1965.

Clark, Kenneth. *The Nude: A Study in Ideal Form.* Washington: National Gallery of Art and Pantheon Books, 1956.

The Classical Spirit in American Portraiture. Providence, R.I.: Department of Art, Brown University, 1976.

Coffey, John W. *Twilight of Arcadia: American Landscape Painters in Rome, 1830–1880.* Brunswick, Maine: Bowdoin College Museum of Art, 1987.

Colagrossi, P. *L'anfiteatro flavio.* Florence: Libreria Editrice, 1913.

Cole, Thomas. *The Collected Essays and Prose Sketches.* Edited by Marshall Tymn. St. Paul, Minn.: John Colet Press, 1980.

———. *Thomas Cole's Poetry.* Edited by Marshall B. Tymn. York, Pa.: Liberty Cap Books, 1972.

Constable, W. G. *Richard Wilson.* London: Routledge & Kegan Paul, 1953.

Cook, Eleanor. "T. S. Eliot and the Carthaginian Peace." *English Literary History* 46:341–55.

Cooper, James Fenimore. *Gleanings in Europe: Italy.* 1838. Edited by John Conron and Constance Ayers Denne. Albany: State University of New York Press, 1981.

Cortissoz, Royal. *The Painter's Craft.* New York: Scribner's, 1930.

Cowdrey, Mary Bartlett, ed. *American Academy of Fine Arts and American Art-Union 1816–1852.* 2 vols. New York: New-York Historical Society, 1953.

———. *National Academy of Design Exhibition Record 1826–1860.* 2 vols. New York: New-York Historical Society, 1943.

Crane, Sylvia E. *White Silence: Greenough, Powers, and Crawford, American Sculptors in Nineteenth-Century Italy.* Coral Gables, Fla.: University of Miami Press, 1972.

Craven, Wayne. "The Grand Manner in Early Nineteenth Century American Painting." *American Art Journal* 11 (April 1979): 5–43.

———. "Henry Kirke Brown: His Search for an American Art in the 1840's." *American Art Journal* 4 (November 1972): 44–58.

———. "Henry Kirke Brown in Italy, 1842–1846." *American Art Journal* 1 (Spring 1969): 65–77.

———. "Horatio Greenough's Statue of Washington and Phidias' Olympian Zeus." *Art Quarterly* 26 (October 1963): 429–40.

———. *Sculpture in America.* 1968. Rev. ed. Newark: University of Delaware Press; New York: Cornwall Books, 1984.

———. "Thomas Cole and Italy." *Antiques* 114 (November 1978): 1014–27.

Crawford, Francis Marion. *Ave Roma Immortalis: Studies from the Chronicles of Rome.* 2 vols. New York: Macmillan, 1898. Rev. ed. 1 vol. 1902.

Crawford, John J. "The Classical Tradition in American Sculpture: Structure and Surface." *American Art Journal* 11 (1979): 38–52.

"Crawford, the Sculptor." *Knickerbocker* 17 (February 1841): 174.

"Crawford's Hebe and Ganymede—H. K. Brown's Indian and Panther." *Crayon* 2 (1855): 82–83.

Creeley, Robert. *The Collected Poems of Robert Creeley 1945–1975.* Berkeley: University of California Press, 1982.

Cummings, Thomas S. *Historic Annals of the National Academy of Design.* Philadelphia: George W. Childs, 1865.

Cunningham, John J., ed. *C. Paul Jennewein.* American Society of Sculpture Series. Athens: University of Georgia, 1950.

Dangerfield, Elliott. *George Inness.* New York: Privately printed, 1911.

Davidson, Abraham A. *The Eccentrics and Other American Visionary Painters.* New York: E. P. Dutton, 1978.

Deiss, Joseph Jay. *The Roman Years of Margaret Fuller.* New York: Thomas Y. Crowell, 1969.

DeKay, Charles. "[Donoghue's] The Young Sophocles." *Art Review* 1, no. 4 (1887): 1–3.

De Mare, Marie. *G. P. A. Healy: American Artist.* New York: D. McKay, 1954.

Dennis, James M. *Karl Bitter: Architectural Sculptor 1867–1915.* Madison: University of Wisconsin Press, 1967.

Desportes, Ulysse. "Giuseppe Ceracchi in America and His Busts of George Washington." *Art Quarterly* 26 (1963): 140–79.

De Staël, Madame. *Corinne; or Italy.* 1807. Translator anonymous. 2 vols. London: Dent & Co., 1894.

Dewey, Orville. *The Greek Slave.* Pamphlet. New York: N.p., 1847.

Dickens, Charles. *Pictures from Italy.* 1846. Edited by David Paroissien. London: Andre Deutsch, 1973.

Dillenberger, John. *Benjamin West.* San Antonio, Texas: Trinity University Press, 1977.

Di Macco, Michela. *Il Colosseo: funzione simbolica, storica, urbana.* Rome: Bulzoni Editore, 1971.

Dinnerstein, Lois. "The Significance of the Colosseum in the First Century of American Art." *Arts Magazine* 58 (June 1984): 116–20.

Douglas, Ann. *The Feminization of American Culture.* New York: Knopf, 1977.

Dreishpoon, Douglas. *The Paintings of Bryson Burroughs.* New York: Hirschl & Adler Galleries, 1984.

Dryfhout, John H. *The Work of Augustus Saint-Gaudens.* Hanover, N.H.: University Press of New England, 1982.

Dudley, Donald Reynolds. *Urbs Roma.* London: Phaidon, 1967.

Dunlap, William. *History of the Rise and Progress of the Arts of Design in the United States.* 1834. Rev. and enl. ed. Edited by Alexander Wyckoff. 3 vols. New York: Benjamin Blom, 1965.

Durand, John. *The Life and Times of Asher B. Durand.* New York: Scribner's, 1894.

[Dwight, Theodore.] *A Journal of a Tour in Italy in the Year 1821. By an American.* New York: Printed for the author, 1824.

Dwight, Timothy. *Greenfield Hill: A Poem.* 1794. Reprint. New York: AMS Press, 1970.

Eadie, John W., ed. *Classical Traditions in Early America.* Ann Arbor: Center for Coordination of Ancient and Modern Studies, University of Michigan Press, 1976.

Earnest, Ernest. *Expatriates and Patriots: American Artists, Scholars, and Writers in Europe.* Durham: University of North Carolina Press, 1968.

Eaton, Charlotte A. *Rome in the Nineteenth Century.* Edinburgh: Constable, 1820.

Edwards, Charles L. *The Antique Statues: Lectures Delivered at the National Academy of Design.* New York: N.p. [c. 1831].

Eliasoph, Philip. *Paul Cadmus: Yesterday and Today.* Oxford, Ohio: Miami University Art Museum, 1981.

Eliot, Samuel. *The History of Liberty.* 4 vols. Boston: Little, Brown, 1853.

———. *The Liberty of Rome: A History.* 2 vols. New York: George P. Putnam, 1849.

Eliot, T. S. *Collected Poems 1909–1935.* New York: Harcourt, Brace, 1936.

Emerson, Ralph Waldo. *The Complete Works of Ralph Waldo Emerson.* Edited by Edward Waldo Emerson. Vols. 5 and 9. Cambridge, Mass.: Riverside Press, [1903–04].

———. *The Journals and Miscellaneous Notebooks of Ralph Waldo Emerson.* Vol. 4. Edited by Alfred R. Ferguson. Cambridge, Mass.: Harvard University Press, 1964.

———. *The Journals and Miscellaneous Notebooks of Ralph Waldo Emerson.* Vol. 10. Edited by Merton M. Sealts. Cambridge, Mass.: Harvard University Press, 1973.

———. *The Letters of Ralph Waldo Emerson.* Edited by Ralph L. Rusk. New York: Columbia University Press, 1939.

Evans, Dorinda. *Benjamin West and His American Students.* Washington: Smithsonian, 1980.

———. "Raphaelle Peale's *Venus Rising from the Sea:* Further Support for a Change in Interpretation." *American Art Journal* 14 (1982): 63–72.

Evans, Grose. *Benjamin West and the Taste of His Times.* Carbondale: Southern Illinois University Press, 1959.

"Exhibitions." *Crayon* 7 (1860): 29–30.

Ezekiel, Moses Jacob. *Memoirs from the Baths of Diocletian.* Edited by Joseph Gutmann and Stanley F. Chyet. Detroit: Wayne State University Press, 1975.

Fairbanks, Charles Bullard. *My Unknown Chum: "Aquecheek."* Edited by Henry Garrity. New York: Devin-Adair Co., 1923.

Fairbanks, Jonathan. "A Decade of Collecting American Decorative Arts and Sculpture at the Museum of Fine Arts, Boston." *Antiques* 120 (September 1981): 590–636.

Fairbrother, Trevor J. "A Private Album: John Singer Sargent's Drawings of Nude Male Models." *Arts Magazine* 56 (December 1981): 70–79.

Fast, Howard. *Spartacus.* New York: Crown, 1950.

Felton, C. C. "Classic Mythology." *North American Review* 41 (October 1835): 327–48.

Fielding, Mantle. *Dictionary of American Painters, Sculptors and Engravers.* 1965. Enl. and rev. ed. Green Farms, Conn.: Modern Books and Crafts, 1974.

Fink, Lois, and Joshua Taylor. *Academy: The Academic Tradition in American Art.* Washington: Smithsonian, 1956.

Flagg, Jared B. *Life and Letters of Washington Allston.* New York: Scribner's, 1892.

Flexner, James Thomas. "George Washington as an Art Collector." *American Art Journal* 4 (Spring 1972): 24–35.

———. *The Light of Distant Skies: American Painting, 1760–1835.* 1954. Reprint. New York: Dover, 1969.

———. *That Wilder Image: The Native School from Thomas Cole to Winslow Homer.* 1962. Reprint. New York: Dover, 1970.

Ford, Brinsley. "The Grand Tour." *Apollo* n.s. 114, no. 238 (December 1981): 390–400.

Foster, Edward Halsey. *The Civilized Wilderness: Backgrounds to the American Romantic Literature, 1817–1860.* New York: Free Press, 1975.

Freeman, James E. *Gatherings from an Artist's Portfolio.* New York: D. Appleton, 1877.

———. *Gatherings from an Artist's Portfolio in Rome.* Boston: Roberts Brothers, 1883.

Freneau, Philip. *The American Village.* 1772. Reprint. New York: Burt Franklin, 1968.

———. *Poems of Philip Freneau.* Edited by F. L. Pattee. 3 vols. Princeton: University Library, 1902.

Friedlaender, Walter. *Claude Lorrain.* Berlin: Paul Cassirer, 1921.

———. *Poussin, A New Approach.* New York: Abrams, 1965.

Fuller, Margaret [Ossoli]. *At Home and Abroad, or, Things and Thoughts in America and Europe.* Edited by Arthur B. Fuller. 1856. Reprint. Port Washington, N.Y.: Kennikat Press, 1971.

———. *Memoirs of Margaret Fuller Ossoli.* Edited by J. F. Clarke, R. W. Emerson, and W. H. Channing. 2 vols. Boston: Phillips, Sampson, 1852.

———. *Woman in the Nineteenth Century.* Edited by A. B. Fuller. 1855. Reprint. Freeport, N.Y.: Books for Libraries Press, 1972.

Gale, Robert L. *Thomas Crawford: American Sculptor.* Pittsburgh: University of Pittsburgh Press, 1964.

Galt, John. *The Life and Studies of Benjamin West.* 2d ed. 2 parts in 1 vol. London: Cadell & Davies, 1817.

Gardner, Albert Ten Eyck. *American Sculpture: A Catalogue of the Collection of the Metropolitan Museum of Art.* New York: Metropolitan Museum of Art, 1965.

———. *Yankee Stonecutters: The First American School of Sculpture, 1800–1850.* New York: Columbia University Press, 1945.

Gardner, Albert Ten Eyck, and S. P. Feld. *American Paintings in the Metropolitan Museum of Art.* Vol. 1, *Painters Born by 1815.* New York: Metropolitan Museum of Art, 1965.

Gebbia, Alessandro. *Città teatrale: Lo spettacolo a Roma nelle impressioni dei viaggiatori americani 1760–1870.* Rome: Officina Edizioni, 1985.

Gerdts, William H. *American Neo-Classic Sculpture: The Marble Resurrection.* New York: Viking, 1973.

———. "The American Painting Collection of Henry Melville Fuller." *Antiques* 86 (July 1964): 66–71.

———. "Chauncey Bradley Ives." *Antiques* 94 (November 1968): 714–18.

———. *The Great American Nude.* New York: Praeger, 1974.

———. *The White Marmorean Flock: Nineteenth Century American Women Neoclassical Sculptors.* Exhibition catalogue. Poughkeepsie, N.Y.: Merchants Press, 1972.

———. "William Wetmore Story." *American Art Journal* 4 (November 1972):16–33.

Gerdts, William H., and Theodore E. Stebbins, Jr. *"A Man of Genius": The Art of Washington Allston (1779–1843).* Boston: Museum of Fine Arts, 1979.

[Gillespie, William Mitchell]. *Rome as Seen by a New Yorker in 1843–4.* New York: Wiley & Putnam, 1845.

Goethe, J. W. *Italian Journey 1786–1788.* Translated by W. H. Auden and Elizabeth Mayer. New York: Schoeken, 1968.

Goodrich, Lloyd. *Thomas Eakins.* 2 vols. Cambridge, Mass.: Harvard University Press, 1982.

———. *Thomas Eakins: His Life and Work.* New York: Whitney Museum, 1933.

Goodrich, Lloyd, and John I. H. Baur. *American Art of Our Century.* New York: Praeger, 1961.

Grant, Michael. *The Roman Forum.* New York: Macmillan, 1970.

Green, Vivien M. "Hiram Powers' *Greek Slave:* Emblem of Freedom." *American Art Journal* 14 (1982): 31–39.

Greene, George Washington. "Letters from Rome." *Knickerbocker* 15 (June 1840): 488–96; 18 (November 1841): 371–78; 19 (April 1842): 293–301, 412–15; 20 (July 1842): 11–14.

Greenough, Horatio. "Do Not Be Afraid of Grace and Beauty." *United States Magazine and Democratic Review* 18 (February 1846): 119–20.

———. *Letters of Horatio Greenough: American Sculptor.* Edited by Nathalia Wright. Madison: University of Wisconsin Press, 1972.

Greenough, Sarah Dana [Loring]. *Arabesque.* Boston: Roberts Brothers, 1872.

[———]. *Lilian.* Boston: Ticknor & Fields, 1863.

Greenwood, Grace [Mrs. Sara Lippincott]. *Haps and Mishaps of a Tour in Europe.* Boston: Ticknor, Reed, & Fields, 1854.

Grigson, Geoffrey. *The Goddess of Love: The Birth, Triumph, Death, and Return of Aphrodite.* 2d ed. London: Constable, 1978.

Groce, George C., and David H. Wallace. *The New-York Historical Society Dictionary of Artists in America 1564–1860.* New Haven: Yale University Press, 1957.

Gummere, Richard M. *The American Colonial Mind and the Classical Tradition: Essays in Comparative Culture.* Cambridge, Mass.: Harvard University Press, 1963.

Hadas, Moses, ed. *A History of Rome from Its Origins to 529 A.D. as Told by the Roman Historians.* Garden City, N.Y.: Doubleday, 1956.

Hadzi, Martha Leeb. "The American Academy [Rome]." *Art in America* 50 (1962): 116–17.

Hale, J. R. "Art and Audience: The *Medici Venus* c. 1750–1850." *Italian Studies* 31 (1976): 37–58.

Harding, Jonathan P., and Harry L. Katz. *The Boston Athenaeum Collection: Pre–Twentieth Century American and European Painting and Sculpture.* Boston: Northeastern University Press, 1984.

Hare, Augustus. *Walks in Rome.* 4th ed. London: W. Isbiter, 1974.

Harris, Neil. *The Artist in American Society: The Formative Years 1790–1860.* New York: Braziller, 1966.

Hartmann, Sadakichi. *Modern American Sculpture.* New York: Paul Wenzel, 1904.

Haskell, Francis. *Rediscoveries in Art.* Ithaca: Cornell University Press, 1976.

Haskell, Francis, and Nicholas Penny. *Taste and the Antique: The Lore of Classical Sculpture, 1500–1900.* New Haven and London: Yale University Press, 1981.

Hawthorne, Julian. *Nathaniel Hawthorne and His Wife.* 2 vols. Boston: Osgood, 1884.

Hawthorne, Nathaniel. *The French and Italian Notebooks.* Edited by Thomas Woodson. Centenary ed. Columbus: Ohio State University Press, 1980.

———. *The Marble Faun.* 1860. Centenary ed. Columbus: Ohio State University Press, 1968.

———. *A Wonder Book for Girls and Boys and Tanglewood Tales.* Vol. 4 of *The Works of Nathaniel Hawthorne,* edited by George Parsons Lathrop. Boston: Houghton Mifflin, 1882.

Hawthorne, Sophia Amelia Peabody. *Notes in England and Italy.* New York: Putnam, 1869.

Headley, Joel T. *Letters from Italy.* New York: Wiley & Putnam, 1845.

Healy, G. P. A. *Reminiscences of a Portrait Painter.* Chicago: N.p., 1894.

Healy's Sitters: A Souvenir of the Exhibition. Richmond: Virginia Museum of Fine Arts, 1950.

Hendricks, Gordon. *Albert Bierstadt: Painter of the American West.* Fort Worth: Amon Carter Museum, 1972.

Hermann, Luke. *British Landscape Painting of the 18th Century.* New York: Oxford University Press, 1974.

Hersey, John. *The Conspiracy.* New York: Knopf, 1972.

Hewins, Amassa. *Hewins Journal: A Boston Portrait-Painter Visits Italy; The Journal of Amassa Hewins, 1830–33.* Edited by Francis H. Allen. Boston: Boston Athenaeum, 1931.

Hicks, Thomas. *Thomas Crawford.* New York: Appleton, 1858.

Hillard, George Stillman. *Six Months in Italy.* 2 vols. Boston: Ticknor, Reed & Fields, 1853.

Hitchcock, Ripley. "Notes on an American Sculptor" [Olin L. Warner]. *Art Review* 1 (March 1887): 1–5.

Honour, Hugh. *Neo-Classicism.* Baltimore: Penguin, 1968.

Hoopes, Donelson F., and Nancy Wall Moure. *American Narrative Painting.* Los Angeles: Los Angeles County Museum of Art, 1974.

Hosmer, Harriet. *Harriet Hosmer, Letters and Memories.* Edited by Cornelia Carr. New York: Moffat, Yard, 1912.

Howard, Seymour. "Thomas Jefferson's Art Gallery for Monticello." *Art Bulletin* 59 (December 1977): 583–600.

Howat, John K. *John F. Kensett, 1816–72.* New Haven: American Federation of Arts, Eastern Press, 1968.

Howells, William Dean. *Criticism and Fiction.* New York: Harper, 1891.

———. *Italian Journeys.* 1872. Rev. ed. Boston: James R. Osgood, 1877.

———. *Roman Holidays and Others.* New York: Harper & Brothers, 1908.

Hudspeth, Robert N. *Ellery Channing.* New York: Twayne, 1973.

Hughes, H. Stuart. *The United States and Italy.* Rev. ed. Cambridge, Mass.: Harvard University Press, 1965.

Hull, Raymona E. *Nathaniel Hawthorne: The English Experience 1853–1864.* Pittsburgh: University of Pittsburgh Press, 1950.

Hunter, Sam. *American Art of the 20th Century.* New York: Abrams, 1972.

Huntington, Daniel C. *Frederic E. Church.* Washington: Smithsonian, 1966.

———. *The Landscapes of Frederic Edwin Church.* New York: Braziller, 1966.

Index of Twentieth Century Artists 1933–1937. Reprint. Arno, N.Y.: College Art Association, 1970.

"The Indians in American Art." *Crayon* 3 (1856): 28.

Ingersoll, Robert. *The Gods and Other Lectures.* Peoria: N.p., 1874.

Inness, George, Jr. *Life, Art, and Letters of George Inness.* New York: Century, 1917.

Ireland, LeRoy. *The Works of George Inness: An Illustrated Catalogue Raisonné.* Austin: University of Texas Press, 1965.

Irving, Washington. *Journals and Notebooks.* Vol. 1, *1803–1806.* Edited by Nathalia Wright. Madison: University of Wisconsin Press, 1969.

———. *Tales of a Traveller.* Philadelphia: Carey & Lea, 1824.

Jacobs, Phoebe. "Diary of an Artist's Wife: Mrs. George Loring Brown in Italy, 1840–1841." *Archives of American Art* 14, no. 1 (1974): 11–16.

James, Henry. *The Art of the Novel: Critical Prefaces.* Edited by Richard P. Blackmur. New York: Scribner's, 1962.

———. *The Complete Tales of Henry James.* Edited by Leon Edel. 12 vols. Philadelphia: J. B. Lippincott, 1962–64.

———. *Daisy Miller.* 1879. New York ed. New York: Scribner's, 1909.

———. *Hawthorne.* London: Macmillan, 1879.

———. *Italian Hours.* 1909. Reprint. New York: Horizon Press, 1968.

———. *Letters.* 4 vols. Edited by Leon Edel. Cambridge, Mass.: Harvard University Press, 1974–84.

———. *The Painter's Eye: Notes and Essays on the Pictorial Arts.* Edited by John L. Sweeney. Cambridge, Mass.: Harvard University Press, 1956.

———. *Parisian Sketches.* Edited by Leon Edel and Ilse Dusoir Lind. New York: New York University Press, 1957.

———. *The Portrait of a Lady.* 1881. New York ed. 2 vols. New York: Scribner's, 1908.

———. *The Princess Casamassima.* 1886. New York ed. 2 vols. New York: Scribner's, 1908.

———. *Roderick Hudson.* 1875. New York ed. New York: Scribner's, 1908.

———. "Taine's Italy." *Nation* 6 (7 May 1868): 373–75.

———. *William Wetmore Story and His Friends.* 2 vols. Boston: Houghton Mifflin, 1903.

Jameson, Anna. *Diary of an Ennuyée.* New ed. London: H. Colburn, 1826.

Jarves, James Jackson. *Art Hints: Architecture, Sculpture, and Painting.* New York: Harper & Brothers, 1855.

———. *The Art-Idea.* 1864. Reprint. Cambridge, Mass.: Harvard University Press, 1960.

———. *Art Studies: The "Old Masters" of Italy.* New York: Denby & Jackson, 1860.

————. *Art Thoughts: Experience and Observations of an American Amateur in Europe.* New York: Hurd & Houghton, 1869.

————. *Italian Sights and Papal Principles Seen through American Spectacles.* New York: Harper & Brothers, 1855.

Jenkyns, Richard. *The Victorians and Ancient Greece.* Cambridge, Mass.: Harvard University Press, 1980.

Johnson, James William. "The Meaning of 'Augustan.'" *Journal of the History of Ideas* 19 (1958): 507–22.

Jordy, William H. *American Buildings and Their Architects: Progressive and Academic Ideals at the Turn of the 20th Century.* 1972. Garden City, N.Y.: Anchor Books, 1976.

Kirk, Clara Marburg. *W. D. Howells and Art in His Time.* New Brunswick, N.J.: Rutgers University Press, 1965.

Kirstein, Lincoln. *Paul Cadmus.* New York: Rizzoli, 1984.

Larkin, Oliver W. *Samuel F. B. Morse and American Democratic Art.* Boston: Little, Brown, 1954.

Lathrop, Rose Hawthorne. *Memories of Hawthorne.* Boston: Houghton Mifflin, 1897.

Lawall, David B. *Asher B. Durand 1796–1886.* Montclair, N.J.: Montclair Art Museum, 1971.

————. *Asher B. Durand: His Art and Art Theory in Relation to His Times.* New York: Garland, 1977.

Leavitt, Thomas W. "George Loring Brown." In *George Loring Brown: Landscapes of Europe and America 1834–1880,* 7–43. Burlington, Vt.: Robert Hull Fleming Museum, 1973.

Leland, Charles Godfrey. *Memoirs.* New York: D. Appleton, 1893.

Leland, Henry P. *Americans in Rome.* New York: Charles T. Evans, 1863.

Leppman, Wolfgang. *Winckelmann.* New York: Knopf, 1970.

Lester, Charles Edwards. *The Artists of America.* 1846. Reprint. New York: Kennedy Galleries, 1970.

"Letter from Italy." *Crayon* 1 (1855): 102.

"Letters from Italy." [Review of J. T. Headley.] *Knickerbocker* 27 (1846): 158–59, 163.

Levetus, A. S. "Isidore Konti: A Hungarian Sculptor in America." *International Studio* 45 (January 1912): 197–203.

Levin, Harry. *The Myth of the Golden Age in the Renaissance.* Bloomington: Indiana University Press, 1969.

Licht, Fred. *Canova.* New York: Abbeville Press, 1983.

————. *Sculpture: 19th & 20th Centuries.* Greenwich, Conn.: New York Graphic Society, 1967.

Lindquist-Cock, Elizabeth. "Stillman, Ruskin and Rosetti: The Struggle between Nature and Art." *History of Photography* 3 (January 1979): 1–14.

Lindsay, Kenneth C. *The Works of John Vanderlyn: From Tammany to the Capitol.* Binghamton, N.Y.: University Art Gallery, State University of New York, 1970.

Lipchitz, Jacques, with H. H. Arnason. *My Life in Sculpture.* New York: Viking, 1972.

Lippold, Richard. "Projects for Pan Am and Philharmonic." *Art in America* 50 (Summer 1962), 50–55.

Longfellow, Henry Wadsworth. *Complete Poetical Works.* Boston: Houghton Mifflin, 1893.

————. *The Works of Henry Wadsworth Longfellow.* Standard Library ed. Boston: Houghton Mifflin, 1886.

Lowell, Robert. *History.* New York: Farrar, Straus & Giroux. 1973.

Lynn, Kenneth S. *William Dean Howells: An American Life.* New York: Harcourt Brace Jovanovich, 1971.

Mabee, Carleton. *The American Leonardo: A Life of Samuel F. B. Morse.* New York: Knopf, 1944.

MacDonald, William L. *The Pantheon: Design, Meaning and Progeny.* Cambridge, Mass.: Harvard University Press, 1973.

Maddox, Kenneth W. *An Unprejudiced Eye: The Drawings of Jasper F. Cropsey.* Yonkers, N.Y.: Hudson River Museum, 1979.

Mahon, Denis, ed. *Il Guercino: Catalogo critico dei Dipinti.* 2d ed. Bologna: Edizioni Alfa, 1968.

Manship, Paul. *Paul Manship.* New York: National Sculpture Society, W. W. Norton, 1947.

————. "The Sculptor at the American Academy, Rome." *Art and Archeology* 19 (February 1925), 89–92.

Manwaring, Elizabeth W. *Italian Landscape in Eighteenth Century England.* 1925. Reprint. New York: Russell & Russell, 1965.

Markus, Julia. "William Page: The American Titian." *Horizon* 22 (March 1979): 19–23.

Matthiessen, F. O. *American Renaissance: Art and Expression in the Age of Emerson and Whitman.* New York: Oxford University Press, 1941.

Maves, Carl. *Sensuous Pessimism: Italy in the Work of Henry James.* Bloomington: Indiana University Press, 1973.

McElroy, Guy. *Robert S. Duncanson: A Centennial Exhibition.* Cincinnati, Ohio: Cincinnati Art Museum, 1972.

McSpadden, J. Walker. *Famous Sculptors of America.* 1924. Reprint. Freeport, N.Y.: Books for Libraries Press, 1968.

Mellow, James R. *Nathaniel Hawthorne in His Times.* Boston: Houghton Mifflin, 1980.

Melville, Herman. *Collected Poems.* Edited by Howard P. Vincent. Chicago: Hendricks House, 1947.

————. *Journal of a Visit to Europe and the Levant.* Edited by Howard C. Horsford. Princeton: Princeton University Press, 1955.

————. *Journal Up the Straits.* Edited by Raymond Weaver. New York: Cooper Square, 1971.

————. *Moby-Dick or, The Whale.* 1851. Edited by Charles Feidelson, Jr. New York: Bobbs-Merrill, 1964.

Memorial Catalogue of the Paintings of Sanford R. Gifford. New York: Metropolitan Museum of Art, 1881.

Merritt, Howard S. *Thomas Cole 1801–1848.* Rochester, N.Y.: Memorial Art Gallery, University of Rochester, 1969.

Middleton, J. I. *Grecian Remains in Italy: A Description of Cyclopian Walls, and of Roman Antiquities of Ancient Latium.* London: Edward Orme, 1812.

Miles, Edwin A. "Young American Nation and the Classical World." *Journal of the History of Ideas* 35 (April–June 1974): 259–74.

Miller, Lillian B. "Painting, Sculpture, and the National Character 1815–1860." *Journal of American History* 53 (1967): 696–707.

Miller, Perry, ed. *The Transcendentalists: An Anthology.* Cambridge, Mass.: Harvard University Press, 1950.

Moore, Rayburn S. *Constance Fenimore Woolson.* New York: Twayne, 1963.

Morse, Samuel F. B. *Samuel F. B. Morse: His Letters and Journals.* Edited by Edward Lind Morse. 2 vols. Boston: Houghton Mifflin, 1914.

Morton, Thomas. *The New English Canaan*. Amsterdam: J. F. Stam, 1637.

Motley, John Lathrop. *The Correspondence*. Edited by G. W. Curtis. 2 vols. New York: Harpers, 1889.

Mumford, Lewis. *The City in History*. New York: Harcourt, Brace, & World, 1961.

[Murray, John, pub.]. "Rome and Its Environs." Part 2 of *Handbook for Travellers in Central Italy*. 3rd ed. London: John Murray, 1853.

Murtha, Edwin. *Paul Manship*. New York: Macmillan, 1957.

Naef, Hans. *Ingres in Rome*. Meriden, Conn.: Meriden Gravure, 1971.

Naylor, Maria. *National Academy of Design Exhibition Records 1861–1900*. 2 vols. New York: Kennedy Galleries, 1973.

Neal, John. *Observations on American Art: Selections from the Writings of John Neal (1793–1876)*. Edited by Harold Dickson. State College: Pennsylvania State College, 1943.

Neil, J. Meredith. *Toward a National Taste*. Honolulu: University Press of Hawaii, 1975.

Newlin, Frederic. *Etchings and Lithographs of Arthur B. Davies*. New York: Mitchell Kennerley, 1929.

Nibby, Antonio. *Del foro romano, della via sacra, dell' anfiteatro flavio*. Rome: Poggioli, 1819.

———. *Roma nell' anno MDCCCXXXVIII, parte seconda: Moderna*. 2 vols. Rome: N.p., 1839.

Nineteenth Century French Sculpture: Monuments for the Middle Class. Louisville, Ky.: J. B. Speed Art Museum, 1971.

Noble, Louis Legrand. *The Life and Works of Thomas Cole*. 1853. Edited by Elliott S. Vessell. Cambridge: Harvard University Press, 1964.

Nordland, Gerald. *Gaston Lachaise: The Man and His Work*. New York: Braziller, 1974.

Norton, Charles Eliot. *Letters of Charles Eliot Norton*. Edited by Sara Norton and M. A. DeWolfe Howe. 2 vols. Boston: Houghton Mifflin, 1913.

Novak, Barbara. *American Painting of the Nineteenth Century*. New York: Praeger, 1969.

———. *Nature and Culture: American Landscape and Painting 1825–1875*. New York: Oxford University Press, 1980.

Novak, Barbara, and Annette Blaugrund, eds. *Next to Nature: Landscape Paintings from the National Academy of Design*. New York: Harper & Row, 1980.

O'Doherty, Barbara Novak. "Thomas Henry Hotchkiss, an American in Italy." *Art Quarterly* 29 (Summer 1966): 3–28.

O'Hara, Frank. *Nakian*. New York: Museum of Modern Art, 1966.

Ormond, Leonée, and Richard Ormond. *Lord Leighton*. New Haven and London: Yale University Press, 1975.

Ormond, Richard. *John Singer Sargent: Paintings—Drawings—Watercolors*. New York: Harper & Row, 1970.

Osgood, Samuel. *Thomas Crawford and Art in America*. New York: John F. Trow & Son, 1875.

The Outdoor Sculpture of Washington, D.C. Washington, D.C.: Smithsonian, 1974.

Panofsky, Erwin. *Meaning in the Visual Arts*. Garden City, N.Y.: Doubleday, 1955.

Parkes, Kineton. "A Classical Sculptor in America: John Gregory." *Apollo* 17 (February 1933): 28–31.

———. "Plastic Form and Colour: The Work of Paul Jennewein." *Apollo* 12 (April 1933): 130–34.

Parry, Ellwood C. "Recent Discoveries in the Art of Thomas Cole: New Light on Lost Works." *Antiques* 120 (November 1981): 1156–65.

———. "Thomas Cole and the Problem of Figure Painting." *American Art Journal* 4 (November 1972): 66–86.

Parsons, Thomas William. *Poems*. Boston: Houghton Mifflin, 1893.

Patterson, Annabel, ed. *Roman Images*. Selected Papers from the English Institute, n.s. no. 8. Baltimore: Johns Hopkins University Press, 1984.

Paulson, Ronald. *Emblem and Expression: Meaning in the English Art of the Eighteenth Century*. Cambridge, Mass.: Harvard University Press, 1975.

Peale, Rembrandt. *Catalogue of Peale's Italian paintings, Now Exhibiting at Sully and Earle's Gallery*. Philadelphia: N.p., 1831.

———. *Notes on Italy Written during a Tour in the Year 1829 and 1830*. Philadelphia: Carey & Lea, 1831.

Pearson, John. *Arena: The Story of the Coliseum*. New York: McGraw-Hill, 1973.

Pelzel, Thomas. *Anton Raphael Mengs and Neoclassicism*. New York: Garland, 1979.

Perkins, Robert F., Jr., William J. Garvin III, and Mary M. Shaughnessy, eds. *The Boston Athenaeum Art Exhibition Index, 1827–1874*. Cambridge: MIT Press, 1980.

Phillips, Mary E. *Reminiscence of William Wetmore Story*. Chicago and New York: Rand McNally, 1897.

Pine-Coffin, R. S. *Bibliography of British and American Travel in Italy to 1860*. Florence: Leo S. Olschki, 1974.

Pinto Surdi, Alessandra. *Americans in Rome, 1764–1870: A Descriptive Catalogue of the Exhibition Held in the Palazzo Antici Mattei. . . .* Rome: Centro Studi Americani, 1984.

Le Pittore Antiche d'Ercolano. Naples: La Regia Stamperia, 1762.

Plon, Eugene. *Thorvaldsen: His Life and Works*. Translated by Mrs. Cashel Hoey. London: Richard Bentley & Son, 1874.

Plowden, Helen Haseltine. *William Stanley Haseltine: Sea and Landscape Painter*. London: F. Muller, 1947.

Plutarch. *Plutarch's Lives*. Translated by John Langhorne and William Langhorne. New York: Harper, 1872.

Poe, Edgar Allan. *Collected Works of Edgar Allan Poe*. Edited by Thomas Olive Mabbott. 3 vols. Cambridge, Mass.: Harvard University Press, 1969.

Praz, Mario. *Antonio Canova: L'Opera completa*. Milan: Rizzoli, 1976.

Preyer, Robert O. "Breaking Out: The English Assimilation of Continental Thought in Nineteenth-Century Rome." *Browning Institute Studies* 12 (1984): 53–72.

Prezzolini, Giuseppe. *Come gli Americani scoprirono l'Italia: 1750–1850*. 1933. Exp. ed. Bologna: Boni, 1971.

Price, General Samuel Woodson. *The Old Masters of the Bluegrass*. Louisville, Ky.: John P. Morton, 1902.

Prime, S. I. *The Life of Samuel F. B. Morse*. New York: D. Appleton, 1875.

Procacci, Giuliano. *History of the Italian People*. Translated by Anthony Paul. New York: Harper & Row, 1970.

Prodo, Michael. *The Critical Historians of Art*. New Haven: Yale University Press, 1982.

Proske, Beatrice Gilman. *Brookgreen Gardens Sculpture*. 1943. Rev. and enl. ed. Murrells Inlet, S.C.: Brookgreen Gardens, 1968.

———. "Horatio Greenough's *Bacchus*." *American Art Journal* 6 (May 1974): 35–38.

Prown, Jules David. *John Singleton Copley*. 2 vols. Cambridge, Mass.: Harvard University Press, 1966.

Quennell, Peter. *The Colosseum*. New York: Newsweek, 1971.

Quick, Michael. *American Expatriate Artists: Painters of the Late Nineteenth Century*. Exhibition catalogue. Dayton, Ohio: Dayton Art Institute, 1976.

Quinn, Arthur Hobson. *A History of the American Drama from the Beginning to the Civil War.* 1923. 2d ed. New York: F. S. Crofts, 1943.

———. *A History of the American Drama from the Civil War to the Present Day.* 1927. Rev. ed. New York: F. S. Crofts, 1936.

Quinn, Vincent. *Hilda Doolittle (H. D.).* New York: Twayne, 1967.

Radius, Emilio. *L'Opera completa di Ingres.* Milan: Rizzoli, 1968.

Ramirez, Jan Seidler. "A Critical Reappraisal of the Career of William Wetmore Story (1819–1895), American Sculptor and Man of Letters." Ph.D. diss., Boston University, 1985.

———. "William Wetmore Story's *Venus Anadyomene* and *Bacchus:* A Context for Reevaluation." *American Art Journal* 14 (1982): 32–41.

Ratcliff, Carter. "Allston and the Historic Landscape." *Art in America* 68 (October 1980): 97–104.

Real Museo Borbonico. 2 vols. Naples: La Stamperia Reale, 1824.

Reinhold, Meyer. *Classica Americana: The Greek and Roman Heritage in the United States.* Detroit: Wayne State University Press, 1984.

Review of *Art Hints* (Jarves). *Crayon* 2 (1855): 101–04.

Review of *Leaves of Grass. Crayon* 3 (1856): 30–32.

Reynolds, Donald Martin. *Hiram Powers and His Ideal Sculpture.* New York: Garland, 1977.

———. "The 'Unveiled Soul': Hiram Powers; Embodiment of an Ideal." *Art Bulletin* 59 (1977): 394–414.

Richardson, Edgar P. *Washington Allston.* 1948. Reprint. New York: Thomas Y. Crowell, 1967.

Richardson, Edgar P., and Otto Wittmann. *Travelers in Arcadia: American Artists in Italy, 1830–1875.* Detroit: Detroit Institute of Art, 1951.

Richardson, Robert D. *Myth and Literature in the American Renaissance.* Bloomington: Indiana University Press, 1978.

Richman, Michael. *Daniel Chester French: An American Sculptor.* New York: Metropolitan Museum of Art, 1976.

———. "The Early Public Sculpture of Daniel Chester French." *American Art Journal* 4 (November 1972): 96–115.

Richter, Gisela. *A Handbook of Greek Art.* 6th ed. London: Phaidon, 1969.

Riencourt, Amaury de. *The Coming Caesars.* New York: Coward-McCann, 1957.

Rimmer, William. *Art Anatomy.* 2d ed. New York: Houghton Mifflin, 1884.

Rivas, Michele. *Les Ècrivains anglais et americains a Rome et l'image litteraire de la societé romaine contemporaine de 1800 à 1870.* Paris: Université de la Sorbonne Nouvelle, Atelier National de Reproduction des Thèses, 1979.

Rogers, Millard F., Jr. *Randolph Rogers: American Sculptor in Rome.* Amherst: University of Massachusetts Press, 1971.

Rosenblum, Robert. *Transformations in the Late Eighteenth Century.* Princeton: Princeton University Press, 1967.

Rosenthal, Deborah. "Alfred Russell's 'La Rue de Nevers.'" *Arts Magazine* 52 (January 1978): 142–44.

Ross, Marion Chauncey, and Anna Wells Rutledge. *A Catalogue of the Works of William Henry Rinehart, Maryland Sculptor 1825–1874.* Baltimore: Peabody Institute and Walters Art Gallery, 1948.

Rossini, Luigi. *Luigi Rossini Incisore: Vedute di Roma 1817–1850.* Rome: Multigrafica Editrice, 1982.

Röthlisberger, Marcel. *Claude Lorrain: The Paintings.* 2 vols. New Haven: Yale University Press, 1961.

Rubin, James Henry. "'Endymion's Dream' as a Myth of Romantic Inspiration." *Art Quarterly*, n.s. 1, no. 2 (Spring 1978): 47–84.

Rusk, William S. *William Henry Rinehart, Sculptor.* Baltimore: Norman T. R. Munder, 1939.

Russell, H. Diane. *Claude Lorrain 1600–1682.* New York: Braziller with National Gallery of Art, Washington, 1982.

Rustengberg, Leona. "Documents: Margaret Fuller's Roman Diary." *Journal of Modern History* 12 (1940): 209–70.

Rutledge, Anna Wells, ed. *The Pennsylvania Academy of the Fine Arts, 1807–1870; The Society of Artists, 1800–1814; The Artists' Fund Society, 1835–1845.* Philadelphia: American Philosophical Society, 1955.

Saint-Gaudens, Augustus. *The Reminiscences of Augustus Saint-Gaudens.* Edited by Homer Saint-Gaudens. 2 vols. London: Andrew Melrose, 1913.

Salomone, A. W. "The 19th Century Discovery of Italy: An Essay in American Cultural History; Prolegomena to a Historiographical Problem." *American Historical Review* 73 (June 1968): 1359–91.

Sanford, Charles L. *The Quest for Paradise: Europe and the American Imagination.* Urbana: University of Illinois Press, 1961.

Sanford Robinson Gifford 1823–1880. Austin: Art Museum at the University of Texas, Austin, 1970.

Sapir, Richard Ben. *The Far Arena.* New York: Seaview Books, 1978.

Schauffler, Robert Haven, ed. *Through Italy with the Poets.* New York: Moffat, Yard, 1908.

Scudder, Janet. *Modelling My Life.* New York: Harcourt, Brace, 1925.

Sculpture in Our Time. Detroit: Detroit Institute of Arts, 1959.

Sculpture of a City: Philadelphia's Treasures in Bronze and Stone. New York: Walker, 1974.

Sealts, Martin M., Jr. *Melville as Lecturer.* Cambridge, Mass.: Harvard University Press, 1957.

Sedgwick, Catherine Maria. *Letters from Abroad to Kindred at Home.* 2 vols. New York: Harper & Brothers, 1841.

Seznec, Jean. *The Survival of the Pagan Gods: The Mythological Tradition and Its Place in Renaissance Humanism and Art.* Translated by Barbara F. Sessions. New York: Pantheon, 1953.

Sharp, Lewis I. "John Quincy Adams Ward: Historical and Contemporary Influence." *American Art Journal* 4 (November 1972): 71–83.

Shaw, Peter. *The Character of John Adams.* Chapel Hill: University of North Carolina Press, 1976.

[Sloan, James]. *Rambles in Italy in the Years 1816–17, by an American.* Baltimore: N. G. Maxwell, 1818.

Somkin, Frederick. *Unquiet Eagle: Memory and Desire in the Idea of American Freedom 1819–1866.* Ithaca: Cornell University Press, 1967.

Soria, Regina. *Dictionary of Nineteenth-Century American Artists in Italy 1760–1914.* E. Brunswick, N.J.: Associated University Presses and Fairleigh Dickinson University Press, 1982.

―――. *Elihu Vedder: American Visionary Artist in Rome.* Rutherford, N.J.: Fairleigh Dickinson University Press, 1970.

————. "Some Background Notes for Elihu Vedder's 'Cumaen Sibyl' and 'Young Marsyas.'" *Art Quarterly* 23 (1960): 71–87.

Souchal, François. *French Sculptors of the Seventeenth and Eighteenth Centuries.* 2 vols. New York: Cassirer, 1977, 1981.

Spassky, Natalie. *American Paintings in the Metropolitan Museum of Art.* Vol. 2, *Painters Born between 1816 and 1845.* New York: Metropolitan Museum of Art, 1985.

Spini, Giorgio. *Italia e America dal settecento all'etá dell'imperialismo.* Rome: Marsilio, 1976.

Starke, Mariana. *Travels in Europe.* 1800, 1820. 9th ed. Paris: A. & W. Galignani, 1839.

Stebbins, Theodore E., Jr., Carol Troyen, and Trevor J. Fairbrother. *A New World: Masterpieces of American Painting 1760–1910.* Boston: Museum of Fine Arts, 1983.

Stechow, Wolfgang. *Dutch Landscape Painting of the Seventeenth Century.* London: Phaidon, 1966.

Steegmuller, Francis. *The Two Lives of James Jackson Jarves.* New Haven: Yale University Press, 1951.

Stein, Roger. *John Ruskin and Aesthetic Thought in America.* Cambridge, Mass.: Harvard University Press, 1967.

Stendhal [Marie Henri Beyle]. *A Roman Journal.* Edited and translated by Haakon Chevalier. New York: Orion, 1957.

Stevens, Wallace. *The Collected Poems.* New York: Knopf, 1954.

Stillman, William James. *Venus and Apollo in Painting and Sculpture.* London: Bliss, Sands, 1897.

Story, William Wetmore. *Excursions in Art and Literature.* Boston: Houghton Mifflin, 1891.

————. *Graffiti d'Italia.* Edinburgh: Blackwood, 1868.

————. *Nero.* Edinburgh: Blackwood, 1875.

————. *Poems.* 2 vols. Boston: Houghton Mifflin, 1886.

————. *Roba di Roma.* 1855. 2 vols. 8th ed. 1877. 13th ed. Boston: Houghton Mifflin, 1887.

Strout, Cushing. *American Image of the Old World.* New York: Harper & Row, 1963.

Strout, Cushing, ed. *Intellectual History in America.* 2 vols. New York: Harper & Row, 1968.

Sumner, Charles. "Crawford's Orpheus." *United States Magazine and Democratic Review* 12 (May 1843): 451–55.

————. *Memoir and Letters of Charles Sumner.* Edited by Edward L. Pierce. 2 vols. Boston: Roberts Brothers, 1877.

Swan, Mabel Munson. *The Athenaeum Gallery 1827–1873.* Boston: Boston Athenaeum, 1940.

Swann, Thomas Burnett. *The Classical World of H. D.* Lincoln: University of Nebraska Press, 1962.

Swedenborg, Emanuel. *Heaven and Its Wonders and Hell: From Things Heard and Seen.* 1758. Translated by J. C. Ager. New York: Swedenborg Foundation, 1960.

Tacitus. *The Annals of Imperial Rome.* Translated by Michael Grant. Baltimore: Penguin, 1956.

Taft, Kendall B. "Adam and Eve in America." *Art Quarterly* 23 (1960): 171–79.

Taft, Lorado. *History of American Sculpture.* 1903. Rev. ed. 1924. Reprint. New York: Arno Press, 1969.

Taine, Hippolyte. *Italy: Rome and Naples.* 1868. Translated by J. Durand. 4th ed. New York: Henry Holt, 1889.

Talbot, William S. *Jasper F. Cropsey 1823–1900*. New York: Garland, 1977.

———. *Jasper Francis Cropsey*. Washington: Smithsonian, 1970.

Taylor, Bayard. *Views A-Foot, or Europe Seen, with Knapsack and Staff*. 2d ed. New York: A. L. Burt, 1848.

Taylor, Joshua C. *William Page: The American Titian*. Chicago: University of Chicago Press, 1957.

Taylor, Joshua C., Jane Dillenberger, Richard Murray, and Regina Soria. *Perceptions and Evocations: The Art of Elihu Vedder*. Washington: Smithsonian, 1979.

Tharp, Louise Hall. *Saint-Gaudens and the Gilded Age*. Boston: Little, Brown, 1969.

Thorne, Thomas. "America's Earliest Nude?" *William and Mary Quarterly* 6 (October 1949): 565–68.

Thorp, Margaret Farand. *The Literary Sculptors*. Durham, N.C.: Duke University Press, 1965.

Ticknor, George. *Life, Letters, and Journals of George Ticknor*. 2 vols. Edited by George S. Hillard and Anna Ticknor. Boston: Osgood, 1876.

Tocqueville, Alexis de. *Democracy in America*. 1835, 1840. Translated by Henry Reeve. Edited by Phillips Bradley. 2 vols. New York: Knopf, 1945.

Topliff, Samuel. *Topliff's Travels: Letters from Abroad in the Years 1828–9*. Boston: Boston Athenaeum, 1906.

Troyen, Carol. *A Private Eye . . . The Stebbins Collection*. Huntington, N.Y.: Heckscher Museum, 1977.

Tuckerman, Henry T. *America and Her Commentators*. New York: Scribner's, 1864.

———. *Book of the Artists*. New York: Putnam, 1867. Reprint. New York: J. F. Carr, 1966.

———. *The Italian Sketch Book*. Philadelphia: Key & Biddle, 1835. 2d ed. enl. Boston: Light & Sterns, 1837. 3d ed. rev. and enl. New York: J. C. Riker, 1848.

———. *A Memorial of Horatio Greenough*. 1853. Reprint. New York: Benjamin Blom, 1968.

———. *Poems*. Boston: Ticknor, Reed & Fields, 1851.

Twain, Mark [Samuel Langhorne Clemens]. *The Complete Travel Books of Mark Twain: The Later Works*. Edited by Charles Neider. Garden City, N.Y.: Doubleday, 1967.

———. *The Innocents Abroad*. 1869. Reprint. 2 vols. New York: Harper & Row, 1911.

Valentine, Lucia, and Alan Valentine. *The American Academy in Rome, 1894–1969*. Charlottesville: University of Virginia Press, 1973.

Vanderbilt, Kermit. *Charles Eliot Norton: Apostle of Culture in a Democracy*. Cambridge, Mass.: Harvard University Press, 1959.

[Vanderlyn, John?]. *Description of the Pictures of Caius Marius and Ariadne Painted by J. Vanderlyn*. N.p., n.d.

Van Rensselaer, Mariana. Introduction to *The Book of American Figure Painters*. Philadelphia: N.p., 1886.

Vasi, Mariano. *Itinerario istruttivo da Roma a Napoli e delle sue vicinanze*. Rome: N.p., 1816.

———. *New Guide of Rome, Naples and Their Environs*. Rome: N.p., 1844.

Vedder, Elihu. *The Digressions of V*. Boston: Houghton Mifflin, 1910.

Vermeule, Cornelius. "America's Neoclassic Sculptors: Fallen Angels Resurrected." *Antiques* 102 (November 1972): 868–75.

———. *European Art and the Classical Past*. Cambridge, Mass.: Harvard University Press, 1964.

Vickery, John B. *The Literary Impact of the Golden Bough*. Princeton: Princeton University Press, 1973.

Vidal, Gore. *Julian.* 2d ed. New York: New American Library, 1965.

———. "The Ruins of Washington." *New York Review of Books,* 29 April 1982, p. 10.

Visconti, Giambattista, and Ennio Quirino Visconti. *Il Museo Pio Clementino.* 2 vols. Milan: Nicolo Bettoni, 1818.

Wallach, Alan. "Cole, Byron, and the *Course of Empire.*" *Art Bulletin* 50 (December 1968): 375–79.

Waller, Susan. "The Artist, the Writer, and the Queen: Hosmer, Jameson, and Zenobia." *Woman's Art Journal* 4 (Spring-Summer 1983): 21–29.

Ware, William. *The Antiquity and Revival of Unitarian Christianity.* Boston: American Unitarian Association, 1831.

———. *Probus, or, Rome in the Third Century.* 2 vols. New York: C. S. Francis, 1838.

———. *Sketches of European Capitals.* Boston: Phillips, Sampson, 1851.

———. *Zenobia.* 2 vols. Boston: J. H. Francis, 1838.

Wasserman, Jeanne, ed. *Metamorphoses in Nineteenth-Century American Sculpture.* Cambridge, Mass.: Fogg Art Museum, 1975.

Weir, Irene. *Robert W. Weir, Artist.* New York: Field-Doubleday, 1947.

Weiss, Ila. *Sanford Robinson Gifford.* New York: Garland, 1977.

Wendell, William G. "Edward Sheffield Bartholomew, Sculptor." *Wadsworth Atheneum Bulletin,* Winter 1962, pp. 1–18.

Wermuth, Paul C. *Bayard Taylor.* New York: Twayne, 1973.

Werner, Alfred. *Inness Landscapes.* New York: Watson-Guptill, 1973.

Whiting, Lilian. "The Art of Franklin Simmons." *International Studio* 25 (May 1905): lii–vi.

———. *Italy, the Magic Land.* Boston: Little, Brown, 1907.

Whitman, Walt. *Leaves of Grass.* Comprehensive Reader's ed. Edited by Harold W. Blodgett and Sculley Bradley. New York: W. W. Norton, 1965.

———. *Uncollected Poetry and Prose.* Edited by Emory Holloway. 2 vols. New York: Peter Smith, 1932.

———. *With Walt Whitman in Camden.* Vol. 2. Edited by Horace Traubel. New York: Mitchell Kennerly, 1915.

Whittier, John Greenleaf. *Complete Poetical Works of John Greenleaf Whittier.* Boston: Houghton Mifflin, 1894.

Wick, Wendy. *George Washington, An American Icon: Eighteenth-Century Graphic Portraits.* Washington: Smithsonian, 1982.

Wilder, Thornton. *The Ides of March.* New York: Harper, 1948.

"William Page Papers." *Journal of the Archives of American Art* 19 (1979): 7.

Williams, William Carlos. *A Voyage to Pagany.* 1928. Reprint. New York: New Directions, 1970.

Willis, Nathaniel P. *Dashes at Life with a Free Pencil.* New York: Burgess, 1845.

———. *Pencillings by the Way.* 1835. New York: Scribner's, 1852.

———. *The Poetical Works.* London: Routledge, 1850.

Wills, Garry. *Cincinnatus: George Washington and the Enlightenment.* Garden City, N.Y.: Doubleday, 1984.

Wilmerding, John, ed. *The Genius of American Painting.* New York: William Morrow, 1973.

Wilmerding, John, Lynda Ayres, and Earl A. Powell. *An American Perspective: 19th Century American Art from the Ganz Collection.* Washington, D.C.: National Gallery of Art, 1981.

Wilsher, Ann. "Tauchnitz 'Marble Faun.'" *History of Photography* 4 (January 1980): 61–66.

Wilton-Ely, John. *The Mind and Art of Giovanni Battista Piranesi.* London: Thames & Hudson, 1978.

Winckelmann, Johann Joachim. *History of Ancient Art.* Translated by George Henry Lodge. 4 vols. in 2. 1849, 1873. Reprint. New York: Frederick Ungar, 1968.

————. *Winckelmann: Writings on Art.* Edited by David Irwin. London: Phaidon, 1972.

Wittman, Otto, Jr. "Americans in Italy." *College Art Journal* 17 (1958): 284–93.

————. "The Attraction of Italy for American Painters." *Antiques* 85 (May 1964): 552–56.

————. "The Italian Experience (American Artists in Italy 1830–1875)." *American Quarterly* 4 (1952): 3–15.

Wolf, Bryan Jay. *Romantic Re-Vision: Culture and Consciousness in Nineteenth Century American Painting and Literature.* Chicago: University of Chicago Press, 1983.

Wölfflin, Heinrich. *Principles of Art History: The Problem of the Development of Style in Later Art.* Translated by M. D. Hottinger. 1932. Reprint. New York: Dover, 1950.

Woodress, James L. *Howells and Italy.* Durham: University of North Carolina Press, 1952.

Wright, Nathalia. *American Novelists in Italy: The Discoverers: Allston to James.* Philadelphia: University of Pennsylvania Press, 1965.

————. *Horatio Greenough: The First American Sculptor.* Philadelphia: University of Pennsylvania Press, 1963.

————. "Horatio Greenough's Roman Sketchbook." *Art Quarterly* 26 (1963): 323–32.

Zafran, Eric. "Edwin H. Blashfield: Motifs of the American Renaissance." *Arts Magazine* 54 (November 1979): 149–51.

Index

Figures in bold indicate volume II.

Pius IX, Pope (*continued*)
cans, **34–36, 39, 40, 43, 48, 129–30, 221;** diplomatic relations with America, **36, 203, 204;** and First Vatican Council, **37–39;** retreat to the Vatican after 1870, **39,** 209–10, 222, 223, 224; death, **41,** 224, 248; liberalism, **110–12, 120–25, 130–31,** 153, 204, 206; restoration, **139, 140, 196, 198–99, 200, 221;** and beggars, **166;** and the aristocracy, **288**
Pius X, Pope, **41, 44, 45, 46, 69, 281, 288, 293**
Pius XI, Pope, **19, 46–48, 50, 66, 67, 68, 323, 332, 335, 337, 342, 343**
Pius XII, Pope, 58, 64, 65; Mariolatry, **18;** described by Americans, **50–53, 55, 57, 67, 68–71,** 366; and Fascism, **348, 351–52;** during World War II, **70–71,** 356, **370, 371, 372, 382**
Plato, 300
Plowden, Helen Haseltine, **226–27, 269–70**
Plumptre, E. H., 356
Plutarch, 12
Poe, Edgar Allan, 59, 61, 168, 232; "The Coliseum," 60
Political repression, **113–14, 118, 135, 137, 141, 191–92, 194, 195,** 315, **349, 369–71, 374–76.** *See also* Censorship; Prisons
Polk, Antoinette, **221**
Pollock, John, **384**
Pompey, tomb of, 77
Ponte Molle, 138
Ponte St. Angelo, **116**
Ponte Sisto, **302**
Porta Maggiore, **381, 383**
Porta Pia, **208, 209, 383**
Porta Pinciana, **209, 370**
Porta del Popolo, **32**
Porta San Giovanni, **383**
Porta San Pancrazio, **105, 106, 302**
Porta San Paolo, **368, 383**
Porta San Sebastiano, 73, **383**
Portico of Octavia, *154,* **154–55**
Positano, **433, 434**
Pound, Ezra, 2, **311, 316–17, 340, 364–65**
Poussin, Nicolas, 17, 85, 90, 97, 132, **439**
—works: *Bacchanal before a Herm* 97,

99; *Et in Arcadia Ego* (1630), 146, 147, 150; *Et in Arcadia Ego* (1650), 146, 148–49, *149; Kingdom of Flora,* 97, 98; *Landscape with a Man Washing His Feet at a Fountain,* 108; *Landscape with Orpheus and Eurydice,* 108, *110; Venus and Adonis,* 215, 216, 217
Powers, Hiram, 211, 227, 342; in Rome, 18, 189; on John Gibson, 191; on classical sculpture, 198, 298, 392; and female nudes, 207, 208–09, 233, 235, 237–39, 241, 389; and the *Venus de' Medici,* 207, 208–09, 243; Swedenborgianism, 238; practicality, 321, 324; and male nudes, 328; social attitudes, **109**
—works: *America,* 239, 258; *California,* 239; *Diana,* 258, 259; *Eve Disconsolate,* 238; *Eve Tempted,* 235, 236, 237, 238, 320; *Fisher Boy,* 320, 321–22, 322, 324, 384; *General Andrew Jackson,* 18, *19,* 188, 190; *Greek Slave,* 233, 234, 235, 237–41, 243, 258, 321, 322; *Proserpine,* 209, 259–60, 260, 321
Pratt, Bela, 355
Praxiteles, 251; *Faun in Repose,* 116, *117,* 285, 288, 300, 313, 316–17; *Knidian Venus,* 200, 202, 233, 235, 251, 282
Praz, Mario, **367**
Pre-Raphaelites, 73, 256
Prendergast, Maurice B.: *Pincian Hill, Afternoon,* **265, 267,** 267, **pl. 6;** *The Roman Campagna,* **267, 268, pl. 5**
Priests. *See* Clergy; Jesuits
Prisons, **166–67.** *See also* Castel Sant' Angelo; Crime; Regina Coeli
Prohibition, **334**
Prostitution, **151, 152,** 203, 223, **360, 388, 389, 396, 400.** *See also* Sexuality
Protestant Cemetery, **210–11, 275, 277, 280, 281, 305**
Protestant Church. *See* American Church in Rome
Protestantism, and art, 195–96, 197
Pudicitia (Livia), 245, 246
Pyramid of Caius Cestius, **210, 430**

Quennell, Peter, **176**

Racism, and the classical ideal, 335, 338–39. *See also* Character, Italian; Slavery